# African Zion

## the sacred art of ethiopia

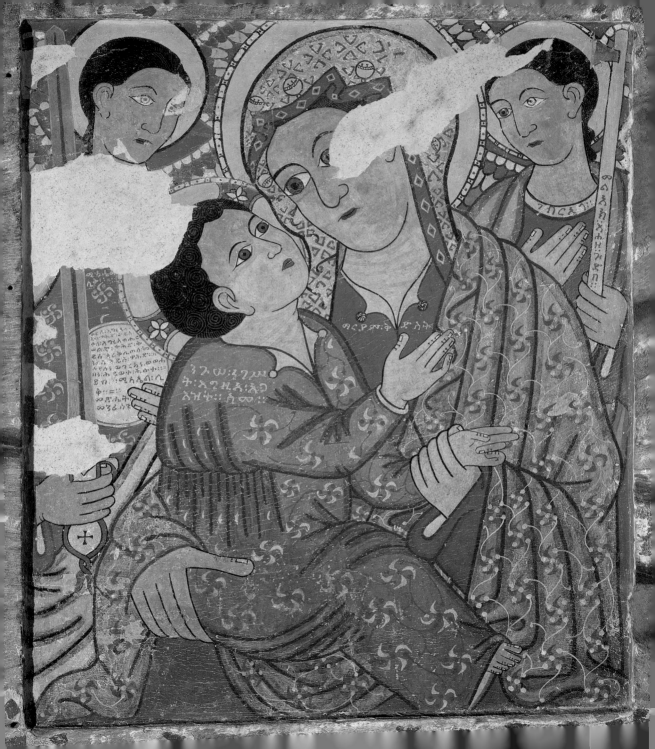

# african zion

## the sacred art of ethiopia

*Catalogue by*
Marilyn Heldman
with Stuart C. Munro-Hay

*Essays by*
Donald E. Crummey, Roderick Grierson,
Getatchew Haile, Richard Pankhurst, Taddesse Tamrat,
Siegbert Uhlig, and Carla Zanotti-Eman

*Edited by*
Roderick Grierson

Yale University Press, New Haven and London
*in association with*
InterCultura, Fort Worth
The Walters Art Gallery, Baltimore
The Institute of Ethiopian Studies, Addis Ababa

*Frontispiece*   *Our Lady Mary with Her Beloved Son and Archangels*
(cat. 6), 1445–80, private collection

*Cover illustrations*

FRONT   *Our Lady Mary, Apostles, Saint George,*
          *and Saint Theodore* (cat. 4), 1445–80,
          Institute of Ethiopian Studies, Addis Ababa

BACK    Processional Cross (cat. 114), 1730–55,
          Institute of Ethiopian Studies, Addis Ababa

Catalogue produced and distributed by
Yale University Press, New Haven and London

Designed by Gillian Malpass
Edited by Robin Jacobson and Toni Rosenberg
Set in Linotron Bembo by Servis Filmsetting Ltd, Manchester
Printed in Italy by Amilcare Pizzi, S.p.A., Milan

Library of Congress Catalog Card Number: 93-60835
A catalogue record for this book is available from the British Library

ISBN 0 300 05819 5 (hardback)
ISBN 0 300 05915 9 (paperback)

This catalogue was first published on the occasion of the exhibition
"African Zion: The Sacred Art of Ethiopia"

The Walters Art Gallery, Baltimore, Maryland
17 October 1993–9 January 1994

The Schomberg Center for Research in Black Culture, New York,
  New York
1 February–29 March 1994

The Menil Collection, Houston, Texas
21 April–19 June 1994

Museum of African American Life and Culture, Dallas, Texas
28 September–30 November 1994

Dusable Museum of African American History, Chicago, Illinois
23 December 1994–26 February 1995

The Chrysler Museum, Norfolk, Virginia
7 June–2 August 1995

California Afro-American Museum, Los Angeles, California
25 September–20 October 1995

The Cleveland Museum of Art, Cleveland, Ohio
14 November 1995–1 January 1996

*Editorial Note* The research of this catalogue is the collaborative
effort of scholars from the United States, Great Britain, Germany,
Ethiopia, and Italy. These scholars used research materials from
French, German, Italian, and Ethiopic sources. Especially in the
absence of any internationally agreed system of transliteration, this
has created inconsistencies in spellings for locations and historical
names which could not be resolved within the deadlines of an
exhibition catalogue. Apologies are made for any confusion that this
may create for the reader.

# CONTENTS

# CONTENTS

# PREFACE

INTERCULTURA IS PLEASED TO BRING to the United States "African Zion: The Sacred Art of Ethiopia," a comprehensive exhibition of Christian art from the Orthodox Church. This exhibition moves to the forefront the accomplishments of Ethiopia, a nation with a rich multicultural heritage that at times has been overshadowed by the political and societal events in the southern and western regions of the continent. The project seeks to expand our understanding of the Ethiopian achievement in the context of historical African diversity. It is significant to note that, although many Westerners assume Christianity came to Africa through a legacy of colonialism or slavery, there is compelling evidence to verify the existence of Christian belief on the continent in ancient times. The origins of the Ethiopian Orthodox Church, which are at once Semitic and Christian, date from the fourth century A.D. This duality of religious traditions emphasizes the diversity of influences in Ethiopian Christianity: the legend of Solomon and Sheba, and the associated Judaic customs; the ancient Egyptian Coptic heritage; and, especially in the seventeenth century, the European influence of Roman Catholicism.

It is with projects such as "African Zion" that InterCultura seeks to fulfill its mission of international cultural exchange through museum exhibitions. There is a movement today in the United States toward maintaining the diversity of our varied cultures, instead of subscribing to the notion of a cultural melting pot. It is, therefore, increasingly important that we understand one another's view of the world and cultivate an awareness of the historical and cultural components of our own perceptions.

This exhibition has been in the planning stages for a number of years, and many people have made significant contributions to the project. I would like to thank Roderick Grierson, one of our founders, who worked tirelessly to bring the project to fruition. Richard Pankhurst, of the Institute of Ethiopian Studies in Addis Ababa, has been an invaluable partner. Marilyn Heldman, Visiting Associate Professor in the Department of Art, University of Missouri, Saint Louis, provided curatorial expertise in the selection of the objects in the exhibition as well as in her contributions to this catalogue.

It has been a privilege to work with our partners, Robert P. Bergman and Gary Vikan of the Walters Art Gallery, in the realization of this project. The exhibition would have been impossible without the generous support of the National Endowment for the Humanities and the National Endowment for the Arts.

James M. Bradburne devised a thoughtful interpretative audiovisual to accompany the exhibition, and Manuel Theodore was generous with his expertise in the conservation of icons and in establishing criteria for the safest possible conditions for the objects in travel and installation.

In addition to Roderick Grierson, Marilyn Heldman, and Richard Pankhurst, other experts generously participated with essays for this catalogue, including Donald Crummey, Getatchew Haile, Stuart Munro-Hay, Taddesse Tamrat, Siegbert Uhlig, and Carla Zanotti-Eman.

We are grateful to the Institute of Ethiopian Studies and the Ethiopian Orthodox Church for their generous support as the major lenders to the exhibition. InterCultura owes thanks as well, to all other lenders in this exhibition. It is our hope that, through their participation, audiences in the United States and beyond will gain a deeper understanding and appreciation of the Ethiopian tradition as it relates to the perceptions of diversity in out day-to-day lives.

Margaret L. Booher
Executive Director, InterCultura

# ACKNOWLEDGMENTS

THE EXHIBITION AND THE CATALOGUE that accompanies it were conceived during conversations with Richard Pankhurst in the library of the Royal Asiatic Society, and then planned at the British Library during the summer months Dr. Pankhurst spent in London away from the great rains of East Africa. Many books on Ethiopia have begun with expressions of gratitude to one or other of three generations of Pankhursts who have devoted their lives to the study of this extraordinary country, and the present catalogue is no exception.

At the First International Conference on the History of Ethiopian Art, organized by Dr. Pankhurst at the Warburg Institute under the auspices of the Royal Asiatic Society, and again at the Tenth International Conference of Ethiopian Studies in Paris, I had the opportunity to meet both Stanislaw Chojnacki and Marilyn Heldman, who have made such distinguished contributions to our understanding of the Ethiopian achievement. As the first curator of the Institute of Ethiopian Studies, Dr. Chojnacki performed an invaluable service by assembling and publishing many of the most important objects in the exhibition, and as the leading American historian of Ethiopian art, Dr. Heldman has done more than anyone to establish its study as a discipline alongside Coptic, Syrian, or Armenian art history, recognized as an integral part of international Byzantine culture.

The other contributors to the catalogue and members of the advisory committee have also been ideal colleagues with whom to work, and during the past months have provided a constant source of inspiration, despite being scattered across three continents. I am especially grateful to Stuart Munro-Hay, whose advice on South Arabian, Aksumite, and a host of other questions has been invaluable.

The enthusiastic collaboration of the director of the Institute of Ethiopian Studies, Bahru Zewde, and of the curator, Girma Kidane, has been essential at every stage of the project, as has that of Gary Vikan, assistant director at The Walters Art Gallery, whose advice and support throughout the organization of the exhibition and the catalogue have been both acute and generous. Without these individuals and the institutions they and their colleagues serve so ably, the project would obviously have been impossible.

Margaret Lorimer Booher achieved that most difficult of compromises, sensitive and efficient administration, and her appointment as executive director of InterCultura at a crucial moment made an enormous contribution to the success of the project. Her colleagues in Fort Worth, Lori al-Aqqad, Melanie Benjamin, Sherri MacNelly, and Sarah Voelker, provided an excellent foundation for such a complex undertaking, while the energy and skill of Marcus Sloan in coordinating the production of the catalogue with Yale University Press, as well as arranging a host of other details, deserve special recognition. Our copyeditors, Robin Jacobson and Toni Rosenberg, have labored far beyond the call of duty, and continued to make improvements to a complicated text until the last possible moment.

Without the dedication of Gillian Malpass at Yale University Press in London, the catalogue would have become extremely difficult, especially given the need to secure photographs of

objects in remote monasteries in Ethiopia. Everyone involved in the project is grateful that a catalogue could be produced to the standards of such a prestigious press under such circumstances.

The board of directors of InterCultura has continued to provide a privileged position from which to explore the diversity of the Eastern Christian heritage, despite the many other responsibilities of its program.

While the National Endowment for the Arts and the National Endowment for the Humanities provided essential funding for the exhibition, the guidance and encouragement of the staff at the endowments have also been a great support throughout the last two years.

Karen Dalton at the Menil Foundation enabled us to draw on her profound and extensive knowledge of African and African American culture, and if she had not introduced the project to her colleagues at other institutions throughout the United States, such an ambitious tour would never have become a reality. Through her, we were also able to discuss the possibility of an academic conference with Henry Louis Gates, Jr., the director of the W. E. B. Du Bois Institute at Harvard, and this valuable opportunity to explore the themes of the exhibition is due to Dr. Dalton's constant enthusiasm.

All the objects in the Institute of Ethiopian Studies, the National Library, and the collections of the Ethiopian Orthodox Church were photographed by Malcolm Varon, whose dedication to his craft has filled us all with admiration. We are also grateful to Bent Juel-Jensen, who generously provided photographs of Aksumite coins, and to Santha Faiia, who allowed us to select photographs taken for her impressive exhibition at the Royal Geographical Society.

Sam Fogg, whose offices on Bond Street themselves contain a library of rare and precious manuscripts, provided funds to prepare a photographic record of manuscripts in the British Library. Everyone who sees them during their unprecedented visit to America will be indebted to his remarkable generosity.

As with other exhibitions of medieval art organized by InterCultura, the consultant conservator Manuel Theodore ensured that rare and precious objects could travel to the United States with minimal risk.

Throughout several years of research at the British Library, Vrej Nersessian has given us complete access to every facility of this most important collection of Syriac and Ethiopic manuscripts. I am also grateful to his colleagues in other departments of the British Library, as well as to the staff at the library of the Oriental Institute at Oxford, the library of the School of Oriental and African Studies in London, the National Art Library, and the London Library. Andrew Burnett permitted extensive loans from the British Museum at very short notice, and his enthusiasm for the project has added immeasurably to its quality.

My own earliest interest in Ethiopia began as an undergraduate reading the Ethiopic text of Enoch with Matthew Black at St. Andrews, and I was then encouraged by Sebastian Brock at Oxford to continue exploring the legacy of Syrian monasticism in the highlands of Africa. My gratitude to these two scholars cannot adequately be expressed. Dreams of an Ethiopian exhibition were later shared with Milbry Polk and Dee Smith, as well as with James Bradburne, who worked so hard on the initial proposals to the National Endowments, and with whom I first saw the holy city of Lalibela.

His Holiness Abuna Paulos has inspired all of us by his devotion to the cause of Ethiopian Orthodox culture, not simply as a legacy from earlier centuries, but as a living tradition for the future. His generous provision of objects from ecclesiastical collections, and his perceptive advice concerning the catalogue, have been invaluable. It has been a unique privilege for the project to have had his blessing.

Roderick Grierson

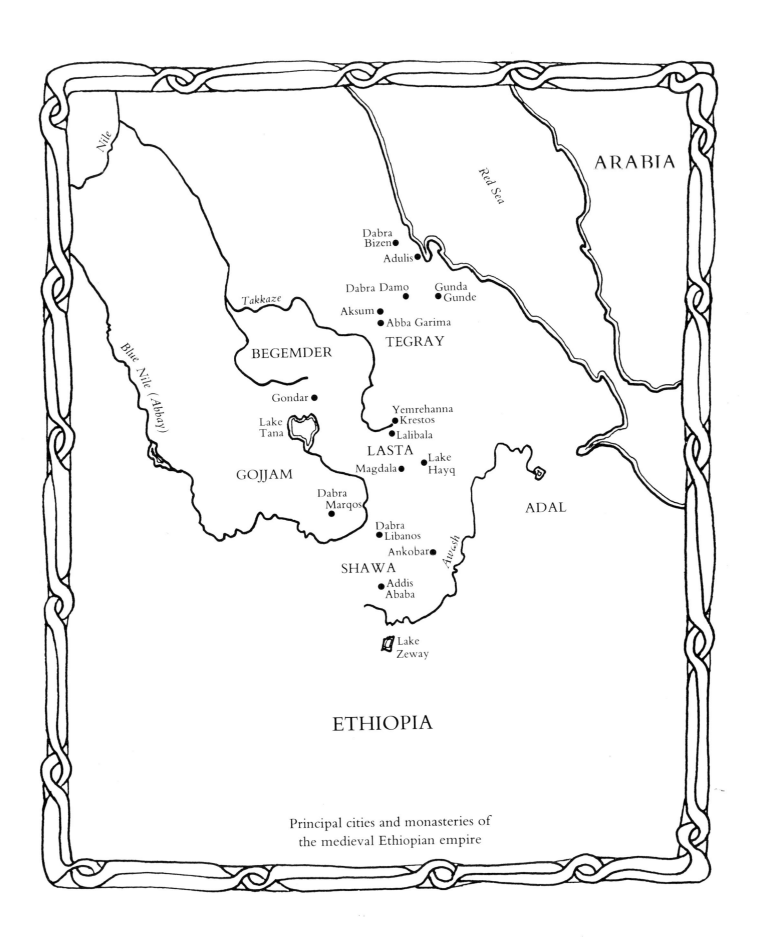

Principal cities and monasteries of
the medieval Ethiopian empire

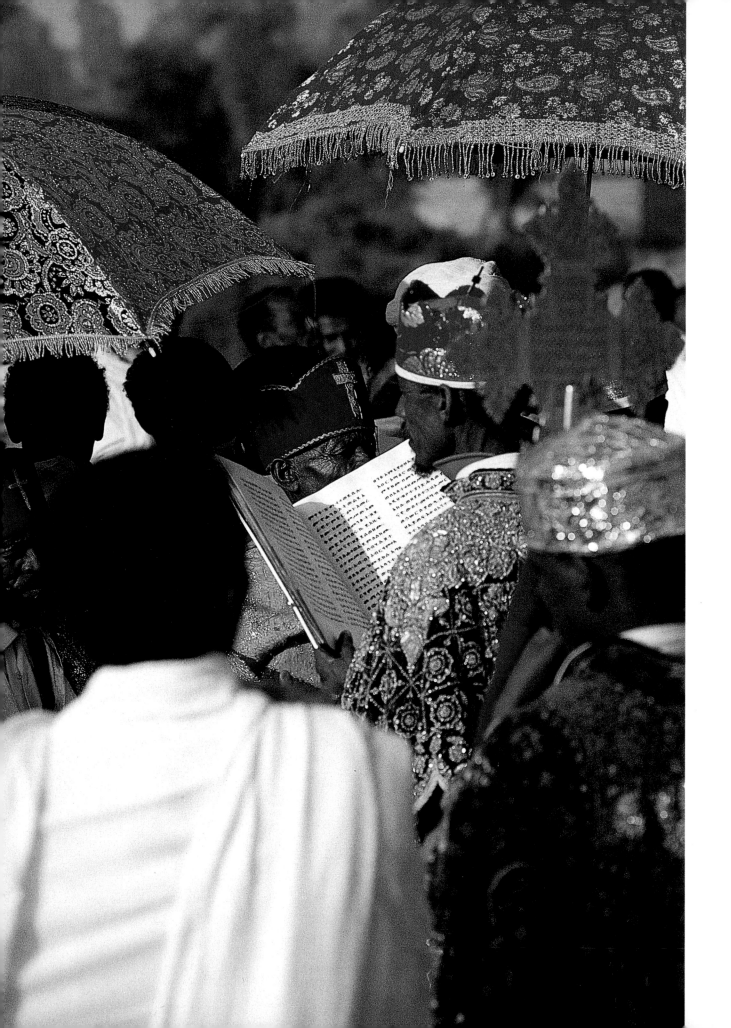

# INTRODUCTION

*Roderick Grierson*

> "It seems that we all belong, ultimately, to Africa."
> —Roland Oliver, *The African Experience*[1]

WHEN HE BEGAN HIS RECENT SURVEY of African history with the sentence quoted above, the emeritus professor of African history at the School of Oriental and African Studies was referring to the origins of the human race. The statement is increasingly seen as true in other senses as well, however, and in ways that might have seemed surprising to previous generations of Europeans or Americans. Even for those who might not accept the more extreme forms of the "Afrocentric" view of history, in which almost all of Western civilization is believed to have been an African invention,[2] the fact that humanity is deeply indebted to the achievements of African civilizations is becoming more obvious.

But with the question becoming the subject of intense political as well as academic debate, it can become all the more difficult to agree on what sort of identity an African civilization is meant to display. In the midst of such complex issues, an exhibition of Ethiopian art can not only provide us with an introduction to this unique society, it can also help us to recognize the diversity of the African achievement, a fact that is not always appreciated by those who live elsewhere.

The history of Ethiopia demands that the present exhibition address another complicated and delicate question as well as the identity of Africa, and that is the legacy of Israel, or perhaps more accurately, the enduring dream of Israel. In one of the most perceptive studies of African culture, Kwame Anthony Appiah embarks on a comparison of black and Jewish communities by observing that both have been defined in the West as possessing a political identity on the grounds of race.[3] By adopting this definition as a basis for their own assessment, he argues, black intellectuals of earlier generations allowed themselves to accept a view of the solidarity of *négritude* which effectively obscured the extraordinary diversity of the traditions found on the African continent.[4]

Such European assumptions about Africa were largely produced by the experience of colonialism and the kinds of encounters with Africa which the colonial system encouraged or permitted. They are often characterized by the kinds of destructive fantasies Edward Said has described in connection with European attitudes toward Islam.[5] In such alien cultures, to which Europeans responded with a curious mixture of condescension and fascination, the shackles of European convention could be set aside, allowing the privileged to wallow in sensual experience of a sort which the blessings of scientific rationality and Christian morality would otherwise prevent. The absurdity, and indeed the immorality, of such assumptions did not make them any less tenacious, and with each generation there has been a tendency to add still more layers to the palimpsest of our impressions of Africa. It is very difficult for us now to look at West African sculpture, for example, without recalling the experiments of the Fauves in Paris during the early years of the century.[6]

1. R. Oliver 1991: 1.
2. For a sympathetic but skeptical review of one of the leading contributions to this position (M. Bernal 1991), see J. Ray 1991.
3. K.A. Appiah 1992: 26.
4. Ibid.: 127.
5. E.W. Said 1978.
6. See, for example, New York 1985. The exhibition stimulated a lively debate in *Artforum*, *Art in America*, and other journals at the time.

*facing page:* In a religious ceremony at Aksum, a priest reads from the Bible written in the ancient Ethiopic language Geez.

I

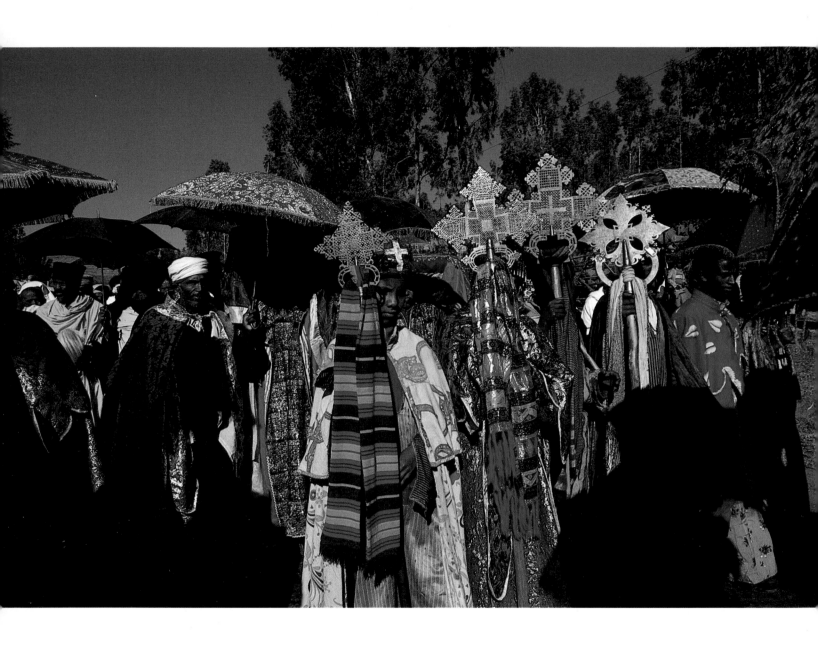

Ethiopia does not fit these illusions of Africa, however, and indeed it was not part of the colonial experience at all. The emperors of Ethiopia not only resisted European invaders, most famously at the Battle of Adwa in 1896, but even expanded their borders as European armies were marching across the continent. While a great many white intellectuals have therefore failed to find a place for Ethiopia in their dreams of Africa, the Conquering Lion of Judah has been a symbol of liberation within the black diaspora, especially since Marcus Garvey found inspiration in the Biblical verses that told of Ethiopia stretching out its hands to God, and of a king arising in Africa. Garvey became in effect the founder of a series of movements, one of the most dramatic consequences being the Rastafarianism from which the Jamaican reggae star Bob Marley emerged to become a great hero of African liberation while Nelson Mandela was still imprisoned.[7]

The present borders of Ethiopia include a range of linguistic and cultural groups so vast that a single exhibition or catalogue would be overwhelmed by them. Just as exhibitions of Coptic art focus on the Christian traditions of Egypt without necessarily including Pharaonic or Islamic objects, our Ethiopian exhibition will concentrate on the Christian empire, beginning in the third century just before the conversion of the kings of Aksum and ending with the collapse of imperial power in the eighteenth century during the Era of the Princes.

There is another similarity to exhibitions of Coptic art, in which objects are considered in much the same way as exhibitions from other parts of the Byzantine world, largely in terms of the methodologies of medieval art history, theology, or social and political history. As we move south along the Nile, however, and into regions where the complexions of the inhabitants become darker, Western academics are often tempted to think more in terms of ethnography or anthropology than art history. A surprising demonstration of this tendency could be seen during the comprehensive Coptic exhibition of 1963–64,[8] when the Austrian organizers installed the Egyptian material in the Akademie der bildenden Künste but the Nubian and Ethiopian material in the Museum für Völkerkunde.[9]

An ambitious attempt to combine these two worlds of anthropology and medieval studies could be seen last year in Paris, during the fascinating exhibition "Le roi Salomon et les maîtres du regard: Art et médecine en Éthiopie," but the result was at times confusing to Ethiopian specialists, let alone to the clergy of the Ethiopian Orthodox Church.[10] There is, after all, a great deal of difference between the court culture of the fifteenth century and the folk beliefs of the nineteenth century, and while it would be surprising if there were no connections at all between them, one must be careful not to slip too easily from one to the other.

There may be an additional problem with imposing an anthropological approach. As Adam Gopnik observed recently in a review entitled "Out of Africa," it is not so much that labels may try to tell you more than anyone really knows about Dogon culture, for example, but that they try to tell you more than the Dogon knew themselves.[11] There is obviously a delicate balance if one is attempting to explain a culture that will seem exotic to most of those who will visit an exhibition. While one must create some sort of bridge, it nevertheless seems essential that such a bridge remain firmly based in the experience of the tradition itself. The present project has been very fortunate, therefore, to rely on Ethiopian as well as European and American scholars, and it is hoped that it reflects an Ethiopian understanding of the role of Ethiopian art.

7. See H. Campbell 1987. For an introduction to the phenomenon of Bob Marley and his place within Rastafarianism, see T. White 1991.
8. Essen 1963.
9. Vienna 1964(B); Vienna 1964(A).
10. Paris 1992.
11. A. Gopnik 1993.

*facing page: Timkat* procession in Gondar (see caption on p. 5).

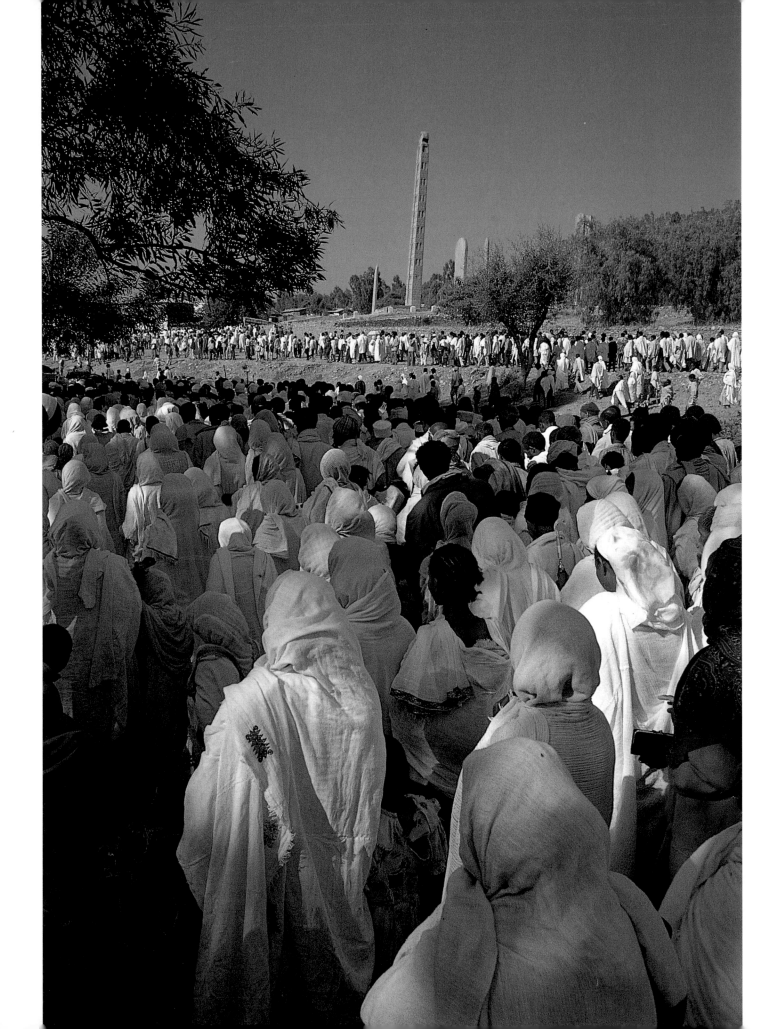

# DREAMING OF JERUSALEM

*Roderick Grierson*

"What has Athens to do with Jerusalem?"
—Tertullian, *De praescriptione*[1]

THE FAMOUS ANSWER OF Tertullian to his own question was, of course, "Nothing!" Throughout the ages, many other Christians have been tempted to agree with the stern Father of the African Church, and to try to recover a faith in which the prophetic call of Semitic religion had not been diluted by the wisdom of Greek philosophy. Two of the greatest and most traumatic events in Christian history, the Iconoclastic Controversy, which disrupted the Eastern Church in the eighth century, and the Protestant Reformation, which transformed Western Europe during the sixteenth century, both represented dramatic shifts in the direction of a Semitic legacy, whether real or imagined.[2]

Among the Eastern churches, however, there were those which actually were Semitic, the Syrians, for example, who preserved the eastern form of the Aramaic language spoken by Christ in Palestine and who mounted the most ambitious missionary program in the history of the Church. Syrian monks followed the Silk Road across the steppes of Central Asia and established Syriac as a lingua franca as far east as the China Sea.

The most intensely Semitic of these Christian societies is the Ethiopian. For most Christians, the claim to constitute the true Israel and inherit the holy city of Jerusalem became a merely eschatological hope, and only one theme among many. In Ethiopia, it became the central fact of life, in Edward Ullendorff's words, "one of the most powerful and influential national sagas in the world."[3]

Perhaps the most detailed and complex analysis of claims to the inheritance of Israel has been provided by Patricia Crone and Michael Cook in *Hagarism*, a study of the origins of the Islamic tradition as an attempt to acquire the holy city and the covenant God made with the patriarch Abraham.[4] While the authors provide a number of insights into the Oriental churches as early rivals of Islam, they have little to say about Ethiopia.[5] This is unfortunate, since the Oriental churches were invariably under the political domination of the great empires of the region: Byzantium, Sassanid Persia, and then the Arab empire and its Turkish and Persian Islamic successors. Even aside from the early Christian ambivalence toward the state, this political dispossession made the claim to any inheritance in the literal sense impossible. Ethiopia, however, was an empire, a theocracy in which Christian monarchs maintained as firm a rule as they could over Christians, Muslims, and everyone else.

In addition, the Islamic claim to inherit the promise of God is the assertion of an alternate line of descent, from Ishmael rather than from Isaac. The Ethiopian claim may involve a less radical reinterpretation but it is even more audacious. It involves the appropriation of the direct line of descent from King Solomon himself, and the assertion that the presence of God had been brought to Ethiopia in the Ark of the Covenant. This presence meant that the Ethiopian emperor ruled in a New Israel, and it gave him a preeminent position among Christian kings,

1. Tertullian, *De praescriptionne*, 7.9.
2. P. Crone 1980.
3. E. Ullendorff 1973: 64.
4. P. Crone and M. Cook 1977.
5. Ibid.: 16.

*facing page: Timkat* ceremony in Aksum. Vast crowds follow a replica of the Ark of the Covenant which is carried in solemn procession.

above even Constantine the Great, who may have possessed hundreds of relics but nothing to rival the Ark.

The Semitic inheritance in Ethiopia is a complex and diverse phenomenon, combining historical and legendary material linked with three ancient civilizations: Arabia, Israel and Syria. Attempts to unravel or reconstruct the process by which this identity arose continue to provoke a lively debate on each of these subjects.

"The kings of Arabia and Saba shall bring gifts."
—Psalm 72.8

Just as Gaul was divided into three parts in the famous words of Julius Caesar, Arabia was seen by the classical geographers as comprising three separate regions: Arabia Petraea, the rocky plains of the north; Arabia Deserta, the wilderness of sand in the vast Empty Quarter; and Arabia Felix, the blessed lands of the south, where abundant rains nourished the trees of frankincense and myrrh whose fragrance sweetened the winds of the Indian Ocean.

Incense was of vital importance in the ancient world. Not only a luxury, it served as a kind of fuel for the machinery of the gods. Without it the ancient rituals could not be performed, and from the inscriptions of the pharaohs to the last of the pagan historians of Rome we hear of the vast quantities consumed and the enormous sums of money required. The incense trade was rumored to have brought the merchants of Arabia great wealth, and the cost of purchasing incense after the long journey by ship or caravan was so onerous that a Roman army was sent into Arabia in the hopes of securing an independent supply.

As early as 1500 B.C., the reliefs carved in the great temple of Deir el Bahri near Thebes record the most famous of all ancient expeditions, the mission sent by the Eighteenth Dynasty queen Hatshepsut to the land of Punt. The reliefs depict the delight of the ancient Egyptian explorers in their discoveries: ivory, ebony, gold, date palms, giraffes, lions, cheetahs held on leashes, and baboons clambering over the rigging of the five ships as they are loaded with treasure for the queen. "Never was the like of this brought for any king who has ruled since the beginning of time."[6]

For centuries, legends of Punt had fascinated Egyptian mariners, and expeditions had set out as early as 2800 B.C. in the reign of the Fifth Dynasty pharaoh Sahure. The inscriptions of Hatshepsut maintain that Punt was known only "from mouth to mouth by hearsay of ancestors" and then make the claim "but I have led them on water and on land, to explore the waters of inaccessible channels, and I have reached the terraces of incense."[7] This would seem to have been the real goal of the expedition, and indeed the reliefs include scenes in which living incense trees are carried back to Egypt.

The precise location of Punt has remained a mystery. Frankincense and myrrh grew on both sides of the Red Sea, although in later centuries it was South Arabia that was most associated with the luxury trade of the desert. As the Greek geographer Strabo reported in the first century, "All these cities are ruled by monarchs and are prosperous, being beautifully adorned with both temples and royal palaces . . . from their trading both the Sabaeans and the Gerrhaeans have become richest of all, and they have a vast equipment of both gold and silver articles."[8]

However, the reliefs at Deir el Bahri depict giraffes, and the inscriptions refer to heavy rains in Punt causing the Nile to flood, suggesting that it must have lain on the African side, in the region of Ethiopia. There was, in any case, close contact between the two shores of the Red Sea, and sometime during the fifth century B.C. inscriptions begin to provide evidence for an Arabian presence in northern Ethiopia. The inscriptions are written in a Semitic language known as Sabaic, after the kingdom of Saba in South Arabia, and the use of the royal titles *mlkn* and *mkrb* suggest that states had arisen in Ethiopia on the South Arabian pattern.

6. N. Groom 1981: 22.
7. Ibid.
8. Strabo, *Geographia*: 16.4.19.

The Semitic languages are usually divided along geographical as well as philological lines into three main groups: Northeast, Northwest, and Southwest, the last group including Arabic, Sabaic, and the classical language of Ethiopia known as Ethiopic or Geez, from which the modern languages of Ethiopia are descended rather in the manner of the Romance languages from Latin. Sabaic and Ethiopic have often been linked, largely for historical rather than philological reasons, especially because the Ethiopian syllabary of 251 characters is usually assumed to have been developed from the ancient South Arabian alphabet. These characters were also retained in Ethiopia for monumental inscriptions in Ethiopic, producing a hybrid usually known as "pseudo-Sabaean." Even though the result would have been unintelligible to most Ethiopians and most Arabians, it may have possessed a symbolic value by demonstrating and affirming Ethiopian connections with the wealth of the ancient South Arabian kingdoms.

However, while it is generally believed that South Arabian culture was brought to Ethiopia, a controversial theory recently proposed by Jacqueline Pirenne suggests the reverse.[9] Assyrian records list the Sabaeans as a people in the north of Arabia rather than the south, and Pirenne suggests that a group of Sabaeans left northern Arabia in the eighth or seventh century B.C. as the Assyrians advanced, and fled southward. In the sixth or fifth century B.C., a second group of Sabaeans crossed the Red Sea to Ethiopia, accompanied by Hebrews escaping from Nebuchadnezzar's capture of Jerusalem. Two centuries later, they also left for South Arabia, taking with them the system of writing and the form of architecture they had developed in Africa. The proposal, though tantalizing, is difficult to assess, and as Stuart Munro-Hay has observed,[10] Dr. Pirenne gave us only a single conference paper. In any case, it would also seem possible to adopt a third position, in which Ethiopia and South Arabia are seen as comprising parts of a single Red Sea cultural area, without either side assuming a dominant position, and in fact this was suggested by Isaac and Felder at much the same time.[11] Furthermore, while objects indicating a relationship with South Arabia were once thought to demonstrate the presence of a superior colonial power, it is now recognized that most of them were likely to have been created by Ethiopians themselves, and a more careful or more subtle analysis of their significance is therefore required.

Although the epigraphic evidence begins in the fifth century B.C., there is no mention of a kingdom in Ethiopia in Greek or Latin sources until the second century A.D., when Ptolemy refers to "Aksum where the palace of the king is located."[12] Nevertheless, it is clear from earlier writers like Strabo and Pliny that a substantial export trade was already conducted from Ethiopia, not only in incense, but in ivory, rhinoceros horn, tortoise shell, apes, and slaves. A precise account of items imported and exported through the port of Adulis on the Red Sea is given in *The Periplus of the Erythraean Sea*,[13] a kind of navigational manual that is usually assumed to have been written during the first century but that may have been composed as late as the third century.[14]

The magnitude of the trade enabled a kingdom of considerable wealth to arise, ruled from the capital at Aksum. The Aksumite kings issued coinage in gold, a rare achievement that indicates not only their prosperity but also the demands of a sophisticated economy. At the time, the only other gold currencies in circulation were those of the empires of Rome, Persia, and India. The kings of Aksum also raised great stelae, some of them a hundred feet in height, the largest monolithic monuments in the ancient world. No inscriptions indicate when they were erected or why, although it is now assumed that they mark the graves of the Aksumite kings.[15] Earlier scholars have connected them with the obelisks of Egypt[16] or with the temples of India,[17] but nothing similar appears to have been erected in South Arabia. Originally the stelae seem to have borne the disc and the crescent, the symbols either of the ancient sun and moon gods of South Arabia or of the royal tutelary deity Mahrem, who was equated in bilingual inscriptions with Ares, the Greek god of war. In the fourth century A.D., however,

9. J. Pirenne 1987.
10. S.C. Munro-Hay 1990(A): 66.
11. E. Isaac and C. Felder 1984.
12. E.L. Stevenson 1932: 108.
13. G.W.B. Huntingford 1980: 20–21.
14. J. Pirenne 1961.
15. S.C. Munro-Hay 1990(A): 136.
16. B. Playne 1965: 279ff.
17. W.H. Schoff 1912: 64–65.

inscriptions of the Aksumite king Ezana replace the phrases of devotion to the pagan gods with the formulae of Christianity, and his coinage replaces the disc and the crescent with the cross.

The conversion to the new faith is confirmed by the contemporary Latin historian Rufinus,[18] who writes that a trading vessel carrying two young Syrians, Frumentius and Aedesius, stopped at one of the Red Sea ports for provisions. Owing to a treaty dispute between Rome and Aksum, the vessel was seized and all the passengers slain except for the two boys. They were taken to the king and employed at court, Frumentius becoming the royal secretary and treasurer, and after the death of the king serving as regent for his son. Conversations with visiting merchants convinced Frumentius that he should become Christian, and from his position at court he undertook the building of churches. When the young prince had grown and Frumentius had completed his regency, the two Syrians left Aksum, Aedesius for Tyre in order to see his parents, and Frumentius for Alexandria, one of the five great centers of the early Church. There he attempted to persuade the patriarch Athanasius to send a bishop to Aksum, but Athanasius consecrated Frumentius himself, proclaiming before the assembled bishops, "What other man shall we find in whom the Spirit of God is as in you, who can accomplish these things?" On his return to Aksum, Frumentius spread the faith throughout the kingdom.

In contrast to the account in Rufinus, the *Ecclesiastical History* of Philostorgius seems to assume that a certain Theophilus was responsible,[19] and indeed a variety of traditions survive about the first evangelization of the country. Both Rufinus[20] and Socrates[21] refer to Matthew, Galasios of Cyzicus prefers Bartholomew,[22] and Epiphanius of Cyprus suggests Andrew.[23] Ethiopian tradition adds a further element by mentioning twin brothers, Asbeha and Abreha, whose names seem to have been taken from two Christian heroes of the sixth century, Ella Asbeha at Aksum, and Abraha across the Red Sea in Himyar.

The conversion of Ezana is often compared to the conversion of the Roman emperor Constantine, but there is a dramatic difference. In the Roman Empire, Christianity had begun among the lower classes of a remote province and after three centuries began to win adherents among the ruling classes in the imperial capital. The conversion of Ezana seems to have been more like the conversion of Vladimir of Kiev in 988, where the conversion of the ruler began the conversion of his subjects. As a result, the church in Ethiopia was not subject to the persecutions that shaped the experience of Christians in Egypt or other parts of the Roman Empire under the pagan emperors. Nevertheless, the king seems to have felt himself to be in a delicate position, and tried to ease the transition from the old faith to the new. Inscriptions in Greek intended for a foreign audience of merchants and ambassadors are explicitly Christian, employing such phrases as "in the faith of God and the power of the Father and the Son and the Holy Ghost." At the same time, Ethiopic inscriptions refer to God as the "Lord of Heaven," an ancient Semitic title that most Ethiopians would have understood as that of a pagan deity.

The adoption of Christianity brought Aksum into the orbit of Byzantium, a diverse and complex world of shifting alliances and temporary orthodoxies. The conversion of the emperor Constantine, after a cross appeared in the sky before the fateful battle at the Milvian Bridge in 312, had transformed the status of the Christian religion. What had once been regarded as an illegal superstition that threatened the empire became the personal religion of the emperor himself, and eventually the religion of the state, consigning the pagan cults to illegality in their turn. As a Christian, Constantine found the capital of his empire polluted by pagan temples and sacrifices, and in 330 he established a new Christian capital at Constantinople, destined to survive the fall of the West to the barbarian armies by a thousand years before finally succumbing in 1453 to the Ottoman Turks.

Constantine's conversion obviously required a complete reappraisal of the significance of the empire in the Christian view of history, and the biographer of Constantine, Eusebius of Caesarea, produced a synthesis in which the emperor was proclaimed as the heir of both

18. Rufinus, *Historia ecclesiastica*: 1.9.
19. Philostorgius, *Historia ecclesiastica*: 3.6.
20. Rufinus, *Historia ecclesiastica*: 10.9.
21. Socrates, *Historia ecclesiastica*: 1.19.
22. Gelasios of Cyzicus, *Historia ecclesiastica*: 3.9.
23. T. Schermann 1907: 108–9.

Abraham and Augustus, the thirteenth apostle, representing in his person the fulfillment of Classical and Semitic traditions.

As the vicar of Christ, the emperor was believed to be responsible for the defense of the empire, which in theory extended over the entire created universe. The rulers of other kingdoms were accommodated in this system as his spiritual sons. He was also responsible for the purity of doctrine, and he summoned the great councils at which bishops debated the nature of Christ and other issues central to the faith. In a theocracy, doctrinal conformity was regarded as of great significance for the unity and health of empire, especially an empire of the size and diversity of Rome, which embraced peoples speaking Latin, Greek, Coptic, Syriac, Armenian, and a host of other languages.

During the controversy provoked in the fourth century by the North African priest Arius, who claimed that Christ was of human rather than divine nature, the emperor Constantius sent word to the Aksumite rulers Ezana and Shaizana that the consecration of Frumentius was invalid, since the patriarch Athanasius who had consecrated him was the leading opponent of the Arian doctrine to which Constantius himself subscribed.[24] While the allegiance of Aksum was to Alexandria rather than to Constantinople and the emperor's claims were ignored, the claims of religious affiliation were becoming increasingly urgent.

Along the trade routes between India and the Mediterranean, the network of kingdoms of the first and second centuries had been replaced by a superpower rivalry between the empires of Rome and Sassanid Persia, and religion was to become an important cement in the edifice of their geopolitical ambitions. When the Roman emperor sent ambassadors to bring the pagans of South Arabia into the Christian community, he discovered that Christians and Jews were already resident in the leading cities and trading centers, including Najran, which occupied a fertile oasis at the junction of the southern caravan routes. The rivalry between Jews and Christians in Najran is recounted in the *Acts of the Martyr Azqir*, which survives in an Ethiopic version.[25] The conflict erupted after the rise to power of Himyarite prince Yusuf Asar, usually known as Dhu Nuwas, a name that may mean "the Lord of the Curl" and refer to his long hair. Dhu Nuwas converted to Judaism, which he may have seen as a way to retain his independence but which brought him into confrontation with an international power and its regional ally.

At the end of the third century, the kings of Aksum had assumed control of parts of southwest Arabia, and in their inscriptions they began to call themselves not only the kings of Aksum but also the kings of various states in South Arabia. According to the Syriac *Letter of Simeon of Beth Arsham*,[26] Dhu Nuwas ousted the viceroy installed from Aksum, and, believing all Christians to be Aksumite agents, decided to eliminate the threat. He attacked the garrison at Zafar and destroyed the church, an event recounted in the *Book of the Himyarites* and confirmed by inscriptions.[27]

The persecution of Christians induced the Byzantine emperor Justin I to write to Kaleb, the king of Aksum, urging him to intervene. The king responded by making preparations for an expedition in about 517, when he learned that Dhu Nuwas had ordered the massacre of all Christians at Najran. In 510–20 Kaleb overthrew and killed Dhu Nuwas and brought Himyar into the Aksumite empire, setting a viceroy on the throne. But only four years later a rebellion occurred in which an Ethiopian general known as Abraha declared himself to be king. Two attempts were made to restore Aksumite control, but without success. Abraha became the sole master of Himyar and Saba, and built a cathedral in Sanaa as a center of Christian pilgrimage in Arabia. According to the eighth-century Muslim chronicler Ibn Ishaq, the Byzantine emperor sent architects and craftsmen to embellish the cathedral with mosaics and marble.

Both Aksum and Himyar were suspicious of Byzantine attempts to involve them in the great game with Sassanid Persia, since the proximity of the Persian army could be a more serious concern than a common religion shared with a distant power. The question of allegiance to

24. The letter is preserved in Athanasius, *Apologia ad imperatorem Constantium*, 31.
25. C. Conti Rossini 1910.
26. I. Shahid 1971.
27. A. Moberg 1924.

Constantinople was to become even more problematic as a result of the theological disputes of the fifth century, especially the continuing debate about the nature of Christ. Athanasius, the patriarch of Alexandria, had been the great champion of what became the Orthodox position when he denounced the claims of Arius that Christ had been merely human. The First Council of Nicaea in 325 called by the emperor Constantine confirmed his rejection of the Arian claims, and in the following generations, theologians attempted to determine how Christ might be both human and divine. The successors of Athanasius in Alexandria, especially the patriarch Cyril, defended the concept of a divine nature; their opponents in Antioch, including Nestorius, who was appointed Patriarch of Constantinople in 428, maintained that two distinct natures were involved, one divine and one human. The Council of Ephesus in 431 condemned Nestorius, but the followers of Cyril were not satisfied, and even though a truce was negotiated in 433, the dispute simmered on.

Another council was summoned to Ephesus in 449, where extremists of the Alexandrian party took control and the assembled bishops were terrified by the presence of fierce monks from the Egyptian desert who demanded that they accept the teachings of Cyril. In the West, Pope Leo condemned the council as a *latrocinium*, a den of thieves, and at a further council held two years later at Chalcedon, a compromise formula was adopted in which Christ was said to be "perfect man and perfect God, two natures without confusion, change, division or separation."[28] To the followers of Cyril, however, this seemed to be yet another compromise with Nestorianism, and despite the attempts of the successive emperors either to negotiate a compromise or impose unity by force, the Chalcedonian definition was not accepted along the frontiers of the empire. In Egypt, in Armenia, and among large numbers of the Syrians, the teachings of Cyril were not to be questioned, and because the Chalcedonian formula was not accepted in Egypt, it was not accepted in Ethiopia. By those who did subscribe to the Chalcedonian decree, these churches have all been described as "monophysite," a term derived from the Greek words for "one nature." The Chalcedonian formula is not, however, regarded as justified within the churches themselves. The Alexandrian position is believed by its adherents not to reduce the person of Christ to a single nature, but to preserve both elements in their appropriate form.

While the rejection of Chalcedon has been seen as a series of nationalist movements disguised in a religious mantle,[29] one should be wary of claims that the theological element was not as important as contemporary sources suggest. In any case, the distinction was not only anachronistic, it now seems increasingly obsolete at a time when religious identity is emerging once again as the touchstone of cultural allegiance.

Although the Ethiopian Church remained loyal to Alexandria in its hostility to Chalcedon, it was far from identical in faith and custom with the Copts, as they came to be called from the Arabic word *Qibt*, signifying "Egypt." At times, the patriarch of Alexandria felt it necessary to attempt to assert doctrinal conformity, as in the eleventh century, when the *History of the Patriarchs of Alexandria* reports that he sent a letter to the Ethiopians urging them to abandon what he regarded as an excessive devotion to "Old Testament customs."[30]

"Behold an Israelite indeed."
—John 1.47

The phrase "Old Testament customs" describes a number of features that the Ethiopian Church shares with Judaism. For example, male children are circumcised on the eighth day, a custom found only among Jews and Ethiopian Christians. The Copts, in contrast, circumcise male children between six and eight years of age. The Ethiopian Church also observes dietary laws governing "clean" and "unclean" animals, along with the regulations for ritual

28. *Acta conciliorum oecumenicorum*: 2.1.2.
29. E.L. Woodward 1916; A.H.M. Jones 1959.
30. Sawirus ibn al-Mukaffa 1950, 330.

cleanliness, especially regarding sexual relations. It preserves the institution of the "levirate" marriage, in which men marry their widowed sisters-in-law in order to preserve the inheritance of their brothers. Ethiopian Christians observe the Sabbath on Saturday as well as the usual Christian Sunday, and construct their churches with a threefold division thought to be modeled on the Temple of Jerusalem.

It is possible to exaggerate the extent to which individual customs may be based on Jewish models, and indeed Ernst Hammerschmidt has followed Maxime Rodinson in rejecting the assumption that the plan of the Ethiopian Church must follow the Temple rather than the early Christian basilica.[31] Nevertheless, the importance of the claim to have inherited the mantle of Israel cannot be denied. The reason for the claim, or at least the most striking manifestation of it, is found in the treatise called the *Kebra Nagast (Glory of the Kings)*.[32] This provides an extended account of the legend of the Queen of Sheba, an elaboration of the Biblical narrative in 1 Kings 10.1–13, which draws on the Old and New Testament and on apocryphal literature like the Book of Enoch.

The *Kebra Nagast* describes how the queen, whom it identifies as the Aksumite queen Makeda, sets out in search of wisdom and crosses the Red Sea to visit King Solomon in Jerusalem. She accepts his religion and bears him a son, although the narrative is at pains to emphasize that the king of Israel was not drawn to the union through the lust of the flesh but from a desire to fill the world with sons who could spread the true faith of the One God of Israel. Indeed, at the moment of consummation, Solomon sees the light of the presence of God depart from him and from Israel and pass on to the new Israel that would be established in Africa.

The author or redactor had obviously set out to glorify the Ethiopian monarchy by claiming that the emperor is the rightful heir of the firstborn of Solomon and therefore takes precedence over all the rulers of the world, including even the emperor of Byzantium. The True Cross may have been preserved as a relic in Constantinople, but Ethiopia possessed the more ancient and powerful Tabernacle of the Law and the Chariot, the Ark of the Covenant, which contained the tablets of the Law given to Moses by God.

Its presence is explained through the events surrounding Menelik, the son of Solomon and Makeda who returned to Jerusalem to be anointed by his father as king of Ethiopia. Solomon sent the sons of the leading families of Israel to accompany the boy, but fearing that they might spend the rest of their lives in a remote part of the world and never see the Ark again, they carried it away with them across the Red Sea to Aksum, with Menelik dancing before it just as his grandfather David had danced on the road to Jerusalem. In the *Kebra Nagast*, the Ark of the Covenant is called "Zion," the ancient Israelite name for the sacred mountain on which God was believed to dwell, and as the central symbol of the Ethiopian identity it is repeated in every church by a *tabot*, a stone tablet placed inside a wooden chest. In fact, it is not the church which is consecrated, but the *tabot* it shelters. This is the focus of Ethiopian worship, and when it is carried in solemn procession, it is accompanied by singing and dancing reminiscent of both David and his grandson Menelik.

This vision of the transfer of legitimacy from the Old Israel to the New has been of such central importance to the Ethiopian identity that when the Napier expedition removed an imperial manuscript of the *Kebra Nagast* in 1868, the emperor Yohannes wrote to the British Foreign Secretary: "There is a book called *Kebra Nagast* which contains the Law of the whole of Ethiopia; and the names of the chiefs, churches, and provinces are in this book. I pray you will find out who has got this book and send it to me, for in my country my people will not obey my orders without it."[33]

The date at which the treatise was composed has been the subject of some controversy. According to tradition, the *Kebra Nagast* was translated into Ethiopic during the reign of Amda Seyon (1314–44), from an Arabic version that was itself a translation from Coptic. It is said to

31. E. Hammerschmidt 1970: 42–50.
32. E.A.W. Budge 1922.
33. Ibid.: xxxiv–xxxv.

have been brought to Ethiopia by Coptic monks in 1225, during the so-called Zagwe dynasty,[34] a time when it would have been of the greatest political importance and volatility.

The power of Aksum had begun to wane in the late sixth century, and with the rise of Islamic Arabia across the Red Sea, its economic base was undermined. The most valuable account of Ethiopia during the early years of the Islamic era is provided by the Arab geographer and historian al-Yaqubi,[35] who confirms that the Ethiopian kingdom had not been destroyed by Muslim expansion in the Red Sea. Nevertheless, Ethiopian authority had been declining for two centuries, and given the Muslim presence along the Red Sea coast, it is not surprising if the centers of power moved south in the direction of Lake Hayq. The kingdom revived in the ninth century, but this move to the south brought it into conflict with other regional powers, and the tenth-century Arab historian Ibn Hawqal records a war with an unnamed queen of the *banu al-hamwiya*.[36] The move south also brought the Christian kingdom into the territory of the Agaw, the largest group of Cushitic speakers, who became the dominant section of the population in the kingdom. In time, even the throne passed into their hands during "the dynasty of the Agaw," the Zagwe.

As members of a different ethnic and linguistic group, the Zagwe seem always to have been regarded by the church hierarchy and the old aristocracy as usurpers, and this accusation of illegitimacy was made in terms of descent from King Solomon. Taddesse Tamrat has suggested that it was during this period, in which Ethiopia was increasingly isolated from the outside world, that a time of intense introspection began, in which inspiration was deliberately drawn from the accounts of social, political, and cultural institutions in the Old Testament.[37] Rather than the legacy of some ancient pre-Christian survival from the Aksumite period, the Semitic emphasis of the Ethiopian Church is a deliberate invention of tradition.

If the *Kebra Nagast* had arrived during the reign of the Zagwe, the court would presumably have exerted considerable effort to prevent its translation, and indeed there is some evidence that it did so. "It came in the days of the Zagwe; and they did not translate it because it says that those who reign, not being Israelites, are transgressors of the Law."[38] This assertion may simply be part of the tradition itself, and one is tempted to ask why, if the document really had undergone redaction as late as the fourteenth century, the narrative did not continue until the thirteenth century in order to emphasize the restoration of the Solomonic line. That the narrative concludes in the sixth century has been seen as a strong argument for an early date, perhaps sometime in the seventh century.[39]

Certainly elements of the tradition were widely circulated in Christian Ethiopia long before the thirteenth or fourteenth century. The story of the Queen of Sheba is referred to by Cosmas Indicopleustes, who visited Aksum just before Kaleb's expedition to South Arabia in 519/20. He mentions that "the Queen of Sheba that is to say of the country of the Himyarites," brought many fine presents to Solomon imported from Ethiopia across the Red Sea.[40] Three centuries later, the *History of the Patriarchs of Alexandria* referred to "Ethiopia which is a vast country, namely the kingdom of Saba from which the queen of the South came to Solomon, the Son of David the King."[41] By the beginning of the thirteenth century, the Armenian Abu Salih reported that "the Ethiopians possess the Ark of the Covenant, in which are the two tables of stone, inscribed by the finger of God with the commandments which he ordained for the children of Israel ... And the Ark is attended and carried by a large number of Israelites, descended from the family of the prophet David...."[42]

Some of the most dramatic attempts to claim the legacy of Israel do seem to have been deliberate, and to have been linked with the hope that the Zagwe dynasty might be able to establish its legitimacy by employing precisely these symbols itself. In the mountains of Tigre, the Zagwe emperor Lalibela constructed a mystical topography, a recreation of the holy city of Jerusalem. Eleven churches were carved from the living rock with a river flowing between

34. Taddesse Tamrat 1977: 124.
35. Al-Yaqubi: 1883.
36. Ibn Hawqal 1964: 56.
37. Taddesse Tamrat 1977: 108.
38. C. Bezold 1909: 140ff.
39. I. Shahid 1976.
40. J.W. McCrindle 1897: 51–52; W. Wolska-Conus 1968, vol 1: 358.
41. Sawirus ibn al-Mukaffa 1943: 118.
42. Abu Salih 1895: 287–88.

them named *Yordanos*, after the River Jordan in Palestine. The names given to the churches and various other sites indicate the intention to create a new Jerusalem. There is, for example, a hill known as "Calvary" under which "the tomb of Adam" is believed to be located. Below it, in a church called "Golgotha" is a crypt containing the "tomb of Christ." Another hill is known as the "Mount of Transfiguration" and a nearby church of "Bethlehem" stands almost the same distance apart as the original in Palestine. While it has been suggested that Lalibela intended to provide an alternative goal of pilgrimage after Jerusalem was captured by Saladin in 1187, the Oriental Churches actually fared rather better under the Muslims than they had under the Latin kingdoms established by the Crusaders, and Saladin is said to have given the Ethiopians the right to a chapel at the Holy Sepulcher and an altar at the Church of the Nativity.[43] It seems more likely, therefore, that the city represents an attempt to secure a connection with the Israelite tradition.

The result is aptly called one of the wonders of the world. The first European visitor, Francisco Alvarez, who described his visit to Lalibela between 1521 and 1525, exclaimed, "I weary of writing more about these buildings, because it seems to me that I shall not be believed if I write more."[44] Even if suspicion remained about the usurping dynasty, the king who actually built the churches has been revered as a saint, and indeed as a type of Christ. He is said to have been poisoned by a brother anxious to advance his own claims to the throne, and to have fallen into a deathly trance for three days, after which he was restored to life. Before he became king, he is said to have flown miraculously to Jerusalem, where Christ displayed the holy city to him, admonishing that when he ruled over his people, he was to build a second Jerusalem in Africa. Certainly the city became, and remained, a center of pilgrimage. It was said that "He who does not make his way to the holy city of Lalibela is like a man who feels no desire to see the face of Our Lord and Savior Jesus Christ."[45] Indeed the desire to make the final pilgrimage of life from so holy a spot transformed the city into a vast mortuary, with underground passages filled with the desiccated bodies of the faithful.

> "The desert shall rejoice."
> —Isaiah 35.1

The most obvious and problematic of supposedly Old Testament customs was observation of the Saturday Sabbath, which provoked a crisis for church and state during the fourteenth and fifteenth centuries. The dispute arose because of differences between the *abun* and the secular clergy, who derived their authority from Alexandria, and the monastic holy men, whose authority was personal and charismatic, representing a tradition brought by two groups of ascetics, the *Sadqan* (Righteous Ones) and the Nine Saints. The differences were of great significance for Ethiopian history because of the relationship of each faction to the court and the demands imposed on the church by the conquest of non-Christian communities.

Monasticism, from the Greek word *monachos*, meaning "solitary," is usually regarded as having arisen in Egypt during the late third century, when individuals like Saint Anthony the Great withdrew to the desert to lead a solitary life wrestling with demonic forces in the wilderness. Anthony had been born into a prosperous peasant family, and taking the Biblical commandment literally, he sold all that he had and gave the proceeds to the poor. The attraction of this way of life was so great that large numbers of followers flocked to the desert, and a communal life developed along lines established by a younger contemporary, a former soldier named Pacomius.

The *Life of Saint Anthony* is attributed to Athanasius, the patriarch of Alexandria by whom Frumentius had been consecrated bishop, and it made Anthony a model for subsequent generations. Indeed the fame of the Desert Fathers became so great that enthusiasts flocked to Egypt from other parts of the Roman Empire.

43. G. Gerster 1970: 89.
44. Ibid.: 85.
45. Ibid.: 89.

The Desert Fathers of Egypt were not unique, however, and indeed an independent tradition of ascetic life had arisen in Syria among the *bnay qyama* (the Sons of the Covenant), as described by the fourth-century Syriac writer Aphraat, known as "the Persian Sage," who seems to have been one of them. They lived in small communities dedicated to chastity and an angelic life in which the soul was kept awake for Christ, a condition described by the Syriac poet and theologian Ephrem of Nisibis.

This tradition was later combined with the Egyptian forms of monasticism brought to Syria by Mar Awgen and his seventy disciples, and Syria was to become home to the greatest of the athletes of the spirit. St. Symeon the Stylite, for example, abandoned the flesh and ascended into the sky, living exposed to the harsh Syrian sun on a pillar forty feet in the air and yet remaining among the people who gathered below him to seek his advice and intercession.

By their determined wrestling with the flesh and their implacable renunciation of the natural life, the holy men were believed to have entered the realm of the angels. They were regarded as the living dead, a dramatic embodiment of the "locus of the holy,"[46] the point at which heaven and earth are believed to meet.

Ethiopian tradition, especially the *Synxarium*, chronicles the arrival of the Nine Saints in the late fifth century, and although the record is not clear, it is thought that these were Syrian holy men fleeing persecution by Byzantine authorities who imposed the Chalcedonian formula by force. Indeed, it has been suggested that the arrival of the holy men may have been part of a carefully planned program developed by opponents of Chalcedon in Alexandria and Aksum who were anxious to strengthen the position of the "monophysite" church.

Despite the claim of Rufinus that Frumentius spread Christianity throughout the Aksumite kingdom, it is likely that new religion was largely confined to the Red Sea port of Adulis and the caravan routes that connected it to the capital. The Nine Saints founded a series of monasteries throughout the region of Tigre, and the greatest of these was Dabra Damo, established by the most famous of the Nine, Abba Za-Mikael, known as Aragawi. For centuries Dabra Damo was to remain one of the most important centers of learning in the empire.

It has been claimed that Ethiopian literature really begins with these Syrian monks and that the language of the Ethiopic Bible contains Syriac elements brought to Ethiopia by them. Arthur Vöobus, for example, insisted that Syrian monks would have traveled with Syriac rather than Greek Bibles, and claimed that Biblical quotations found in Ethiopian patristic literature were evidence of one of the earliest Syriac translations.[47] Vöobus was rather obsessed with discovering lost "Old Syriac" quotations, however, and without any firm knowledge of the Syriac manuscript tradition, the Ethiopian manuscript tradition, or the way in which the translators of the time set about their task, it was frankly impossible to make such claims. Fortunately, critical editions of both Syriac and Ethiopic versions are now beginning to appear, and it seems likely that the earliest Ethiopic translations were actually made from the Greek. Syriac and Coptic influences are also likely, but much of what has been thought to be Syriac may have entered from later Arabic versions.[48]

In the following centuries, holy men continued to play an essential role in the spread of the Christian faith, an activity of the greatest importance as the emperors added new lands through conquest. The rivers and mountains of Ethiopia created great natural obstacles between the various regions, contributing to a marked ethnic, linguistic, and religious diversity. The nomadic court of the medieval period was one way of attempting to overcome regional isolation, although its arrival was no doubt regarded with horror by most of the population because of the financial burdens it imposed, and it may have been a greater success at eliminating regional threats than promoting national unity.

While a shared culture was necessary for effective rule, the *abun* and the secular clergy played very little role in this, owing to the custom of sending *abun*s from Egypt. Few Egyptian monks

46. P. Brown 1973.
47. A. Vöobus 1954: 253ff.
48. R. Zuurmond 1989.

of any ability or ambition would have been enthusiastic about the idea of spending the rest of their lives in a strange land far from the monasteries or the great churches of the Copts. In fact, the Egyptian hierarchy occasionally seems to have regarded the position as a place of exile for troublesome monks. In any case, the differences between Ethiopia and Egypt could mean that even the most gifted Egyptian could have difficulty adjusting to his new circumstances. He would have been raised in a Christian minority subservient to Muslim overlords, and it could be difficult to set aside fears for the community in Egypt at a time when Ethiopian emperors were pursuing vigorous policies against their Muslim neighbors.

Even aside from the personal qualities of the *abun*s, the long and difficult journey between Egypt and Ethiopia, and the necessity of persuading the Muslim authorities in Egypt to allow the Coptic patriarch to appoint a successor, often meant that years could pass between the death of one *abun* and the arrival of the next. As a result, the survival of the Ethiopian Church could be placed in jeopardy. Only the *abun* was permitted to consecrate bishops and thereby ensure an adequate supply of clergy. In the tenth century, the *History of the Patriarchs of Alexandria* records a letter written by the Ethiopian emperor to the king of Nubia: "I have mentioned this to you, my brother, in fear that the Christian religion might pass away and cease among us. Six patriarchs have sat on the throne and have not paid attention to our lands, which are abandoned without a shepherd. Our bishops and priests are dead and our churches are ruined."[49]

In such circumstances, the holy men rose to unusual prominence, especially during the fourteenth century, once the Solomonic dynasty had been restored. While the monastic movement may have begun in Egypt among peasants, most of the the great holy men of Ethiopia appear to have been of aristocratic origin. Following the model of Kaleb, who is said in the *Kebra Nagast* to have retired to a monastery after his campaigns for the faith, it became a tradition in Ethiopia for those who abandoned a political career to enter monastic life. As a result, younger members of aristocratic families, who could not themselves inherit, often chose monastic careers as an alternative. This choice became even more attractive after the restoration of the Solomonic dynasty, when the emperors attempted to exert central control over regions that had previously maintained a considerable degree of independence.

One of the essential techniques of central control was the traditional system of land tenure known as *gult*, in which land was granted by the emperor on a personal basis, without hereditary rights. This meant that the emperor possessed the means to reward those whose behavior pleased him and punish those whose behavior did not. In a world in which such absolute and comprehensive authority was dispensed from the throne, the holy man was virtually the only independent force. His authority was based on ascetic prowess, on a position outside the social order won by a display of spiritual courage. It was not his relationship with the emperor but his relationship with God which gave him his power. Such independence meant that the holy man could easily become a focus of regional identity, and the monasteries therefore provided a career for members of the regional nobility who would otherwise have been restricted by the growth of Solomonic control.

The controversy regarding the Saturday Sabbath exploded in the midst of such rivalries. It had been gathering for some time, and in the *Collection of Canons* of Ibn al-Assal, compiled in 1238, the authorities in Egypt specifically rejected it as a Jewish custom.[50] When the *abun* and the secular clergy upheld the position of Alexandria and attempted to eliminate the Sabbath, they were opposed by the monk Ewostatewos, who was born to a noble family around 1272. At an early age he had entered the monastery of his uncle and was made deacon and ordained priest. Within a few years, he left the monastery and began to gather his own disciples. When he emerged as the champion of the Sabbath, the hostility of the church hierarchy became so intense that he left Ethiopia for a lengthy sojourn in Egypt, Jerusalem, and finally Armenia.

The controversy became particularly threatening for the established church after the

49. Sawirus ibn al-Mukafa 1943: 171–72.

50. J. Muyser 1937.

Ewostatewosites were excommunicated and so prevented from acquiring new priests, because they simply evolved their own organization in defiance of the rest of the church. The *abun* requested the help of the emperor Dawit, but in view of the support that the movement was gaining, Dawit refused to tolerate further persecution. Instead he attempted to find a compromise in which the Ewostatewosites were allowed to occupy churches and monasteries that had been taken from them and to establish new communities. At the same time, the Alexandrian position on the Sabbath was to be kept at all other churches and at the court. As with most attempts at compromise, neither party was satisfied, and the position of the *abun* was seriously weakened by the tolerance the emperor was prepared to display toward the dissidents.

The controversy was only resolved during the reign of the emperor's grandson Zara Yaqob, who favored the Ewostatewosites and was anxious to avoid a more serious schism. He therefore made his peace with them and began to address the question of the Alexandrian party in a diplomatic manner. In 1450 he convened the Council of Dabra Mitmaq, at which the Egyptian bishops formally authorized the observance of the Saturday Sabbath and the Ewostatewosites agreed to receive holy orders from the Egyptian prelates.

Despite his success in resolving the Ewostatewosite crisis, Zara Yaqob's own reign was disrupted by a second great controversy. A learned and skillful theologian himself, the emperor was concerned to establish unity of belief, especially at a time when the success of his military campaigns was placing large numbers of infidels within his borders and threatening to fragment the teachings of the Church. As he wrote in his treatise *Mashafa Birhan* (*Book of Light*), "Our country Ethiopia is surrounded by pagans and Muslims in the east as well as in the west."[51] He therefore promoted a cult of the Mother of God as a new focal point for Ethiopian worship, which had an enormous impact on Ethiopian spirituality and Ethiopian art. No icons survive from before his reign, and it seems likely that they were introduced by Zara Yaqob as part of the cult.

The cult had in fact first appeared during the reign of his father, Dawit, along with the first translations of the *Taamra Maryam* (*Miracles of Mary*), but it was greatly promoted by Zara Yaqob, who believed himself to owe his life to her. As a child conceived through prayers and vows offered to Mary, he had been dedicated to her as soon as he was born, and marked with a brand on his body. He believed himself to be her slave, and called on his subjects to see themselves in the same way: "Now listen, all you Ethiopians, men and women! You are slaves of Mary, who received you as a tithe so that you might be her gift from her son. Always take refuge with her, because she is capable of saving you from all evil."[52]

The cult was resisted by the followers of the monk Estifanos, who was born in the last years of the fourteenth century to a noble family in the northern province of Agame. He was given a religious education and was made a deacon at the age of eighteen. He then began to gather followers who were known for their opposition to the monarchy. Although their enemies frequently charged them with refusing to venerate the Mother of God, their opposition seems to have been directed toward the imperial nature of the cult rather than its object. Indeed, when Estifanos was summoned to court, he seems to have pushed for a separation of church and state in a way that would have been very alarming to the Ethiopian establishment, and announced that he did not admire the king for his Israelite birth, but would prefer to respect him as a Christian king of a Christian people.[53]

After the success of the Council of Dabra Mitmaq, Zara Yaqob was not about to tolerate another threat of schism, and according to the chronicles of the time, he severely tortured Estifanos and his followers "and called them enemies of Mary, telling the people that they were like the Jews, because of their refusal to prostrate themselves before the king."[54] There was no immediate resolution of the problem. Estifanos died in exile, and the vehemence of imperial propaganda made any kind of reconciliation extremely difficult. It may be that only the shock

51. Zara Yaqob 1964: 151.
52. Quoted in Getatchew Haile 1983(B): 99–100, n. 33.
53. Taddesse Tamrat 1966: 108.
54. Quoted in Getatchew Haile 1980(C): 227.

of the Muslim invasion was sufficient to heal the wounds and establish the unity of the Church once more. The threat to the Church posed by the Muslim invasions of Ahmad Grañ and Amiz of Adal, in the 1530s, was so immediate and so intense that any differences could be forgotten.

A third group in which the monastic movement seems to have grown at a time when imperial power was expanding is perhaps the most fascinating of all, the Beta Esrael (House of Israel), known in Ethiopia as the Falasha (Exiles) and in the West as the "Black Jews." The Falasha cult comprises a mixture of pagan, Jewish, and Christian elements, and since they did not know any of the religious law promulgated after the Pentateuch, such as the Midrash or the Talmud, it is sometimes suggested that they preserved an archaic form of Judaism dating from before the Babylonian exile. Ignazio Guidi believed that they were the descendants of the Jewish garrison at Elephantine in Egypt,[55] which Herodotus reports as having revolted owing to the length of their term of duty.[56] Ullendorff suggested that they were the descendants of Aksumites who resisted conversion to Christianity and that they preserved Judaic customs that were established in South Arabia and brought to Ethiopia.[57] They reflected the religious syncretism of Aksum, and the influence of Christianity on their cult was made all the easier by the "Old Testament" customs of the Ethiopian Church.

The institution of monasticism is nevertheless very surprising, given Jewish hostility to this form of asceticism, and it has therefore also been suggested that the Beta Esrael simply represent the most extreme Judaizing tendency within Ethiopian Christianity. Unpublished Falasha texts apparently support the view that the tradition is primarily the result of developments in Ethiopia from the fourteenth century onward,[58] and the earliest account of them in Ethiopian tradition is in the chronicle of Amda Seyon. It describes their resistance to Amda Seyon, who had sent troops against them, and reports that "originally these people were Christians, but now they denied Christ like the Jews who crucified Him, and for this reason he sent an army to destroy them."[59]

Steven Kaplan sees monasticism arising as Falasha regions came under strong pressure during the reign of Amda Seyon, since it provided a way of enforcing and invigorating the identity of their society despite the loss of political independence.[60] This was all the more important after the emperor Yeshaq passed a decree that deprived them of property and from which the name Falasha may derive: "He who is baptized in the Christian religion may inherit the land of his father; otherwise let him be a *falasi*."[61]

In such religious and political disputes between the monastic holy men, the emperor, and the Alexandrian clergy may lie the essential stimulus for the growth of Ethiopian literature during the fourteenth and fifteenth centuries.[62] Owing to the disasters of the invasion by Grañ, the Church tried to preserve and even embrace everything that survived the conflagration, even though many of the texts had been written as polemics and represented conflicting doctrines. These contradictions are only now being explored by scholars like Getatchew Haile, as unpublished material is analyzed through the Ethiopian Manuscript Microfilm Library, and some of the themes will be considered in his essay on Ethiopic literature.

55. I. Guidi 1932: 95.
56. Herodotus, *Historia*: 2.30.
57. E. Ullendorff 1968: 117.
58. S. Kaplan 1988.
59. J. Perruchon 1889: 293.
60. S. Kaplan 1984: 126–27.
61. R. Bassett 1882: 12, 101.
62. See Getatchew Haile 1981(B).

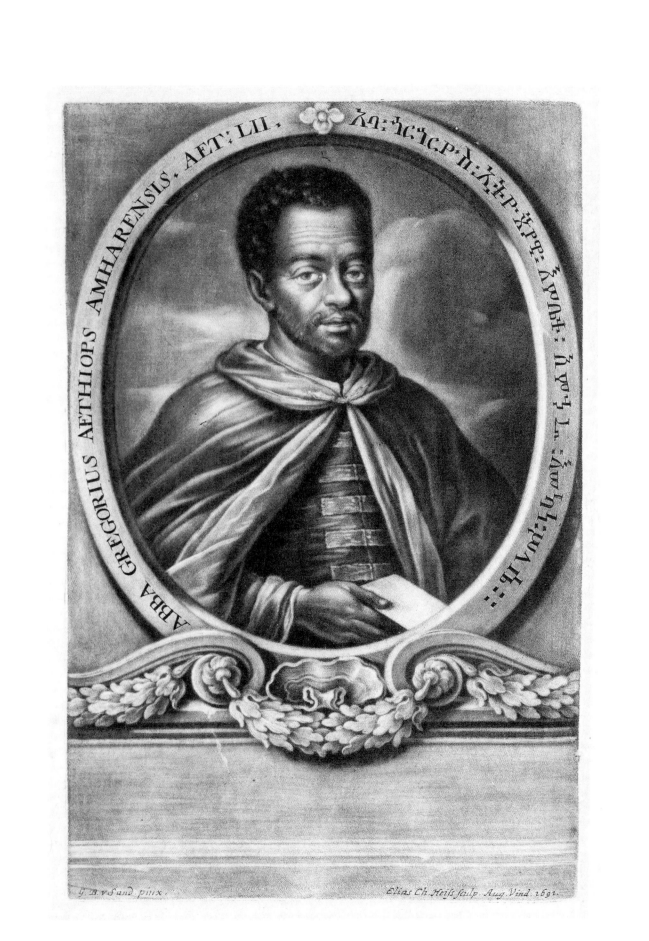

ABBA GREGORIUS AETHIOPS AMHARENSIS. AET: LII. አባ፡ኀርጎርዮስ፡ኢትዮጵያዊ፡

G. B. v Sand. pinx.                    Elias Ch. Heis sculp. Aug. Vind. 1691.

# ETHIOPIA REVEALED: MERCHANTS, TRAVELERS, AND SCHOLARS

*Richard Pankhurst*

## Ancient Greek Perceptions

THE ANCIENT GREEKS, who invented the name Ethiopia, used the word to refer to the country inhabited by "burnt," or dark-skinned, people south of Egypt. The Greek image of the Ethiopians was that of a remote people. In the ninth century B.C., Homer described them in the *Odyssey* as *eschatoi andron*, "the most distant of men." He stated that they lived "at earth's two verges, in sunset lands and lands of the rising sun." During the fifth century B.C., Herodotus also observed that the Ethiopians inhabited "the ends of the earth," and Aeschylus agreed that theirs was a "land far off, a nation of black men," who lived "hard by the fountain of the sun where is the river Aethiops."

The Ethiopians were regarded by the Greeks as one of the best peoples in the world. Homer speaks of them in the *Iliad* as "the blameless Ethiopians." He claims that they were visited by Zeus, the king of the gods, by the goddess Iris, who went to their country to participate in their sacrificial rites, and by Poseidon, the sea god, who "lingered delighted" at one of their feasts. This theme was later taken up in the first century B.C. by Diodorus Siculus, according to whom Hercules and Bacchus were both "awed by the piety" of the Ethiopians, whose sacrifices, he claims, were the most acceptable to the gods.[1]

## Early Trade Contacts

Although such early writers romanticized the country, other foreigners, among them traveling merchants, were better informed. Such visitors included many Egyptians, Indians, and Arabs who had traded with the Red Sea coast of Ethiopia since time immemorial.

The region now called Ethiopia was part of a vast stretch of land on both sides of the southern Red Sea, part of which the ancient Egyptians knew as the Land of Punt. Egyptian vessels probably reached the area as early as the first or second dynasty (3400–2980 B.C.). Such contacts continued for several millennia. This is evident from the story of the Egyptian queen Hatshepsut, who around 1495 despatched five vessels that sailed south in search of myrrh and other tropical produce. A record of the event is preserved in Egyptian hieroglyphic inscriptions on a famous temple at Thebes in Upper Egypt.[2] Indian trade, which was facilitated by the "trade winds" blowing each year in the Red Sea and Indian Ocean, was also of great antiquity. It is, notwithstanding, far less well documented.[3]

★　　★　　★

1. For a useful summary of Greek conceptions of Ethiopia, see D. N. Levine 1974: 1–5.
2. See R. K. Pankhurst 1961: 3–44; id. 1984.
3. On this trade see R. K. Pankhurst 1974.

*facing page:* Abba Gregorius.

19

## The Coming of Christianity

The situation by early Christian times was, however, much clearer. One of the best-informed writers on the area, who seems to have lived in Egypt around the first or second century A.D., and wrote in Greek, was the unknown author of *The Periplus of the Erythraean Sea*. Perhaps the captain of a ship, or a customs official, he drew up a very factual and remarkably detailed account of the Red Sea commerce. One section of his work describes the trade of the Ethiopian capital of the time, Aksum, which was situated in what is now the north of the country, and gives a considerable amount of data on the commerce of its port, Adule, or Adulis, which lay nearby on the Red Sea coast.[4]

The image of Ethiopia was transformed by conversion to Christianity. This took place in the early fourth century after two Greek-speaking Christian youths from Syria were shipwrecked off the Red Sea coast. They were brought to the capital, Aksum, where they met the king, who appointed one of them, Frumentius, as a royal scribe and treasurer. Frumentius spent much of his time working to spread the Christian faith, and later traveled to Alexandria to ask Patriarch Athanasius to appoint a bishop. The prelate asked who was more fitting than Frumentius to hold this post, and accordingly consecrated him as the first bishop in Ethiopia.[5]

The coming of Christianity was followed by the arrival of many Christians from other parts of the Roman Empire. The most notable of them were the Nine Saints, who came from Syria and adjacent areas around the fifth century and established important monasteries in the north of the country. This period thus witnessed the establishment of the monastic system, with the creation of church schools, as well as the translation of the Bible and other Christian writings into the Ethiopian language, Geez.[6]

One of the effects of these developments was that the earlier conception of Ethiopia as an almost celestial land known only to the gods was shattered. The coming of Christianity brought about important, very tangible religious ties with Jerusalem, a place of pilgrimage for Ethiopians throughout the centuries, as well as with Coptic Egypt and other countries of the Christian Orient.

As many Ethiopian pilgrims traveled to Jerusalem, and not a few devout Ethiopian Christians remained there, it became a place of special contact with other Christians from many lands. Such relations are particularly evident in the case of the Armenians. It is quite possible that the Armenian Mesrop Mashtotz, who lived in Jerusalem in the fifth century, copied several letters of the Ethiopian alphabet when devising his alphabet for the Armenian language. He doubtless saw them in Ethiopic manuscripts in the possession of Ethiopian ecclesiastics who resided in the city.[7] A number of Armenian manuscripts that were later bound in the Holy City are encased in pages of strong parchment taken from Ethiopic manuscripts. The Armenians presumably acquired them from their Ethiopian fellow Christians.[8]

An important event in this period of history was a visit to the Aksumite kingdom in the early sixth century by the Egyptian who later became a monk known as Kosmas Indikopleustes. He included some details about the country in his *Christian Topography*, where he described it as an integral part of the Christian world, "with churches of Christians ... where the Gospel of Christ is proclaimed." He also produced the first visual record of the realm: a few rough sketches, still extant, which depict an Aksumite traveler, the Aksumite port of Adulis, and several Aksumite wild animals.[9]

## The Arabs and the Prophet Muhammad

Despite increasing knowledge of the country, the old image of Ethiopian piety endured, and it found an echo a century later when the early followers of the prophet Muhammad were

4. G.W.B. Huntingford 1980; L. Casson 1989.
5. Sergew Hable Sellassie 1972: 97–105.
6. E.A.W. Budge 1928, 1: 152. On the Ethiopian traditional system of church schools, see E.S. Pankhurst 1955: 232–66.
7. D.A. Olderogge 1974.
8. On early Ethiopian contacts with Armenia, see R.K. Pankhurst 1977.
9. J.W. McCrindle 1897: 20; W. Wolska-Conus 1968–73.

persecuted in Mecca. Their leader appears to have been well acquainted with Ethiopia, for as a posthumous child he had been brought up by his grandfather, Abd al-Muttalib, who had often traveled there on business. According to Muslim tradition, when Abd al-Muttalib learned of his disciples' difficulties he advised them to seek refuge in Ethiopia, or Abyssinia as the Arabs preferred to call it. Pointing across the Red Sea to the West he is said to have spoken of it as "a country where no one is wronged, a land of righteousness." His wisdom became apparent when his followers were given asylum at Aksum. Their enemies subsequently despatched an embassy, with gifts, demanding forcible repatriation of the refugees. Ashama ibn Abgar (Armah?), the ruler of Aksum at the time, is said to have replied: "Even if you were to offer me a mountain of gold, I would not give up these people who have taken refuge with me."

When the persecution in Arabia came to an end the refugees duly returned home. They did this with the assistance of the Aksumite monarch, who provided them with two ships. One of the refugees, Umm Habibah, returned to marry Muhammad, on which occasion the Aksumite king sent her a dowry. She later told her husband much about Ethiopia, and is said to have given him a graphic description of the beauty of the principal church in Aksum.[10] This was the great Church of Saint Mary of Zion, in which Ethiopian tradition claims that the Ark of the Covenant is preserved to this day.[11]

Relations between Muhammad and the people of Aksum were said to be cordial, and when the king died, the prophet prayed for his soul. He subsequently ordered his followers to "leave the Abyssinians in peace," thus exempting them from his *jihad* or Holy War against unbelievers. Some of the earliest converts to Islam included a number of Ethiopians. The best known of them was the prophet's devoted follower Bilal, who served as his first muezzin, calling the faithful to prayer.[12]

The Arab historian al-Yaqubi, who wrote in the late ninth century, gives a fairly detailed and apparently authentic account of the Aksumite region. The northern coastal strip, he indicates, was by then coming under increasing Muslim influence. Further inland, however, lay a powerful Christian kingdom. Al-Yaqubi refers to the Ethiopian ruler as the *najashi*, an Arabic rendering of the Ethiopian title *negus*, or "king." The capital, we are told, was at Kubar, whose location today is unknown, and the realm stretched as far as the Red Sea coast and included the island of Dahlak.

The picture was later confirmed by another Arab writer, al-Masudi, who noted in 935 that the Abyssinian capital, "Kubar," as he called it, was "a great city and the seat of the government of the *najashi*." The kingdom had "many towns and extensive territories stretching as far as the Abyssinian sea" and included part of the opposite coast of the Yemen. A third Arab author, Ibn Hawqal, writing in 977/8, provided the additional information that the Gulf of Aden port of Zayla was in possession of Abyssinian Christians who traded peacefully with the Muslims of the Yemen. He reminded his readers that Abyssinia was a land not subject to the Holy War.[13]

The Arabs were responsible for giving Ethiopia the designation "Abyssinia," by which it is often known. This latter name, which dated back to early Aksumite times, had its origin in Arab contact with a people called the Habashat, who lived in the African coastal area immediately opposite the Yemen. The word *Habashat* was later transformed into *habash*, an Arabic term that also means "mixed." The name *Habash*, in the course of time, came to be adopted in many parts of the world, and is found, for example, in English as *Abyssinia*, in French as *Abyssinie*, in German as *Abyssinien*, and in Italian as *Abissinia*.[14]

Over the centuries, the inhabitants always referred to their country as Ethiopia, and have seldom made use of the name Abyssinia. As the official title used in royal chronicles and in the letters of its monarchs, the name Ethiopia had a special appeal in that it was used in the Bible. The designation Abyssinia, on account of its association with the term *habash*, seemed by contrast derogatory. Although it is rarely used, however, *habash* is by no means entirely

10. W. Muir 1878: 74–75, 86, 92, 386; W.M. Watt 1953: 30, 109–17, 182–86. The Quran, it is interesting to note, contains many borrowings from the ancient Ethiopian language, Geez; see A. Jeffery 1938.

11. For a recent popular account giving one version of how the Ark may have arrived at Aksum, see G. Hancock 1992.

12. W. Muir 1878: 617.

13. For a summary of the accounts of al-Yaqubi, al-Masudi, Ibn Hawqal, and other Arab writers, see J.S. Trimingham 1952: 49–52, 61–62.

14. E.A.W. Budge 1928, 1: 120, 130.

shunned by Ethiopians, who when referring to their national clothing may speak of *habasha lebs*, literally "Abyssinian clothing."[15]

## Medieval Egyptian Contacts

Ties between Ethiopia and the Christians of Egypt, which Frumentius had initiated in the fourth century, were greatly strengthened during the thirteenth century. Power in Ethiopia at that time shifted southward to Shewa, in what is now the center of the country. There, a new Solomonic dynasty under Yekuno Amlak emerged, claiming descent from Solomon and the Queen of Sheba.

It was customary for the Ethiopians to obtain their *abun*, or metropolitan, from the Coptic Church in Egypt. The latter, though rich and long established, was by then subordinate to the Muslim rulers of the country, upon whom the Ethiopians were thus dependent for their patriarch. The coming of such prelates from Egypt served not only to keep the Ethiopian and the Coptic Church in the communion, but also to increase Egyptian consciousness of the great Christian neighbor to the south. The flow of the Ethiopian Christian pilgrims, who traveled through Egypt to Jerusalem and the Holy Land, often annually in large groups, was also facilitated.[16]

Egyptian perceptions of Ethiopia were influenced throughout this time by the occasionally vexed question of the Nile, which constituted the lifeblood of Egypt. Much of the water and silt reaching that country originated in the Ethiopian highlands. The Egyptians therefore felt themselves dangerously dependent on their southern neighbors, who, they feared, might divert the waters of the Nile. This fear was in fact unfounded, for at the time no one would have possessed the technical ability required for such a vast undertaking.

Be that as it may, letters and embassies between the two countries were frequently exchanged. Most, like a famous epistle from Yekuno Amlak to the sultan Baybars in 1273, dealt with the despatch to Ethiopia of an Egyptian *abun*, but others were concerned with the question of the Nile. Whenever the flow of water reaching Cairo declined, either because of the failure of the Ethiopian rains or because of an increase in vegetation in the Sudanese swamps, the Egyptians would suspect an Ethiopian plot, and the rulers of Ethiopia were not averse to seeking diplomatic advantage from Egyptian anxiety.[17]

The Egyptians were interested not only in the Christian empire but also in its Muslim dependencies to the south, east, and west. These stretched over a vast area and included Ifat, Adal, Fatagar, Dawaro, Hadeya, and Bali. One of the first writers to study these territories was an Egyptian courtier, Ibn Fadl Allah al-Umari (d. 1349), who learned about them from Ethiopian Muslims visiting Cairo and who left a valuable account of their geography and economic and political life.[18]

## The Kingdom of Prester John and the Council of Florence

Medieval European knowledge of Ethiopia meanwhile owed much to the arrival in Jerusalem of a steady influx of Ethiopian Christian priests, monks, and pilgrims. Their importance was recognized in 1189 by the sultan Salah ad-Din, the Muslim Ayyubid ruler of Egypt, better known in the West as Saladin. After driving the Latin clergy from the Holy City, he granted the Ethiopians the Chapel of the Invention of the Cross in Jerusalem and a station in the Grotto of the Nativity in Bethlehem.[19]

News of the Ethiopian presence in the Holy Land, and of the Christian country from which they came, duly percolated to Europe. This gave rise to the belief that Christian Ethiopia might prove a useful ally in the Crusades against Islam then under way. One of the first Europeans to

15. A. d'Abbadie 1881: 9; I. Guidi 1901: 7; T.L. Kane 1990: 14.
16. E. Cerulli 1953–57, vol. 1: 1–108.
17. On Ethiopian-Egyptian relations, particularly with regard to the Nile, see Taddesse Tamrat 1972: 256, 261–62; E.D. Hecht 1988.
18. M. Gaudefroy-Demombynes 1927: 1–39.
19. E. Cerulli 1953–57, vol. 1: 16, 31–33, 36–37, 119–21.

urge the advantages of such an alliance was Guillaume Adam, a Dominican monk who had visited the island of Socotra in the Gulf of Aden, and made several attempts to enter the remote Christian empire. In 1317 he drafted a plan for the king of France in which he argued that it would be possible to eradicate the Saracens with Ethiopian cooperation. Elaborating on this idea in 1332, he drew the attention of the French monarch to the existence of a strong Christian people inhabiting "the mountains in the direction of Egypt," a phrase evidently referring to Ethiopia.[20]

The idea of a grand Christian alliance against Islam was reinforced by the legend of Prester John, which had been circulating in the West since the thirteenth century. It held that there was a powerful Christian ruler in India, or somewhere in that region, who was determined to liberate the Holy Sepulcher from the infidel. This belief found expression in a fictitious letter that gained extensive currency at the time. In it the mysterious monarch, Prester John, extended a cordial invitation to the rulers of Europe to enter his service, and promised in return that his European supporters would receive high administrative office and large estates.[21]

Such imaginary offers attracted considerable interest in Europe, where the supposed epistle of Prester John was translated into several languages. Strenuous efforts were made to locate the fabulous ruler, but when they met with no success the belief in an Asian Prester John was abandoned. It was replaced by the idea that the imaginary monarch was none other than the Christian emperor of Ethiopia, whose existence had by then been long attested.

Contacts between Ethiopia and Western Europe drew appreciably closer in the late fourteenth and early fifteenth centuries. A Florentine trader, Antonio Bartoli, is believed to have entered the country some time in the 1390s, and a Sicilian, Pietro Rombulo, in 1407. The latter spent no less than thirty-seven years in the country before being despatched by its ruler on a mission to India and China. Rombulo later returned to his homeland, with an Ethiopian priest, Fere Mikael, as part of a four-man embassy from the emperor Zara Yaqob (r. 1433–68). The first official European embassy to Ethiopia had meanwhile been sent from France by the Duc de Berry. It consisted of a Neapolitan called Pietro, a Frenchman, and a Spaniard. Pietro married an Ethiopian, returned to Europe, and attempted to set out for Ethiopia again in 1432.

European awareness of the country, which owed much to the reports of Rombulo and Pietro, was heightened when news spread that an Ethiopian delegation was to attend the Council of Florence in 1441. The embassy consisted, it later transpired, of no more than two monks, who had been sent not from Ethiopia but from the Ethiopian community in Jerusalem. Their arrival was nonetheless important in further diffusing knowledge about their distant country.

Other European maritime powers were by this time also much interested in Ethiopia. The Venetians, who were the commercial rivals of the Egyptians, sought in particular to develop commercial contacts with the regions to the south. The rulers of Spain and Portugal were also aware of possible advantages to be drawn from contact with Ethiopia. Already in 1428 Alfonso, the king of Aragon, had received a letter from the emperor Yeshaq proposing an alliance against Islam, to be cemented by a double dynastic marriage. This failed to materialize, but Alfonso subsequently despatched a message to the emperor Zara Yaqob in 1450 offering to send him a number of skilled craftsmen, whom the Ethiopian monarch had requested.[22]

The extent of European knowledge of Ethiopia early in the second half of the fifteenth century is apparent from the detailed data found on two of the principal maps of the period. The first was the notable Florentine map *Egyptus Novelo*. Produced around 1454 under the supervision of the painter Pietro del Massajo, it probably owed much to information obtained from the Ethiopian delegates to the Council of Florence thirteen years earlier. The second was the even more famous *Mappamondo* designed in 1460 by Fra Mauro, who expressly states that he owed much to Ethiopian ecclesiastics. The latter were probably members of the community in

20. Taddesse Tamrat 1972: 252.
21. V. Slessarev 1959: 1–31; E. Ullendorff and C.F. Beckingham 1982: 1–11; R. Silverberg 1972.
22. Taddesse Tamrat 1972: 254, 257–59, 264–67; R. Lefevre 1965; id. 1967–68; S. Tedeschi 1974.

Jerusalem, some of whom from time to time made their way to Venice. Several later attracted the attention of a Venetian scholar, Allesandro Zorzi, who interviewed them between 1519 and 1524 and produced valuable itineraries of the routes they had taken to and from their native land.[23]

The opening of contacts between Ethiopia and the West resulted meanwhile in the establishment in the country of a small but culturally important foreign community, mainly from Venice, Naples, and Genoa. Prominent among them were two Venetian artists, Nicolo Brancaleon and Hieronomo Bicini, who deserve mention in any history of Ethiopian art.[24]

## The Portuguese and the Jesuits

The Ethiopian Christian state in the early sixteenth century faced two major threats. The first, and more general, was the expansion of the Ottoman Turks around the Red Sea. The second was the increasing power of the Muslim state of Adal, a territory to the east of Shewa. Its rulers, because of their relative proximity to the coast, were beginning to gain access to firearms.

The Ethiopian monarch of this time, the emperor Lebna Dengel (r. 1508–40), was then a minor. Power therefore rested in the hands of a regent, the redoubtable empress Eleni. The daughter of Muhammad, the Muslim ruler of Hadeya, southwest of Shewa, she had become a Christian to marry Zara Yaqob, the great grandfather of Lebna Dengel. Despite her Muslim origins, she was worried by the growing power of the Turks. In 1509 she therefore despatched an Armenian merchant called Matthew with a letter to Manoel I of Portugal proposing a defensive alliance against them.

Because Matthew was an Armenian, and obviously not an Ethiopian, his credentials as the imperial envoy were not easily accepted by the Portuguese. He accordingly ran into many difficulties. Manoel, however, eventually decided to send him back to Ethiopia, with a Portuguese diplomatic mission. Led by Duarte Galvan, an old man who died on the journey and was replaced by Rodrigo de Lima, it landed at the Red Sea port of Massawa in 1520 and duly proceeded to the court of Lebna Dengel in Shewa. The monarch had by then come of age. A proud young man, he felt confident that he could contain all his enemies and saw little interest in the Portuguese alliance earlier proposed by his regent. He therefore kept his visitors in the country for some six years, without concluding any alliance with them.

This protracted stay was of immense importance, for it enabled the chaplain of the mission, Francesco Alvares, to write his memoirs, which were entitled *Verdadera Informaçam das terras do Preste Joam das Indias* (*Truthful Information about the Countries of the Prester John of the Indies*) and were published in Lisbon in 1540. Alvares, a kind and sensible man, wrote in a simple and lively style, vividly describing most aspects of the political, religious, and cultural life of the country. One of the most interesting sections of his book is devoted to the remarkable rock-hewn churches of Lalibela, in the province of Lasta, on which he was the first foreign traveler to report. His detailed account of the Christian empire he had seen is the more valuable in that it was written immediately before the invasion in 1527 of Ahmad Grañ, the Muslim ruler of Adal, which was greatly to weaken the state that Alvares had so painstakingly described.[25]

The subsequent defeat of Grañ and his death in battle in 1543 owed much to intervention by a Portuguese force led by Cristovao da Gama, son of the famous Vasco. One of his companions, Miguel de Castanhoso, subsequently wrote a useful account of the campaign and of the country in which he and his comrades had fought.[26]

As a result of this victorious involvement in Ethiopian affairs, the Portuguese and their Spanish neighbors became keenly interested in the country, and conceived the idea of converting it from its traditional Orthodox faith to Roman Catholicism. Ignatius Loyola, the founder of the Society of Jesus, volunteered to go to Ethiopia in person, and although he never

23. O.G.S. Crawford 1958: 13, 16–20, 194–204.
24. R.K. Pankhurst 1961: 70, 72, 289–92; S. Chojnacki 1983: 533; D. Spencer 1989.
25. C.F. Beckingham and G.W.B. Huntingford 1961.
26. R.S. Whiteway 1902.

went, the Jesuits were entrusted by the Pope with the task of conversion. A Jesuit mission led by Andre de Oviedo accordingly landed at the coast in 1557. Five days later the Turks occupied Massawa, constituting a formidable barrier to further communication.[27]

Despite this enforced isolation, Ethiopia was by now relatively well-known to European scholars. This is evident, for example, in the famous map of Abraham Ortelius *Presbiteri Johannis, sive Abissinorum imperii descriptio*, which was first issued in 1573. Dedicated to David, the "son of Prester John," it appeared as an *additamentum*, or supplement, to the *Theatrum orbis terrarum* of 1570, and was then included in all later editions.[28]

Notwithstanding the Turkish blockade at the coast, another Jesuit, Pero Paes, succeeded in entering the country in 1603. By his missionary activity, and the attractive offers of military support from Spain, he won the favor of the emperor Za Dengel (r. 1603–4) and subsequently of his successor, the emperor Susneyos (r. 1606–32). The latter attempted to convert the country to Roman Catholicism by force, but this led to rebellion and civil war. Susneyos was obliged to reinstate the Orthodox faith, after which he abdicated in 1632 in favor of his son Fasiladas, who immediately exiled the Jesuits from his capital and later from the entire country.

Although it was short-lived, the Jesuit presence was of major importance. With the support of the emperor, the missionaries traveled widely throughout the empire and produced very useful annual reports on their activities. Several Jesuits, notably Manoel de Almeida,[29] Jeronimo Lobo,[30] and Manoel Barradas,[31] also wrote detailed accounts of the land, its people, and their social, religious, and cultural life, while Pero Pais penned a very creditable history of the country.[32] The writings of the Jesuits, which describe the situation in the aftermath of the wars of Ahmad Grañ, were just as informative, although perhaps not so amusingly written, as those produced by Alvares during the golden age of the empire a century earlier.

## Abba Gregorius and Hiob Ludolf

Throughout this time a steady stream of Ethiopian Christians continued to travel abroad on pilgrimage, often by way of Egypt and mainly to the Holy Land, but also to Rome. In the latter city the Holy See purchased a house for them in 1539. Later known as Santo Stefano dei Mori, it was situated just behind Saint Peter's.

The Ethiopian presence in Rome proved of considerable importance to scholarship. In 1649 Hiob Ludolf, a young German deeply interested in linguistics, traveled there in the hope of extending his knowledge of the Ethiopian classical language, Geez, which up to then had been studied only from books. Learning that there were four Ethiopians in the city, he lost no time in making their acquaintance. "I addressed them," he later recalled, "and acquainted them how desirous I was to learn the Ethiopick language. They surround me, and wonder, and at length demand the Reasons; to which, being hard, they return the Answer: that that could not be done out of Ethiopia, for it was a thing of great Labour, and much Time; that there was indeed one Gregorius there, a very Learned Man (whom they showed me), but that he neither understood Latin nor Italian." The German replied that he "desired that they would only resolve some Doubts," and "satisfy" his "Difficulties," for he had "already acquired the Rudiments of that Language."

At this point, Ludolf continues, Gregorius, "understanding from his Companions what I desired, immediately runs in, and fetches a great Parchment Book, curiously writ, and bids me read. . . . At this they could not abstain from Laughter, especially Gregorius. . . . But when I went about to interpret, they turned their Laughter into Admiration, scarce believing that that Language, which seemed so difficult (as they said) to the Fathers of the Society [that is, the Jesuits], who abode so long in Ethiopia, could be learned without a Master."

Thus began one of the most remarkable of scholarly associations. As Ludolf recalls: "I daily

27. C.F. Rey 1979: 205–6, 208; P. Caraman 1985: 10–15, 68.
28. R.V. Tooley 1969: 88–89.
29. Reproduced in C. Beccari 1905–17, vols. 5–7. For translated excerpts in English see C.F. Beckingham and G.W.B. Huntingford 1954.
30. D. M. Lockhart 1984.
31. Reproduced in C. Beccari 1905–17, vol. 4.
32. P. Pais 1945. Also reproduced in C. Beccari 1905–17, vols. 2–3.

visited Gregorius: But at the beginning we did not converse; for he understood no European language besides the Portuguese, and that I had not learned. He was then beginning to learn the Italian: So we did a long time confer by an Interpreter . . . and at last began to discourse imperfectly ourselves. Afterward we spoke in the Ethiopick, which neither of us had ever spoke; for among the Habessins the Amharic Dialect is used in speaking . . . the Ethiopick only in writing. Concerning speaking the Ethiopick, I had not so much as dreamed. So that we were forced, that we might understand each other, to use a Tongue to which neither of us had been accustomed."[33]

Ludolf was fortunate in winning the friendship of Gregorius, who proved to be both well informed and a scholar of integrity. Old enough to be Ludolf's father, he was an important source of linguistic and other information, and added significantly to what his young friend could glean from the writings of Alvares, the Jesuits, and others.[34]

The help of the learned Ethiopian enabled Ludolf to publish the first Geez grammar and dictionary, the *Grammatica aethiopica*, and the *Lexicon aethiopico-latinum*, both in 1661. He also wrote one of the finest histories of the country, the *Historia aethiopica* of 1681, along with an important *Commentarius* in 1694. Later, he wrote the first Amharic grammar and dictionary, the *Grammatica linguae amharicae* and the *Lexicon amharico-latinum* in 1698. Because of the importance of these works, their illustrious author has been referred to as the founder of Ethiopian studies in Europe.[35]

## Isolation from the West

After the expulsion of the Jesuits in the early seventeenth century, the rulers of Ethiopia cut themselves off from the West. The emperor Fasiladas went so far as to order the execution of any Catholic priests entering the country. The result was that there is only one Western account of this period of any interest, and even that may be imaginary. The book purports to be by an Italian called Giacomo Barrati, who penetrated only the periphery of the country.[36]

Ethiopian diplomatic contacts with the East were on the other hand greatly expanded. Missions led by an Armenian named Murad made their way from the Ethiopian capital at Gondar to India, Persia, and the Dutch Indies.[37] In an effort to consolidate such relations, the Ethiopian rulers of this time despatched various gifts, including elephants and zebras, the latter being regarded as objects of great wonder in Asia, and at least one rhinoceros.

An envoy from the Yemen, Hassan ibn Ahmad al-Haymi, likewise made his way to Gondar, where he was courteously received by Emperor Fasiladas in 1648.[38]

The rulers of the East in this period were thus in much closer contact with Ethiopia, and therefore better informed about it, than those in the West. So, above all, were Armenian merchants who continued to trade and travel between the country and the outside world.[39]

## Samuel Johnson and James Bruce

Despite its isolation from the West, interest in Ethiopia engendered by the writings of the Jesuits continued well into the eighteenth century. One of those influenced by their works was Samuel Johnson, the future lexicographer. When he went down from Oxford in 1732 without any money, he earned a first commission of five guineas by translating a French version of the memoirs of Lobo into English. Retaining his interest in Ethiopia throughout his life, in 1759 he made it the setting of his famous novel *The Prince of Abyssinia: A Tale*.[40] The first page bore the somewhat different title *The History of Rasselas, Prince of Abyssinia*, for which reason the work was overnight referred to as *Rasselas*, the name by which it is known to this day.

As the country where the Nile had its source, Ethiopia attracted the attention shortly

33. H. Ludolf 1682.
34. On the life of Ludolf, and his role in Ethiopian studies, see C. Juncker 1710; E. Haberland 1969; and E. Ullendorff 1973: 9–11.
35. For bibliographic details on the works of Ludolf and other writings on Ethiopia from this period, see G. Fumagalli 1893.
36. G. Baratti 1670.
37. E.J. van Donzel 1979.
38. E.J. van Donzel 1986.
39. O.T. Topouzian 1974.
40. S. Johnson 1759.

afterward of a Scottish laird, James Bruce of Kinnaird, who made it his ambition to "discover" the source of the river. He did this despite the fact that the source had been visited, and described, by the Jesuits a century and a half earlier, and had of course been known by the local inhabitants since time immemorial.

Bruce landed at Massawa in 1769 and spent the next few years in the Ethiopian interior, mainly at Gondar. During his residence and travels he delved deeply into Ethiopian history and tradition, and took copious notes of what he saw and heard. On eventually returning to his native Scotland and attempting to describe his discoveries in Ethiopia, he faced an atmosphere of disbelief. At one dinner party he was asked whether there were any musical instruments in Ethiopia, and when he replied that he remembered seeing a lyre, the wit George Selwyn whispered to his neighbor: "I am sure there is one less since he came out of the country."

Undeterred by such skepticism Bruce proceeded to dictate his memoirs to an amanuensis, and thus produced one of the most important, and readable, travel books of all time. This was his famous five-volume *Travels to Discover the Source of the Nile*, which appeared in 1790. It was later translated into French and widely reprinted both *in toto* and in numerous abridged versions.[41]

The *Travels*, though in places opinionated, pompous, and gossipy, was valuable in that it made Ethiopian society alive and real for European readers. The author presented the public of the day with a vivid account of the Gondarine empire, which was then in a state of decay. He also introduced his readers to the Ethiopian royal chronicles, which until then had been known only through Jesuit writings in Portuguese, and his work was influential in that it continued to be read throughout many generations.[42]

Although Bruce was the principal traveler of the period, he was preceded by three other notable visitors. The most important of these was the French physician Charles Poncet,[43] who visited Gondar at the end of the seventeenth century and treated the emperor Iyasu I for a troublesome skin complaint. The others were the Czech missionary Remedius Prutky[44] and an Armenian jeweler, Yohannes Tovmacean,[45] both of whom made their way to Gondar in the middle of the eighteenth century and wrote interesting accounts of the capital.

## The Early Nineteenth Century

The early nineteenth century witnessed the arrival in Ethiopia of a number of travelers from Western Europe, who contributed greatly to foreign knowledge of the country.[46] Some of the earliest came from Britain and to a lesser extent Germany and Switzerland, others from France, and one from Belgium.

At least ten British travelers of note visited the country in this period. Six of them, Henry Salt,[47] Nathaniel Pearce,[48] William Coffin,[49] Joseph Wolff,[50] Mansfield Parkyns,[51] and Walter Plowden,[52] wrote about Tigray and the north of the country. Two others, Charles Johnston[53] and William Harris,[54] the leader of a mission laden with presents from the British East India Company, described Shewa. The indomitable Charles Beke[55] traveled to Gojjam in the west, while the famous Orientalist Richard Burton,[56] best known as the translator of the *Thousand and One Nights*, spent ten brief but memorable days in the walled city of Harar in the east.

Foremost among the German travelers was the renowned scientist Edouard Rüppell.[57] He was followed by the nobleman A. von Katte[58] and by the Protestant missionaries Karl Isenberg and Ludwig Krapf, both of whom were employed by the Church Missionary Society in London.[59] These four Germans between them covered a wide stretch of territory. A Swiss missionary, Samuel Gobat,[60] meanwhile traveled from Tigray to Gondar, and later conceived

41. J. Bruce 1790.
42. On Bruce's life see J.M. Reid 1968.
43. See "The Journey of Charles Poncet from Cairo into Abyssinia and Back," in W. Foster, ed. 1949: 89–105; S. Tedeschi 1966.
44. J.H. Arrowsmith-Brown 1991.
45. V. Nersessian and R.K. Pankhurst 1982.
46. On this travel literature in monograph form, see R.J. and R.K. Pankhurst 1978. On nineteenth-century periodical studies, see H.G. Marcus 1972.
47. For Salt's reports see G. Annesley 1809; H. Salt 1814.
48. N. Pearce 1831.
49. Coffin's writings are included in N. Pearce 1831.
50. J. Wolff 1839.
51. M. Parkyns 1853.
52. W.C. Plowden 1868.
53. C. Johnston 1868.
54. W.C. Harris 1844.
55. C.T. Beke 1846.
56. R.F. Burton 1856.
57. W.P.S.E. Rüppell 1838–40.
58. A. von Katte 1838.
59. C.W. Isenberg and J.L. Krapf 1843; J.L. Krapf 1867.
60. S. Gobat 1834.

the idea of despatching to the country missionary craftsmen, who would not only preach, but also help the rulers of the country in various technical matters.

France meanwhile was represented by the bizarre Saint Simonian missionaries Edmond Combes and Maurice Tamisier,[61] by the learned brothers Arnaud and Antoine d'Abbadie,[62] by two naval officers, Pierre Ferret Galinier and Joseph Galinier,[63] by the adventurer Rochet d'Héricourt,[64] and by an important scientific mission headed by Théophile Lefebvre.[65] Most of these Frenchmen traveled widely throughout the country, although Rochet d'Héricourt confined his interest mainly to Shewa. A single Belgian, Edouard Blondeel van Cuelebroeck,[66] also visited Ethiopia, and devised a scheme for the colonization of the country.

The above travelers were all in one way or another memorable. Henry Salt, for example, drew fine sketches that were turned into memorable engravings.[67] Rüppell laid the foundation for the study of Ethiopian botany and natural history.[68] Isenberg, and later Antoine d'Abbadie, produced valuable Amharic dictionaries, the former in English and the latter in French.[69] Lefebvre's mission compiled a six-volume scientific report of unparalleled importance, with two fine atlas volumes.[70] Parkyns wrote a delightful, and culturally very significant, volume of reminiscences.

These early-nineteenth-century travelers were followed in the ensuing decades by many others, some of whom made their way further to the south and west.[71] Such travelers, to cite but a few examples, included the Austrian explorer Philipp Paulitischke[72] and the Italian Luigi Robecchi-Bricchetti,[73] both of whom visited Harar; an Italian geographical mission, which traveled from the port of Zayla to the frontiers of Kaffa;[74] and the Frenchman Jules Borelli[75] and the Austrian Friedrich Bieber,[76] both of whom also made their way to the southwest. Another traveler of note was the Englishman James Theodore Bent,[77] who wrote about Aksum and its environs. His book, aptly entitled *The Sacred City of the Ethiopians*, appeared in 1894 and gave a valuable account of Aksumite antiquities.

## The Coming of Ethiopian Manuscripts to Europe

The external image of Ethiopia had meanwhile been enriched in the second half of the century by the arrival in the West of a sizable number of hitherto unknown Ethiopian manuscripts. Many of them came quite fortuitously as a result of the dispute between the reforming emperor Tewodros II (r. 1855–68) and the British government. Angered that a letter he addressed to Queen Victoria was never answered, Tewodros detained a British consul and several other Europeans. The British government at first attempted to accommodate his wishes, even going as far as despatching to Massawa some craftsmen he had requested. Negotiations between the two parties later reached a deadlock, and the British responded by despatching an armed expedition against the mountain citadel at Maqdala, better known abroad as Magdala. There the Ethiopian troops were easily defeated by British weaponry, whereupon the emperor committed suicide rather than fall into the hands of his enemies.[78] The British troops then looted the capital, and carried off from the Church of Madhane Alam, and elsewhere, well over three hundred manuscripts. These were deposited in the British Museum and several other libraries in Britain, and proved of seminal importance to European scholarship on Ethiopia.[79]

## Foreign Scholars: August Dillmann, Enno Littmann, Ignazio Guidi, Carlo Conti Rossini, and Ernest Wallis Budge

The second half of the nineteenth century and the first decades of the twentieth witnessed a remarkable renaissance of Ethiopian studies abroad. This owed much to the endeavors of a number of notable European scholars who devoted their lives to the study of Ethiopian

61. E. Combes and M. Tamisier 1838. On the Saint Simonian travelers, see also R. K. Pankhurst 1969; and on French travelers of the period in general, see G. Malecot 1972.
62. A. d'Abbadie 1868; id. 1898.
63. P.V.A. Ferret Galinier and J.G. Galinier 1847–48.
64. C.F.X. Rochet d'Héricourt 1841; id. 1846.
65. T. Lefebvre 1845–48.
66. E. Blondeel van Cuelebroeck 1838–42.
67. H. Salt 1809.
68. W.P.S.E. Rüppell 1826–31; id. 1835–40; id. 1845; id. 1869–73.
69. C.W. Isenberg 1841; A. d'Abbadie, 1881.
70. For reproductions of these and other early engravings, see R.K. Pankhurst and L. Ingrams 1988.
71. These travelers came from various countries. On the Germans see Bairu Tafla 1981; and on the Russians see C. Zaghi 1972.
72. P. Paulitschke 1888.
73. L. Robecchi-Bricchetti 1896.
74. A. Cecchi 1885–87.
75. J. Borelli 1890.
76. F.J. Bieber 1920–23.
77. J.T. Bent 1894.
78. On the emperor Tewodros, and his dispute with the British government, see P. Arnold 1991; Yacob Beyene, R.K. Pankhurst, and Shiferaw Bekele 1990: 3–243.
79. On Tewodros's library and its fate, see R.J. Pankhurst 1973; id. 1989. The bulk of the Magdala manuscripts brought to England are catalogued in W. Wright 1877.

language and history. They laid the basis for the scientific study of the country that has continued to the present day. Space permits us to tell of only five, although these are perhaps the most important.

The first, and probably the most illustrious, was August Dillmann, a German linguist with a profound interest in Ethiopian history. Described as a "second Ludolf," he was the author of an excellent Geez grammar, the *Grammatik der äthiopischen Sprache*, published in 1857, which was later translated into English. He also produced a comprehensive Geez dictionary, the *Lexicon linguae aethiopicae*, and several valuable studies of ancient and medieval history.[80]

Another German student of Ethiopian culture, who rose to prominence a generation or two later, was Enno Littmann, one of the first foreign scholars to carry out extensive research in the country itself. He was the leader of the early twentieth-century Deutsche Aksum-Expedition, which laid the foundation for later Ethiopian archeology through its excavations at Aksum. The results of the expedition were published in 1912 in an impressive four-volume report. Also interested in oral history, Littmann collected traditions in Western Eritrea, which appeared in his five-volume *Publications of the Princeton Expedition to Abyssinia* of 1910 to 1915. In addition, he edited and translated several historical texts in Geez and wrote a number of studies on Ethiopian legends of the Queen of Sheba, ancient Ethiopian relations with India, and other historical matters.[81]

The first Italian scholar of Ethiopian affairs, Ignazio Guidi, had meanwhile emerged. Aided by a trustworthy Ethiopian informant, Dabtara Kefla Giyorgis, he compiled a remarkably comprehensive Amharic-Italian dictionary, the *Vocabolario amarico-italiano* of 1901. He also edited and translated many notable Geez texts, including the *Fetha Nagast*, or traditional Ethiopian penal code, several late-seventeenth- and early-eighteenth-century royal chronicles, and part of the Ethiopian *Synaxarium*, comprising lives of the saints. In addition, he wrote on numerous aspects of Ethiopian ecclesiastical and secular history.[82]

A second Italian scholar of note was Carlo Conti Rossini, a government official who followed in Guidi's footsteps by editing and translating a variety of Ethiopian historical and hagiographical texts. A prolific writer, he also studied many aspects of Ethiopian culture, and is remembered for his *Storia d'Etiopia*, a major contribution to Ethiopian ancient and medieval history which appeared in 1928.[83] Later, spurred by Italian interest resulting from Mussolini's decision to invade the country, he wrote several works on modern Ethiopian history. In 1941 he founded a scholarly journal, the *Rassegna di Studi Etiopici*, which was first published by the Ministry of Italian Africa in Rome and has continued to appear to this day.

One of those most interested in the Ethiopian manuscripts taken by his compatriots from Tewodros's citadel at Maqdala was the British Egyptologist Sir Ernest A. Wallis Budge. He translated into English, and published in lavishly printed editions, no less than nine important Geez works. These included the *Miracles of the Virgin Mary*, the *Romance of Alexander the Great*, and the entire Ethiopian *Synaxarium*, which he issued with the title *The Book of the Saints of the Ethiopian Church*. Besides translating over half a million words, Budge also wrote a *History of Ethiopia, Nubia and Abyssinia*, which appeared in 1928 and has been consulted over the years by a great many scholars.[84]

## Marcel Cohen and His Students

Ethiopian studies in the twentieth century owe no small debt to a renowned French Semitist, Marcel Cohen. Deeply interested in the Semitic languages of Ethiopia, he visited the country in 1910 and 1911 and wrote an interesting account of his linguistic and other investigations in his *Rapport sur une mission linguistique en Abyssinie* of 1912. His publications also included a valuable Amharic grammar, the *Traité de la langue amharique*, which appeared in 1936.[85]

80. C.F.A. Dillman 1857; id. 1859; id. 1907.
81. E. Littman 1904; id. 1910–15; id. 1912; id. 1926.
82. I. Guidi 1897; id. 1901; id. 1903; id. 1912.
83. C. Conti Rossini 1928. For a bibliography of Conti Rossini's writings, see G.C. Stella 1984.
84. E.A.W. Budge 1928(B), with bibliographic details on some of the author's writings on p. 633; id. 1928(A).
85. M. Cohen 1912; id. 1936. For references to Marcel Cohen's writings on Ethiopia, and those of many other linguists referred to in these pages, see W. Leslau 1965.

Cohen was also a notable teacher at the Sorbonne in Paris, and several of his students later played important roles in Ethiopian studies, including Maxime Rodinson,[86] Wolf Leslau,[87] Stefan Strelcyn,[88] Joseph Tubiana,[89] and Roger Schneider.[90]

## Enrico Cerulli and Edward Ullendorff

Prominent among twentieth-century European students of Ethiopia was the Italian scholar Enrico Cerulli, who, like his compatriots Guidi and Conti Rossini, was concerned with a wide range of linguistic, historical, and cultural studies. An official of the Italian state as well as a man of letters, he was vice-governor of Italian East Africa during the Italian fascist occupation of the country. He was later accused of war crimes by the postwar Ethiopian government, although he was never actually charged.

A prolific writer but apparently a poor administrator, Cerulli was involved in most areas of Ethiopian studies. These included a study of Oromo, or Galla, oral history, *The Folk-literature of the Galla of Southern Ethiopia*, which appeared in 1922; a compilation of Arabic writings on Ethiopia, *Documenti arabi per la storia dell'Etiopia*; a history of Ethiopian legends about the Virgin Mary, *Il libro etiopica dei miracoli di Maria*; and a history of Ethiopian literature, *Storia della letteratura etiopica*. He was also the author of a multi-volume, *Studi Etiopici*, which was published between 1936 and 1950, and dealt with the languages and histories of many of the lesser-known regions of the country, particularly those to the south, east, and west.[91]

In Britain meanwhile Edward Ullendorff, a Semitist, contributed significantly to the growth of Ethiopian studies. He was noted both for his teaching, mainly at Manchester and London, and for his many linguistic and historical publications on the country. These ranged from *Semitic Languages of Ethiopia: A Comparative Phonology* and *Ethiopia and the Bible* to a translation of the first volume of the autobiography of the emperor Haile Selassie. Ullendorff was the author also of an invaluable general introduction to the country and its people.[92]

## Modern Ethiopian Studies

The 1960s saw the appearance on the Ethiopian academic stage of the first foreign-trained Ethiopian scholars, among them historians and linguists, as well as students of most other disciplines.[93] Three of the first Ethiopian historians to teach in the History Department of Haile Selassie I University, later Addis Ababa University, covered virtually the entire span of Ethiopian history from ancient to late medieval times.[94]

Sergew Hable Sellassie, an ancient historian who had obtained his doctorate in Germany, joined Haile Selassie University before becoming director of the Ethiopian Manuscript Microfilm Library. He is perhaps best known for his *Ancient and Medieval Ethiopian History to 1270*, which appeared in 1972, and for the extensive *Bibliography of Ancient and Medieval Ethiopian History* of 1969.[95]

Taddesse Tamrat, who holds a doctorate from the School of Oriental and African Studies in London, was later director of the Institute of Ethiopian Studies, and dean of the College of Social Sciences in Addis Ababa University. He is the author of the important monograph *Church and State in Ethiopia 1270–1527*, published in 1972, and of many articles on medieval Ethiopian history.[96]

Merid Wolde Aregay, also a doctor from the School of Oriental and African Studies, specialized in the sixteenth and seventeenth centuries, but later wrote scholarly studies of later periods as well. His writings cover such varied subjects as Ethiopian land tenure, the political geography of Ethiopia, the history of technology, the impact of firearms, and the history of millennialism.[97]

86. See, among other things, M. Rodinson 1964; id. 1967; id. 1971.
87. On Leslau's work and bibliography, see S. Segert and A.J.E. Bodrogligeti, eds. 1983.
88. See, among other things, S. Strelcyn 1968–73; id. 1978.
89. See, among other things, J. Tubiana 1966.
90. R. Schneider 1972–76; id. 1976; id. 1983.
91. E. Cerulli 1922; id. 1943; id. 1936–51; id. 1956(B).
92. E. Ullendorff 1955; id. 1968; id. 1976.
93. On the role of Ethiopian historians in this period, see Bahru Zewde 1990.
94. For a detailed bibliography of these and other writings of the period, see J. Abbink 1990.
95. Sergew Hable Sellassie 1972.
96. Taddesse Tamrat 1972.
97. Merid Wolde Aregay 1964; id. 1984(A); id. 1984(B).

Within little more than a decade, Ethiopian scholars from Addis Ababa University thus came to exercise a significant role in Ethiopian history, a field of scholarship which only a generation before was virtually entirely in foreign hands.[98]

Ethiopian studies have certainly advanced since the pioneering essays of Ludolf in the seventeenth century, and a vast amount of research on the country has been undertaken, particularly since the last century. Much, however, has still to be accomplished. Ethiopia is as large as France and Spain combined, and its history is just as long and complicated. The number of scholars engaged in Ethiopian studies, when compared with those in these two countries, is infinitesimal, and despite centuries of dedicated work from the scholarly point of view it remains in many ways a virgin country. It is a land in which numerous important discoveries, we can be sure, are still to be made.

98. For a bibliography of writings on Ethiopian studies after 1957, see J. Abbink 1990.

# CHURCH AND STATE IN ETHIOPIA: THE EARLY CENTURIES

*Taddesse Tamrat*

THE ORIGINS OF THE Ethiopian state whose sacred art is celebrated in this catalogue go back as far as the middle of the first millennium B.C. The earliest traces of an organized state in northern Ethiopia predate the fifth century B.C., when we have inscriptions of two contending families ruling over a territory they called *DMT*, or Daamat. By the time the inscriptions were made, the state and the civilization associated with it were well established.

A string of settlements, beginning with Kaskase on the edge of the Akala-Guzay plateau overlooking the Bay of Zula and continuing to Matara, Yeha, and Hawilti-Malazo, just to the southeast of the future site of Aksum, formed the major centers of this ancient Ethiopian state. Inscriptions, ruins of temples, water reservoirs, and other material remains have been discovered in each of these sites. The civilization of the period is known as "Ethio-Sabean" because of the obvious relations with the kingdom of Saba in South Arabia, and it seems to have continued intact until the rise of Aksum in the first century A.D.

Although little is known about the beginnings of Aksum, it inherited many of the territories and much of the political structure of the Ethio-Sabean civilization. The flourishing Aksumite state acquired a new dimension from later contacts that developed with the Greek rulers of Egypt, who had a special interest in the African coast of the Red Sea and left ruins and inscriptions at various sites.[1] When Aksum emerged in full bloom in the first and second centuries A.D., it had already assumed the position of partner with the Mediterranean powers in the international maritime trade conducted through the Red Sea.

The *Periplus of the Erythraean Sea*, written by an unknown Greek-speaking merchant who visited the area in about 70 A.D., depicts Aksum as a relatively strong state with full control of the Red Sea coast up to the straights of Bab-el-Mandeb, and of the hinterland as far west as the districts beyond the Takkaze River, where its elephant hunters were active. Its port of Adulis on the Bay of Zula was the center of an active import and export trade, and the importance of Mediterranean connections was such that the Aksumite king, Zoskales, spoke Greek.[2]

From that time on, not only spoken Greek but Greek documents as well were of crucial importance for Aksumite history. One of the earliest and most important Greek documents in this connection is the *Adulis Inscription*, written in about A.D. 150 on the back of an ancient throne that had been erected in the port of Adulis many centuries earlier. The stone slab bearing the inscription had fallen off the throne and was so badly damaged that when the Aksumite king Kaleb ordered a copy to be made for him in about A.D. 525, the name and titles of the king who had erected the inscription could not be recovered.[3] In this invaluable document, the Ethiopian state is depicted for the first time in its historic role as a great *rassembleur* of the enormous variety of ethnic and linguistic groups in the Ethiopian region.

The *Adulis Inscription* set the tone for the many activities of Ethiopian monarchs throughout the interior of Ethiopia and the Horn, who seem to have taken it as a model. The king of the

1. C. Conti Rossini 1928: 60–63.
2. W. H. Schoff 1912: 22–24.
3. J. W. McCrindle 1897: 54–66.

*facing page:* Priests, silver sistra in hand, perform "the dance of David before the Ark" in the early dawn light.

33

*Adulis Inscription* attempted quite deliberately to bring the many diverse populations he cited into a wider territorial bond. Under his hegemony there would be peace among the "nations," as he called them, law and order both internally and along the frontiers, freedom of movement and safe travel on the caravan routes, and an uninterrupted flow of import and export goods by land and sea for the international trade on which Aksum was so dependent. The peoples he brought together in this way included, in his words, those "spread over wide waterless plains in the interior of the frankincense country" and their neighbors closer to the sea, to whom he gave "instructions to guard the coast."

All the issues with which the king of the *Adulis Inscription* was concerned, especially the basic themes of the incorporation and integration of diverse populations into a single state, are also evident in the inscriptions and chronicles of many of his successors: Ezana (r. about 325), Kaleb (r. about 525), Amda Seyon (r. 1314–44), Sayfa Arad (r. 1344–71), Dawit (r. 1380–1412), Yishaq (r. 1413–30), Zara Yaiqob (r. 1434–68), and Baeda Maryam (r. 1468–78). Tributary dependency and the essentially indirect form of imperial rule instituted over the incorporated populations were preserved throughout these centuries.

The movement southward of Semitic-speaking peoples was also connected with this early period. The intensive campaigns described in the *Adulis Inscription*, and the widespread state of emergency they must have engendered in the interior of northern Ethiopia, may have been at least partly responsible for the dispersal of ancient speakers of Ethio-Semitic southward through the high ridge separating the water basins of the Red Sea and the Nile Valley. Recent glotochronological studies by historical linguists indicate that the two main branches of North and South Ethio-Semitic had already achieved their separate identities by about 300 B.C., as early as the kingdom of Daamat. Geez, Tigre, and Tigrigna, which constitute the North Ethio-Semitic languages, continued to flourish in what were the heartlands of the kingdoms of Daamat and Aksum in Tigray and of what is now Eritrea. Speakers of the South Ethio-Semitic languages, Amharic, Argobba, Harari, and Gafat/Gurage, gradually moved farther south and southeast and divided into two groups: Amharic and Argobba on the one hand, and Harari and Gafat/Gurage on the other. This occurred sometime between 300 B.C. and A.D. 100.[4]

In its initial stages, the southward movement of Ethio-Semitic speakers was probably connected with the dynamic process of social evolution, the formation of states, territorial expansion, and the incorporation of diverse populations which had been taking place in northern Ethiopia since the fifth century B.C. However, the communities that developed in the south seem not to have been official settlements established by the state itself. Rather, they seem to have constituted gradual and spontaneous population movements, with groups of South Ethio-Semitic speakers slowly breaking off from one another and settling among predominantly Kushitic speakers. The Gafat/Gurage groups interacted with Omotic speakers as well, and all underwent the crucial processes of linguistic, cultural, and social interaction that led to integration within their respective host milieux. Nevertheless, distant recollections of a common origin with North Ethio-Semitic speakers must have persisted over the centuries. These recollections were activated particularly during the Zagwe dynasty after the twelfth century, when the most northerly group of South Ethio-Semitic speakers, the Amhara, began to act as an effective bridge between North and South Ethio-Semitic, initiating a period of revival and growth for the ancient Aksumite traditions of state and society throughout the Ethiopian highlands.

After the king of the *Adulis Inscription*, the most important Aksumite monarch was perhaps Ezana, who reigned in the middle of the fourth century A.D. He was the first Aksumite ruler to become Christian and to establish the Church in his kingdom, actions that had a permanent impact on the history and cultural life of the people of the region as a whole. Also significant was his decisive defeat of the rival kingdom of Meroe in about A.D. 325.[5] This was a landmark in

4. Taddesse Tamrat 1977: 125–29.
5. Sergew Haile Sellassie 1972: 105–7.

the history of Aksum and the Ethiopian states that succeeded it, not because there were any permanent territorial gains in that direction, but because the only other ancient African state with legitimate claims in the Nile Valley came to an end, once and for all.

Meroe was not succeeded by any other major power for a very long time, until the rise of the Funj kingdom of the Sennar in the early sixteenth century. This meant that Aksum became the only state organization of significant international standing in the region between the Red Sea and the Nile Valley. In the absence of any local rival to challenge its power, the Ethiopian state tended to consider the hinterland of the Red Sea as a vast sphere of influence which it could bring under effective tributary status piece by piece, whenever the need arose and whenever it possessed the requisite military force.

This tradition was inherited intact by the Zagwe and particularly by the Solomonic dynasty. The latter simply assumed that the interior of Ethiopia and the Horn was an exclusive preserve destined to become entirely their domain, and they worked hard to put it into effect whenever possible. This attitude was enhanced by the relatively weak socioeconomic position of the surrounding populations, which always displayed a sense of awe and respect toward the Ethiopian state and its destructive powers, and toward the vast natural resources of the interior which it controlled.

The extent to which this claim to extensive spheres of influence could be realized depended on how much military power the Ethiopian state had at its disposal in any given period. For the Aksumite kingdom, the highest point of achievement seems to have been reached in the golden age between the reigns of Ezana and Kaleb. By the latter part of the eighth century, the complete transformation of the international order in the region, following the rise of Arab power in the Middle East, the eastern Mediterranean, and North Africa, had robbed Aksum of its position of prominence and its altered maritime orientation.

The Aksumite state now had to concentrate all its efforts on the effective control of its sphere of influence in the south, the very direction in which related South Ethio-Semitic speakers had begun to move in earlier centuries, long before the conversion of Ezana. The centre of the kingdom could no longer be maintained at the ancient site of Aksum, increasingly located at the northern extremity of a territory now expanding to the south. There is a crucial period of some four hundred years, between the middle of the eighth and the twelfth centuries, for which we have practically no Ethiopian documentation, but during which extremely vital developments must have taken place. The Ethiopian state and society that emerged after this period differed in many respects from those of the early days of Aksum. The cultural changes that seem to have taken place during the intervening period resulted in the great synthesis of the ancient Aksumite traditions of state and society: a fusion of the early Christian and Biblical teachings transmitted through Aksum and the native African traditions of the predominantly Kushitic peoples of the area. This synthesis produced the distinctive fabric of Christian *habasha* culture that has characterized the image of the Ethiopian state since medieval times.

Arab historians and geographers are our primary chronicles for the fascinating period between the ninth and thirteenth centuries. Essentially they portray a strong and rather exotic Christian polity inspiring great respect among neighboring peoples through the considerable power at its disposal. In about 870, Al-Yaqubi described it as follows:

> It is a spacious, important country. . . . The Arabs still go to it for trading and the [Ethiopians] have mighty cities, and their coast is Dahlak. As to the kings in the land of Al-Habasha they are under the control of the great king [Najashi] to whom they show obedience and pay taxes. The Najashi is of the Jacobite Christian faith. The Zenj are the last of the *Habasha*.[6]

The picture he draws is of a viable state, with an extensive sphere of influence in the interior of Ethiopia and the Horn and with no credible rival in the region. The extent of the sphere of

6. Al Yaqubi ibn Wadih 1883: 219.

influence can be judged by the fact that by the mid-tenth century, when Al-Masudi and Ibn-Haukal were writing, it was not only Dahlak that served the Habasha state as a port, Zeila was also becoming increasingly important. Ibn-Haukal describes it in relation to the Ethiopian interior, beyond "the wilderness and the deserts difficult to cross."[7] This already points to the Shawan plateau as the platform of communication between the Habasha state and the port of Zeila on the Gulf of Aden.

The center of the Habasha state moved to Adafa, later renamed Lalibela after the most famous king of the dynasty. The state was now under the control of the native Agaw, who constituted the major Kushitic-speaking people of the northern highlands of Ethiopia. The Agaw occupied a very large area in ancient times and served as the most important substratum for the later development of the ancient communities of both North and South Ethio-Semitic speakers. The ancient Ethio-Sabean and later Aksumite civilizations were essentially superimposed on this Agaw Kushitic base, and the Agaw peoples east and north of the Takkaze seem to have constituted an integral part of the population of the north Ethiopian state from the beginning. After the center of the state had moved to the south, the Agaw gradually began to dominate the various institutions of the kingdom, finally establishing a dynasty of their own. The Agaw of this region had been Christian since at least the sixth century, and their new dynasty, known as Zagwe, preserved the ancient traditions of Aksum and contributed to the cultural synthesis described above. The dynasty had a firm hold on its central provinces of Wag and Lasta, Amhara, Tigray, and southern Eritrea. Northern Eritrea and Shawa were, in effect, satellites, and the western Agaw of what are now the regions of Gondar and Gojjam were gradually brought into the network of relations with the central Agaw state.

By the end of the thirteenth century, the Agaw gave way to the most northerly speakers of South Ethio-Semitic, the Amhara, who dominated the political scene until the sixteenth century. It may be said that the Habasha cultural synthesis was brought to its perfection during this period. Strongly committed to bring about the revival of the golden days of Aksumite power, the new dynasty set out by forging a new ideology of Solomonic legitimacy[8] based on traditions passed down from the later days of Aksum, whose institutions they began to emulate. During this period, the territory of the Ethiopian state reached its greatest extent since ancient times, with enormous additions being made especially in the years between the reigns of Amda Seyon (1314–44) and his great-grandson Yishaq (1413–30).[9]

Amda Seyon set out to reunite the ancient provinces of Aksum and bring the natural resources of central, western, southern, and southeastern Ethiopia under his control. In his official statements, he sounds very much like the king of the *Adulis Inscription* and Ezana, on whom he seems to have modeled himself. In a land grant issued a few years after his accession to power, he declared:

> [In 1317], I went to war ... [and] God delivered all the people of Damot into my hands: its kings, princes, rulers, and its people, men and women without number, whom I exiled into the land of other people. After that God gave me all the people of Hadya, men and women without number. And after that God delivered the king of Gojjam into my hands with all his troops.... And after that God delivered into my hands the ruler of Enterta with all his army, his people, his relatives, and all his country as far as the Cathedral of Aksum. And I, Amda Seyon, went to the Sea of Ertra. When I arrived there, I mounted an elephant and entered the sea. And I took my arrows and spears, killed my enemy, and saved my people.[10]

It was indeed a long march from the coast of Eritrea in the north to Hadya and the middle Omo valley in the south, from Ifat, Fatagar, Dawaro, Bali, and far into the Harar plateau in the

7. G. Wiet 1964: 56.
8. E. A. W. Budge 1922.
9. Taddesse Tamrat 1972(A): 119–55.
10. Id. 1970.

east,[11] and to Gojjam and Damot in the west. Amda Seyon set out to establish himself as a veritable warrior king. Not only did his exploits impress his countrymen, but news of them was spread very widely by merchants and by Christian and Muslim pilgrims to the holy places of Palestine and South Arabia. The private secretary of a contemporary sultan of Egypt reported an exaggerated tradition that nevertheless reflects the great variety of dependent principalities under Ethiopian control: "It is said that he has ninety-nine kings under him and that he maketh the hundredth himself." Amda Seyon literally scoured the Ethiopian highlands in every direction, and a contemporary bard sang the following in his honor in the fashion of the time:

> Amda Seyon, the patriot,
> Restorer of the frontier lands;
> Whom have you spared in the borderlands,
> Without slapping them in the face,
> And taking away their children and wives?
> . . . . . . . . . . . . . . . . . . . .
> Amda-Seyon who spread his fame [far and wide],
> . . . . . . . . . . . . . . . . . . . .
> By Sea as far as Ertra. [12]

Thus, for almost a thousand years after Ezana first established the Christian faith in Aksum, the Ethiopian state consolidated its hold in the interior at its own pace and without serious challenge from any other state organization of significant strength. Wherever the state gained additional tributary dependencies in the highland areas, churches were constructed to serve the religious needs of the new administrative and military officials who settled there. As more meaningful interaction developed between these officials and the local people, the people were encouraged to join in the services of the church and follow its teachings and practices. Where the clergy were men of learning, they often entered into debate with local leaders on the relative merits of their respective beliefs.

According to many hagiographical traditions, these early discussions often led to dramatic confrontations between the two groups, in which each attempted to demonstrate the superiority of its own rituals and religious world view.[13] Especially since the Christian clerics received the support of the state, they were usually victorious in the disputes and established themselves more firmly in the area. In many cases, old centers of religious worship, such as hilltops, were chosen as sites for new churches or monasteries, and sacred trees were cut down to serve as construction material for the new buildings. This seems to have been done deliberately to demonstrate the impotence of the ancient animist deities.[14] In time, local leaders agreed to participate in and benefit from the considerable patronage of the Church; special dispensations made it easier for them to do so, particularly regarding the rigorous demands of Church customs such as fasting.[15]

The Christian identity of the area became increasingly evident with the construction of churches throughout the highland districts under the Christian kings. Each of these churches tried to provide some education, at least to the children of clerical families, but more advanced instruction was not generally available in the early centuries. Until the middle of the thirteenth century, by which time Christian communities had been established as far south as the upper waters of the Awash river in Showa, it was mainly the old monasteries established by the Nine Saints in Tigray which provided educational facilities to the whole of the Ethiopian Christian highlands. It seems that these ancient monasteries, together perhaps with a few Zagwe churches in Lasta, continued to be the major cultural centers of Christian Ethiopia. The careers of Christian leaders in medieval Amhara and northern Shawa indicate that any ambitious young man had to travel all the way to northern Ethiopia to receive serious religious and literary

11. J. Perruchon 1889.
12. These songs were published by I. Guidi 1889.
13. See, for example, C. Conti Rossini 1896.
14. Id. 1905.
15. Taddesse Tamrat 1972(B).

training. When they returned to their native districts, some of them opened their own small schools. For many years, however, none of these schools seems to have attained any particular significance beyond providing very elementary instruction in reading and writing to a handful of local children.

A major breakthrough was made in about 1248, when a young monk named Iyasus Moa (c. 1211–92) came to Lake Hayq in Amhara and opened a small monastic school at the island church of Saint Stephen. He was born at Dahna, in the Agaw district of Lasta bordering on the Takkaze river. While still a young boy, he left his home and traveled to northern Tigray, joining the famous monastery of Dabra Damo. There he studied for many years under the abbot Abba Yohanni, who also conferred on him the monastic habit. Iyasus Moa was a very serious student and distinguished himself as an outstanding calligrapher. He apparently copied many early books while in Dabra Damo, and is renowned for having left a large collection of manuscripts at the time of his death at Hayq in 1292. According to the traditional account of his life,[16] one of his pupils, Yikunno Amlak (1270–85), became the founder of the Solomonic dynasty, and there are other more reliable indications that the island monastery of Hayq continued to be one of the most important cultural centers of the Solomonic kings until the wars of Ahmad Gragn.[17]

Many of the pupils of Iyasus Moa later acquired considerable fame as the leading monastic leaders of the Ethiopian Church. Abba Hirute Amlak is believed to have been the founder of the important island monastery of Daga Estifanos at Lake Tana. Many others are said to have founded similar communities in medieval Amhara and Begemdir. The most outstanding student of Iyasus Moa was Abba Takla Haymanot of Shawa (d. 1313). He studied at Hayq for nine years and then went to visit the ancient monasteries of northern Ethiopia, especially Dabra Damo and other centers of learning in Tigray, where he stayed for more than ten years. In all these places he undertook further religious and monastic training, gaining the deeper insight into the history and ecclesiastical traditions of Ethiopia that ensured his undisputed leadership of the Church. He returned briefly to Hayq with a large number of followers, but was advised by Iyasus Moa to go back to his native Shawa. It was for this reason that he established himself at Dabra Libanos, which became one of the most important religious centers of Christian Ethiopia. There Takla Haymanot trained the disciples who later established monastic and educational centers throughout Shawa, Damot, Gurageland, and wherever Christian settlements were to be found throughout the country.[18] His followers became so widely spread that most of the monastic centers of Ethiopia derive their origins from his spiritual leadership, and are therefore known collectively as "the House of Takla Haymanot."

Other monastic leaders emerged in northern Ethiopia during the same period, and they also established cultural centers. Of these new leaders, Abba Ewostatewos deserves particular mention. Born in Garalta in central Tigray, he studied under his uncle, the abbot of Dabra Maryam. He then left Garalta and began teaching in Sarae, in what is today southern Eritrea gathering many students there who later founded their own monastic centers in the area. Ewostatewos himself was persecuted by his colleagues in the Church, especially for insisting on the Old Testament custom of the Saturday Sabbath. He went to Egypt, apparently to plead his case before the patriarch, and traveled on to Palestine, Cyprus, and Armenia, where he died after fourteen years of self-imposed exile.[19] He was accompanied by a few of his followers on his foreign travels, and some of them returned to Ethiopia after his death. Together with the disciples who had remained in Ethiopia, they organized themselves into a major monastic group known as "the House of Ewostatewos," as distinct from the followers of Takla Haymanot. Important cultural and educational centers, such as Dabra Maryam of Qohain and the famous Dabra Bizan on the eastern edge of the Hamassien plateau, were later established by the followers of Ewostatewos.[20]

16. S. Kur 1965.
17. Taddesse Tamrat 1970.
18. Id. 1972(A): 169–96.
19. B. Turaiev 1905.
20. C. Conti Rossini 1901.

By the fifteenth century numerous churches and monastic centers had been established at crucial points from northern Hamassien to Lake Zway in the south, and from the eastern edge of the Ethiopian plateau to beyond Lake Tana in the west. Like the ancient foundations of the Nine Saints in Tigray and southern Eritrea, these new religious centers began to provide the only educational facilities available in the Christian highlands. The traditions about the founders and later leaders of these communities provide a great deal of historical material that allows us to reconstruct the educational programs of the monastic schools.

Each community ran as many schools as size and resources permitted. The schools were administered by senior members of the community especially known for their learning and exemplary character. Like universities today, the monasteries and major churches of Ethiopia competed with each other to attract famous teachers, and the prestige of a community depended largely on the quality of the teachers it employed. The level and content of the courses progressed from elementary reading and writing to advanced instruction in church music, including the singing, chanting, and ritual dancing associated with it; highly demanding courses in *qine*, or oral poetry; and detailed analysis and *tirgum* (interpretation) of the Old and New Testaments and other canonical works accepted by the Ethiopian Church. Beyond their essentially religious contents, the educational programs involved discussions in history, including the origin of the state and its different peoples, as well as philosophical and cosmological issues. More practical courses in advanced calligraphy and traditional painting were also given whenever masters in these fields were available.

The richly endowed royal churches and the great monasteries possessed the necessary resources to offer this instruction. The island monasteries of Lakes Tana and Hayq were especially renowned for their educational programs, as was the royal court. At least three royal chapels traveled with the emperor wherever he went, and they were staffed by the cream of the ecclesiastical hierarchy. The best scholars were recruited to teach in the schools attached to each of the chapels, and it was in the schools of the royal court that many of the children of the emperor and the aristocracy, as well as members of clerical families, began their studies. The *kahinata dabtara*, as the more ascetic monastic groups called the clergy of the court with some derision, was composed of some of the most highly educated individuals in the empire. With the Egyptian metropolitan also being an integral part of the royal court, all acceptable innovations in literature or the visual arts were usually introduced at that level, and it was the learned *kahnata dabtara* who had the first opportunity to adopt them and supervise their diffusion throughout the empire.

Although most graduates of these schools joined the prestigious clerical service, many were also recruited into civilian or military service. The Church exercised considerable influence over the elite in all sectors of life. Indeed, many of the royal princes who later became emperors such as Dawit (r. 1380–1412), Zara Yaiqob (r. 1434–68), and Naod (r. 1494–1508), are known to have attended the monastic schools. Zara Yaiqob and Naod, who were noted for their scholarship, wrote a number of original works in the Ethiopic language. Naod is affectionately remembered by the clergy of Dabra Libanos for having descended from his throne during one of his visits, mingling with the *dabtara* and joining them in their sacred songs and ritual dances.

From the beginning, there was a close relationship between church and state in Ethiopia. The royal founders of the Aksumite Church, Ezana and his brother Saizana, have been canonized under the names Abrha and Atsbha, and the hagiographical traditions that have come down to us depict them not only as great rulers but also as powerful leaders of the Church. Many other kings after them, like Kaleb and his son Gebre Meskel in Aksumite times, Yimriha Kristos, Lalibela, and Naakuto Laab of the Agaw dynasty, and Dawit, Tewodros Zara Yaiqob, and Naod of the Solomonic period, are remembered as decisive figures in the life of the Church during their reigns. The basic notion of divine kingship was enshrined in the legend of the

Queen of Sheba, which in effect made the kings distant relatives of Christ. At a more mundane level, the fact that the spiritual head of the Ethiopian Church, the *abun*, had to be an Egyptian and therefore a foreigner, enhanced the power of the monarchs over the Church. The intensely competitive nature of the great monasteries could only further the power of the monarchs. There is no doubt that, next to the *abun*, whom he could sometimes dismiss and send back to Egypt, the head of the Church in a national sense was the Christian monarch himself. As such, he wielded great power, even in the most important theological matters. An outstanding example of this phenomenon is Zara Yaiqob, who made many theological judgments in his treatises which have been used as reference works by the Church until our own time.

The Ethiopian monarch also had the responsibility of defending and protecting the Church and looking after its needs. The emperors provided the Church with large grants of land and with the other resources they used to undertake their educational and religious functions. The vast territories that had come under their control, particularly during the Solomonic period, were used by the emperors to maintain the huge ecclesiastical and military hierarchy that developed around their courts and throughout their domains. The most important resources that the monarchs had at their disposal were the land and the inhabitants over which they had established a tributary status, and it was through the allocation and reallocation of these resources among their innumerable retainers that they maintained their power. As early as the Aksumite period, the king of the *Adulis Inscription* described the tributary relations he established as follows: "Upon their submission, I restored their territories to them subject to the payment of tribute. Many others besides these submitted on their own accord, and became likewise tributaries." The system seems to have continued throughout the following centuries, and the Solomonic kings established similar relations in the far more extensive areas under their control across the Ethiopian highlands.

However, the Solomonic kings were unable to develop a centralized system of administration for their vast empire. Most of their dependencies were administered by local chiefs or princes, who transmitted the required tributes, maintained law and order locally, kept the trade routes open and safe, contributed local forces for the emperor's campaigns, and executed other orders issued by the royal court. Successions to the chieftaincies or principalities had to be approved by the court, which could give preference to particular branches of the local ruling families. When military garrisons were established to increase security for the empire, their living expenses had to be provided by the local inhabitants through the tributary system.

Unlike the kings of Aksum, and those of the Agaw dynasty at Lalibela, the Solomonic emperors developed no urban centers until the rise of Gondar in the seventeenth century, and ruled instead from a series of nomadic courts. These courts moved continuously, bringing a great deal of havoc to the areas they visited since the local inhabitants had to provide for the upkeep of the large retinues during their sojourn. The movements of the court were connected mainly with security needs, but moves to richer areas were often made in search of better supplies of food and fuel. Furthermore, an almost continuous state of emergency existed during much of the Solomonic period, which required the royal court to be on constant alert. The Ethiopian Christian monarchs were facing a new challenge to their traditional claims of an exclusive sphere of influence over the vast hinterland of the Red Sea, throughout the interior of Ethiopia and the Horn. As noted earlier, this claim had held fast since the conquest of Meroe by Ezana, and the Ethiopian state had no serious rival in the area for many centuries. However, by the eleventh century, Muslim principalities had begun to rise along the main trade routes between the interior and the Gulf of Aden.

One of the earliest places where Islam was preached in public with official tolerance was the city of Aksum, during the life of the prophet Muhammad himself.[21] Between the ninth and tenth centuries, therefore, before any Muslim principalities had been established in the area,

21. J. S. Trimingham 1952: 44–46.

Muslim Arab merchants came to conduct business with the Habasha kingdom. Settlements and tomb inscriptions associated with these early merchants have been found at various sites in northern Ethiopia.[22] The merchants gradually succeeded in converting some of their Ethiopian trading partners, and a number of Ethiopian Muslim communities emerged along the major trade routes, especially those leading to the ports and markets on the Gulf of Aden where the kingdom of the Habasha, as the Arab writers called it, was vulnerable.

By the thirteenth and fourteenth centuries, there was a chain of Muslim communities constituting independent merchant principalities stretching from the northeastern part of Shawa through Ifat, Fatagar, Hadya, Dawaro, Bali, and the Harar plateau.[23] Because of their connections with major Arab states in Yemen, Egypt, and Baghdad, specifically mentioned by Al-Yaqubi, these principalities had a share of the import and export trade, and they constituted a fresh challenge to the maintenance of a unified state system in the region. It was essentially to resolve this problem that Amda Seyon, his sons, and grandsons led their energetic campaigns throughout the Ethiopian highlands. Their central policy was to bring the natural resources of the interior of Ethiopia and the Horn under their control, to preserve the trade routes that led in various directions into the interior, and to draw the small Muslim communities into a commercial partnership by bringing them into the ancient network of tributary relations that had characterized the Ethiopian state since Akumite times.

To Amda Seyon and his successors, the fundamental issue was not religion or ethnicity, but the territorial unity of the ancient Ethiopian state. A person might speak Kushitic, Nilo-Saharan, Omotic, or Semitic languages and profess any religion, including animism, Christianity, or Islam, but was nevertheless an Ethiopian. In about 1332, when his power was challenged by a rebellious Muslim leader, Amda Seyon is reported to have shouted, "I am the emperor of all the Muslims in the land of Ethiopia!"[24] Another incident showed that the emperors saw themselves as more than simply the rulers of Christian subjects. On one occasion an angry group of Ethiopian priests brought to Amda Seyon a man who had been converted to Christianity but later reverted to his earlier ways. Amda Seyon is said to have told them, "Let him be; let him go in peace and live in accordance with the traditions of his ancestors."[25]

This tolerance infuriated the more fanatical clergy, and along with the violent quarrels he had with aggressive monastic leaders on the question of his unorthodox matrimonial practices, led to rumors that Amda Seyon had himself become Muslim. Upon reaching Cairo, the news was recorded with much optimism by the private secretary of the sultan: "It has been reported to us that the king . . . has been secretly converted to Islam, and that he continues to practice Christianity only to preserve his crown."[26]

The maximalist notions of Amda Seyon about the Ethiopian state and the integrity of its territorial limits laid the cornerstone for the policies of all his successors. Sayfa Arad, Dawit, and Yishaq advanced his policy of restoring the ancient Aksumite frontiers by sending huge expeditionary forces not only into the Eritrean highlands and coastal regions, but also deep into the Beja country and the Takkaze-Atbara Valley. In these campaigns they were following almost exactly their distant Aksumite predecessors, the king of the *Adulis Inscription* and Ezana. The medieval Ethiopian expeditions in the direction of the Nile Valley and into the Egyptian sphere of influence are reported by both Egyptian and European historians of the time, and Dawit was congratulated for his actions in a letter from Henry IV of England, the earliest known message to Ethiopia from a European monarch.[27]

On the home front, Dawit also energetically pursued the policy of maintaining the territorial unity of the kingdom. One of his most impressive feats was the long march into the Harar Plateau in pursuit of the Walasma rebel prince, Saadedin, who had grown up with him at the court of his father, Saya-Arad. He followed him as far as Zeila, and had him captured and executed on the island where he was hiding, still called Bar-Saadedin. Dawit's son, Yishaq, was

22. M. Schneider 1967.
23. An excellent example is given in E. Cerulli 1941.
24. J. Perruchon 1889.
25. Taddesse Tamrat 1972(A): 117.
26. Ibid.
27. Ibid.: 250–59.

41

another warrior emperor in the best traditions of his great-grandfather, Amda Seyon. He marched to the extremities of the Ethiopian highlands: to Massawa on the Eritrean coast; to Gondar against the Falasha; to Matakkal against the Agaw and the Gumuz; to Bizamo, Innarya, Janjero, Walamo, Alaba, and deep into the Harar Plateau and Somali country. It is interesting to note that it was in connection with the reign of Yishaq that the Somali were first mentioned in a historical document.[28] As with Amda Seyon, the military exploits of Yishaq were a favorite subject for the songs of the bards of the day:

> Zan Yishaq, your visage,
> Your countenance is so alarming!
> . . . . . . . . . . . .
>
> [The vanquished] themselves said to you,
> . . . we shall pay your tribute,
> The tribute we used to pay to your father.
> Do let us deliver your horses,
> Do let us deliver your mules,
> . . . . . . . . . . . .
>
> And your gold in the proper weights,
> Only spare our lives for posterity![29]

The frontiers and the territorial integrity of the Ethiopian state remained largely intact until the first quarter of the sixteenth century, attaining the greatest degree of consolidation and relative tranquility during the reigns of Zara Yaqob and his son and immediate successor, Baida Maryam (1468–78). It was during this period that many of the literary and artistic traditions of the Ethiopian Church emerged, and the beauty and wealth of many of the royal churches in Bali, Dawaro, Shawa, Damot, Amhara, and throughout northern Ethiopia were rapturiously described by the chronicler of the Imam Ahmad Ibn Ibrahim, known as Gragn (fl. 1520–43). Unfortunately, only a very small portion of this glorious cultural heritage survived the destructive forces of human history.

28. E. Cerulli 1957(A): 111.
29. I. Guidi 1889.

# CHURCH AND STATE IN ETHIOPIA: THE SIXTEENTH TO THE EIGHTEENTH CENTURY

*Donald E. Crummey*

THE MEDIEVAL SOLOMONIC KINGS of Ethiopia, especially Zara Yaeqob, had brought about a synthesis of church and society, in effect a new religious nationalism, which did not go long unchallenged. In the reign of his great grandson Lebna Dengel (r. 1508–40), a series of upheavals and challenges began which shook Christian Ethiopia to its core.

In the later 1520s a remarkable and gifted leader, Ahmad ibn Ibrahim, nicknamed Grañ (the Left-handed), forged a movement of the subject peoples of the eastern empire unified around Islam. In 1529 his troops defeated the Ethiopian royal army at Shembra Kure and threw off Christian domination. In subsequent years they overran the Christian highlands, which they occupied from 1531 to 1543. The effect of this decade was profound. A Christian chronicler lamented, with what degree of exaggeration we cannot judge, that not one in ten Ethiopian Christians held to his faith. Churches were plundered, manuscripts burned, and monks and priests massacred by the thousands. Much of the cultural legacy of the country was lost, and the paintings and artefacts described in this catalogue can only hint at what must once have been.

The convulsions of the 1530s and 1540s destroyed the frontier defenses of both Muslim and Christian states in Ethiopia and opened the door to a large-scale immigration by the Oromo people. They also encouraged European intervention. A small Portuguese military expedition had a hand in the eventual defeat of Gran in 1549. Its members settled in Ethiopia, and at the very end of the century some Ethiopian rulers turned to Portugal and Spain for assistance.

The Oromo speak a Kushitic language, only distantly related to the Semitic languages of Ethiopian Christians. They emerged in southern Ethiopia and were organized in age groupings and clans rather than kingdoms. They proved mobile and adaptable in exploiting the weaknesses of both Muslim and Christian established powers. Raiding parties, followed by settlers, attacked first the eastern highlands, then the western. By 1600 they were firmly established in much of the Rift Valley of south central Ethiopia and in parts of Shawa which had been central to the kingdom of Zara Yaeqob and his successors. Oromo raiding parties presented an irrepressible challenge to the armies of the Christian state, whose resources they drained. Their settlements meant the disappearance of the Christian presence in certain areas for decades, sometimes centuries.

In the 1610s the emperor Susenyos (r. 1607–32) turned to a small group of Jesuit missionaries for assistance in solving chronic military and social unrest, which had undermined his position. In the 1620s he supported a disastrous attempt to convert the country from Orthodoxy to Roman Catholicism. The Jesuits foolishly sought to eradicate everything distinctive about Ethiopian Christianity and to replace it with European practices. The result was to worsen every problem the emperor wanted to solve. Social unrest increased, and in 1632 the emperor abdicated in favor of his son Fasiladas (r. 1632–67).

The great traumata had irreversible effects. In 1632 the territory of the empire was much reduced from its height around 1500. Oromo, unassimilated either to Christian culture or to the politics of the Solomonic state, now occupied what had been the homeland of the Amhara and other lands on which earlier rulers had depended for tribute. In reestablishing social and political order, Fasiladas and his successors returned to the example of Zara Yaeqob. They sought to rebuild the state and its society in close association with the Christian Church. For a brief period, from the mid-seventeenth to the mid-eighteenth century, they succeeded. Under their aegis the arts of architecture, painting, poetry, and writing flourished. To them we owe much of our knowledge of historic Christian Ethiopian culture and many of the objects described in this catalogue.

Fasiladas moved his center of operations to the area north of Lake Tana, one favored by his predecessors, who had based themselves on the coastal plain to its northwest. He moved farther off, some forty kilometers from the lake and more than three hundred meters higher up, to a spur of land that jutted between the Angarab and Qaha Rivers. Nearby, there was a church on the Qaha dedicated to Jesus and possibly a regional market. Fasiladas built a castle in which he could pass the season of the rains. Tradition attributes to him a number of other buildings as well. His successors, his son Yohannes I (r. 1667–82) and his grandson Iyasu I (r. 1682–1706), added to the buildings, and by the later seventeenth century Gondar had emerged as the first fixed capital of any lasting consequence since the times of the Zagwe.

At its height in the early eighteenth century, Gondar had three major industries: government, trade, and learning. The Christian kings continued to move around as their medieval predecessors had. However, for more than four generations they returned to pass the rains at the same place, in increasingly large, walled palaces. This gave an element of stability that many earlier capitals had lacked. So far as trade was concerned, Gondar was well located at the intersection of major regional and international networks. The Lake Tana basin was bordered by varied highland regions to its southeast, east, and north, while to the west the land sloped away to lowlands. From each of these areas goods flowed across the basin to other regions. Gold, civet musk, and slaves—the Ethiopian goods most avidly sought in the international market—came primarily from lands to the south of the basin beyond the great bend of the Abbay. Gondar established itself as a center through which all these goods could flow, sending the international commodities westward to markets in the Sudan or northward to markets at Massawa and the Red Sea coast. Trade lent a somewhat cosmopolitan air to the national capital. Through taxation, it also provided a means of enhancing the imperial coffers. The main source of national wealth derived from agriculture and herding. Through the system of *gult* the court drew tribute from farmers and herders, and for the decades in which Gondar flourished, they must have drawn generously, for they were able to establish and endow a host of churches whose clergy supported the third industry of the capital, education.

Tradition claims that there were forty-four churches in Gondar. There were certainly two or three dozen, and in the mid-eighteenth century the priests, monks, and scholars attached to them would have numbered several hundreds. They attracted pupils from all over the country, Tegrenna speakers from the north, Shawans from the south. They produced a host of major works through copying and illustrating older manuscripts and composing new treatises. Chroniclers recorded the activities of all the major rulers from Yohannes II, who came to the throne in 1667, to Iyoas, who was deposed a hundred years later in 1769. They also began the process of compiling the records of earlier generations. Scholars produced original works of theology.

In a larger sense Gondar became the new center of the Ethiopian Church, replacing, to some degree, both Aksum and the monastic centers that had held sway during the medieval period. This reflected both the model of Zara Yaeqob and the extent to which the church had become

fused with the social order of the country at this time. In theory, there was a clear distinction between clerical and lay, between people who had been consecrated by the bishop to the holy orders of the church and those who had not. Military activity and the bearing of arms were associated with lay males, on the one hand, and literacy with clerical males, on the other. In practice, the lines were often blurred and confused, as the sources for the period make clear.

Historical documents are unusually rich for the Gondarine period. In addition to narrative histories and discursive theologies, we have records of grants of land to churches, of the holding of church lands, and of clerical organization. These records are organized around the divine liturgy. The clergy lists specify the order in which priests are to serve according to the church's calendar of feasts and fasts. Lands were given to individual churches to support their needs: for building maintenance and repair, for consumable supplies like incense and communion bread and wine, for special services commemorating the major donor, and in support of the clergy who performed the liturgy and adorned it with music and poetry. Included among the clergy of a very large church would be specialists in different branches of church learning. It was a requirement of each priest or deacon or chorister holding church land that he perform specific liturgical acts on specific liturgical occasions.

The fusion of church and society is revealed by the lists of serving clergy and the holders of church land. These lists are permeated by women and secular noblemen, neither of whom could even enter that part of the church in which the sacraments were consecrated, let alone undertake such actions themselves. Each had the obligation to see that a task was performed, but they would hire someone else or direct a retainer to do it.

If the Church was fully immersed in the society of north central Ethiopia in the eighteenth century, Gondar was at the center of the Church in a way probably unprecedented since the zenith of Aksum. During the first centuries of the Solomonic era the Church had possessed a number of centers. One was the royal court where the bishops resided. Others were to be found in such monasteries as Hayq Estifanos in Wallo and Dabra Libanos in Shawa, thanks to the ability and vigor of their leaders and their proximity to the center of political power.

Gondar eclipsed them all. Following the establishment of the royal court, the bishop settled in the Gondar parish of Saint Gabriel, with a rural residence at Janda in Dambeya, toward Lake Tana. The *echage*, the nominal abbot of Dabra Libanos, moved from the mother monastery in Shawa to Azazo, about ten kilometers away from Gondar. There he took over a rich fief that the Jesuit missionaries had previously held. The monks of Ewostatewos were well represented in Gondar through the endowment on their behalf of at least one of its churches. The influence of the capital was strongly felt in Tegray to the north. The cathedral of Aksum had been destroyed in the *jihad* of the 1530s. It was finally rebuilt in a rectangular Gondarine style, and Gondarine forms of church land endowment were introduced in the neighboring Tegray town of Adwa. Finally, Gondar derived prestige from the nearby presence of ancient monasteries on the islands of Lake Tana and to the northwest in the wilderness of Waldebba.

In attracting them to Gondar the rulers of Ethiopia amply provided for the bishop, the *echage*, and the ranks of learned clergy. They founded churches and endowed them with lands. The first such church was established by the emperor Fasiladas at Qoma in southern Gondar province on the edge of the Abay River precipice. Fasiladas also endowed the church of the Savior of the World in Gondar itself, close to the castle compound. His son, Yohannes II, founded a church to God the Father at Tadda not far from the capital on the way to the eastern highlands. The son of Yohannes II, Iyyasu I, built the most famous church in the capital, Dabra Berhan Sellase, dedicated to the Trinity. Succeeding rulers maintained the tradition. In the 1720s Bakaffa endowed a number of churches in Gondar itself, and in and around Lake Tana. Iyyasu II (r. 1730–55) and his mother, the empress Mentewwab, were lavish in their foundation of Qwesqwam Dabra Sahay on the western outskirts of Gondar, and of a church to the Trinity

on the island of Narga in Lake Tana. The last major endowment in the capital was the Baata Church, which received the favor of the emperor Takla Haymanot (r. 1769–77).

Gondar created a tradition of founding and endowing churches, which continued in the provinces for two generations after the reign of Takla Haymanot. A movement in this direction was already under way. Around 1750 in the Tegray town of Adwa, the local ruler Mikael endowed a church in honor of his patron saint. In the 1790s in the highlands southeast of Gondar, to the east of the town of Dabra Tabor, a nobleman called Haylu built a church at Este dedicated to Jesus. At much the same time two churches to the south of Este, on the Gojjam side of the Abbay, were endowed, at Mota to Saint George, and at Qaranyo (Calvary) to the Savior of the World. Early in the nineteenth century, Maru, the ruler of the provinces between Gondar and the lake, and on to the west, built and endowed a church to Mary at his residence of Fanja, in Dambeya. Finally, in the 1830s a rich establishment was created at Darasge on the edge of the Semen mountains, again in honor of Mary and again by a provincial ruler.

In these and many other ways, the Gondarine rulers sought to draw on the power of religion to strengthen their kingdom. Their efforts were in vain. The Church proved internally weak and divided, while the kingdom itself was being undermined by the great noblemen. The reign of Iyyasu II proved one of steady decline, a process that intensified in the reign of his son and successor, Iyoas (r. 1755–69). In the ensuing crisis, Iyoas was assassinated. Traditional historiography interprets this event as ushering in a new era, the *Zamana Masafent* (Era of the Princes), in which the monarchy rapidly sank into disrepute and impotence and the country was divided by competing magnates who recurrently fought each other for supremacy. The decline and collapse came about primarily through secular forces, but the church played a role in intensifying them.

The Ethiopian Church was deeply affected by its encounter with the Jesuit missionaries in the early seventeenth century. Doctrinal controversies proved especially difficult, since the traditions to which the Roman Catholic and Ethiopian Orthodox Churches belonged diverged following disagreements at the Council of Chalcedon in 451 over the definition of the nature of Christ. While both churches accepted humanity and divinity as equal components in his nature, they disagreed over precisely how those natures were related to each other. The ancient disagreement was revived with some vehemence and became a lasting problem because the Ethiopians were divided in their response. The various doctrinal schools that arose within the Ethiopian Church continued to debate the issue raised by the Jesuits for a century and a half after their departure. The competing schools took on regional and institutional facets. One school, known as the *Qebat* (Unctionists), was particularly strong among the monks of Saint Ewostatewos and in the province of Gojjam. Another, the *Saga* (Grace) faction, was sustained by the monks of Takla Haymanot, in some of the central provinces and in parts of Shawa. These bitter doctrinal quarrels accentuated other divisions in the country and undermined the authority of the bishop. Several bishops were deposed because of their stands on doctrinal issues, and two of them, in the early and mid-nineteenth centuries, were humiliated and abused.

The Church proved an inadequate instrument for rebuilding the state. Nevertheless, it contributed greatly to the cultural life of the nation and its legacy is precious. The paintings on the walls and in the manuscripts of the Ethiopian churches, of the Gondarine and other periods, not only tell us about the aesthetics and skills of the people who made them. They are lasting testimonies to the deep integration of church, state, and society in Ethiopia and powerful witnesses to a past whose contribution to the future remains to be fulfilled.

SELECTED REFERENCES

Abir, M. 1980.
Bruce, J. 1790.
Beckingham, C.F., and G.W.B. Huntingford 1954.
Crummey, D.E. 1973.

# ETHIOPIC LITERATURE

*Getatchew Haile*

ETHIOPIC IS THE NAME given by Western scholars to the language in which the Christian literature of Ethiopia has been preserved. The Ethiopians themselves call the language Geez, and its role in the Ethiopian Church is often compared to that of Latin in the Roman Catholic Church. Geez continues to this day to be the language of traditional education, even though it ceased to be a spoken language more than a thousand years ago.

Apocryphal literature from the period of both the Old and the New Testament is extremely significant to our understanding of the origin and development of Christianity, even though it was not included in the Biblical canon. The discovery of these apocryphal texts and the exploration of their impact on the Christian religion has therefore absorbed a great deal of scholarly energy, and Ethiopic has been one of the more fertile areas of enquiry.

It is tempting to maintain that translations from foreign sources add little or nothing to the history of literature. It is better, one might argue, to read any text in the original. However, the original texts of many important works are no longer extant, and as a result, Ethiopic translations can be of great importance. For example, the Book of Enoch, the Book of Jubilees, and the Ascension of Isaiah have been preserved in their entirety only in Ethiopic versions.

Another reason for interest in Ethiopic literature is the opportunity it offers to explore the Ethiopian contribution to Christianity. Like all other Christian communities, Ethiopia has also produced an indigenous Christian literature that is an integral part of the history of the religion. This is preserved in the form of royal chronicles and hagiographies of the local saints, as well as accounts of theological controversies and locally composed anaphoras.

During the Aksumite period, Geez (sometimes written in South Arabian script) and Greek were used in Ethiopia as written languages. Greek was used at least until Christianity became the state religion, and internal evidence of a textual nature makes it clear that the local Church received its first Christian literature through Greek.

With its harbor of Adulis on the Red Sea, the Aksumite kingdom had close ties to the Roman Empire. Christian merchants from Syria must even have settled in Aksum, the capital of the kingdom. When providence brought young Frumentius from Syria to Aksum by the accident of his shipwreck at Adulis, he organized this community to be the first church in Ethiopia. His access to the palace, first as a "secretary of state" and later as someone with influence over the princes, helped him to promote Christianity to the status of a state religion. Frumentius later went to Alexandria in about 330 and returned to Aksum as its first bishop, ordained by Saint Athanasius, the archbishop of Alexandria.

Religious books translated from Greek during this period include the books of the Bible, the monastic rules of Pachomius, a collection of theological and Christological treatises known as the *Qerilos*, the Ascension of Isaiah, the *Paralipomena of Baruch*, the *Physiologus*, and the *Shepherd of Hermas*. Although evidence is lacking, it is not unreasonable to conjecture that some liturgical books were also translated into Geez for the new Church.

The Old Testament was translated from the Septuagint, the Greek version current when

Christianity emerged in Palestine. There are some indications that the Ethiopic version was subsequently revised using the Massoretic Hebrew text of the Old Testament.

Scholars are now scrutinizing the Geez version of the New Testament to determine which of the several Greek recensions might have served as the *Vorlage*, that is, the text from which the translation was made. At the present time, most specialists assume that the *Vorlage* was the Lucianic text then current at Antioch. The Geez New Testament manuscripts we have inherited show that the translation was revised several times, mostly on the basis of Arabic versions.

In addition to the apocrypha of the Septuagint, the Ethiopic Bible contains pseudepigrapha, notably the Book of Enoch and the Book of Jubilees. Additional texts like the Testament of Our Lord, the *Synodicon* (the Apostolic Decrees), and the *Didascalia* (the Apostolic Constitutions) were probably not translated from the Greek but are nevertheless considered by the Ethiopian church to be as authoritative as any Biblical scripture. According to the *Synodicon*, the canonical scriptures of the Church are eighty-one in number.

The foundation of Ethiopian hymnody was laid by Saint Yared during the Aksumite period. His collection of hymns known as the *Diggwa* remains to this day the nucleus of the antiphonary for the year in the Ethiopian Church. The collection has, of course, been supplemented by compositions in honor of other saints who arose after the death of this Aksumite priest. The three types of melodies for singing the hymns were also probably composed by Yared. According to his hagiographer, Yared received them from three birds when he was transported to heaven.

The *Physiologus*, or *Homily of Saint Physiologus* (*dersan za-qaddus fisalgos*) is a work on the nature of animals and plants. It was popular in Europe, especially during the Middle Ages. The importance of its Ethiopic version lies in the last paragraph of each entry, which deals with the symbolic meaning of the nature of the animal or plant in question.

The *Regulae Pachomii*, the monastic rules of the abbot Pachomius of Egypt, came to Ethiopia during this period, indicating that Ethiopian Christianity was shaped by monastic principles from the beginning. Indeed, the division of the Christian kingdom into monastic areas rather than bishoprics shows the power of monasticism in Ethiopia. The hagiography of a certain Abba Matta states that the anchorite came to Ethiopia on the recommendation of Abba Pachomius himself, who flourished between 290 and 346. In Ethiopia, Matta is said to have met and befriended a local monk, an indication that he came to Ethiopia not to introduce monasticism but to strengthen it. The Aksumite period is characterized by the visits of many monks, including the famous Nine Saints, who came to Ethiopia with their own religious texts, which would then have been translated into Geez.

The *Qerilos* is a collection of theological treatises by Church Fathers, including Cyril of Alexandria, after whom it is named, Epiphanius of Cyprus, and John of Antioch. This collection was brought to Ethiopia most probably by monks who were ardent opponents of the doctrinal formula adopted at the Council of Chalcedon in 451, and were therefore followers of the famous Alexandrian theologian.

The Aksumite dynasty was apparently followed by rulers who attempted to destroy the literary heritage of the young Church. The Zagwe dynasty (1137–1270), which replaced the invaders, is famous for the rock-hewn churches of Lalibela. As far as literature is concerned, no significant work has come down to us from their period, either translations or local compositions. On the other hand, we do have significant works of local origin as well as translations that were created under the so-called Solomonic dynasty of the Shoa-Amhara period. During this period, a metropolitan by the name of Abba Selama (1348–88) brought a number of liturgical books to Ethiopia, some of which were translated into Geez. One was a collection of homilies to be read especially during Passion Week.

The *Kibre Negest* (*Glory of the Kings*) was among the first books to appear in Geez during this period. This is a legendary history which claims that Ethiopia, through the union of the Queen of the South (that is, Ethiopia) and King Solomon of Israel, has replaced the old Israel and become the African Zion.

It was also probably during this time that the *Synaxarion* of the Coptic Church was translated from Arabic into Geez. The *Synaxarion* is a compendium of short biographies of the saints of the Church, with notices of the feasts and fasts of the year. Valuable biographies of Ethiopian saints were later inserted into the original translation.

A large number of *gedlat* (*Lives*) of non-Ethiopian saints and martyrs were translated at Ethiopian monasteries, especially Debre Hayq in the modern province of Wollo. The martyrs were mostly victims of the persecution of Diocletian, and the genre was used as a model in composing *gedlat* for Ethiopian saints.

The fifteenth century saw the rise of Retua Haymanot (The Man of the Orthodox Faith), Abba Giyorgis of Gasicha or Segla, and the emperor Zera Yaiqob. All three wrote homilies or sermons to be read at the celebration of different festivals during the year. These homilies are supposed to be admonitions to the faithful, calling them to the practice of righteousness. A study of the homilies shows, however, that they are really treatises dealing with theological controversies that had created divisions among the clergy and the monks. Most of the heresies treated by Abba Giyorgis in his *Masehafa mastir* (*Book of the Mystery*) involve theological and Christological questions, such as Arianism, Nestorianism, and Eutychianism. Giyorgis may have taken the trouble to write about them to such an extent because he had discovered adherents on Ethiopian soil.

Abba Giyorgis is most popular for his *Masehafa saatat* (*Book of Hours*). This work replaced the Coptic *Horologium* that was in use until then. The new *Book of Hours* for the twenty-four hours of the day included a collection of hymns in honor of the saints of the Church. The collection is titled *Agziabher nagsa* (*The Lord Reigneth*) (cf. Ps. 92[93]:1).

No one knows who "The Man of the Orthodox Faith" was, since the writer employed this nom de plume to preserve his identity. His collection of homilies for the major feasts of the year is an interesting compendium of theological treatises which still awaits editing and publication. The same writer may have composed some of the many anaphoras of the Ethiopian Church.

The homilies by the emperor Zera Yaiqob were explicitly designed to extirpate local dissension, and he attempted to refute dissident views by mentioning the names of their authors: Estifanos (Stephen), Gemalyal (Gamaliel), Zemikael, Fre Maher, and Atsqa. Estifanos was the founder of the so-called Istifanosite heresy, according to which he and his followers refused to prostrate themselves before the icon of Our Lady Mary and in honor of the person and name of the monarch. Estifanos was a simple monk, interested in monastic asceticism rather than theology. The other dissidents were highly educated and sophisticated intellectuals, if we can judge from the accounts of their "heresies." It is regrettable that no work ascribed to them has yet been identified; either they did not write, or their works were banned, confiscated, and destroyed by order of the palace.

The main point of discord between the king and the dissidents was in the interpretation of the Trinity: how can God be three persons and one person at the same time? The explanation offered by the dissidents differed radically from that of the king. They compared God to a single sun that had three features: the disc (corresponding to God the Father), the light (corresponding to God the Son), and the heat (corresponding to God the Holy Spirit). Following some of the Church Fathers, the king compared the Trinity to three suns (the Father, the Son, and the Holy Spirit) whose light is united in his divinity.

Another problem that Zera Yaiqob addressed was the medieval tendency to superstition. As his treatises *Masehafa berhan* (*Book of Light*) and *Tomara tesbet* (*Book of Humanity*) indicate, he

combated these beliefs vigorously and composed special prayers against them, entitled *Sayfa sellase* (*Sword of the Trinity*). His concern was all the greater because he evidently believed in the power of magic himself.

Geez magic is characterized by the use of "unknown" words, each to be said or written a definite number of times (for example, three or seven or twelve times) to invoke or ward off evil spirits or demons, which are believed to be the source of all ailments and natural disasters. These unknown words, or secret or hidden names (*asmat*), are spells that are believed to possess a miraculous power released when the words or names are either recited or carried in written form on parchment. Zera Yaiqob believed that these were names of the evil spirits, and while he severely curtailed the proliferation of magic during his reign, it seems that he inadvertently left the door open for a revival when he permitted the practice if the names used were those of God:

> And now, I disclose to you what I found in the palace: a book of (secret) names which was copied during the time of my brother, King Yishaq.... The clergy of the royal camp used to read it when pestilence or other diseases broke out. The (secret) names were not names of God, but names of demons who help the one who invokes them until they destroy him. Behold, I destroyed it by the power of God and removed from the palace every name not found in the Eighty-one Canonical Scriptures.... May the punishment of every man with whom a name is found that is not in the Eighty-One Canonical Scriptures be that of an idol-worshipper [that is, death by stoning].

Instead of abandoning the spells as commanded by the emperor, the practitioners of magic made the *asmat* appear to be hidden names of God. Some are secret, at least in the sense that they are obscure to those who do not know their origin, for example, *ilah* (from Arabic), *tewos* (from Greek), and *adonay* (from Hebrew). It is believed that God answers prayers instantly when called by these hidden names. In fact, there is a strong belief that divine miracles, such as the crossing of the Red Sea by the Israelites, the raising of the daughter of Jairus by Christ, and the victory of David over Goliath, were all performed by reciting certain formulae, for example, *talitha cumi* (Mark 5:41); *eli eli lama sabachthani* (Matt. 27:46); and *ephphatha* (Mark 7:34). The extensive literature in Geez on the subject includes prayers given to Moses, who employed them before Pharaoh; to the disciples when Christ sent them into the world; to Peter, whom the Gospel calls "the key"; to Mary, when she prayed at the sepulcher of her son; to the archangels, who carry them written on their wings; and to Saint Sissinius, which women carry to prevent infant mortality. The funeral ritual is supplied with magical words, including those of the prayers called *Lefafa sedq* (*Bandlet of Righteousness*), believed to have been written in the hand of Our Lord himself. As its other name, the *Book of Life*, implies, it is thought able to bring the dead directly to heaven.

According to local tradition, the use of hidden names began when the Mother of God insisted that her son tell her his own hidden name. After much hesitation, he answered her prayers by telling her the hidden names whose origins are still unknown. The *Prayer of Our Lady Mary at Bartos*, the *Bandlet of Righteousness* or *Book of Life*, the *Prayer of Protection* for each of the seven days of the week, and the *germa mogas* (prayer for acquiring charisma), all involve *asmat*. The *Dirsane Maryam*, a homiliary in honor of Mary which contains her *asmat* prayer, is read in church on some of the days dedicated to her.

In his homilies, Zera Yaiqob also addressed the refusal of the so-called heretics to believe that God has an image (*malk*). As the king reported in one of his homilies, they quoted John 1:18 ("No one has ever seen God") and asked, "Whom shall [we] say he looks like, if no one has ever seen him?" The king, on the other hand, believed that God has the appearance of a man, basing his argument on Genesis 1:26–27, where God says: "Let us make man in our image.... So God created man in his own image, in the image of God he created him...."

Zera Yaiqob's doctrinal campaign was directed against a group he describes as *ayhud* (the Jews). A major part of his *Masehafa milad (Book of Nativity)* is a ferocious attack on this group for denying the incarnation of the Word of God. While he seems to have used the term *ayhudawi* (Jew) to describe anyone whose Christology was not in agreement with his own, nevertheless he was also preoccupied with establishing the Jewish Sabbath as a holy day. In most other Christian communities, the observance of the Saturday Sabbath has been superseded by the observance of Sunday. However, the Ethiopian Church accepts both the Old and New Testaments as two breasts that nourish the faithful, and believes that because the first letter of the name of Jesus is also the ancient Semitic numeral ten, none of the Ten Commandments should be set aside. Through his writings as well as the temporal power of his office, Zera Yaiqob was able to force the Ethiopian Church to continue observing Saturday.

The composition of one of the collections of hymns to the saints of the Church, titled *Egziabher nagsa (The Lord Reigneth)*, is attributed to Zera Yaiqob, as is the prayer book *Sebhata fequr (Praise of the Beloved)*. This communal prayer is designed to be recited when a community is in tribulation, and those taken captive by the infidel were especially recommended to use it.

Two codes on penitential canons, both entitled *Faws manfasawi (Spiritual Healing)*, appeared in Geez during this period. Tradition maintains that the second was composed locally, after Zera Yaiqob had become dissatisfied with the first, which had been translated from Arabic. Of the two penitential rituals, the *Qendil (Candle)* was a translation, while the *Masehafa bahrey (Book of Pearl* or *Prayer of Anointing)* was Zera Yaiqob's own composition.

Of all his achievements, Zera Yaiqob is remembered most for his compositions in honor of Our Lady Mary. The veneration he accorded her virtually elevates her to the status of her son. Hymns and prayers to her and to her icons were composed in great numbers, and accounts of her miracles came to Ethiopia from most of the Christian world, including Spain, France, Palestine, and, above all, Egypt. Translations and accounts of local miracles were studiously copied by the emperor's secretaries and were sent to monasteries throughout Ethiopia to be read with the same veneration given to the Gospels. More than six hundred accounts of miracles performed by Our Lady Mary have survived.

One of the consequences of the religious war during the sixteenth century was the movement of the palace from Shoa-Amhara to Gondar in the west. Gondar may have been too remote for the Muslims of Adal to assault it from the east, but the kingdom was not out of the reach of the Oromo, whose invasion devastated a great deal of the material culture that escaped the Islamic assault. Yet the flight to Gondar may indirectly have encouraged the growth of Ethiopic literature. Many scholars of the kingdom took refuge at the royal camp from the various perils of the time. These scholars were active in translating religious literature from Arabic, in recording the royal chronicles day by day, in revising some of the New Testament scriptures and, most of all, in composing *melkeat* (images).

These *melkeat* are hymns in praise of *malk* (the parts of the body of the saints), and describe the beauty of their hair, the power of their arms, the tenderness of their hearts toward the needy, and so forth. Most *melkeat* consist of a series of stanzas, each of five lines. It is possible that this genre of literature began during the fifteenth century, but it definitely reached its peak during the Gondarine period.

The collection of hymns to the saints by a certain Arke Sillus also belongs to this era. The collection is called by the name of its author, *Arke*, and has made its way into the Synaxary. Many, if not most, Synaxary manuscripts conclude each entry with an *Arke* hymn composed in honor of the particular saint, and a few Synaxary entries are limited to the *Arke* hymn itself.

The collection of *Diggwa* hymns, which the Aksumite Yared began and which grew during the course of time, received its *melekket* (musical notation) during this period. Other collections of chants, including the *Ziq* in honor of the saints, were also composed during this time.

*Qine* poetry belongs to the same genre of hymns which began before this period but flourished during it. The basic difference between *qine* and other hymns is that a *qine* poem is intended to be used only once, at a particular church. It is a "disposable" hymn, following Psalm 32 (33):3 ("Sing unto Him a new song, play skillfully on the strings, with loud shouts") which articulates the need for such hymns in the liturgy. Real education in traditional Ethiopia starts at the *qine* school, since this is the place where students learn to develop their critical faculties for the first time, analyzing the logical structure of the Geez language.

It is not clear whether the *Masehafa qedar* (ritual for penitential baptism) was translated during this period or the previous one. The ritual is used to purify the believer who polluted himself by associating, especially sexually, with unbelievers. Another contribution of this period is the *Fethat Negest* (*Code of Kings*). Translated from Arabic, it served the state as a code of ecclesiastical and civil law until the middle of this century.

The liturgical texts of the Ethiopian Church include the *Qeddase*; the collections of chants; the rituals for baptism, funerals, Passion Week, ordinations, and the consecration of church buildings and *tabots*; the daily prayers of the *Saatat* (*Horologion*); and the prayer of incense.

The *Qeddase* contains the daily schedule of prayers (the office), the sections of the preparation of the Eucharist which do not change from week to week and are of Egyptian origin (the ordinary), and the different anaphoras or Eucharistic prayers. It is not certain how many anaphoras there might have been in the Ethiopian Church. At least as many as eighteen are found in the manuscripts known so far. But the official number, as seen in the great majority of manuscripts and in the printed books, is fourteen. Each of these carries the traditional name(s) of its author(s), which are in most cases pseudonyms. These are the anaphoras of the Apostles, Our Lord Jesus Christ, John Son of Thunder, Our Lady Mary (by Cyriacus of Bahnasah in Upper Egypt), the Three Hundred and Eighteen Orthodox Fathers (of the Council of Nicea), Athanasius of Alexandria, Basil of Caeasarea, Gregory of Nyssa, Epiphanius of Cyprus, John Chrysostom, Cyril of Alexandria, James of Sarug, Diosocus, and Gregory Thaumaturgus. To these are added the less frequently used anaphoras of Our Lady Mary (by Nathanael the Apostle) and Gregory (unidentified), and the less familiar anaphoras of Saint Mark and Saint James the Brother of Our Lord. The first two come from the *Synodicon* and the *Testament of Our Lord*, and as such are of foreign origin, as are the anaphoras of Saint Mark, Saint Basil, and Saint James the Brother of Our Lord. The rest are clearly of local composition. The theological controversies that troubled the Church in the fourteenth and sixteenth centuries concerning the nature of the Trinity, the observance of the Sabbath, the veneration of the Holy Cross, and Our Lady Mary are treated in most of these anaphoras. Even the office prayers that are in origin clearly Coptic have been enlarged to include local concerns, as the following dialogue shows.

> Deacon:
> Pray before the Cross,
> All you, the faithful,
> Holding it on the right
> And renouncing Satan,
> For it has been sanctified by the blood of Christ the
> Savior.
>
> Congregation:
> Honored art thou, O Cross, king of woods,
> Honored art thou, O Cross.
> And honored is the blood of the Divinity, the Word which
> sanctified thee.

Priest:

> In honor of this Cross,
> We Christians prostrate ourselves with fear and awe,
> For the Son himself in person
> hath sanctified it with his blood, not with that of
> others,
> When, on this Cross,
> Divinity died in his humanity
>
> .   .   .   .   .   .   .   .   .   .
>
> With this standard of the Cross,
> The Apostles of the One who died on it
> Worked miracles
> By casting out demons
> And crushing idols.
> For this reason, the teachers of the Holy Gospel have
> commanded
> That we prostrate ourselves before the Cross and the
> Mother of God.
> These two creatures deserve the glory of the creator,
> For they equal (him) in their honor.
>
> .   .   .   .   .   .   .   .   .   .
>
> Honor and glory are meet for her,
> with worship and prostration to her together with her
> Son,
> On earth and in heaven,
> In the seas and in the abysses.

The liturgy is classified as Alexandrian basically because the invariable sections of the Eucharist prayers and the pattern according to which the anaphoras of local authorship were composed are both of Alexandrian origin.

The anaphora commonly used is that of the apostles, while the others are confirmed to special occasions. The anaphora of Mary by Cyriacus, for example, is used on feast days of the Blessed Virgin, and the anaphora of Mary by Nathanael when the nation faces natural calamities such as famine or pestilence. The anaphora by Gregory of Nyssa is known as "the Hosanna on Palm Sunday anaphora."

The Egyptian *Horologion* that contains the schedule of daily prayers or "hours" was replaced by the *Horologion* of Abba Giyorgis, primarily because the former consisted of little more than the chanting of Psalms. The *Horologion* of Abba Giyorgis, on the other hand, contains beautiful hymns to the saints. As it was intended for the monastic community, the prayer was designed for the twenty-four hours of the day. In monasteries today, it is employed in the early morning, at the hours of nine, twelve, three, and six, before bed, and at midnight. In other churches, the entire prayer is performed at about six in the evening.

Each day of the year is dedicated to one or more saints, including the apostles, evangelists, Desert Fathers, martyrs, and archangels. The day chosen is either one on which the saint went to his or her eternal rest or performed certain miracles, or on which a church was dedicated to his or her name. An enormous number of intricate hymns (doxologies) have been composed to honor the saints. These include those found in the *Diggwa* (the antiphonary for the year), which also contains chants for the eve of the feast; the *Mezmur*, for the seasons; the *Zimmare*, which are chanted during Mass; the *Mewaset*, which are chanted when commemorating the dead; and the

*Miraf*, which is used for chanting the Psalter (a collection of the Psalms of David, Biblical canticles, and praises of Mary for each of the seven days of the week and an additional canticle for Sunday). The most recent in the series of Ethiopian hymnaries is the *Ziq*, which incorporates new verses of litany, the *Melkiat*, and a stanza from the fifteenth-century hymn to the Blessed Virgin entitled *Mahilete tsige* (Canticle of the Flower).

The official position of the Church is that the saints intercede and pray for the faithful before God. The faithful are therefore expected to pray to them in order to obtain their intercession when they ask God for forgiveness of sins. But the hymns composed in honor of the saints depict them as capable of performing acts that are otherwise reserved for God. They can answer all kinds of prayers, including those for the forgiveness of sins, as the following hymns demonstrate:

> To Saint George:
> Draw me out of the pit of perdition.
> You who rescued the girl from Beirut from the mouth
> of the dragon, rescue my soul from a murderous enemy.
> Preserve the rest of my life from every temptation.

> To Saint Gebre Menfes Qiddus:
> Save me, lord, from the hidden snare of Satan.
> Save me, the oppressed, from the oppression.
> Drive away my enemies, the host of the fallen Devil.

> To the Archangel Michael:
> O Michael, embellished in the garment of light,
> Befriending you is beautiful at all times.
> You are a forgiver of sins, O friend of the souls of the
> faithful.

> To the Archangel Gabriel:
> O Gabriel, the angel of salvation,
> Save me, as you saved the Three Men with your two wings,
> when they were put in the fire.

Ethiopian Christianity can be characterized as monastic. The faithful have great respect for the monastic life. Some hold it as the ideal, others aspire to it, and still others end their lives as monks and nuns, retiring to monasteries at an advanced age or remaining in their houses. Ethiopian monasticism originated in the deserts of Egypt, and the hagiographical literature is rich in the *gedlat* (Lives) of desert anchorites and recluses who dwelt in cells within monastic enclosures. The ascetic life is based on the principle that the weaker the body becomes, the stronger the spirit becomes, a path that is believed to open the possibility of communicating with God. The techniques of weakening the body and strengthening the spirit include rigorous fasting, adoration consisting of uninterrupted prostrations hundreds of times a day, and standing for hours in prayer. At a certain stage of this strict asceticism, direct communication with God begins. God speaks to the saint in visions or appears to him or her in the form of a visitor, just as the Trinity appeared to Abraham in the form of three visitors. While it is occasionally possible to encounter anchorites in the wilderness, the hermits who live in cells are frequently visited by the faithful in the hopes of receiving guidance from them.

At the moment of death, an especially holy man or woman receives a promise from God that he will forgive the sins of those who in the name of the saint pray, build churches, give alms to the poor, and prepare food to mark his or her memorial day. This *kidan* (promise or covenant)

does not elevate the saints to the status of divinity, but the *debteras* who compose hymns to the saint and the faithful who pray to them do not always adhere strictly to this distinction.

The monastic literature includes *gedlat* of both Ethiopian and foreign saints normally written by their disciples or followers; the *Gannat* (*Garden*), a collection of sayings of the Desert Fathers; and the writings of the Syrian mystics, Isaac of Nineveh, Philoxenus of Mabbug, and the Spiritual Elder (John Saba). The acts of the saints, which include dozens of miracles, have become a major source of religious, social, and political history for Ethiopia, as well as an inspiration for the poets who compose hymns.

The decline of Gondar, under the pressure of the Oromo, and the fragmentation of the kingdom into semi-independent principalities also meant a decline in Geez or Ethiopic literature. For various reasons, teachers started to produce educational materials in Amharic, the spoken language of most Christians of the kingdom. The appearance of Amharic literature marked the beginning of the end for Geez literature.

The civil wars of the sixteenth century and the assault of the Muslims on the Christians and their institutions, followed by the Oromo invasion, did a great deal of damage to the cultural heritage of the nation. Famous churches and monasteries were looted and burned along with all the books they contained. The destruction of the heritage has continued to this day, through famine, civil war, and tourism. Refugees and victims of famine have several ways of putting their hands on the manuscripts preserved in church libraries, which they then sell to souvenir collectors. The attempts by UNESCO or by German foundations to save the contents of the remaining manuscripts on microfilm have been valuable but insufficient.

In 1973, a microfilming project was launched by the Hill Monastic Manuscript Library (HMML) of St. John's University in Collegeville, Minnesota, and the Ethiopian Manuscript Microfilm Library (EMML) in Addis Ababa, with the cooperation of Vanderbilt University in Nashville, Tennessee. The aim of the project is to save what has survived, at least on microfilm, and through the support of the National Endowment for the Humanities and the Ford Foundation, it has achieved a remarkable success. Much remains to be done. The work that was interrupted during the previous regime needs to be resumed without delay. In fact, preserving the manuscript tradition of the Ethiopian Church requires nothing less than an international effort.

SELECTED REFERENCES

Cerulli, E. 1968.
Daoud, M., and Marsie Hazen 1954.
Getatchew Haile. 1991.
Hammerschmidt, E. 1987.
Kaplan, S. 1984.
Macomber, F.W. 1975.
Ricci, L. 1991.
Varenbergh, J. 1915–16.
Wendt, K. 1961
Yacob Beyene 1990.

# ETHIOPIAN MANUSCRIPTS AND PALEOGRAPHY

*Siegbert Uhlig*

DURING THE FIRST MILLENIUM B.C., merchants and settlers from Arabia Felix crossed the Red Sea and established settlements in the vicinity of present-day Massawa, and in the following centuries they slowly pushed inland, bringing with them sociopolitical structures and a cultural heritage that were highly developed in comparison to indigenous forms. Early epigraphic monuments and the survival of Semitic personal and place names on Ethiopian territory attest the gradual expansion of the Arabian enclaves toward the south and the west. While these settlements remained thoroughly South Arabian in outlook and culture for quite some time, a synthesis of African and South Arabian elements began eventually to develop into an Ethiopian culture. One of the most lasting and influential cultural contributions of South Arabia to Africa proved to be its language and alphabet, and a comparison of the Old South Arabian languages and alphabet with the language and script of Classical Ethiopia (Geez) furnishes ample evidence for this fact. Almost without exception the Ethiopic letters are derived from South Arabian models.

Early inscriptions and coins found in Ethiopia demonstrate that in the beginning Geez was written without vowels, like the South Arabian languages and indeed almost all the other Semitic languages. However, even in the early Aksumite period the Ethiopians began to attach vowels to their inherited consonantal forms and thus initiated its development into a syllabary, an essentially syllabic script. This syllabary has since dominated Ethiopian literary production, even though it took several more centuries for it to be refined into a completely adequate syllabic system. Vowelless inscriptions dating from the eleventh and twelfth centuries and some manuscripts of the twelfth, thirteenth, and even fifteenth centuries bear evidence of the freedom Ethiopian scribes continued to display in matters of vocalization.

For centuries, manuscript writing continued to cling to the models of letter design that had been developed in the epigraphic period. The signs continued to have a rather rectangular shape, as if they had not been written with pen and ink on vellum but had been hammered and chiseled into stone. Curved lines were avoided and straight vertical and horizontal strokes from left to right gave the manuscripts their characteristic appearance until the first half of the fifteenth century. This monumental style of manuscript writing is aesthetically very appealing, as is its South Arabian ancestor, and quite often these early Ethiopian manuscripts are masterpieces of calligraphy.

There has been a great deal of scholarly discussion about the dating of the oldest extant Ethiopian manuscript, and no consensus has yet been reached. The lack of comparative material makes it virtually impossible to decide conclusively whether the Gospel manuscript known as Abba Garima I (fig. 1) dates from the tenth century or sometime later. However, meticulous examination of the manuscript, especially of its inscriptions and colophons, indicates that it was

Fig. 1. Abba Garima I.

57

Fig. 2. Bibliothèque Nationale:
Éth. 163, fragment 3 (detail).

most likely not written later than the end of the twelfth or the beginning of the thirteenth century.

When we look at the bulk of Ethiopian manuscripts, and more than twelve thousand specimens have been microfilmed or catalogued so far, paleographic criteria enable us to discern several periods.

1. The first period that can be clearly defined came to an end in the second half of the fourteenth century. Unfortunately, it is represented by the rather small number of twenty extant manuscripts. Its distinguishing feature is the monumental script mentioned above. The characters are slender and tall, and this feature is further accentuated by the rather fine line produced by the pens that were used at the time (fig. 2). Only a few rigid and rectangular characters, normally six to seven, are written in each column. Ample space is left between the letters, which lends the manuscripts a monumental appearance. The vowel marks attached to the letters are disproportionately large. Trapezoid and triangular forms dominate the ductus. According to our present knowledge, ornamentation at the beginning of a manuscript or at the beginning of a new text within a larger volume is rare. If it does occur, it is of great simplicity. Manuscripts of the fourteenth and fifteenth centuries exhibit a special feature: on the left margin of individual columns various signs may be found that either mark reading units, comparable to our chapter or verse separators, or indicate where the author is quoting an earlier text. These markers themselves consist of various basic patterns that may be repeated to form more complex structures. After the fifteenth century they gradually ceased to be employed.

2. The years between the second half of the fourteenth century and the middle of the fifteenth century were marked by a less monumental script (fig. 3). Unlike the earlier period, which is dominated by clear-cut, slender, rectangular shapes, it conveys an irregular, uncoordinated impression. At times the letters seem to float between the lines. The signs also become broader, and the tendency is increased by the use of broader pens. Along with a diminution of letter size, this produces an impression of greater sturdiness. On the whole, the second period is a phase of transition, in which the tension between more traditional and more innovative styles was not yet resolved. As a result, one may encounter rectangular forms next to curved, and thick forms next to slender. The aesthetic principle for scribes was no longer a desire for uniformity but an attempt to write a clear and readable syllabary.

Fig. 3. Ethiopian Monastic Manuscript
Library: 1824.

58

3. From the middle of the fifteenth until the middle of the sixteenth century the scribes wrote more rounded characters, creating a pleasing cursive appearance (fig. 4). At the same time, they could be careless in the execution of their task and tended to compress the forms. The strokes at the top of the characters which slant diagonally from lower left to upper right form an important feature of the script of this period. The tendency described earlier to produce broader and more compressed letters continued in this period. As a result, we may tentatively label this style as "square script." In this century a first movement toward standardization can also be detected, initiating a development that was to gain momentum in subsequent centuries. At the same time the marginal reading signs and separators so characteristic of the first period decline in quality and finally disappear, but the number of decorative ornaments in the manuscripts increases dramatically.

4. The fourth great period in Ethiopian paleography is to be defined from the middle of the sixteenth until the second half of the seventeenth century. During this period considerable changes occurred. The signs again become more regular and uniform (fig. 5). They return to a slender form produced with a finer pen and at times they might even be termed fragile. The characters all tend to have approximately the same height, and the downstrokes are parallel to each other and set at a steeper angle. As a result, more characters than ever before can be packed into each line. In this period the shape of the codices also begins to change into a square. This new shape offered the possibility of producing pages with three columns instead of the usual two. The ornaments of the period are less elaborate and attractive than those of earlier periods.

5. Splendidly ornamented and calligraphically impressive manuscripts were produced in Ethiopia during the Gondarine period (fig. 6). The impressive *gwelh* script between the middle of the seventeenth century and the second half of the eighteenth century received its name from its appearance: although it is usually no larger than the script of the previous period, it conveys an impression of clarity, majesty, and confident calligraphic sensibility. The characters of this period are regular, rectangular, and often very large, in extreme cases up to one inch in height. Downstrokes are normally straight and of even width; horizontal strokes are at times extremely fine. This very clear script of unparalleled uniformity, occasionally bordering on monotony, stands out in the history of Ethiopic calligraphy. Since it was employed mainly on official documents and within the sphere of the royal court, it may be called a "royal script."

Fig. 4. Vatican City, Biblioteca Vaticana: Aeth. 5.

Fig. 5. Tanasee 110.

Fig. 6. British Library: Or. 608.

6. Parallel to the style described in the preceding section is another which is calligraphically much less elaborate. Its approximate temporal limits are the middle of the seventeenth and the middle of the nineteenth century. With the end of the Gondarine period the diversity of calligraphic style becomes increasingly pronounced. This development culminates in the nineteenth century, when the virtual absence of any significant common features renders the distinction of separate styles, and thus the exact dating of manuscripts, almost impossible. In general, manuscript production greatly increased at the end of the seventeenth century, and codices were no longer something rare and precious. This development brought with it a deterioration in manuscript quality. The script tended to be written in a less careful and at times even clumsy manner. Moreover, the tendency to write with speed quite often produced inclined or bent forms instead of the upright characters of earlier times. In comparison with the Gondarine script, the characters were small and delicate, and the style was therefore known as *raqiq*. In these centuries, the scribes abandoned their debt to the traditional monumental styles and the aesthetic concept linked to them.

7. In discussing the scripts of the nineteenth and twentieth centuries, we are leaving the domain of Ethiopian paleography in the strict sense. Several different modes of writing evolve and exist together, including a bulky type of script characterized by a rather crude sense of proportion, with large, widely spaced characters and the orientation of the letters along the base lines. In the latter half of the nineteenth century, something like a script for everyday use began to evolve. It is still employed today, and is marked by the inclination of the characters. Whereas before the nineteenth century almost all texts were written on parchment, the twentieth century saw the rise of paper as a writing medium in Ethiopia, although it did not completely replace parchment.

Calligraphic and material criteria are not the only means of dating an Ethiopian manuscript. Aside from these paleographic features, dates given in the text itself and contemporary or later glosses or other notes can provide useful evidence.

An Ethiopian scribe wanting to date his manuscripts had several systems of reckoning at his disposal. He could give the date according to the "year of the [creation of the] world" (5493 or 5492 B.C.), the "year of the incarnation [of Christ]" (A.D. 7 or 8), or the "year of the martyrs" (A.D. 283 or 284). All these systems are themselves subdivided into different cycles. Datings according to the Muslim *higra*-era (A.D. 622) are also used, as well as eras of only local relevance, for example the reckoning from the foundation of the influential monastery of Bizan. Frequently the same date is given according to two or more of the systems mentioned above. A direct dating may also be given by noting the year of the reign of a monarch or a local prince, or the regency of a patriarch, metropolitan, or abbot in which a given manuscript was copied. Even though the dates of the relevant term of office are not always known exactly, this manner of dating more often than not provides sufficient information to satisfy our curiosity. Within the chosen regency, the dating is generally very reliable, since scribes usually derived their knowledge from their own experience.

Datable, as opposed to dated, manuscripts are those which contain notes in the margin or on originally blank folia that indicate at least the time when the additions were made, and before which the manuscript as a whole must have been written. This is not a rare occurrence, and Ethiopian manuscripts quite often provide the most varied information, including details of all kinds of land transactions side by side with evidence for the construction and repair of buildings, inventories of monastic possessions, business documents and wills, and notes on the translation of ecclesiastical texts into Geez. The most common are remarks concerning the patrons, scribes, and later owners of the manuscript.

Aside from these various types of annotating, the colophon usually placed at the end of the

codex is the standard location of technical data or other information relating to date. The colophon typically has a fixed structure, some of its main elements being:

1. an absolute date: "in the year $x$ of era $y$";

2. a relative date: "and in the year of $x$ of the regency of our king $y$";

3. further temporal indicators, which may be chosen from a variety of bewildering chronological segmentators, for example the four-year cycle of the evangelists, the date in relation to the Jewish New Year, and so on.

More than one absolute date is often given, and the confirmation of these with relative dates or other indicators usually enables us to determine the exact date of the manuscript, even if the scribe may have inadvertently erred in one of the designations.

However, only about 15 percent of Ethiopian manuscripts are either dated or datable in the manner described above, and paleography therefore retains an important place in the process of investigation. If it were employed with proper care, only a few manuscripts would require a safety margin of more than fifty years.

Despite recent progress, many questions in the field of Ethiopian paleography remain open. Alongside the temporal categories, for example, it is almost certain that detailed research could produce insights into regional and even local differentiations of script, *gwelh* perhaps developing out of a regional style that was adapted by the imperial court and then gained more general recognition. However, it is still too early to present any definite conclusions regarding such local or scriptorial traditions.

SELECTED REFERENCES

Leroy, J., S. Wright, and O.A. Jäger 1961.
Uhlig, S. 1988.
Uhlig, S. 1990.

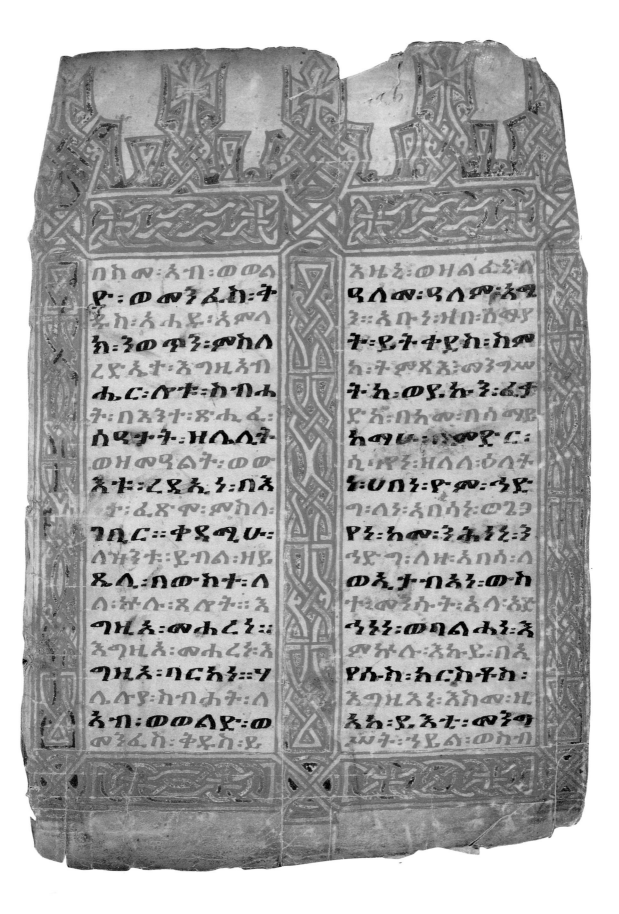

በከመ፡እብ፡ወወለ
ድ፡ወልንፊክ፡ት
ፈክ፡እሐዱ፡አምላ
ክ፡ንወጣን፡ምክለ
ሪድኤት፡እግዚእብ
ሔር፡ሎቱ፡ክብሐ
ት፡በእንተ፡ጽሐፈ፡
ስዳታት፡ዘሴላት፡
ወዘለዓልት፡ወ
እቱ፡ሪደኤ፡ነ፡በእ
ታ፡ፈደግ፡ምክለ
ገቢር፡ቀደሚሁ፡
ለኢንተ፡ይግብል፡ዘይ
ጼሊ፡በውክተ፡ለ
ለ፡ኮሉ፡ጸሎት፡እ
ግዚእ፡መሐረነ፡
እግዚእ፡መሐረቱ፡እ
ግዚእ፡ባርክነ፡ግ
ሊሎየ፡ክብሐት፡ለ
እብ፡ወወልድ፡ወ
ልንፊክ፡ቅዱስ፡ይ

እዜነ፡ወዘለፈጸለ
ዳለው፡ዳለም፡እግ
ን፡እቡን፡ዘበ፡ስቃያ
ት፡ይትቀየክ፡ክም
ክ፡ትምጸእ፡ወንግሠ
ደሽ፡በእለ፡ክሰዓየ
ክጣሩ፡ዠ፡ምዶ፡ር
ሲ፡የን፡ዘለለ፡ዕለት
ፉ፡ሀበን፡ዮም፡ጓይ
ግ፡ለን፡እበሳነ፡ወጎን
የፉ፡ክሙ፡ንሕነፉ፡ን
ጓድ፡ግ፡ለዙ፡እበሰ፡ለ
ወኢታብእን፡ወክ
ተመንሁት፡እለ፡ጻየ
ጓንነ፡ወባልሐነ፡እ
ምኮሉ፡እክዶ፡በእ
የሉክ፡ክርስቶስ፡
እግዜእ፡እስመ፡ዚ
እክ፡ይእቲ፡ልንጓ
ሠት፡ጓይል፡ወስብ

# LINEAR DECORATION IN ETHIOPIAN MANUSCRIPTS

*Carla Zanotti-Eman*

THE TERM *harag*, a Geez word meaning the tendril of a climbing plant, refers to a particular type of illumination made of bands of colored lines interlaced in a geometrical pattern and used to frame the pages of Ethiopian manuscripts. This type of decoration was not employed by scribes before the second half of the fourteenth century, and it is the second half of the fourteenth and the fifteenth centuries which can be considered the golden age of *harag* illumination.[1]

The most decorated of all manuscripts are the Psalters, which are generally adorned with eighteen *harag*, fourteen of which frame the 151 Psalms of David. Sometimes in a particularly elaborate Psalter, such as the fifteenth-century manuscript 76 in the Institute of Ethiopian Studies, each Psalm is illuminated and one may count as many as 173 *harag*.

A characteristic feature of such *harag* is that each is noticeably different from any other, even within the same manuscript. The scribes seem to have been intent on designing *harag* that were of the same basic style but that differed in the pattern of interlacing, in the decorative motifs sprouting from the central band, in the methods of finishing the ends of the lines, and in the chromatic shadings.

Research is still in its infancy, and because of the huge variety of *harag* it can be difficult to distinguish the characteristic features of different regions or periods.[2] One obvious distinction in the *harag* of the fourteenth and fifteenth centuries can be made on the basis of whether black or red is used for the outline. The *harag* of the first type are richly colored with yellows, reds, greens, blues, and grays, the enclosed black outlines acting as background to enhance the chromatic effect. In the second type, only yellow, gray, and red are used, along with the neutral color of the parchment as a background.

Assuming that the documented practice of scribes in the nineteenth and twentieth centuries preserves the traditions of earlier centuries, *harag* were constructed on the basis of a system of dot grids initially arranged by the scribe in sets of squares. Undulating strands were then laid out by joining the dots in repeating geometrical patterns to create the impression of a continuous interwoven line. The grid might consist of as few as four dots or as many as sixteen.

These patterns were arranged on the page in a number of different structures. The columns of text were often enclosed by three bands of *harag*, a wide horizontal area that ran across the top of the page and two perpendicular extensions beneath it which created a frame for the text. More luxurious manuscripts were not only completely framed by the addition of a horizontal band at the bottom of the page, but also had an additional vertical band at the center of the page which divided the text into two columns. Occasionally, the horizontal band at the top of the page was interrupted at the center, above the space where the text was divided into two columns. This central area was either left blank or was decorated with a few strokes of the pen to emphasize the interruption of the pattern. The interrupted ends were further decorated with symmetrical floral motifs extending to the top of the page. The two halves of the horizontal band were given

1. S. Uhlig 1989: 56–58.
2. Ibid.

Fig. 1. Psalter, fifteenth century, Institute of Ethiopian studies, MS 74, f. 126r.

63

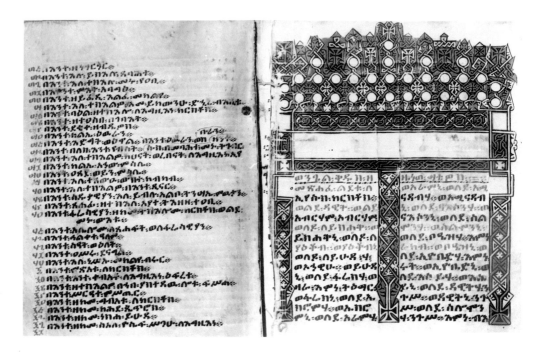

Fig. 2. Four Gospels, fifteenth century, Monastery of Gunda Gunde (Ministry of Culture file "Tigre 1, Archaeological Sites and Churches").

perpendicular extensions at the borders, which descended to a point between the sixth and tenth lines of the text. The *harag* in manuscript 242 in the Institute of Ethiopian Studies exemplify this type of structure, designed on a system of the six-dot grid.

The Monastery of Gunda Gundi, center of the dissident Estifanosite movement during the fifteenth century, was the source of the most refined *harag* of the time.[3] Invariably outlined in fine black lines, they enclose an abundance of vivid colors, including lemon yellows, grayish blues, olive greens, and reds.

The period from the middle of the fifteenth century to the middle of the sixteenth century represented a decline in the standards of the golden age, while the seventeenth century was a

3. A. Mordini 1953: 29–70.

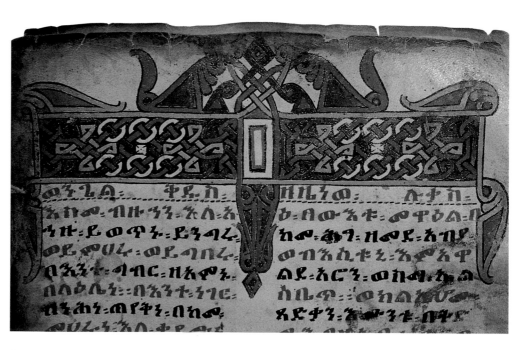

Fig. 3. Four Gospels, fifteenth century, Institute of Ethiopian Studies, MS 242.

Fig. 4. Psalter, eighteenth century, Institute of Ethiopian Studies, MS 242.

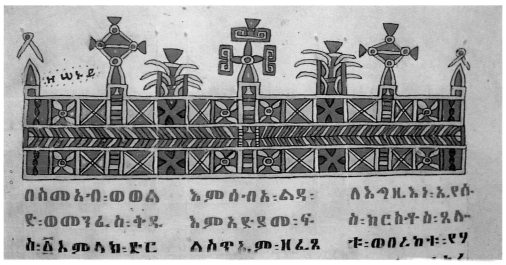

Fig. 5. Acts of Saint George, nineteenth century, Institute of Ethiopian Studies, MS 1087.

period of transition to a different form of decoration.[4] Along with *harag* constructed from the dot-grid system, there also appeared simplified forms in which all colors were eliminated except black and red, a reduction of both form and color which became more evident in the *harag* of the eighteenth century. Indeed, the illumination was reduced at that time to a single horizontal band, usually divided into two sections by three parallel lines in black. The decorative element was provided not by the undulating strands, but by the repetition of angular elements like triangles and by the alternation of blank vellum and dark colors.

In the nineteenth century, the horizontal band was further subdivided into a number of squares into which various geometrical forms, such as chevrons, lozenges, ellipses, and triangles, were fitted. Other devices of the same period include simple palmettes or repetitive eyes, faces, birds, and crosses emerging from the top of the *harag*. Pale yellows, ochers, grays, and greens were once again used to refine and enrich the decorations. These latter types of decoration were characteristic of the province of Shawa, which had been separated for many years from the north of the empire by the Oromo, who had settled in between.[5] Shawan scribes developed their own forms of expression, identified by more simple geometrical patterns and by decorative motifs such as the protecting eye which are characteristic of the ornamentation of magic scrolls.[6]

In the second half of the nineteenth century, there was a revival in the production of

4. C. Zanotti-Eman 1992: 475–94.
5. S. Chojnacki 1983: 469–97.
6. J. Mercier 1979: 30.

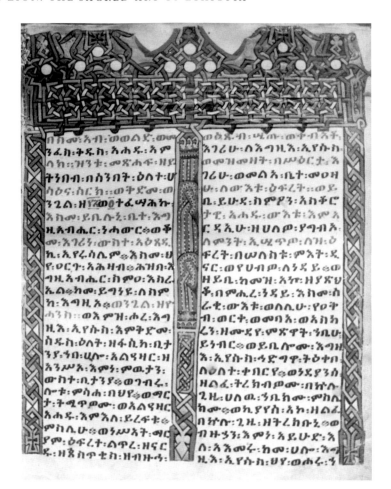

Fig. 6. Gebre Hemamat, fifteenth century, Monastery of Gunda Gunde, Mordini 62.

Ethiopian manuscripts. With the aim of replenishing a cultural heritage that had been devastated by war, the emperor Menelik II established a scriptorium in the imperial palace which continued to operate until 1954. It was staffed by more than 150 scribes.[7] In these surroundings, the art of *harag* was reborn and restored to the splendors of the fourteenth and fifteenth centuries, in contrast to the simpler geometric decorations of the seventeenth and eighteenth centuries. There was a return to the dot-grid system, and the decorative bands were embellished with interlacing. The stylized loose ends of the *harag* of the early scribes began to be transformed into long leaves of acanthus.

A number of scholars have been intrigued by similarities between Ethiopian illuminations on the one hand and Byzantine, Coptic, Syriac, or even Celtic patterns on the other, but it can be difficult to prove direct links between *harag* and any of the others.[8] However, the framework in which *harag* are arranged presents additional questions. One ornamental device common to all Christian manuscript illumination, whether Eastern or Western, can be seen in the canon tables, a tabular concordance of the four Gospels which was made by Eusebius, bishop of Caesarea and biographer of the emperor Constantine during the fourth century. The concordances were housed in a set of arcades, forming as it were an impressive atrium at the entrance of the sacred text itself.[9] From the fourth century onward the canon tables were spread throughout the Christian world and became an integral part of virtually all Gospel manuscripts. Ethiopian scribes continued to use this device until the fourteenth and fifteenth centuries, with a few tables produced as late as the seventeenth century.

7. Haile Gabriel Dagne 1989. 215–23.
8. S. Uhlig 1984: 318–35.
9. C. Nordenfalk 1963: 17.

66

One of the leading historians of Oriental Christian manuscripts during the middle years of the present century, Jules Leroy, made a comparative study of the canon tables of ten manuscripts, all datable to the fourteenth and fifteenth centuries.[10] He noted that the manuscripts of Gunda Gundi formed a distinctive group. Whereas the canon tables of the other manuscripts present two common features, conforming to the ancient Byzantine and Eastern iconographic models, and listing the concordance in a uniform manner, the three manuscripts from Gunda Gundi are quite different. In comparison with the bird and plant motifs which invariably embellish the canon tables of the other manuscripts, the decorations of the Gunda Gundi canon tables are more compact architectural constructions, enclosed in a more rigorously geometrical layout. The architrave and the plinth of the arch are decorated with interlaced knots and rings; the columns are more slender and stylized; the curtains on the sides of the columns have become elongated strips without any knot; and the lunette is no longer decorated with overlapping strips, but instead with crosses and undulating interlaces laid out with the dot-grid technique.

One of the few recent scholars to address the question of *harag*, Csilla Perczel, has noted that the scribes of Gunda Gundi transformed the architectural motifs of the canon tables to an elegant arrangement of surface pattern,[11] and indeed this process of transformation may be most obvious with the canon tables of Gunda Gundi. It is intriguing, therefore, that only the Gunda Gundi manuscripts are known to contain *harag* composed of parallel bands arranged in a manner reminiscent of an architectural facade,[12] and an examination of a manuscript from the Gunda Gundi scriptorium, identified by Mordini as number 76, reveals *harag* whose centerpiece consists of a knotted band similar to the curtains usually seen in the Fountain of Life of the canon tables.[13] The repeated circular motif in the lower range of the band is a survival of the hooks that would have held the curtains had they not been eliminated by the scribe.

During the nineteenth century, the French manuscript specialist Antoine d'Abbadie suggested that *harag* arose in the monastery of Dabra Bizen, which was one of the primary centers of the Ewostatian monastic community.[14] His assumption may have been based on local oral tradition; no further evidence has been found to support it. The other dissident monastic movement of northern Ethiopia, the Estifanosites of Gunda Gundi, may have played a more central role in the development of linear decoration, and one of the tasks of further research will be to assemble the surviving evidence and analyze it in the context of the political and cultural developments of the fifteenth century.

10. J. Leroy 1961(A): 173–204.
11. C. F. Perczel 1989. 59–62.
12. C. Zanotti-Eman (forthcoming).
13. A. Mordini 1954: 29–48.
14. A. d'Abbadie 1859: 29.

# CATALOGUE

*facing page* Icon (cat. 13) with its carrying case

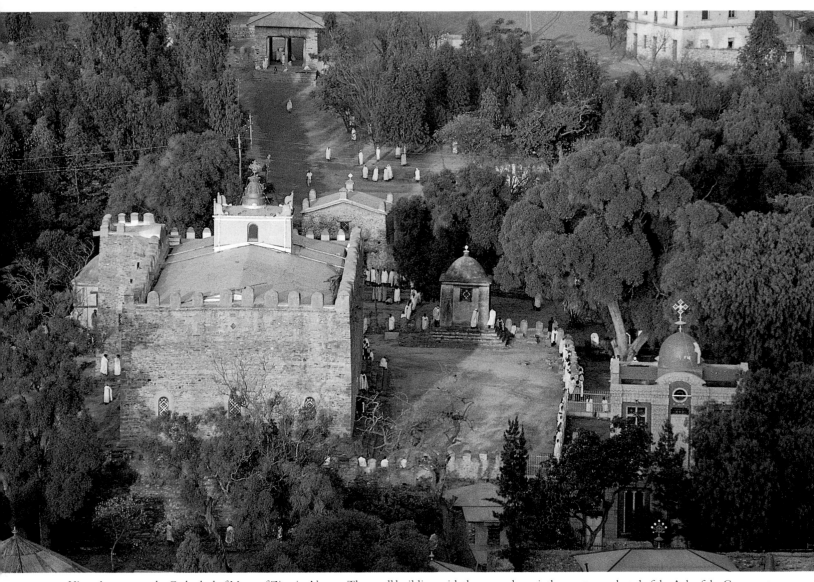

View down onto the Cathedral of Mary of Zion in Aksum. The small building with the green dome is the sanctuary chapel of the Ark of the Covenant.

# MARYAM SEYON: MARY OF ZION

*Marilyn E. Heldman*

AT THE COUNCIL OF EPHESUS IN 431, Mary received the title of *Theotokos* (the One Who Bore God). During the following centuries, she acquired a more central role in the theology and spirituality of both Eastern and Western Churches,[1] but the history of the cult of Mary in Ethiopia is unique.

## Our Mother Zion

The ancient metropolitan cathedral at Aksum is the mother church of Ethiopia. It is dedicated to *Seyon* (Zion) or *Maryam Seyon* (Mary of Zion), and its altar tablet is inscribed *Emmena Seyon* (Our Mother Zion).[2] The oldest church in Ethiopia, it may have been founded as early as the mid-fourth century by Ezana when he converted to Christianity. The *Mashafa Aksum* (Book of Aksum),[3] a seventeenth-century work preserving some ancient traditions, states that the cathedral was built by Abreha and Asbaha (the legendary founders of the Ethiopian Church who are probably to be identified with Ezana and his brother Saiazana), "by means of a miracle, for previously there was there a great lake." The two rulers are said to have ascended a mountain to ask God to reveal where they should build a cathedral. "And Our Lord descended and stood between them and took earth and cast it where it is now; it became dry land. A column of light burst from it, and on it the kings built the sanctuary, there where it is to this day." The miniature of the Ascension in the Gospels of Qwahayn Dabra Maryam (fig. 1) depicts the Virgin *orans* standing upon a square decorated with two fish. This rectangular "footstool" decorated with fish is a schematic representation of the lake filled with earth, and the orant figure of the Virgin is a symbolic representation of the cathedral at Aksum.

The great Aksumite edifice, perhaps constructed in the fourth century and then altered and restored over the next millennium, was destroyed in the mid-sixteenth century and rebuilt on a smaller scale. The original church, with its five aisles, may have been modeled on the Church of the Holy Sepulcher or one of the other great five-aisled Constantinian churches. The dedication to Zion may suggest that Aksum came to be regarded as the new Jerusalem. The annual feast celebrated in honor of Mary on 21 Hedar (November 30) is the festival of Mary, the Mountain of Zion.[4]

The dedication of the cathedral to the Mother Church of Zion and to Our Lady Mary, the Mother of God, was understood to be synonymous. It therefore follows that an icon of Our Lady Mary may also be regarded as a symbolic representation of the Mother Church. The icon of Our Lady Mary and the Infant Christ between the apostles Peter and Paul, painted by the greatest Ethiopian artist of the fifteenth century, Fere Seyon, is a portrait of Mary the Mother Church (cat. 5).

A group of Gospel manuscripts produced in northern Ethiopia during the fourteenth century is decorated with images of the Virgin *orans* standing between the archangels Michael and Gabriel. Above her is a vision of Christ in Glory surrounded by the Four Beasts of Heaven (cat.

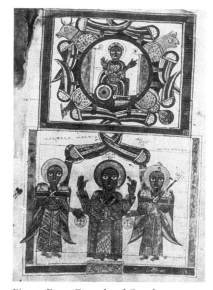

Fig. 1 Four Gospels of Qwahayn Dabra Maryam: the Ascension. [Photo courtesy of David Buxton]

1. I. Kalavrezou 1990.
2. M. E. Heldman and Getatchew Haile 1987: 9.
3. CSCO Script. Aeth. Series Altera 8.
4. B. Velat 1966: 26.

54). This composition represents both the Ascension and the Second Coming, and may also be regarded as an icon of Mary of Zion. While the composition survives only in manuscripts, such an image may have decorated the original cathedral at Aksum. A similar scheme is found on a sixth-century pilgrim ampulla from Palestine which shows the Virgin *orans* beneath a vision of Christ in Glory. She is flanked by Saint John the Baptist carrying an inscribed scroll and Zachariah the Priest bearing a censer.[5]

By the sixteenth century, and probably earlier, the cathedral at Aksum came to be regarded as the resting place of the Ark of the Covenant. According to the mythopoeic epic *Kebra Nagast* (Glory of the Kings), the Ark had been taken from the Temple in Jerusalem by Menelek, the son of the Queen of Sheba and King Solomon. Accompanied by the sons of Solomon's courtiers, Menelek returned to the land of his mother and brought the Ark with him.[7] In the *Glory of the Kings*, the Ark is called "Zion," that is, "the Ark of Zion," the dwelling place of the Lord. For this reason Mary can be identified with the Ark, having been the dwelling place of the Lord herself, and she can also be connected with the Temple and the Holy of Holies in which the presence of the Lord was believed to rest while the Ark was preserved within. Indeed, this association is suggested by the miniature of Mary attended by angels in the Gospels of Krestos Tasfana (cat. 65).

Yekunno Amlak, the founder of the dynasty that came to power in 1270, asserted that he was descended from Menelek. He thereby claimed descent not only from the ancient rulers of Aksum but from the ancient kings of Israel as well. As a result, the dynasty established by Yekunno Amlak came to be known as the Solomonic dynasty, and certain members of the imperial court were known as Israelites, because they claimed descent from the young men who had accompanied Menelek when he left Jerusalem.[8]

The term "Zion" appears in the names of several early rulers of the so-called Solomonic dynasty, such as Yagbea Seyon (He [God] shall bring back Zion) and Amda Seyon (Pillar of Zion). These kings, and all the members of their dynasty, employed Old Testament typology to justify their reign. The term was not limited to an exclusively political role, however. One of the wives of the emperor Dawit was named Seyon Mogasa (Grace of Zion); the most gifted of all Ethiopian painters took the name Fere Seyon (Fruit of Zion) when he became a monk; and several holy men of the monastery of Saint Stephen at Hayq were named Gabra Seyon (Servant of Zion). Nevertheless, within an Ethiopian context the dedication of the cathedral to Zion and to *Maryam Seyon* remains at the center of its significance.

The association in Ethiopian literature of the mother church and Mary the Mother of God makes it difficult to distinguish between them, if indeed such a distinction were ever possible. The equivalence of these terms is demonstrated by phrases contained in land grants of the cathedral at Aksum. The emperor Sayfa Arad (r. 1344–72) granted land to the cathedral for "the commemoration of my Lady Mary," and Zara Yaeqob (r. 1434–68) granted a charter to "our mother Seyon, the Cathedral of Aksum," for "the commemoration of my Lady Mary."[9] The Marian feast of 21 Sane (June 28) celebrates the building of churches dedicated to Mary, and commemorates in particular the building of the first church, which was dedicated to Mary at the command of Christ.[10]

## Our Lady Mary as Intercessor

On 21 Miyazya (April 29), the Ethiopian Church celebrates the festival of Our Lady Mary as Intercessor. The Synaxary reading for this day explains that when Mary intercedes with her Beloved Son on behalf of the children of men, she prevails upon him to forgive the sins of everyone who calls on her name.[11] This festival is one of the thirty-two, or in some sources thirty-three, commemorations of Our Lady Mary which the emperor Zara Yaeqob introduced

5. A. Grabar 1958, pls. 53 and 60.
6. M. E. Heldman 1992(A): 226.
7. E.A.W. Budge 1922.
8. F. Alvares 1961, vol. 2: 462–63; Abu Salih 1895: 288.
9. G.W.B. Huntingford 1965(B), nos. 7 and 13.
10. E.A.W. Budge 1928(A), vol. 4: 1020–23; R. Basset 1924: 583–88.
11. E.A.W. Budge 1928(A), vol. 3: 817.

into the Ethiopian calendar. These commemorations are one facet of the mandatory celebration of Our Lady Mary which Zara Yaeqob promulgated in 1441 in an attempt to promote unity throughout his empire.[12]

The ritual of celebration in her honor included the recitation of hymns, prostration before her icon, and the reading of three miracles from the *Miracles of Mary*. This ritual was incorporated into the liturgy for Sundays and for the thirty-two annual feasts in her honor.

The *Miracles of Mary* had first been translated from Arabic into Geez under the patronage of the emperor Dawit (r. 1382–1413), but its reading was not introduced into the liturgy until 1441. Panel painting had not been a routine activity of Ethiopian artists before this time, but the new Marian ritual created an immediate and urgent need for images of Mary. The monk Fere Seyon has been identified as a painter for the court of Zara Yaeqob, and he is known to have produced a number of icons for the new ritual of veneration. The complex schemes of the panel paintings attributed to him were inspired by the hymns recited in honor of Mary and by the theological treatises of Zara Yaeqob.[13] From this time until the present, the devotional image of Our Lady Mary has been the most popular subject of Ethiopian sacred art and literature.

## The Covenant of Mercy

Another important Marian feast, the *Kidana Mehrat* (Covenant of Mercy), is commemorated on 16 Yakkatit (February 23). It celebrates the promise Christ made to Mary to accept her intercessions on behalf of anyone devoted to her.[14] According to the Synaxary reading for this day, anyone who commemorates the feasts of Our Lady Mary or even gives a drop of water in her name will be forgiven every sin.[15] The reading also relates how angels brought Mary to her Beloved Son on His throne, where He took her hand and kissed her mouth. This line is an allusion to the Song of Songs (1:2), and the gesture symbolizes the role of Christ as the Bridegroom and the role of Mary as the Bride. Miniatures and icons of the late Solomonic period (cat. 11) illustrate the Covenant of Mercy by showing the two seated upon a throne with their hands raised and joined, a visual confirmation of the promise made by Christ to His mother.

## Our Lady Mary at Mount Qwesqwam

Qwesqwam (in Arabic *Kuskam*) is the name of a village in Upper Egypt near the mountain upon which the monastery and church of al-Muharraka are still standing. The monastery marks the site where the Holy Family is said to have dwelt during their exile in Egypt, and the monastery church with its well of healing waters was a celebrated pilgrimage site by the twelfth century. That a community of Ethiopian monks flourished there during the fourteenth and fifteenth centuries is attested by Ethiopic manuscripts from the monastery now in the collection of the Bibliothèque Nationale in Paris,[16] one of which was sent to the monastery by the emperor Sayfa Arad.[17]

Popular devotional literature encouraged the pilgrimage, especially the homily attributed to Theophilus of Alexandria on the Virgin Mary and the site where the Holy Family stayed during their escape. Translated from Arabic into both Syriac and Geez, it is recited annually on 6 Hedar (November 15). Theophilus recounts how, while he was at Qwesqwam, Mary appeared to him and described the difficulties encountered by the Holy Family during their exile. The cult of Mary at Qwesqwam inspired a Geez poem entitled *Image of the Virgin Mary on Mount Qwesqwam*[18] as well as tales of miracles wrought by Mary while she lived there. The latter were added to the collection of stories known as *Taammera Maryam* (Miracles of Mary).

On 6 Hedar (November 15), the Ethiopian Church commemorates the appearance of Christ

12. E.A.W. Budge 1923: xlvi–xlix.
13. M. E. Heldman (forthcoming).
14. E. Cerulli 1957(B).
15. E.A.W. Budge 1928(A), vol. 2: 635–38.
16. H. Zotenberg 1877, nos. 32, 42, and 52.
17. Ibid., no. 32.
18. M. Chaîne 1913, no. 175.

and his disciples on Mount Qwesqwam for the consecration of its church.[19] The homily of Theophilus compares the holy mountain at Kuskam in Egypt with the holy mountain of Zion, and refers to Mary as "Mary of Zion."

The Byzantine iconographic type known as the Mother of God of Tenderness was usually employed for Ethiopian images depicting Our Lady Mary as she journeyed to Qwesqwam, but the composition may also refer in a more general way to the sojourn of the Holy Family in Egypt. The composition expresses Mary's concern for her Son. She consoles Him by tenderly resting her cheek against His (cat. 65). A diptych of the seventeenth century (cat. 106) depicts the sojourn in Egypt alongside the Crucifixion, because the painful ordeals encountered by Mary during the Flight into Egypt prefigured her sorrows at the death of her Son.

## Our Lady Mary at Dabra Metmaq

The feast of Dabra Metmaq on 21 Genbot (May 29) is one of the thirty-two mandatory feasts of Our Lady Mary introduced by Zara Yaeqob. The celebration commemorates the annual appearance of Our Lady Mary for five days in May (21–25 Genbot in the Ethiopian calendar) at the Church of Dayr al-Magtas (the Monastery of the Baptistery) in the Nile Delta. Mary appeared miraculously within a circle of light in the cupola of the church, surrounded by angels, prophets, martyrs, and equestrian saints. An account of this miracle appears in the Ethiopian Synaxary[20] as well as in the *Miracles of Mary*.[21]

By a tragic coincidence, in the same year that the feast of Dabra Metmaq was introduced into the calendar of the Ethiopian Church, the Ethiopian court learned of the destruction of the Church of Dayr al-Magtas. The annual appearance of Our Lady Mary in the church had attracted such large crowds of pilgrims from Upper and Lower Egypt that it aroused the enmity of local Muslims, and in 1437/8 a group of Muslim holy men destroyed the church.[22] When the news of its destruction reached the Ethiopian court at Tagwelat in Shoa, the emperor wept and ordered that a church dedicated to Our Lady Mary be built in Shoa at a site to be named Dabra Metmaq (the Monastery of the Baptistery). The Egyptian Church of Mary at the Monastery of the Baptistery was therefore raised again in Ethiopia.[23] Unfortunately, the Church of Dabra Metmaq built by Zara Yaeqob does not seem to have survived the depradations of Ahmad Grañ in the early sixteenth century, but the feast of Dabra Metmaq remains a major festival celebrated with great solemnity, especially by women.[24]

In the last years of the eighteenth century, the Church of Dabra Metmaq Maryam at Gondar was founded by the emperor Takla Giyorgis, surnamed "the End of the Monarchy."[25] A triptych, datable to the period after 1730, shows the celebration of the miraculous appearance of Our Lady Mary at Dabra Metmaq (cat. 14).

## The Icons of Saint Luke

According to Ethiopian tradition, a fragment of the True Cross, seven icons of Mary painted by Saint Luke, and an icon of the *Kwerata Reesu* painted either by Saint John the Evangelist or by Saint Luke were brought to Ethiopia during the reign of the emperor Dawit.[26] Recent investigations confirm that Dawit did receive a relic of the Cross as a gift from the Republic of Venice, but the remaining objects, the icons by Saint Luke and the icon of the *Kwerata Reesu*, did not arrive until the reign of Lebna Dengel (1508–40).[27] Five of the seven icons attributed to Saint Luke have been identified by Diana Spencer.[28] They are, with perhaps a single exception, Cretan or Italo-Cretan icons datable to the sixteenth century. The so-called *Kwerata Reesu* is an Italo-Cretan icon of the Man of Sorrows, known in Greek as *Akra Tapeinosis* (Utmost Humiliation), which is preserved at an ex-monastery church that also possesses one of the icons

19. E.A.W. Budge 1928(A), vol. 1: 211–12; G. Colin 1988: 254–55.
20. E.A.W. Budge 1928(A), vol. 3: 917–18.
21. E. Cerulli 1943: 195–205.
22. Abu Salih 1895: 319.
23. J. Perruchon 1893: 55–57.
24. B. Velat 1966: 26.
25. Getatchew Haile 1988.
26. A. Caquot 1955(A): 100.
27. M. E. Heldman 1992(B); id. (forthcoming).
28. D. Spencer 1972; id. 1974.

of Mary attributed to Saint Luke, a Cretan icon of the Mother of God of Tenderness.[29] These two icons were evidently brought to Ethiopia together, and reached the church in which they are now preserved at the same time.

The icons attributed to Saint Luke are holy objects, so holy that they have been given special names and are usually concealed in fabric. Traditions in Ethiopia concerning Saint Luke as a painter, and the presence of these post-Byzantine icons in Ethiopian collections, provide evidence of the development of the cult of holy icons. While prayer may be addressed to any visual image, whether painted upon a church wall or a wood panel, certain icons are believed to be inherently holy. This concept apparently did not develop in Ethiopia until the early sixteenth century, and neither the icons of Mary attributed to Saint Luke nor the Italo-Cretan Man of Sorrows inspired many close imitations by Ethiopian painters.

## The Virgin of Santa Maria Maggiore

Saint Francis Borgia of the Society of Jesus was devoted to the image of the Virgin at the Church of Santa Maria Maggiore in Rome (fig. 2). In 1569 Pope Pius V gave the Jesuits permission to print reproductions of this early medieval painting, and members of the order disseminated these prints throughout the lands in which they worked as missionaries. The image may therefore have reached Ethiopia with the Jesuits as early as the 1570s. According to Western tradition, the image of Santa Maria Maggiore was one of seven icons in Rome painted by Saint Luke, yet Ethiopian sources never acknowledged the claim. Indeed, there is no relationship of style or iconography between the Virgin of Santa Maria Maggiore and icons attributed by Ethiopians to Saint Luke. Perhaps this is the reason why the iconography of the Virgin of Santa Maria Maggiore was not rejected in the seventeenth century when the Jesuits were expelled from Ethiopia. The Ethiopian Church, it seems, did not consider this type to be a Jesuit image, and it therefore remained a popular subject in Ethiopia.

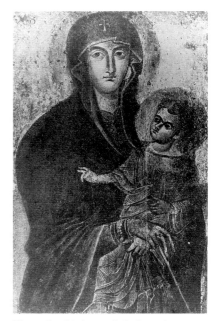

Fig. 2 *La Madonna di S. Luca*, icon from Santa Maria Maggiore, Rome. [Photo taken from Kondakov, *Ikonografija Bogomateri* (St. Petersburg 1915, vol. 2, fig. 77]

29. D. Spencer 1974: 207.

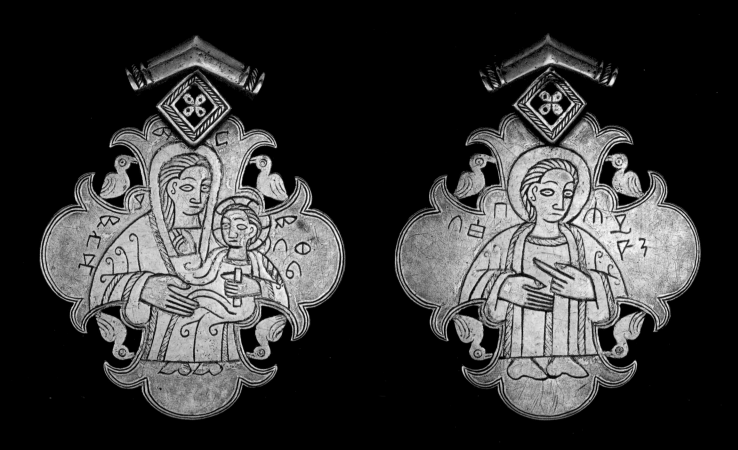

Cat. 1  Cross pendant showing (*left*) Mary with her Son
and (*right*) Mary, the Mother Church

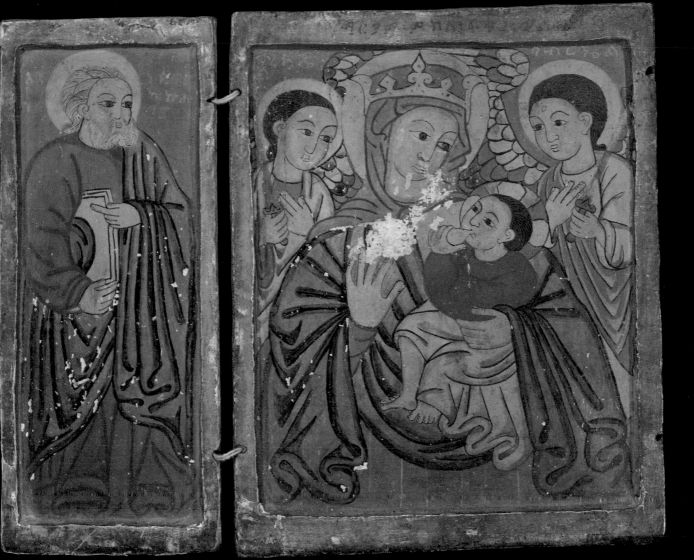

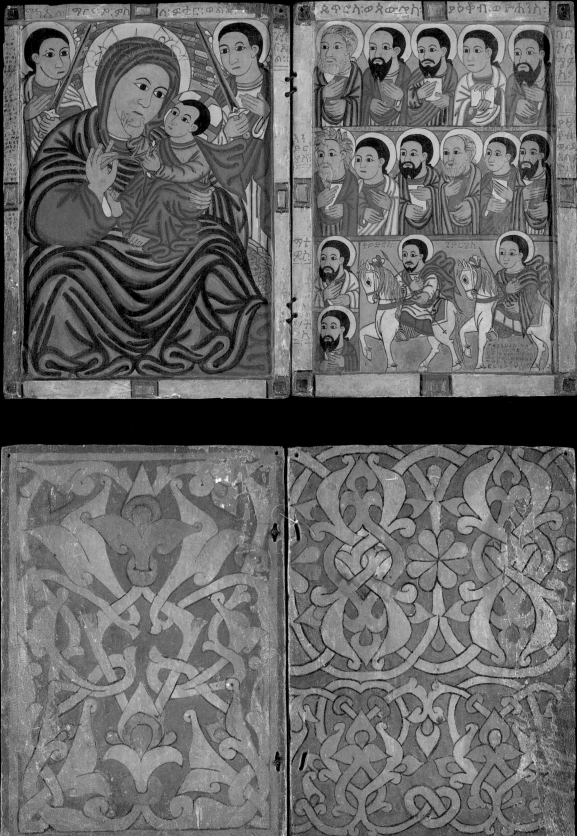

Cat. 4  *Our Lady Mary, Apostles, Saints George and Theodore*

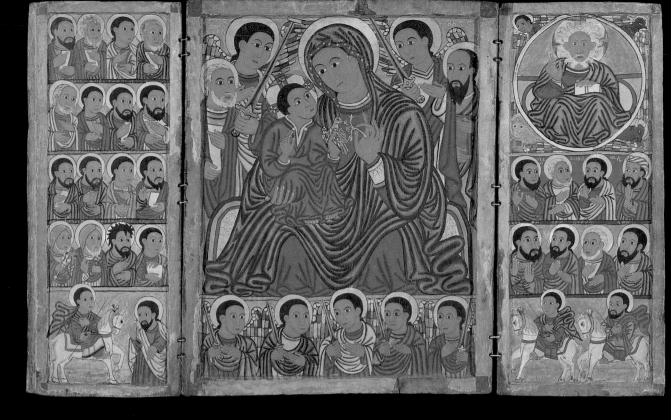

Cat. 5 *Our Lady Mary with Her Beloved Son, the Ancient of Days,*
*Prophets, Apostles, and Saints*

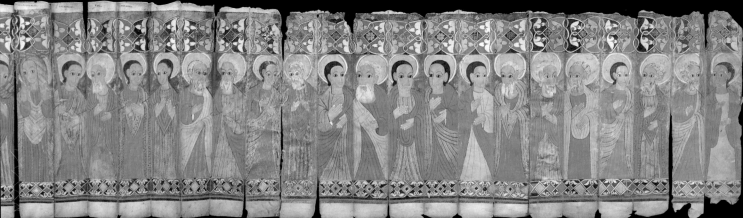

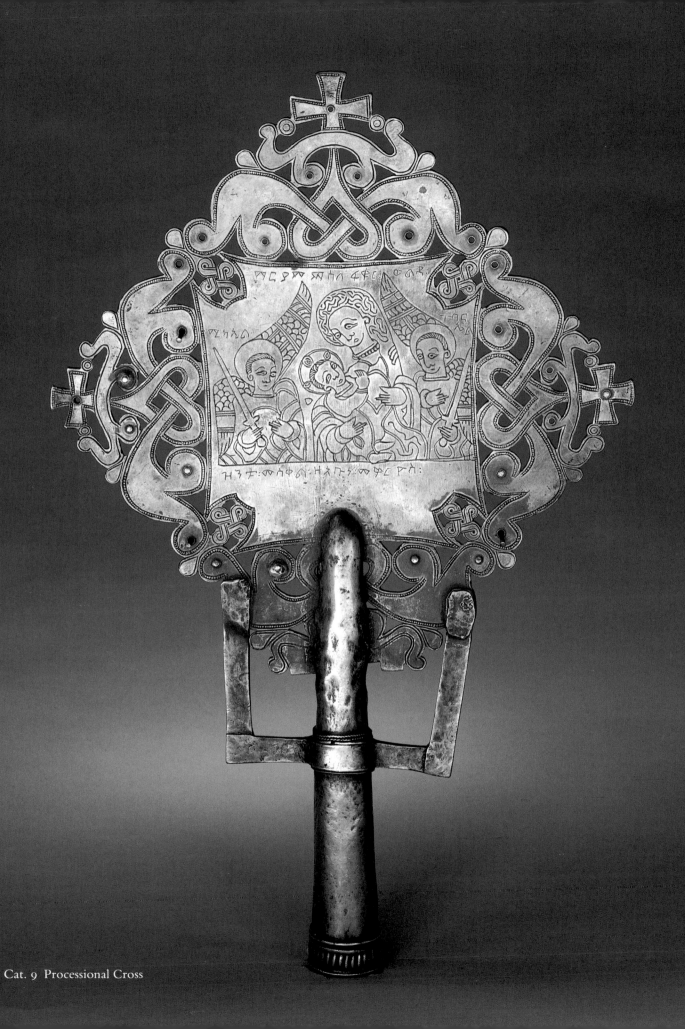

Cat. 9 Processional Cross

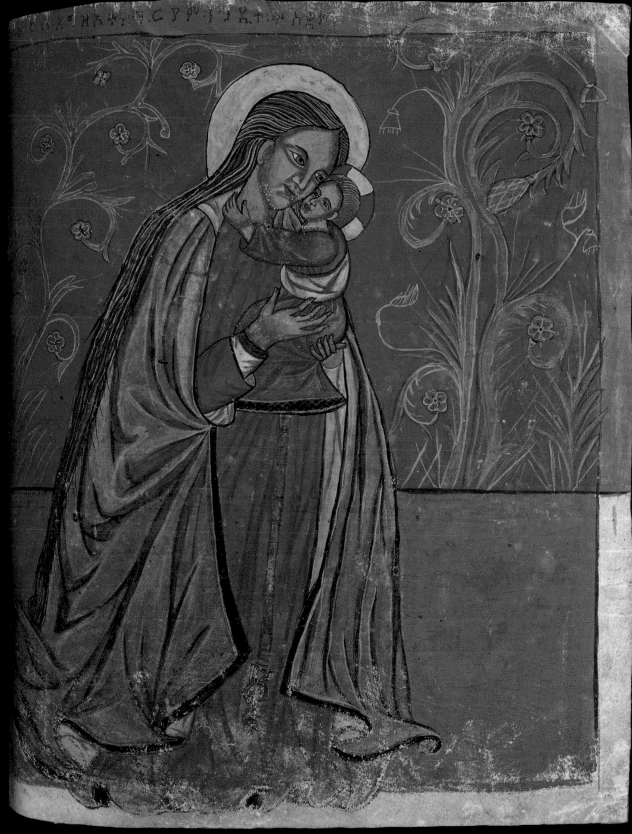

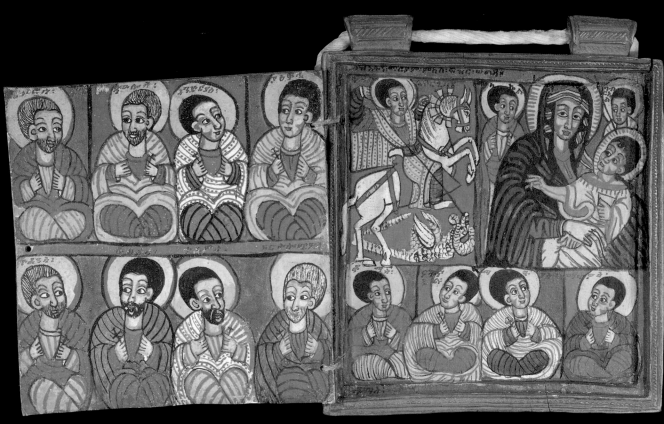

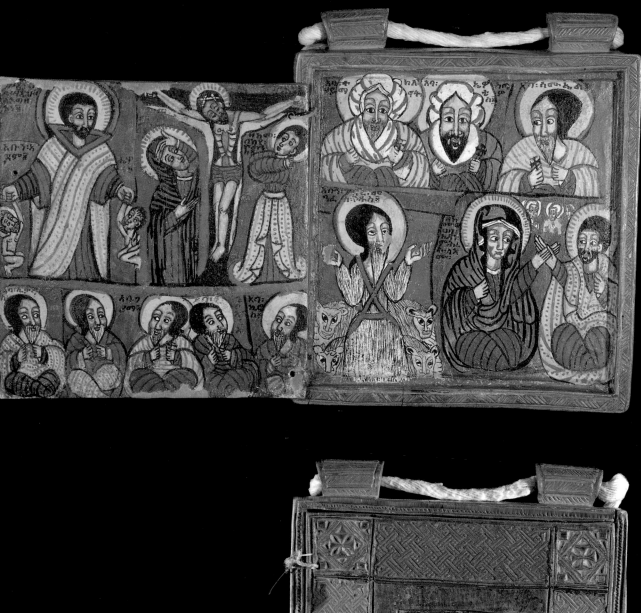

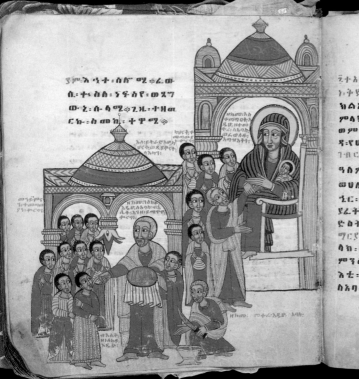

ያሙ፡እቤተ፡ስሎሜ፡ቀፌ፡ወ
ሲ፡ተ፡ስአ፡ነፍሶ፡ወእገ
ወ፡ሉ፡ላሜጊዜ፡ተዘ
ርኩ፡ስመስ፡ተዋሜ

ከዛቅተ፡
እስተዘ
ሀርሐ፡ዲያቆ
ናት፡

ወንፈቃተ
ቲተወመ
ያንተመ

እስመወ፡አ
ተጣፀቅት
ዘጸበል፡
ማርያም፡
እግዝእት

ዘከመ፡ሳበከ
እኂዘ፡ዕንዝ
መንግስተ፡
ፀበል

ወእስተ፡ዘተ
ዘተፈወመ
ያ፡ንፋሱ

ኅ፡ተመ፡ወቀሬ፡እዴሁ፡እዛቅ

ጌተ፡እምሪሃ፡ለእግዝእተ፡ኅሉ
ነ፡ቅድስት፡ድንግል ። በ
ክልኤ፡ማርየም፡ወላዲተ፡እ
ም፡ለእኩፀ፡ሎታ፡ወበረኩተ
ወም፡ሕረተ፡ፋቀር፡ወለ
ዲያሁሉ፡ም፡ስተ፡ገብረ፡
ገብር፡ሊ ።           ለዓለም
ዓስም፡እሜኖ
ወሉ፡ዕብ፡እሲ፡መንኮስ
ቴር፡ዘስመ፡ይኩሐት
ዴፈ፡ሪ፡ድንግ፡እግዝእት፡ት
ሆስ፡ድንግሴ፡በ፡ክልኤ
ማርየም     ወላዲተ፡እም
ሳከ፡በ፡ክሉ፡ሀሉ፡ወእ
ምዕስ፡ነበረ፡ወስተ፡ዩ
እተ፡ይብር፡ወመ፡ዎዕሲ፡ዲ
እግ፡ገብር፡ሊ፡ ሊ፡ተ፡ዲ

ጌዓት፡ዘእስለእስኮ፡ዴ
ያወ፡እት፡ቃተ፡በ፡ቤተ
ክርስቲያን፡ወመሬ፡ኦት
ቲ፡ሃሎ፡ውስተ፡እድ፡ሁ
ወእምኍሬ፡ንፋሜ፡እ
ሎተ፡ንዋም፡ስበ፡የሐ
ሩ፡መነኮሳት፡ወስተ፡
ቶወ፡ዩኑ፡መ፡ወየሐ
ር፡ይ፡ክሐተ፡ወስተ፡በ
ክርስቲያን፡ወይ፡በወፅ
ው፡ስተ፡እርኂ፡ም፡እነተ
ፀ፡ወደተ፡ወ፡ም፡ተ፡ወመ
ሥዕለ፡ለእግዝእተ፡ት
ሆስ፡ድንግሴ፡ማርያ
ወላዲተ፡እምላክ፡ዘለወ
ት፡በንዴተ፡ሃረ፡ባዌ
ይዋጦን፡እሎተ፡ወነ

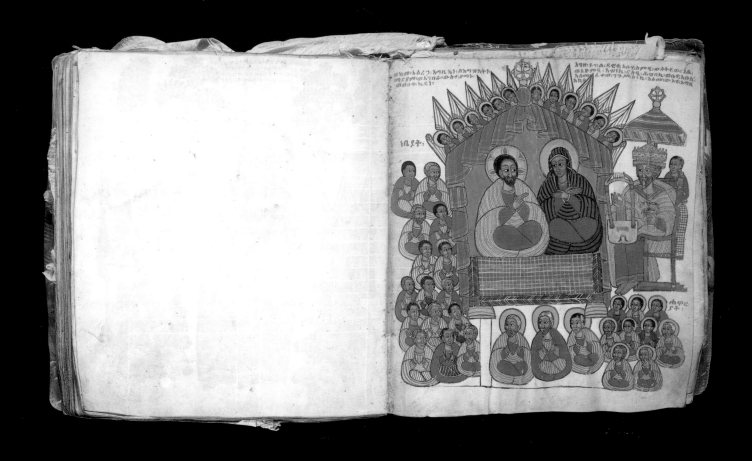

Cat. 12 *Miracles of Mary*, f. 125r: Mary enthroned with Christ

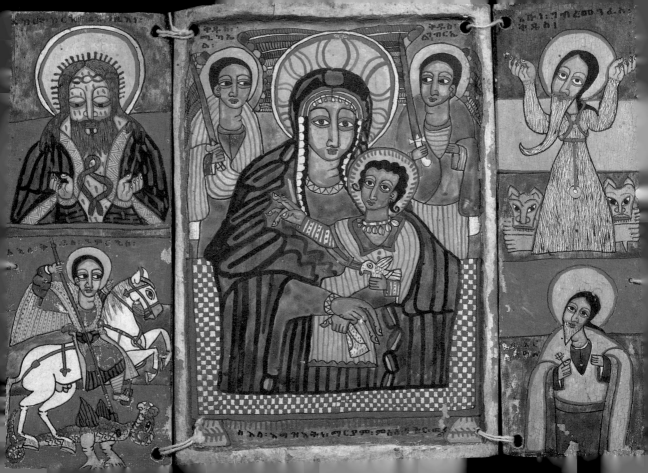

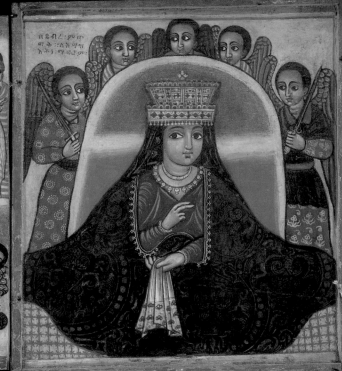

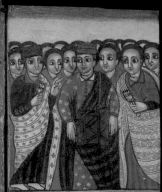

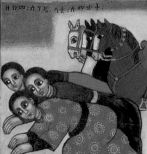

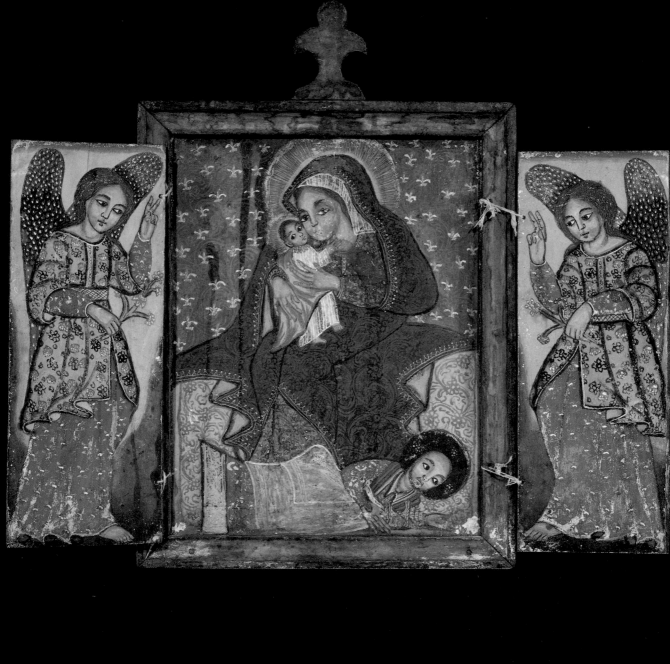

Cat. 15 *Our Lady Mary with Her Beloved Son, Archangels, and Suppliant*

## 1 Cross Pendant

Provenance unknown, fifteenth
century
Silver gilt
$4\frac{1}{16} \times 3\frac{1}{8}$ in. (10.3 × 8 cm)
Church of the Archangel Gabriel,
Tegre

An incised gilt figure is drawn on each side of
this cross pendant. On one side, Mary
holding the Infant Christ is inscribed "Mary
with her Son." She is Mary, the Mother of
God. On the other side, the woman with the
halo is inscribed "By the power of Zion"; she
is Mary, the Mother Church.

The cross, which is made to be worn, can
be dated to the mid-fifteenth century. The
emperor Zara Yaeqob introduced the
mandatory cult of Our Lady Mary to the
Ethiopian Church and encouraged the faithful
to wear an icon or portrait of Mary.
Fifteenth-century Ethiopian literary sources
mention the wearing of an image of Mary on
one's chest but do not stipulate the icon.

Few examples of pendant crosses of this
kind remain. An Ethiopian silver-gilt cross of
similar form (figs. 3 and 4) can also be dated
to the mid-fifteenth century. One side of this
cross depicts God the Father surrounded by
the Four Beasts of Heaven; the other side
depicts Jesus Christ the Son in the arms of his
mother, Mary.

The art form of a portrait or icon upon a

pendant cross may have been introduced
during the reign of the emperor Zara
Yaeqob. However, portraits of the Lord,
Mary, and the saints had long been popular
subjects of Ethiopian wall painting and
manuscript illumination.

## 2 Miracles of Mary (Taammera Maryam)

Central Ethiopia, early fifteenth
century
Gold on parchment, wood end boards
Church of Mary, Amba Geshen

The present manuscript of the *Miracles of
Mary*, produced at the palace scriptorium of
the emperor Dawit (r. 1382–1413), is
decorated with seven full-page miniatures of
Our Lady Mary. Each miniature introduces a
major section of text, and the initial page of
each section is beautifully decorated with a
headpiece, a rectangular bar filled with
interlaced bands of color from which rise and
fall arabesques topped by finials in the shape
of a cross.

The stories of Our Lady Mary, known
collectively as the *Miracles of Mary*, received
pictorial decoration in Ethiopia only rarely
until the seventeenth century, when the
manuscripts that were produced for royal and
noble patrons were lavishly illustrated with
narrative images. Most of the miniatures of

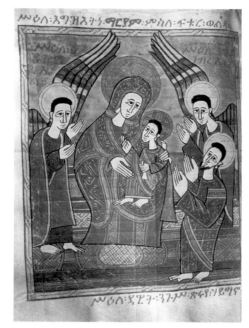

Cat. 2 *Miracles of Mary*. [Photo courtesy of
Diana Spencer]

the present manuscript have no narrative
content. Even the Annunciation, which does
illustrate a Gospel story (Luke 1:26–38),
emphasizes the status of Our Lady Mary as
the Mother of God as much as her role in the
events of the Incarnation. The miniature of
Mary praying while Christ raises His apostle
Matthias presents a narrative, the precise
textual source of which is unknown. All the
iconic miniatures of Our Lady Mary with her
Beloved Son depict a praying figure
identified as *Negus* Dawit, the Ethiopian
emperor for whom the *Miracles of Mary* was
first translated from Arabic to Geez. As a
devotee of Our Lady Mary, he prayed daily
before her icon.[1]

According to an account of a miracle of
Our Lady Mary, a foreigner, probably a
Copt who was employed at Dawit's
scriptorium as a translator of texts from
Arabic to Geez, made the gold paint for
embellishing the halo, dress, and name of
Mary in each of these miniatures. When he
failed in making a second batch of gold paint,
prayers to Our Lady Mary resolved the
problem.[2] The paint became luminous, and
the illumination of the *Miracles of Mary* was
completed.

The opulent headpieces that embellish the
text pages are some of the earliest datable
examples in Ethiopian manuscripts.

Fig. 3 Silver-gilt cross pendant showing
Mary with her Son. [Photo by M. Heldman
© 1993]

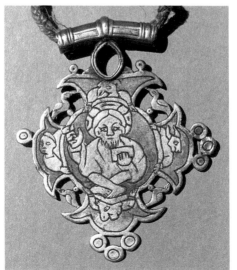

Fig. 4 Silver-gilt cross pendant showing God
the Father. [Photo by M. Heldman © 1993]

Comparisons suggest that they derive from the illuminated headpiece of Islamic manuscripts, which were used as a model for Christian Arabic manuscripts, one of which probably supplied the inspiration for the present ornament.

MINIATURES    Miniature 1: Our Lady Mary with her Beloved Son. Miniature 2: Our Lady Mary with her Beloved Son. Saint Michael. Saint Gabriel. *Negus* Dawit, whose faith is strong. Miniature 3: Our Lady Mary with her Beloved Son. Saint Michael. Saint Gabriel. *Negus* Dawit, crowned by the faith of the Trinity. Miniature 4: Our Lady Mary with her Beloved Son. Saint Michael. Saint Gabriel. *Negus* Dawit, who loves the Lady [Mary]. Miniature 5: Our Lady Mary with her Beloved Son. Saint Michael. Saint Gabriel. *Negus* Dawit, whose faith is pure. Miniature 6: How Our Lady Mary prayed. How Our Lord Jesus Christ raised His apostle Matthias. Miniature 7: How Gabriel announced to Our Lady Mary.

1. Getatchew Haile 1983(C): 31.
2. E. Cerulli 1943: 89–90.

SELECTED REFERENCES
Heldman, M. E. (forthcoming).
Spencer, D. 1967.

## 3    Homiliary in Honor of Our Lady Mary (*Dersana Maryam*)

Central Ethiopia, 1400–1410
Parchment, leather-covered end boards
11$\frac{13}{16}$ × 8$\frac{7}{8}$ in. (30 × 22.5 cm), 251 ff.
Church of Bethlehem, near Dabra Tabor

Full-page miniatures introducing the individual homilies decorate this collection of homilies for feasts of Our Lady Mary. The bishop Cyriacus of Behensa is the author of the homily on the glory and mourning of Mary (*Laha Maryam*), which is recited during the services of Good Friday.[1] His portrait and the miniature of the Crucifixion accompany his homily.

A portrait of the bishop Basil of Caesarea introduces his homily on the dedication of the Church of Mary. It is recited on 21 Sane (June 28), the feast that commemorates the consecration of the churches of Our Lady

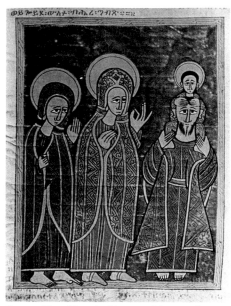

Cat. 3 Homiliary in Honor of Our Lady Mary.

Mary. The homily on the death of Mary by Saint John the Evangelist is accompanied by the miniature of her body surrounded by Christ and the apostles and by a portrait of Saint John dictating the homily to his disciple Prochorus.

An episode from the homily of Theophilus, patriarch of Alexandria, is the subject of another miniature. The homily is recited on 6 Hedar (November 15), the feast of Our Lady Mary and the Infant Christ at Qwesqwam.[2] The miniature depicts Yosa, the son of Joseph, who came to Qwesqwam to warn the Holy Family of Herod's anger. The Child told him to sleep with his head placed upon a rock for a pillow, and immediately Yosa died. His soul went to heaven, and he was buried at Qwesqwam.

The miniatures are identical in style with those of the *Miracles of Mary* (cat. 2) and the Octateuch and Gospels (cat. 67) which were produced for the emperor Dawit. The present manuscript can therefore be attributed to his palace scriptorium as well. Like some of the frontispiece miniatures of his Gospels, the miniature of the death of Mary derives its composition from a Byzantine model.

These Marian homilies reflect Dawit's personal devotion to Our Lady Mary. Like the *Miracles of Mary* and the Octateuch and Gospels, they were probably made for his personal use.

MINIATURES    Presentation of Mary to the Temple; Annunciation; Flight to Egypt; Holy Family at Qwesqwam and the fate of Yosa; Crucifixion; Saint John the Evangelist with Prochorus; Death of Our Lady Mary; Bishop Cyriacus; Bishop Basil; Our Lady Mary with the Infant Christ; Saint John the Evangelist.

1. M. A. van den Oudenrijn 1959.
2. C. Conti Rossini 1912: 463–65.

SELECTED REFERENCES
Chojnacki, S. 1983, fig. 5.
Jäger, O. A. 1957, pls. 3, 6, 9, 12, and 15.
Leroy, J. 1967, pls. 12 and 13.

## 4    Our Lady Mary, Apostles, Saint George, and Saint Theodore

Fere Seyon (?)
Central Ethiopia, 1445–80
Tempera on gesso-covered wood panels
17$\frac{5}{16}$ × 12$\frac{5}{16}$ in. (44 × 31.3) closed
Institute of Ethiopian Studies, no. 3980

Our Lady Mary, inscribed "Mary with her Beloved Son," and the archangels Michael and Gabriel are accompanied by the apostles and equestrian saints Theodore and George in this devotional image. The apostles are inscribed. From left to right, they are "Peter and Paul"; "James and John"; "Bartholomew"; "Andrew"; "Philip"; "Thaddeus"; "Nathaniel"; "Thomas"; "James, son of Alpheus"; "Matthew"; and "Matthias."

The engaged frame is decorated with simulated inset gems in the form of slightly recessed panels painted blue. Two different arabesque designs decorate the reverses of the panels, indicating that the icon was not intended for permanent display. It was very likely carried before the congregation during the ritual of veneration or temporarily displayed on a stand. Sometime after the two panels were painted, holes were cut into the top corners of each one, probably so that the icon could be suspended on the wall of the church.

The present diptych can be attributed to Fere Seyon. The style and the iconographic program are almost identical with those of the triptych which is attributed to him (cat.

5), and in both the treatment of drapery folds and hems and the style of the figure, it is close to the only extant panel which is signed by him (cat. 76).

None of the icons attributed to Fere Seyon is identical with another. If a certain motif is repeated, it is presented in a different context. Where Fere Seyon's triptych in Addis Ababa also depicts Mary offering the sprig of flowers, the present diptych combines this motif with that of the Child caressing His mother's chin, a gesture that Fere Seyon borrowed from a European devotional image. In Western European tradition, this gesture signified erotic communication, and in the realm of religious art, the gesture signified that Christ is the Bridegroom and Mary is the Bride of Christ. The identification of Mary as the Bride of Christ is based upon Christian interpretations of the Song of Songs in the Old Testament.[1]

The motif of the Child caressing His mother's chin may have been introduced to Ethiopian painting without its symbolic meaning, which might explain why it appeared relatively rarely. In contrast, the motif of Mary's offered sprig of flowers, borrowed from an Italian devotional image, was recognized as a Marian symbol[2] and became quite popular. The sprig of flowers refers to a verse for Sunday in the *Praise of Mary* (*Weddase Maryam*): "Mary, you are the flower of delicious perfume which has blossomed from the tree of Jesse." By referring to the prophecy of Isaiah (11:1) "a bud shall blossom," it symbolizes the Virgin Birth. The symbolic flower frequently appears in fifteenth-century Ethiopian icons of Mary.

The arabesque design that overlays Mary's headcover and halo may be a symbol of her status as Queen of Heaven. Although no other icon attributed to Fere Seyon shows her wearing a diadem, a few Ethiopian icons datable to the second half of the fifteenth century do show Mary wearing a crown. Popular Marian devotions, such as the *Praise of Mary* and the *Gate of Light*, do not employ Queen of Heaven as an epithet of Mary; however, several homilies of the emperor Zara Yaeqob refer to Mary as "Queen of Heaven and Earth," "Queen of the Apostles and Martyrs," and "Queen of us all."[3] As the monk Fere Seyon was a painter for the royal court, the iconography of Mary wearing a crown may have been developed within the context of Zara Yaeqob's patronage. Nevertheless, it was not until the eighteenth century that Ethiopian artists commonly depicted Our Lady Mary wearing a royal crown (cat. 14).

1. L. Steinberg 1983: 110–15.
2. M. E. Heldman (forthcoming).
3. Getatchew Haile 1991: 3–4, 29, 32.

SELECTED REFERENCES
Heldman, M. E. (forthcoming).
Paris 1974, no. 102.

## 5 Our Lady Mary with Her Beloved Son, the Ancient of Days, Prophets, Apostles, and Saints

Fere Seyon (?)
Central Ethiopia, 1445–80
Tempera on gesso-covered wood panels
$24\frac{13}{16} \times 40\frac{3}{16}$ in. (63 × 102 cm) open
Institute of Ethiopian Studies, no. 4186

Each of the three rectangular panels is carved with an engaged frame. The wing panels are cut with notched outer edges so that they fit tightly when the triptych is closed, which very likely contributed to the fine state of preservation of the interior surfaces. The reverse of the central panel is painted with a cross framed by an arabesque border; the closed wings are painted with an identical design.

Our Lady Mary, inscribed "Image of Mary with her Beloved Son," is flanked by the archangels Gabriel and Michael and the apostles Peter and Paul. The archangels beneath are inscribed "Rufael," "Urael," "Fanuel," "Saquel," and "Ramuel."

The right wing is dominated by a representation of Daniel's vision of the Ancient of Days (*Beluya Mawael*), at the four corners of which are the Four Beasts, inscribed "Face of a Man," "Face of an Eagle," "Face of a Lion," and "Face of a Bull." Both Ezekiel (1:10–11) and Saint John the Evangelist (Revelation 4:6–8) saw Four Beasts around the throne of God. The prophets, who gaze upward, begin in the second register with a figure who may be Isaiah, followed by Daniel, Ezekiel, and Moses; below are Habakkuk or Enbaqom, Nahum, Jeremiah, and Amos. The mounted soldiers Saints Victor and Theodore, joined by Saint George in the opposite wing, gaze toward Our Lady Mary and the Infant Christ.

The left wing is crowded with rows of half-length portraits: the Twelve Apostles; the evangelists; James, brother of Our Lord and first bishop of Jerusalem; and two indigenous Ethiopian saints, Takla Haymanot and Samuel, wearing the monastic cap (*qob*). The standing figure beside Saint George is Saint Alexius, or Gabra Krestos ("Servant of Christ"), as he is known in Ethiopia. All but him look toward Our Lady Mary with the Infant Christ.

Takla Haymanot (d. c. 1313) founded the monastery of Dabra Asbo, endowed and renamed Libanos by the emperor Zara Yaeqob. Samuel (d. c. 1379) is the founder of Dabra Halleluya near Aksum, a monastery generously endowed by the emperor Dawit (r. 1382–1413). The foundations of these two holy ascetics became wealthy and powerful by virtue of their royal endowments. The presence of the holy men was intended to suggest that contemporary indigenous monastic leaders supported the recently introduced cult of Mary as Intercessor.

While the figure of Our Lady Mary dominates the devotional image, the other figures reflect the statements of the emperor Zara Yaeqob concerning the appearance of God and the role of Our Lady Mary in the events of the Incarnation. He wrote that because of Our Lady Mary, the apostles saw with their bodily eyes the Son of God, whom the prophets had seen only with spiritual eyes.[1] Therefore, while the prophets gaze upward at the vision of the Ancient of Days, the apostles and saints gaze upon Our Lady Mary with the Infant Christ.

1. Getatchew Haile 1992: 99–103.

SELECTED REFERENCES
Heldman, M. E. (forthcoming).
Paris 1974, no. 101.
Stuttgart 1973, no. 2.

who became man in order to redeem humanity.

Fere Seyon nearly always depicted the archangels Michael and Gabriel holding the swords of Ethiopian nobles, as if they were attendants at the heavenly court, yet the present icon depicts the archangel Gabriel with an axe. In this rare instance, neither the axe nor the sword seems to refer to aristocratic status. Rather, both appear to be symbols derived from the theological tract *On the Agreement of the Eighty-One Canonical Scriptures*, by the emperor Zara Yaeqob, the champion of Our Lady Mary. "The sword of the Gospel" and "the axe of the Law" are vivid metaphors which he introduced in his condemnation of those who would bring separation between the Old and the New Testament.[2] Further, he emphasized the status of Mary, who gave birth to the One whom the prophets prophesied, the One in whom the Law was fulfilled. In its depiction of Mary with her Beloved Son, flanked by the archangels carrying a sword and an axe, the icon is a visual transcription of Zara Yaeqob's praise of Mary, who brings together the Old Testament and the New Testament, the Law and the Gospels.

The pursed and slightly parted lips of the Child, and His curly black hair, rendered by rows of perfectly shaped spirals, exemplify the elegant draftsmanship of Fere Seyon.

1. M. Daoud and Marsie Hazen 1954: 67, sect. 104; 87, sect. 80.
2. Getatchew Haile 1992: 114–17.

SELECTED REFERENCES
Heldman, M. E. 1984.
———. (forthcoming).

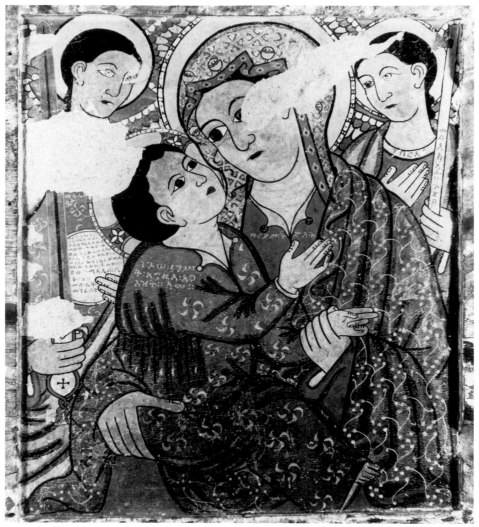

Cat. 6 *Our Lady Mary with Her Beloved Son and Archangels.* [Photo by M. Heldman © 1993]

### 6 Our Lady Mary with Her Beloved Son and Archangels

Fere Seyon (?)
Central Ethiopia, 1445–80
Tempera on gesso-covered wood panel
23 × 22¾ in. (58.4 × 57.8 cm)
Private collection

The right-hand panel of a diptych, this icon of Our Lady Mary holding the Infant Christ and flanked by the archangels Michael and Gabriel presents a tender portrait of a mother and her child. However, various iconographic details and extensive inscriptions create a theologically complex devotional image. Mary's dress is inscribed "Saint Mary," and on the shoulder of the Infant Christ is written

"King of Kings, Lord of Lords." Gabriel's collar is inscribed "Gabriel"; on the handle of his axe is written "Angel who holds the axe." Michael's framed disk, inscribed "Spiritual Mirror," bears the following passage: "Michael the arch[angel] says, 'Holy is God the only Father, Holy is the Word of God the only Son, Holy is the Paraclete the only Holy Spirit Who sanctified us, blessed us, and gave us eternal life.'"

This is the Eucharistic prayer in the anaphora of the apostles and the anaphora of Our Lord,[1] the two Ethiopic liturgies in use during the reign of Zara Yaeqob. The officiating priest recites this prayer over the Eucharistic bread, which becomes the Body of Christ. The Infant Christ is both King of Kings and Christ the Redeemer, Son of God

### 7 Our Lady Mary with Angels, Apostles, Saints, and Prophets

Lake Tana (?), second half of fifteenth century
Parchment, wood handle
38 9/16 × 6⅛ in. with handle (98 × 15.5 cm)
Dabra Tana Qirqos, Lake Tana

The parchment portion of this large fan with wood boards and handle consists of thirty pleated panels. Each panel is painted with a standing figure, bordered above and below by a design of interlacing bands of color and

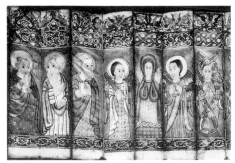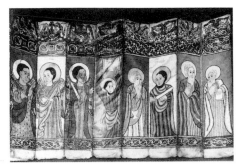

Cat. 7 *Our Lady Mary with Angels, Apostles, Saints, and Prophets.*

arabesque finials. When opened, the fan makes a wheel, at the apex of which is the Virgin *orans* flanked by archangels, a seraph, a cherub, the apostles to her right, and Old Testament leaders to her left. All figures are identified by inscription. From left to right, they are "Saint Nathaniel"; "Saint Anthony the Hermit"; "Saint Stephen the Deacon"; "Saint Thaddeus"; "Saint Matthias"; "Saint James, the brother of Jesus"; "Saint Matthew"; "Saint Thomas"; "Saint Philip"; "Saint Bartholomew"; "Saint John"; "Saint James"; "Saint Peter"; "Saint Paul"; "Saint Andrew"; "the archangel Michael"; "Our Lady Mary"; "the archangel Gabriel"; "Seraph"; "Cherub"; "the archangel Saquel"; "the archangel Ramuel"; "the archangel Raphael"; "Moses," with the Law; "Aaron the Priest," with a censer; "Joshua" the military leader, with a sword; "Abraham"; "Isaac"; "Jacob"; and "Abba Macarius."

The omission of Saint Qirqos suggests that this icon was not made for the Church of Saint Qirqos at Dabra Tana. The portrait of Saint Stephen the Deacon, a popular saint in the Ethiopian Church, does not necessarily suggest a connection with Daga Estifanos at Lake Tana.

The style of figures and the rich interlace ornament (*harag*) display connections with the style of miniature painting that had been developed by the last quarter of the fifteenth century at a major Ewostatewosite monastery, perhaps Dabra Maryam Qwahayn.[1] The shape of the lips, the elegance of the archangels, the high forehead of Saint Paul, and the tight, even ripples of the hem of Mary's dress are all characteristic of the style of Fere Seyon (fl. 1445–80). The Virgin *orans* as intercessor (fig. 5) appears in manuscript illumination of the fifteenth century.

In pleated form and decoration, the present icon can be compared with a Carolingian liturgical fan, the flabellum of Tournus.[2] Extant examples of liturgical fans are the metal disk type, about thirty centimeters in diameter, and the pleated parchment variety, fewer of which survive.[3] By the sixth century, the use of fans in the Eastern Churches to prevent flies from settling upon the sacrament was well attested.[4] Although the use of the liturgical fan (*maraweht*)[5] in the Ethiopian service has not been clearly documented, the transformation of a fan that was actually used into this large form does indicate that the liturgical fan itself was still in use during the fifteenth century.

The present oversized fan was created for

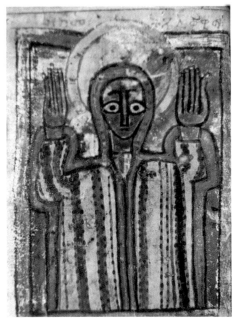

Fig. 5 *Mary at Prayer*, British Library, Or. 13156, f. 62v. [By permission of the British Library]

use as a liturgical icon in response to the mandatory veneration of Our Lady Mary which the emperor Zara Yaeqob had introduced in the 1440s. The prayer inscribed above the figure of Our Lady Mary at the top of the fan, "Our Lady Mary, the Mother of God, may her prayer and the prayer of all the saints protect us," echoes the litany of the anaphora of Our Lady Mary.[6]

This remarkable form was briefly popular during the second half of the fifteenth century. A similar icon fan, decorated with figures in the Ewostatewosite style, is at the Church of Dabra Seyon in Tegre,[7] and a fragment, now in a private collection, is decorated with figures in the Gunda Gunde style.

1. M. E. Heldman 1989: 5–8.
2. D. Gaborit-Chopin 1988; K. Wessel 1971.
3. R. B. Green 1951: 153–55.
4. M. Mundell-Mango 1986: 151–54.
5. W. Leslau 1987: 477.
6. M. Daoud and Marsie Hazen 1954: 105, sect. 9–14.
7. G. Gerster 1970: pl. 45.

SELECTED REFERENCES
Essen 1963, no. 552.
Jäger, O. A. 1957, pl. 4.
UNESCO 1961: 14.

### 8  *Our Lady Mary with Her Beloved Son and Saint Peter*

Central Ethiopia, second half of
    fifteenth century
Tempera on gesso-covered wood
    panels
$7\frac{15}{16} \times 11$ in. (20.1 × 28 cm) open
Institute of Ethiopian Studies, no. 4117

The central panel of the present triptych, inscribed "Mary and her Beloved Son," reflects the style of Fere Seyon's signed panel at Dabra Daga Estifanos (cat. 76). A solemn portrait of Saint Peter, holding a large book in his hands, fills the left panel. The right panel, which is missing, probably showed Saint Paul, as he and Saint Peter played a central role in founding the universal apostolic Church, of which Mary is a symbol.

The theme of the nursing Virgin is linked to the oeuvre of Fere Seyon, although it is otherwise uncommon to Ethiopian icons of Our Lady Mary. Mary's arabesque crown can

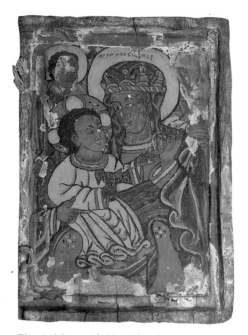

Fig. 6 *Mary with Her Beloved Son*, Institute of Ethiopian Studies, no. 7159. [Photo by Malcolm Varon, NYC © 1993]

be compared with the decorative arabesque diadem of Fere Seyon's Marian diptych (cat. 4) and with devotional images that reflect his style, for example a small painted panel in the collections of the Institute of Ethiopian Studies (fig. 6).

Although Mary crowned as Queen of Heaven was associated more with the Church of Rome, this identity was not exclusive to it.[1] James, patriarch of Alexandria (819–30), had a vision of Mary wearing a great crown.[2] Mary wears a crown in the grand Nativity mural of Faras Cathedral, a major monument of medieval Nubia.[3] Several homilies of the emperor Zara Yaeqob, which are contemporary with the present icon, refer to Mary as "Queen of Heaven and Earth," "Queen of the Apostles and Martyrs," and "Queen of us all."[4]

In the broadest sense, the style and iconography of this icon, which can be assigned to the second half of the fifteenth century and placed within the circle of Fere Seyon, exemplify the impact of Zara Yaeqob's thought upon Ethiopian painting. Not only did he introduce the cult of Mary and promote the veneration of her icon, but his vision of Christian universalism, reflected in his attempts to establish diplomatic relations with European powers, fostered an

interest in the teachings of the Church of Rome and the religious art of Europe.

The inscription "Our Father Peter, Rock of the Faith" derives from Matthew 16:18: "You are Peter, the Rock; and on this rock I will build my church. . . ." The inscription was not intended to make reference to papal claims of jurisdictional supremacy.[5]

1. A. Cameron 1978: 82–85.
2. B. Evetts 1974: 442.
3. K. Michalowski 1967, pls. 64 and 65.
4. Getatchew Haile 1991: 3–4, 29, 32.
5. J. Meyendorff 1974: 97–99.

SELECTED REFERENCES
Heldman, M. E. (forthcoming).

## 9    Processional Cross

Central Ethiopia, second half of
    fifteenth century
Silver, gold bosses
12 13/16 × 8 1/8 in. (32.6 × 20.7 cm)
Institute of Ethiopian Studies, no. 4142

This is typical of an unusual type of processional cross produced during the fifteenth century.[1] Such crosses are cut from relatively thin sheets of silver or brass (never bronze), and areas of pierced work are limited to the framing arabesque and interlace designs. At the core is a short-armed cross, the broad surface of which is incised with iconic portraits. This cross is rare because the arabesque frame is decorated with gold bosses fastened with silver rivets. The shaft and lower arms, like the cross itself, are formed from sheets of silver.

Incised on the obverse of the present cross is a half-length portrait of Mary nursing the Infant Christ, inscribed "Mary with her Beloved Son," with the archangels Michael and Gabriel holding swords; on the reverse is an incised portrait of Saint George riding his horse and carrying a spear with a cross on the handle. Mary and Saint George became a popular combination in Ethiopian devotional images after they were given credit for bringing victory to the emperor Zara Yaeqob over the sultan Badlay of Adal on Christmas Day, 1445.[2] In a story of Our Lady Mary which was composed during the reign of Zara Yaeqob, she explains to the child whom she has restored to health:[3] "George follows me always. He never parts from me wherever I go. I send him all places for help."

The mandatory veneration of Our Lady Mary introduced by the emperor Zara Yaeqob included a procession of the image of Mary before the congregation. Her portrait appeared not only on panel paintings, but on painted fans (cat. 7) and incised crosses such as this one.

Processional crosses are carried today much as they were in the early sixteenth century, when Francisco Alvarez observed that church services were concluded with a procession in which four or five crosses are carried on poles. The cross is carried in the left hand because a censer is carried in the right hand.[4] An inscription names a monastic, *Abuna* Maqareyos, as the donor of this cross.

1. E. Moore 1989: 112.
2. M. E. Heldman (forthcoming).
3. Getatchew Haile 1992: 201.
4. F. Alvarez 1961: vol. 1, 77.

SELECTED REFERENCES
Moore, E. 1971: 35–36, fig. 24.
Paris 1974, no. 100.
Stuttgart 1973, no. 43.

## 10    *Our Lady Mary Journeying to Qwesqwam*

Central Ethiopia (?), early sixteenth
    century
Parchment
10 5/8 × 8 1/4 in. (27 × 21 cm)
British Library, Or. 641, f. 180r

A separate painting of Mary on parchment, inscribed "Image of Our Lady Mary Journeying to Qwesqwam," has been inserted into a manuscript of the *Miracles of Mary.* Most of the pages of this beautifully copied manuscript were produced during the reign of Fasiladas (r. 1632–67); the remainder of the text was copied for the emperor Yohannes I (r. 1667–82). A prayer for Yohannes and the empress Sabla Wangel is written on the reverse of the miniature.[1] For this reason, it seems likely that the painting, originally a separate devotional image on parchment, rather than the more usual wood panel, was included in the *Miracles of Mary* at the order of the emperor Yohannes. Single icons on parchment are not common, although the *sensul,* a "chain" of iconic images on a parchment strip, does indicate that icons were painted on parchment.

The miniature appears to date to the early sixteenth century. The pose of the two figures, especially the tender embrace and the manner in which the left hand of Mary holds the Child, reflects a Byzantine icon known as the Mother of God of Tenderness. Mary's long, uncovered hair is typical of northern European iconographic traditions of the fifteenth and early sixteenth centuries, and can be compared with a painting of the Virgin and the Child by Quentin Massys.[2] During the early sixteenth century, there were many contacts between Ethiopia and the rest of the Christian world, and these contacts are reflected in Ethiopian religious art of the period.

Especially during the sixteenth century, depictions of Mary which follow the iconography of the Mother of God of Tenderness were associated with the pilgrimage site at Kuskam in Egypt, known as "Qwesqwam" in Ethiopia, where the Holy Family is said to have rested. A miniature in the early fourteenth century Gospels of Krestos Tasfana (cat. 65) includes a similar image accompanied by a much longer inscription: "How going toward Dabra Qwesqwam Mary wept for her Beloved Son during the journey and how Salome helped her; Joseph, how he wept with her."

Both images invite the viewer to contemplate the difficulties encountered by the Holy Family during their exile in Egypt. This is the theme of the popular Ethiopian homily on Qwesqwam which is attributed to Theophilus, patriarch of Alexandria.[3]

1. J. Leroy 1962(A): 81.
2. E. Panofsky 1953, vol. 2, fig. 490.
3. C. Conti Rossini 1912.

SELECTED REFERENCES
Cerulli, E. 1943: 206–10.
Leroy, J. 1962(A).
Meinardus, O.F.A. 1965: 28–29.
London 1978, no. 71.
Wright, W. 1877, no. 80.

## 11 Our Lady Mary with Her Beloved Son, Michael, and Gabriel; Saints, the Crucifixion, Christ Raising Adam and Eve, and the Covenant of Mercy

Gondar, late seventeenth century
Tempera on gesso-covered wood panels
$5\frac{3}{4} \times 4\frac{13}{16}$ in. (14.5 × 12.3 cm) closed
Institute of Ethiopian Studies, no. 3387

One face of the present double-sided pendant diptych opens to reveal Mary and the Infant Christ, inscribed "Our Lady Mary with Her Beloved Son," flanked by the archangels Michael and Gabriel. Mary is accompanied by Saint George, her companion in iconic programs since the fifteenth century. In her role as Mary of Zion, the Mother Church, she is also accompanied by the Twelve Apostles, arranged in chiastically colored pairs. Just as Mary is the Mother Church, so are the apostles the foundation of the Church.

The opposite face opens to depict Ethiopian saints and three Christological scenes: the Crucifixion, Christ Raising Adam (inscribed "Our Father Adam") and Eve, and the Covenant of Mercy (Kidana Mehrat). The inscription reads "How He gave the Covenant of Mercy to His mother." The image of Mary and Christ seated together with joined hands symbolically signifies the promise of Christ to answer the prayers of those who make supplications in the name of His mother, Our Lady Mary. The granting of the Covenant is celebrated as a major Marian feast on 16 Yakkatıt (February 23).

Beside Christ and Mary stands Gabra Manfas Qeddus (Servant of the Holy Spirit), the famous hermit whose sanctity tamed the wild beasts. In the upper register, beginning at the left, are inscribed portraits of Takla Haymanot, Ewostatewos, and Samuel. On the opposite panel are depicted several of the Nine Saints, the legendary group that is said to have brought monasticism to Ethiopia in the late fifth century. From left to right, they are Liqanos, Pantalewon (?), and Garima (inscription illegible). Abba Kiros, who is also depicted, was not one of the Nine Saints.

The present icon is larger than a pendant diptych actually made to be worn on one's chest, and in the range of its painted images it is closer to the programs of monumental painting than to the design of most devotional images. The exterior faces of the diptych panels, like the smaller bilateral pendant diptychs of the late seventeenth or early eighteenth century, are carved with a centralized cross design that reflects the carved designs of contemporary wood altar tablets.[1] As the consecrated altar tablet is too holy for the gaze of profane eyes, the historical development of these designs has never been traced. It seems likely that they were first developed for the altar tablet, or for decorated book covers, and then transferred to the realm of the icon. This is another example of how the art of the icon borrowed from other forms of sacred art.

1. J. M. Hanssens and A. Raes 1951: 435–50.

SELECTED REFERENCES
Paris 1974, no. 128.
Stuttgart 1973, no. 18.

## 12 Miracles of Mary (Taamera Maryam)

Gondar, second half of seventeenth century
Parchment, wood end boards
Dabra Warq, Gojjam

Numerous illustrations and iconic miniatures that represent the major feasts of Mary, and symbolize her role as intercessor for those who invoke her name in prayers, are contained in the present collection of the Miracles of Mary. These include the enthronement of Mary beside Christ in Heaven and the Covenant of Mercy (Kidana Mehrat). The narrative miniatures follow the text of the story which they illustrate, and after reading the words of each passage, the faithful would then "read" the illustrations.

The depiction of the story of the bishop of Rome shares a page with four lines of text, the concluding lines of the story. Three successive episodes of the story are combined in this single miniature. On the left is depicted the bishop offering holy communion to the faithful; in the foreground is the devout woman who kissed his hand as she received communion. Overcome by a sinful thought, the bishop cut off his hand. This episode is depicted at the center bottom of the page. The last episode of the story fills the right half of the composition. Mary, feeling compassion for the bishop, miraculously manifested herself from her painted image and joined his severed hand to his arm.

Such marked interest in narrative miniatures, in images that tell a story, typifies

the art of the Later Solomonic period; it may have been stimulated by the lay royal patrons who sponsored the art of the monasteries. The great monastic centers at Dabra Libanos and Dabra Hayq Estifanos had been destroyed during the sixteenth century, and major monastic establishments had moved to the environs of Lake Tana and Gondar, the new capital, where they were supported by the monarchy.

This is one of a group of manuscripts of the *Miracles of Mary* which are lavishly decorated with miniatures in the First Gondarine style. These manuscripts share a related cycle of illustrations. Each image follows, but does not copy, an Ethiopian archetype that may have been created at Gondar during the reign of Fasiladas (1632–67). The style of the present manuscript is closely associated with the patronage of the Gondarine monarchy. The location of the workshop in which these miniatures were produced is unknown; however, it seems likely that Gondar was the site. Priests from Dabra Warq say that it once was an important center where books were copied and illustrated for Gondarine kings.

The name of the original owner of the manuscript has been erased and replaced with the name "Enbaqom."

SELECTED REFERENCES
Annequin, G. 1972.

### 13 Our Lady Mary with Her Beloved Son, Kwerata Reesu (Christ with a Crown of Thorns), and Saints

Gondar (?), late seventeenth or early eighteenth century
Tempera on gesso-covered wood panels (and two-piece leather carrying case)
$6\frac{11}{16} \times 8\frac{15}{16}$ in. (17 × 22.7 cm) open
Institute of Ethiopian Studies, no. 3492

The central panel is filled with a portrait of Mary seated on the throne, inscribed "Image of Our Lady Mary with her Beloved Son," flanked by the archangels Michael and Gabriel. The left panel, divided into two registers, depicts a copy of the imperial palladium known as the *Kwerata Reesu*

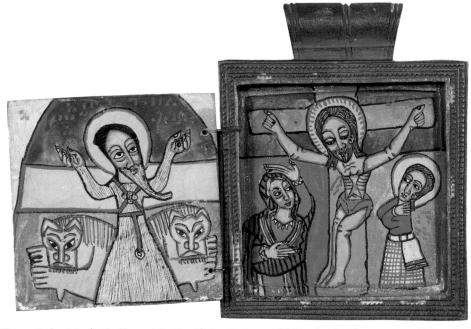

Fig. 7 *Gabra Manfas Qeddus and the Crucifixion*, Institute of Ethiopian Studies, no. 3794. [Photo by Malcolm Varon, NYC © 1993]

(incompletely inscribed "How Our Lord"), and Saint George spearing a dragon (inscribed "Image of Saint George"). In the upper register of the right panel are the holy hermit Gabra Manfas Qeddus[1] and Arsenius, an Egyptian monastic saint.[2] Although the cult of Gabra Manfas Qeddus had become popular in Ethiopia, the presence of these two hermit saints suggests that this personal devotional image was created for a monastic patron.

Such elements in the drawing as the elongated necks and oversized hands may initially divert attention from the brilliant artistry of this painting. Judiciously placed bands of background color and the inspired treatment of pattern, such as the red drops of blood that appear on Christ's face, beard, hair, and blue mantle, or the checkered border of Mary's throne, create an impressive setting for the holy figures. The triptych presents a dramatic visual focus for spiritual devotions.

A small pendant double diptych in the collection of the Institute of Ethiopian Studies can also be attributed to the painter of the present icon (fig. 7). The painter's oeuvre was not limited to panel painting, for some of the miniatures in a manuscript of the *Miracles of Mary* in Paris[3] can be attributed to the same artist.[4] The small scale of this triptych

suggests that the painter was a miniaturist by training.

Our Lady Mary's general iconic type follows the Virgin of Santa Maria Maggiore (fig. 2), the icon in Rome whose likeness had been disseminated throughout the world by Jesuit missionaries. Portuguese Jesuits brought it to Ethiopia perhaps as early as the late

Fig. 8 Child wearing a necklace of cowrie shells. [Photo by M. Heldman © 1993]

Fig. 9 Baby-carrier decorated with cowrie shells. [Photo by M. Heldman © 1993]

sixteenth century. The Infant Christ carries a Dove, the motif which had been introduced to Ethiopian painting by Fere Seyon in the mid-fifteenth century, and He wears a necklace of cowrie shells, an apotropaic

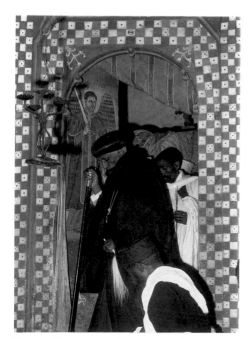

Fig. 10 Entrance to the sanctuary in a modern church at Senafe. [Photo by M. Heldman © 1993]

device the efficacy of which for infants and small children is still recognized in rural Ethiopia (figs. 8 and 9). The cowrie shell, like the shell upon which Venus was carried to the seashore, is symbolic of feminine generative power.[5] The red-and-white checkered throne of Our Lady Mary can be compared with the dark-and-light checkered pattern that decorates the entrance to the Holy of Holies in many Ethiopian churches (fig. 10). This simple motif, like the arched wings of the archangels, may suggest the well-known Old Testament metaphor of Our Lady Mary which is repeated in the Ethiopic *Praise of Mary*: "You are the tabernacle which is called the Holy of Holies."[6]

The pleated edge of Mary's white veil follows the portrait of Mary in the murals of the Church of Saint Anthony in Gondar,[7] founded by the emperor Yohannes I (r. 1667–82). The patches of color on the faces indicate close ties with the First Gondarine style. A date of the last third of the seventeenth century, therefore, or the early decades of the eighteenth century, is suggested.

1. E.A.W. Budge 1928(A), vol. 3: 755–72.
2. Ibid.: 885–87.
3. Bibliothèque Nationale, Paris, Abb. 114, ff. 91v–92r.
4. C. Conti Rossini 1912–15 (1912): 66–72; S. Chojnacki 1983, fig. 142.
5. A. A. Barb 1953. 204–7
6. B. Velat 1966: 294–95.
7. J. Leroy 1967, pl. 21.

SELECTED REFERENCES
Chojnacki, S. 1983, fig. 112.

## 14 *Our Lady Mary at Dabra Metmaq*

Gondar, after 1730
Tempera on gesso-covered wood panels
$14\frac{1}{4} \times 12\frac{11}{16}$ in. (36.2 × 32.3 cm) closed
Institute of Ethiopian Studies, no. 4144

The heavily modeled faces, the backgrounds that shade from yellow to green or red, and the sumptuous costume of Our Lady Mary are typical of later Ethiopian painting, known as the Second Gondarine style. Also typical is close attention to veristic detail. The sistra and the liturgical drums[1] are carried by the priests and nuns; the sistrum and the drum,

known as the *kabaro*, are still used today (fig. 11). The heavy two-tiered crown of Mary is identical with the imperial crown of Iyyasu II, and the empress Mentewwab wears such a crown in the portrait that adorns the wall of the church she founded at Lake Tana, Narga Sellase.[2] The blue cape of Mary suggests a patterned cut-velvet fabric. An identical fabric design, circular medallions filled with a floral pattern, decorates the costume of Christ Enthroned in a wall painting of the Church of Wayna Daga Rufael near Lake Tana.[3]

Unlike many Ethiopian triptychs, which present several loosely related themes, this triptych represents just one: the appearance of Our Lady Mary at Dabra Metmaq. The central panel is inscribed "Our Lady Mary at Dabra Metmaq." The upper register of the two side panels is inscribed "How priests and chaste virgins praise her"; beneath, the angels, inscribed "How the angels bow down before her," and Saints George, Mercurius, and Theodore, inscribed "How the martyrs bow down before her," prostrate themselves before her.

The inscriptions and the visual imagery of the triptych present the miracle as it is related in the Ethiopian Synaxary. The reading for 21 Genbot (May 29) describes how all Christian communities celebrate the festival of the appearance of Our Lady Mary at Dabra Metmaq as she was seated upon light in a circle in the cupola of the church. The archangels appeared, and the martyrs appeared, Saint Mercurius mounted upon a black horse, Saint Theodore upon a red horse. Saint George descended from his horse and they all bowed before her.[4] The account of the appearance of Our Lady Mary at Dabra Metmaq in Ethiopic collections of the *Miracles of Mary* adds that Saint George rode

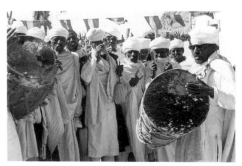

Fig. 11 Priests playing the *kabaro* and sistrum. [Photo by M. Heldman © 1993]

a white horse and Saint Theodore rode a red horse, just as they were depicted on their icons. The right hand of Our Lady Mary is raised, blessing those who praise her, while her left hand holds a large handkerchief. According to the story of the miracle, it was the custom for the faithful, at the moment the vision of Mary appeared, to remove their caps, crowns, and headcovers and throw them high into the cupola. One year a servant threw her handkerchief up into the cupola and Mary took it in her hand.[5]

The triptych combines two events: the ritual that commemorates the miracle at Dabra Metmaq, in which priests and nuns carry sistra and drums, and the miracle itself, in which Mary appeared in a circle of light.

1. M. Powne 1968: 15–16.
2. G. Annequin 1975: 98.
3. E. Hammerschmidt and O.A. Jäger 1968, fig. 25.
4. E.A.W. Budge 1928(A), vol. 3: 917–18.
5. E. Cerulli 1943: 195–99.

SELECTED REFERENCES
Paris 1974, no. 157.
Stuttgart 1973, no. 21.

## 15 *Our Lady Mary with her Beloved Son, Archangels, and Suppliant*

Gondar, after 1730
Tempera on gesso-covered wood panels
16 × 18⅞ in. (40.7 × 48 cm) open
Institute of Ethiopian Studies, no. 3574

Our Lady Mary and the Infant Christ are depicted on the central panel of the present triptych with a suppliant, an unnamed nobleman, at the feet of Mary; standing archangels flank the mother and her child. The image of Mary departs from the usual iconography of this period, which follows the portrait of the Virgin of Santa Maria Maggiore in Rome (fig. 2). Here, Mary is depicted holding the Infant Child to her cheek, a pose which in Ethiopian painting is associated with the iconographic type of "Our Lady Mary at Qwesqwam." Qwesqwam is the site in Egypt where the Holy Family was said to have lived in exile.

The present icon is probably intended to recall a devotional image at the empress Mentewwab's Church of Qwesqwam at Dabra Sahay on the outskirts of Gondar, whose altar tablet was dedicated to Our Lady Mary at Qwesqwam, according to the Royal Chronicle.[1] Mentewwab was devoted to the cult of Mary at Qwesqwam, and she gave the name Dabra Sahay, "Mountain of the Sun," to the site at which this church was built. Evidently her intention was to rival the church on the outskirts of Gondar which the emperor Iyyasu had named Dabra Berhan, "Mountain of Light." The name Dabra Sahay was meant to signify more than verbal

punning or one-upmanship, for names and their meanings were and still are seriously considered by Ethiopians. In fact, one of Mentewwab's names was Berhan Mogasa, "Light of Grace."

The icon presents a florid example of the Second Gondarine style, a trend that was supported by the empress Mentewwab. The garments of Mary and the archangels are carefully rendered cut-velvets, brocades, and print fabrics; the cloth of honor that hangs behind Mary is blue brocade, decorated with a fleur-de-lis pattern. Such focus upon luxury fabrics typified the patronage of Mentewwab. The icon of Our Lady Mary which was created for the Church of Qwesquam at Dabra Sahay was made not only with paint but with applied luxury fabrics ("silk with threads of gold and silver"). It depicted Mentewwab "taking refuge before the Virgin."[2] The icon of Qwesqwam at Dabra Sahay is not extant, but a mural at the Church of Narga Sellase at Lake Tana depicts Mentewwab as a suppliant before Mary.[3] Fabrics depicted in the present icon are as opulent as those in the description of the icon of Qwesqwam at Dabra Sahay. Even the motif of the archangels offering a bouquet of flowers to Mary follows Mentewwab's icon of Mary on the walls of Narga Sellase.

The frame of the triptych is constructed of molding with miter joint corners, and can be compared with a similar frame of an icon in the collections of the Institute of Ethiopian Studies (cat. 119). Although the two seem to be of the same date, they do not appear to be by the same painter.

1. Guidi 1912: 96.
2. Ibid.: 106.
3. J. Leroy 1967, pl. 40.

# AKSUMITE COINAGE

*Stuart C. Munro-Hay*

AN EXCEPTIONAL FEATURE OF THE Aksumite kingdom was its coinage. No other sub-Saharan African state issued its own independent coinage in ancient times—indeed no other African state at all, since those in North Africa (Libya and Mauretania) fell under Roman dominion. Almost no other contemporary state anywhere in the world could issue in gold, a statement of sovereignty achieved only by Rome, Persia, and the Kushan kingdom in northern India at the time of Aksumite power. The simple fact of Aksum's coin production over several centuries bears witness to the cultural and economic development of the state. Coinage is also the only medium to survive, apart from some categories of archeological finds like pottery, in which we can observe some of the artistic trends current in Aksum at the time.

Aksum commenced its coin issues at the end of the third century A.D. Trade links with the Roman world, South Arabia, India, and Ceylon had doubtless made it seem worthwhile for the Aksumite kings to issue their own coinage. This would have replaced the foreign coinage that appears, from information given in the mid-first-century guidebook called *The Periplus of the Erythraean Sea*, to have been used previously by foreign merchants at the Aksumite port of Adulis.

The kings of Aksum struck coins of gold, silver, and bronze. Issues in the lesser metals, uniquely, were sometimes overlaid with gold on important symbols like the cross, the crown, and the royal head. The names of about twenty otherwise totally unknown kings of Aksum are preserved on their coinage, which thus constitutes a vital element in any attempt to reconstruct Aksumite chronology.

The coinage spans the period between approximately A.D. 270–90 and the seventh century, when Aksumite power began to wane. The weight of the coinage appears to have been closely linked with the Roman system, and the heaviest Aksumite gold coins were equal to the Roman half-aureus. As the Roman system changed, so the Aksumite system followed, settling finally on a weight of about 1.60 g, the weight of the Roman tremissis after the monetary reforms of Constantine the Great. Later the Romans produced a lighter tremissis, but Aksum remained with the heavier type, perhaps to offset another feature of the coinage, its debasement.

While there seems to have been an interest in maintaining a similar weight system, Aksum failed to retain the purity of gold that made Roman coinage so reliable. The first kings issued coins of reasonably high gold content, but by the reign of Ezana in the mid-fourth century, the percentage of gold had already fallen from the 90s to the 80s. It may be been this which caused the Aksumite ruler contemporary with the reform of Theodosius I, around A.D. 383, not to follow the weight reduction to about 1.51 g. Fifth- and sixth-century rulers issued coins with percentages of gold in the upper 60s and 70s, the lowest gold percentage recorded so far during the reign of Kaleb being 64.2 percent. After him, the percentage levels for rulers like Ella Gabaz and Ioel sank to the early 50s. Gold coins of Iathlia, which is probably a badly written rendering of the royal name Hataz, known from the silver and bronze coinage, have not yet been measured, but on the basis of inspection appear to be a very pale gold that doubtless contains a

heavy admixture of silver. This debasement, although it would have been profitable to the issuers at first, must eventually have struck a profound blow to the confidence of users, and may have contributed to the collapse of the monetary system in the seventh century.

The symbolism of the coinage was of crucial importance in a world where such mobile items formed an excellent medium for propaganda. Endubis, the first king of Aksum to issue coins, established the general outlines of style which were followed fairly closely by his successors. The primary image was that of the king himself, the absolute ruler claiming divine affiliation. From the time of Aphilas, the successor of Endubis, the kings can be seen on the obverse of the gold pieces, wearing the elaborate high Aksumite tiara supported on a little colonnade of columns. Above their heads are the divine symbols, the disc and crescent. Since the kings call themselves, on their surviving inscriptions from the pagan period, "Son of Mahrem," perhaps it is this deity that the symbols represent, or perhaps the whole Aksumite pantheon is symbolically invoked by them. The cross succeeded to this predominant position with the conversion of Ezana, probably around A.D. 330.

The kings are dressed, as the half-length profile busts show, in fringed robes and wear necklaces, bracelets, armlets, and probably finger-rings. They hold a sword, a spear, or in Christian times, a hand cross. The bust is framed by two stalks of wheat, doubtless representing one of the vital crops on which the prosperity of Aksum depended. Apart from an early type of Aphilas, only Gersem, one of the last rulers to issue coins, replaced the profile bust with a frontal image on his gold coins. Perhaps under Byzantine influence, this was to become common on the silver and bronze.

As a way of emphasizing the importance of the royal position in the state, the king was also represented on the reverse of the gold coins; such a double representation of the royal image is almost unique in world coinage. On these examples the king does not wear a tiara but a sort of close headcloth or helmet. Endubis alone, the founder of the series, was depicted wearing this type of headgear on both the obverse and reverse of his gold pieces, without the tiara. On silver and bronze coins, this headcloth image is the norm for the obverse; a variety of designs appear on the reverse, although in the later series tiared heads begin to appear on the obverse of the lesser metal pieces as well.

Aphilas, or perhaps the master of his mint, was evidently an innovator. He experimented with fractions and a number of different designs. His gold coins introduced a tiaraed bust, a facing bust on a half-weight issue, and a tiny one-sixth(?) aureus piece, with an anepigraphic obverse and a legend occupying the entire space of the reverse. He issued two weights of silver, one with gilding on the royal bust, and three different weights of bronze. Such variety seems to have proved unnecessarily complicated, however, and later kings issued fewer types.

The phenomenon of gilding may have been instituted to raise the value of the coins of lesser metals or perhaps to encourage by its opulence the use of coinage in the remoter reaches of the kingdom. In the central area, royal payments for services could distribute coin, and demands that taxes be paid in coin could also force its acceptance. But in less accessible areas, barter would have remained the customary method of exchange, and some other inducement may have been required to promote the use of coinage. At Adulis or at other market centers, foreign coinage was of course already used. Whatever the case, the difficult and expensive technique of gilding, which Aksumite coinage alone employed, persisted almost from beginning to end of the series.

Perhaps the most characteristic reverse motif on silver and bronze coins after the conversion of Ezana is the cross. Ethiopian art has exploited the form of the cross to a high degree, but on these coins some of the earliest developments can be seen: Latin and Greek crosses, cross-crosslets, diamond-centered crosses inlaid with gold, and other variants. It seems almost certain that the Aksumite kings were the first Christian rulers to display the cross on their coins, sometime not long after A.D. 330.

The legends on the coins are at first in Greek, on all three metals. Later there is a gradual change. Geez comes to predominate on the lesser metals, while Greek is retained for the gold, an indication of its status in the international trade of the time as the lingua franca of the Roman Orient. Wazeba alone of the early kings employed Geez on his gold and silver. On bi-regnal issues of Wazeba and Ousanas, the obverse of Wazeba with its Geez legend contrasts with the Greek on the reverse of Ousana, and possibly these two kings reigned together. The king MHDYS (his name is known only in unvocalised Geez) appears to have been the first to use Geez on the bronze, issuing a coin with a legend apparently following the famous vision of Constantine the Great: "In hoc signo vinces" ("By this sign you will be victorious"). On one silver issue of Ioel, in the sixth century, the two languages are combined, Geez on the obverse and Greek on the reverse.

The kings proclaimed messages to their people through the potent medium of the legends on coins. Some of the earliest Christian examples, very probably issued by Ezana himself, show the cross in the center surrounded by the words "May this please the people," doubtless a form of conversion manifesto. Other legends declare "By the grace of God," or "MHDYS, by this cross he will conquer," and later messages read "Joy and peace to the people," "Christ is with us," or "Mercy and peace."

Rare diversions from the royal busts and crosses are found on two types with an architectural reverse. One type, with the reverse legend "Za-ya Abiyo la Madkhen," perhaps issued by Wazena, shows an arch supported on double columns and sheltering a gold-inlaid cross. The second, of Armah, depicts the columns supporting a central gold-inlaid cross, flanked by two others, with a key-shaped object under the arch. These pieces may refer to the conquest of Jerusalem by the Persians in 614, alluding either to Calvary or to the Holy Sepulcher.

The later gold issues, of the kings Allamidas, Ella Gabaz, Ioel, Hataz/Iathlia, Israel, and Gersem, are thin-flanned pieces, with degenerate Greek legends and badly cut dies. By the sixth century, after the famous expedition of Kaleb to the Yemen, a campaign that may have required the production of a large number of gold issues to pay the troops, the great days of Aksum were over. This is reflected in the coinage itself. It is difficult to be specific, but it seems very likely that the coinage continued until Aksum ceased to be the capital of the Ethiopian kingdom, probably around 630. In the upper levels of many of the great structures in the city, or in squatter rooms built around their ruins, coins of the later kings abound. Whatever it was that brought the end of Aksum as a capital, the coinage failed to outlast the city itself. The Persian conquest of the Yemen around 570, their attacks on Roman Egypt and Syria some fifty years later, and the rise of the Arabs after 630 were all events which must have helped destroy the Red Sea trade that had made Aksum wealthy and powerful. It may be that overuse of the land around Aksum, along with changes in climate, left the hinterland unable to support a large population any longer, compelling the Ethiopian kings to depart for more fertile districts. With the failure of the Red Sea trading system and the eclipse of their international position, they no longer needed to issue coinage. The capital and the monetary system were abandoned together.

SELECTED REFERENCES

Munro-Hay, S. C. 1984(A).
Munro-Hay, S. C. 1984(B).
Munro-Hay, S. C. 1991: 180–95.
Munro-Hay, S. C. Forthcoming.
Oddy, W. A., and S. C. Munro-Hay 1980.

*Note for following catalogue entries:* The conventional abbreviations used by numismatists for the metals are as follows: AV, gold; AR, silver; AE, bronze. These are derived from the Latin names for these metals.

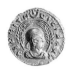
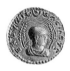

## 16 Endubis AV I

Late third century
Gold
15 mm
British Museum 1989–5–18–1, M-H 45

Several internal features of the coinage make it virtually certain that Endubis was the first king of Aksum to issue coined money. Among these features are the weight, the purity of the gold, the raised relief on all metals, and the general design. In addition, a comparison with the weight of the Roman aureus suggests that these coins were produced somewhere between 270 and 290, and represented the equivalent to half a Roman aureus (one-sixtieth of a pound of gold, with a theoretical weight of 2.72g). The known gold weights of Endubis range up to 2.81g, perhaps reflecting the practice of minting a given number of pieces from a pound of gold, a process which results in some slightly overweight and some slightly underweight pieces.

Endubis began the coinage with a modest set of types: one of gold, one of silver, and one of bronze (or copper – no analyses have yet been made). All are very similar in design, the gold being distinguished only by the two wheat stalks which flank and surround the bust of the king on both faces.

The king, wearing the so-called headcloth (it appears to be a cloth bound over the head with a tie or ribbon visible at the rear), is shown facing to the right on both faces of the coins, doubtless an assertion of his preeminent position as the head, indeed the embodiment, of the state. While this double representation is very unusual on any other coinage, it was standard for the entire Aksumite series, the only development being that for the gold coins issued after Endubis, the obverse head wears the royal crown instead of the headcloth.

The disc and crescent, prominently displayed at 12 o'clock on both faces, almost certainly refers to one or all of the deities in the Aksumite pantheon, and after the

conversion of Ezanas around 330 it was replaced by the cross.

With this coin we have the essentials of what Endubis must have considered desirable to present to the outside world, as well as to his own people: his own supreme status as king of Aksum; the ears of the grain, which was a source of prosperity to the country; and the religious symbols, which would also have reiterated his own semi-divine rank. Many aspects of the original design became permanent features of the series; even the "portrait" of the king remained unchanged for centuries.

The legend was in Greek, no doubt a result of the raison d'être for the coinage, the enhancing of trade on the Red Sea route. It simply reiterated the supreme position of Endubis by detailing his name and titles: "Endubis, King of the Aksumites, Man of Dakhu." This last, written in Greek as *BISI DAKHU,* derives from the Geez word *beesya* ("Man of. . . ."), and is of uncertain significance. It has been suggested that it is some sort of clan name, perhaps deriving from the king's maternal clan, since it differs for each king. It may also have been a regiment name, since some of the military groups known from inscriptions bear designations similar to these *Bisi-* names. It may even represent both, if the regiment names originated from the clan names.

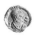

## 17 Aphilas AV I

c. 300
Gold
7 mm
British Museum 1989–5–18–7, M-H 48

With Aphilas, who appears from the coinage to have been the successor of Endubis, a period of vigorous experimentation began, both with the denominations and with the design of the coins. One innovation of his reign was the tiny gold piece exhibited here, apparently representing, at around 0.30–0.34g, one-sixth of the weight of the large gold pieces struck by Endubis (cat. 16).

The coin was evidently struck on too small

a flan to show very much detail, so the compromise was reached of placing the royal bust, wearing the headcloth, on the obverse accompanied only by the disc and crescent symbol. The head and shoulders type of bust was employed, and there was no legend. On the reverse, however, the slightly abbreviated legend "King Aphilas" (only the final letter is missing) filled the entire field.

The coin is fairly frequently found; indeed, it is by far the most common of the gold pieces of Aphilas, and it would seem probable that it was intended as a gold piece for common use. The fact that, at least as far as present evidence indicates, no further issues were produced either of this weight or of the half-weight piece described below, may imply that despite the attempt to spread the use of the gold in smaller units, only large pieces were in the end worth producing. The minting of the gilded silver (cat. 18), a further innovation of Aphilas, may have had something to do with this.

A unique half-weight gold coin of Aphilas is also known (AV 3, M-H 50) (illus. below), the only half-weight gold piece so far found for the entire Aksumite series. This coin has a

number of unusual features, although the general idea of a head with a tiara on the obverse and with a headcloth on the reverse is retained. However, the obverse displays a facing bust, and the crown is lower than the high tiara, a style often seen later until the end of the series. The wheat stalks have also been omitted, and on both sides the legend has been abbreviated, as on two silver types of Aphilas. On the obverse, the king holds upright what appears to be a sword or a spear.

The largest gold piece of Aphilas (AV 2, M-H 49) (illus. below) is similar in weight and flan to that of Endubis but abandons his predecessor's plain basic design, instead elaborating the royal bust, particularly on the obverse, by including a number of items of the royal regalia.

The most prominent feature is the Aksumite tiara, a high crown which can be seen on the best pieces to consist of a

colonnade of miniature pillars, with capitals and bases, supporting four elements which rather resemble the *atef*-crown of the Egyptian and Meroitic kings. Behind the head still appears the ribbon seen on the headcloth, triangular or rounded in shape.

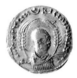

This seems to hint that perhaps the headcloth was still retained as a padding for the tiara, which was doubtless made of precious metals and therefore quite heavy; no Aksumite crown has yet been found, but the silver carnelian-studded crowns of their sometime vassals, the Noba kings, have been recovered from tombs at Ballana and Qustul in Nubia.

The royal bust on these Aphilas pieces is extended downward to the base of the coin, and the simple draped head and shoulders bust of the Endubis type is developed to include the arm. The king holds a short stick or scepter on the obverse, and a bunch of drooping strands terminating in dots on the reverse. This latter motif possibly represents fruit on a branch, or perhaps a fly whisk, an item of regalia known from medieval descriptions of the royal coronations of the kings of Ethiopia at Aksum. One of the later accounts of the coronation of an Ethiopian ruler at Aksum mentions that two great nobles assigned to accompany the king carried olive branches to be used as fly whisks, and it is not impossible that this is what the tiny image on the coins represents. The title *aqabe tsentsen* (Keeper of the Fly Whisk) is known from a land grant purporting to date from 1225, during the reign of Lalibela, and such items of royal regalia are common in African monarchies.

Some of the coins of this type show an outer border in a flowing guilloche pattern. This was never used again, the outer borders of future Aksumite issues being either plain or beaded circles.

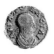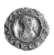

## 18 Aphilas AR 2

c. 300
Silver
12 mm
British Museum 1989–5–18–13, M-H 52

Until very recently, only two silver issues of Aphilas were known, but a third has now been published.[1]

The commonest, and the most interesting, of the Aphilas silver issues is the gilded type. On the obverse is the royal bust, head and shoulders only, wearing the headcloth with a triangular ribbon behind. The disc and crescent symbol appears at 12 o'clock, with an abbreviated legend standing for "King Aphilas."

On the reverse is a tiny central bust of the same type as that on the obverse, set in a circle. Considering its size, the die-cutters seem generally to have made a good job of the work. All the main features are perfectly clear; even the minuscule lines above the forehead, which represent stretch marks on the headcloth or perhaps some sort of aigrette, are visible. Outside the circle runs the legend, with the disc and crescent symbol at 12 o'clock. The legend reads *IAPHILAS BASILEUS* (King Iaphilas). This is the only issue of Aphilas to add the extra *I* at the beginning of his name. It might be considered to represent a word break, except that it does not occur at the beginning of *basileus*.

However, the most remarkable thing about this issue is the gilding. A thin sheet of gold covers the royal bust inside the inner circle. Sometimes, if not cleanly applied, the gold spreads in places over some of the letters of the legend. What led Aphilas to employ this costly and difficult procedure on his silver can only be conjectured, but whatever the motive was, it was one which lasted; gold was applied to silver or bronze coins throughout virtually the entire period of the coin issues. It might have been designed simply to encourage use of the coinage locally, in addition to the international use of the gold

for trading purposes, by making it obvious that the coins had a real, rather than a merely representational, value. It might have been done to avoid the issue of larger, heavier, silver pieces, whose weight is usually well over twice that of the gilded issues, if silver was a rare metal in Aksum at that period. No doubt there was an awareness of the artistic and iconographic side of things as well. The king appeared haloed in gold, an indication of his wealth as well as an impressive portrait. Possibly, too, this was considered a better way of producing coinage which could circulate as fractions of the gold pieces, without the necessity of minting fractions in gold itself. In this case, these coins might have been issued later in the reign of Aphilas, after the abandonment of the gold fractions described in the previous entry.

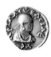

The other Aphilas silver issues included a large module piece (AR 1, M-H 51) (illus. above), which resembled the silver type of Endubis, except that some of the letters of the legend appear beneath the bust, and the recently published third type, of the same weight as the gilded pieces.

1. S. C. Munro-Hay 1990.

## 19 Aphilas AE 1

c. 300
Bronze
17.5 mm
British Museum 1873, M-H 53

The bronze of Aphilas includes, like his gold and silver, three separate issues. All three have features in their design which were not much used on the coinage of later kings.

Two of the Aphilas bronze types have facing busts on the obverse. The most unusual piece, exhibited here, is known from

a single example in the British Museum. It is by far the heaviest Aksumite coin known, with the high relief 4mm thick. It weighs 4.83g but must have been even heavier originally, since it is now rather worn as well as pierced with a hole. The other type (AE 3, M-H 55), except for the obverse facing bust, resembles the heavier silver issue of Aphilas (AR 1, M-H 51) in design as well as weight.

The AE 2 type of Aphilas (M-H 54) differs little from the single known bronze issue of Endubis. However, the legend "Aphilas King of the Aksumites, Man of Dimele" is broken in the middle of the word *AKSOMITON* (of the Aksumites) and continues on the reverse.

The reverse is unusual in that it does not depict the king again, but instead replaces his image with a single ear of wheat, which occupies the whole field. Along with the use of two wheat stalks as a frame for the king's bust on the gold, this may be a testimony to the importance of the crop to the Aksumite economy. Some years later, and from the number of issues we might assume that Aphilas had a considerable reign, perhaps spanning the later years of the third and the early years of the fourth centuries, Ezanas also employed this design on a bronze piece issued during his pagan period (before c. 330).

However, a number of bi-regnal issues with Ousanas have been found, with Wazeba in the chief position, perhaps indicating that he was the paramount ruler but had invited a colleague or a son to rule with him, a method not long since adopted in the Roman world by Diocletian with the Tetrarchy. Such a stratagem might theoretically ensure trouble-free succession. Although at this stage of our knowledge proof is impossible, we might imagine that Wazeba succeeded Aphilas after the latter had enjoyed a lengthy reign, and that his dual reign with Ousanas was instituted to relieve the burden on a single aging ruler as well as to ensure continuity. It does not seem likely that these coins resulted simply from an accidental striking at the mint, since there are several examples known from different dies.

The dual-reign coins have another unusual feature, in that they are also bilingual. This is because all Wazeba's coinage so far known was issued with Geez legends, while Ousanas, like all the other early coin-issuing Aksumite kings, used only Greek.

The silver issue of Wazeba is an almost exact copy of the gilded issue of Ousanas, except that it lacks the gilding, and as on the single known gold piece of Wazeba, the language used is Geez. On the gold piece his *beesya*- name is written *Zagalay*. There is also a monogram representing the letters *WZB*. On the silver issue, the legend reads only "King Wazeba" on the obverse and "Wazeba King of Aksum" on the reverse.

Never again were the details so clearly executed, although even by this time the heavier relief of the coins of Endubis and Aphilas had been abandoned. It may be that to commence the series Endubis had imported expert die-cutters, perhaps from Alexandria, where the current coinage resembled that produced at Aksum. Others may have followed, but even by the next reign, that of Ezanas, a degeneration of quality in the die-cutting had begun.

Ousanas, whose name might stand for Wazena in Geez, issued a number of variants on the basic Aphilas large-module gold type, with some minor additions. The variations between types consist mainly of changes in the arrangement of letters. Additional features which are visible are the spikes included on the tiara, the armlets and bracelets on the king's arms, and a number of dots which appear either at the juncture of the wheat stalks or around the disc and crescent symbol. There can be as many as six of these, perhaps representing lesser divinities in the stellar pantheon.

The bust of the king on the obverse can be very elegant, with much of the detail of the crown and the king's jewelry clearly visible. Like Wazeba, and Ezanas on his pre-Christian issues, the king holds a long spear. With the introduction by Ezanas of an inner beaded circle on his Christian gold issues (cat. 25), the royal busts became more compressed, and such details could no longer be included.

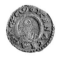

## 20 Wazeba/Ousanas AR 1

Early fourth century
Silver
13 mm
British Museum 1989–5–18–37, M-H 66

It is tempting to regard Wazeba as an ephemeral ruler, briefly a successor to Aphilas and perhaps co-regent with Ousanas. Only one gold piece of his is known to date (AV 1, M-H 67), in the Cabinet de Médailles in Paris (Bibliothèque Nationale N.3.458), and although his silver issue is quite common, no bronzes in his name survive. Altogether, Wazeba is not nearly as well represented by the coinage as any of his predecessors or successors.

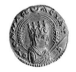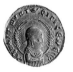

## 21 Ousanas AV 1

Early fourth century
Gold
16 mm
British Museum 1925–11–12–1, M-H 56–58

With the gold of Ousanas, or perhaps with the unique Geez gold piece of Wazeba (see under cat. 20), the Aksumite die-cutters reached the zenith of their achievement.

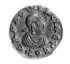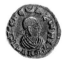

## 22 Ousanas AR 2

Early fourth century
Silver
15 mm
British Museum 1989–5–18–15, M-H 60

The large-module silver coins of Ousanas are the last of the series at this size, subsequent silver coins being smaller with touches of gilding. The large silver, of two types

distinguished by small variants in the legend, are very plain pieces, both faces showing a head and shoulders royal bust, the king wearing the headcloth and accompanied by the disc and crescent at 12 o'clock and a Greek inscription: "Ousanas King of the Aksumites, Bisi Gisene." There appear to be different styles of workmanship in the preparation of these coins, perhaps because experienced die-cutters who might have been trained in Alexandria were giving way to less efficient local trainees.

A variant of this type shows the obverse bust extending to the base of the coin (AR 4, M-H 62).

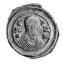 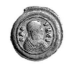

## 23  Ousana (Ousanas) AR 1

Early fourth century
Silver
15 mm
British Museum 1989–5–18–28, M-H 65

A number of the Ezanas issues (two silver and one bronze), as well as this example in silver of Ousanas, show no religious symbol. Otherwise, such an omission occurs on no other Aksumite coin issues during the entire series.

The issue of Ousanas is of undistinguished design, both obverse and reverse showing only the royal bust wearing the headcloth inside an inner and outer circle. The name Ousana, or much more rarely Ousanas, appears on the obverse, and the abbreviation *basileu* or variants meaning "king" on the other. However, the interest of the coin lies in its omission of the religious symbols.

It seems valid, in view of the preeminent position accorded to such symbols in all other cases, to consider that this omission represents something of importance to the rulers concerned. Since Ezanas, as his coins and inscriptions show, converted to Christianity, there was evidently a good reason in his case. But what of Ousanas?

The well-known story of the Syrian Greek, Frumentius, who rose from captive

status to that of royal secretary and treasurer under Ezanas's father, and then to virtual ruler of the country under the regency of the queen-mother, may have had further ramifications. When the regency ended and the young king succeeded to full power, Frumentius went to Alexandria, where the patriarch Athanasius consecrated him first bishop of Aksum. Is it possible that even in the time of Ezanas's father moves had been made in the direction of Christianity? The qualities of Frumentius had impressed the king, probably Ousanas Ella Amida, and earned him those positions of high trust and even intimacy to which he was promoted. Perhaps royal interest in Christianity had already begun, or even grown to such an extent as to be reflected in this unusual omission of the disc and crescent symbol on the coinage. The primary source for the tale of Frumentius's strange history, Rufinus of Aquileia, who claimed to have heard it personally from Frumentius's companion, Aedesius of Tyre, did not mention anything that might allow us to believe such a possibility. However, he did not actually mention the conversion of Ezanas either, which is known to have taken place from local sources, Aksumite coins and inscriptions. It is only this one coin issue which makes the suggestion a possibility, but coins are themselves a primary source, and what was depicted on them was carefully selected. If Ousanas did indeed manifest an interest in Christianity, the regency must have seen a temporary reversion to the old symbols, since Ezanas issued a whole series of coins bearing the disc and crescent before making the official change to the cross.

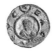 

## 24  Ezanas pre-Christian AR 1

Mid-fourth century
Silver
12 mm
British Museum 1968–4–1–3, M-H 72

Before his conversion, Ezanas issued coins in gold, silver, gilded silver, and bronze, all with

the name and legend written in Greek and with the disc and crescent.

The silver type exhibited here follows closely the preceding silver of Aphilas, Wazeba, and Ousanas, although rarely if ever equaling the earlier issues in technical accomplishment. The disc and crescent symbols remain prominent on both faces of the coin, and the legend is in Greek.

The pagan gold issue of Ezanas, the last of the pagan gold series, was very similar in design to the gold issues of Ousanas, who may very well have been his father, the king named as Ella Amida on Ezanas's own inscriptions and known in Geez tradition as Ella Allada. Proof of this identity may well rest in the inscription published by the Deutsche-Aksum Expedition, which includes the phrase *B'S . . . SNM* after the name Ella Amida.[1] Enno Littmann, the leader of the expedition, identified the king concerned as Ezanas; however, the letter *s* in the king's *Bisi-* name precludes this identification, as the *Bisi-* name of Ezanas is well-known both from coins and inscriptions as Alen (Alene) or Halen. The only possibility among all the known Aksumite *Bisi-* names is Gisene, the *Bisi-* name of Ousanas on his coins. Further study of the inscription at Aksum may now be possible, and should resolve the problem.

1. F. Littmann et al. 1913, vol. 4, no. 8.

## 25  Ezanas Christian AV 1

Mid-fourth century
Gold
15 mm
British Museum 1921–3–16–1, M-H 81–82, 84–85

Some time before the Aksumites implemented the change of weight, following the extension of the monetary reform of 309 by the emperor Constantine the Great to the Eastern Roman Empire in 324, Ezanas issued a new gold series with overt Christian symbolism. The traditional date given in the Ethiopian chronicles for the conversion of

Ethiopia is about 330–33, close enough to the change of the coinage to be credible. If a few years elapsed before the developments in the Roman monetary system were sufficiently implemented to be adopted by the kings of Aksum, we have a date for this issue which is very close to the date established by tradition.

The cross appears in four places on the new issue. Attempts to dismiss these crosses as "space fillers" can be ignored, since a unique Christian bronze coin of Ezanas (AE 1, M-H 83) shows a single unmistakable cross above the king's head at 12 o'clock, replacing the disc and crescent.

A new feature (or nearly new, since it appears in an incomplete form on the reverse of the single known gold coin of Wazeba) is the inner beaded circle dividing the royal bust and the frame of wheat stalks from the legend. This continues throughout the remaining series, except for a few issues during the fifth and probably the early sixth century and one gold issue of Ioel.

Among the gold issues of Ezanas is one of the postreform weight, with the name written as Ezana, not Ezanas. The style is exactly the same as the Ezanas issue of the prereform weight, with the inner beaded circle. The mean gold content of the pagan, prereform, and postreform issues is extremely close, making it impossible to identify these coins as emanating from separate kings dating to later centuries, as some scholars who were unwilling to admit the early conversion of Aksum to Christianity have tried to suggest.

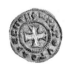

## 26  Anonymous Issue AR 2

Mid- to late fourth century
Silver
14 mm
British Museum 1989–5–18–59, M-H 86

At some point during the mid- to late fourth century a new feature appears, the issue of anonymous coins. The name of the king, which would of course have been well-known to contemporary Aksumites, is not included in the legend. It is replaced by a motto, an inclusion which later became popular on coins with royal names as well. Since the first of these mottoes is in the form of a manifesto announcing the conversion to Christianity, the silver and bronze coins which carried it may well have been issues of Ezanas himself, or perhaps of an early successor of his such as Eon (cat. 27).

Inside two circles, the obverse of the anonymous silver depicts the image of the king wearing the headcloth. A brief legend, reading *BAKH ASA*, appears here for the first time. It has not been satisfactorily interpreted, but may be an abbreviated form of *Basileus Khabasinon* (King of the Habashat), since this title, the origin of *Abyssinia*, the ancient and attractive but now disused name for Ethiopia, is the one used in Arabian inscriptions. There the kings are referred to as "*Najashi* of Aksum and Habashat." *Najashi* is the Arabic rendering of the Ethiopic *negus* (king). It is certainly a possible explanation, but on later gold coins a fuller form of the legend reads *BAS SIN BAKH ASA*; in this issue, there is never a *B* in the last triplet, as there should be if "Habash" were meant, although it does appear on some of the silver coins.

The reverse of the coin is both innovative and impressive. A Greek cross, with a hollowed central cross shape carefully filled with gold and surrounded with a beaded circle, occupies the central field. Around it is a Greek legend reading "May this please the country." The "this" of the legend certainly refers to the elaborate central cross, and the coin thereby comprises something of a political manifesto.

At the same time, it seems, an anonymous bronze coin[1] of very similar type was issued. It differs only in that the obverse inscription reads *basileus* (king) and the reverse cross is not gilded. Along with a second, rather later, anonymous bronze issue[2] bearing a gilded dot in the center of the cross and a tiaraed royal bust with the legend *BAKH ASA* on the obverse, this is the commonest of all Aksumite issues. So many of these coins have been found, hundreds as compared to mere dozens of other issues, that it seems likely they each remained standard issues for more than one reign. Examples of this type also traveled, or at least were copied; they have been found, most unusually for the Aksumite

series, at Meroe in the Sudan; at several places in Israel, including Jerusalem and Caesarea; in Egypt; and at Baalbek in the Lebanon.

1. S. C. Munro-Hay 1984(A): 87.
2. Ibid.: 99.

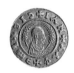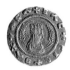

## 27  Eon AV 1

Late fourth century
Gold
16 mm
British Museum 1915–1–8–78, M-H 88–89

The coins of the king called Eon Bisi Anaaph have often been attributed by an alternative reading to "Anaafeon," but it seems clear that the letters designate the *Bisi-* title of the king as on the coins of Endubis, Aphilas, Wazeba, Ousanas, and Ezanas.

Eon is known only from his gold coin issues, many new examples of which came from the al-Madhariba hoard.[1] The coins seem from their style to be very close to some of the gold issues of Ezanas, certain older features such as the four-element tiara or the triangular ribbon behind the head surviving on some dies, along with the use of the *Bisi-* title.

Eon's coins seem to be the first on which the still-uninterpreted legend *BAS SIN BAKH ASA* appears, although part of this legend appeared on the anonymous silver issue (cat. 26). Analysis of the gold content of Eon's gold coins seems to confirm his place just after Ezanas.[2]

1. S. C. Munro-Hay 1989(A): 90–92.
2. W. A. Oddy and S. C. Munro-Hay 1980.

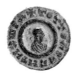

## 28   Ouazebas AE I

Late fourth to early fifth century (?)
Bronze
17 mm
British Museum 1969–6–24–8, M-H 91

The bronze issue of Ouazebas, which from the number of surviving examples known seems to have been extensive, introduced a new feature to the bronzes: a halo of gold around the king's head on the reverse, similar to that already seen on the silver of Aphilas and Ousanas. Unfortunately, because of the conditions in which many of these coins have been buried, the prevalence of bronze disease means that it is quite rare to come across specimens in good condition, although the adherence of the gold is generally very good.

The obverse of these coins shows a bust of the king between two barley stalks, as on the gold Aksumite issues, with a cross at 12 o'clock and the legend "King Ouazebas" written in Greek. On the reverse, a smaller royal bust enclosed in a circle is backed by an overlay of gold. The legend, running around this circle, begins with a cross at 12 o'clock followed by the Greek phrase "May this please the country," the same legend as on the anonymous silver coins and the two anonymous bronze issues noted in entry 26.

Coins of Ouazebas were found associated with the fallen fragments of the great stele at Aksum, a juxtaposition which may indicate that the stele fell during his reign, possibly in the late fourth or early fifth century.[1]

1. S. C. Munro-Hay 1989(B): 151.

## 29   MHDYS AE I

Late fourth to early fifth century
Bronze
15 mm
British Museum, 1989–5–18–249, M-H 94

The name of this king is not known from any source other than his Geez coins, which include no vocalization in the script. His name might be pronounced something like Mehadeyis. The obverse of MHDYS coins show him wearing the headcloth, enclosed by wheat stalks as on the gold issues. Above is a cross, breaking the legend "MHDYS King of Aksum." Wazeba (cat. 20) and MHDYS were the only kings before Kaleb to issue coins with Geez legends.

On the reverse is a new feature for the bronze issues, a Greek cross with a small punched central hole filled with gold. The cross is surrounded by a beaded circle, outside which runs the Geez legend "By this cross you shall conquer." This is an almost exact translation of the famous motto of the emperor Constantine the Great, who saw in a vision before the battle of the Milvian Bridge a cross with the words *In hoc signo vinces* (By this sign you will conquer). This is the earliest known use of the Geez word *masqal* (the cross). In some rare cases the punctuation marks are visible on the legend (illus. below).

Many examples of the MHDYS bronzes have been overstruck by the second bronze anonymous issue noted in entry 26, showing that these anonymous issues were probably direct successors to those of MHDYS. It is impossible to be certain about the sequence of the kings MHDYS, Ouazebas, and Eon Bisi Anaaph, apparently close successors of Ezanas, and there are very puzzling features about

their coin production. Until recently, it was thought that Eon produced only gold, using anonymous silver and bronze issues for his other metals, and that Ouazebas and MHDYS, on the contrary, issued only bronze coins, using anonymous gold with the legend *BAS SIN BAKH ASA*. However, new discoveries have shown that we still do not have the entire series, and that what we do have is very confusing to interpret.

A silver type of MHDYS (AR I, noted in M-H 93, but only known at that time from casts [illus. above]) which had been regarded as suspect has now been authenticated, and a new bronze coin has recently been discovered,[1] apparently intermediate between the anonymous *BAKH ASA* silver (cat. 26) and MHDYS. The obverse is exactly the same as the anonymous silver issue, but the reverse is new to the series. A gold-inlaid cross stands between two wheat stalks, surrounded by the retrograde legend "May this please the country." This opportune find helps to confirm that some of the features which were thought to be too unusual for the MHDYS silver to be genuine can be attested on an earlier bronze coin, of whose authenticity there is absolutely no doubt. A further recent discovery by Dr. B. Juel-Jensen is of a silver coin with close resemblances on both faces to the MHDYS silver, but with the royal name broken off (illus. below). The coin seems genuine enough, and the four-element tiara would presumably place it not later than the time of Eon.

As an incidental comment, these coins, and indeed all the succeeding ones, preclude the theory that the conversion of Ezanas was not permanent in the Aksumite royal house. One need only look at the coins to see an unbroken series of unequivocally Christian mottoes and symbols, proving beyond doubt

that the Aksumite kings, once converted, remained Christian. Possibly, indeed probably, the court conversion long preceded that of the entire country. The coins, like the Geez hagiographies, indicate that when Christian missionaries such as the Nine Saints came to Ethiopia to work in the remoter countryside, they were likely to have met with royal sponsorship rather than indifference or persecution.

1. B. Juel-Jensen 1991: 39.

### 30  Ebana AV 1

Fifth century
Gold
17 mm
British Museum 1904–4–4–1, M-H
95–96

The gold coins of Ebana were minted in a large number of types with minor variations of style or different letters or symbols, perhaps mint marks, placed above the king's head. Ebana was probably an immediate successor of Eon, or perhaps even ruled conjointly with him. As his gold coins are by far the most common of all Aksumite gold, and were produced from many different dies, it may be assumed that he reigned for a considerable time. The discovery of the al-Madhariba hoard, which alone contained 538 examples of Ebana gold, has allowed some interesting die-link comparisons to be made.[1]

In the works of Arturo Anzani, the father of Aksumite numismatics, and a number of other scholars,[2] the royal name was read Esbael or Esbana, owing to uncertainty about the interpretation of the Greek letters. By the time of Ebana, the clearer writing of the earlier coins had changed to a more cursory style, in which the letters *S*, *B*, and *E* were often written the same, as were the *A* and the *L*. However, it seems that the four sets of three Greek letters which make up the reverse legend were intended to be read as *Ebana Basileus* (King Ebana), although the *i* of

*basileus* is always missing. This of course associates the coins with the silver issue which also bears the name Ebana (cat. 31). The obverse legend contains the mysterious letters *BAS SIN BAKH ASA* noted in entry 27 on the coins of Eon, and on some anonymous gold issues as well.

1. See S. C. Munro-Hay 1989(A): 93–94.
2. A. Anzani 1926.

### 31  Ebana AR 1

Fifth century
Silver
15 mm
British Museum 1968–4–1–5, M-H 97

One of Ethiopia's notable contributions to artistic form is the development of a number of elaborate themes based on the cross. On the coins, as well as on painted, appliqué, or stamped pottery, some early versions of the multiform cross can be seen.

An elegant version occurs on the silver issue of Ebana, dated from his position in the coin sequence to the fifth century. One silver coin of his was found at the site of the ancient capital of the kingdom of the Hadhramawt, in the Yemen, the only recorded find of an Aksumite silver coin outside Ethiopia itself.

Ebana's silver issue, often overstruck on the anonymous silver type noted in entry 26, was formerly thought to be the first of the Aksumite silver showing the tiara which Aphilas had first displayed on the gold. With confirmation that a previously suspect silver coin of MHDYS is in fact genuine, the introduction of the tiara on silver coins can be attributed to him (cat. 29). The crowned bust of the king and the legend *EBANA* appear within an inner beaded circle.

The reverse of the coin employs the style of cross called the cross-crosslet. The central lozenge-shaped area is inlaid with gold, and each of the four equal branches ends with a cross. In a way, it is the logical development of the four crosses in the legend of the gold coins of Ezanas and his successors, combined

with the large central cross of the anonymous silver and bronze issues. The small crosses break the legend, which reads *basileus* (king), written in pairs of letters. Oddly enough, in view of the spelling mistake on the gold type above, the order on all the dies is wrong. It is usually *BS AS IL EU,* and one reads *BS IL SU SE.* None has yet been found reading correctly *BA SI LE US.*

Dr. Bent Juel-Jensen, a specialist in Ethiopian manuscripts as well as Aksumite numismatics, has pointed out that one of the coins issued in England during the late eighth century by the king Offa of Mercia has a reverse which bears a very close resemblance to the reverse of the silver issue of Ebana of Aksum.[1] So close are the two designs that despite the considerable separation in space and time, it is hard to attribute their similarity to pure chance. However, an equally close type is that of the late sixth- or early seventh-century Aksumite king Hataz, whose own design doubtless derived from that of his predecessor Ebana.

1. B. Juel-Jensen 1989.

### 32  Nezana AR 1

Fifth century
Silver
17 mm
British Museum 1969–6–24–15, M-H 111

The coin shown here, a silver piece of Nezana, adds to the problem of Nezana-Nezool noted in the following entry. The king is depicted wearing the headcloth and surrounded by the legend *Nezana Ba[sileus?].* But above his head, in the place usually reserved for the cross at this period and thus in a position of some significance on the flan, is a Geez monogram, in which the letters *NZWL* can be discerned. These should almost certainly be read, after the name known from the gold type shown below, as Nezool. Whether the ensemble is supposed to

read King Nezana-Nezool, or King Nezana and King Nezool, is not known.

The reverse shows a cross pattée, with a gilded central boss. The legend, broken by the cross into four parts, is in the form of the motto *THEOU KHARI*. This is probably an abbreviation of the phrase *Theou Eukharistia* (By the grace of God), also used by later kings.

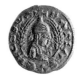

## 33  Nezool AV 1

Fifth century
Gold
18 mm
British Museum 1969–6–24–16, M-H
113–14

The study of the coins of Nezool and the closely associated Nezana (AV 1, 2, 3, AR 1, M-H 108–11) has greatly benefited from the discovery of the al-Madhariba hoard.[1] Previously all three of the known types of Nezana's gold were represented by unique examples. A closely associated anonymous type was known from two examples, while one of Nezool's two types was also unique. Now that a further seventeen coins of Nezana, including a new fourth type, have been discovered along with eight coins of a related anonymous type and forty-three coins of Nezool in the hoard of Aksumite and late Roman gold coins at al-Madhariba, considerable progress has been made.

It seems that the anonymous pieces are merely a subtype die-linked with both Nezana and Nezool, who are also linked. The same dies seem to degenerate between the anonymous issue and Nezana, on the one hand, and the issues of Nezool on the other. If these in fact represent two kings, not one ruler with alternative names, Nezool would seem to be the later.

The coins of Nezana and Nezool, together with certain issues of Ousas/Ousana (Ousanas) (cat. 34–35), all to be dated in the late fifth and early sixth centuries, temporarily abandoned the inner beaded circle. This was used on all gold issues since Ezanas, and on all subsequent coins except for one of Ioel's two gold issues (cat. 42).

1. S. C. Munro-Hay 1989(A): 96–98.

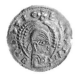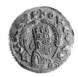

## 34–35  Ousas/Ousana (Ousanas) AV 1a, 2

Late fifth to early sixth century
Gold
17.5 mm
British Museum 1969–6–24–12
Ousana, 1989–5–18–336 Ousas, M-H
100–107

The names Ousas, Ousana, and Ousanas appear on a series of gold pieces, some with and some without the inner beaded circle which first appeared on both sides of the Ezanas Christian issues (cat. 25). Until the discovery of the al-Madhariba hoard,[1] it was very difficult to say whether these coins belonged to one, two, or even to three kings.

By this time the coins were struck on thin flans, with a gold content of about 71 to 74 percent. The quality of the die-cutting had fallen considerably, and many of the Greek letters had degenerated: *A* and *L* are often the same, as are *B*, *S*, and *E*. The general pattern of obverse tiaraed head, wheat stalks, and cross at 12 o'clock is retained, with the headcloth style on the reverse. Some types have what seem to be mint marks above the obverse head. The reverse legend is a Christian motto. *Theou Eukharistia* (By the grace of God).

Thirty-six pieces were known altogether when the present author produced his catalogue *The Coinage of Aksum* in 1984, but the thirty-five new pieces from al-Madhariba have now allowed cross-comparisons and die-linkages which seem to establish firmly enough that all the different types are very closely connected. The two Ousas types with an inner circle were found to be linked with each other, and one type was linked with the rare gold issue of Ousana, while the Ousas type without an inner circle was linked with Ousana.

In this web of connections, there are two possibilities: either Ousas is an abbreviation of Ousana (Ousanas), or, just possibly, there were two contemporary rulers called Ousas and Ousana (Ousanas). The parallel situation of the preceding rulers Nezana and Nezool can be cited, but in that instance there is not the close resemblance of names which could indicate abbreviation. Aksumite onomastics is scarcely a well-developed study, but from the number of other names ending in -ana or -anas, it does seem more likely that Ousana (Ousanas) is the royal name. It may be the same as the Geez Wazena, known from a later bronze issue (cat. 39).

Previously none of these names was represented in silver, but now a silver type with the name Ousanas is known. The present author has suggested that this was a forerunner of the Nezana silver issue,[2] but a study of the al-Madhariba hoard indicates that in fact the influence was in the other direction. Close similarities between coins of the Ousas/Ousana (Ousanas) series and those of Kaleb make it very likely that this series directly preceded Kaleb. If so, Ousana (Ousanas) may well be Kaleb's father, Tazena (Thezena, Thiezena), known from the coins and the one surviving inscription of Kaleb as well as from Geez king lists.

1. S. C. Munro-Hay 1989(A): 98–99.
2. S. C. Munro-Hay 1984(A): 104.

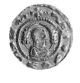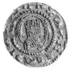

## 36–37  Kaleb AV 1d, 3d

First half of sixth century
Gold
17 mm
British Museum 1929–11–7–8, 1910–
12–7–1, M-H 117, 122

The long list of royal names from Aksumite coins is keyed into history in only two places.

The first certain identification with a known historical ruler is that of Ezanas Beesya Halen, son of Ella Amida (cats. 24 and 25). He is known not only from inscriptions, but also from a letter sent around 356 by the Roman emperor Constantius II to Aizanas and Sazanas of Aksum, cited in the writings of the patriarch Athanasius of Alexandria. The second is Kaleb Ella Atsbeha Beesya Lazen, son of Tazena.

Whereas Ezanas was apparently forgotten by Geez tradition, Kaleb was not destined to such oblivion. Ezanas was subsumed into the legendary brother kings who led Ethiopia to conversion, Ella Abreha and Atsbeha, although these names might conceal his still-unknown *Ella*- name. Kaleb, whose name is preserved correctly by Geez and Syriac writings, was also known throughout the Christian Orient under distorted forms of his *Ella*- name (Hellesthaeus, Elesbaan et al.) as the hero of Aksum's greatest foreign adventure, the conquest of the Yemen from the Jewish king of Himyar, Yusuf Asar Yathar, around 519/20. While it was fairly obvious that the tales subsumed under these names belonged to the same period, the conclusive proof that Kaleb and Hellesthaeus et al. were identical had to await the publication of an inscription which gave the king's full titulary.

Kaleb minted a larger number of gold issues than any other king of Aksum, although most are merely subtypes with variations deriving from die-cutters' individual tastes or errors. It may be that the need to pay for the Himyarite war was one cause of this increased minting of gold. The gold content averages 71 percent.

What may be the earliest type (AV 2, M-H 118) closely resembles coins of Ousas/Ousana (Ousanas), with the motto *Theou Eukharistia* (By the grace of God). It employs, in common with another type (AV 1, M-H 116), the monogram *KLB* at 12 o'clock on the obverse, reminiscent of the use of monograms on Wazeba's gold and Nezana's silver.

The other type, in numerous variants without the monogram, including the one shown here, employs the reverse legend *UIOS THEZENA* (Son of Tazena), a filiation confirmed by Kaleb's inscription. The Geez hagiographies and king lists also preserve the name Tazena as that of Kaleb's father. The coinage, however, does not. We can only presume that if Tazena really was a king, he is represented in the series under another name. The most probable is Ousas/Ousana (Ousanas) (cat. 34–35). Just possibly, this insistence on the filiation conceals a palace revolution, and a need to assert legitimacy, but Ezanas also used his filiation in inscriptions, although never on coins.

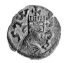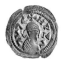

## 38    Kaleb AR I

First half of sixth century
Silver
14 mm
British Museum 1969–6–24–9, M-H 125

The silver issue of Kaleb exhibits no complex crosses or other imagery, merely the two types of royal bust with the tiara and the headcloth. It does, however, include the royal monogram, as on some of the gold issues noted in entry 36–37, and a motto in Geez, "May this please the city," which may be a translation into the local language of the Greek motto "May this please the country" used on the earlier anonymous bronzes. This is perhaps rendered more probable by the fact that Kaleb's very rare bronze pieces bear this Greek motto. These bronzes are exactly the same as the second of the two anonymous bronze series noted in entry 26, except for the replacement of the word *BAKHASA* with the name Kaleb in Greek.

After Kaleb, Aksumite power apparently began to decline. His famous expedition resulting in the conquest of the Yemen and the installation of a viceroy, Sumuyafa Ashwa, was seemingly the zenith of Aksumite hegemony. The military coup which installed Abreha in the Yemen against Kaleb's wishes around 525 perhaps signaled the beginning of the end. Kaleb may have had a co-ruler, since an inscription of Sumuyafa uses the plural, referring to himself as viceroy for "the najashis of Habashat," and a gold coin of Kaleb is die-linked with one of Allamidas. However, it seems that none of his successors could venture to conquer overseas.

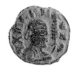

## 39    Wazena AE I

Sixth century
Bronze
16.5 mm
British Museum 1989–5–18–409, M-H 140–1

A suggestion that the Allamidas (Ella Amida) whose coins are die-linked with Kaleb's presumed last gold issue is identical with the Wazena who issued coins in silver and bronze may help to put some order into the very complicated chronology of the later Aksumite kings.[1] None of them are otherwise known to history. The coinage is the only indication we have of their existence, until archeology can piece together more of the Aksumite legacy.

Wazena issued a great many bronze coins, with a number of small variations in legend and with different mint marks which are closely allied to those of Ioel (cat. 43). On the obverse, the king appears wearing the headcloth and holding a stalk of wheat or barley sometimes topped with a cross. Whether this is an item of regalia, some sort of scepter, or is supposed to represent a real grain stalk, is not known. Around the rim of the coin runs a Geez legend, broken by the grain stalk. It has been interpreted to read "He who is fitting for the people," but like the Geez legend on Kaleb's silver issue (cat. 38), it could be a translation into Geez of the familiar Greek phrase "May this please the country" used on so many earlier issues, the last time by Kaleb on his very rare bronzes.

If Ella Amida, whose coins are die-linked to those of Kaleb, was really his co-regent, a system which might have been adopted since Kaleb was away from Aksum during the Himyar war, such a parallel would be logical. Conceivably, too, this co-regency might explain the pattern of the metals: Kaleb's abundant gold contrasting to the rare Allamidas pieces, and Kaleb's rare bronzes contrasting with the common Wazena type. On the other hand, of course, Kaleb may have allowed the second of the very common

anonymous types to continue to serve him instead of issuing much bronze.

The reverse of Wazena's bronzes depicts a cross, including motifs from those on the silver coins of Ebana and Nezana (cats. 31 and 32). From a central voided and gold-inlaid area, the four main arms of the cross emerge to terminate at the edge of the coin in further small crosses. This main cross-crosslet also has smaller hammer-headed intermediary arms. The legend, broken by the cross-crosslet into four pairs of letters, reads *ZWZN ZNGS*, which may mean either "Of Wazena, of the King" or "Of the King, Za-Wazen."

One uncertain element is the shape of the fillet-tie on the Wazena bronzes. It is always represented as an oval, in sharp contrast to the "tail"-like style of later kings such as Ioel, Hataz, Gersem, and Armah. It remains possible that Wazena's coins belong elsewhere in the series, perhaps even supplying the still-missing bronze of Ousas/Ousana (Ousanas); but there are problems with this placing too,[2] and the position after Kaleb seems most likely.

The similarity between the reverse of a coin of Offa of Mercia and types of Ebana and Hataz has been noted in entry 31. There is also a type of Offa's silver which uses, on the obverse, a cross-crosslet design precisely paralleling that used by Wazena.

1. S. C. Munro-Hay 1984(B): 117–18.
2. See S. C. Munro-Hay 1984(B) for a full discussion.

## 40 Ella Gabaz AV 1

Sixth century
Gold
18 mm
British Museum 1929–11–7–10, M-H 131

The coins of Ella Gabaz employ the *Ella*-name of a king whose other names remain unknown, although it is possible to make

suggestions from the available numismatic and inscriptional material.[1]

The royal name, or rather epithet, means something like "He of the *Gabaz*," a word used for a sacred structure, perhaps even referring to the *Gabaza Aksum*, a title of the cathedral of Mary of Zion in Aksum. In his sole surviving inscription, Kaleb refers to his conquests and then says, "I built his *Gabaz*," alluding perhaps to a church in Himyar, or possibly to restoration work at the cathedral of Aksum on his return from Arabia.

The coins of Ella Gabaz have his name written in Greek letters, with the additional two letters *NG*, which seem to be an abbreviation of the word *negus* (king). If this interpretation is correct, it is the only occasion when Greek letters are used to spell the word on the Aksumite coinage. All other later Aksumite coins write the word "king" in Greek, although incorrectly and in abbreviated form.

Otherwise, the coins of Ella Gabaz resemble the rest of the later gold of Ioel, Israel, "Iathlia" (Hataz), and Gersem.

1. S. C. Munro-Hay 1984(B).

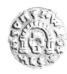

## 41 Za-ya Abiyo la-Madkhen Negus AR 2

Sixth century
Silver
16.5 mm
British Museum, 1969–6–2–21, M-H 142–44

This designation is not a royal name, but a religious motto apparently meaning "The King who exalts the Savior." There is still considerable confusion about the three silver types which bear this motto, but the present author has made an attempt to attribute them.[1]

The first type is designated "anonymous," since it bears no further hint as to the name of its issuer, the obverse legend simply reading

"King of Aksum." A second type carries a monogram consisting of the three letters *AGD*; just possibly, they might stand for Ella Gabaz, a king known from a gold issue (cat. 40). The words "King of Aksum" also appear on this issue. The third type has the obverse legend *Negus Wazena*, which seems to ally this silver issue with the bronze of Wazena described in entry 39.

Although there are differences in style between the first two and the last, the coins are closely allied in general appearance. On the obverse is a facing bust of the king wearing a low, sometimes arcaded, crown. There are several varieties of this, but all are inlaid with gold. The head of the king is flanked by the pendilia-like appendages also found on coins of Ioel and other late Aksumite kings.

The reverse is quite new in the Aksumite numismatic repertoire, and foreshadows a design later used frequently in manuscript paintings. A central cross, voided and inlaid with gold, is enclosed by an arch. The supporting columns of the arch are double, with bases and capitals, while the arch itself is shown as a series of blocks. On exceptionally well cut dies, these blocks are shaped rather like skittles, narrowing toward the top and terminating with a bulbous end (illus. below). This is a feature of arches depicted in Ethiopian manuscript paintings.

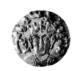
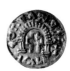

Around the outside edge of the coin appears the legend. On rare occasions some vocalization appears on the letters, which is very unusual in the Aksumite series. Such vocalization is always partial, never complete.

The interpretation of the reverse design is difficult, but the mention of the Savior in the legend would seem to suggest that a scene in Jerusalem, a frequent place of pilgrimage for Ethiopians, is not unlikely. The Church of the Holy Sepulcher would be one possibility. On silver pieces of Armah (cat. 50), the three crosses naturally suggest Calvary, and this design might represent an amalgamation of both places. As Jerusalem fell to the Persians in 614, it might be possible that the event and

its aftermath have some connection with these Aksumite issues.

1. S. C. Munro-Hay 1984(B).

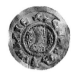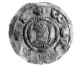

## 42   Ioel AV 1

Mid- to late sixth century (?)
Gold
17 mm
British Museum 1921–3–16–2, M-H 133

Ioel issued a substantial coinage: two types of gold, two of silver, and four of bronze, two of which may simply be the silver struck on bronze flans. His issues show some imagination in the design, with certain features which might indicate Byzantine inspiration.

The gold of Ioel, except for the omission of the beaded inner circle on the second type, may be taken as a specimen for later Aksumite gold coinage. The gold coins of the king Israel are in fact by far the most common, since the Italian archeologist Paribeni found a pot at the Aksumite port of Adulis containing thirty-two pieces. These were later stolen from the Museo Africano in Rome, and have reappeared in many auctions.

The chief characteristics remain the same as with the earlier gold, but the royal busts inside the inner beaded circles on both obverse and reverse are very sketchy, and the wheat stalks are drawn in a cursory manner. On the obverse, a cross at 12 o'clock begins the legend, an abbreviated form of "King of the Aksumites": *BASILI AKSOMI*. The reverse bears the name of the king, divided into four sections by four crosses. In the case of Ioel, these four sections are composed of a single letter each.

Generally similar issues are known for Ella Gabaz, Israel, "Iathlia" or Hataz (see under cat. 46), and Gersem. Measured gold content for these coins ranges between 56 and 71 percent, but optical inspection of a gold coin

of Israel in Berlin, and two of "Iathlia" in Addis Ababa, all of which have a very silvery aspect, lead one to conclude that some coins might be even more debased than these readings suggest. It is difficult to believe that such debased gold coins were issued for anything other than prestige, since they cannot have been acceptable as gold pieces.

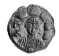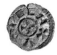

## 43   Ioel AR 1

Mid- to late sixth century (?)
Silver
12.5 mm
British Museum 1968–4–1–6, M-H 134

The silver type of Ioel shown here is unusual in that it is the only bilingual coin in the Aksumite series, since the Wazeba/Ousanas type (cat. 20) was produced by combining dies of other types already in use.

The obverse design depicts the king frontally, wearing a sort of cap with a cross on it above the forehead. This may be a frontal view of the headcloth. There are two small pendants at each side, possibly depicting ears or perhaps pendilia in the Byzantine fashion. Certain small symbols, perhaps mint marks, appear at different places on the obverse: crescent, cross, circle, or three dots. The legend, in Geez, reads "King Iyoel."

The reverse of this silver type of Ioel displays a small cross in a circle, with a gold-inlaid center. Around this are the Greek letters *ARESEKHU*, possibly standing for *arese Khristou* (By the grace of Christ).

A resemblance of style has been noted with coins issued by the Byzantine emperor Maurice around 582–92, which might help to set an approximate date for Ioel's reign. After Kaleb, Aksum may have been in decline, another severe blow coming in the 570s when the Persians seized the Yemen from Abreha's dynasty, which at least paid tribute to Aksum, and expanded to the Red Sea. However, Aksum remained part of the international world. Trade doubtless continued along the old routes, even if it was

curtailed by Persian expansion. The metropolitan bishops and their entourages, traditionally Alexandrian appointees, also seem to have continued to travel south; the coins with their Christian symbolism and mottoes indicate that the Church remained intact.

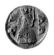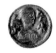

Ioel also issued another silver type (AR 2, M-H 135) which was similar to one of Gersem's silver types (cat. 48). An example is illustrated here (above) to show the vocalization in the word *negus* on the reverse.

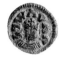

## 44   Ioel AE 3

Mid- to late sixth century (?)
Bronze
14 mm
British Museum 1989–5–18–399, M-H 138

This bronze issue of Ioel shows another frontal view of the king, this time wearing a low crown decorated with a central cross, and the same pendilia flanking the head as on the silver type noted in the previous entry. Small symbols resembling those on the silver, perhaps batching marks, occur at different places in the field. The legend reads *Negus Iyoel* (King Ioel).

The reverse is unusual for Aksumite pieces, being based not on the customary Greek style of equal-armed cross, but on the Latin cross, with a longer stem. This stands in the center of the field, surrounded by the motto "Christ is with us."

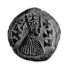

## 45   Ioel AE 1

Mid- to late sixth century (?)
Bronze
14.5 mm
British Museum 1989–5–18–363, M-H
136

Another of Ioel's bronze issues depicts a profile bust of the king wearing a crown, with the legend *negus* (king), on the obverse. The reverse bears a Greek cross, sometimes with a central boss, with the four letters making up the name of the king interspersed between the arms of the cross.

## 46   Hataz AR 1

Late sixth century (?)
Silver
17 mm
British Museum 1989–5–18–500, M-H
157

Since the earlier work of Arturo Anzani on Aksumite coins,[1] it has been customary to place the issues of Hataz (sometimes divided between two kings, Hataz I and II) at the very end of the Aksumite series. However, after careful consideration of stylistic and other evidence, it seems more likely that either Gersem, who was also expanded by Anzani into Gersem I and II, or Armah really belongs in this position. The suggested identification of the gold bearing the otherwise unknown name "Iathlia" as the missing gold of Hataz, since the Ethiopian name Hataz may have been rendered as "Iathaza" or something similar in Greek, has removed one of the main points for assigning Hataz a very late date. It was supposed, plausibly enough, that the king who had

abandoned the issuing of gold was likely to come after those who still minted it. Armah, on the other hand, still has no gold attributed to him, although his bronze and silver are relatively common.[2]

If the identification of the Iathlia gold type as an issue of Hataz is accepted, Hataz issued one gold, two silver, and three bronze types, two of the bronze differing in no way from the silver except for the metal. The other bronze type is described in the following entry.

The silver type of Hataz shown here displays a frontal crowned bust of the king on the obverse, with the name King Hataz. The king holds a hand-cross in front of his chest. On the reverse is a large cross-crosslet very similar to that of Ebana's silver (cat. 31), with a central lozenge forming a frame for a smaller Greek style cross inside. The legend, interspersed between the cross-crosslet arms just as for Ebana, reads "Mercy to the people," as does the legend on the extremely rare bronze coins of the king Israel (AE 1, M-H 150).

1. A. Anzani 1926.
2. For a general discussion of the position of the later Aksumite kings in the sequence, see S. C. Munro-Hay 1984(B).

## 47   Hataz AE 1

Late sixth century (?)
Bronze
17.5 mm
British Museum 1989–5–18–502, M-H
160

This bronze issue of Hataz has a remarkably elegant design, although very few perfect specimens survive, and it was this which made Anzani speculate that there had been two kings called Hataz.[1] The Hataz who coined this issue would, according to his typology, have been the earlier of the two, Hataz I.

The obverse is anepigraphic, the first such

coin since the tiny gold issue of Aphilas at the beginning of the series (cat. 17). The center of the coin is occupied by a frontal bust of Hataz, his robes depicted by horizontal lines across the chest and curving vertical lines on the shoulders. The king wears a cap-like crown, surmounted by a cross at the top of the coin. The crown has a band across the forehead containing three arches, each enclosing a dot. Two pendilia emerge from the edges of this band, a fact which makes it more likely that these appendages are pendants rather than ears, since the latter would emerge below the crown rather than from it. The royal bust is flanked by two wheat stalks, and from their stems arise two staves supporting crosses beside the king's shoulders.

The reverse depicts a Greek cross within an octagonal frame, surrounded by the legend "Hataz, King of Aksum."

1. A. Anzani 1926.

## 48   Gersem AR 1

Late sixth to early seventh century (?)
Silver
17 mm
British Museum 1989–5–18–492, M-H
154

Although Armah is often placed before Gersem in chronological tables, there is no real certainty about their relative positions in the sequence of coin-issuing Aksumite kings.

The later Aksumite kings Ioel, Hataz, and Gersem all share an iconographically simple type of silver, repeated in Hataz's and Gersem's case in bronze. There is no motto, and no features other than the royal busts or perhaps a small symbol which might be a mint mark.

The silver issue of Gersem, on a thin flan of very debased metal, shows little skill in the preparation of the dies. On the obverse is a more or less rudimentary half-length bust of the king wearing a crown consisting of four

spikes topped with dots, with three intermediate dots representing jewels or some other decoration. The pleats of the robe are shown by wave-like curved lines. The king's arm is shown, and he holds a hand-cross in front of his chest. The letters *GR SM* appear in two groups on either side of the bust, indicating the name Gersem.

The reverse is almost exactly the same, except that the king wears the headcloth, depicted in an extremely vestigial fashion. As in the case of most of the rulers after Kaleb, the ribbon or knot at the rear of the crown and the headcloth are shown as a simple streamer, instead of the closed oval of earlier times. The oval had itself succeeded a triangular form used until about the time of Eon Bisi Anaaph. The legend reads *NG S* (king), and occasionally some of the letters may be vocalized. In the field on both faces there may be a small disc and crescent, or a dot or circle.

## 49  Gersem AE 1

> Late sixth to early seventh century (?)
> Bronze
> 16 mm
> British Museum 1989-5-18-496, M-H
> 155

The most common bronze of Gersem seems to be derived directly from a type used by Hataz for one of his silver and one of his bronze issues. Like the coins of Hataz, it also resembles Byzantine types.

On the obverse is a facing bust of the king, wearing a crown consisting of five spikes with dots in the four intermediate spaces. Pendilia hang beside the face. The king sometimes wears a necklace, and sometimes an arm is visible. There may be armlets on his upper right arm, which is folded in front of his chest, the hand occasionally holding a cross on his left side. Another cross appears on the right to balance it. On some dies, the folds of the robes, and the general shape of the body with the two flanking crosses, are very reminiscent of the bronze type of Hataz (cat. 47). The legend reads *Negus Gersem*.

The reverse seems to be derived directly from the very rare bronze issue of the king Israel,[1] and is not unlike some of Hataz's pieces (cat. 46). There is a central Greek cross,

contained in a diamond-shaped frame composed of dots, with larger dots at three of the points of the diamond, the fourth meeting the cross represented by the letter *t* of the word *Krestos* (Christ) in the Geez legend "He conquers through Christ."

> 1. S. C. Munro-Hay 1984(A): 150.

## 50  Armah AR 1

> Late sixth to early seventh century
> Silver
> 16 mm
> British Museum 1989-5-18-430, M-H
> 146

A rather similar design to the coins of Za-ya Abiyo la-Madkhen Negus (cat. 41) occurs on the silver issue of Armah. On the obverse, the king is depicted wearing a crown and holding a hand-cross, a pose which appears frequently on the later silver, and on the second anonymous bronze type. There is a wheat stalk terminating with a cross behind the king, resembling the "scepter" held by Wazena on his bronzes (cat. 39). The Geez legend reads *Negus Armah*.

On the reverse, another architectural scene is depicted. Two double columns support an arch, itself crowned with a Greek cross voided and inlaid with gold. From the capitals of the columns two additional crosses on short staves emerge to flank the central cross. Under the arch is a curious key-shaped object, also voided and inlaid with gold. The legend "Mercy and peace" surrounds the design. Suggestions as to the interpretation of the design are given in entry 41.

 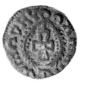

## 51  Armah AE 1a

> Late sixth to early seventh century (?)
> Bronze
> 19.5 mm
> British Museum 1989-5-18-448, M-H
> 147-48

A very common bronze coin, the largest ever produced in Aksum, was issued by Armah, whose silver has been described in the preceding entry. The flan ranges from 17mm to 22mm in diameter.

The obverse shows a unique representation of the king, full-length and seated on a high-backed throne. The king is depicted wearing a crown and an ankle-length robe. In his hand he holds a long staff topped with a cross. The Geez legend reads "King Armah." A number of symbols, conjectured to be mint control marks or batch marks, occupy various spots in the field, as already seen on coins of Wazena, Ioel, and others. Letters and marks of this kind appear erratically in the Aksumite series, some earlier gold issues of Ezanas, Ebana, and Ousana also bearing similar marks above the king's head on the obverse.

On the reverse is a cross, flanked by two barley stalks. The cross, like those on the coins of Za-ya Abiyo la-Madkhen (cat. 41), is voided in the center and inlaid with gold. It stands on a short stave which emerges from a ring, from which the wheat stalks also spring. The legend appears in two versions; on a few rare examples it reads "Joy and peace to the people," but the most common type is "Let there be joy to the people." The reverse design seems to recall the one already used more than two centuries earlier by MHDYS on his silver issue, and on the newly discovered anonymous bronze coin noted in entry 29.

It may be fanciful to speculate from such slight evidence, but there seems to be a different tone to the mottoes in this latest period of coinage. The royal and religious mottoes of the earlier series now seem to have given way to pleas for mercy, joy, and peace for the peoples of the kingdom. Possibly the powerful empire built up by the long line of kings from Gadarat and Adhebah in the early third century, augmented and maintained by Ezanas and Kaleb, was collapsing under outside pressures. The Persian conquests in Egypt, Syria, and Palestine, as well as the Yemen, must have damaged Aksumite trade. Muslim traditions state that the *Najashi* who was reigning around 615, whom they name "Ashama ibn Abjar" and who may have been Armah himself, suffered from wars and rebellions. The evidence is tenuous, but it seems that by this time the great days of Aksum were over, and that the capital was soon to be moved elsewhere.

# THE HERITAGE OF LATE ANTIQUITY

*Marilyn E. Heldman*

AFTER AKSUM'S LONG HEGEMONY during the period of late antiquity, ending in the seventh century, it seems that the Ethiopian power centers were consistently shifted ever further southward. Ethiopian rulers in the post-Aksumite period still controlled a powerful realm, but the political center was no longer at Aksum. The direct successor of Aksum may have been Kubar, a capital mentioned by Arab geographers in the ninth and tenth centuries. Its location still remains unidentified today. In the latter half of the tenth century, the Ethiopian kingdom was apparently very nearly destroyed by the Queen of the Bani al-Hamwiyya, but it recovered to last some 170 years more until the advent of the Zagwe dynasty. The Zagwe capital was at Roha or Lalibala in Lasta. The dynasty lasted from about 1137 until 1270, when a new line of kings, generally referred to as the Solomonic dynasty, seized power. These kings ruled from centers in the provinces of Amhara and Shoa.

The history of the arts in Ethiopia during this time can be conveniently divided into an early and a late Solomonic period, the former beginning in 1270 with the reign of Yekunno Amlak and continuing until the reign of Lebna Dengel (1508–40), with the year 1527 as a watershed. In this year Muslim invasions led by Ahmad Grañ of Adal caused tremendous destruction, and architecture, manuscripts, and paintings in vast numbers perished.

With the advent of the late Solomonic period, beginning with the emperor Galawdewos (1540–59), some artistic and cultural activity would have been able to resume. This period is generally held to have ended with the murder of the emperor Iyoas in 1769. The event ushered in the era called Masasint (Judges), characterized by a weak throne under the control of powerful regional lords. This state of affairs only ceased after 1855 with the reorganization of the Ethiopian monarchy under Tewodros (1855–68).

As the capital of the state that flourished in the Ethiopian highlands between the first and the seventh centuries A.D., Aksum had retained its hegemony over the Ethiopian highlands and part of the coastal strip during the period of late antiquity. Artistic traditions from this period remained viable through later centuries.

The economic and political stature of Aksum was dependent upon its role in the international trade that moved through the Red Sea, to which the port of Adulis gave it access. Although never part of the Roman Empire, the Aksumite state was the southern outpost of the Hellenized eastern Mediterranean world. Stuart Munro-Hay has demonstrated that in both its weight and its iconography the coinage of Aksum was linked to the coinage of the Roman Empire, and it therefore stands as a witness to the participation of Aksum in the sophisticated economy of the eastern Mediterranean. When the trade routes of the Red Sea shifted during the seventh century, the foundation of the Aksumite economy was shattered. The state ceased to mint coins, and Aksum itself was abandoned as the capital of the highland empire.

The decision of the Aksumite king Ezana to convert to Christianity in the early fourth century, a date traditionally believed to be 333, was an event of extraordinary significance. It marked the official beginning of integration into the wider Christian world. In later centuries,

Figs. 12 and 13 Rhinoceros (top) and ox or bull with a snake. Carved wood panels from the Church of Mary, Asmara. [Photos by M. Heldman © 1993]

even when the economy of the Aksumite empire had contracted, Ethiopians continued to belong and continued to think of themselves as belonging to this wider Christian world.

On the coins of Ezana and his successors, the Christian symbol of the cross replaced the pagan disc and crescent. Before his conversion, Ezana had styled himself in monumental inscriptions proclaiming victory over his enemies as "the son of Mahrem," identified in Aksumite Greek inscriptions with Ares, the Greek god of war. After his conversion, however, Ezana styled himself "Gabra Krestos" (the Servant of Christ).

The process by which Christianity grew from the religion of the royal house to become the religion of the Aksumite state is unknown, although the changing role of Christianity within the Roman Empire may throw some light upon the question. The Edict of Milan in 313 had given Christianity the status of *religio licita*, and thenceforth the emperor Constantine endowed it with his wealth and prestige. Both Constantine and his biographer, Eusebius of Caesarea, may have envisioned membership in the Church as constituting membership in a Christian world empire, but Christianity did not become the sole state religion until late in the fourth century, and the process of conversion continued long after. There is no reason to assume that either Frumentius, ordained by Athanasius as bishop of Aksum, or Ezana himself had conceived of Christianity in exclusive terms. However, the Aksumite king Kaleb Ella Asbeha, who reigned from about 515 to 540, is said to have gathered "his people" unto God, and this may suggest at least the intention of a national conversion.[1]

Traditions recorded in the *Book of Aksum*[2] credit this same king Kaleb Ella Asbeha with building the great metropolitan cathedral at Aksum, whose altar was dedicated to "Our Mother Zion." In its size, its plan, and its dedication, the cathedral followed the Church of Zion in Jerusalem, which had been built in 340 on Mount Zion, the traditional site of the Last Supper. A pilgrim to Jerusalem in 518 described the church as "Holy Zion, the Mother of All Churches,"[3] and the cathedral at Aksum was intended to create a new version of this holy site.[4] Ella Asbeha was also known as Kaleb,[5] a name referring to the Israelite leader who followed the Lord "with his whole heart" (Numbers 14:24–5), and while another Ethiopian tradition states that it was Ezana who built the Cathedral of Aksum, it is unlikely that either Ezana or Frumentius could have conceived of building a cathedral that was in plan or dedication a deliberate copy of the Church of Zion. It was their contemporary, Cyril of Jerusalem (351–86), who first taught that the earthly city of Jerusalem was the Holy City, and thereby created a foundation for the development of Christian pilgrimage to Jerusalem and the cult of holy sites there.

Christianity was more than a sacred text and a set of doctrines. With the adoption of the religion came many different elements, including particular literary genres, distinctive architectural forms, specific artistic traditions, and the calendar still used in Ethiopia today.

Very little Christian art from the Aksumite period survives. Excavations at the Red Sea port of Adulis have revealed the structural outlines of three oriented churches, following the plan of the basilica but constructed of typical Aksumite materials and techniques. Associated with these churches are fragments of prefabricated marble furnishings carved at one or more eastern Mediterranean quarries. These imported fragments probably date from the sixth century, and similar marble chancel panels and posts may be seen at Constantinople, Ravenna, and in early Byzantine churches in the Negev.[6]

Later Ethiopian art suggests that the sixth century was the period when specifically Christian style and iconography was introduced to Ethiopia. Much of the evidence consists of manuscripts of the Gospels, but there are other examples as well. Wooden ceiling panels from the narthex of the church at Dabra Damo and from the now demolished Church of Mary at Asmara[7] are carved with a variety of animals (figs. 12 and 13). They are part of a natural history of the terrestrial world known as "the Lord's estate," a theme typical of Byzantine art of the late

1. Getatchew Haile 1981(A): 34.
2. C. Conti Rossini 1910.
3. J. Wilkinson 1977: 5, 66.
4. M. E. Heldman 1992(A): 226–27.
5. R. Schneider 1974: 773.
6. M. E. Heldman 1988(A).
7. H. Maguire 1987.

fifth and sixth centuries.[8] The animals of these carved ceiling panels can be compared with those carved upon the ceiling beams in the nave of Justinian's church at Mount Sinai.[9]

During the reign of the Byzantine emperors Justin and his nephew Justinian (518–27), and again during the reign of Justinian alone (527–65), the court of Kaleb Ella Asbeha received embassies from Constantinople. These were motivated not only by a desire to curb Persian expansion in South Arabia, but also by Justinian's universalist theories of a world Christian empire.[10] The *Chronicle* of John Malalas records that Elesboas, as Kaleb was known in Greek texts, received luxurious gifts from the Constantinopolitan court.[11]

According to Ethiopian tradition, Kaleb retired around 540 to the Monastery of Abba Pantalewon, one of the Nine Saints, near Aksum. When he entered monastic life, he sent a delegation to Jerusalem with a crown to be hung before the door of the tomb in the church of the Holy Sepulcher.[12] His donation of this crown reveals the continuity of his devotion to the Holy City, already displayed in the dedication of the cathedral at Aksum to Mary of Zion.

The sixth century also appears to have been the period in which Ethiopia received works of art depicting the holy sites in Jerusalem. Although no such works have survived in Ethiopia, the distinctive three-miniature frontispiece of a group of fourteenth-century Ethiopian Gospel manuscripts follows the iconography of pilgrimage sites in Jerusalem known from sixth-century pilgrim ampullae.[13] Even though no Palestinian souvenir ampullae have been excavated in Ethiopia so far, the early Byzantine iconography of the holy sites may have been transmitted to Ethiopia by other media.

During the Aksumite period the Greek text of the Gospels was brought to Ethiopia and translated into Geez. Along with the Greek text came a standard method of Gospel manuscript production, as well as the Eusebian canon tables with their characteristic decoration and tholos miniature, and portraits of the evangelists. The structure of Ethiopian Gospel manuscripts produced before 1500 preserves the traditions of Late Antique book tradition. The quires of the manuscripts are, with a few exceptions, quaternions. Each of the Gospels is allotted a separate set of quires, and its initial page is copied upon the first recto leaf of a quaternion. Greek Gospel manuscripts from this period are typically composed of an initial quire or quires with prefaces and canon tables, and this arrangement is also characteristic of Ethiopian manuscripts produced before 1500. Late Antique techniques of book production, possibly introduced by the sixth century, remained a living tradition in Ethiopian monastic scriptoria, passing from one generation to the next. By the end of the fifteenth century, this had been supplanted by innovations in Gospel illumination and by the simplification of the canon tables. The canon table scheme of Ethiopian Gospel books with their decoration of animals and plants provides the most persuasive argument for exchanges with an eastern Mediterranean center of Gospel book production and illumination during the sixth century. The exchange was probably in the form of illuminated Greek Gospels, and perhaps even of prefabricated canon table frames.

Canon tables are sets of numbers that indicate parallel passages in the various Gospels. The first table lists the agreements between all four Gospels, the second table the agreements between Matthew, Mark, and Luke. The following tables exhibit various other combinations, until the tenth and final table, which comprises a list of passages which appear in only one Gospel. The entire scheme is the invention of Eusebius of Caesarea, and includes a prologue in the form of a letter from him describing how the tables were to be used. The prologue and the tables were both presented in a series of architectural frames decorated with animals and plants.

The reconstructed scheme of canon tables in early Greek Gospels consists of two pages of prologue and eight pages of canon tables, or three pages of prologue and seven pages of canon tables, with a final miniature of a circular temple or tholos. In the mid-tenth century the canon tables of Greek manuscripts were extended to ten pages. The canon tables of virtually all Ethiopian Gospel manuscripts copied before 1500 follow the early Greek scheme.

8. D. Krencker 1913: 182–98; F. Anfray 1965(B): 13–14.
9. G. H. Forsyth and K. Weitzmann 1973.
10. W.H.C. Frend 1970: 11.
11. E. Jeffreys, M. Jeffreys, and R. Scott 1986: 269.
12. J. Wilkinson 1977: 83, quoting the account of the *Acta Sanctorum*.
13. A. Grabar 1958.

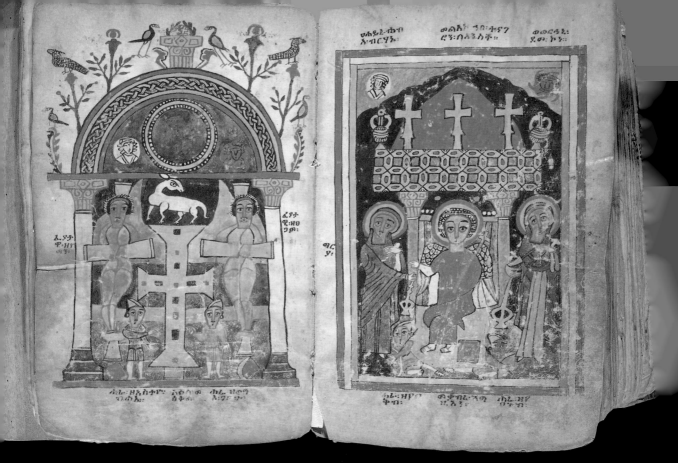

Cat. 54. Four Gospels, ff. 10v–11r: the Crucifixion and the Holy Women at the Tomb

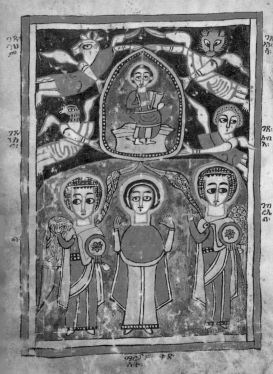

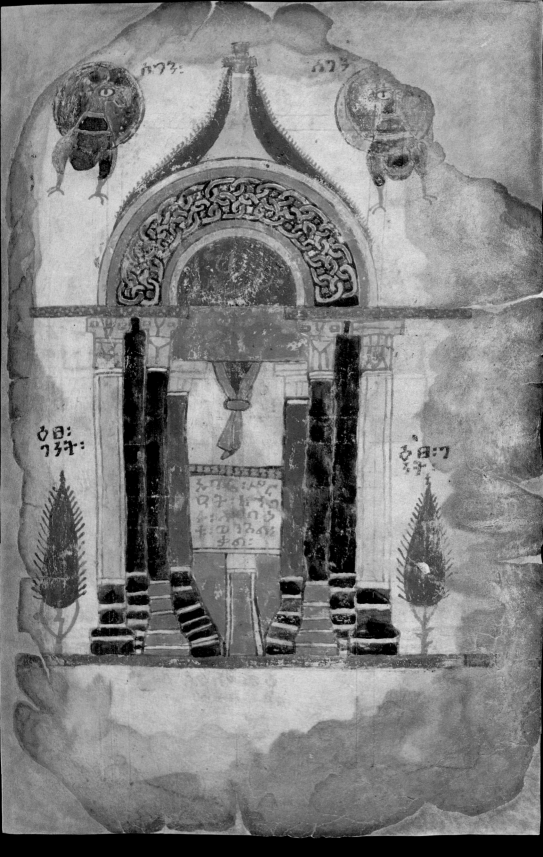

Cat. 55 Four Gospels (fragment): tholos

Cat. 55 Four Gospels (fragment): Saint Matthew

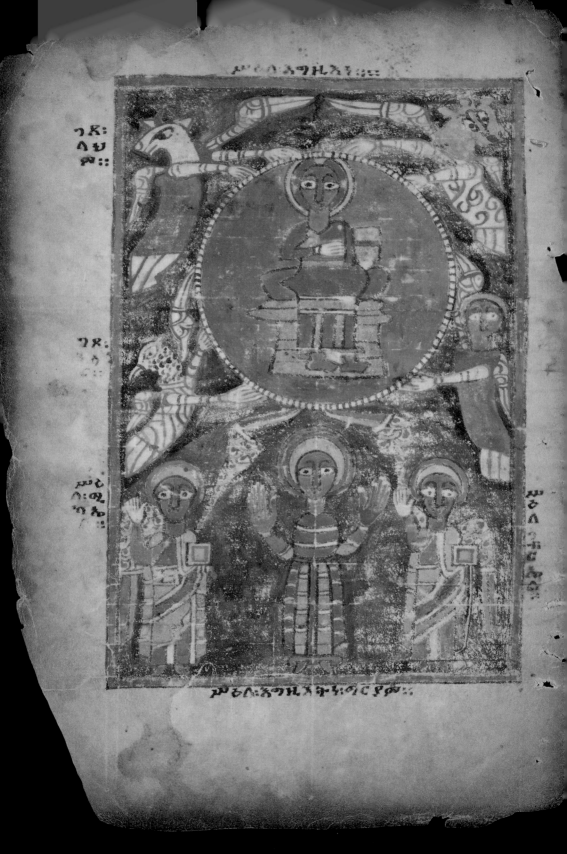

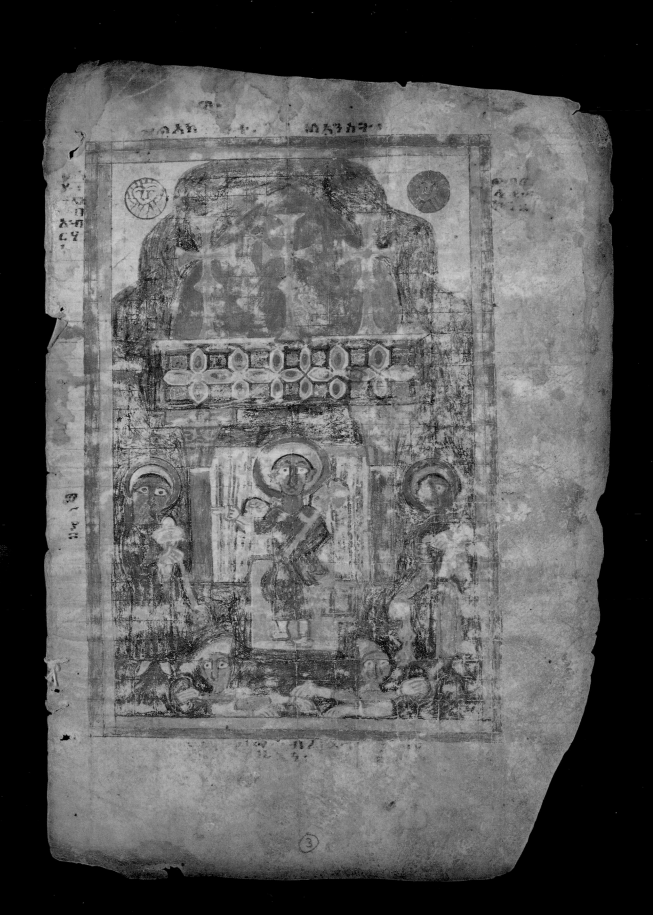

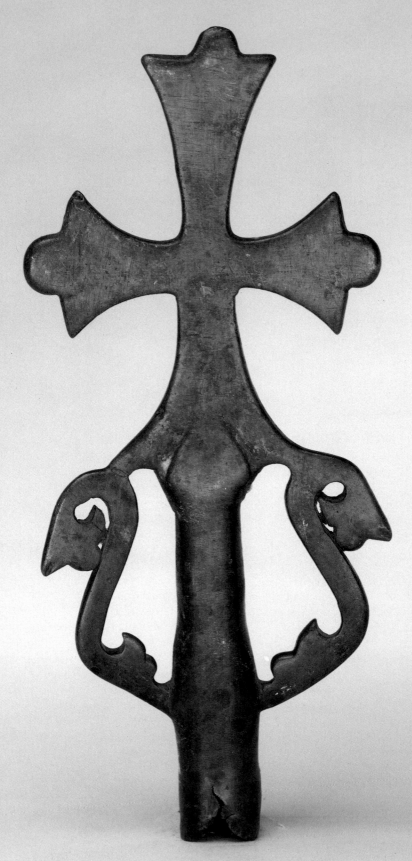

Cat. 58 Processional Cross

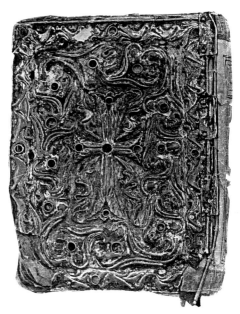

Cat. 52 Metal cover. [Photo by Donald Davies © 1993]

## 52 Abba Garima Gospels I

Provenance unknown, before 1270
Parchment, metal end covers
$13\frac{3}{8} \times 8\frac{11}{16}$ in. (34 × 22 cm), 174 ff.
Monastery of Abba Garima, Tegre

According to tradition, the monastery from which this manuscript takes its name was founded by Isaac, also known as Abba Garima, one of the Nine Saints who came to Ethiopia from the Roman Empire in the late fifth century. Monks of Abba Garima's monastery reported to Donald Davies that Abba Garima himself had copied this manuscript, and that he had completed the task in a single day. God stopped the sun's course one afternoon so that Abba Garima could finish copying his Gospels before night fell.[1]

A more explicit history of the present manuscript can be reconstructed only by analyzing the letter forms, the text, and the style of the decorated pages. The text folios are in relatively good condition, but the folios containing the evangelist portrait and the canon tables are stained and their edges worn. The conjoint folios of the canon tables, separated by wear at the gutter, have been rearranged incorrectly. Patterns of wear as well as stains along what are now the outer

edges of the folios suggest that the separation along the gutter and the subsequent disorder occurred long ago.

While detailed arguments to support the conclusion are too lengthy to be presented here, an analysis of style and comparisons with the canon tables of Greek and Armenian Gospel manuscripts suggest that the canon table frames and the evangelist portrait of Abba Garima Gospels I may have been created as early as the sixth century. The date of the Gospel text, which appears to have been created after the canon table frames were painted, is uncertain.[2] It may be that the Gospel manuscripts to which the folios with the canon tables and the evangelist portrait were joined became so worn that they were replaced with a newly copied manuscript to which were added the worn but precious decorated folios.

The present manuscript and a second volume at the Monastery of Abba Garima, in which Abba Garima Gospels II and III are bound together, share two disassembled sets of decorated canon tables and two incomplete sets of evangelist portraits. Most of the canon tables, which are disordered, are bound within the present manuscript.

The remainder of our discussion will focus upon the two fragmentary sets of decorated canon table folios. One set of decorated canon tables originally consisted of three pages of Eusebian prologue and seven pages of richly embellished architectural frames. The arch of the frames rests upon rather short, wide columns, and their curtains have parted to reveal the sacred numbers of parallel Gospel passages.[3] A second set of decorated canon tables originally consisted of two pages of Eusebian prologue and eight pages of architectural frames with slender, tapered columns and bell-shaped capitals.

The frames of both sets of tables display Corinthian capitals and marble columns as well as Late Antique ornamental motifs. The upper portion of each folio is filled with flora and an extraordinary variety of birds, including a strutting rooster, a crane, and a guinea fowl. It is very likely that a pattern book, the sources of which derived from classical scientific illustration,[4] was used to make the paintings, and the frames are undoubtedly the work of a painter who was conversant with the traditions of Early Byzantine Gospel decoration.

The metal covers, one of which is fragmentary, are decorated with the Cross in a field of leaves, "the Tree of Life in the midst of the garden" (Genesis 2:9).[5]

1. Conversation between the author and Donald Davies, 1986.
2. S. Uhlig 1988: 144–75; R. Zuurmond 1989, pt. 1, 45–51.
3. For parted curtains as a sign of revelation, see E. H. Kantorowicz 1963: 160.
4. K. Weitzmann 1977, pl. 20.
5. E. Kitzinger 1974: 7–8.

SELECTED REFERENCES
Leroy, J. 1960.
Leroy, J. 1968.
Macomber, W. F. 1979: 1–4.

## 53 Abba Garima Gospels II and III

Provenance unknown, before 1270
Parchment, metal covers
259 + 161 ff.
Monastery of Abba Garima, Tegre

Abba Garima Gospels II, which is currently bound together with Abba Garima Gospels III, has no evangelist portraits, and its decorated canon tables are of indifferent quality.[1] The leaves of both manuscripts are in disorder, and there are lacunae in the text. Like Abba Garima Gospels I (cat. 52), Abba Garima Gospels III may have served as a replacement text for an earlier Gospel manuscript that was discarded owing to wear. Our discussion will focus upon the evangelist portraits and the architectural miniatures in Abba Garima Gospels III.[2]

While a single, uninscribed portrait is bound into Abba Garima Gospels I, four evangelist portraits are bound into Abba Garima Gospels III. One of the standing evangelists can be identified as Saint Matthew, because the last part of the Gospel preface (Gessawe serat) is written on the recto of the miniature. One evangelist is seated before a fish-shaped lectern; he can be identified as Mark, because the recto side of this folio bears the last lines of the Gospel of Matthew. The remaining two evangelist portraits cannot be clearly identified; their inscriptions are of a later date, and are not necessarily reliable. It is possible that the five

portraits are the sole surviving miniatures of two sets of evangelist portraits. Another possibility is that the four evangelist portraits constitute a complete set and that the fifth standing figure is a donor portrait.

A sixth-century date is suggested for the portraits, which appear to have been produced at the same time and place as the decorated canon table frames in the present volume and in Abba Garima Gospels I. The borders of the portraits' frames are filled with Late Antique decorative motifs like those that embellish the canon table frames. The short, high-waisted figures stand full-face, like the evangelists carved in relief on the sixth-century throne reliquary preserved at San Marco in Venice.[3] The square, solemn faces of the evangelists can be compared with the portrait medallions in the apse mosaic of the emperor Justinian's church at the Sinai monastery, which is datable to the period 548–565.[4]

Bound into Abba Garima Gospels III are two full-page miniatures with architectural compositions, one of which, a circular structure known as a tholos, served as the concluding page or finispiece of the set of decorated canon tables.[5] (Only in Ethiopian Gospel decoration did the tholos remain a familiar thematic element through the fifteenth century). The motif of the tholos with a conical roof supported by four marble columns symbolizes the harmony of the four Gospel texts, which is demonstrated by the numbered sections in the canon tables that provide a concordance of parallel passages.[6] The columns represent the four Gospels, and the circle, with no beginning and no end, expresses their unity.

A miniature painted with a rectangular structure originally completed the second set of canon tables. Resting upon a podium, the structure is reached by a monumental staircase and is flanked by harts, surely a reference to Psalm 42:1: "As a hart longs for running streams, so do I long for Thee, O God." This unique composition may represent the life-giving power of the Gospels and the Church. The grand staircase, often used in symbolic depictions of the Temple in early Christian art, may suggest the fulfillment of prophecies concerning the Temple.

1. R. Zuurmond 1989, pt. 2: 50–53.
2. Ibid.: 48–50.

3. New York 1984: 98–105.
4. G. H. Forsyth and K. Weitzmann [1973], pls. 157, 160, and 161.
5. C. Nordenfalk 1938: 102–8.
6. C. Nordenfalk 1982: 36.

SELECTED REFERENCES
Leroy, J. 1960.
Leroy, J. 1968.
Macomber, W. F. 1979: 5–11.

## 54   Four Gospels

Northern Ethiopia, early fourteenth
    century
Parchment, new wood end boards
$11\frac{1}{8} \times 7\frac{5}{16}$ in. (28.2 × 18.5 cm),
    232 + 2 ff.
Dabra Maar, Tegre

One of a family of Gospel books produced at a monastery in northern Ethiopia in the fourteenth century (cats. 55 and 56), this manuscript is particularly well preserved. Each manuscript in the group is decorated with a frontispiece of three miniatures, the imagery of which was inspired by the Early Byzantine cult of holy places in Jerusalem. It is likely that the prototype of this frontispiece was introduced to Ethiopian Gospel decoration during the sixth century.

The miniature that represents the Crucifixion does not depict the crucified body of Christ. Instead, the image of the Lamb of God (John 1:29) is placed above a jeweled Cross, the symbol of Christ's victory over death. The jeweled Cross that was erected in the chapel of Golgotha, the site of the Crucifixion, marked the site of His triumph.

The miniature of the Holy Women at the Tomb, a pictorial synonym for the Resurrection of Christ, follows the Gospel account of Saint Matthew (28:1–7). As the two Marys came to the tomb bearing ointments with which to anoint the body of Christ, an angel descended, removed the stone at the door of the tomb, and sat down. The soldiers who were guarding the tomb fell as if dead. The angel told the women that the body of Christ was not in the tomb. This miniature not only illustrates the Gospel account but also represents the domed rotunda of the Holy Sepulcher in Jerusalem. The red square by the feet of the angel is the stone from the door of the tomb, a relic

venerated by pilgrims who came to visit the tomb of Christ within the rotunda of the Holy Sepulcher.[1]

The third miniature is an abbreviated version of the Ascension. The apostles who witnessed the Ascension (Acts 1:9–11) are not depicted, leaving only Christ in majesty above the orant figure of His mother, Mary. The two angels of the New Testament narrative, here inscribed "Mikael" and "Gabriel," arch their wings above the head of Mary, suggesting the association between Mary and the Holy of Holies of the Temple as well as its prophetic fulfillment in the Church.

The scribal colophon (f. 230v) refers to the Year of Mercy 525, which occurred during the reign of Amda Seyon (1314–44), and names the Monastery of Dabra Maara Makan, another form of the name by which the monastery is now known.

MINIATURES   Eusebian prologue, ff. 5r–6r; canon tables, ff. 6v–9v; tholos, f. 10r; Crucifixion, f. 10v; Holy Women at the Tomb, f. 11r; Ascension, f. 11v; Saint Matthew, f. 14v; Saint Mark, f. 76v; Saint Luke, f. 114v; Saint John, f. 178v.

1. J. Wilkinson 1977: 60, 96.

SELECTED REFERENCES
Heldman, M. E. 1979.
Lepage, C. 1987.

## 55   Four Gospels (fragment)

Northern Ethiopia, fourteenth century
Parchment
$11\frac{5}{8} \times 7\frac{1}{2}$ in. (29.5 × 19 cm)
Institute of Ethiopian Studies, no.
    3475a–b

Two leaves of two bifolia have been detached from a manuscript of the Gospels in the library of the Church of Mary of Zion at Lake Zeway.[1] The leaf with the tholos on the recto followed the canon tables, and the Crucifixion on the verso of the leaf was the first miniature of the multiple frontispiece, which probably consisted of three miniatures: the Crucifixion, the Holy Women at the Tomb, signifying the Resurrection, and the Ascension.[2]

The second leaf, with a miniature of Saint

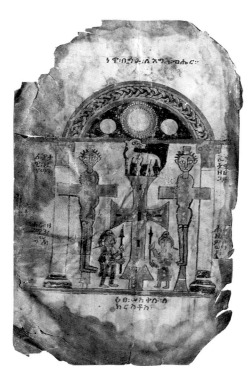

Cat. 55 Four Gospels: the Crucifixion.
[Photo by M. Heldman © 1993]

Matthew on the verso, introduced the Gospel of Saint Matthew; its recto carries a brief note of dedication. The dedication names Abba Filpos of Dabra Mahfad, a monastery that appears to have been located in northern Ethiopia.[3] It seems likely that the Gospel manuscript to which this fragment belongs was one of the many objects carried to Lake Zeway for safekeeping during the Muslim invasion of highland Christian Ethiopia in the 1530s.

In style and iconography, this miniature of the Crucifixion resembles the one in the Gospel fragment in the Nationalmuseum in Stockholm (cat. 56); the latter originally had a three-miniature frontispiece depicting the Crucifixion, the Resurrection, and the Ascension.[4] The Dabra Maar Gospels (cat. 54) and the Gospels of Sayfa Arad[5] also follow this frontispiece program.[6]

Both the tholos composition[7] and the miniature of the Crucifixion reflect the Early Byzantine heritage of Ethiopian art. The inscription of the tholos, "Order of the canons, the way the Four Gospels agree with their verses," notes the purpose of the canon tables, whose numbered sections refer to parallel passages of the Gospel texts. In contrast to the tholos of four columns in

Abba Garima Gospels III, this tholos with six or eight columns presents a variant upon the archetypal form. The prototype, an eight-column tholos that can be found in Carolingian Gospels, apparently was developed for a Greek manuscript. However, the symbolism of the tholos remains unchanged, because the number eight also signified the idea of harmony, or agreement.[8]

The cypress trees that flank the tholos are inscribed "tree of the Garden," that is, Paradise. Each representation of the peacock is inscribed "ostrich" (*sagan*). In Ethiopia, the ostrich was a royal bird, as was the peacock in Byzantium.

The miniature of the Crucifixion reflects the description of the events in the Gospel texts. It depicts the two thieves, inscribed "Thief of the right side" and "Thief of the left side," and the two soldiers, inscribed "Soldier of the right side" and "Soldier of the left side." The artist did not distinguish the soldier who bore the spear from the one who administered vinegar by means of a sponge in the Gospel narrative, and indeed the miniature is essentially symbolic. Most dramatic is the depiction of Christ as the Lamb of God, inscribed "Behold the Lamb of God" (John 1:29), above the Cross, a jeweled Cross like the one erected in the chapel of Golgotha at the Church of the Holy Sepulcher in Jerusalem.[9]

The present miniature can also be compared with depictions of the Crucifixion on ampullae from the sixth and early seventh centuries, in which pilgrims took home sanctified oil from Jerusalem's holy places. These show a bust of Christ above the Cross.[10] Indeed, the iconography of the three-miniature frontispiece with the Crucifixion, the Resurrection, and the Ascension is similar to the ampullae from Jerusalem.

1. S. Chojnacki 1983: 34, 490.
2. M. E. Heldman 1979.
3. S. Grébaut and E. Tisserant 1935, no. 46.
4. C. Nordenfalk 1979.
5. Bibliothèque Nationale, Paris, Éth. 32.
6. M. E. Heldman 1979; C. Lepage 1987.
7. C. Nordenfalk 1938: 102–8.
8. K. Schneider 1950: 81.
9. K. G. Holum 1977: 163–67.
10. A. Grabar 1958, pls. 10 and 11.

SELECTED REFERENCES
Heldman, M. E. 1979.

## 56 Four Gospels (fragment)

Northern Ethiopia, fourteenth century
Parchment
$10\frac{13}{16} \times 7\frac{1}{4}$ in. (27.5 × 18.5 cm), 32 ff.
Nationalmuseum, Stockholm, B 2034

This fragment of the Gospels consists of a single leaf with two illuminated pages of the Eusebian prologue, explaining how the tables were to be used; a single leaf with decorated canon tables; a single leaf with two scenes from the life of Christ; three evangelist portraits; and leaves with fragmentary texts of Saints Matthew, Mark, and John.

The miniatures are close in style to the Gospel fragment of the Institute of Ethiopian Studies (cat. 55) and may have been produced in the same scriptorium at an unidentified monastery in northern Ethiopia. Comparison with the fragment in Addis Ababa, the Dabra Maar Gospels (cat. 54), and the Gospels of Sayfa Arad[1] suggests that the frontispiece of the present Gospels consisted of three full-page miniatures: the Crucifixion, now missing, the Holy Women at the Tomb, and Christ in Glory with Mary in her role as the Mother Church, Mary of Zion (*Maryam Seyon*).

The decoration of these several Gospel manuscripts reflects Late Antique and Early Byzantine iconography. The canon table fragments were part of a set comprising a decorated prologue and seven pages of canon tables, a program devised by Eusebius, bishop of Caesarea in the early fourth century.[2] The miniatures of the three-page frontispiece symbolically refer to the Death, the Resurrection, and the Ascension of Christ. Representations of the three scenes and of holy sites in Jerusalem often appear on souvenir ampullae that were produced for pilgrims in Palestine during the sixth and early seventh centuries, and similar representations probably decorated the imposing churches that were built upon the holy sites. The most popular holy sites were Golgotha, the site of the Crucifixion; the Tomb of Christ, the site of the Resurrection; the Mount of Olives, with the footprints of Christ, the traditional site of the Ascension; and the Church of the Apostles on Mount Zion.[3] The frontispiece miniatures of this group of manuscripts preserve the emphasis upon the holy sites of Jerusalem.

The source of this sixth-century iconography is unknown. It is possible that the miniaturists had access to a Gospel book from the Aksumite period which was illustrated with similar miniatures.

1. Bibliothèque Nationale, Paris, Èth. 32.
2. C. Nordenfalk 1938: 65–93.
3. K. Weitzmann 1974.

SELECTED REFERENCES
Heldman, M. E. 1979.
Nordenfalk, C. 1979: 17–21.

## 57 Canon Table (fragment)

Central Ethiopia
Fourteenth to early fifteenth century
Parchment
$13\frac{3}{8} \times 8\frac{5}{8}$ in. (34 × 21.9 cm)
Institute of Ethiopian Studies, no. 5023a–b

These two parchment leaves were originally a bifolio. The physical evidence of the inner edges of each leaf and the canon tables written upon them indicate that the two leaves were once joined. Canon II fills the recto of the first sheet and canons III and IV fill the verso; canon V is on the recto of the second sheet and canons VI and VII are on the verso.

While nothing is known of the manuscript to which the fragment originally belonged, it would seem to have possessed a three-page Eusebian prologue and seven pages of canon tables. Along with the prologue, the canon tables formed a prefatory section to the text of the Gospels.

The remainder of our discussion will focus upon the canon table frames. These are decorated with arabesque leaves, flowering branches, and brightly colored birds. Some of the birds are inscribed "*Tir*," a noun derived from the verb "to fly," which is usually applied to divination based on the flight of birds.[1] The inscription suggests that in addition to their charming appearance, these birds may have had a symbolic significance.

The tabular concordances referring to parallel verses in the Gospels are enclosed within architectural frames decorated with flora and fauna of the terrestrial world. The scheme and its decoration were introduced in the early fourth century by Eusebius, bishop of Caesarea. Canon tables became an essential part of decorated manuscripts of the Gospels, regardless of the language and wherever produced – at the monasteries of Ireland; Charlemagne's court; the Byzantine capital, Constantinople; or highland Christian Ethiopia.[2]

The architectural frame, in the form of an arch, preserves the structure of a Late Antique prototype. The arcade rests firmly upon a ground line, and its elements follow the classical order of column shaft and capital, although the column capital is rendered as a striped ball and the marble column shaft is flattened by the simple band of ornament. Ethiopian architects had borrowed the ground plan of the Christian basilica from the Mediterranean world, but indigenous Ethiopian building traditions did not utilize the Doric, Ionic, or Corinthian orders of Greek and Roman architecture. Rather than directly reflecting Ethiopian architectural tradition, these canon table frames are pictorial elements that derive from the Late Antique heritage of Ethiopian manuscript decoration.

1. W. Leslau 1987: 600–601.
2. C. Nordenfalk 1938.

## 58 Processional Cross

Provenance unknown, before 1400 (?)
Bronze
$9\frac{1}{16} \times 3\frac{7}{8}$ in. (23.1 × 9.9 cm)
Institute of Ethiopian Studies, no. 4655

This small processional cross with hollow shaft was cast in one piece. The precise casting technique and the simple form prompted Moore to suggest a date of the twelfth or thirteenth century,[1] but there are no precisely dated comparative materials with which to establish a chronology. The edges are worn and the surface is oxidized.

The lower arms terminate in an arabesque design. The outline is derived from an early Byzantine form, in which leaves branch from the foot of the cross.[2] Such leaved crosses long remained a popular decoration for Byzantine church doors. The leaves signify that this is the Life-giving Cross (Genesis 2:9). An Ethiopic hymn to the Cross makes reference to this profound symbolism:[3] "Hail to the wood of the Cross which was drenched with the blood of the godhead, until it sprouted a leaf of life...."

The Geez word *ez* signifies both "tree" and "wood," making the tree of the Cross and the wood of the Cross synonymous. In this way, the Cross is understood to be "the Tree of Life in the midst of the Garden" (Genesis 2:9).

1. E. Moore 1971: 14–15, fig. 4.
2. E. Kitzinger 1974: 8.
3. Getatchew Haile 1983(A): 22.

SELECTED REFERENCES
Moore, E. 1971.
Moore, E. 1989: 110.

# THE ZAGWE DYNASTY: 1137–1270

*Marilyn E. Heldman*

ETHIOPIAN HISTORICAL TRADITIONS yield conflicting information about the duration of the Zagwe dynasty, although the date of its downfall is known. In 1270 Yekunno Amlak established the so-called Solomonic dynasty, overthrowing what later Solomonic propaganda was anxious to describe as a dynasty of usurpers. The truth, however, may have been the reverse.

The long period between the abandonment of Aksum as a political capital, perhaps by the seventh century, and the establishment in the twelfth century of the Zagwe ceremonial center of Roha, now known as Lalibala, is virtually undocumented. With few exceptions, there is an almost complete absence of manuscript sources. Getatchew Haile has suggested that only "a systematic destruction of the past on religious grounds" during the early years of Yekunno Amlak's new dynasty can explain this discontinuity.[1]

However, few manuscripts from before 1270 have survived. These include the two Gospel books with canon tables and evangelist portraits at the Monastery of Abba Garima, which were probably preserved because of their traditional association with Abba Garima, one of the Nine Saints. Manuscripts such as these preserved Late Antique canon table models and the early Byzantine iconography of the holy sites of Jerusalem.

Even if internal historical documentation is lacking, the achievements of royal patronage during the Zagwe period remain visible. The most famous is the magnificent ceremonial center carved from living rock in the mountains of Lasta. Originally named Roha, an echo of the Arabic name for Edessa, the holy city of the Syrian Christians, it is known today as Lalibala after the Zagwe king whose purported tomb became a pilgrimage site. The rock-hewn churches of Lalibala continue to attract pilgrims as well as foreign visitors.[2] Hagiographies of the saintly kings of the Zagwe, written years after the dynasty was replaced, acknowledge the celebrated accomplishments of their patronage.

According to the *Life of Yemrehanna Krestos*, one of the Zagwe kings during the late twelfth century, it was he who inaugurated the tradition of hewing structures from living rock.[3] Although the tradition may describe the origins of the Zagwe ceremonial center, it does not accurately reflect the evidence of surviving monuments in northern Ethiopia. These suggest that Aksumite stone-working traditions never fell into disuse. A large number of subterranean tombs cut from bedrock[4] as well as monuments of dressed stone demonstrate that the rock-hewn structures of Lalibala have Aksumite precedents. In the area southeast of Aksum many rock-hewn churches survive, few of which can be dated. At Degum in the open plain of Geralta, some 100 kilometers southeast of Aksum, is a group of rock-hewn monuments including one or two churches, a funerary chapel and tomb, and a baptistery. Claude Lepage has persuasively argued that this group predates the twelfth century and the rock-cut structures at Lalibala.[5]

The great ceremonial center of the Zagwe dynasty may do more than simply display a continuity with Aksumite architectural traditions. It may also have been intended to recall,

1. Getatchew Haile 1985(B): 41.
2. G. Gerster 1970; L. Bianchi Barriviera 1962–63.
3. Taddesse Tamrat 1972(A): 58.
4. S. C. Munro-Hay 1989(B): 161.
5. C. Lepage 1972.

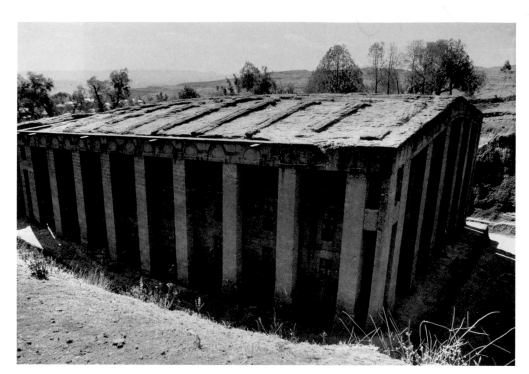

Fig. 14 Church of the Redeemer, Lalibala. [Photo by M. Heldman © 1993]

Fig. 15 Painted birds in the central nave of the Church of Mary, Lalibala. [Photo by M. Heldman © 1993]

6. M. E. Heldman 1992(A): 230–31.

Cat. 59 (*facing page*) Processional Cross.

perhaps even to recreate, the ancient capital of Aksum. The largest church at Lalibala, the Church of the Redeemer (fig. 14), may be an architectural copy of the original Cathedral of Mary of Zion at Aksum. It has the rare and distinctive exterior colonnade, which it shares with a proposed reconstruction of the Cathedral of Mary of Zion.[6]

The murals of the Church of Mary at Lalibala include portraits of saints and scenes from the life of Christ. A painted frieze of animals, including humped cattle, birds, and fowl (fig. 15), follows the iconography of "the Lord's estate," a Late Antique theme which was introduced during the Aksumite period.

Although the traditional Aksumite elements in the arts of the Zagwe dynasty can be demonstrated, the extent of the innovations introduced during this period is impossible to assess at present. The undated paintings of the Church of Mary, notable for their Gospel narratives, and the carved, painted, and inscribed wood chests (*manbara tabot*) for the altar tablet, give a limited glimpse of the wealth and beauty of the arts of the Zagwe period.

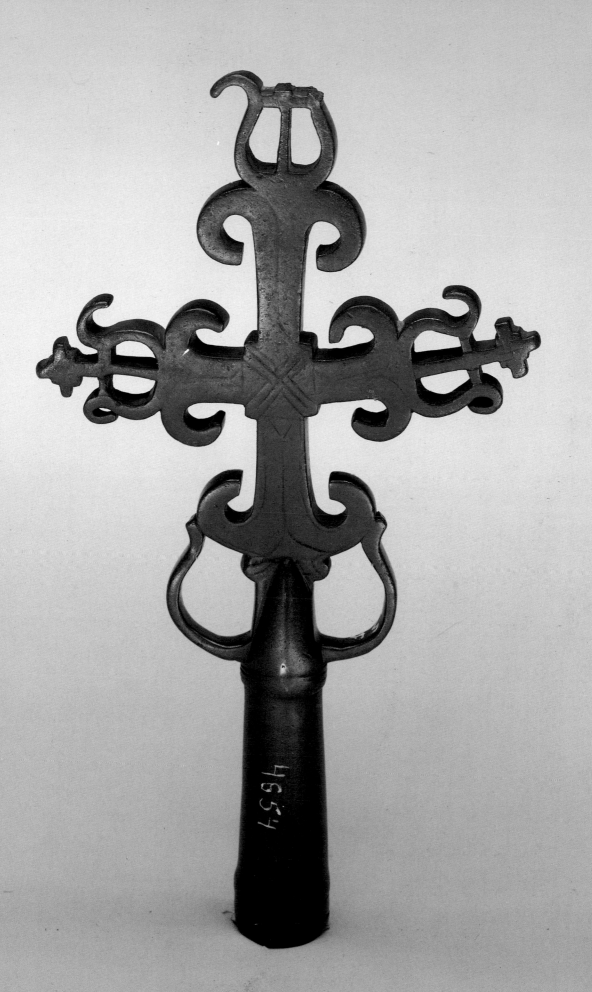

## 59 Processional Cross

Provenance unknown, thirteenth
    century (?)
Bronze
$8\frac{7}{8} \times 4\frac{7}{8}$ in. (22.5 × 12.4 cm)
Institute of Ethiopian Studies, no. 4654

The cross and hollow shaft were cast in one
piece. At the center of the design is a cross
with flaring arms from which erupt
secondary crosses partially framed by pairs of
leaf-like projections. Such multiplication
suggests the life-giving power of the Cross.

SELECTED REFERENCES
Moore, E. 1971: 16, fig. 6.

## 60 Processional Cross

Lalibala (?), date unknown
Silver
Church of Mary, Lalibala

This rare and beautiful silver cross is plain in
outline, and its decorative additions are
limited to small cross finials and circles at the
ends of the arms. The simple manner of
attaching the shaft to the cross obscures
neither the outline nor the pierced patterns.

Of its seven design units, five are arranged
vertically and two form the horizontal arms.
Each unit itself is a cruciform design. The
design at the central crossing is like a patté
cross; four units are swastika crosses; and two
are simple crosses.

The window openings of rock-hewn
churches at Lalibala are embellished with
identical cruciform designs (figs. 16 and 17).
The cross designs that fill the windows were
not intended to be merely decorative. As the
sign of the Cross is believed to have the
power to avert evil, cross designs were placed
in windows to protect these openings against
evil forces attempting to enter.[1] The
multiplication of cross units in the design of
the present icon may have been intended to
increase its efficacy.

The age of this cross has not been
determined; however, its repertoire of design
motifs was current during the twelfth and
thirteenth centuries.

    I. S. Kur 1972: 21–22.

Fig. 16 Window in the Church of Mary,
Lalibala. [Photo by M. Heldman © 1993]

Fig. 17 Windows in the Church of
Immanuel, Lalibala. [Photo by M. Heldman
© 1993]

Cat. 61 (*facing page and right*) Coffer. [Photos
by Malcolm Varon, NYC © 1993]

## 61 Coffer (*Manbara Tabot*)

Provenance unknown, thirteenth
    century (?)
Carved wood
$20\frac{7}{8} \times 9\frac{1}{4}$ in. (53 × 23.5 cm)
Institute of Ethiopian Studies, no. 3077

The top and two sides of this coffer, which
was carved from a single piece of wood, are
decorated with cruciform designs. A third
side is carved with a six-part interlace pattern.
The fourth side opens into a central cavity in
which the altar tablet was stored. The
opening of the coffer is framed by a band of
swastika crosses, in contrast to the bands of
arabesques that frame the other sides. Such
decorative variety is also characteristic of
processional crosses that have been assigned to
this period. The cross with flaring ends (front
side) can be compared with a processional
cross of similar shape (cat. 59).

The coffer is an altar chest in which the
consecrated altar tablet is stored and upon
which the altar tablet is placed for the
celebration of the Divine Liturgy. Because of
its sanctity, the altar tablet is never displayed
uncovered before the laity. Francisco Alvarez,

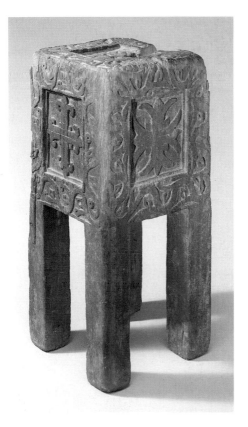

who was a member of the Portuguese delegation to Ethiopia during the years 1520 to 1526, wrote of the reverence afforded the altar tablets. Only priests could carry them. When the peripatetic Ethiopian court with its palace churches moved from one site to another, each altar tablet was covered with silk or brocade fabric and carried in procession, preceded by a processional cross and censer as well as a ringing bell.[1] This reverence is still observed (fig. 18). In an event such as fire or theft, a consecrated altar tablet may be removed from its church; a few altar tablets have entered European collections in this way. Several wood altar tablets in the Vatican library are incised with designs based upon the equal-arm cross;[2] the designs that are carved on the top and sides of this altar chest are similar to these.

1. F. Alvares 1961, vol. 2: 323–24.
2. J. M. Hanssens and A. Raes 1951: 444, 448.

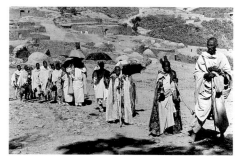

Fig. 18  Procession with altar tablet, Senafe. [Photo by M. Heldman © 1993]

## 62  Coffer (*Manbara Tabot*)

Lalibala, early thirteenth century (?)
Wood
$34\frac{1}{4} \times 16\frac{1}{8}$ in. (87 × 41 cm)
Church of Golgotha, Lalibala

The top and sides of this coffer are carved with an equal-armed cross composed of bands of small, circle-framed crosses. The large cross is framed by a border of arched forms that are identical with window infilling designs of rock-hewn churches at Lalibala (fig. 19). These infillings are depicted on one of the stelae at Aksum which simulates architectural forms; like all the storied stelae at Aksum, it dates to the period

Fig. 19  Pair of simulated windows, carved stele fragment, Aksum. [Photo by M. Heldman © 1993]

before 400.[1] This traditional motif is also found in the window infilling of medieval churches.[2]

A prayer inscribed on three sides of the coffer names Lalibala, the Zagwe ruler whose reign is not securely dated; a Coptic source indicates that he reigned in 1210.[3] It is curious that nine of the ten coffers whose inscriptions were published by Gigar Tesfaye[4] name Lalibala as the dedicator, while the tenth names no dedicator.

Lalibala's prayer is addressed to Hananiah, Azariah, and Misael, the Three Holy Children who were rescued from King Nebuchadnezzar's fiery furnace by an angel of the Lord (Daniel 3). Their hymns, known as the Prayer and Song of the Three (the second and third hymns of Daniel), are Biblical canticles.[5] Lalibala's prayer is unusual because it makes no direct reference to the deliverance of the Three Children by an angel, instead merely asking for their prayers.

INSCRIPTIONS   O three youths, Hananiah, Azariah, and Misael, martyrs of Christ, pray for me before God the Father, before Christ the Son, and before the Paraclete, the Holy Spirit, so that your prayers may obtain clemency and mercy for the servant of God, Lalibala, forever, Amen.

1. S. C. Munro-Hay 1989(B): 150–52.
2. G. Gerster 1970, pls. 110, 111, and 152.
3. A. Khater and O.H.E. Burmester 1970: 192–93.
4. Gigar Tesfaye 1984.
5. B. Velat 1966: 393–94.

SELECTED REFERENCES
Gigar Tesfaye 1984: 119–20, pls. 6 and 7

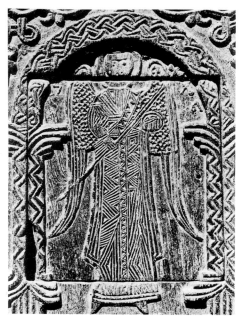

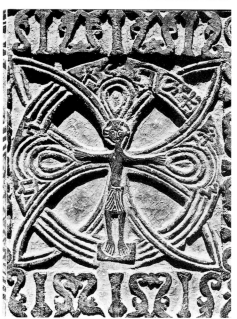

Cat. 63 (*top and above*)  Coffer. [Photos taken from Georg Gerster, *Churches in Rock* (London 1970), pls 211, 209, © Phaidon Press Ltd]

## 63  Coffer (*Manbara Tabot*)

Lasta, twelfth to the thirteenth century (?)
Wood
Telasfarri Estifanos, Lasta

This wood coffer is rare because it is carved with figurative compositions. A coffer at the

Church of Mary at Lalibala exhibits a similar scheme;[1] however, most coffers are decorated with simple cruciform designs. The top of the coffer, the primary surface, is carved with a figure of Christ Crucified. Two opposite sides are carved with an archangel standing within an arcade. The other two sides are carved with architectural designs, the arcade of which frames a representation of a coffer decorated with a cruciform rosette.

The decoration of the coffer brilliantly sets forth in literal as well as symbolic terms its function and meaning. Within is stored the consecrated altar tablet, a slab of wood, stone, or gold which is placed upon the coffer during the Divine Liturgy so that the chalice and paten can be set in it. At present, it is the custom of the Copts to set a consecrated wood altar board into the top of the altar.[2]

The importance of the altar coffer is suggested by the multiplication of terms by which it is named. The Geez word for "coffer" or "chest" is *tabot. Sellat*, the word for "tablet," refers to the consecrated altar tablet. In actual practice, however, as it takes on the name of the coffer in which it is stored, the tablet is called *tabot.* In the Geez translation of the Bible, *tabot* refers to the Ark of the Covenant; by extension it also refers to the tablets on which the Ten Commandments were inscribed.

These terms reflect the fact that the Biblical Ark of the Covenant is regarded as a type of the Christian altar, and the sanctuary of the church is understood to be symbolically the Holy of Holies of the Temple, the dwelling place of the Lord. The coffer frequently is termed *manbar* (throne) or *manbara tabot* (throne of the altar tablet), thus suggesting the divine presence. (Byzantine commentaries interpreted the altar as the throne of God.)[3]

The figure of the Crucified Christ is a reference to the Eucharistic sacrifice of the Divine Liturgy in which the Crucifixion is symbolically reenacted. Upon four concentric circles that frame the figure of Christ are carved the words "Four Beasts." These are the Four Beasts "who have no bodies and which are the Wheels of God that bear His Divine Throne...."[4] The Four Beasts of Heaven, symbolized by the four concentric wheels or circles, signify the divine presence and demonstrate that the *manbara tabot* is the throne of the Lord.

Each of the two architectural compositions on the sides bears an inscription, "Seraphim," those six-winged creatures which Isaiah (6:1–3) saw beneath the throne of God. His testimony is presented in the Synaxary reading for the Feast of the Four Beasts.[5] The carved inscriptions apparently refer to the pairs of winged designs that fill the upper corners of the composition. The architectural compositions may represent the Ark within the Holy of Holies of the Temple or the altar within the sanctuary of the church, or both.

The geometric forms of the majestic archangels carved on two sides of the coffer are comparable to geometric figures of fourteenth- and fifteenth-century manuscript illumination. However, the wide decorative border carved on the top of the coffer appears to be a variety of pseudo-Kufic decoration which is not seen in later Ethiopian art.

INSCRIPTIONS Four Beasts. Cherubim. Seraphim. Gabriel. Michael.

1. S. Strelcyn 1979: 155.
2. P. Grossmann 1991.
3. R. F. Taft 1991.
4. E.A.W. Budge 1928(A), vol. 1: 221; G. Colin 1988: 268–69.
5. E.A.W. Budge 1928(A), vol. 1: 221–22; G. Colin 1988: 270–71.

SELECTED REFERENCES
Gerster, G. 1970: 141–42, pls. 209–11.

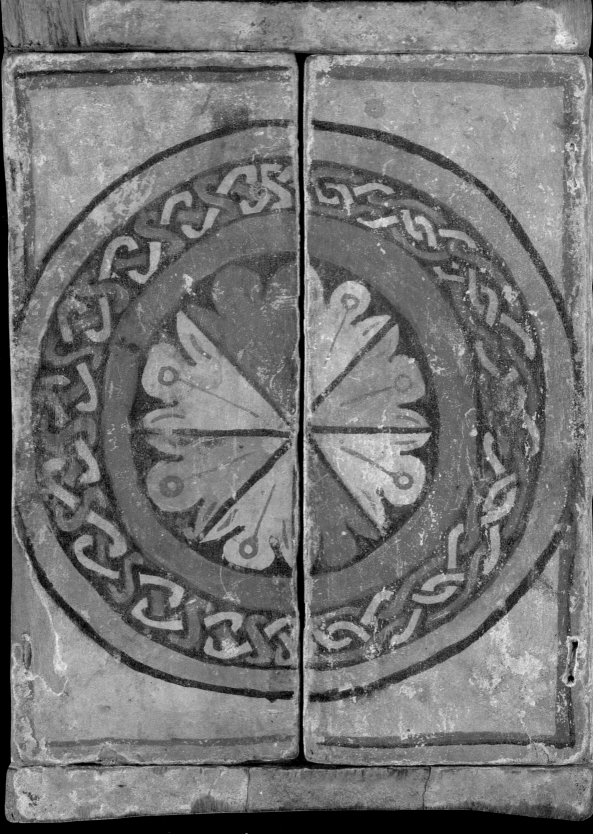

# THE EARLY SOLOMONIC PERIOD:
## 1270–1527

*Marilyn E. Heldman*

IN COMPARISON WITH EARLIER PERIODS OF Ethiopian history, the Solomonic dynasty is well documented, but the wealth of documentation is relative, and much remains to be learned of artisans, patrons, and centers of artistic training and production. The distinctive styles of manuscript illumination await localization, and information concerning workshop practices and the training of artists is virtually nonexistent.

In 1270 Yekunno Amlak overthrew the reigning Zagwe dynasty and established what has come to be known as the Solomonic dynasty, although his new dynasty should more properly be termed the Tagwelat dynasty after his homeland in the district of Tagwelat in Shoa. Yekunno Amlak based his claim to legitimacy upon his alleged descent from the rulers of ancient Aksum, who were said to be the descendants of Menelek, son of King Solomon and the Queen of Sheba. Rulers of this new dynasty presented a religious justification for overthrowing their predecessors by casting aspersions upon the orthodoxy of the Zagwe rulers. In the process, the Solomonic emperors embarked on a cultural revolution, and when new translations were prepared of central religious texts, many of the records of the past were lost.[1]

With the establishment of the new dynasty, the fortunes of Dabra Hayq Estifanos in Amhara rose immediately. The monastery had been founded around 1248 by Iyyasus Moa, a monk from Dabra Damo. The emperor Yekunno Amlak bestowed upon the abbots of Dabra Hayq a special title (*aqqabe saat*) and endowed their monastery with great wealth. Its reputation as a center of learning was maintained throughout the sixteenth century, and the scriptorium produced some of the finest illuminated manuscripts of the late thirteenth and fourteenth centuries. Portraits of the abbots Iyyasus Moa and Krestos Tasfana decorate the Gospels they presented to Dabra Hayq Estifanos.

The monastery of Dabra Asbo in Shoa was founded by Takla Haymanot around 1284. It did not begin to rival Dabra Hayq Estifanos until after 1445, when it was endowed by the emperor Zara Yaeqob and renamed Dabra Libanos. By the end of that century, its abbots had assumed a significant role as patrons of the arts, most notably Marha Krestos, who was abbot from 1463 to 1497. He built a church of Our Lady Mary at his monastery and had it decorated with murals of Mary and portraits of the prophets, apostles, and martyrs.[2] In 1532 the monastery was looted and its churches and library destroyed by the troops of Ahmad Grañ, but the *Ritual for Passion Week*[3] commissioned by him survived the destruction (fig. 20).

Lake Tana harbored no significant monastic population until the second half of the fourteenth century. The islands were covered with trees and provided ideal sites for individual hermits or entire monastic communities; however, the local populations remained hostile to attempts at Christianization until the early fifteenth century. The earliest monastic community at Lake Tana, Dabra Tana Qirqos, was established after 1250. During the reign of Amda Seyon (1314–44) it received imperial favors, and became the center for monastic expansion, asserting

Fig. 20 Illuminated page, *Ritual for Passion Week*, made for Abbot Marha Krestos, British Library, Or. 597, f. 225r. [By permission of the British Library]

1. Getatchew Haile 1985(B): 47.
2. S. Kur 1972: 94.
3. British Library, Or. 597.

Cat. 85 (*facing page*) Side B of triptych, closed.

its authority over the younger monastic communities in the area.[4] These included Dabra Daga Estifanos and Dabra Gwegweben at the eastern shore of the lake. The latter was the monastery of Fere Seyon, the painter who signed his name to the large devotional image he painted for the Church of Saint Stephen (Estifanos) on Daga Island.

The dynastic church of the emperor Yekunno Amlak, near Lalibala, was hewn from living rock and thus survives as a testament to his newly acquired role of emperor and patron. His portrait on a pier within the church shows him flanked by two abbots of the monastery associated with the church. The accompanying inscription proclaims his foundation of the church and acknowledges the assistance of one abbot as the supervisor of the project.[5] This rare portrait documents the ways in which secular rulers and monastic leaders used artistic patronage as a means of establishing their authority and enhancing their prestige.

The major documents of Ethiopian recorded history are royal chronicles, land grants entered into the margins of manuscripts, and the *Lives* of local saints. Because there was no reason to record information about workshop practices, this aspect of the history of Ethiopian art remains virtually unknown. However, the *Lives* of Ethiopian saints occasionally give incidental information about the training of artisans and the production of objects.

According to the *Life of Iyyasus Moa*, the saint received his training as a scribe at the venerable Monastery of Dabra Damo. Later in his career, after having founded Dabra Hayq Estifanos, he made twenty-four lamps with his own hands for the monastery church of Saint Stephen.[6] Where he learned the craft of metallurgy is not indicated. Metalworking was generally considered an occupation suitable only for outsiders of low status, usually non-Christians. The contempt displayed toward such artisans did not apply within the confines of the Christian monastery, however, where church lamps, hand and processional crosses, and chalices and patens were produced by monastic craftsmen. Monasteries were also centers of training in chant, singing, and painting,[7] and it seems that most artisans were monks, although it was possible to enter a monastery without taking monastic vows in order to obtain training as a scribe or a painter.

The activity of illuminators at various monastic centers explains the simultaneous development of different styles of painting. During the second half of the fifteenth century two separate monastic houses in northern Ethiopia, the house of Ewostatewos and the house of Estifanos, developed distinctive styles of illumination.[8] However, most of the styles of this period cannot be associated with a particular monastic workshop.

The Ewostatewosite workshop, possibly located at Dabra Maryam Qwahayn, produced a lavishly decorated manuscript of the Psalms, Canticles, and Marian prayers[9] for Belen Saggad, the governor of Sarawe in northern Ethiopia.[10] The emperor Dawit (r. 1382–1413) established a scriptorium with illuminators in his royal palace, and a number of beautiful books were copied and decorated there (cats. 2 and 68).

The emperor Zara Yaeqob in particular recognized the power of the visual image as an effective means of public communication. He sponsored the production of panel paintings of Our Lady Mary, a necessary adjunct for the mandatory ritual of Marian veneration he introduced in 1441, and encouraged the development of iconographic programs to express the message of his teachings concerning the central position of Our Lady Mary in the Christian scheme of salvation.[11]

The monk Fere Seyon was the primary painter of the workshop or small circle of painters employed by Zara Yaeqob's court. The extent to which the painter himself created the iconographic programs of his panel paintings is unknown, but he developed a distinctive style that influenced Ethiopian Marian icons of the second half of the fifteenth century. Fere Seyon's triptych (cat. 5) expresses the message of the theological treatises written by Zara Yaeqob to explain the role of Mary in the events of the Incarnation.

4. Taddesse Tamrat 1972(A): 189–93.
5. M. E. Heldman and Getatchew Haile 1987: 3–4.
6. S. Kur 1965: 18, 32.
7. E. A. W. Budge 1898: 3–4, 31–32.
8. M. E. Heldman 1989.
9. Bibliothèque Nationale, Paris, fonds d'Abb. 105.
10. J. Leroy 1967, pls. 9–11.
11. M. E. Heldman (forthcoming).

One member of Fere Seyon's circle, *Abuna* Mabaa Seyon, also known by his monastic name, Takla Maryam, may have played an active role in the introduction of a new iconography of the Crucifixion. He was a monk and abbot of a monastic community at Endagabtan in central Ethiopia. The commemoration of the Crucifixion on the twenty-seventh day of each month was instituted by him.[12] *Abuna* Mabaa Seyon may have composed the *Book of the Passion of Our Lord*, a homiliary of the Passion and Crucifixion,[13] and he is likely to have encouraged the depiction of Christ dead or dying upon the Cross (cat. 85).

Our knowledge of these two painters is limited, but the few facts we possess do allow us to formulate an outline of their careers. Most Ethiopian painters, metalworkers, and builders remain anonymous.

All the rulers of the Solomonic dynasty founded churches, most of which were located in their dynastic homeland of Amhara and Shoa. Royal churches were lavishly decorated with murals and church furnishings, gold and precious fabrics, but all that survives are dazzling accounts of their wealth and beauty. The churches and their furnishings were destroyed during the Muslim occupation of the Christian highlands during the early sixteenth century.

The emperors Dawit, Yeshaq, and Zara Yaeqob attempted to recruit European artisans to work for them.[14] Engaging foreign craftsmen was a prerogative reserved for the imperial family and a few favored courtiers, because the products of these artists and artisans, like other imported luxury goods and works of art, were tangible symbols of noble status. European craftsmen may have introduced to *Abuna* Mabaa Seyon and Fere Seyon the idea of signing their work. The best-known European to work at the Ethiopian court was Nicolò Brancaleon (fl. c. 1480–1526), who painted the murals of the royal church of the emperor Lebna Dengel, and also produced illuminated manuscripts and devotional images (cat. 88). This widespread network of patronage by which abbesses, abbots, emperors, and aristocrats sponsored the building and decoration of churches and the production of metalwork, illuminated manuscripts, and devotional images collapsed abruptly after 1527 with the Muslim invasions.

12. Getatchew Haile 1985(A): 254.
13. Getatchew Haile and W. F. Macomber 1981: 248–49.
14. M. E. Heldman 1990.

አበዓል፡ዘቀዲሒ፡ካህናት፡ዘገብረ፡ዲያቢ፡ግ
ዘለዲየሉ፡ዉሎ፡ወዴየሉ፡ከ፡ወዘነር፡ከተሰ
ተከሪ፡ተፈሊ፡ስን፡ካህናት፡አገብርት፡እግዚ
አ፡ጠሀቅ፡ለዉሳ፡አበዉ፡ለበንት፡ወሎዮን
፡ ፡ሮጌ፡ንኤ፡ዲ፡ለሱፈ፡ጥሪሰክርከዶ
ተፊፈ፡ከ፡ይዋ፡ር፡በጀሠገ፡ከኞ፡እርዝከ

አ፡ለሐ፡ሂ፡ህ፡ጠ፡ሰበ፡ክ፡ሀ፡ ፡ቅ፡ደ፡ሁ፡ህ
፡ረ፡ በ ፡ ፡ ጠ፡ ከሰ፡ ፡ ፡ ፡ ፡ ፡ ፡ ፡ ፡ ላ፡ ሰ፡ በ፡ ሃ፡ ለ

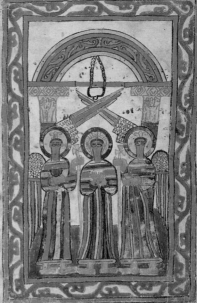

ዘከወ፡አብ፡ለዖ፡ለወሪየም፡ወክተ፡ቤተ፡ወ

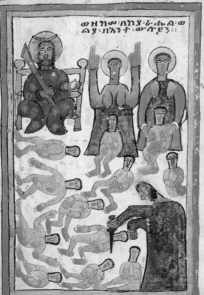

ዘከወ፡ዕቶሰ፡ሀርፆኩ፡ሕ፡ፃ፡ተ፡ዘቤተ፡ልሐም

ወዘከወ፡በከ፡ራሐ፡ወ
ልያ፡በንተ፡ወሎዮን

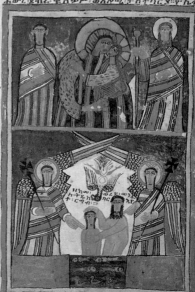

ዘከወ፡በከቡ፡ዖርዖም፡በንተ፡ትፈር፡ወለዴ፡እንዜ
ተ፡ወዴ፡ረ፡ከተ፡ቃ፡ወአለፃ፡ተ፡ከ፡በ፡ርከ፡ቦ፡

በ፡ከ፡አጠ፡ወ፡ቾ፡ሃ፡ሐኑ፡ሰ፡ዴ፡የኑ፡ከ፡ዒ፡ከ፡ኤ፡ፅ፡ወገበር
፡ል፡ፅ፡ዘከወ፡ከሰሰ፡ም

Cat. 65  Four Gospels of Krestos Tasfana.
*Facing page top* ff. 8v–9r: abbots and holy men of Hayq Estifanos; Entrance of Mary into the Temple
*Facing page bottom* ff. 11v–12r: Saint Mark, Gospel of Saint Mark

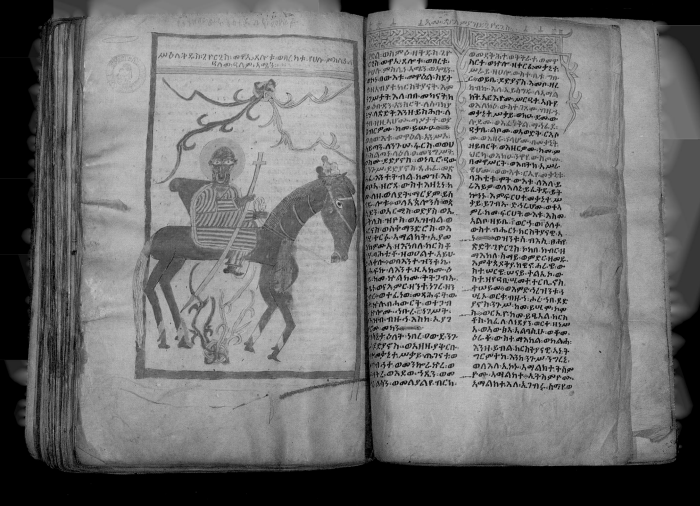

መሕትዮዱ ቅዮርጊስ ወዓዲኣት ወበርኬታ የሀሉ ምስለን ሃሌ ዉዲኒ ዲና አÜን

Cat. 66 (*above*)  *Acts of Saints and Martyrs*, ff. 157v–158r: Saint George

Cat. 68 (*facing page*)  Pauline Epistles.
Top, ff. 99v–100r: Paul, Silvanus, and Timothy. Bottom, ff. 54v–55r: Paul and Timothy

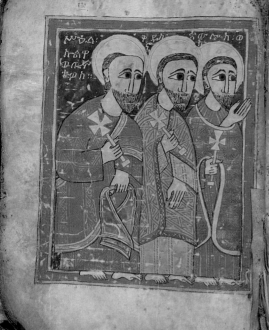

ለስብአ᎓ተስሎኒቀ᎓ወ
ተጸሕፈ᎓እንዘ᎓ሀሎ᎓ብ
ሔራብ᎓ ፡ ፡ ፡
ጿውሎክ᎓ወክልዋየን
ወመዋቲ᎓ወክስልተ
ክሪስቲያን᎓ዘተሰሎን
ቂ᎓መአመናን᎓በእግዚ
አብሬርአብ᎓ወአግዚ
እን᎓አየሱክ᎓ክርስቶስ
ጿስለም᎓ለክሙ᎓ወጿጋኔ
ግዚአብሔር᎓አኮ᎓ኮ
አግዚእን᎓አየሱክ᎓ክ
ርስቶስ᎓አኩ᎓ኮ᎓ትለስ
ወአእግሔር᎓ዘልፈ᎓በ
አንቲአክሙ᎓ለኩፍልሕ
መወን᎓ወይ᎓ተዛዒ
ርታክሙ᎓ወተርጊ᎓ብጾ
᎓ወአእክሯዝ᎓ብር
ይጿማፐታክሙ᎓ጿጿፈ
ርክሙ᎓ወትሪ᎓ብፒ᎓

ተአስፈኮ᎓ወበእግዚእ
ኮ᎓ኢየሱክ᎓ክርስቶክ
በቀዳየ᎓ወአግራአብሔ
ር᎓አቡነ᎓ናአምር᎓አንዘ᎓
ሃፉ᎓ፋጐን᎓በ᎓ጿ᎓እግዚ
አብሔ᎓ጐክ᎓አሙ᎓ ንፈ᎓ ሀ
ክ ᎓አክአሙ᎓አአንተ᎓
ምህርቲን᎓ንበሔ᎓ሙ᎓አ
ገርበሐቲ᎓ዳዴ᎓ በዝበ᎓
ል᎓ወበዘ ᎓ ፈ᎓ ቀዳ
ወበበ᎓ ዙ᎓ ፈ᎓ ሰሐ᎓ ጿጿ
መአ ᎓ ን᎓ ተአ መራ᎓ ዘጿ᎓
ን᎓ በ ᎓ ነ ᎓ ቤ ᎓ በእንቲ᎓
ክ ᎓ ወ ᎓ አ᎓ ንተ᎓ መን᎓ ቲ᎓
ኃ᎓የተ᎓ ወልስ ᎓ ክ᎓ ወ ᎓ ተ᎓
ክ᎓ ፋ ᎓ ክ ᎓ መ ᎓ ቀ᎓ ለ᎓ አግ᎓ ዚ᎓
ብ ᎓ ሔ᎓ ራ ᎓ ብ᎓ ዘ᎓ ዱ ᎓ ዕ᎓ ሐ᎓
ም᎓ ሰ᎓ ለ ᎓ ፋ᎓ ሰ᎓ ለ᎓ ፈ᎓ መ᎓
ፈ᎓ ክ᎓ ቀ᎓ ዴ᎓ ክ᎓ ወ᎓ ት᎓ አ᎓
ወ᎓ እ᎓ ር ᎓ ስ ᎓ ሃ᎓ ለ᎓ አ᎓ ስ᎓ አ᎓

---

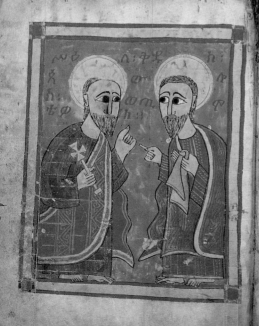

ጿውሎክ᎓ ሐ᎓ ወረ᎓ ያ᎓ ሀ᎓ ል
አየሱክ᎓ ክርስቶክ᎓ በ
᎓ ቃ᎓ ደ᎓ አግዚአብ᎓ ዘሔኮ᎓
ጢ ᎓ ዋ᎓ ቲ ᎓ ወ᎓ ክ᎓ አ᎓ ን᎓ ለ ᎓ ቤ᎓
ተ ᎓ ክ᎓ ርስ ᎓ ቲ ᎓ ያ᎓ ን᎓ አ᎓ ጿ᎓ ጿ᎓ ሳ᎓ በ᎓
ር᎓ አግዚ᎓ አብ᎓ ሔ᎓ ራ᎓ ዕ᎓
ሀ ᎓ ገረ᎓ ቆ᎓ ሮ᎓ ን᎓ ቶ᎓ ክ᎓ ወ᎓ ለ᎓
ሰ ᎓ ለ ᎓ ም᎓ ቀ᎓ ዴ᎓ ሰ᎓ ን᎓ ዘ᎓ ሙ᎓
ገ᎓ ረ ᎓ አ᎓ ክ᎓ ሃ᎓ የ ᎓ ᎓
ሰ᎓ ለ᎓ ም᎓ ለ ᎓ ክ᎓ ሙ᎓ ወ᎓ ዳ᎓ ነ᎓
አግዚ᎓ አ᎓ ብ᎓ ሔ᎓ ራ᎓ ክ᎓
ነ ᎓ ወ ᎓ አ᎓ ግ᎓ ዚ᎓ እ᎓ ነ᎓ አ᎓ የ᎓ ሱ᎓
ክ᎓ ክ᎓ ር᎓ ስ᎓ ቶ᎓ ክ᎓ ወ᎓ ይ᎓ ተ᎓ ገ᎓ ረ᎓
አግ᎓ ዚ᎓ አ᎓ ብ᎓ ሔ᎓ ር ᎓ አ᎓ ኩ ᎓ ኮ᎓
ለ᎓ አ᎓ ግ᎓ ዚ᎓ እ᎓ ነ᎓ አ᎓ የ᎓ ሱ᎓ ክ᎓
ክ ᎓ ር᎓ ስ᎓ ቶ᎓ ክ᎓ ወ᎓ አ᎓ ቡ᎓ ሁ᎓
የ᎓ ሐ᎓ ረ ᎓ ት ᎓ ወ᎓ ሃ᎓ ጿ᎓ ሀ᎓ ለ᎓ ወ᎓
አ᎓ ም᎓ ላ᎓ ክ᎓ ለ᎓ ተ᎓ ፈ᎓ ሰ᎓ ሐ᎓
ት᎓ ዘ᎓ አ᎓ ክ᎓ ተ᎓ ፈ᎓ ሰ᎓ ሐ᎓ ነ᎓ ነ᎓
ማ᎓ ስ ᎓ ለ ᎓ ሐ᎓ ማ᎓ ን᎓ ነ᎓ ክ᎓ ሙ᎓
ነ ᎓ ክ᎓ ሀ᎓ ለ᎓ አ᎓ ስ᎓ ተ᎓ ፈ᎓ ሳ᎓ ለ᎓

ጿ᎓ ወ ᎓ ላ᎓ ክ᎓ ሎ᎓ ᎓ ሐ᎓ ዋ᎓ ረ᎓ የ᎓ ᎓ ᎓ ᎓
ክ᎓ ወ᎓ እ᎓ ቱ᎓ ፈ᎓ ሰ᎓ ሐ᎓ ን᎓ ዘ᎓
አ᎓ ክ᎓ ተ᎓ ፈ᎓ ሰ᎓ ሐ᎓ ነ᎓ እ᎓ ግ᎓ ዚ᎓ አ᎓
ብ᎓ ሔ᎓ ር᎓ ወ᎓ በ᎓ ክ᎓ ም᎓ በ᎓ ዝ᎓
ሐ᎓ ዋ᎓ ር᎓ ያ᎓ ለ᎓ ብ᎓ ር᎓ ሃ᎓ ክ᎓
በ᎓ ላ᎓ ዕ᎓ ለ᎓ ኩ᎓ ለ᎓ ሙ᎓ ሁ᎓ የ᎓ ፈ᎓
የ ᎓ ፋ᎓ ይ᎓ ፈ᎓ ሰ᎓ ሐ᎓ ን᎓ በ᎓ ክ᎓
ር᎓ ስ᎓ ቶ᎓ ክ᎓ ወ᎓ አ᎓ መ᎓ ነ᎓ ሐ᎓
መ᎓ ም᎓ ኑ᎓ አ᎓ ም ᎓ አ᎓ ን᎓ ተ᎓ ም᎓
ት᎓ ህ ᎓ ን᎓ ነ ᎓ ወ ᎓ ተ᎓ ተ᎓ ረ᎓ ፈ᎓
ሐ᎓ ᎓ ወ᎓ ᎓ አ᎓ ᎓ ᎓ ᎓ ᎓ ᎓ ᎓ ᎓ ᎓ ᎓
ወ᎓ ᎓ ᎓ ᎓ ᎓ ᎓ ᎓ ᎓ ᎓ ᎓ ᎓ ᎓ ᎓ ᎓

ጿ᎓ ᎓ ተ᎓ ጸ᎓ ነ᎓ ᎓ ለ᎓
ዕ᎓ ሌ᎓ ክ᎓ ሙ᎓ በ᎓ ተ᎓ ቅ᎓ ዋ᎓ ግ᎓ ቱ᎓
ወ᎓ አ᎓ ቱ᎓ ሐ᎓ ማ᎓ ም᎓ ዘ᎓ ብ᎓
ር᎓ ሐ᎓ ዋ᎓ ል᎓ ብ᎓ ሕ᎓ ዘ᎓ በ᎓ ክ᎓
በ᎓ ላ᎓ ዕ᎓ ለ᎓ ኩ᎓ ል᎓ ሁ᎓ የ᎓ ፈ᎓
ደ᎓ ፈ᎓ ፈ᎓ ሰ᎓ ሐ᎓ ን᎓ ክ᎓ ክ᎓
ር᎓ ስ᎓ ቶ᎓ ክ᎓ ወ᎓ አ᎓ መ᎓ ነ᎓ ሐ᎓
መ᎓ ም᎓ ኑ᎓ አ᎓ ን᎓ ተ᎓ ም᎓
ት ᎓ ህ᎓ ን᎓ ነ ᎓ ወ ᎓ ተ᎓ ተ᎓ ረ᎓ ፈ᎓
ሐ᎓ ᎓ ወ᎓ አ᎓ ግ᎓ ዚ᎓ እ᎓ ነ᎓ ᎓ ᎓ ᎓
ወ᎓ ᎓ ᎓ ᎓ ᎓ ᎓ ᎓ ᎓ ᎓ ᎓ ᎓ ᎓ ᎓ ᎓

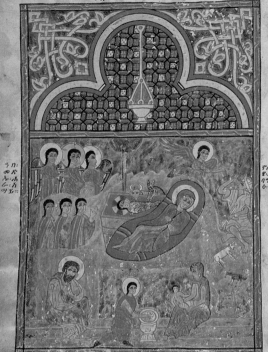

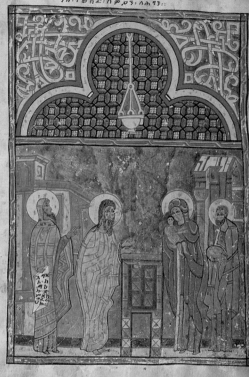

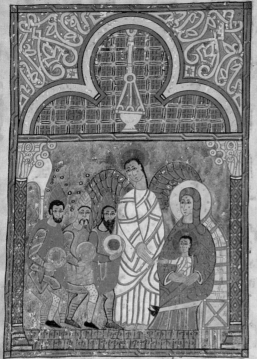
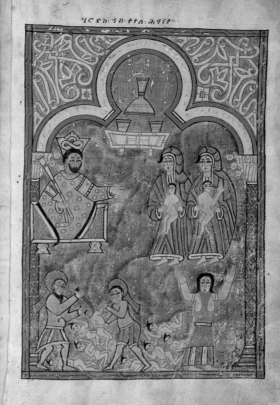

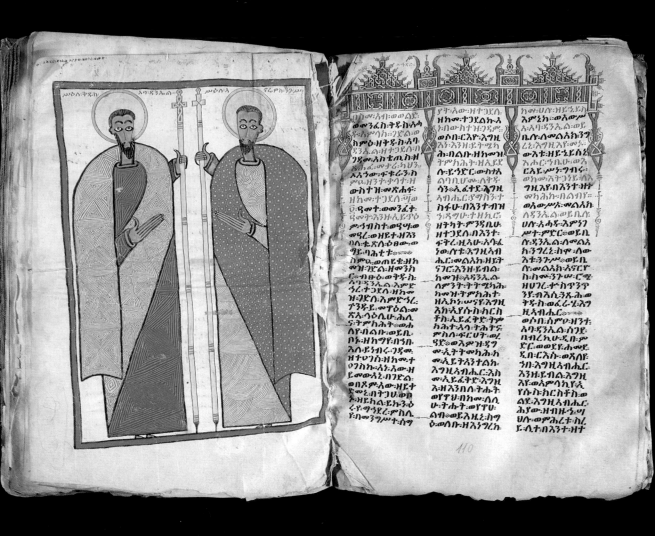

መስሉ፡ታድክት፡ኤጸረሐበ

በእንተ፡እንግድና
ወንቱ፡አስተር፡አል
ይፈዩ፡እስመ፡ወደ
ተራ፡ስክበ፡ወእተ
ወዞሎ፡ወዮሱ፡ስ
ይወቱ፡ወናዝያወሕ
ር፡ስንን፡ዘበየጸወ
ለእግዚአብሔር
በንቡ፡አሕዛበ
ክሙ፡እተ፡በክበ፡ግ
ሙራ፡በስሊ፡ዘ
ሙ፡ያሜክር፡ወ
ዮሰንን፡ምስለ
ታለወጣግበር
ሙኂ፡ሥሮተ፡ወ
ወእተ፡ብእሲ፡
ኤእንኩ፡ሊተ፡ብ
ስተ፡እኃዝ፡ወጣዚ
ወስተ፡እኁተ፡ወደ
እቲ፡ዘወ፡መንን
ሥተ፡እንገ፡ብገናኤ፡
ወገ፡ወለተ፡ዘፈ
ፋደ፡ ስፊ፡ ወከ፡ ሳ፡ዔ
ፈደ፡ክበ፡ወበነ
ሊተ፡ ኂርተ፡እ ስቲ
ተ፡ ወፈ፡ ረ ፡ ሒ ተ፡እ ን
ዘ፡ እብ ከ ር ፡ ወበ ሔ
ት፡ ታ ፋ ቅ ር ፡ በ በ ሊ ፡ ወ
ዘ፡ አ በ ከ ር ፡ ዘ ግ ሐ
ይ ፈ ደ ፡ ታ ስ ተ ረ ፡ ሕ
ት ፡ ለ ስ ል ያ ተ ፡ ወ
ሳ ን ፡ ወ ክ ሩ ን ፡ ሰ ግ
ዕ ት ፡ ወ ተ ደ ሊ ፡ በ ስ ን

ዘእንተ፡እንኩሃ
ወንበ ም ፡ወ ጣ ን ፡ኤ
ተ ጋ ብ ኑ ፡ ወ ዘ ን ፡
ወ ስ ክ በ ፡ ት ፡ በ ር ክ
ቴ ጸ ን ፡ ወ ለ ስ ኤ ህ ዛ ፡
ያ ፈ ቅ ሩ ፡ ይ ጓ ን ፡ ወ ን
ጓ ፡ ት ፡ እ ከ ሙ ፡ ወ ን
ፍ ፡ እ ን ዝ ፡ ደ ሀ ዋ ፡ ል
እ ተ ፡ እ ኩ ፡ አ ስ ከ ፡
እ ን ተ ፡ ከ ሃ ኡ ፡ ዘ ወ
ደ ፡ ዘ የ ፈ ቲ ር ፡ ኡ
ን ዲ ፡ ያ ፈ ቲ ዋ ፡
ስ ሙ ፡ ሰ ር ቀ ፡ ተ ፡ በ ።
ቲ ፡ በ ም ግ በ ር ፡ ወ
ሉ ፡ ኂ ሩ ፡ ወ በ ረ ሀ ዊ ፡
እ ን ግ ፡ አ ብ ክ ር ፡
ወ ስ ለ ሱ ፡ እ ን ኩ ፡ ስ
እ ፈ ሪ ፡ ህ የ ፍ ፡ እ ን ገ
አ ብ ፡ ሊ ፡ ተ ፡ ወ እ ተ
ሎ ፡ አ ሐ ቲ ፡ ወ ስ ተ ፡
ወ ስ ዮ ፡ አ ስ ሁ ፡ አ ስ
ክ ፡ ወ ስ ዳ ፡ ወ ዳ ራ ፡
ከ ፡ ወ ስ ዳ ፡ ወ ስ ፈ
 እ ን ገ ፡ ከ ። ከ ፡ ሃ ዋ ለ ፡
ው ፡ አ ሐ ቲ ፡ ገ በ ቲ ፡
ይ ዲ ፡ ሳ ዝ ፡ በ ጓ ና ሁ ፡
በ ለ ፡ ኂ ፡ ሳ ፡ ወ ሮ ፡ ስ ዳ ፡
ለ ፡ አ ደ ፡ ራ ፡ ከ ፡ ወ ን ።
እ ስ ቲ ፡ ተ ፡ ስ ም ራ ፡ እ ግ
እ ፡ ዘ ፡ ት ፡ ክ ወ ፡ ዘ ዝ ፡ ።
ሕ ይ ፡ ወ ተ ፡ ን ፡ በ ሙ ፡ ነ ል ፡
ፈ ፡ ወ እ ቱ ፡ ወ ጣ ዕ ሰ

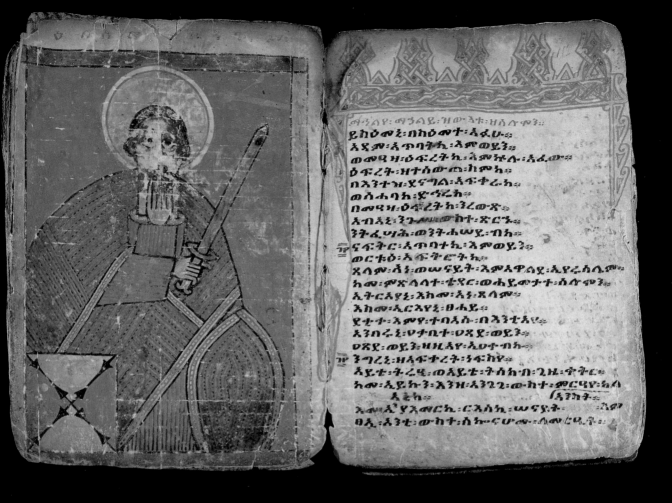

መኃልየ፡መኃልይ፡ዘውእቱ፡ዘሰሎሞን።

ይስዕመኒ፡በስዕመተ፡አፉሁ።
እደው፡እጣባትኪ፡እምወይን።
ወመዓዛ፡ዕፍረትኪ፡እምኵሉ፡እፈው።
ዕፍረት፡ዘተሰውጠ፡ከሞኪ።
በእንተዝ፡ደናግል፡አፍቀራኪ።
ወስሐገኪ፡ድኅሬኪ።
በመዓዛ፡ዕፍረትኪ፡ንሮፀ።
አብአኒ፡ንጉሠ፡ውስተ፡ጽርኁ።
ንትፌሣሕ፡ወንትሐዋየ፡ብኪ።
ናፍቅር፡እጣባትኪ፡እምወይን።
ወርቱዕ፡አፍቀሮትኪ።
ጸላም፡አነ፡ወ ሠናይት፡አዋልደ፡እየሩሳሌም።
ከመ፡ምዕላሳተ፡ቄዳር፡ወሐየ መታተ፡ሰሎሞን።
ኢትርእያኒ፡እስመ፡አነ፡ጸላም።
እስመ፡ኢርእየኒ፡ፀሐይ።
ደቂተ፡እምየ፡ተባእሉ፡በእንቲአየ።
እንበሪኒ፡ሀገበተ፡ውጸደ፡ወይን።
ውጸደ፡ወይን፡ዘዚአየ፡ኢዐቀብኩ።
ንግሪኒ፡ዘአፍቀረት፡ነፍስየ።
እ ይቴ፡ትሬዒ፡ወአይቴ፡ትሰክብ፡ጊዜ፡ቀትር።
ከመ፡ኢይኩን፡እንዘ፡አ ጋጉ፡ወከተ፡መርዓዊ ፡ [እ ]ጋ ዝብ  ክ፡
አ ሌ።
እመ፡አ ያእማርኪ ፡ርእስኪ ፡ ወ ሠ ነ ት ፡ አ ው
ፀ ኢ፡ አ ን ቲ፡ ወ ከ ተ ፡ ስ ኵ ር ሆ ሙ ፡ ሰ ወ ፡ በ ሪ ኀ ።

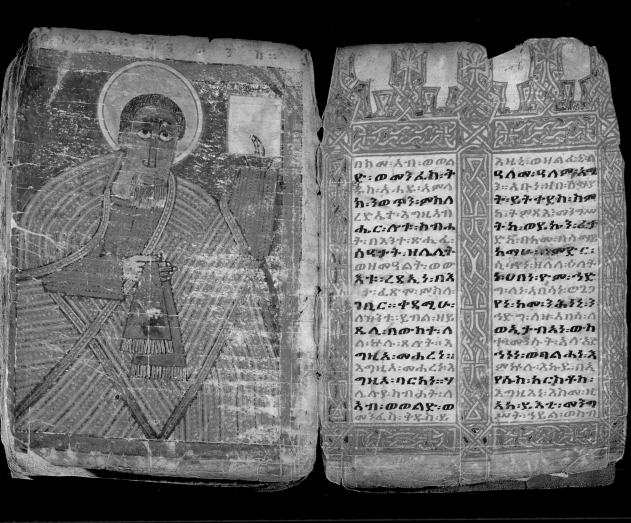

በክመ፡እብ፡ወወለ
ድ፡ወመንፈስ፡ት
ዴክ፡አሐደ፡አምላ
ክ፡ንወጣን፡ምከለ
ረይኤተ፡እግዚእብ
ሔር፡ሶቱ፡ስብሐ
ት፡በእንተ፡ጸሐፊ
ስዋታት፡ዘሴሊት
ወዘመዓልት፡ወ
እቱ፡ረደኢ፡ነ፡በእ
ታ፡ፈደማ፡ምስለ
ገቢር፡ቀደሚሁ፡
ለሁጸት፡ደብል፡ዘይ
ዴሊ፡ከውከተ፡ለ
ሉቱሱ፡ጸሎት፡እ
ግዚኤ፡መሐረኑ፡
እግዚኤ፡መሐረታ፡እ
ግዚኤ፡ባርኸኑ፡ሃ
ሊሉዩ፡ክብሐት፡ለ
እብ፡ወወልድ፡ወ
መንፈስ፡ቅዱስ፡ዩ

እዚኤ፡ወዘለሬ፡�8
ዳለመ፡ዓለም፡አጎ
ን፡አቡን፡ዘበ፡ሰማ
ክ፡ታይት፡ተየስክ፡ክመ
ት፡ታምጸጼ፡መንግሥ
ት፡ክ፡ወይ፡ክን፡ፈ
ኖሽ፡በለመ፡በሰዋ
አጣሙ፡አገምደ፡ር
ሲወን፡ዘለሰ፡ሳሳት
ኑ፡ሀባነ፡ዮም፡ንደ
ግለን፡አበሳ፡ወኃ
የ፡ክመ፡ንኋሬን
ኘደግ፡ለዘ፡አበሳ፡ለ
ወኢታብአን፡ወ
ተመጐክ፡ት፡እሳ፡ለ
ኅነ፡ወባለ፡ሐኑ፡ኛ
ምኞ፡እኩዩ፡በእ
የሉክ፡አርክቶክ፡
እግዜኑ፡እስመ፡ዚ
ኢኬ፡ኢቲ፡ልንግ
አንተ፡ኃይል፡ወክቡ

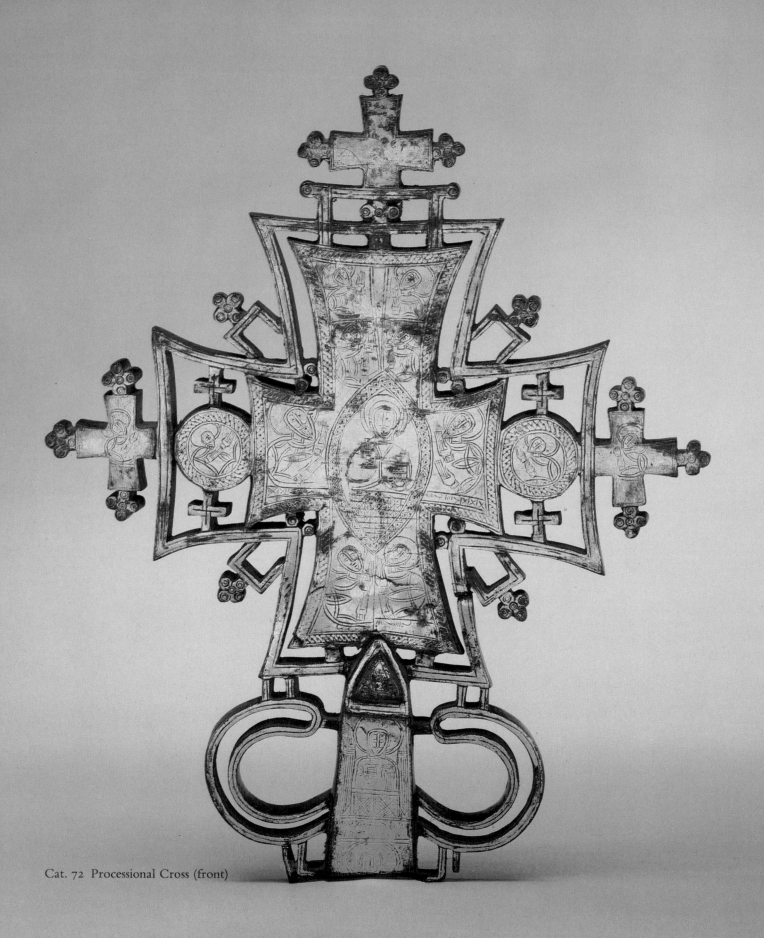

Cat. 72 Processional Cross (front)

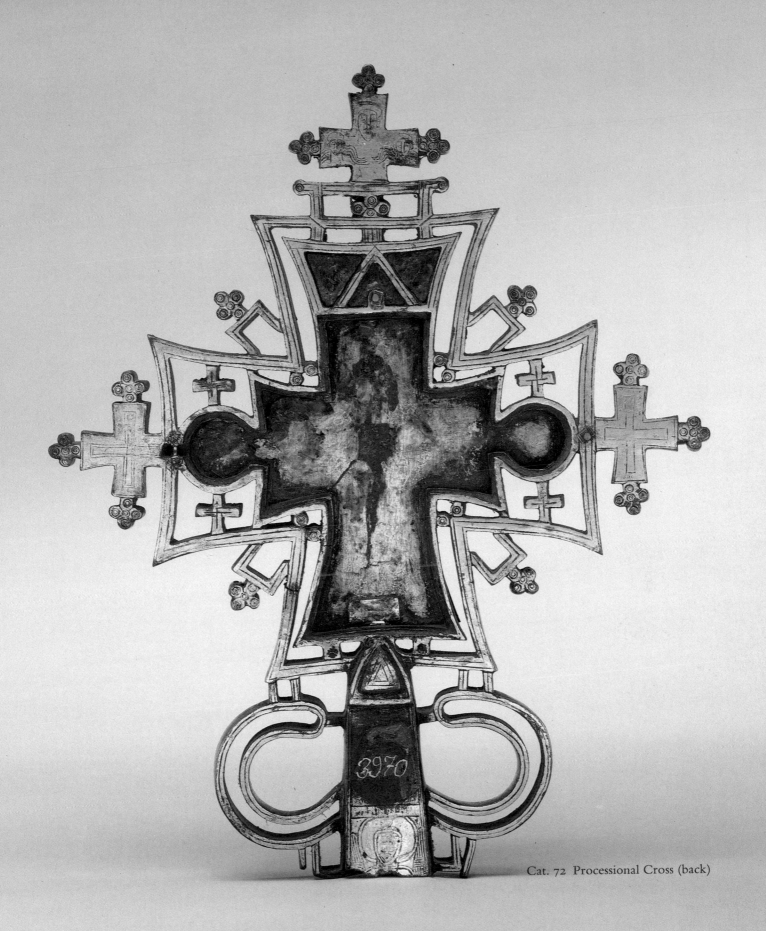

Cat. 72 Processional Cross (back)

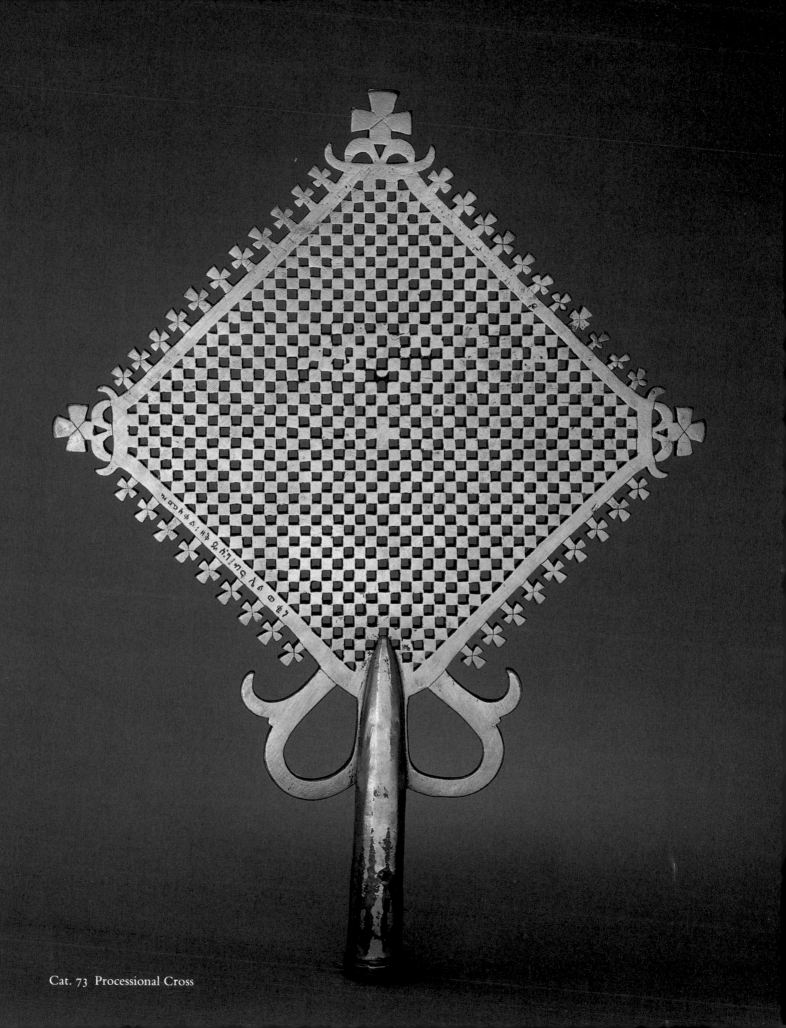

Cat. 73 Processional Cross

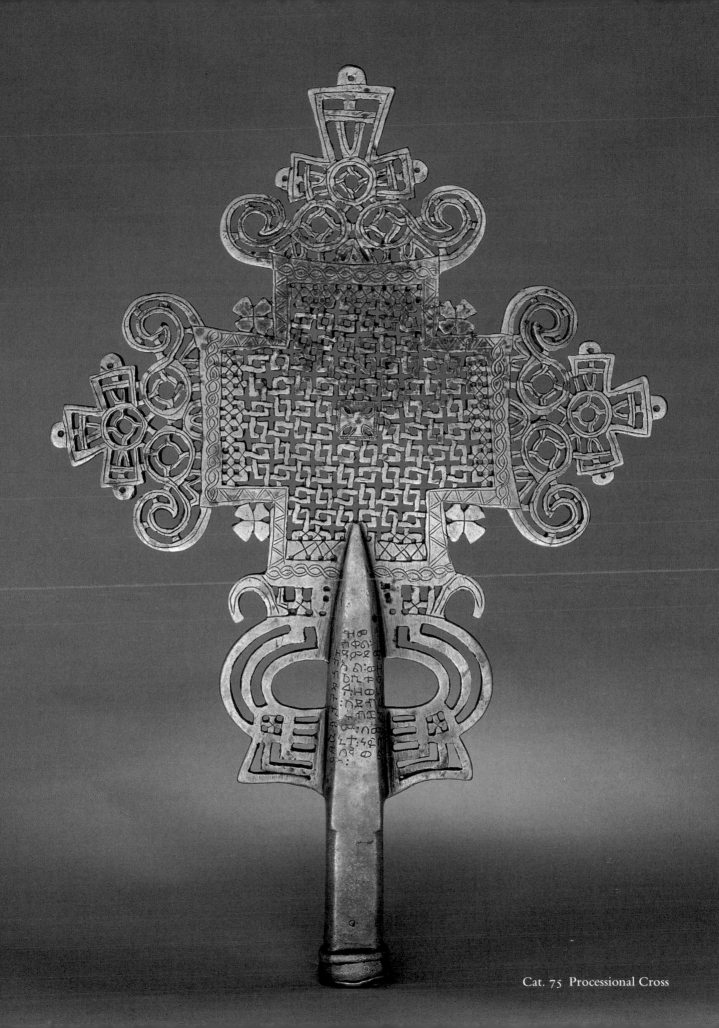

Cat. 75 Processional Cross

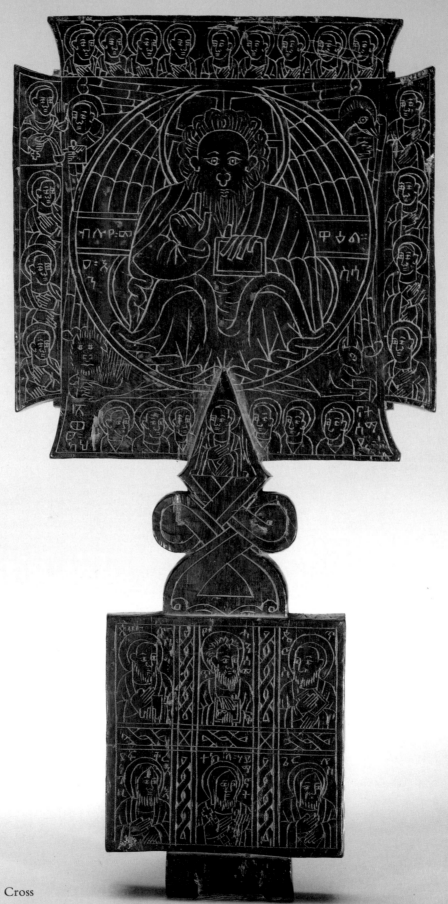

Cat. 78 Processional Cross

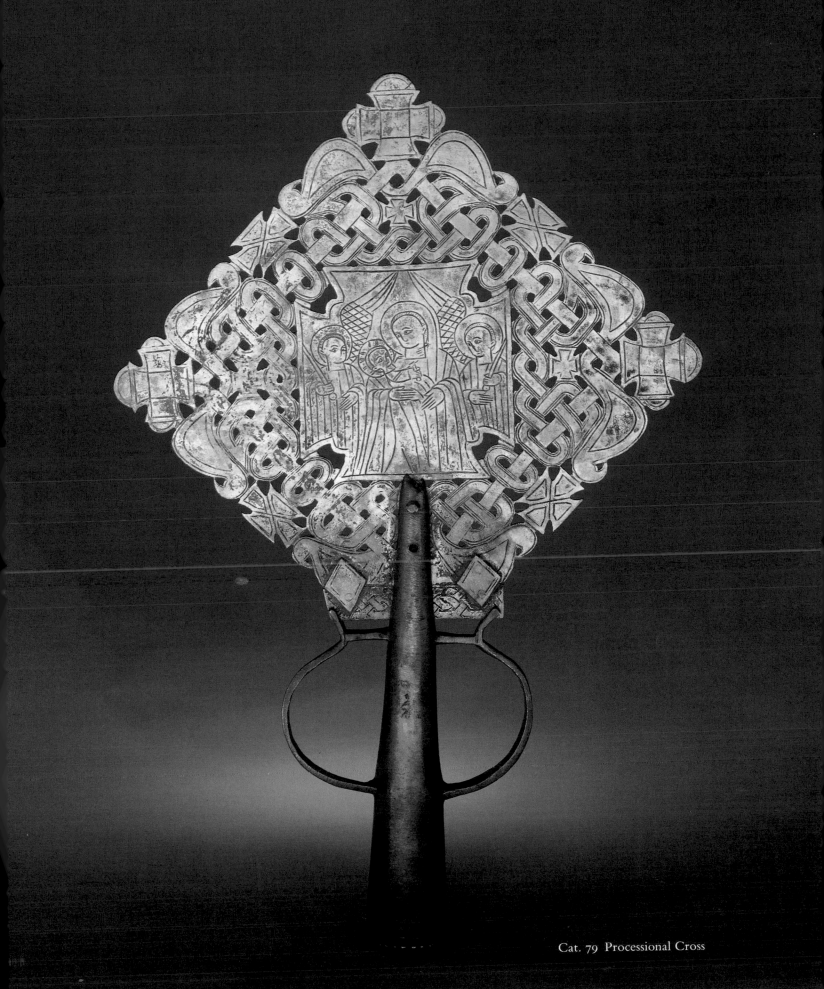

Cat. 79 Processional Cross

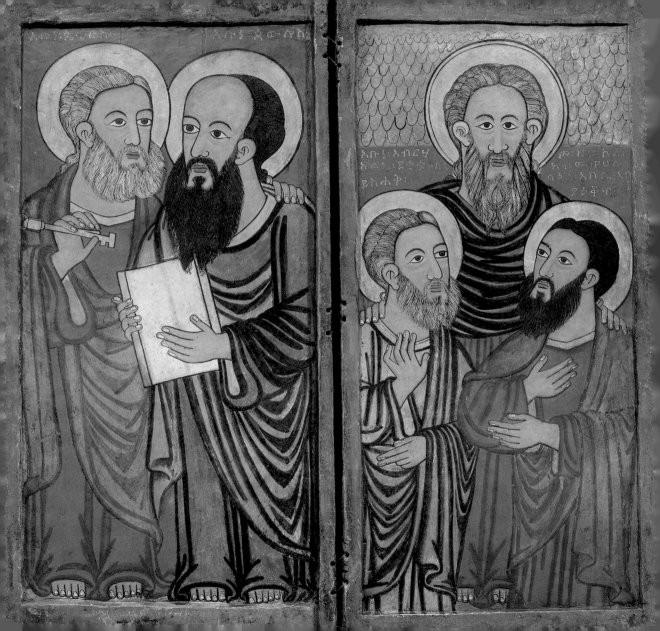

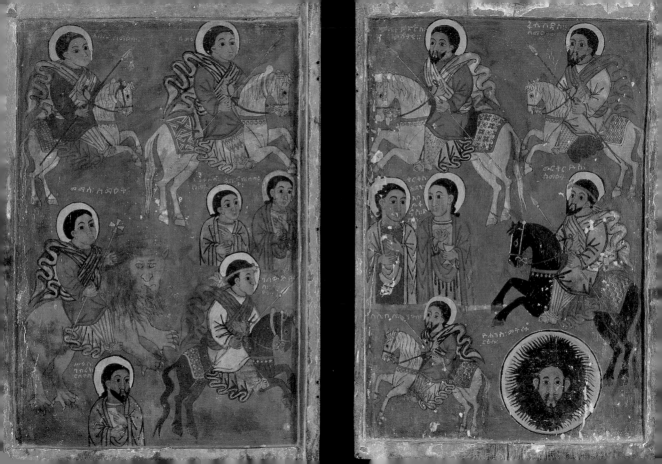

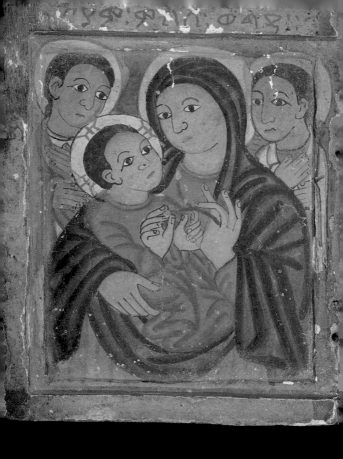

Cat. 82. *Our Lady Mary with Her Beloved Son*

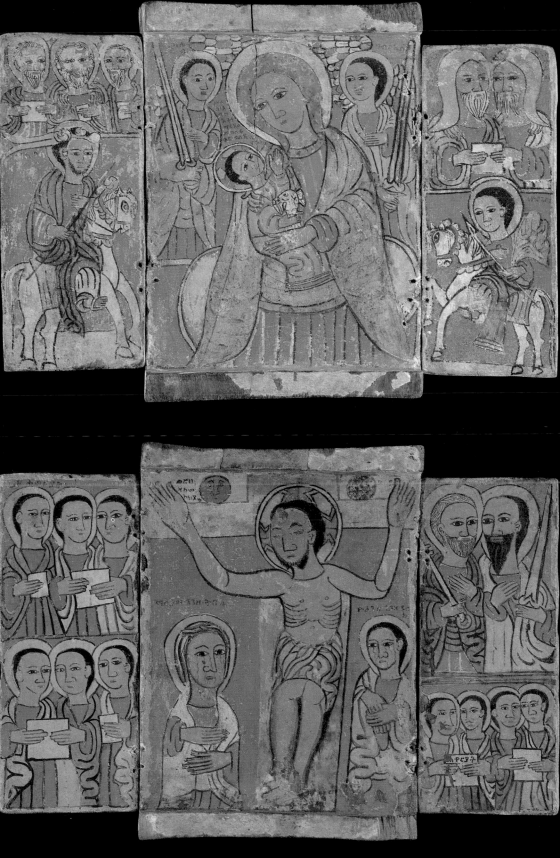

Cat. 85 *Our Lady Mary with Her Beloved Son, Crucifixion*

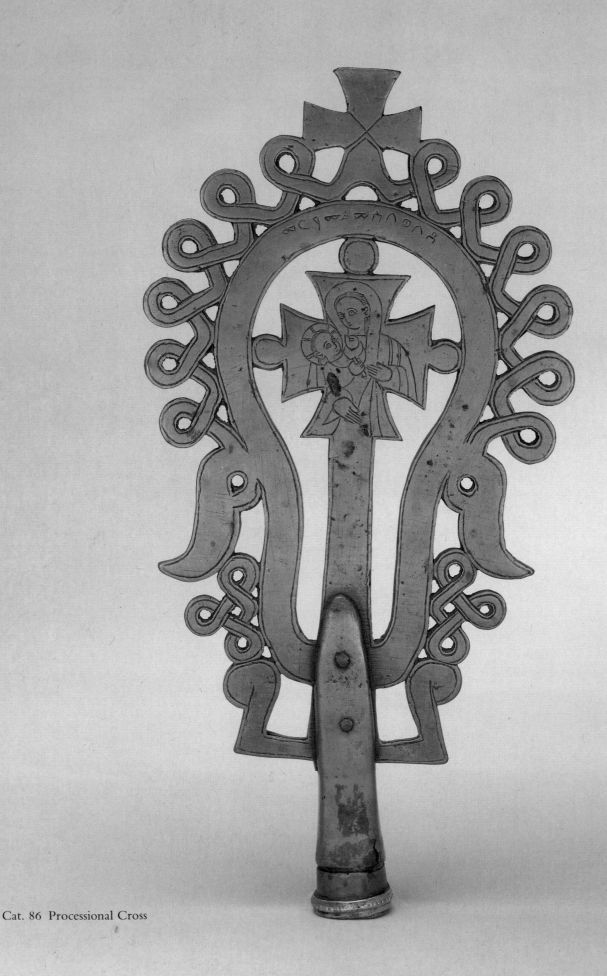

Cat. 86 Processional Cross

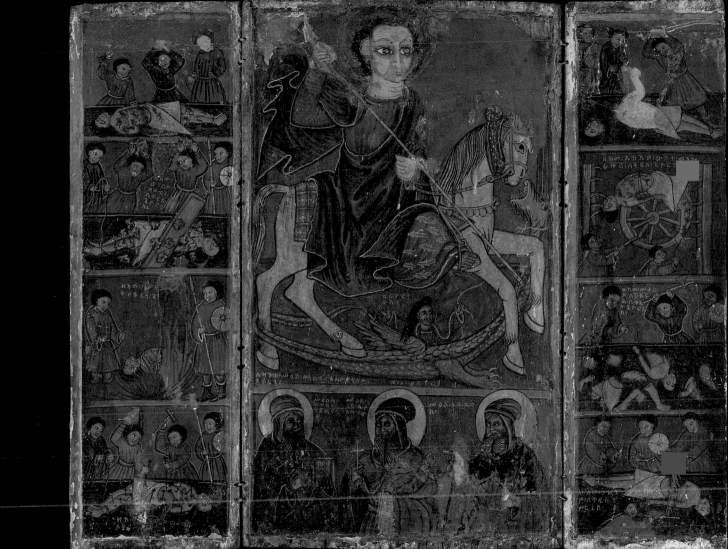

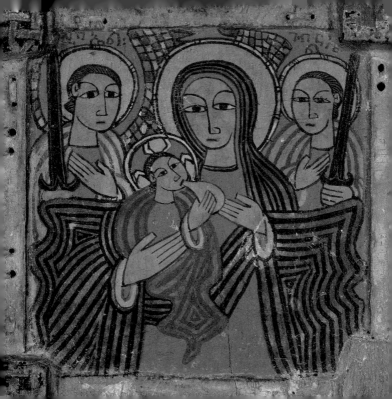

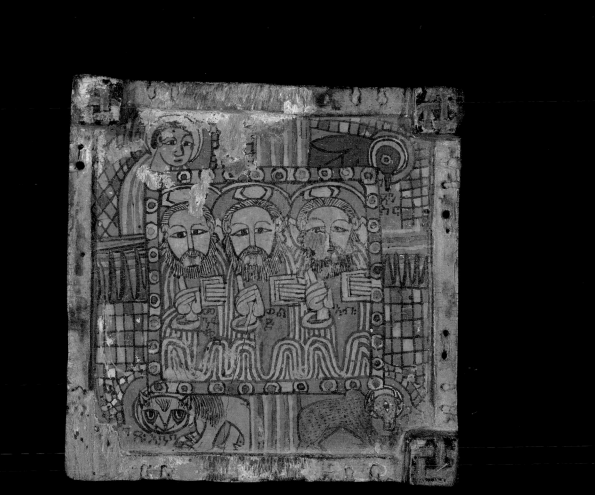

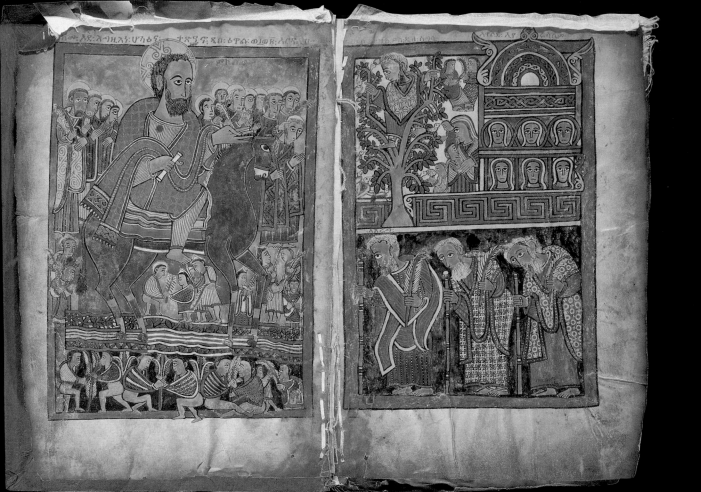

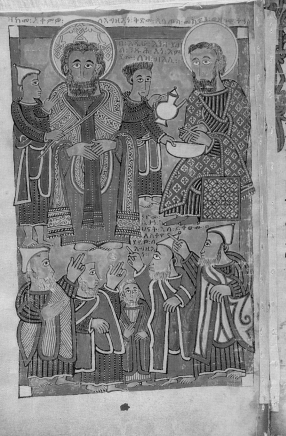

በከመ፡ እቀተሉ፡ ለእግዚእነ፡ ቅዱስ፡ እዴ፡ ለሐዋ፡ እሰ፡ ወእጐ፡ ወጓ፡

ወመዐርቦ፡ ከተሰበ፡ በጳራ፡ ዘየጓገም፡ ወየዘኪ፡ ቶ፡
እሪተ፡ ዘ ዴዓገም፡ ወየ ዘኪ፡ ቶ፡ ው፡ ፋቱኑ፡ በ ከ መ ፡ ይ በ ዬ
ለ፡ መ ሡ ፡ ለ ደ ወ ፡ እ ስ ራ ኤ ፡ ነ ፡ እ ን ዚ ኣ ብ ሔ ር ፡ ወ ለ ጠ
ል፡ እ ሰ ዑ የ ፡ ሰ ኬ ወ ፡ ይ ል ፡ ለ ፡ በ ል ብ ክ ፡ ኮ ብ ፡ እ ጥ
ም ዘ ፡ ወ ዮ ዮ ር ፡ ከ መ ፡ በ ሪ ፡ ፋ ኑ ም ፡ እ ን ዚ ኣ ብ ሔ ር ፡
እ ፡ ተ በ ዑ ኣ ፡ በ ከ መ ፡ እ ሕ ዘ ፡ ለ ው እ ት ው ፡ ሕ ዝ ብ ክ ሂ ፡
ብ ፡ ሾ ሎ ም ፡ እ ሰ ፡ ይ ፈ ሰ ፡ ም ቅ ፡ ለ ፡ ገ ጸ ክ ፡ በ በ ይ ኑ ፡
ው ፡ እ ን ዚ ኣ ብ ሔ ር ፡ ወ ጸ ም ፡ ዘ እ በ ስ ፡ እ ግ ዚ
የ ም ፡ ገ ጸ ክ ም ፡ ከ ማ ሁ ፡ እ ብ ሔ ር ፡ እ ት ዋ ረ ሳ ፡ ለ ዛ
ት ፡ ይ ም ሰ ሉ ፡ እ ስ ከ ፡ እ ስ ፡ ቲ ፡ ም ዮ ር ፡ ቡ ር ከ ታ ፡ እ
ዑ ዕ ክ ፡ ታ ለ ፡ እ ግ ዚ አ ብ ፡ ላ ፡ በ በ ይ ኑ ፡ ን ዊ ች ው ፡
ሔ ር ፡ እ ም ነ ዕ ከ መ ፡ ከ ወ ፡ ለ ው እ ት ው ፡ እ ሕ ዘ ብ ፡ እ ም
ዑ ፡ እ ስ ራ ኤ ፡ ናሁ ፡ እ ት ፡ ፋ ኑ ው ፡ እ ግ ዚ እ ብ ሔ ር ፡
ተ ወ ሀ የ ፡ ለ የ ር ደ ና ስ ፡ ፈ እ ም ቅ ዮ ፡ ገ ጸ ክ ፡ ወ እ ተ ፡
ለ ግ ፡ ከ መ ፡ ት ሕ ዘ ፡ ት ት የ በ በ ይ ኑ ፡ ጀ ይ ቃ ክ ፡ ወ እ ክ
ረ ሱ ው ፡ ለ እ ሕ ዘ ብ ፡ ሀ በ ፡ በ በ ይ ኑ ፡ ን ጸ ል ፡ ል ብ ከ ዘ ፡
ይ ት ፡ እ ለ ፡ ወ ለ ጸ ን ዑ ት ፡ ሀ ረ ፡ ት ቦ ው ን ፡ እ ን ተ ፡ ት ት ዋ ረ ሳ ፡
ት ፡ እ ለ ፡ ይ ጸ ዕ ቁ ፡ አ የ ኑ ፡ ለ ም ዮ ር ም ፡ እ ለ ፡ በ በ የ ፡
ሀ በ ይ ት ፡ እ ለ ፡ አ ራ ፋ ት ክ ፡ ነ ፡ ን ዊ ች ው ፡ ለ ው እ ት
ጀ ር ን ፡ ይ በ ጃ ሕ ፡ እ ስ ክ ፡ ው ፡ እ ሕ ዘ ብ ፡ አ ጥ ፋ ኡ ው ፡
ሰ ዛ ይ ፡ ሕ ፕ ብ ፡ ሀ በ ይ ፡ ወ ፡ ም ፡ ገ ጸ ክ ፡ ከ መ ፡ ይ ፋ ቃ ኪ ፡
ነ ፋ ዕ ተ ፡ እ ለ ፡ ት ብ ሰ ም ፡ ደ ና ፡ ዘ ወ ሐ ለ ፡ እ ግ ዚ አ ብ ፡
እ ን ተ ፡ ወ ታ እ ም ር ፡ የ ም አ ፡ ሔ ር ፡ ለ ስ በ ዊ ከ መ ፡ ለ ስ ፡
ው ፡ እ ን ዚ አ ብ ሔ ር ፡ እ ም ፡ በ ር ሀ ም ፡ ወ ለ ይ ስ ሐ ቅ መ ፡
ሰ ኬ ክ ፡ የ እ ም ር ፡ ወ ዘ ም ፡ ለ የ ዕ ቆ ብ ፡ ወ ተ እ ም ር ዮ ፡
ገ ጸ ክ ፡ እ ስ ት ፡ ዘ ይ ዊ ዮ ኣ ፡ ም ፡ ከ መ ፡ እ ኮ ፡ በ በ ይ ነ ፡ ሻ
ው እ ት ፡ ወ ው እ ት ፡ ይ ሴ ር ፡ ይ ቅ ክ ፡ ዘ ይ ሁ ስ በ ፡ እ ግ ዚ
ዮ ው ፡ ወ ው እ ት ፡ ዮ ን ት ፡ አ ብ ሔ ር ፡ ለ ራ ሀ አ ክ ሱ ት ት
ው ፡ እ ም ቅ ዮ ፡ ገ ጸ ክ ፡ ወ ፡

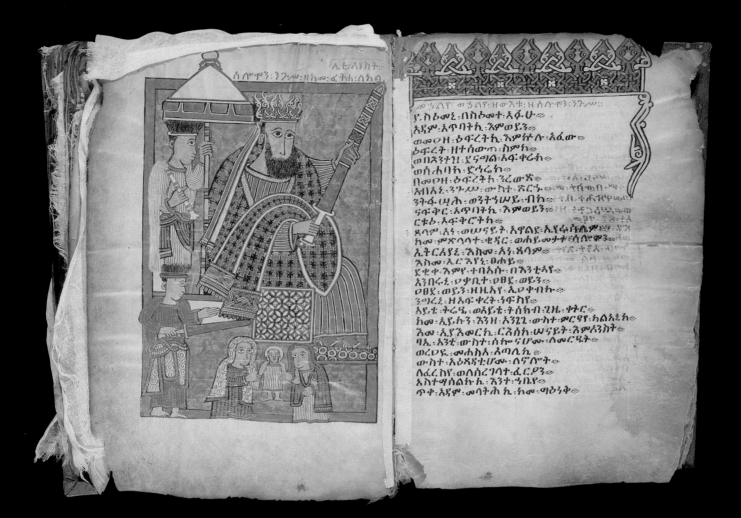

መዓልየ፡ ወዓልየ፡ ዘዉእት፡ ዘ ሰሎሞን፡ ንጉሠ።
የ፡ ስዕመኒ፡ በስዕመተ፡ እፉ ሁ።
አያዳም፡ አጥባትኪ፡ እ ምወይን።
ወመዐዛ፡ ቅፈረትኪ፡ እም ዕ ሉ፡ እሪ ው።
ዕፉረት፡ ዘተ ሰወጠ፡ ስምክ።
ወበእን ትዝ፡ ደናግል፡ አ ፉ፡ ቀ ራክ።
ወሰ ሐ ባክ፡ ድ ሳሬ ክ።
በ መዐዝ፡ ዕ ፉረ ትክ፡ ንረ ው ጽ።
አብአኒ፡ ን ጉሠ፡ ውስተ፡ ጽር ኍ።
ን ት ፈ ሣ ሕ፡ ወን ት ን ሠ ይ፡ ብ ክ።
ና ፉ ቀ ር፡ አጥ ባ ት ኪ፡ እ ም ወ ይ ን።
ር ቱ ዕ፡ አ ፉ ሮ ት ክ።
ጸ ዓ ም ፡ አ ነ ፡ ወ ሠ ና ዪ ት ፡ አ ዋ ል ደ ፡ ኢ የ ሩ ሳ ሌ ም።
ክ መ ፡ መ ጸ ሳ ዕ ተ ፡ ቂ ዳ ር ፡ ወ ሐ የ መ ተ ፡ ሰ ሎ ሞ ን።
ኢ ት ር አ የ ኒ ፡ እ ስ መ ፡ አ ነ ፡ ጸ ዓ ም።
እ ስ መ ፡ ኢ ር እ የ ኒ ፡ ፀ ሐ ይ።
ደ ቂ ቀ ፡ እ ም የ ፡ ተ በ እ ሱ ፡ በ እ ን ቲ አ የ።
አ ን በ ሩ ፊ ፡ ዐ ቃ ቤ ተ ፡ ዐ ፀ ይ ፡ ወ ይ ን።
ዐ ፀ ይ ፡ ወ ይ ን ፡ ዘ ዚ አ የ ፡ ኢ ዐ ቀ ብ ኩ።
ን ግ ረ ኒ ፡ ዘ አ ፉ ቀ ረ ት ፡ ነ ፉ ስ የ።
እ የ ቲ ፡ ት ራ ዔ ፡ ወ አ ይ ቲ ፡ ት ሰ ክ ብ ፡ ገ ዜ ፡ ቀ ት ር።
ክ መ ፡ ኢ ይ ኩ ን ፡ እ ን ዘ ፡ አ ን ገ ገ ፡ ው ስ ተ ፡ መ ር ዔ የ ፡ ካ ል አ ኒ ክ።
እ ለ ፡ አ የ ን ወ ር ኪ ፡ ር እ ሰ ክ ፡ ሠ ና ይ ት ፡ እ ም ነ ን ት ።
ፃ ኢ ፡ አ ን ቲ ፡ ው ስ ተ ፡ ሰ ኮ ና ሆ ሙ ፡ ለ መ ር ዔ ት ።
ወ ር ዐ ዬ ፡ መ ሐ ስ አ ፡ አ ጣ ሊ ኪ ።
ው ስ ተ ፡ አ ዕ ጻ ጻ ቲ ሆ ሙ ፡ ለ ኖ ሎ ት ።
ለ ፈ ረ ስ የ ፡ ወ ለ ሰ ረ ገ ላ ተ ፡ ፈ ር ዖ ን ።
እ ስ ተ ዋ ሰ ል ኩ ኪ ፡ እ ን ተ ፡ ኅ በ የ ።
ጥ ቀ ፡ አ ዳ ም ፡ መ ላ ት ሕ ኪ ፡ ከ መ ፡ ዋ ዕ ነ ቅ ።

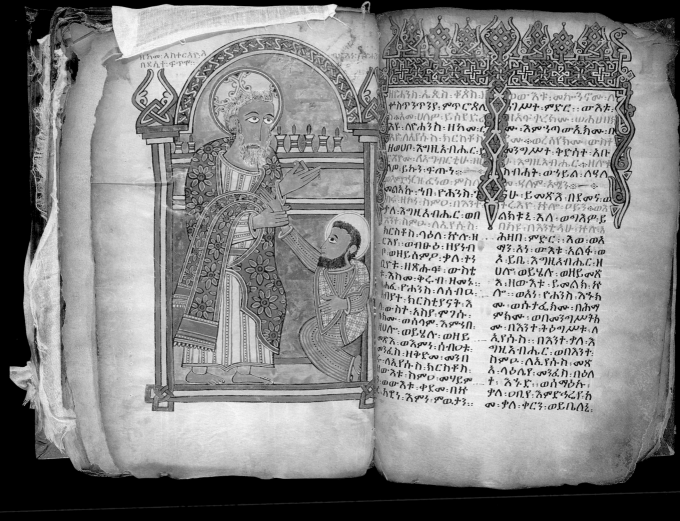

ዕዝራ ፡ ፫ ፡ መጽሐፈ
ዘዘ ፡ ፫ ፡ የውጣ ፡ ማበ
ሊያተ ፡ ስብሐ ፡ ፳ ፡ ወ
ክብቡ ፡ ፴ ፡ መንፈሰ
ጌሳይ ፡ ፭ ፡ እፖስ ፡ ገባ
ያተ ፡ ንኡ ፡ ፩ ፡ ወ፪ ፡
ስሂያክ ፡ ነግደ ፡ ፱ ፡ እር
ምያክ ፡ ነቢይ ፡ ፱ ፡ ሕሙ
ቅሴል ፡ ነቢይ ፡ ፱ ፡
ወንጌል ፡ ፱ ፡ ሐዋርያ ፡
ግበር ፡ ፳ ፡ ዘ ጻውሎ ፡
መ ሊ እ ኩተ ፡ ፩ ፡ ወ ፩ ፡
ሐ ዋ ር ያ ት

ዘ ዘ ት ፡ እ ን እ ፡ በ እ ን
ት ሥ ር ዐ ት ፡ ለ ክ መ ተ ሀ
ሮ ፡ እ ም ን ጴ ፡ ኢ ጻ ክ
ቶ ጾ ብ ክ ፡ ወ እ ን ተ መ ፡ ሀ
እ ን ዘ ተ ሃ ሬ ል ወ ፡ ፖ ተ ተ ፡
ን ኑ ፡ ወ ስ ል መ ፡ ተ ረ ክ ፡
ወ እ ስ ኢ ተ ዘ ዘ ሕ
ት ክ ኩ ን ኑ ፡ ወ ሕ ጊ በ
ደ ሮ ቲ መ ፡ ፡ ዘ ሰ ፊ ት ረ
ክ ዉ ፡ ኩ ን ኑ ፡ በ ኢ ተ ዕ ጸ
ዘ ዘ መ ቴ ተ ወ ፡ ተ ች ፡ ኤ
ኒ ፡ ወ ይ እ ዜ ኒ ፡ ወ ዘ ፊ ል
ፊ ሰ ዳ ሰ ወ ፡ ዓ ለ ም ፡
ሜ ን

ዘ ን ተ ፡ ሒ ን ፡ ዳ ቡ ፡ ዘ ዘ ሞ ር
ያ ተ ፡ ተ ዱ ሰ ፡ ዘ ን ገ ሬ ፡ ተ ለ
ም ነ መ ፡ ወ የ ኢ ት ፡ ት ብ
መ ፡ ል ብ ዋ ስ ት ፡ ዘ ሐ
ብ ር ፡ ል ቲ ፡ እ ር ጸ ኢ ሁ ፡
ለ እ ግ ዜ ኢ ን ፡ ክ ር ከ ት ክ
ወ ና ለ ከ ፡ ፡ ፻ ፡ ወ ፬ ፡ ት እ
ዘ ዘ ፡ ፩ ፡ በ እ ን ት ፡ ሄ ለ
ት ፡ ኢ ጻ ክ ፡ ተ ጾ ስ ት ፡ ወ ሀ
ታ ፡ ጾ ጾ ሰ ተ ፡ ወ በ ፎ ን ፡ ፩
ሄ ሰ ፡ የ ሃ ሰ ወ ፡ ኢ ጻ ክ
ተ ጾ ስ ት ፡ ለ ሃ ሌ መ ተ ፡ ሊ ቲ
ጻ ጾ ስ ት ፡ ኢ ክ መ ፡ ኢ ሄ
ት ራ አ ም ፡ ዘ ን ተ ፡ ዘ ዘ ን ጾ ብ
ለ ፡ በ ሀ ለ ዊ ፡ ጉ ባ ኤ ሁ መ ፡
ለ ኢ ጻ ክ ፡ ተ ጾ ስ ት ፡ ወ ሀ
ሰ ፡ መ ጥ ር ፡ ብ ሊ ጥ ፡ ዘ ሙ
እ ተ ፡ እ ጻ ክ ፡ ፀ ኒ ገ ር ፡
ክ ቡ ፡ ለ ስ ፡ ሀ ለ ወ ፡ ወ ስ
ች ወ ን ተ ፡ መ ክ ፡ ፡ ወ ሂ
እ ዘ ም ፡ ለ ክ ል ን ፡ ሐ
ዘ ዘ ብ ፡ በ ፬ ን ረ ፡ መ ለ እ
ክ ቲ ሁ መ ፡ ፡ ፭ ፡ ተ ና ና ፡
እ ም የ ፡ ብ ተ ክ ፡ ዘ ስ ም ፝
እ ዊ ክ መ ፡ ኢ ሠ ሃ ም ፝ ኢ
ጻ ክ ፡ ተ ጾ ስ ፡ ወ ይ ክ ን ፝ ፡
ዘ ን ተ ፡ በ ክ ም ሪ ት ፡ ሰ ብ

እ ብ ሊ ጹ ፡ ሦ ስ ም ፡ ወ
ሄ ኩ ን ፡ ጾ ጾ ስ ፡ አ ው ሊ ተ ፡
ጾ ጾ ስ ት ፡ ዘ የ መ የ ዎ ፡ ወ
ዘ ሃ ሰ መ ፡ ሲ ዛ ሰ ፡ ተ ኢ ጻ ፡
ለ ፡ ተ ጾ ስ ት ፡ ፭ ፡ አ መ ፡ ፻ ፡
እ ክ መ ፡ ዘ ን ተ ፡ ዘ ዚ ዎ ከ የ
ም ን ጾ ፡ ወ ሂ ለ ተ ፡ ተ ሰ
ከ ፡ ወ ዲ ያ ፍ ኝ ፡ ወ ሂ ደ ፡
አ ሕ ፡ እ ም ዑ ተ ፡ ኢ ጻ ክ
መ ፡ ወ ክ ተ ፡ መ ሃ ር ፡ ሀ
መ ፡ በ በ ፡ ሦ ር ያ ተ ፡ ክ ቡ
ን ፡ በ ሠ ም ረ ተ ፡ ኤ ለ ፡ ያ
ሰ ፡ ቱ ፡ መ ፡ ፡ ፪ ፡ ቀ ና ና ፡
እ ሜ ፡ ኢ ጻ ክ ፡ ተ ጾ ክ ፡ ኢ
ው ፡ ተ ሰ ክ ፡ አ ው ፡ ዲ ያ ቶ
ን ፡ ዘ ተ ተ ደ ዮ ፡ ሕ ጊ ክ ር
ክ ተ ች ፡ በ ወ ስ ጥ ፡ ት ም ር ፡
ዓ ን ፡ ወ አ ት ረ ፡ ያ ፡ ዲ ያ ፡
ሠ ዋ ሂ ፡ መ ና ር ፡ አ ው ፡ ሐ
ሊ በ ፡ ወ ስ መ ፡ አ ተ ር ፡
በ ፡ ሀ ፎ ን ት ፡ ክ ተ ፡ ወ ደ ን ፡
ክ ተ ፡ ሰ ክ ር ፡ አ ው ፡ እ ም ፡
አ ም ያ ክ ፡ ዘ ን ጾ ር ፡ ፎ ን ፡
ሰ ተ ፡ አ ው ፡ በ ፅ ደ ፡ ፡ ወ ዲ
ም ን ተ ፡ ሄ እ ን ስ ስ ተ ፡ ኢ

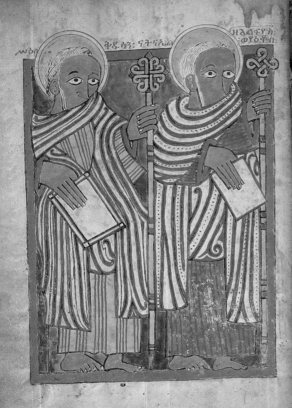

ቀዱሳን፡ ናትናኤል        ዘጸልፎይስ፡ ወየዕቆብ

ታርንጓ፡ ዜሰፉ፡ ታላፃ፡ ዘ         ዝ፡ አብሐር፡ዘንጉ፡በእንተ፡ዕ
ርንሥ፡የዕክ፡አፈ፡ወርቅ፡ሊ         በየ፡ ጥበ፡ዘሪ ሳይንደ፡ሙሲ
ቁ፡ ጸደ ሳት፡ ዘ ዎ ዕ ብ ጥ ፡ ፐ ን ዓ         ወይ ፁ ፀ ፡ በ እ ን ተ ፡ ታ ላ ፀ፡
ግር፡በእንተ  ፡ ታ ላ ፀ ፡ ዘ ነ በ ፡         ሆ ሉ፡ ወ ክ ተ ፡ ገ ዝ ፋ ፡ ጸ ላ ፀ ፡ ዘ
እ ግ ዜ ፡ አ ብ ሐ ር ፡ ለ ሙ ሊ ፡ በ ደ         ብ ን ፡ ወ ደ ፍ ፡ ብ ር ሳ ፡ ለ ዩ ፡ ፍ ት
ብ ረ ፡ ሲ ና ፡ ወ ደ ም ፀ ፡ ዒ ደ ዝ ፡ ኤ የ ደ         ወ ለ ክ ፀ ፡ ወ ዓ ይ ፡ ይ ሊ ባ ሴ ፡ ብ
የ ሕ ፡ አ ፍ ቀ ር ፡ ከ ብ ሐ ተ ፡ እ ግ ሐ         ቀ ደ ም ፡ እ ግ ዜ ፡ አ ብ ሐ ር ፡ ና ፡ ወ በ
አ ብ ሐ ር ፡ ዘ አ ል ፀ ፡ ማ ል ቴ ፡ ወ ሐ         ቀ ሬ ን ፀ ፡ ወ በ የ ፀ ፡ ከ ተ ፡ በ እ ን ተ ፡ ጸ ላ ፀ ፡
ኤ የ ፀ ፡ ማ ል ቀ ፡ እ ስ ክ ፡ ለ ዳ ለ ፀ ፡         ሐ ሁ ፡ ወ እ ሱ ፡ ተ ፡ ያ በ ደ ሐ ክ ፡ ወ
ወ ለ አ ው ፡ ፍ ተ ፡ ክ ፀ ፡ እ ም ር ፡ አ         ክ ተ ፡ ወ ቢ ፡ ሐ ፡ የ በ ጸ ፡ ሐ ፀ ፡ ወ መ የ ፀ ፡
እ ም ር ፡ በ እ ን ተ ፡ ዘ ፀ ሰ በ ፡ ፀ         ሃ ዓ ፡ ወ ለ አ ው ፡ ፍ ቀ ደ ፡ ክ ፡ ታ ፡
ደ ፡ ሙ ሊ ፡ ሐ ፡ ዬ ፍ ፀ ፡ እ ም አ ኩ ፡ ሐ         ም ር ፡ ዘ ፀ ሐ ፡ ሥ ሉ ፡ ዝ ፡ ም ፡ ደ ፡ ስ
ብ ፀ ፡ ከ ፀ ፀ ፡ ዘ ፀ ፡ የ ፀ ፡ ዕ ፀ ፡ አ ፀ ፀ         ማ ፡ ዘ ለ የ ፡ ዕ ፀ ፡ ታ ለ ፡ አ ፀ ፀ
ዘ ፡ ነ በ ር ፡ ሊ ፡ ሙ ሊ ፡ ም ፀ ፡ ዕ ፀ ፀ         ፀ ፀ ፡ ዘ ደ ር ፡ በ ለ ፡ ዘ ፡ ክ ፀ ፡ አ ለ ፀ ፡
ወ ፍ ላ ፀ ፡ ለ ዕ ፡ ደ ብ ር ፡ እ ን ሐ         እ ዝ ፡ ዓ ዕ ፀ ፡ ፀ ፡ ዘ ፀ ፡ ለ ዕ ፡ ደ ፡ በ ር ፡
የ ፀ ና ፀ ር ፡ ም ክ ስ ፡ እ ግ ፀ ፡ አ ብ ሐ         ወ ወ ሰ ፡ ወ ታ ፡ ወ ጥ ፀ ፡ ዕ ፀ ፡ ወ
ር ፡ እ ን ዝ ፡ ፀ ፀ ፡ ም ፀ ፡ የ ር ፡ ዕ ፀ ፡ ዘ ዕ ፀ         ፀ ፡ ገ ፀ ፡ ከ ፀ ፀ ፡ ዘ ፀ ፡ አ ፀ ፀ ፡ ዘ
እ ም ዕ ፀ ፡ ወ ፀ ፀ ፡ ፀ ፀ ፡ ም ፡ ዳ ፡ ፀ ፀ         ፀ ፡ ፀ ፀ ፡ ወ ፀ ፀ ፡ ፀ ፡ ዕ ፀ ፡ ተ ፡ ዓ ፀ ፀ ፡ ፀ ፡ ገ ፀ ፡
በ ፀ ፡ ፀ ፡ ጸ ፀ ሕ ር ፡ በ ፀ ፀ ፡ ወ ክ ተ ፡         ሙ ፡ ወ ፀ ፀ ፡ ፀ ፡ ለ ፀ ፀ ፡ ፀ ፀ ፡ ፀ ፀ ፡ ሀ
መ ፀ ፍ ፡ ፀ ፀ ፀ ፡     እ ክ ፀ ፡ መ ፀ         ሙ ፡ ወ ፀ ፀ ፀ ፡ ፀ ፡ ወ ፀ ፀ ፡ ፀ ፡ ፀ ፀ ፡ ኝ
ዕ ፀ ፡ ዘ ወ ፀ ፀ ፀ ፡ ፀ ፀ ፀ ፀ ፡ ር ፡ ዕ ፀ ፡ ሐ         ለ ፀ ፀ ፡ ከ ፀ ፡ ወ ፀ ፀ ፡ ፀ ፀ ፀ ፡ ኝ ፡ ፀ ፡ ፀ
ሙ ለ ፡ ወ ል ፡ በ ለ ፀ ፡ ሐ ፀ ፡ ክ ፀ ፡ ወ         ፀ ፡ ወ ፀ ፡ ዕ ፀ ፡ አ የ ፀ ፀ ፡ ፀ ፀ ፡ ፀ ፡ በ ፀ
እ ፀ ፀ ፀ ፡ ማ ፀ ፡ ወ ፀ ፡ ሐ ከ ፀ ፡ ወ ለ ፀ         ሉ ፡ ፀ ፀ ፡ ወ ፀ ፡ ም ፀ ፡ ዕ ፀ ፡ ወ ፀ
ም ፡ በ እ ን ተ ፡ ዘ ፀ ለ ፡ ዕ ፡ ፀ ለ ፀ ፡ ወ         ፀ ፡ ር ፡ ክ ፡ ፀ ፡ ም ፀ ፡ ፀ ፡ ወ ፀ ፡ ፀ ፡
ክ ፀ ፡ ወ ፀ ፀ ፡ ፀ ፀ ፡ ፀ ፀ ፡ ቀ ፀ ፡ ሀ ፀ ፀ         ፀ ፡ ወ ፀ ፡ ከ ፀ ፡ ፀ ፀ ፡ ዓ ፀ ፡ ፀ ፡ ዕ ፀ
ግ ዝ ፀ ሐ ር ፡ ሀ ፀ ፀ ፡ ወ ፀ ፀ ፡ ፀ ለ ፀ         ፀ ፡ ከ ፡ ክ ፡ ፀ ፡ እ ን ፡ ወ ፡ ት ፀ ፡ ከ ፀ ፡ ፀ ፡
ተ ፡ ወ ፀ ፡ ሲ ለ ፀ ፡ ሐ ፀ ፀ ፀ ፀ ፡ ወ ፀ         በ ፡ ደ ፡ በ እ ን ተ ፡ አ ፀ ፡ ክ ፀ ፡ ከ ፡ ፡ ዝ ፡
ቀ ፡ ዘ ፀ ፡ ም ፀ ፡     በ ፀ ፀ ፡ ዘ ፀ ፡ ለ         ተ ፡ ፀ ፡ ፀ ፡ ግ ፀ ፡ ፀ ፀ ፡ ፀ ፡ ፀ ፡ ፀ ፀ ፡
እ ፀ ፡ ፀ ፀ ፡ ወ ክ ፀ ፀ ፀ ፡ በ ፀ ዕ ፀ ፡ ም         አ ፀ ፀ ፡ ፀ ፡ አ ፀ ፀ ፡ አ ፀ ፀ ፡ ወ
ኮ ሉ ፡ ዘ ፀ ፀ ፡ ፀ ፀ ፡ በ እ ን ተ ፡ ፀ ፀ ፡ ፀ         እ ፀ ፡ እ ፀ ፡ አ ፀ ፀ ፡ ከ ፀ ፡ ወ ፀ ፡ ፀ ፀ
ተ ዕ ፀ ፀ ፡ ፀ ፡ በ እ ን ተ ፡ ደ ፡ ወ ፀ ፀ ፡         ፍ ቀ ር ፡ ለ እ ግ ሐ ፡ አ ፀ ፀ ር ፡ ፀ
ሐ ፀ ፀ ፡ ወ ፀ ፀ ፡ እ ፀ ፡ ደ ፡ ወ ፀ ፡ ፀ ፡         ላ ፡ ፀ ፡ ክ ፡ በ ፀ ፀ ፡ ፀ ፀ ፡ ወ ፀ ፀ
ፀ ፀ ፡ ዘ ፀ ፡ ፀ ፀ ፡ ፀ ፀ ፡ ፀ ፀ ፀ ፀ ፡ ፀ         ሉ ፡ ፀ ፀ ፡ ወ ፀ ፀ ፡ ፀ ፡ ፀ ፀ ፡ ፀ ፀ ፡
ፀ ፡ ፀ ፀ ፡ ፀ ፀ ፀ ፡ ፀ ፀ ፀ ፡ ወ ፀ ፀ ፀ ፀ ፡         ዘ ፡ ፀ ፀ ፀ ፡ እ ፀ ፀ ፡ ፀ ፡ ፀ ፀ ፡
ወ ፀ ፀ ፀ ፀ ፡ ፀ ፀ ፡ ፀ ፀ ፀ ፀ ፀ ፡ ፀ         ፀ ፀ ፀ ፀ ፡ ፀ ፡ እ ፀ ፡ ም ፡ ፀ ፡ ከ ፀ ፀ ፡
ፀ ፀ ፀ ፡ እ ፀ ፡ ፀ ፀ ፀ ፀ ፡ ፀ ፀ ፡ ፀ ፀ         አ ፀ ፡ ዕ ፡ ወ ፀ ፡ ፀ ፀ ፡ ፀ ፀ ፀ ፀ ፀ
ፀ ፀ ፡ ፀ ፀ ፡ እ ፀ ፀ ፡ ፀ ፡ ዕ ፡ ፀ ፡ ፀ         እ ፀ ፡ እ ፀ ፀ አ ፀ ፀ ፀ ፡ ፀ ፀ ፀ ፡ ዘ ፀ ፀ

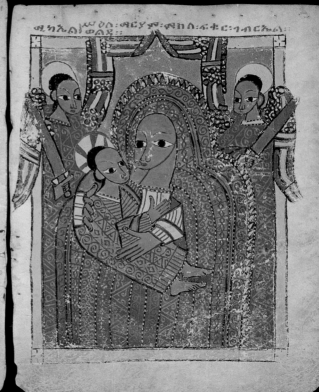

ፈ፡ገብርኤን
ስላዕቱ፡ክ
ርስቶስ፡
በረከቱ፡
ተሀዩን፡ስ
ዕሴን፡እ
ዲን፡እ

በስመ፡እብ፡ወወ
ልድ፡ወመንፈስ፡
ቅዱስ፡፡ገድል፡ወ
ከምዕ፡ዘብፁዕ፡
ወቅዱስ፡ዐማደ፡ሃ
ይማኖት፡ማሳቴ
ት፡ክርስቲያን፡እ
ብ፡እስጢፋኖስ፡
ሰባሴ፡እክሊል፡
ዘፈጸመ፡በድር፡
በጽንዐ፡መዊእ፡
በሀገረ፡ጓትር፡
በመንባለፉ፡ስ

ደብ፡ፀር፡፡፡
ወኮን፡ክሳሉ፡ስ
መዑ፡እመ፡ነወጊ፡
ለወርኁ፡ታኅሣ
ሥ፡በስላመ፡እግ
ዚ፡እብሔር፡ጸሎ
ቱ፡ወበረከቱ፡ት
ሁሉ፡ምስሴኒ፡ስ
ዳለመ፡ዓለም፡እ
ሜን፡፡፡
ወኮን፡ዘብእሲ
እምብሔረ፡ም
ሥራቃ፡ለገበዘ

## 64 Four Gospels of Abbot Iyyasus Moa

Dabra Hayq Estifanos, 1280/1
Parchment, wood end boards
10$\frac{13}{16}$ × 6$\frac{7}{8}$ in. (27.5 × 17.5 cm), 346 ff.
Dabra Hayq Estifanos, EMML no. 1832

A full-page portrait of Abbot Iyyasus Moa (d. 1292) and the note on f. 24v, stating that he commissioned this manuscript for the monastery he had founded about thirty years earlier,[1] leave no question concerning the age of the manuscript or the identity of its patron. This act of patronage set a precedent followed by the abbot's successor, Krestos Tasfana, whose portrait decorates the Gospels that he commissioned for Dabra Hayq Estifanos (cat. 65).

The Gospel book of Iyyasus Moa is the oldest *dated* Ethiopian illuminated manuscript and the earliest example of a revised Gospel recension.[2] The lavishly decorated canon tables and finispiece miniature in the form of a tholos attest the antiquity of Ethiopian Gospel decoration; the canon tables follow a pattern of layout and decoration that goes back to the period of late Antiquity.[3]

The multiple frontispiece includes scenes from the life of Christ as well as iconic miniatures and two Old Testament paradigms of Salvation: Daniel in the lion's den with Habakkuk and the Three Holy Children in the Fiery Furnace. The scene of Mary in the Temple, flanked by angels whose wings arch above her head, may be a reference to Ethiopia's Cathedral of Mary of Zion. This miniature is repeated in the Gospels of Krestos Tasfana. The portrait of Saint Stephen the Deacon refers to the saint to whom the church of Dabra Hayq Estifanos (Stephen) is dedicated. The miniature of the head of Saint Mark, the relic miraculously delivered to the Coptic patriarchs of Alexandria, is unique to this manuscript.

The miniatures reflect the style of a thirteenth-century Copto-Arabic workshop located in Cairo.[4] Reflections include a particular decorative treatment of garments (as in the miniature of Mary, John, and Peter) and the arabesque-filled pink background of the portrait of Saint Stephen.

MINIATURES  Saint Iyyasus Moa, f. 5v; canon tables ff. 7r–11v; tholos, f. 12r; Cross framed with an arcade, f. 12v; head of Saint Mark, f. 13r; Saint Paul, f. 13v; Saint Timothy, f. 14r; Saint Peter, f. 14v; Mary in the Temple, f. 15r; Saint Stephen, f. 15v; Saint Cyriacus [Qirqos] with his mother [Julitta], f. 16r; Daniel in the lion's den with Habakkuk, f. 16v; Three Holy Children in the Fiery Furnace, f. 17r; Annunciation (upper register), Proof of the Bitter Water (lower register), f. 17v; Nativity, f. 18r; Adoration of the Magi, f. 18v; Flight to Egypt, f. 19r; Massacre of the Innocents, f. 19v; (missing folio); Entry into Jerusalem (second half), f. 20r; Washing of the Feet, ff. 20v–21r; and Mary, John, Peter Repentant, f. 21v; Arrest of Christ, f. 22r; Crucifixion, f. 22v; Ascension, f. 23r; Saint Matthew, f. 35v; Saint Mark, f. 132v; Saint Luke, f. 184v; Saint John, f. 269v.

1. Taddesse Tamrat, 1970: 88.
2. R. Zuurmond 1989, vol. 2: 55–56.
3. C. Nordenfalk 1938.
4. L.-A. Hunt 1985.

SELECTED REFERENCES
Getatchew Haile and W. F. Macomber 1981: 293–301.
Heldman, M. E. 1983.
Taddesse Tamrat 1970.

## 65 Four Gospels of Krestos Tasfana

Dabra Hayq Estifanos, c. 1320
Parchment, wood end boards, 319 ff.
+ Quire A
11$\frac{5}{8}$ × 8$\frac{1}{16}$ in. (29.5 × 20.5 cm)
National Library, Addis Ababa, MS 28 (olim 5)

This richly illuminated manuscript was produced at Dabra Hayq Estifanos and presented to the monastery's church by its abbot, Krestos Tasfana. Three pages of Eusebian prologue to the canon tables, seven pages of canon tables, and a finispiece miniature in the form of a tholos (ff. 1r–6r) follow a Late Antique pattern of layout and decoration[1] that had been introduced to Ethiopia by the sixth century. Following the canon table apparatus is a multiple frontispiece of full-page miniatures, most of which depict scenes from the life of Christ.

The series begins with a miniature of Mary's Entrance to the Temple, an event not attested by the Gospels but commemorated on 3 Tahsas (December 12) as a feast of the Church.[2]

The miniatures of the Gospel frontispiece depict events from the life of Christ and Mary which are commemorated liturgically by the Church. According to apocryphal traditions, Mary was presented to the Temple in Jerusalem as a child, and she lived there in the Holy of Holies, cared for by angels, until she reached puberty. The miniature of her Entrance to the Temple in the Gospels of Krestos Tasfana depicts three frontal figures beneath an arch, which signifies the Holy of Holies. Mary is flanked by angels who offer food; the cup and the disk, which resembles a paten, suggest that they administer to her the bread and wine of the sacrament. Their outspread wings frame her figure, just as the outspread wings of cherubim reached across the chamber of the Holy of Holies of the Temple and covered the Ark (I Kings 6:23–28, 8:7). Later Christian commentators frequently saw the Ark as a prototype of Mary, because both had contained the presence of God. This bold, symmetrical composition presents Mary as a symbolic figure: she is the new Temple and the Church. The suspended lamp, drawn with a less sure hand, is a later addition.

The carefully composed, hieratic miniatures of the Gospels of Krestos Tasfana are peopled by solemn, immobile figures. Their eyes, set high in elongated faces and framed by large compass-drawn halos, meet ours, inviting us to witness the holy truths presented by the miniatures.

The frontispiece is introduced by a portrait of Krestos Tasfana in the company of his illustrious predecessors, holy men and abbots of Dabra Hayq Estifanos: Gabra Seyon, a holy man; Iyyasus Moa (d. 1292), the founder; Za-Iyyasus (d. 1292); and, at the right, Krestos Tasfana (?–1316 or 1317–?). Prayers for Krestos Tasfana are included in this miniature and in the lower margin of the portraits of Saint Mark and Saint John, which manifest a monastic emphasis. Both saints wear a monastic garment, a cape with a characteristically pointed hood or cap. It can be compared with that of the Egyptian abba Arsenius (fig. 21), whose portrait decorates one of the arches of Gannata Maryam, the

Fig. 21 Abba Arsenius, Church of Gannata Maryam, Lasta. [Photo by M. Heldman © 1993]

dynastic church of the emperor Yekunno Amlak (r. 1270–85).

The monastic cap is emblematic of the holy office, and the inscribed name identifies the person. This is the extent to which these images can be classified as portraits. Less symbolic portraits, with representations of contemporary dress and hair styles, generally do not appear in Ethiopian painting until the late Solomonic period.

MINIATURES    Canon tables, ff. 1r–6r; abbots of Dabra Hayq Estifanos, f. 8v; Entrance of Mary to the Temple, f. 9r; Annunciation, and Proof of the Water, f. 9v; Nativity, f. 10r; Adoration of the Magi, f. 10v; Flight to Egypt, f. 11r; Massacre of the Innocents, 11v; Holy Family at Dabra Qwesqwam, and Baptism, f. 12r; Entry into Jerusalem, f. 12v–13r; Denial of Peter, f. 13v; Arrest of Christ, f. 14r; Crucifixion, f. 14v; Burial of Christ, f. 15r; Appearance of the Resurrected Christ, f. 15v; theophanic vision of Christ in Majesty, f. 16r; Saint Matthew, f. 17v; Saint Mark, f. 111v; Saint Luke, f. 163v; Saint John, f. 251v.

1. C. Nordenfalk 1938.
2. B. Velat 1966: 26.

SELECTED REFERENCES
Essen 1963, no. 565.
Pawlos Sadwa 1952.
Taddesse Tamrat 1970.
UNESCO 1961, pls. 1–5.

## 66    Acts of Saints and Martyrs (*Gadla Samatat*)

Dabra Hamlo, Aksum, 1382–88
Parchment, leather-covered wood end boards
$18\frac{7}{8} \times 12\frac{3}{16}$ in. (48 × 31 cm), 234 + 1 ff.
Astit Kidana Mehrat, Ankobar, EMML no. 2514

The manuscript's colophon (f. 234v) names two scribes, Mareqos and Nob; their monastery, Dabra Hamlo, in the district of Aksum; and the person for whom the manuscript was commissioned, General Marqoreyos, an officer of the emperor Dawit. It was created during the reign of Dawit (1382–1413) and the episcopate of the metropolitan Salama (1348–88). At present the manuscript is the property of the Church of the Covenant of Mercy (*Kidana Mehrat*) at Astit in Ankobarr, not far from the sites of the fifteenth-century royal courts.

The stories of forty-eight saints and martyrs, some well-known and some obscure, are arranged according to the order in which they are commemorated in the Church calendar. A full-page iconic portrait introduces the life of the respective saint, although many sections have no frontispiece miniature. These portraits, each of which is inscribed with a prayer to the saint depicted, were used as devotional images. A single frontispiece miniature, a portrait of Mary with her Son flanked by the archangels Michael and Gabriel, introduces the entire collection. This miniature makes no reference to a specific hagiographic text, and it has no inscribed prayer. Mary, framed by an arch of angel wings, symbolizes the Mother Church.

The manuscript and its images are historically important because they relate precise information concerning the book's production. Why a figure as illustrious as General Marqoreyos chose to patronize the scriptorium of this monastery near Aksum is unclear. Perhaps the lack of monastic scriptoria in Amhara and Shoa, the lands of the royal courts, was a factor which prompted the emperor Dawit to establish his palace scriptorium and workshop in the last years of the fourteenth century.

MINIATURES    Mary with the Infant Christ, f. 2r; John the Baptist, Zacharias, and Elizabeth, f. 2v; vision of Saint Eustathius, f. 9v; Cyprianus and Justina, f. 24v; Sergius and Bacchus, f. 26v; Mamas, his father, Theodotus, and his mother, Theophina, f. 43v; Stephen and Habibos, f. 51v; Zenobius and his mother, Zenobia, f. 52v; Mercurius killing the emperor Julian, f. 64v; Cyriacus or Qirqos with his mother, Julitta, f. 125v; Saint George, f. 157v.

SELECTED REFERENCES
Getatchew Haile and W. F. Macomber 1983: 6–14.
Heldman, M. E. (forthcoming).

## 67    Octateuch, Four Gospels, and Synodicon

Central Ethiopia, early fifteenth century
Parchment, wood end boards
Church of Mary, Amba Geshen

Three texts that are usually presented in separate volumes are combined in this manuscript, known as the *Book of Small Grains of Tef (Masehafa Tefut)* because of the minute size of its script. (Tef is a cereal of very fine grains which is widely cultivated in highland Ethiopia.) The manuscript is embellished with many miniatures, the style of which is identical with the miniatures of the *Miracles of Mary*, also at Amba Geshen (cat. 2). Both manuscripts can be attributed to the palace scriptorium of the emperor Dawit (1382–1413).

Each section of the text is introduced by a full-page miniature depicting either a Biblical author or a heroic character featured in the text. The Gospels text has a multiple frontispiece of twenty-three miniatures; some of these are related to the Gospel frontispieces produced at Dabra Hayq Estifanos, which include the Massacre of the Innocents; the Arrest of Christ; Peter Repentant, Mary, and John; and the Appearance of Christ to Mary of Magdala. Other miniatures, including the Nativity, the Transfiguration, and the

Resurrection, follow relatively recent Byzantine models. The three apostles in the Transfiguration miniature can be compared with the same figures in the Transfiguration of the manuscript produced for the Byzantine emperor John Cantacuzenus between 1370 and 1375.[1]

Amba Geshen is the site of two churches, one dedicated to Mary, the other to God, and since the fifteenth century it has been known for the relics received from the emperor Zara Yaeqob. The term *amba* refers to a flat-topped mountain. During the fifteenth and early sixteenth centuries, this natural fortress was used as a prison for royalty; the male descendants of Yekunno Amlak, with the exception of the reigning emperor and his sons, were confined there.[2] It is likely that the present manuscript has been the property of one of the churches at Amba Geshen beginning since the reign of Zara Yaeqob. Numerous later notes make it a precious historical document.

The late seventeenth-century replica of the manuscript, apparently produced on order of the emperor Iyyasu I (r. 1682–1706), is now in the British Library (cat. 107).[3]

MINIATURES [folio numbers unavailable] Moses receiving the tablets of the Law, frontispiece to Genesis; Moses, Servant of the Lord, writing the Law, frontispiece to Exodus; Aaron the Priest with the budding staff, frontispiece to Leviticus; Aaron, frontispiece to Numbers; Moses, frontispiece to Deuteronomy; Joshua and the Angel of the Lord, frontispiece to Joshua; Judah and Kaleb, frontispiece to Judges; Ruth, Naomi, and Boaz, frontispiece to Ruth; Eusebius and Carpianus; Eusebian prologue to the canon tables; canon tables; Annunciation to Zechariah; Presentation of Mary to the Temple; Annunciation; Nativity; Adoration of the Magi; Baptism; Massacre of the Innocents; Transfiguration; Entry into Jerusalem; Washing of the Feet; Peter Repentant, Mary, and John; Arrest of Christ; Crucifixion, with Mary and Saint John; Crucifixion, with the two thieves; Descent from the Cross; Lamentation; Entombment; Holy Women at the Sepulcher; Resurrection (Christ Raising Adam and Defeating the Angel of Darkness); Appearance of Christ to Mary of Magdala; Ascension; vision of Ezekiel; Majestas Domini; Saint Matthew;

Saints Matthew and Mark, frontispiece to Gospel of Matthew; Saints Matthew and Mark, frontispiece to Gospel of Mark; Saints Luke and John, frontispiece to Gospel of Luke; Saints Luke and John, frontispiece to Gospel of John; Twelve Apostles, frontispiece to Synodicon.

1. Bibliothèque Nationale, Paris, gr. 1242, f. 92v; J. Beckwith 1970, fig. 294.
2. Taddesse Tamrat 1974: 533–34.
3. British Library, Or. 481.

SELECTED REFERENCES
Caquot, A. 1955(A).
Heldman, M. E. 1972: 377–79.
Spencer, D. 1967: 103.

## 68 Pauline Epistles

Central Ethiopia, early fifteenth century
Parchment, wood end boards
$13\frac{3}{4} \times 10$ in. (35 × 25 cm), 144 ff. (foliation disturbed)
National Library, Addis Ababa, no. 27

Full-page miniatures of Saint Paul, or of Saint Paul with a colleague, introduce each Pauline Epistle, and richly embellished headpieces decorate the first page of each epistle text. The miniatures are identical in style with the miniatures of the Octateuch, Gospels, and Synodicon now at the Church of Mary at Amba Geshen, and therefore this manuscript too can be attributed to the palace scriptorium of the emperor Dawit (r. 1382–1413).

The fourteen collected letters of Saint Paul to Christian communities do not invite pictorial illustration because they are so abstract. Indeed, manuscripts of the Pauline Epistles usually do not receive decoration, but in order to create a richly illuminated book, a portrait of the author or of the author with another figure was introduced as a frontispiece to each epistle.

Five portraits of Paul are missing, namely, those which introduced I Corinthians, II Thessalonians, I Timothy, Titus, and Philemon. One miniature of Paul (f. 124v) is clearly out of place, and the portrait of Saint John the Evangelist may have derived from another manuscript of the same scriptorium.

While the figures do not generally reflect Byzantine style, the high forehead of Saint

Paul follows the standard physiognomy of Saint Paul in Byzantine art. The palace workshop of the emperor Dawit did have access to Byzantine painting, perhaps in the form of icons that had come to the Ethiopian court by way of the Egyptian patriarchal office.

MINIATURES   Paul and Phoebe, f. 3v (f. 3r, blank); Paul and Timothy, frontispiece to II Corinthians, f. 54v; Paul and Titus, frontispiece to Galatians, f. 70v; Paul and Timothy, frontispiece to Ephesians, f. 79v; Paul and Timothy, frontispiece to Philippians, f. 87v; Paul and Epaphroditus, frontispiece to Colossians, f. 93v; Paul, Silvanus, and Timothy, frontispiece to I Thessalonians, f. 99v; Paul and Timothy, frontispiece to II Timothy, f. 109v; Paul, f. 124v (f. 124r, blank); Paul, frontispiece to Hebrews, f. 125v; John the Evangelist, f. 142v (f. 142r, blank).

SELECTED REFERENCES
Essen 1963, no. 569.
Heldman, M. E. (forthcoming).

## 69 Four Gospels

Dabra Hayq Estifanos (?), late fourteenth or early fifteenth century
Parchment; stamped, leather-covered wood end boards
$14\frac{15}{16} \times 10\frac{1}{4}$ in. (38 × 26 cm), 237 + 2 ff.
Dabra Kebran, Lake Tana, EMML no. 8308

This richly illuminated manuscript has a multiple frontispiece of nineteen full-page miniatures, preceded by three pages of Eusebian prologue; seven pages of canon tables, all lavishly decorated; and a miniature in the form of a tholos. A portrait of the author introduces each Gospel text.

The frontispiece with scenes from the life of Christ begins with the Annunciation and ends with a miniature of the Ascension. While the miniatures appear to have been painted by a single artist, they fall into three or four stylistic groups. The miniatures of the Passion cycle are closely related to those of the multiple frontispiece cycle in the Gospels produced for Iyyasus Moa and Krestos Tasfana, the two abbots of Dabra Hayq Estifanos.

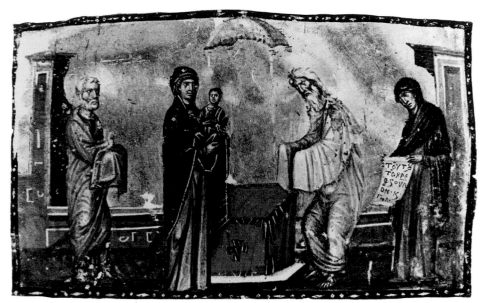

Fig. 22 Presentation of Christ in the Temple, miniature from a Byzantine Gospel book at Mount Athos, Iveron, cod. 5, f. 230r. [Photo taken from S.M. Pelekanidis *et al.*, *The Treasures of Mount Athos* (Athens 1975), vol. 2, fig. 38, by permission of Ekdotike Athenon S.A.]

The miniature of the Presentation of Christ in the Temple typifies those which closely follow Byzantine iconography as well as style, although none could be mistaken as Byzantine. The Presentation gives a rare insight into the process of creating a miniature. The standard Byzantine iconography for this event, as in a miniature in a Gospel book at Mount Athos,[1] depicts the prophetess Anna with the priest Simeon (fig. 22) following the description of Saint Luke (2:22–38). Here, Simeon is accompanied by a bearded prophet, whose scroll reads: "I heard report of thee and was afraid." This, the first line of the Ode of Habakkuk and one of the great messianic prophecies of the Old Testament, identifies the bearded figure as Habakkuk. With his presence, the miniature of the Presentation of Christ is transformed so that it relates more closely to an Ethiopian baptismal ceremony. Following the pattern of the Old Testament law of purification (Leviticus 12:1–8), forty days after birth a male child is taken to church, where he is baptized and given a godfather, while a female infant is taken to church eighty days after birth, baptized, and given a godmother. For this reason, the figure of a male prophet is more appropriate than the figure of the prophetess named in the text of Saint Luke. The painter has also added in the center of

the composition a typically Ethiopian altar chest (*tabot*).

Numerous notes added to blank folios of the Gospel book make this manuscript a historical document as well as an artistic treasure; however, the notes are not particularly helpful in determining the precise age of the manuscript or its place of production. A note on folio 1r, dated July 29, 1412 in a nonscribal hand, names Dabra Kebran, although the history of the monastery yields no suggestion of an active scriptorium that might have produced the manuscript.

Limited use of dull and grainy reddish gold to embellish a few miniatures suggests a connection with the scriptorium of the emperor Dawit, at whose palace manuscripts were embellished with gold, but not without some technical difficulty.[2] Ethiopian painters did not routinely use gold leaf or gold paint. Illuminated manuscripts attributed to Dawit's palace scriptorium share a distinctive style that differs from the style of the Dabra Kebran miniatures; for example, none of the text pages of the Dabra Kebran Gospels are decorated with the interlace ornament that typifies the illuminated manuscripts from Dawit's scriptorium. The Passion series and the miniature of the Massacre of the Innocents show similarities to the illuminated

Gospels from Hayq Estifanos, which suggests that the Dabra Kebran manuscript was copied and decorated at Dabra Hayq Estifanos. Furthermore, the text of the Kebran Gospels is virtually identical with text recension of the Gospels of Iyyasus Moa of Dabra Hayq Estifanos.[3]

MINIATURES Canon tables, ff. 4r–8v; tholos, f. 9r; Annunciation, f. 10r; Nativity, f. 10v; Presentation of Christ in the Temple, f. 11r; Adoration of the Magi, f. 11v; Massacre of the Innocents, f. 12r; Baptism, f.12v; Transfiguration, f. 13r; Entry into Jerusalem, ff. 13v–14r; Washing of the Feet, f. 14v; Peter Repentant, Mary, and John, f. 15r; Arrest of Christ, f. 15v; Crucifixion, f. 16r; Descent from the Cross, f. 16v; Entombment, f. 17r; Holy Women at the Tomb, f. 17v; Christ Raising Adam and His Children, f. 18r; John and Peter, Christ appears to Mary Magdalene, f. 18v; Ascension, f. 19r; Saint Matthew, f. 22v; Saint Mark, f. 84v; Saint Luke, f. 121v; Saint John, f. 182v.

1. Mount Athos, Iveron, cod. 5, f. 230r.
2. E. Cerulli 1943: 87–93; Getatchew Haile 1983(C): 28.
3. R. Zuurmond 1989, pt. 2: 67–68.

SELECTED REFERENCES
Hammerschmidt, E. 1973: 84–91, pls. 20–22.
Heldman, M. E. 1980
Leroy, J. 1962: 183–86.
UNESCO 1961, pls. 7–21.

## 70 *Acts of Saints and Martyrs*

Northern Ethiopia (?), 1382–1413
Parchment, leather-covered wood end boards
$22\frac{7}{16} \times 15\frac{9}{16}$ in. (57 × 39.5 cm), 159 ff.
Church of Maryam Seyon, Lake Zeway, EMML no. 7602

In this collection, portraits serve as frontispiece miniatures introducing each biography (*gadl*) of a monastic saint. The size of the manuscript, its beautifully copied script, and its full-page miniatures suggest that it was commissioned as a gift for a monastic community; notes naming the emperor Dawit place it in the late fourteenth or early fifteenth century.

Elongated forms, enlarged hands, and geometricized webs of drapery characterize

these impressive portraits. The style places the manuscript within a small group that includes the liturgical Psalter in Addis Ababa (cat. 71) and the *Acts of Saints and Martyrs* at Aksum.[1] Hammerschmidt and Jäger compared the miniatures in this book to an illuminated manuscript of Marian prayers in the collections of the Staatsbibliothek Preussischer Kulturbesitz in Berlin.[2]

It is not known where these various manuscripts were produced. During the years of the Adalite invasion in the early sixteenth century, churches and monasteries at Lake Zeway served as repositories for properties of churches that had been destroyed. Thus, the current location of the present manuscript provides no indication of its source.

MINIATURES   Saint Markos, f. lv; Abba Sinoda, f. 7v; Abba Besoy, f. 38v; Saint Eupraxia, f. 56v; Abba Isaiah (of Scete), f. 73v; Abba Pantalewon (of Aksum), f. 82v; Saint Gabra Krestos, f. 89v; Abba Hilarion, f. 95v; Abba Yohanni, f. 107v; Abba Daniel and the emperor Honorius, f. 109v; Saint Anbamarina, f. 113v; Abba Bakimos, f. 118v; Abba Yohannes, f. 123v; Abba Matta (of Ethiopia), f. 125v; the Blessed Arkaladius, f. 128v; Abraham the Second, f. 131v; Saint Maximus and Saint Dumatheus, f. 140v.

1. J. Leroy 1967, pls. 15 and 16.
2. E. Hammerschmidt and O. A. Jäger 1968: 48–50.

## 71   Psalter, Song of Songs, and Night-Prayers

Northern Ethiopia (?), second half of fifteenth century
Parchment, wood end boards
$9\frac{1}{16} \times 6\frac{5}{16}$ in. (23 × 16 cm), 129 ff.
Institute of Ethiopian Studies, MS 74

This manuscript, copied for monastic liturgical use, comprises the Psalms of David; the Song of Songs, introduced by its purported author, King Solomon; and Night-Prayers, introduced by Saint Anthony, the founder of Christian monasticism. An elaborate interlace structure frames the first page of the Night-Prayers, and a wide headpiece of interlace decorates the beginning of the Song of Songs. The scribe reduced the

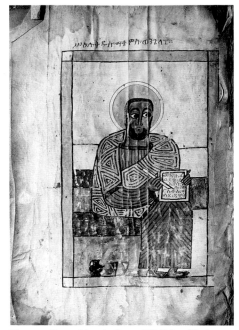

Fig. 23  Gospel book from DibDib, Akala Guzay: Saint Matthew. [Photo by M. Heldman © 1993]

number of lines on pages that begin a text section in order to create sufficiently wide margins for the ornament.

These portraits are typical of a highly abstracted figure style that had developed by the late fourteenth century. The apparent simplicity of the style represents the distillation of a more naturalistic style. Although strictly two-dimensional, the figures sit or stand in three-quarter view, and the network of diagonal parallel lines that covers their bodies was inspired by the structure of garments and drapery folds. The diagonal bands that run across the body of Solomon are actually the decorated edges of his robe. The folding chair on which Solomon sits is transformed into an *X*-decorated rectangle that visually anchors the portrait and rhymes with the diagonals of his garment and sword.

Illuminated manuscripts at the cathedral at Aksum and elsewhere in northern Ethiopia (fig. 23) suggest that this Psalter is the product of a monastic scriptorium in that area.

King Solomon's sword is a symbol of noble status, as were fine imported Arabian swords at the Ethiopian court. The gesture of placing his hand at his face signifies

contemplation, and seems to have been borrowed from the pensive type of evangelist portrait.[1] It may also be related to gestures that were utilized in religious performance.[2]

MINIATURES   "Image of King Solomon," f. 117v; ornamental headpiece of interlace (*harag*), f. 118r; "Image of Abba Anthony," f. 125v; two columns of text framed by interlace decoration, f. 126r.

1. A. M. Friend 1927: 124.
2. J. Doresse 1959: 172–73.

SELECTED REFERENCES
Paris 1974, no. 96.
Stuttgart 1973, no. 26.

## 72   Processional Cross

Provenance unknown, early fifteenth century
Cast bronze, incised bronze sheet
$13 \times 10\frac{9}{16}$ in. (33 × 26.9 cm)
Institute of Ethiopian Studies, no. 3970

This bronze processional cross was assembled in an unusual manner. The entire open framework of a cross within a cross was cast in one piece, and a sheet of bronze was then attached to one side of the central cross. Incised drawings of the Lord framed by a mandorla of light and acclaiming figures of the apostles decorate the central cross, and the archangels Michael and Gabriel, inscribed, decorate the shaft. Inscriptions that identify the Twelve Apostles and the figure of the Lord as God the Father may have been added later. The style of the incised figures suggests a date of the first third of the fifteenth century.

On the reverse of the cross, evidence suggests that the hollow central cross had received some substance or a visual image, or both, and that it had been covered by a hinged metal plate.

SELECTED REFERENCES
Moore, E. 1971: 28–29, fig. 19.

## 73 Processional Cross

Provenance unknown, fifteenth
   century (?)
Gilt bronze
$19\frac{11}{16} \times 14\frac{3}{8}$ in. (50 × 36.5 cm)
Wuqien, Church of Saint Gabriel,
   Tegre

This gilt bronze cross, cast in one piece by the
lost-wax process, displays the impressive
technical skills of an anonymous Ethiopian
monastic artisan. A checkered open-work
pattern surrounds a small central cross. A
cross motif, growing from a pair of leaf-like
forms, projects from the sides and top of the
processional cross, while a row of simple
crosses decorates the perimeter. Such
proliferation of the cross motif is visually
striking and implies the life-giving power of
the Cross.

   The inscription reads: "This cross of Saint
Gabra Elwaqen." Neither the saint nor his
church has been identified. If the inscription is
contemporary with the manufacture of his
cross, then, according to palaeographic
considerations, it can be no older than the
sixteenth century. However, it is possible that
the inscription was added some time after this
piece had been cast.

## 74 Processional Cross

Central Ethiopia, 1434–68
Bronze with gold and insets of glass
   paste, niello decoration
$19\frac{9}{16} \times 13\frac{3}{16}$ in. (49.7 × 33.5 cm)
Dabra Daga Estifanos, Lake Tana

This processional cross of ajouré design carries
a central medallion, on one side of which is
Christ on the Cross in high relief. The other
side depicts Christ, inscribed "Jesus," seated in
majesty with an open book in hand. Both
sides of the shaft are decorated with a bearded
figure holding a book, possibly Saint Peter
and Saint Paul. An inscription on the shaft
reads: "This cross was given to Dabra
Nagwadgwad by King Zara Yaeqob for the
eternal life of his soul."

   While the general pattern and shape of this
cross are typical of Ethiopian processional
crosses of the fifteenth century,[1] the use of
gilt, glass paste insets, and niello marks this

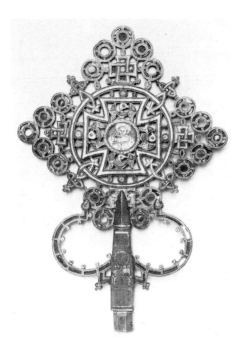

Cat. 74 Processional Cross. [Photo taken
from *Koptische Kunst: Christentum am Nil*,
exh. cat., Essen, 1963]

work as a special object. It is not known
where it was produced. Although liturgical
objects of metal were made by monastic
craftsmen, metalworking generally was
considered a low-status occupation to be
pursued by non-Christians.

   The church and monastery at Dabra
Nagwadgwad in Tagwelat, in central
Ethiopia, was founded as a royal mausoleum
by the emperor Zara Yaeqob. The remains of
his father, the emperor Dawit, were brought
there, and there he too was buried.[2] The
emperor Naod (r. 1494–1508), during the
third year of his reign, exhumed the body of
his grandfather Zara Yaeqob and brought it
to Dabra Daga Estifanos at Lake Tana.[3] Zara
Yaeqob's inscribed processional cross
probably accompanied his mortal remains in
the transfer to the Church of Saint Stephen at
Daga Island. In 1533, the Church of Dabra
Nagwadgwad was burned by the troops of
Ahmad Grañ and its treasures looted.[4] The
cross of Zara Yaeqob at Daga Estifanos
appears to be the sole remaining object from
the richly endowed royal Church of Dabra
Nagwadgwad.

1. E. Moore 1971, figs. 26, 28.
2. J. Perruchon 1893: 53–54, 83–86.
3. J. Perruchon 1894: 365.

4. Shihab ad-Din 1909: 314; R. Basset 1882,
   vol. 119: 98.

SELECTED REFERENCES
Essen 1963, no. 492.
Hammerschmidt, E. 1973, fig. 12.
Volbach, W. F., and J. Lafontaine-Dosogne
   1968: 372, pl. 432.

## 75 Processional Cross

Provenance unknown, fifteenth
   century (?)
Brass
$19\frac{9}{16} \times 13$ in. (49.7 × 33.1 cm)
Institute of Ethiopian Studies, no. 4652

This cross, cast in one piece, is embellished
with pierced designs, the primary pattern
being a series of interlocking squares. The
pattern is one of many geometric designs that
decorate wood screens and friezes of
Ethiopia's oldest churches. Because these
traditional designs change very little, crosses
without incised figurative images are often
difficult to date. The basic form of this cross –
broad central cross with short arms, the ends
of which terminate in curvilinear designs
culminating in a small cross – is like that of
the processional crosses whose incised figures
date them firmly to the second half of the
fifteenth century (cat. 9). The closed loops
formed by the lower arms are similar to the
cross of the emperor Zara Yaeqob (cat. 74). A
very similar cross has been published by
David Buxton;[1] another is in the collections
of the British Museum.[2]

   Crosses with pierced designs are displayed
effectively in procession, either silhouetted
against the open sky or shimmering by the
reflected light of lamps and candles within a
church interior.

INSCRIPTIONS   This cross belongs to Amda
Mikael and his wife Esa, which they have
given to the Church of Dabra Kerbu [?] so
that it may be for the salvation of their souls
and that of their son.

1. D. Buxton 1970, pl. 126.
2. London 1978, pl. 32.

SELECTED REFERENCES
Moore, E. 1971: 31, fig. 21.
Paris 1974, no. 10.
Stuttgart 1973, no. 44.

76 *Our Lady with Her Beloved Son and Saints Peter, Stephen, and Paul*

Fere Seyon
Central Ethiopia, c. 1445–68
Tempera on gesso-covered wood panel
$70\frac{1}{16} \times 40\frac{3}{16}$ in. (178 × 102 cm)
Dabra Daga Estifanos

This magnificent panel is signed by its painter, Fere Seyon, a monk of Dabra Gwegweben at Lake Tana. The icon was painted for the monastery church of Saint Stephen at the island of Daga, Lake Tana. The upper register depicts Mary seated on the throne and nursing her Infant Son; the courtly milieu is suggested by archangels who carry ceremonial swords like nobles at the royal court. Below are Peter and Paul, the heads of the apostles, and Stephen the Deacon, to whom the monastery church is dedicated.

The style of Fere Seyon is distinctive. His figures are depicted with round faces, almond-shaped eyes, and pursed lips, and the edges of their garments fall in a cascade of ripples. He developed this style from a synthesis of elements taken from Byzantine and Italian quattrocento devotional images.

Although this icon is the only extant work signed by Fere Seyon, a group of icons that share a common style and iconography have been attributed to him.[1] The emperor Zara Yaeqob had introduced a mandatory ritual of veneration of Our Lady Mary and her icon, and Fere Seyon, who worked as his painter, created a new symbolic vocabulary for Marian icons. He introduced the motif of a gray dove to the hand of the Infant Christ. The gray dove was a well-known literary metaphor of Our Lady Mary,[2] but it had not been used as a visual symbol until this time. With the portrait of Mary, Fere Seyon combined portraits of the apostles, either Peter and Paul by themselves or the group of Twelve Apostles. This combination echoes the hymn of the ritual of veneration, which praises Mary "who gave birth to our Salvation" and honors the apostles.[3]

INSCRIPTIONS   Mary with her Son Jesus. Holy Gospel of Saint Peter the Apostle. This image was made in the days of our king Zara Yaeqob and our abbot Yeshaq of Daga.

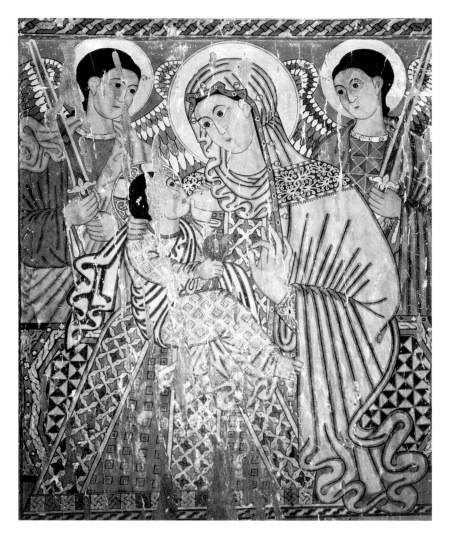

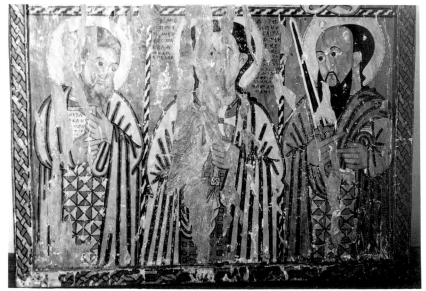

Cat. 76 Upper register: Mary with the Infant Christ and Archangels. Lower register: Saints Peter, Stephen, and Paul.

The painter [is I], the meek Fere Seyon the sinner from Dabra Gwegweben. Remember me in your prayers, O children [monks] of this place, forever and ever. Amen.

1. M. E. Heldman (forthcoming).
2. B. Velat 1966: 287, 296.
3. E.A.W. Budge 1923: liii.

SELECTED REFERENCES
Anfray, F. 1965(A): 16–17.
Heldman, M. E. 1984: 133.
Heldman, M. E. (forthcoming).

## 77 Our Lady Mary with Her Beloved Son and Saint John the Evangelist, Apostles

Fere Seyon (?)
Central Ethiopia, c. 1445–80
Tempera on gesso-covered wood panel; cross-carved in relief on verso
$66\frac{1}{8} \times 43\frac{11}{16}$ in. (168 × 111 cm)
Dabra Rema Madhane Alam

The figure style, general design, and size of this splendid panel, attributed to Fere Seyon, are close to those of his signed panel at the

Cat. 77 Our Lady Mary with Her Beloved Son and Saint John the Evangelist, Apostles. [Photo by M. Heldman © 1993]

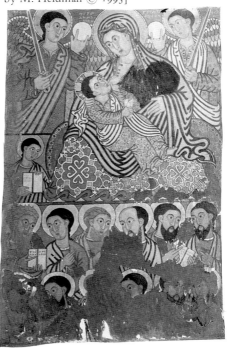

monastery church of Saint Stephen at Daga Island. Areas of paint are flaked, and one area is discolored. Brief inscriptions give no indication that the panel was painted for this monastery church, dedicated to Christ the Savior of the World (*Madhane Alam*), at Rema Island, Lake Tana.

The upper register depicts Mary seated on the throne and nursing her Infant Son. The inscription reads: "The pure Virgin Mary with her child, the firstborn of Sabaoth [that is, the Lord]." A courtly milieu is suggested by archangels who carry ceremonial swords, like nobles at the royal court. At the feet of Mary is a half-length figure, on whose book is written the first lines of the Gospel of Saint John, "In the beginning was the Word. . . ." This not only identifies the figure as Saint John but also refers to the Infant Christ. Half-length portraits of the apostles fill the lower register. The books are inscribed "Holy Gospel of Matthew" and "Holy Gospel of Andrew."

The placement of John the Evangelist at the feet of Mary was inspired by the theological writings of the emperor Zara Yaeqob, for whom Fere Seyon worked. The emperor's collection of prefaces for the ritual recitation of the *Miracles of Mary*, known as the *Revelation of the Miracle (Raeya Taammer)*, repeatedly praises John as the visionary who saw the miracle of Our Lady Mary.[1]

Nearly all Ethiopian panel paintings are small enough to be carried before a congregation or placed upon an icon stand or *manbar* (throne).[2] This large panel and the Daga Estifanos panel signed by Fere Seyon are exceptions. They are too large and too heavy to have been paraded in the ritual display. A passage in an account of a miracle composed during the reign of Zara Yaeqob suggests that this panel may initially have been used as an altarpiece: "There was a church in a monastery. There, on the altar, was an icon of Our Lady Mary and her Beloved Son together with the images of Michael and Gabriel. The monks celebrated the Eucharist beneath the icon."[3] In other words, a painted panel of Our Lady Mary sat upon an altar table.

In its size and vertical shape, the Rema panel is like the Italian altarpiece of the Enthroned Madonna and Child which sat upon the altar table. Nevertheless, how and where this panel and Fere Seyon's panel at

Daga Estifanos were originally displayed is unclear. Today, the area in which the altar is located is curtained or otherwise closed from the view of the laity. Small devotional images may be displayed by suspension or attachment to piers or doorframes before this curtained area.

1. Getatchew Haile 1992: 70–145.
2. Heldman, M. E. (forthcoming).
3. Getatchew Haile 1992: 168–69.

SELECTED REFERENCES
Anfray, F. 1978: 163–64, 168–69.
Heldman, M. E. (forthcoming).

## 78 Our Lady Mary and the Ancient of Days

Fere Seyon (?)
Central Ethiopia, c. 1445–80
Ebony
$10\frac{5}{8} \times 5$ in. (27 × 12.8 cm)
Institute of Ethiopian Studies, no. 4329

The incised wood icon imitates the form of the manual cross carried by Ethiopian priests and monks. The central cruciform panel is shaped like the central panel of contemporary metal processional crosses (cat. 79), and the handle is joined to the main panel with an imitation metal flange. Because of the abbreviated length of the handle, this cross cannot be carried in the usual fashion.

Finely rendered drawings decorate both faces of the icon cross. One side depicts Mary, inscribed "Our Lady Mary with her Beloved Son," surrounded by the Seven Archangels, while in the panel beneath, Saint George sits astride his horse with his billowing cape around him. On the reverse, a theophany in the form of the Ancient of Days (Daniel 7:9) is surrounded by the Four Beasts and the Twenty-Four Priests of Heaven; all are inscribed. A priest in the upper-left corner swings a censer, as described in the vision of Saint John (Revelation 5:6–8). The panel beneath, divided into two registers, is filled with inscribed portrait busts. Saint John the Baptist is flanked by Saints Peter and Paul. Three saints in the lower register suggest ties with the monasteries of Lake Tana. Saint Yafqeranna Egzi, on the left, was the founder of Dabra Gwegweben at Lake Tana's eastern

shore, and Gerelos, on the right, his disciple, established a monastery in Enfraz, an area north of Lake Tana. Takla Haymanot, in the center, represents his monastic foundation of Dabra Libanos. In December 1445, this monastery received imperial endowment; the prominence of Takla Haymanot suggests that the cross was produced after this date.

The icon can be attributed to Fere Seyon. Its subject is particularly close to that of the Addis Ababa triptych (cat. 5), one of the devotional images attributed to him. The draftsmanship of the icon cross is tighter than that of the painted icons. The difference results from the incising process; otherwise, the incised drawings of the icon cross are close in style to the painted icons of Fere Seyon.

This object presents a unique innovation, in which the manual cross of the priest and ordained monk has been transformed into a private devotional image. The *Life* of Saint Krestos Samra, a female monastic who established a monastery at Lake Tana during the reign of Zara Yaeqob, describes an identical devotional image that she held as she prayed.[1]

 1. E. Cerulli 1956(A): 14.

SELECTED REFERENCES
Heldman, M. E. (forthcoming).

## 79    Processional Cross

Ethiopia, second half of fifteenth
    century
Brass
$15\frac{3}{8} \times 10\frac{3}{16}$ in. (39.1 × 25.9 cm)
Institute of Ethiopian Studies no. 4486

This cross is typical of the processional crosses of the fifteenth century. The central cruciform panel has a broad surface on which an iconic portrait is incised. A web of interlace with small crosses frames the central cross, and each of the three outer corners is embellished with a small cross and a pair of arabesque leaves. The shaft and lower arms are crude replacements.

The portrait of Mary on the central cruciform panel was inspired by the ritual veneration of Marian icons which was introduced by the emperor Zara Yaeqob. The incised drawings of Mary with the Child and

archangels and the three saints follow the style of Fere Seyon, the painter of Marian devotional images who worked for the court of Zara Yaeqob. The cross can be compared with the ebony icon-cross attributed to Fere Seyon (cat. 78). The three saints are uninscribed, and because they have no identifying characteristics they remain anonymous. Similar groups of three figures, Christ with Saints Peter and Paul or Abraham with Isaac and Jacob, are typical of the icons of Fere Seyon.

SELECTED REFERENCES
Heldman, M. E. (forthcoming).
Moore, E. 1971: 40–41.

## 80    *Saints Peter and Paul, Abraham with Isaac and Jacob*

Fere Seyon (?)
Central Ethiopia, 1445–80
Tempera on gesso-covered wood
    panels
$22\frac{1}{16} \times 12\frac{1}{8}$ in. (58 × 30.8 cm) left panel;
    $22\frac{1}{16} \times 11\frac{7}{16}$ in. (58 × 29 cm) right
    panel
Institute of Ethiopian Studies, no. 4324

These two inscribed portraits correspond visually and symbolically. Peter rests his hand on the shoulder of Paul in a gesture of harmonious accord, and the Old Testament patriarchs, Abraham, Isaac, and Jacob, are united by identical gestures. The figures of Isaac and Jacob repeat the physical types of Peter (gray hair and short gray beard) and of Paul (dark hair and dark beard). Because the figures are virtually identical to the figures of Fere Seyon's panel at Daga Estifanos (cat. 5), these triptych panels should be attributed to Fere Seyon.

Although these two panels have been described as forming a diptych, the holes for joining them are not aligned. The ridge on the inner edge of the left panel indicates that they are wing panels of a triptych. In its original state, the triptych was closed by folding the wing panels over a central panel of equal dimensions; the ridge on the inner frame of the left panel facilitates this process.

Comparisons with the Marian triptych of Fere Seyon (cat. 5), the wings of which are painted with apostles and prophets, suggest that the missing central panel was painted

with Mary and her Beloved Son. This would express the emperor Zara Yaeqob's characterization of Our Lady Mary: she "brought together the two Laws – the Old and the New Testament – into one holy Church, catholic [and] apostolic."[1] The emperor, in the tract from which these lines are quoted, demonstrated the essential harmony of the Scriptures. The patriarchs, physically similar, stand in joined pairs as if to express this ideal harmony.

The inscription of the right panel reads "Our Father Abraham who is with his two children. May their blessing be upon Aboli, our father." This suggests that the triptych was presented to a monastery, and that the abbot of the monastery was named Aboli.

 1. Getatchew Haile 1992: 105–7.

SELECTED REFERENCES
Heldman, M. E. (forthcoming).
Paris 1974, no. 103.
Stuttgart 1973, no. 4.

## 81    *Equestrian Saints, Anchoritic Saints, King Lalibala, Saint Stephen, and the Head of Saint John the Baptist*

Fere Seyon (?)
Central Ethiopia, between 1445 and
    1480
Tempera on gesso-covered wood
    panels
$20 \times 13\frac{3}{4}$ in. (50.8 × 35 cm) left panel;
    $20 \times 13$ in. (50.8 × 33 cm) right panel
Institute of Ethiopian Studies, no. 4053

The left panel is carved with a ridge at its inner edge so that it could be folded over the right panel when the triptych was closed. Although the mounted saints encircle the half-length saints in their midst, the true visual and thematic center of the original composition, on the missing central panel, would have been the portrait of Our Lady Mary with her Beloved Son.

The outer ring of holy riders, clockwise from the upper left, consists of Aboli,[1] George, Theodore the Anatolian, Basilides, Mercurius, King Lalibala,[2] Claudius, and Mamas. All but Mamas are soldier saints. Saint Mamas rides a wild lion,[3] a feat that signifies the Edenic harmony between man

and beast prophesied by Isaiah (11:6–9). Such harmony was the goal of anchoritic life. Ethiopia's Saint Gabra Manfas Qeddus[4] is depicted with the lions and panthers that were tamed by his presence (cat. 13).

A half-length portrait of Gabra Krestos and the head of John the Baptist[5] occupy the lower corners, while half-length portraits of Entawos the Martyr and Abba Nob, on the left panel, and Qirqos the Child and Stephen the Deacon, on the right panel, occupy the center.

These saints have been selected with great care. Mamas riding a lion symbolizes anchoritic life and the monastic ideal. King Lalibala (d. c. 1225) and the military martyr saints were role models for the males of Ethiopia's aristocracy, each of whom trained in the art of horsemanship. By the fifteenth century the cult of the holy king Lalibala had become popular throughout highland Christian Ethiopia. Episodes from the *Lives* of Abba Nob, George, Theodore, Claudius, Mercurius, and Basilides are featured in the collection of homilies and miracles entitled *Homilies in Honor of the Angels*, created for the emperor Zara Yaeqob.[6] Fere Seyon, the painter to whom these panels are attributed, worked at the court of Zara Yaeqob.

The half-length saints in the center of the panels present a Eucharistic theme that relates to the missing portrait of the Infant Christ of the original central panel. Stephen the Deacon, on the right panel, prepares to offer the sacrament. He holds a yellow chalice and a communion spoon (*erfa masqal*), the "spoon of the Cross," so termed because of the cross-shaped finial at the end of the handle. The cross-spoon is used to serve the bread and wine, the holy body and the blood of the Savior.[7] Stephen the Deacon is assisted by Cyriacus (Qirqos) the Infant at his right. The central half-length pair on the left panel, Entawos and Abba Nob, gaze toward the center, joining Stephen and Qirqos in the celebration of the liturgy.

Entawos the Martyr had a vision of the White Lamb upon the altar.[8] Abba Nob the Confessor, one day after having performed the liturgy, had a vision of Christ sitting upon the altar.[9] Were the missing central panel present, the gaze of Abba Nob and Entawos would be focused upon Christ, the Lamb of God, the vision seen upon the altar.

1. E.A.W. Budge 1928(A), vol. 4: 1177–78.
2. J. Perruchon 1892.
3. E.A.W. Budge 1928(A), vol. 1: 18.
4. E.A.W. Budge 1928(A), vol. 3: 755–72.
5. E.A.W. Budge 1928(A), vol. 2: 658–60.
6. Getatchew Haile and W. F. Macomber 1981: 318–29.
7. M. Daoud and Marsie Hazen 1954: 13.
8. E.A.W. Budge 1928(A), vol. 4: 1225–26.
9. Ibid.: 1028–29.

SELECTED REFERENCES
Heldman, M. E. (forthcoming).

## 82 Chalice

Central Ethiopia (?), early fifteenth
    century (?)
Silver gilt
Monastery of Abba Garima, Madara

On the interior of this chalice is an incised standing figure of Christ in Majesty, whose mandorla is held by four winged figures, each with the face of one of the Four Beasts. The design within the cup evokes the presence of Christ in the consecrated wine. It resembles the illustrations of the Octateuch and Gospels produced at the palace scriptorium of the emperor Dawit (r. 1382–1413). Thus the chalice is datable to the early fifteenth century.

The chalice is but one of the necessary furnishings of a church. The consecrated altar stone or tablet (*sellat*) and the chest in which it is stored (*tabot*), often collectively termed *tabot*, are essential. For the celebration of the liturgy, each church must have at least one chalice (*sewwa*), a paten (*sahl*), and a communion spoon (*erfa masqal*, lit. "spoon of the Cross") for administering the Eucharist to the faithful. Historical inventories, such as the inventory of the Church of Berber Maryam,[1] list gold and silver chalices and patens. These, as well as crosses, sistra, censers, and lamps, were produced at monasteries by monks trained as metalworkers.

1. A. Caquot 1955(B): 112–15.

SELECTED REFERENCES
Playne, B. 1954, fig. 10.

Cat. 82 Chalice. Design taken from B. Playne, *St. George for Ethiopia*, 1954, fig. 10.

## 83 *Our Lady Mary with Her Beloved Son*

Central Ethiopia, second half of
    fifteenth century
Tempera on gesso-covered wood panel
$4\frac{7}{16} \times 3\frac{3}{8}$ in. (11.2 × 9 cm)
Institute of Ethiopian Studies, no. 3985

This single panel from a diptych is carved with an engaged frame within which a second panel was originally fitted. Note the holes on the right edge for its attachment. The missing panel may have been painted with a portrait of Saint George. He is the saint who often accompanies Our Lady Mary on Ethiopian icons of the second half of the fifteenth century.[1] Indeed, the Synaxary of the Ethiopian Church[2] advises that those who love Our Lady Mary should have her portrait painted with the portrait of Saint George "so that it may be a port of salvation for those who pray in his name."

This panel with Mary offering her Son a sprig of flowers follows an iconography established by Fere Seyon. The rounded faces and the rippled hem that falls over the right leg of the Infant Christ reflect the style of this most influential painter of the fifteenth century.

The small size of the panel suggests that it may have been worn or carried as an apotropaic object. Contemporary sources demonstrate that such small painted panels were worn on the person. The emperor Zara Yaeqob wore an image of Mary upon his chest,[3] and a contemporary, Abba Takla Hawareyat, wore an "image of Mary with her Beloved Son" in the same manner.[4] Once, while the nun Saint Krestos Samra was at prayer, Jesus Christ, carrying a painted panel bearing the Ancient of Days, appeared and hung the panel around her neck.[5] The author of her *Life* surely intended to demonstrate that the Lord sanctioned the wearing of an icon in this manner.

1. M. E. Heldman (forthcoming).
2. E.A.W. Budge 1928(A), vol. 4: 1224.
3. E. Cerulli 1933: 93.
4. Taddesse Tamrat 1974: 521, 523.
5. E. Cerulli 1956(A): 11.

SELECTED REFERENCES
Heldman, M. E. (forthcoming).

## 84 *Saint George, Busts of Christ, Saints Peter and Paul*

Takla Maryam
Central Ethiopia, mid-fifteenth century
empera on gesso-covered wood panel
$9\frac{7}{16} \times 5\frac{1}{8}$ in. (24 × 13 cm)
Private collection

In this left-hand panel of a diptych, the figure of Saint George appears between short pink curtains suspended from the bar, which separates him from the upper register and the portrait busts of Christ flanked by Saints Peter and Paul. The repainted portion of the figure of Saint George does not hide the damage sustained when an attached object, perhaps the gold shaft of his spear, was removed.

A long, painted inscription fills most of the red background plane: "Saint George the Martyr. May his prayer keep Elsabet and me the sinner, its painter Takla Maryam. And forget not the one who commissioned the painting, Zena Hawareyat. Salutation to George, head of the martyrs. May your intercession be shield [and] grace for us. Amen."

The epithet "the sinner" indicates that Takla Maryam was a monk; Zena

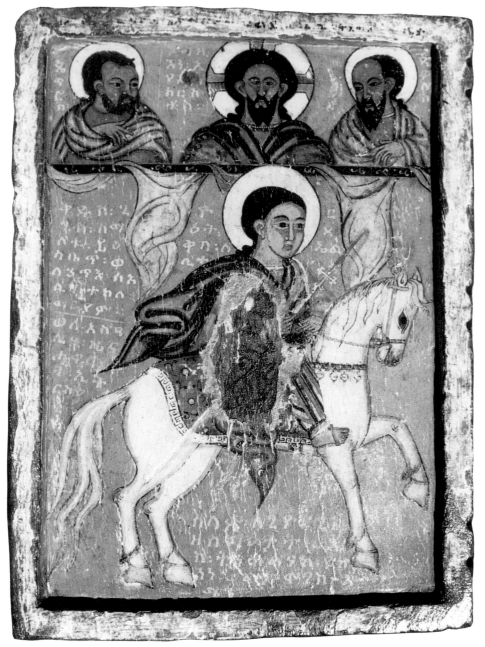

Cat. 84 *Saint George, Busts of Christ, Saints Peter and Paul.* [Photo by M. Heldman © 1993]

Hawareyat, the patron, is unknown. Elsabet too is unknown, but, because she appears to have been closely associated with Takla Maryam, she may have been a nun.

Although the style of this icon is close to that of Fere Seyon, the inscription names Takla Maryam as the painter. Takla Maryam and Fere Seyon share the unique distinction of having signed a painted panel. This and the similarity of their styles suggest that the two painters had been colleagues.

Takla Maryam is the name of a famous holy man who was abbot at Endagabtan during the reign of Zara Yaeqob. He was also named Mabaa Seyon (lit., "Gift of Zion"). His *Life* says that he received the name Takla Maryam in the monastery and that he had trained as a painter before taking his monastic vows.[1] Thus, it appears that the painter of this icon should be identified as *the* Takla Maryam, abbot at Endagabtan, a location west of the modern city of Addis Ababa.[2]

1. E.A.W. Budge 1898: 31–32.
2. Taddesse Tamrat 1988: 145.

SELECTED REFERENCES
Heldman, M. E. (forthcoming).

## 85 Our Lady Mary with Her Beloved Son, Crucifixion

Central Ethiopia (?), second half of
fifteenth century
Tempera on gesso-covered wood
panels
$12\frac{3}{16} \times 17\frac{5}{16}$ in. (31 × 44 cm) open
Institute of Ethiopian Studies, no. 3450

One side of the triptych opens to show Mary
and the Infant Christ, inscribed "Image of
Our Lady Mary with her Beloved Son
Jesus." Inscribed figures of the archangels
Michael and Gabriel flank Mary's throne. The
right panel, divided into two registers, depicts
two Ethiopian holy men, Takla Haymanot
and Samuel, with Saint George. The left
panel depicts an equestrian portrait of the
sainted Ethiopian king Lalibala of the Zagwe
dynasty; the three half-length portraits in the
upper register are uninscribed. Saint Lalibala
wears an earring, a symbol of kingship,[1] and
his headdress, a fillet tied around his forehead
with the ends streaming behind in the wind,
is also a royal tradition.[2]

The second side opens to depict Christ on
the Cross, with the figure of Mary, inscribed
"Mary weeping," and the figure of Saint
John the Evangelist, inscribed "John
weeping." The red moon is inscribed "The
moon, how it became blood." The
inscription beside the blue disc of the sun has
been lost, but it probably read "The sun, how
it became dark." The entire cosmos mourns
the death of Christ. Portraits of apostles fill
the wings. Saint Peter carries a large key, the
symbol of his position as head of the apostles,
and Saint Paul carries a sword, his identifying
symbol in the art of the Roman Church.[3]
The portraits of Saints Peter and Paul can be
compared with their representations in the
icons of Fere Seyon (cats. 5 and 80). The
exterior wing panels are painted with a
rosette design, the significance of which is not
apparent.

The two primary panels reflect major
innovations in public and private devotions

during the fifteenth century. The portrait of
Our Lady Mary with her Beloved Son and
the accompanying figure of Saint George
relate to the cult of Our Lady Mary as
Intercessor that was introduced by Emperor
Zara Yaeqob.

The panel with the dead Christ relates to
the new focus in private devotions upon
Christ's suffering on the Cross. Mary and
Saint John invite the viewer to share their
grief. The monthly feast of the Crucifixion
(*Tazkara Madhen*), commemorated on the
twenty-seventh day of each month,[4] was
instituted by *Abuna* Mabaa Seyon, also
known as Takla Maryam.[5] *Abuna* Mabaa
Seyon may have composed the *Book of the
Passion of Our Lord*.[6] He appears to have been
instrumental in promoting the new
iconography of Our Lady Mary and Saint
John mourning Christ upon the Cross.
Although he was a renowned painter, no
Crucifixion icon by his hand is known today.

1. M. E. Heldman (forthcoming).
2. J. Bruce 1790, vol. 3: 551–52.
3. L. Eleen 1982: 38–39.
4. E.A.W. Budge 1928(A), vol. 3: 744–45.
5. Getatchew Haile 1985(A): 254.
6. Getatchew Haile and W. F. Macomber
   1983: 206; Getatchew Haile and W. F.
   Macomber 1981: 248–49.

SELECTED REFERENCES
Heldman, M. E. (forthcoming).
Paris 1974, no. 112.
Stuttgart 1973, no. 1.

## 86 Processional Cross

Lasta (?), second half of fifteenth
century
Cast bronze
$12\frac{5}{16} \times 6\frac{1}{4}$ in (31.2 × 15.8 cm)
Institute of Ethiopian Studies, no. 4104

This bronze ajouré cross is attached to a
hollow shaft by two rivets; the brass beaded
ring at the base of the shaft is probably a later
addition.[1] The cross is composed of a simple
central cross enclosed within a pear-shaped
frame, the latter elaborately decorated with a
cross finial, a pair of arabesques or stylized
leaves, and loops of interlace. The central
cross is incised with the body of Christ, and
the frame above is inscribed "Crucifixion, the
Cross of Dasar." The other side depicts Mary

with the Infant Christ, and is inscribed "Mary
with her Son."

Although the cross has been dated by Eine
Moore to the twelfth or thirteenth century,
the juxtaposition of the Crucified Christ with
an iconic portrait of Mary with her Son is
typical of Ethiopian devotional images during
the second half of the fifteenth century and
early sixteenth century (cat. 85). Otherwise it
is rare. This combination of subjects is
featured in a miracle of Mary composed for
the emperor Baeda Maryam (r. 1468–78); as a
child he had a vision of an "icon of Our Holy
Lady Twice Virgin Mary with her Beloved
Child, and an icon of the Crucifixion of her
Son."[2]

The cross comes from Lasta. Processional
crosses in this same general shape (that is, a
central cross enclosed within a pear-shaped
frame) appear to have been popular in Lasta,
for they may be seen in the collections of the
churches of Lalibala in Lasta.[3] However, the
crosses in these collections are not engraved
with iconic images.

1. E. Moore 1971: 18.
2. Getatchew Haile 1982: 52.
3. G. Gerster 1970, pl. 77; D. Buxton 1970,
   pl. 122.

SELECTED REFERENCES
Moore, E. 1971: 17–18, figs. 7 and 8.
Paris 1974, no. 92.
Stuttgart 1973, no. 38.

## 87 Mary Nursing the Christ Child, Holy Trinity with the Four Heavenly Creatures

Provenance unknown, early sixteenth
century (?)
Tempera on gesso-covered wood panel
$4\frac{1}{4} \times 4\frac{1}{8}$ in. (10.8 × 10.5 cm)
Institute of Ethiopian Studies, no. 3898

It is difficult to reconstruct the original form
of the icon from this single panel. With Our
Lady Mary and her Beloved Son on one side
and the Holy Trinity on the other, this
appears to have been the primary panel of the
icon. Pairs of small holes in all four sides of
the engaged frame (some still filled with
string) and the raised squares at the corners
(one is broken) indicate that in its original
form it was not a simple double-sided

diptych or triptych. In addition, the small size indicates that it may have been worn or carried for apotropaic purposes. The emperor Zara Yaeqob, who denounced the pagan use of charms and amulets, wore an image of Our Lady Mary upon his chest.[1]

The present icon, like the Daga Estifanos icon of Fere Seyon, depicts the Infant Christ nursing at His mother's breast, flanked by the archangels Michael and Gabriel holding decorative swords. The violet color of the Child's gown is included in the palette of icons attributed to Fere Seyon and those which reflect his influence, but in its style this icon does not reflect those works.

Icons of the nursing Mary are rare in Ethiopian art, although this theme is developed in the ever-popular hymn *Praise of Mary* ("Praise for Friday," sec. 3):[2] "O Mary, the God-bearer, [you are] the spiritual city wherein dwelt God the Most High. For you carried in your hand the One who sits upon the cherubim and seraphim; and He who feeds all of flesh by His plenteous goodness took your breasts and suckled milk." The juxtaposition of the two images, the nursing Infant Christ with the Triune God whose throne is surrounded by the Four Beasts of Heaven, echoes the imagery of this Marian hymn.

The Holy Trinity is depicted as three identical, book-holding bearded men, whose cruciform halos are identical with the halo of the Infant Christ. They are inscribed, from right to left, "Father," "Son," "Holy Spirit." Although Geez is written from left to right, the placement of the Father at the right allows the Son to "sit at the right hand of the Father."[3]

Although the present icon reflects fifteenth-century painting in its style, the motif of the Holy Trinity suggests an early sixteenth-century date. No Ethiopian examples of this theme can be securely placed in the period before 1500. The Holy Trinity is the primary focus of two devotional images that, because of their stylistic similarities with a signed picture book by Nicolò Brancaleon,[4] are datable to the second or third decade of the sixteenth century (fig. 24). However, these two icons are not close stylistically to the present painting of the Holy Trinity, and they are of little help in establishing a date for this panel.

The portrayal of the Holy Trinity as three

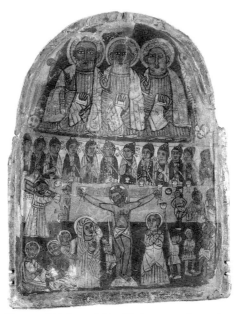

Fig. 24 *Trinity and Crucifixion*, central panel of a triptych, Institute of Ethiopian Studies, no. 3992. [Photo by Malcolm Varon, NYC © 1993]

identical, bearded men with books and cruciform halos was not new. A fresco of the Trinity at Faras Cathedral in Nubia, dated to the late eleventh century, depicts the Trinity in this form, and its painted frame demonstrates that the fresco painter followed an icon of the Holy Trinity.[5]

1. E. Cerulli 1933: 93.
2. B. Velat 1966: 86–87.
3. M. Daoud and Marsie Hazen 1954: 41.
4. D. Spencer 1989, figs. 85 and 86.
5. K. Weitzmann 1970: 336.

SELECTED REFERENCES
Chojnacki, S. 1983, fig. 37.

## 88 Saint George and Scenes of His Martyrdom

Nicolò Brancaleon
Central Ethiopia, between 1480 and 1526
Tempera on gesso-covered wood panels, gesso-covered fabric
$24\frac{3}{8} \times 28\frac{5}{16}$ in. (62 × 72 cm) open
Institute of Ethiopian Studies, no. 4191

The triptych is signed beneath the central figure of Saint George: "I, Marqoryos the

Frank [Afrengi], painted this painting." This is the name assumed by the Venetian Nicolò Brancaleon after he arrived in Ethiopia; his employment at the Ethiopian court can be documented from about 1480 to 1526. The term "Frank" refers to any Western European.

The central panel of the triptych is dominated by a portrait of Saint George subduing the dragon and rescuing the young woman of Beirut (*Birutawit walat*). She is the very small figure holding the dragon's leash. The lower register is filled with portraits of three half-length saints, from left to right: Takla Haymanot, Ewostatewos, and Kiros. Takla Haymanot, an Ethiopian saint, founded the monastery of Dabra Libanos (Asbo), and Ewostatewos, an Ethiopian saint and monastic reformer, inspired disciples who founded a monastic "house" in Tegre. Kiros is a monastic saint, the brother of the emperor Theodosius the Great (r. 379–95).[1]

Each of the two lateral panels presents four scenes from the martyrdom of Saint George. All but those in the top register are inscribed, although two badly flaked inscriptions are illegible. From the left, top to bottom, the scenes depict scourging the martyr, pinning his body beneath a stone, burning his body, and nailing him to a wooden plank; from the right, top to bottom: beheading, cutting his body while on a wheel, dismembering him, and sawing his body in half. These tortures are described in the Encomium on Saint George ascribed to Theodotus, bishop of Ancyra.[2]

A damaged surface in the upper central panel was repaired by fixing canvas to the area and repainting it. This repair is not recent. The lower-right corner of the central panel and the damaged portions of the wings were also repainted.

This signed devotional image, by a Venetian artisan who spent more than thirty years working in Ethiopia for Ethiopian aristocratic patrons, exemplifies the process of artistic cross-fertilization which is characteristic of Ethiopian painting during the fifteenth and early sixteenth centuries. Brancaleon combined an old-fashioned Italian Quattrocento treatment of drapery and a simple drawing style with neutral spatial backgrounds, decorative color, and a rejection of naturalistic figure scale. These elements, along with such exotic touches as

the turban-like hats of the three monastic saints, formed a style that was compatible with contemporary Ethiopian painting. His work was popular at the royal court, where the possession of a Brancaleon conferred status upon its owner.

Brancaleon observed and used indigenous Ethiopian traditions of iconography and style. The three half-length saints, two of whom are indigenous, follow the pattern introduced by Fere Seyon. Brancaleon also offered novelty. The young woman of Beirut has leashed the dragon, a narrative detail taken from the popular *Golden Legend,* by the thirteenth-century Genoese bishop Jacobus de Voragine.[4] Earlier Ethiopian icons had not combined the central iconic portrait with small panels depicting episodes from his life. This novelty, however, was not the invention of Brancaleon. Such an arrangement was common to Byzantine panel painting. Late- and post-Byzantine icons of Saint George, from which Brancaleon may have derived the scheme,[5] did not serve as the immediate models for his depictions of the martyr's ordeals. However, the snake-like form of the dragon is typically Byzantine.[6]

1. E.A.W. Budge 1928(A), vol. 4: 1095–99;
   I. Guidi 1911: 281–86.
2. E.A.W. Budge 1930: 169–276.
3. M. E. Heldman (forthcoming).
4. Jacobus de Voragine 1941: 232–38.
5. M. Chatzidakis 1977, pl. 134; K.
   Weitzmann 1978, pls. 34 and 35.
6. M. Vassilaki 1989: 210.

SELECTED REFERENCES
Taddesse Tamrat 1972(A), pl. 5.

## 89 *Ritual for Passion Week (Gebra Hemamat)*

Northern Ethiopia, second half of
  fifteenth century
Parchment; leather-covered wood end
  boards
$18\frac{1}{8} \times 11\frac{13}{16}$ in. (46 × 30 cm), 255 ff.
Dabra Abuna Marawi Krestos, Tegre

The *Ritual for Passion Week* is a collection of Bible readings and homilies that are recited during the church services of Passion week.[1] Full-page miniatures serve as frontispieces, introducing homilies or major sections of text.

The miniatures and ornamented headpieces display the style of illumination that was developed at an Ewostatewosite monastery, probably Dabra Maryam Qwahayn (Eritrea), during the second half of the fifteenth century. Illuminated manuscripts produced by this scriptorium include the Synodicon at Mahal Zage (cat. 90) and the Psalter of Belen Saggad.[2]

The present manuscript is unusual because the *Ritual for Passion Week* rarely receives pictorial decoration. In this way it can be compared with the Psalter of Belen Saggad, which contains Psalms, Canticles, Prayers of the Hours, and the *Praise of Mary* and is decorated with many figurative miniatures, including scenes from the life of Christ. As these two manuscripts demonstrate, the traditional patronage of the decorated book had not been displaced, although the emperor Zara Yaeqob had so encouraged the production of panel paintings that he neglected the support of manuscript illumination. Neither the patron nor the recipient church of the present manuscript has been identified: it may have been ordered by Belen Saggad, the governor of Sarawe.

The Psalter of Belen Saggad and the present manuscript share a rare composition. The miniature depicts the appearance of Our Lord to John the Evangelist on the Island of Patmos (Revelation 1:12–19): "I turned to see whose voice it was that spoke to me; and when I turned I saw seven standing lamps of gold, and among the lamps one like a son of man.... When I saw him, I fell at his feet as though dead. But he laid his right hand upon me and said, 'Do not be afraid. I am the first and the last, and I am the living one; for I was dead and now I am alive for evermore, and I hold the keys of Death and Death's domain.'" In the *Ritual for Passion Week* the miniature introduces a section that begins with a homily by John, patriarch of Constantinople. As the readings for Saturday of Passion week include the Revelation of Saint John, the miniature is particularly appropriate. In the Psalter of Belen Saggad, this composition is used as the frontispiece to the *Praise of Mary.* Several miniatures of the Passion in the present manuscript are based upon popular Western European prints: they mark the introduction to the Ethiopian iconographic tradition of Passion scenes derived from Western European art.

MINIATURES   Entry into Jerusalem, ff. 1v–2r; Holy Fathers Abraham, Isaac, and Jacob, f. 2v; headpiece of interlace an arabesques, f. 3r; Washing of the Feet, f. 99v; headpiece of interlace and arabesques, f. 100r; Arrest and Flagellation of Christ, f. 117; headpiece of interlace and arabesques, f. 118; Christ before Pilate, f. 123v; headpiece of interlace and arabesques, f. 124r; Christ with a Crown of Thorns, f. 137v; headpiece of interlace and arabesques, f. 138r; Carrying the Cross, f. 147v; headpiece of interlace and arabesques, f. 148r; Three Marys Weeping at the Crucifixion (John 19:25), f. 157v; headpiece of interlace and arabesques, f. 158r; Crucifixion, f. 169v; headpiece of interlace and arabesques, f. 170r; Joseph and Nicodemus shroud the body of Christ, f. 188v; headpiece of interlace and arabesques, f. 189r; Three Youths in the Fiery Furnace, f. 203v; headpiece, f. 204r; Daniel and Suzanna, f. 207v; headpiece, f. 208r; Judgment of Solomon, f. 210v; headpiece, f. 211r; the Lord appears to John on the Island of Patmos, f. 221v; headpiece with interlace and arabesques, f. 222r.

1. Getatchew Haile and W. F. Macomber 1981: 232–33; S. Strelcyn 1978: 57–71.
2. Bibliothèque Nationale, Paris, fonds d'Abb. 105.

## 90 Synodicon (*Sinodos*)

Northern Ethiopia, Dabra Maryam
  Qwahayn (?), second half of
  fifteenth century
Parchment, leather-covered wood end
  boards
$15\frac{3}{8} \times 10\frac{5}{8}$ in. (39 × 27 cm), 190 ff.
Mahal Zage Giyorgis, Gojjam, EMML
  no. 8128

The Synodicon is a collection of canon laws ascribed to the apostles.[1] Because of their purported authorship, miniatures of the apostles function as author portraits.

The miniatures are typical of the style of illumination developed at a major monastery of the disciples of Ewostatewos in northern Ethiopia during the second half of the fifteenth century. Very similar miniatures decorate a Synodicon at Akala-Guzay, in Eritrea, and the Psalter copied and illuminated for Belen Saggad,[2] dated 1476/7,

and the *Acts of Saints and Martyrs*,[3] dated 1466/7.[4] The Ewostatewosite monastery where the illuminators worked has not been identified, but circumstantial evidence suggests that it was Dabra Maryam Qwahayn in the district of Sarawe.

The illuminators developed the double portrait with standing figures, which they used to decorate the Synodicon as well as manuscripts of the *Combat of the Apostles*,[5] for which they also are appropriate illustrations. The miniature of John and Philip may be compared with the portrait of Thomas and Matthew (fig. 25) in the Synodicon from Akala Guzay, a product of the same workshop.

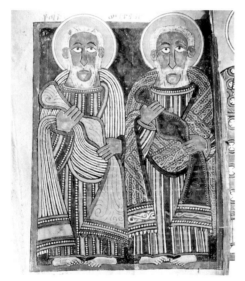

Fig. 25 Synodicon from Akala Guzay: Thomas and Matthew.

Manuscript illumination serves many purposes. Miniatures and abstract designs (*harag*) may function as markers for particular sections of text. In addition, these author portraits have a more serious purpose; they authenticate the accompanying texts by affirming that they were written by the apostles. This was important for the Ewostatewosites, who used the Synodicon to demonstrate the orthodoxy of the celebrating of the Saturday as well as the Sunday Sabbath. This was the controversial issue over which their founder Ewostatewos had gone into exile in about 1338. In 1449 the emperor Zara Yaeqob convened a church council at Dabra Metmaq in Shoa at which the orthodoxy of observing the two Sabbaths

was recognized, and the followers of Ewostatewos were formally admitted into the Orthodox Ethiopian Church.

Although the original disciples of Ewostatewos established monastic houses in Eritrea, there are monasteries in Gojjam with Ewostatewosite affiliation. How the present manuscript came to this church in Gojjam is unknown.

MINIATURES   John and Philip, f. 56v; Bartholomew, f. 64v; Thaddeus, f. 94v; Nathaniel and James, f. 155v.

1. Getatchew Haile 1979: 136–37.
2. Bibliothèque Nationale, Paris, fonds d'Abb. 105.
3. EMML no. 1479.
4. M. E. Heldman 1989: 5–8.
5. E.A.W. Budge 1935.

SELECTED REFERENCES
Essen 1963, no. 118.

## 91   *Life* of Estifanos and *Life* of Abakerazun

Gunda Gunde, after 1480
Parchment, wood end boards
$4\frac{15}{16} \times 6\frac{1}{8}$ in. (12.5 × 15.5 cm), 204 ff.
New York Public Library, Spencer Collection, Ethiopic MS 7

This manuscript contains hagiographies of two Ethiopian saints: Estifanos, founder of an Ethiopian fundamentalist monastic sect who died in about 1450 after having been disgraced at the imperial court, and Abakerazun, abbot of the monastery at Gunda Gunde who died between 1475 and 1479. It is a valuable historical document of the Estifanosite sect. Dabra Garzen, the major monastery of the followers of Estifanos, was founded at Gunda Gunde in Agame shortly after his death. The *Lives* of these two holy men were composed, copied, and embellished with miniatures and ornamental headpieces at Dabra Garzen not long after the death of Abakerazun. In style, the miniatures and the elaborate ornamental headpieces are typical of illuminated manuscripts that were produced at Gunda Gunde and at other Estifanosite monasteries in Agame during the late fifteenth and the sixteenth centuries.[1]

The series of full-page miniatures at the

beginning of the manuscript asserts the legitimacy of the Estifanosite movement. The great holy men of Egypt, Paul the Anchorite, Saint Pacomius, Macarius, and Anthony, inscribed "Father of Monks," are presented as the spiritual fathers of Estifanos and Abakerazun, thus answering the charge, first brought against them by the emperor Zara Yaeqob (r. 1434–68), that Estifanos and his followers were heretics. Indeed, the Estifanosites were commonly known as the enemies of Mary, because they objected to prostrating themselves before icons of Mary, reserving the worship for the Father, the Son, and the Holy Spirit. The portrait of Mary with her Son counters the charge that they were enemies of Mary. They were not; in fact they recited daily the *Praise of Mary* (*Weddase Maryam*).[2]

Antonio Mordini acquired the present manuscript at the Monastery of Gunda Gunde in 1939.

MINIATURES   Abba Paul, f. 2r; Abba Pacomius, f. 2v; Abba Macarius, f. 3r; Abba Anthony, f. 3v; Our Lady Mary with her Beloved Son, f. 4r; *Abuna* Estifanos, f. 4v; interlace ornament, beginning of the text of *Gadla Estifanos*, f. 5r; *Abuna* Abakerazun, f. 113v; interlace ornament, beginning of the *Gadla Abakerazun*, f. 114r.

1. M. E. Heldman 1989.
2. Getatchew Haile 1983(B): 100–101, with further bibliography.

SELECTED REFERENCES
Essen 1963, no. 577.
Heldman, M. E. 1989.
Mordini, A. 1953: 49.

## 92   Four Gospels

Dabra Garzen, Gunda Gunde; late fifteenth or early Sixteenth century
Tempera on parchment
$13\frac{3}{8} \times 10\frac{1}{4}$ in. (34 × 26 cm)
Church of Gannata Maryam, Lasta, EMML no. 7219

This beautifully decorated manuscript of the Gospels exemplifies the style associated with the Estifanosite monastery of Gunda Gunde in Agame. The miniatures can be compared with those of a manuscript of the Gospels (Leroy's Gospel C) in the library of Gunda

Gunde.[1] The two manuscripts may have been decorated by the same painter.

The scheme of Gospel decoration developed at the Monastery of Gunda Gunde, which departs from the usual Ethiopian design, was followed here. The Eusebian prologue to the canon tables is not placed within a decorative frame. The canon tables take up eight pages, instead of the usual seven; the decoration of the canon table frames is limited to rich interlace embellishment entwined with crosses and arabesques; and there is no tholos miniature to mark the end of the series of canon tables. Only one scene from the life of Christ, the Crucifixion, appears, and it is combined with a miniature of Our Lady Mary and her Beloved Son, to whom a prayer is addressed. These miniatures are followed by three pages with portraits of the Twelve Apostles. The scheme appears to have been inspired by icons that combined an image of the Crucifixion with a portrait of Our Lady Mary with her Beloved Son. Icons of the fifteenth century also combine portraits of the apostles with Our Lady Mary. The apostles symbolize the Church, and Mary is the Mother Church, Mary of Zion (*Maryam Seyon*). The archangels' wings are arched above her head like the raised wings of the cherubim in the Temple.

The miniature of Mary is inscribed with a brief prayer: "Image of our holy Lady Mary with her Beloved Infant Son. May her prayer be with us. Amen." An inscription also accompanies the miniature of the Crucifixion: "Image of the Crucifixion of our Savior Jesus Christ as the diligent angels guard over His honored body, which is in the nature of His divinity, to whom is glory and worship

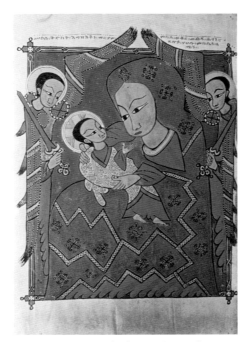

Cat. 92 Four Gospels, f. 20v: Our Lady Mary with Her Beloved Son. [Photo by M. Heldman © 1993]

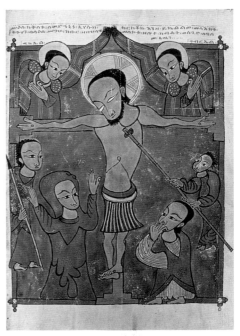

Cat. 92 Four Gospels, f. 20r: Crucifixion. [Photo by M. Heldman © 1993]

forever. Amen." These inscriptions affirm the iconic nature of the miniatures: they are devotional images.

Later notes (f. 12r, f. 118v) explain how this Gospel book became the property of the Church of Gannata Maryam in Lasta. The manuscript had been purchased by the ruler Mahedara Krestos of Lasta, whose son, Qerelos, donated it to Gannata Maryam. Qerelos was king of Lasta in 1723.[2]

MINIATURES Canon tables, 13r–16v; Crucifixion, f. 20r; Our Lady Mary, f. 20v; Four Apostles: Peter; Andrew; James, Son of Zebedee; and Philip, f. 21r; Four Apostles, f.

21v; Four Apostles: James, Son of Alpheus; Matthias; Paul; James, Brother of Our Lord, f. 22r; Saint Matthew, author portrait, f. 22v; interlace decoration, beginning of Gospel of Saint Matthew, f. 23r; Saint Mark, author portrait; Saint Luke, author portrait; Saint John, author portrait.

1. J. Leroy 1967, pls. 5–7.
2. Getatchew Haile 1985(B): 42–45.

SELECTED REFERENCES
Heldman, M. E. 1984: 133.
Heldman, M. E. 1989: 11.

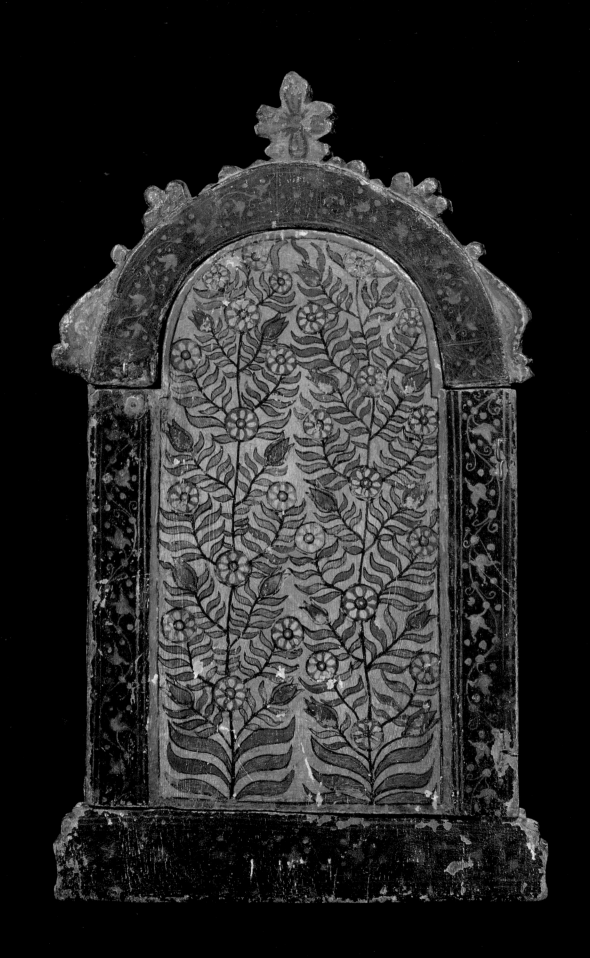

# THE LATE SOLOMONIC PERIOD:
## 1540–1769

*Marilyn E. Heldman*

DURING THE YEARS OF Adalite invasion, from 1527 to the death of Ahmad Grañ in 1543, much of the artistic patrimony of the early Solomonic period went up in flames. Royal churches and the great monasteries with their libraries, including Dabra Damo and Dabra Libanos, were burned. The artistic traditions of the previous two and a half centuries were threatened with annihilation, but all was not lost. Churches and monasteries at inaccessible sites, notably Gunda Gunde and the churches at Lake Zeway, escaped the Muslim troops, and the rock-hewn churches of Tegre and Lasta would have been too substantial to be destroyed. Determined action of heroic monks and priests saved icons and manuscripts. Some were hidden, others were carried to remote locations; some looted manuscripts were later ransomed.[1]

Order did not return to highland Ethiopia at the death of Grañ or at the defeat of his troops, for the influx of the Oromo, whose arrival had begun in the early sixteenth century, brought more destruction and disorder.

Thus ended a historic period that had begun with the overthrow of the Zagwe dynasty in 1270 and the establishment of the so-called Solomonic dynasty by Yekunno Amlak. The dynasty that claimed descent from King Solomon continued to reign, but the mid-sixteenth century marked a turning point in the fortunes of its rulers and the structure of Ethiopian society.

The period from about 1550 to 1665 offers few securely dated or datable works, whether icons or illuminated manuscripts. Devotional images seem to have been produced in considerable quantities; icons of Our Lady Mary were still needed for the ritual of veneration, and the demand for private devotional images did not diminish. Few illuminated manuscripts can be assigned to this period; however, manuscripts with beautiful calligraphy were produced. A notable example is the earliest extant copy of the revised version of the Ethiopian Synaxary. It is dated December 16, 1581.[2] The court of the emperor Sarza Dengel (r. 1563–97) was the setting of a brilliant revival of Ethiopian literature and learning, but no devotional images can be directly associated with his court or with the group of scholars involved in the literary revival. The icons that can be placed in the period between 1550 and 1665 follow models derived from Western European engravings and popular prints. These apparently replaced pictorial models that had been lost in the early sixteenth century. The history of fifteenth-century and early sixteenth-century Ethiopian painting reflects an interest in imported visual models, and it seems likely that even without the devastation caused by the Grañ, Ethiopian painters would have been receptive to the influx of western Ethiopian prints.

The Passion of Christ, His death, and the Raising of Adam and Eve are the most common subjects for devotional images produced in the first years of this new era, the late Solomonic period. These subjects appear on triptychs, as well as on very small double-sided diptychs carved with a hollow cylinder at the top so that they could be worn suspended from a cord.

1. Getatchew Haile 1980(B): 378.
2. Getatchew Haile and W. F. Macomber 1982: 67–68.

Cat. 110 (*facing page*) Triptych closed.

Obviously the latter were private devotional images, but in many cases, the only distinction between a private devotional image and an icon for public veneration is the form. This lack of differentiation between private art and public art is also true of illuminated manuscripts, particularly illustrated books like the *Miracles of Mary* made for aristocratic patrons. It is often unclear whether these were made for personal use and then presented to a church at a later date, or intended to be presentation pieces from the time of their commission.

During the last decades of the sixteenth century, Ethiopia received copies of the venerated icon of the Virgin of Santa Maria Maggiore, named after the church in Rome where it was displayed.[3] Disseminated throughout the world by Jesuit missionaries, the iconography was brought to Ethiopia by Portuguese Jesuits from their provincial headquarters in Goa. Although the Jesuits were expelled by the emperor Fasiladas when he ascended the throne in 1632, the type of the Virgin of Santa Maria Maggiore remained a permanent addition to Ethiopian painting.

Indian garments and poses that may have been derived from Indian painting typify some icons of the Raising of Adam and Eve. These Indian elements might be attributed to models introduced by the Jesuits. The *Chronicle of the Emperor Sarza Dengel* indicates that Indian fabrics and entire garments were imported and worn by the Ethiopian aristocracy. Specifically named is the *qaftan* (caftan),[4] a long-sleeved outer garment very much like the costume worn by Christ in depictions of the Resurrection.

After 1550, the center of the highland Christian empire shifted from Shoa and Amhara toward the northwest, the area north and east of Lake Tana. The emperor Sarza Dengel built a stone castle and established a capital at Guzara.[5] The emperor Suseneyos (r. 1607–32) built a castle at Danqaz, and built the Church of Takla Haymanot at Azazo. His successor, the emperor Fasiladas (r. 1632–67), built a stone castle at Gondar, remarkably similar in style to Sarza Dengel's castle at Guzara, as well as seven churches at Gondar. The emperors who came after him followed the example of building castles and founding churches at Gondar. In this way what had been a market town before the reign of Fasiladas became the first permanent capital of the Solomonic emperors. In Gondar, and perhaps at nearby Azazo, were the monastic scriptoria and workshops patronized by the Gondarine court, producing manuscripts illuminated in what are now known as the First and Second Gondarine styles. Gondar, the new permanent capital, had become the primary center of artistic production in Ethiopia.

The Gondarine kings adopted as their imperial palladium an early sixteenth-century European panel painting of Christ crowned with thorns. A fairly direct copy of this imperial icon appears in an eighteenth-century manuscript from northern Ethiopia, illuminated with miniatures in the Second Gondarine style (cat. 121). Ethiopian sources name this icon the *Kwerata Reesu* (the striking of his head), a phrase that alludes to Gospel accounts of the humiliation and beating of Christ before the Crucifixion (Matthew 27:27–30; Mark 15:16–20). The icon includes no narrative elements, and presents a devotional image of the agony through which Christ achieved his victory over the forces of evil. (Although James Bruce reported that this icon had been painted by Saint Luke, it should not be confused with the Italo-Cretan icon of the Man of Sorrows, also known as the *Kwerata Reesu*.)

The icon was not only a royal talisman. The image of Christ wearing a crown embodied the emperor's right to rule, especially since loyalty to the emperor was sworn upon the *Kwerata Reesu*. It is first mentioned in the royal chronicles in 1672, when the emperor Yohannes went on a military expedition with "the image of Our Lord Jesus Christ known as the *Kwerata Reesu*" and the *tabot* of Maryam Seyon from the court church at Gondar known as Gemja Bet Maryam (the Church of Mary near the Treasury). The use of a holy object as a palladium in battle was an established practice. The emperor Amda Seyon (r. 1314–44), when embarking upon a military expedition, had taken with him the altar tablet of Saint Qirqos from the monastery church of

3. U. Monneret de Villard 1947.
4. F. A. Dombrowski 1985: 24–25.
5. R. K. Pankhurst 1982: 94–99.

Tana Qirqos.[6] As the palladium of the Gondarine emperors, the *Kwerata Reesu* appears in numerous devotional images and illuminated manuscripts from the late seventeenth century onward. The icon remained the royal palladium until it was taken from the emperor Tewoderos II at the battle of Maqdala in 1868 and removed to England. Its present location is unknown.[7]

For the Gondarine emperors, patronage of the arts was a means of displaying imperial status. The wars and population movements of the sixteenth century had changed the nature of Ethiopian society. The regional aristocracy seized strategic military roles and broke the absolute power of the emperor. Although his position as a warrior-king was no longer absolute, however, his role of patron of the arts remained considerable.

Fasiladas continued the royal tradition of promoting religious architecture and the attendant art of mural painting. Unfortunately, Gondar was sacked several times during the nineteenth century, by the soldiers of the emperor Tewoderos in 1864 and 1866 and by the Dervishes twenty years later, and none of the original foundations of Fasiladas remains. Furthermore, no illuminated manuscripts can be attributed to his patronage.

The earliest examples of the First Gondarine style are found in manuscripts associated with the emperor Yohannes I (r. 1667–82) and his empress Sabla Wangel. Mural fragments from the Church of Saint Anthony at Gondar, which were removed to Paris in the 1930s, are similar in style to manuscripts illuminated in the First Gondarine style, but the date of these paintings is uncertain. While Yohannes I founded three churches at Gondar, one of which was dedicated to Saint Anthony,[8] an abbreviated royal chronicle insists that the church was built by the emperor Yostos in 1715.[9] However, the latter notice may refer to the repair or rebuilding of a church founded by Yohannes I.

The origins of the First Gondarine style are unknown. Gondar itself seems the most likely location; the style was fully developed by 1665 and was still followed in the early eighteenth century. Workshops where painters were trained and where icons and illuminated manuscripts were produced appear to have been associated with churches and monasteries near the capital. During the early Solomonic period, important stylistic traditions developed at different leading monasteries, but during the late Solomonic period Gondar became the religious and artistic as well as political center of the empire. Painters from Gondar worked at the nearby churches of Lake Tana, and the undated murals of the Church of Dabra Sina near Gorgora at Lake Tana are very close to the murals of the Church of Saint Anthony at Gondar.[10]

The neutral-ground style of illumination, characteristic of the First Gondarine style in manuscripts, seems to have been inspired by Western European woodcuts and engravings. The new popularity of narrative illustrations in manuscripts may be attributed to the arrival of new visual models, particularly the printed *Evangelium arabicum*.

A group of luxury manuscripts of the *Miracles of Mary*, with large numbers of illustrations, must have been produced at a single scriptorium. Each manuscript follows, but does not copy, an archetype that may have been created at Gondar, perhaps during the reign of Fasiladas or for Yohannes I. The relationship between this seventeenth-century cycle of illustrations and the unique copy of the *Miracles of Mary* illustrated with line drawings for the emperor Lebna Dengel is not yet clear.[11] Although these illuminated manuscripts of the *Miracles of Mary* survive as the property of important churches and monasteries, they may originally have been made for the private enjoyment of lay patrons.

The Second Gondarine style, a variation of the First Gondarine style, is associated with the patronage of the regent empress Mentewwab and her son the emperor Iyyasu II (r. 1730–55). While much remains to be discovered about its initial development, this florid style is distinguished by its heavy modeling of flesh, carefully rendered patterns of imported fabrics, and shaded backgrounds changing from yellow to red or green.

6. I. Wajnberg 1936: 18–22.
7. R. K. Pankhurst 1979: 170–87.
8. Getatchew Haile 1988, citing EMML no. 1706.
9. R. Basset 1882: 334.
10. W. Staude 1959.
11. D. Spencer 1972: 89–90.

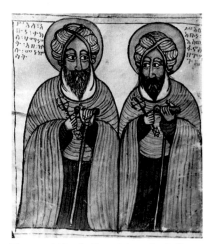

Fig. 26 *Life of Abuna* Mazgaba Sellase: *Abuna* Takla Haymanot and Estifanos.

12. G. Annequin 1976: 219, 230. Annequin (1976: 233) suggests that Abba Sebhat Laab was an artist who painted a picture of the Trinity for the original church. Abba Sebhat Laab was the author of a devotional hymn, a *malk* (image), in honor of the Trinity (Getatchew Haile 1988, citing EMML no. 1706).

13. S. Uhlig 1988: 638–39.

Typical of murals and manuscripts produced in both the First Gondarine and Second Gondarine styles are expanded narrative cycles including realistic details of clothing, furniture, hair styles, and even genre scenes. Such elements reflect the interests of aristocratic lay patrons. Although these realistic details of costumes and accessories are emphasized, painters continued to work without any indication of light source or shadow, or any suggestion of the three-dimensional spatial relationships associated with realism in modern Western painting.

The establishment of a chronology of the Second Gondarine style has been hindered by the incorrect dating of a key monument. The Church of Dabra Berhan Sellase on the outskirts of Gondar was founded by the emperor Iyyasu I around 1694. The present church, its interior covered with murals in the Second Gondarine style, has been incorrectly identified as the structure of Iyyasu I. It is, however, a later replacement, built and decorated between 1815 and 1826, and among the murals are several portraits of the emperor Egwala Seyon, who reigned from 1801 to 1818.[12]

An undated manuscript of the Revelation of Saint John, copied in the first years of the eighteenth century,[13] is decorated with a number of miniatures offering excellent examples of the Second Gondarine style. The names in the original colophon have been erased and replaced with the names of Iyyasu II and Walatta Giyorgis, the baptismal name of Mentewwab, wife of the emperor Bakkaffa (r. 1721–30) and regent empress for her son. It is likely that the illustrations were added when the manuscript was acquired by the empress Mentewwab.

In approximately 1733, Mentewwab and Iyyasu II established the monastery church of Qwesqwam Dabra Sahay on the outskirts of Gondar. Its original structure was destroyed, but in the new church is a lavishly illustrated manuscript of *Nagara Maryam* (History and Miracles of Our Lady Mary), whose illustrations exemplify the Second Gondarine style (cat. 113). The empress Mentewwab's Church of Narga Sellase at Lake Tana is also decorated with murals in the Second Gondarine style. She appears in these paintings herself, crowned on horseback and as a suppliant before Our Lady Mary.

The *Miracles of Mary* continued to be a popular text for extended cycles of illustrations. Similar cycles were also added to other texts, such as the *Nagara Maryam* and the *Dersana Mikael* (Homiliary of the Archangel Michael). A notable innovation is the illustration of hagiographic texts of local saints. The illustrated *Life* of Saint Walatta Petros, a nun from Lake Tana, includes scenes of Lake Tana and of nuns at work, and exemplifies a new category of illuminated manuscript for which genre scenes were created.

The First and the Second Gondarine styles appear to have remained localized at Gondar and

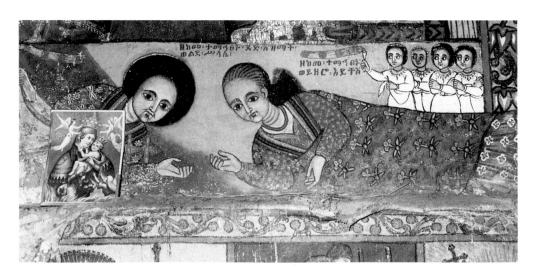

Fig. 27 *Dajamach* Walda Sellase and *Waysaro* Eyetshash at the feet of Mary, wall painting in the Church of the Trinity at Chalaqot, Tegre. [Photo by M. Heldman Ⓒ 1993]

the royal churches and monasteries of Lake Tana. Both styles are represented in the collection of illuminated manuscripts in the Estifanosite monastery at Gunda Gunde. The *Life* of *Abuna* Mazgaba Sellase, a monk of this Estifanosite community,[14] is illustrated with portraits similar in style to the portraits in the manuscript of the *Haymanota Abaw* (Faith of the Fathers), which is datable to the reign of the emperor Yohannes and Sabla Wangel (cat. 100). Portraits in the *Life* of *Abuna* Mazgaba Sellase depict Estifanosite saints, such as Abakerazun with Gabra Masih, and Estifanos with Takla Haymanot of Dabra Libanos (fig. 26). The latter is inscribed "Abuna Takla Haymanot, father of all the monks," and thereby gives him precedence over *Abuna* Estifanos, the founder of the Estifanosite house. The manuscript must have been produced at Gondar for presentation to the monastery at Gunda Gunde.

During the nineteenth century, the Second Gondarine style was widely patronized by local rulers in northern and central Ethiopia. The church at Chalaqot in Tegre is decorated with paintings in the Second Gondarine style, including portraits of the local rulers, Walda Sellase (d. 1816) and Waysaro Eyetshash as suppliants at the feet of Our Lady Mary (fig. 27). Isenberg and Krapf[15] observed that a painter from Gondar had come to Ankobarr to decorate a church for the prince Sahla Sellase in Shoa (r. 1813–47).

14. Kinefe-Rigb Zelleke 1975: 85.
15. C. W. Isenberg and J. L. Krapf 1843: 85.

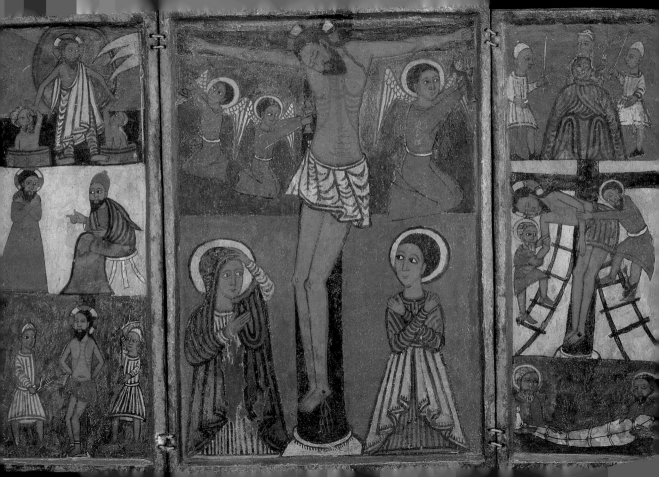

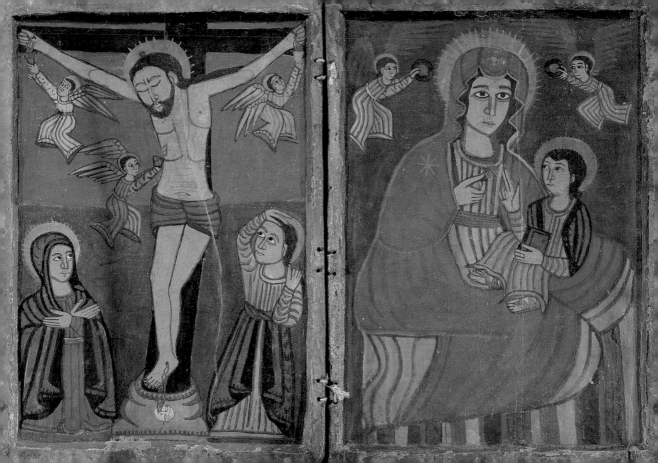

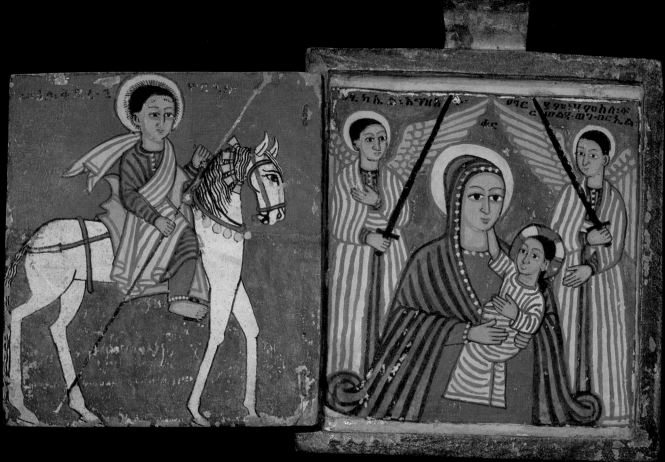

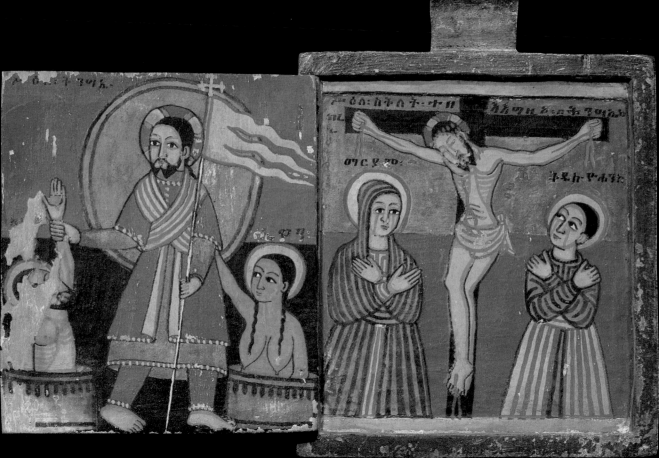

Cat. 96 Processional Cross

وتبعه في الطريد

## الفصل الخامس والثلثون ٠

فلما قربوا من يروشليم عند بيت فاجي وبيت عنيا جانب
طور الزيتون ارسل اثنين من تلاميذه وقال لهما
امضيا الى القرية التي اما مكما فعند دخولكما اليها
تجدان جحشاً مربوطاً لم يركبه احد من الناس قط خلّاه
واتياني به فان قال لكما احد ما تفعلان بهذا فقولان الرب
يحتاج اليه فمن ساعته يرسله الي ها هنا فذهبا ووجدا
عفواً مربوطاً عند الباب خارجاً عند الطريق خلّاه
فقال لهما قوم من القيام هناك ما تصنعان و تحلان
العفو فقالا لهم كما قال يسوع فتركوهما وجآ بالعفو الى

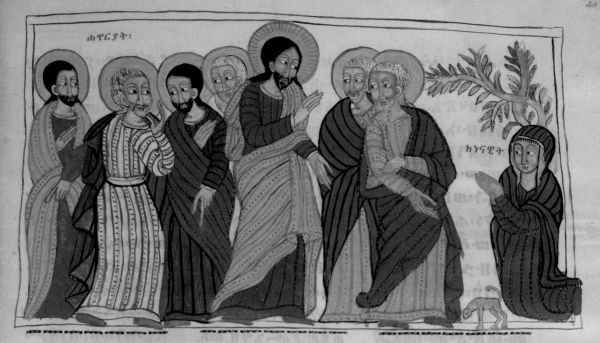

ሐዋርያት፡

ከነናዊት፡

ወመጽአት፡ወቀረባ፡ከ
ገደት፡ሎቱ፡ለእግዚእ፡
ኢየሐስእ፡ ዘይብል፡
እግዚእየ፡ር፡ድኢነ፡ወ
አውሥእ፡ወይቤላ፡ኢ
ኮነ፡ወናየ፡ነዊ፡እ፡ኅብ
ስተ፡ውሉድ፡ከመ፡የሀ
ቡ፡ለከለባት፡ቀወት፡ቤሎ፨

እወ፡እግዚእ፡እከመ፡
እንለ፡አለባት፡ኒ፡ይበል
ዑ፡እምፍርፋረት፡ዘ
ይወድቅ፡እምኔ፡ማዕ
ዳተ፡አጋእዝቲሆ፡መ
ወእምዝ፡አውሥእ፡እ
ግዚእ፡ኢየሱከ፡ወይቤ
ላ፡እብእሲቶ፡ዓቢይ፡ሃ

ይማኖት፡ከ፡ለይኩን፡ኢ፡
በከመ፡ተአመንኪ፡ወ
ዘከመ፡ትፈቅዲ፡ወሐ
ይወት፡ወለታ፡ስቤሃ፡
ምይእቲ፡ሰዓተ፡ቀወ፡ኒ፡
ወነሊፍ፡እግዚእ፡ኢየ
ሱከ፡እምህየ፡ሐረ፡ወበጽሐ
ወ ዓደ፡ወ ብ፡ሐረ፡ገሊላ፨

ዘአመ፡ፈ፡ወሰመ፡እግዚ፡እንለይ፡ዕውራን፡

| | | |
|---|---|---|
| ወይቤልዎ፡እግዚኢ፡እ<br>ሙ፡ይትከሠታ፡አዕይ<br>ቲ፡ነቀወ፡አምሐርዎ፡ለእ<br>ግዚ፡እ.የሱክ፡ወመሐ<br>ሮሙ፡እግዚ፡እ.የሱክ፡ | ወገሠ፡ሙ፡ወለ፡ክፍሙ፡<br>አዕይንቲ፡ሆ፡ሙ፡ቀወ፡ደ፡ቤ<br>ሎሙ፡በከሙ፡ሃይማኖ<br>ትክሙ፡ወአ.ሚኖ፡ትክሙ፡<br>ይኩንክ፡ሙ፡ቀ፡ጠበ.ጊ፡ዜ፡ሃ፡ | ነጽሩ፡ሶቤሃ፡ወ፡ተ፡ክሠ፡ት፡<br>አዕይንቲ፡ሆ፡ሙ፡ወር፡እ<br>ዩ፡ስቤ.ሃ፡ወ፡ተ፡ለ፡ው፡ሥ፡ቀ |

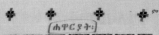

✜   ✜   ✜   ✜

ሐዋርያት፡

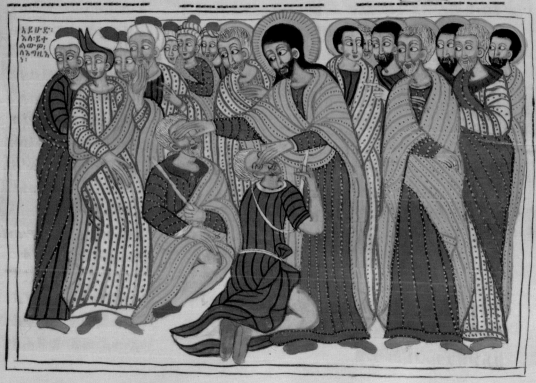

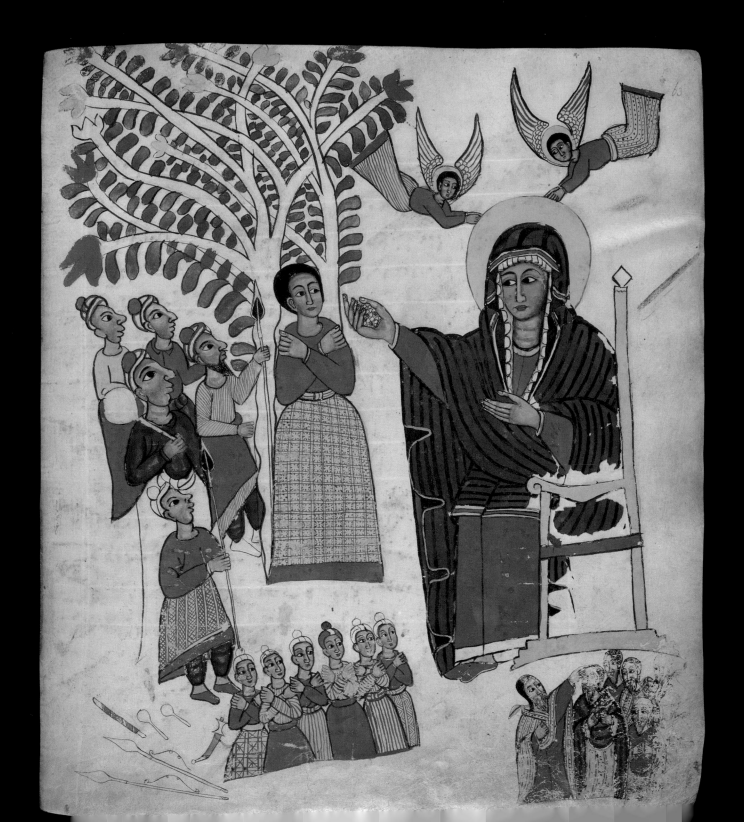

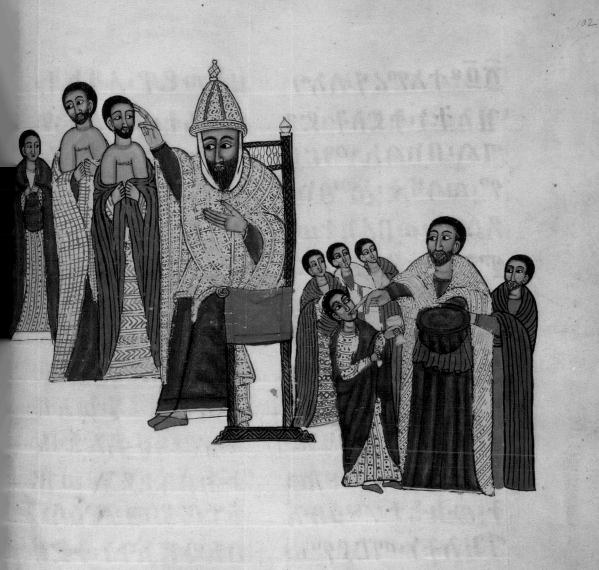

Cat. 102 (*facing page*) *Mary, Saint George, Takla Haymanot, Ewostatewos, Gabra Manfas Qeddus*

Cat. 103 Both sides of the diptych closed

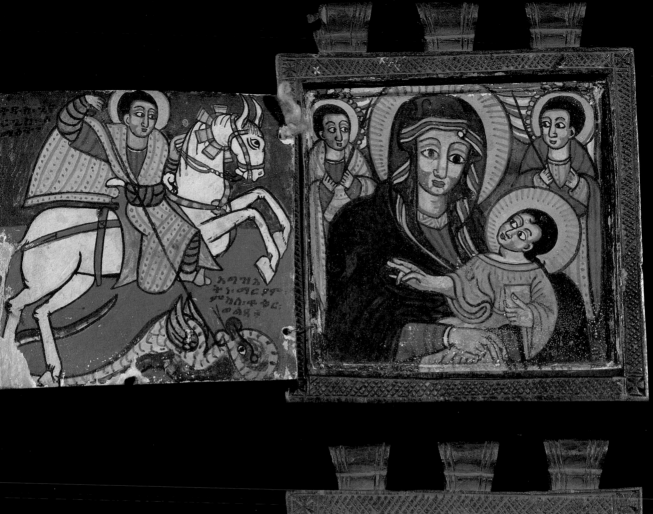

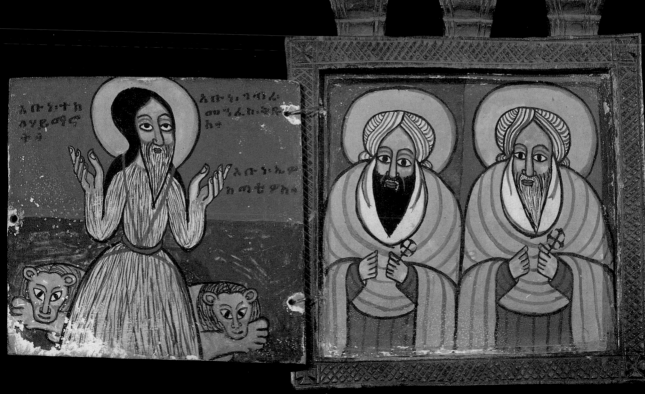

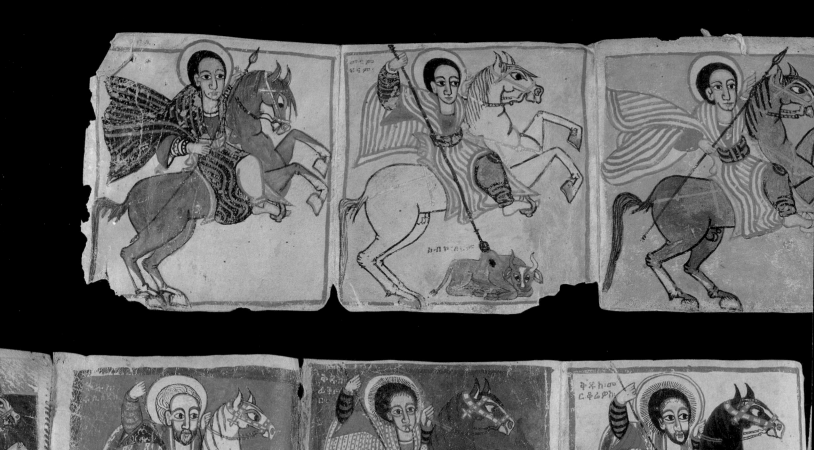

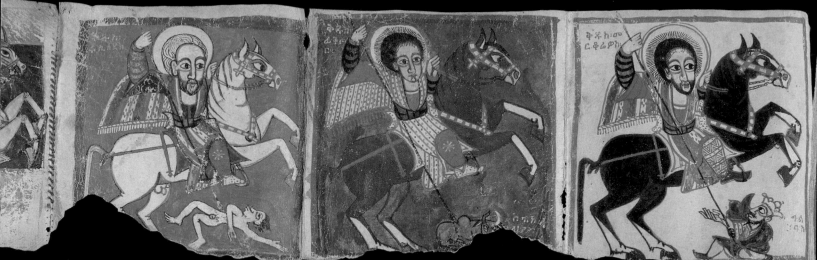

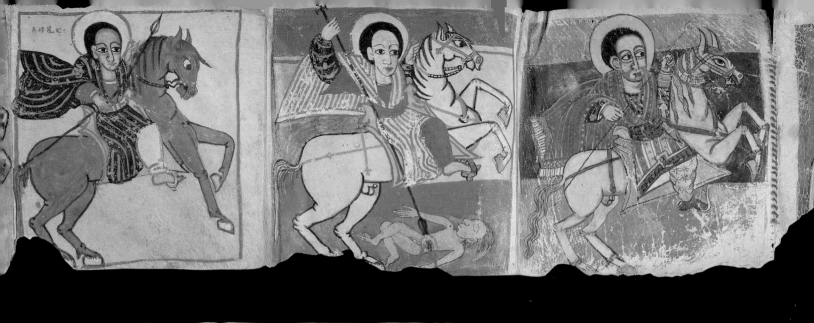

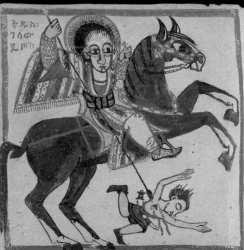
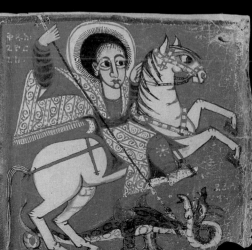

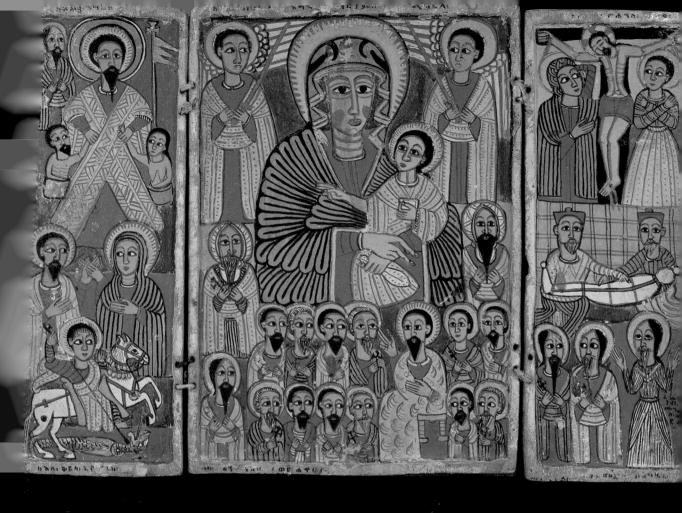

Cat. 104  *Our Lady Mary, Christ Teaching the Apostles, Crucifixion,*
*Joseph and Nicodemus with the Body of Christ, Christ Raising Adam and Eve,*
*Covenant of Mercy, Saint George, Gabra Manfas Qeddus, Samuel, and Madhanina Egzie*

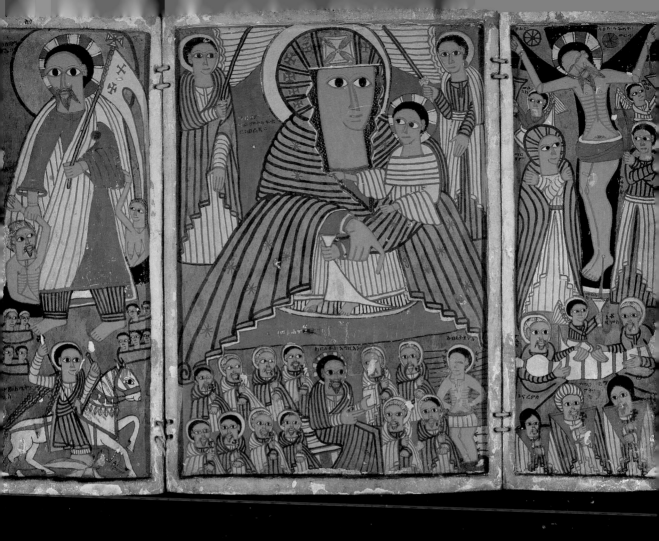

Cat. 105  *Our Lady Mary with Her Beloved Son, Christ our Lord with the Twelve Apostles,*
*Crucifixion with Joseph and Nicodemus, Christ Raising Adam,*
*Saints George, Sebastian, Honorius, Takla Haymanot, and Ewostatewos*

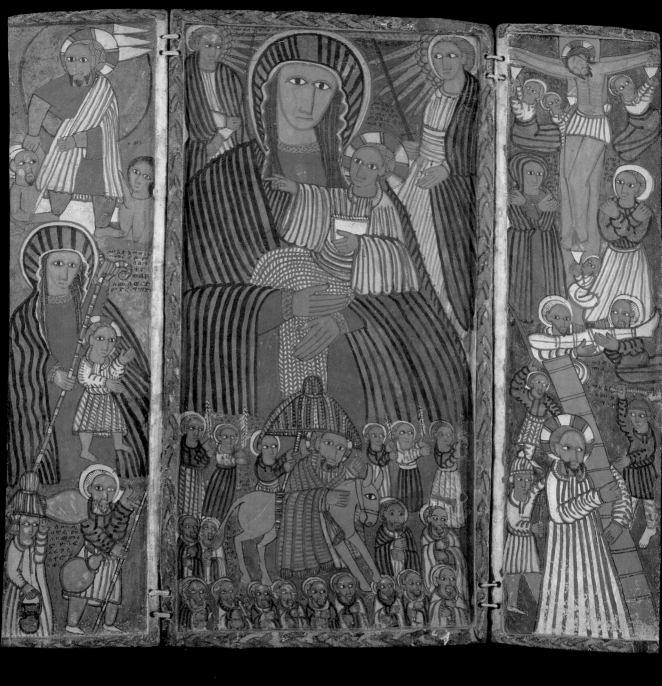

Cat. 106 *Our Lady Mary with Her Beloved Son, the Entry of Christ into Jerusalem,*
*Carrying the Cross, Crucifixion, Flight to Egypt, Christ Raising Adam*

Cat. 107 (*facing page*) Octateuch, Four Gospels, and Syndicon.
*Top* f. 104r: Peter Repentant, Mary and John. *Bottom* f. 107r: Lamentation

ማርያም፡
ወዮሐን
ስ፡ነዉር
እይም፡እ
ምርሐቈ

ናይበ‌ከያሁ፡እንስተ፡ስአየሱስ፡ማ‌ክኤል፡ወገበርኤል፡እንዘ፡ይኔጽሩ፡ናበ፡እግዚ፡እነ‌ክርስቶስ፡

ኒቆዲሞስ፡
እ‌መድ‌እ‌ስ
ፈዋቀ‌ስበግ
ዝዘሩ‌እግዚ
እነ፡

በሰሶ

ማርያም፡
መግደ
ዊት።።

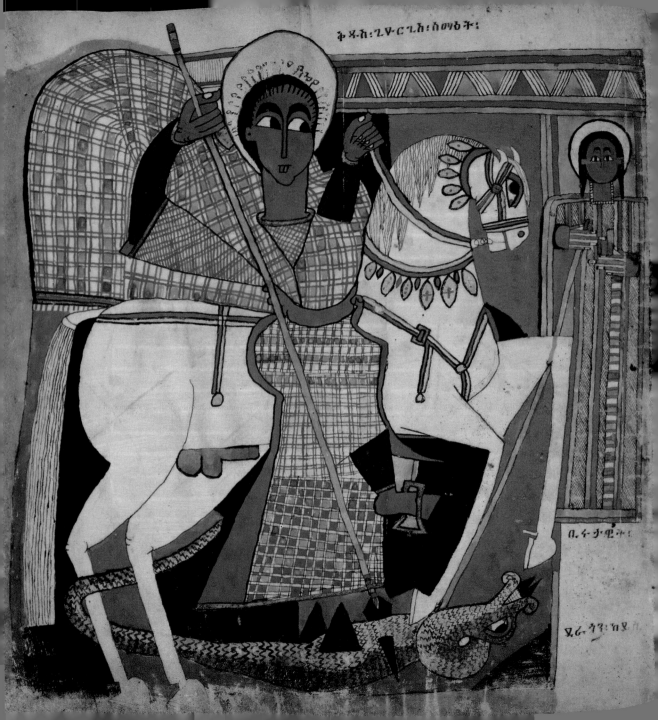

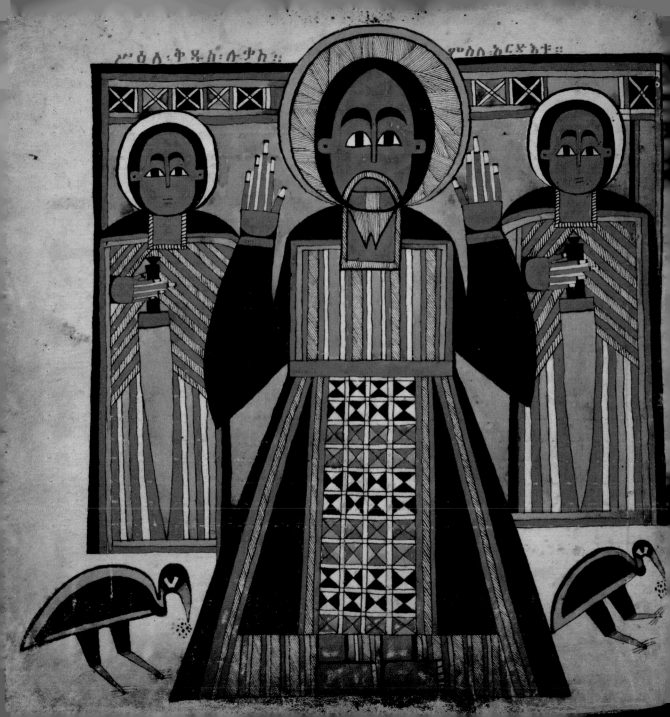
ሥዕለ፡ቅዱስ፡ሉቃስ፨          ምስለ፡እርኅደ፡እቱ፨

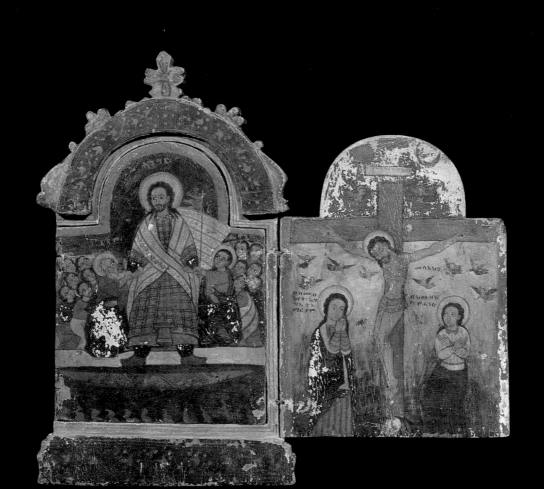

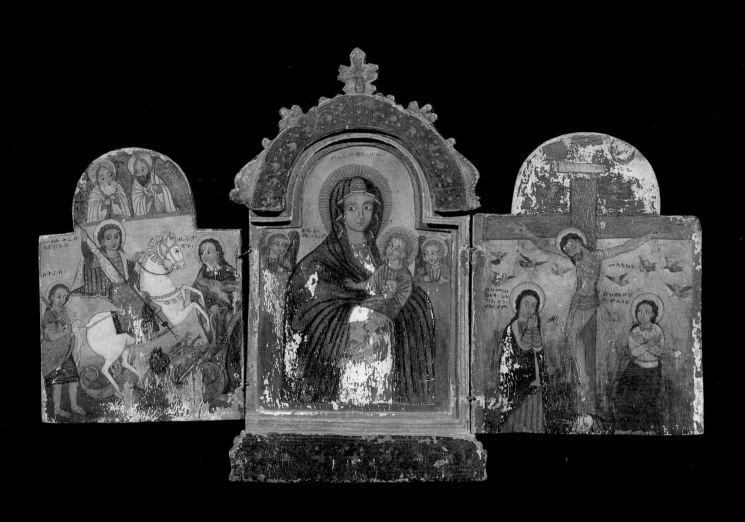

Cat. 110 (*above and facing page*)  *Our Lady Mary, Crucifixion, Christ Raising Adam and Eve,*
*Saint George and the Young Woman of Beirut, Saints*

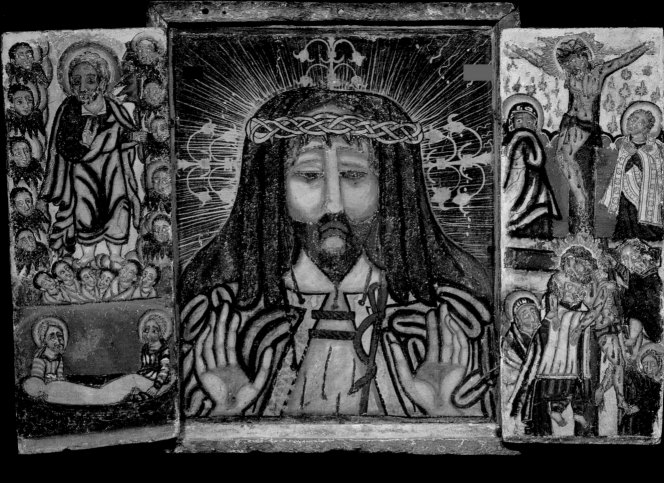

Cat. 111 *Kwerata Reesu (Christ with a Crown of Thorns), Passion and Resurrection*

Cat. 112 (*facing page*) Chalice

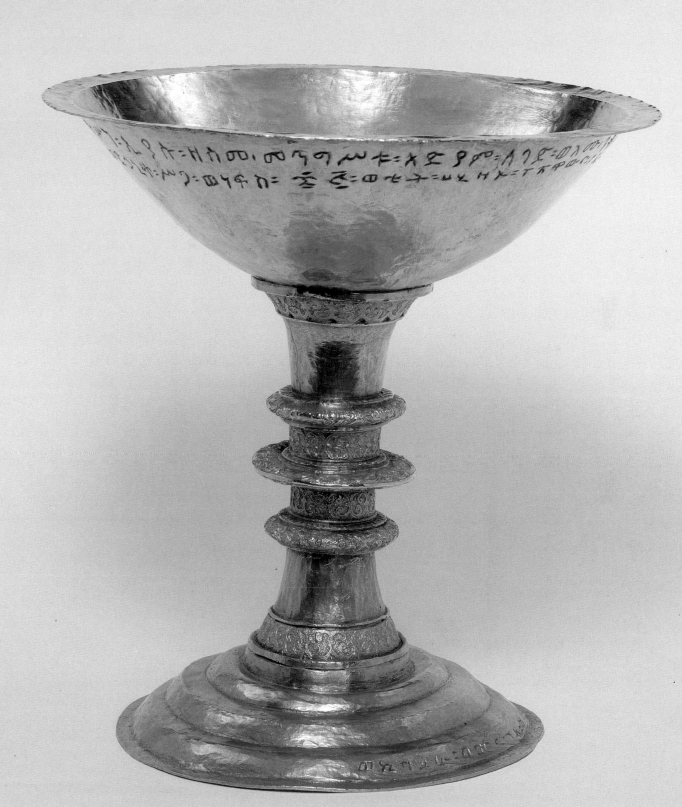

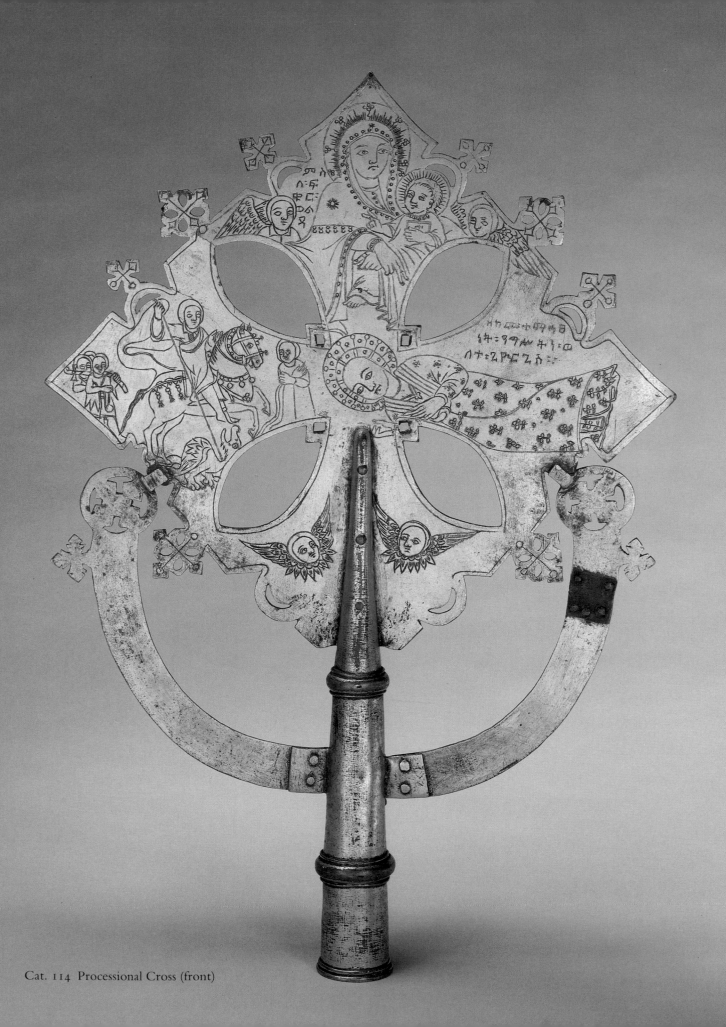

Cat. 114  Processional Cross (front)

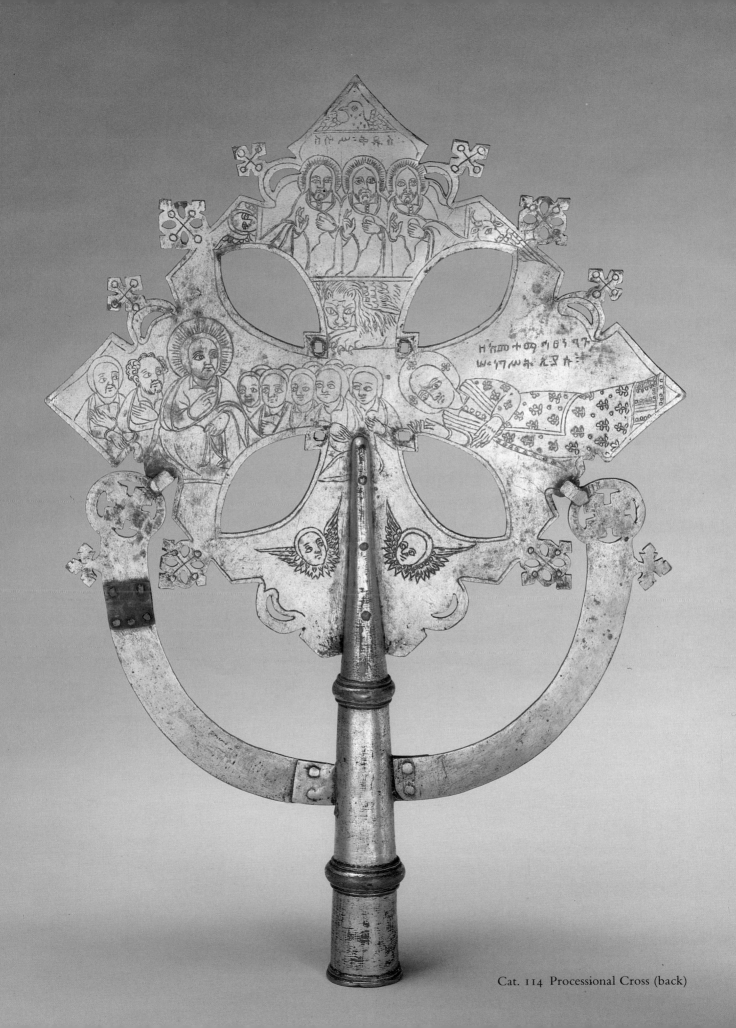

Cat. 114 Processional Cross (back)

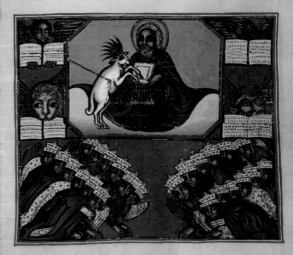

ወሰብ፡ጠዳ፡ቀዳማዊ፡
መአኸኩ፡ ነበረ፡ወ
ሳት፡ም ከሱ፡ደ ም፡ድ
ር ፡ወወረደ፡ወከተ ም
ድ ር ፡ወ እውናዩ፡ ሣል
ከተ፡ ለ ም ድ ር ፡ወ እ ዉ
ዳ ፡ኩ ሉ፡ ሣ ዕ ሩ ፡ወ ሐ
መ ል ማ ለ ፡ ⁘
• • • • • •

ወሰብ፡ጠዳ፡ካለእ፡መ
ል አ ከ ፡ወ ረ ፡ ው ከ ተ ፡ ቢ
ሐ ር ፡ እ ሳ ት ፡ዋ ቢ ፡ ዘ መ
ጠ ን ፡ ገ ብ ር ፡ እ ን ዘ ፡ ይ ን ድ
ድ ፡ ወ ኮ ነ ፡ ደ መ ፡ ሣ ል
ከ ተ ፡ እ ደ ህ ፡ ለ ባ ሕ ር ፡ ወ
ሞ ተ ፡ ኩ ሉ ፡ ሣ ል ከ ተ ፡ ን
ደ ፡ ሁ ለ ዘ ሁ ሉ ፡ ወ ከ ተ ፡
ዓ ሐ ር ፡ ዘ ፈ ፡ ዋ ረ ፡ ዘ ፡
መ ን ፈ ስ ፡ ሐ ይ ው ት ፡ ወ
ሣ ል ከ ተ ፡ እ ደ ፡ ሆ ነ ፡ ለ እ
ሐ ማ ር ፡ ማ ስ ና ፡ ⁘

እዘ እውረዱ፡ክ፡
እመ እተል፡በ
እንቲ አነ፡ከም
ዓነ፡እ ምላክ፡ነ
ወመ ድኅኒ፡ነ፡

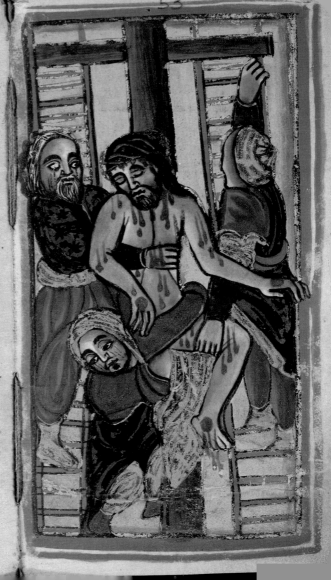

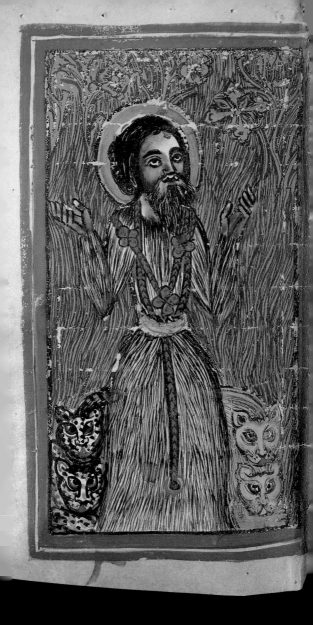

Cat. 116 Prayers, f. 2v: Gabra Manfas Qeddus

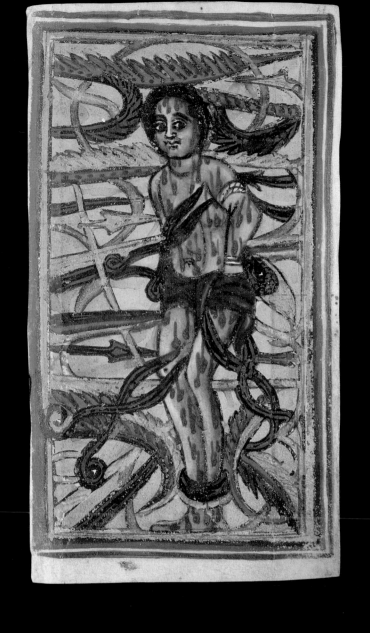

Cat. 116 Prayers, f. 4r: Martyrdom of Saint George

Cat. 117 (*following page*) Collection of Prayers to Our Lady Mary.
*Top* ff. 2v–3r: Abba Takla Haymanot and Abba Ewostatewos with suppliant
*Bottom* ff. 98v–99r: Our Lady Mary with Her Beloved Son and suppliant, Crucifi

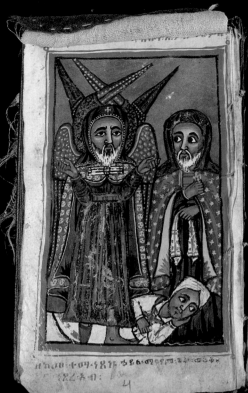

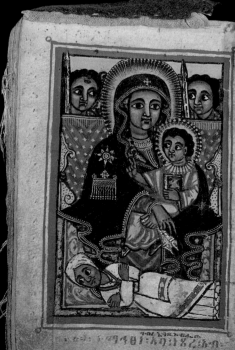

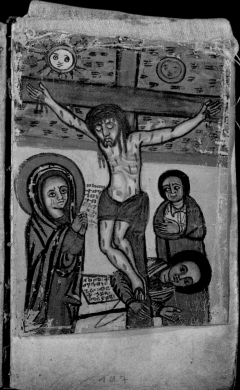

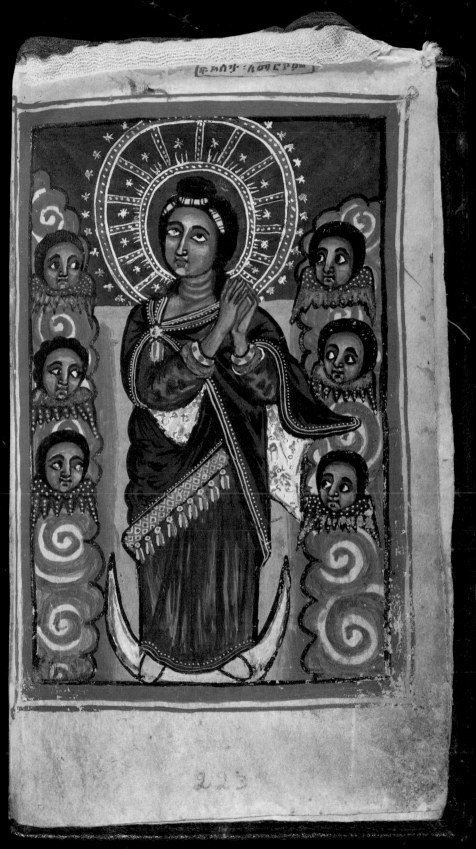

Cat. 117  Collection of Prayers to Our Lady Mary,
f. 113v: Assumption of Mary

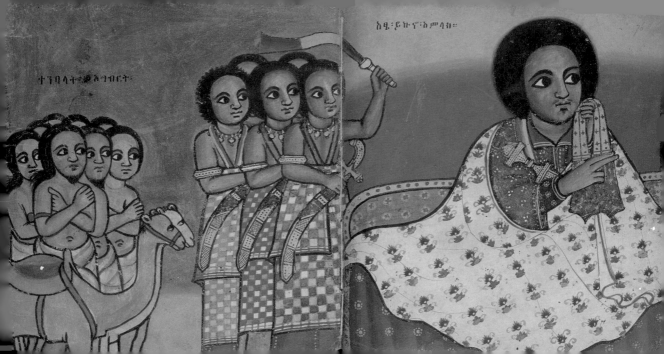

ተንባላት፡ወአግብርት፡ አዜ፡ይኩኖ፡አምሳከ።

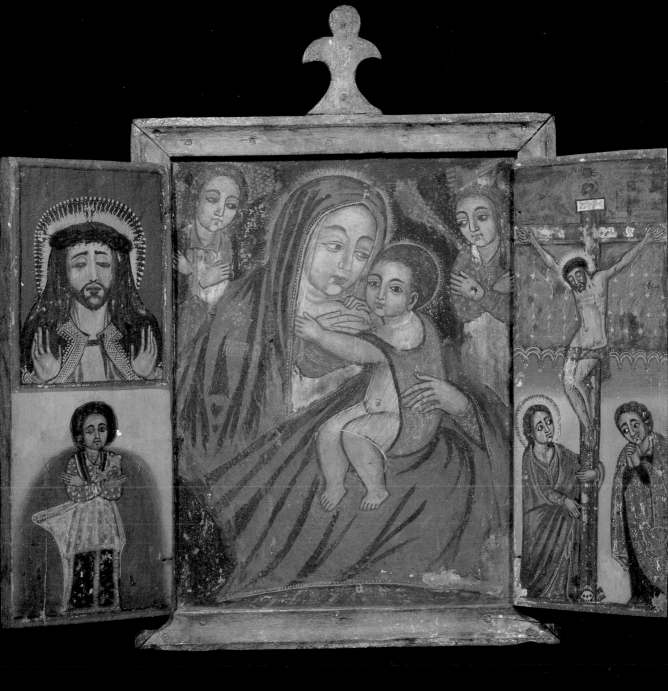

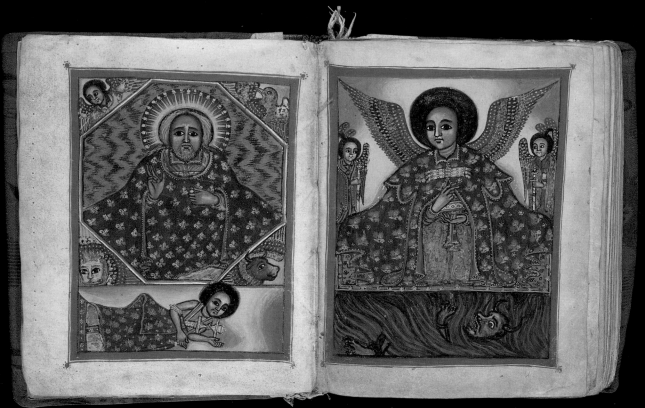

ለዘይቀየም፡ የታሁ ፨
እምእሊ፡ትው፡ማንገ፡
ት፡ለብሉ፡የመ፡ዋዕል
ታ፡ሒቲ፡ክነፌ፡ ፡ወሃ
ዱሁ፡ክሞ፡ር ስዮሙ ፨

ኤ፡ሩ፡ካሆ፡ኚ፡ስመ፡ልእክ
ት፡ዲ፡ደ፡ቀ፡ኚ፡በአም፡ዕ
ሲሁ፡ ፡ደት፡ፃል፡ዐ፡ድ
ወ፡ነፍ፡የ፡ኒዝ፡ በኢ
ካ፡ልአ፡ኚ፡ ይ፡ፍ፡ር ፨

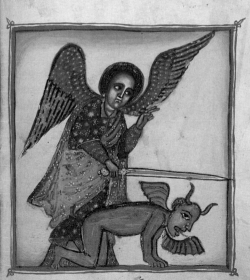

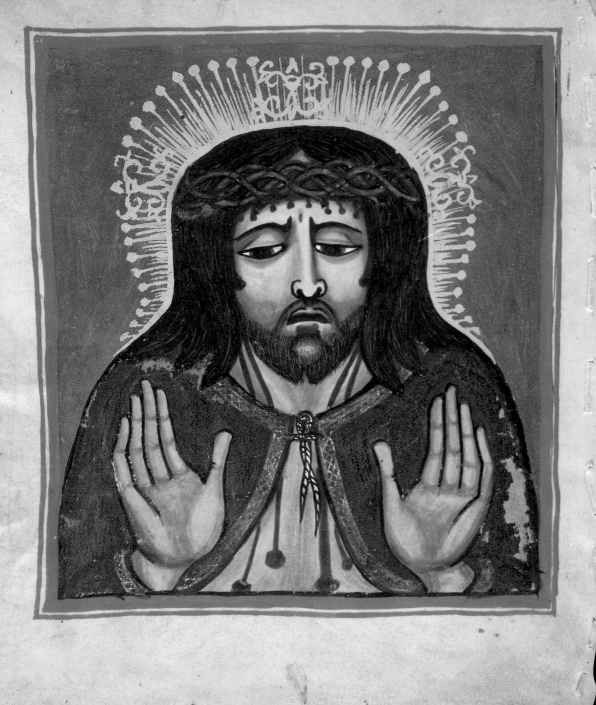

ዘካዕ፡ተክሉ፡ባ፡

Cat. 121 Homiliary in Honor of the Archangel Michael,
f. 5v: Christ with a Crown of Thorns

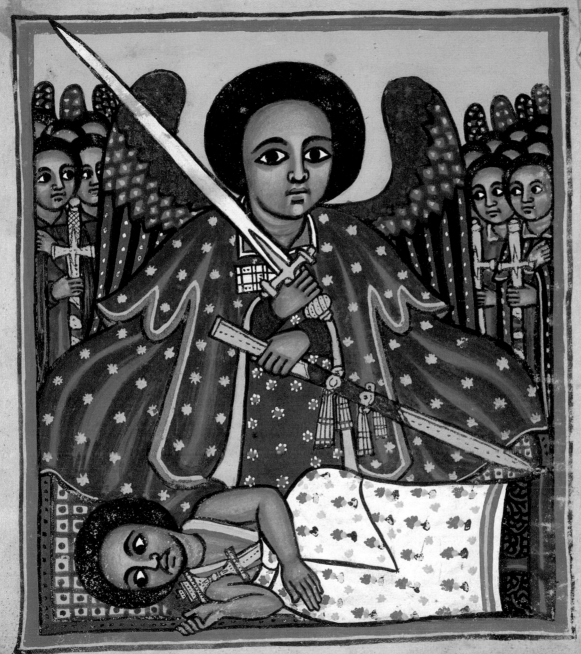

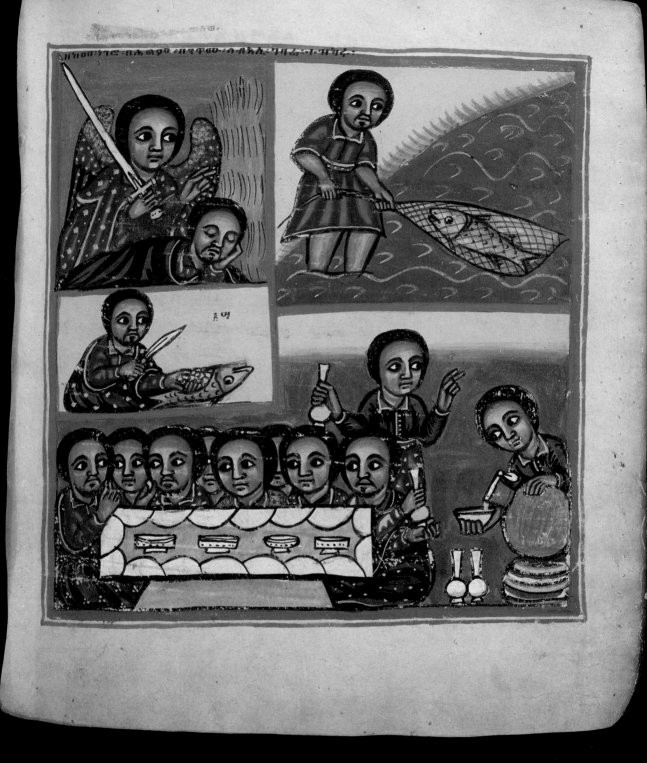

Cat. 121 Homiliary in Honor of the Archangel Michael,
f. 24r: the story of Dorotheus and Theopista

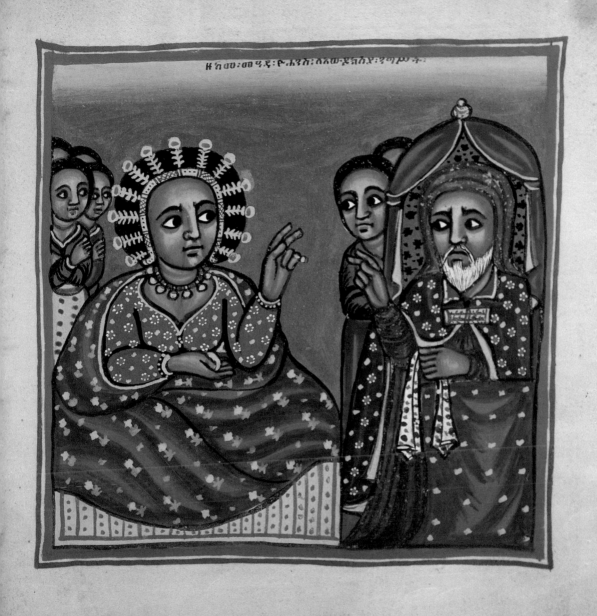

ዘእመውዓፊ፡ዮሐንስ፡ለስወዳስኅ፡ኃጣሁ፡

Cat. 121  Homiliary in Honor of the Archangel Michael,
f. 96r: the empress Eudoxia and Saint John Chrysostom

## 93 Crucifixion, Christ Raising Adam and Eve, Scenes of the Passion

Central Ethiopia (?), second half of
    sixteenth century (?)
Tempera on gesso-covered wood
    panels
$12\frac{15}{16} \times 18\frac{1}{4}$ in. (32.9 × 46.4 cm) open
Institute of Ethiopian Studies, no. 3672

The scheme of this icon follows the pattern of the Saint George triptych by Nicolò Brancaleon, in which the narrative scenes of the wing panels develop the devotional theme of the central panel. In the present triptych, the central panel presents the Crucifixion; the wing panels present scenes of the Passion and the Resurrection (Christ Raising Adam and Eve).

The redemptive sacrifice of Christ is to be contemplated with Mary and John the Evangelist, who stand as witnesses beside the Cross. Three angels collect the holy blood of Christ in blue chalices and demonstrate the Eucharistic significance of the Crucifixion.

The scenes of the Passion and the Resurrection are not presented in strict chronological order. The more important scenes, the Resurrection and Christ with a Crown of Thorns, are placed in the two upper registers, juxtaposing the humiliation of Christ with His triumph over death. On the left panel from top to bottom are Christ Raising Adam and Eve; Christ before Pilate (identifiable by an inscribed version of the scene, fig. 28); and the Flagellation. The right panel depicts, from the top, Christ covered by a blue drape, which represents his blindfolding and beating at the house of the High Priest (Mark 14:64; Luke 22:63–64); the Deposition; and Joseph and Nicodemus with the body of Christ.

Narrative scenes of the Passion had been introduced to Ethiopian painting by Brancaleon. He also introduced a version of Christ Raising Adam and Eve.[1] In this version, Christ is clothed only in a white mantle (fig. 29), as he is routinely depicted in Western European representations, known as the Harrowing of Hell, which represent Christ walking into the mouth of Hell and raising Adam.[2] On the other hand, Brancaleon's Adam and Eve with the Old Testament Righteous are fully clothed, as in

Fig. 28  Scenes of Christ's Passion, left panel of a diptych, Institute of Ethiopian Studies, no. 4132. [Photo by Malcolm Varon, NYC © 1993]

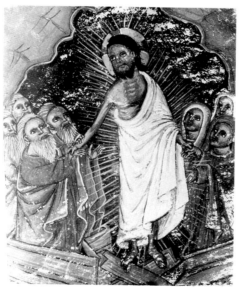

Fig. 29  *Christ Raising Adam and Eve*, a miniature by Nicolo Brancaleon. [Photo courtesy of Diana Spencer]

Byzantine representations of the Resurrection (*Anastasis*).[3] What came to be the standard Ethiopian version of Christ Raising Adam and Eve added a banner of victory and depicted Adam and Eve unclothed, motifs borrowed from Western European

iconography of the Harrowing of Hell. However, this scene is more than a new combination of Western European and Byzantine elements. It is an important new theme for Ethiopian devotional images (cat. 106).

This triptych is similar in style to several small diptychs in collections of the Institute of Ethiopian Studies (cat. 95). The Crucifixion panel exhibits strong similarities with another diptych of the Institute of Ethiopian Studies (cat. 94). The site of the workshop that produced these devotional images has not been identified.

1. D. Spencer 1974: 209, 217.
2. G. Schiller 1971, figs. 137–40.
3. A. D. Kartsonis 1986.

SELECTED REFERENCES
Paris 1974, no. 116.
Stuttgart 1973, no. 6.

## 94 Crucifixion, Our Lady Mary with Her Beloved Son

Central Ethiopia (?), second half of
    sixteenth century
Tempera on gesso-covered wood
    panels
$13\frac{1}{8} \times 9\frac{1}{4}$ in. (33.3 × 23.5 cm) closed
Institute of Ethiopian Studies, no. 4460

This diptych is similar in style to a triptych of the Passion (cat. 93), a work which, like this icon, is difficult to date or localize.

Redemption, the theme of this devotional image, is expressed by the juxtaposition of Our Lady Mary with the Infant Christ and the Crucified Christ mourned by Mary and John. At the foot of the Cross, the skull of Adam receiving blood from the wounds of Christ repeats the theme of redemption.

Details of this devotional image refer to the Eucharist. The Crucifixion depicts small angels collecting blood from the wounds of Christ into chalices, and the opposite panel depicts two small angels hovering beside Our Lady Mary and the Infant Christ. Each angel carries a round object that appears to be a paten, painted blue like the chalices of the opposing panel. In the Prayer of the Consecration of the Paten, the priest prays: "Bless this Paten so that it may be a Paten of

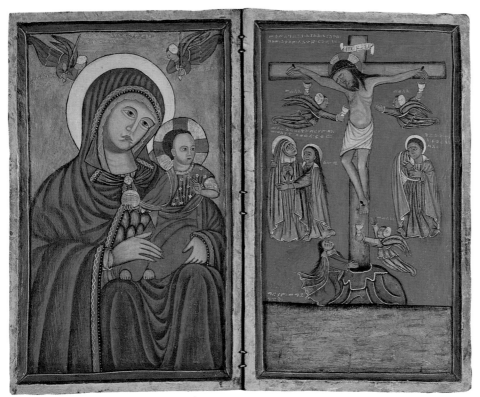

Fig. 30 *Our Lady Mary with Her Beloved Son, Crucifixion*, Institute of Ethiopian Studies, no. 4325. [Photo by Malcolm Varon, NYC © 1993]

SELECTED REFERENCES
Chojnacki, S. 1983: 229–30.

## 95 *Our Lady Mary with Her Beloved Son and Saint George, Crucifixion with Christ Raising Adam and Eve*

Provenance unknown, second half of sixteenth century (?)
Tempera on gesso-covered wood panels
$7\frac{1}{4} \times 10\frac{1}{4}$ in. (18.5 × 26 cm) open
Institute of Ethiopian Studies, no. 3702

The form of this devotional image, a double-sided diptych, became popular during the seventeenth century as a pendant icon, worn suspended by a cord around the neck. The subjects, Mary with the Infant Christ and Saint George, and the Crucifixion with Christ Raising Adam and Eve, became the standard program for these pendant icons.

The present icon, the painted surface of which is flaked in a few areas, provides one of the earliest examples of the diptych carved with a loop for suspension. This particular one is considerably larger than the usual pendant diptych, which suggests that it may not have been intended to be worn.

The style of the paintings is distinctive. The palette is limited to yellow-green, red-

Salvation, the holy body of Thy only-begotten Son Jesus Christ being laid upon it for the remission of sin...."[1] And in the Prayer of the Consecration of the Chalice, he prays: "Bless this Chalice and fill it with pure blood so that it may be a spring of life, even of the holy blood that ran from the side of Thy Son our Lord Jesus Christ for us, because He was crucified to prepare us for the remission of sin with His blood."[2]

Our Lady Mary with the Infant Christ and angels carrying patens can be compared with the *Virgin of the Passion*, the popular Creto-Venetian icon created by the Cretan painter Andreas Ritzos (fl. 1451–92). His icon depicts a pensive Mary and startled Child toward whom fly the archangels Michael and Gabriel carrying instruments of the Passion. An example of this Creto-Venetian icon type, paired with a panel of the Crucifixion, is in the collections of the Institute of Ethiopian Studies (fig. 30). In the present icon, the robe of Mary, red rather than the usual blue, provides further evidence of the painter's exposure to the influence of Creto-Venetian icons, in which a red robe is typical.

A line of brown discoloration runs diagonally across the Crucifixion panel, which was probably burned by a candle.

1. M. Daoud and Marsie Hazen 1954: 5.
2. Ibid.. 6.
3. T. Gouma-Peterson 1968; id. 1972.

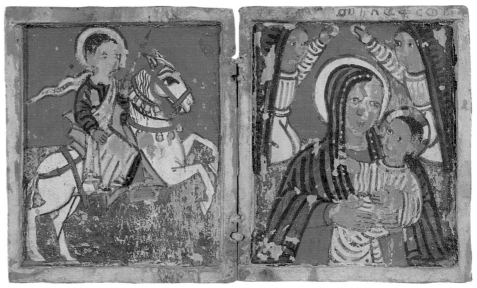

Fig. 31 *Our Lady Mary with Her Beloved Son, Saint George*, Institute of Ethiopian Studies, no. 3561. [Photo by Malcolm Varon, NYC © 1993]

orange, yellow, light blue, and black. Forms are rendered as flat planes. The manner in which the figures are drawn (for example, the palm of Adam's raised hand and Eve's nude torso) combines simplicity with a suggestion of three-dimensionality. The same artist may have painted an unpublished diptych in the collections of the Institute of Ethiopian Studies (fig. 31). The present icon is related in style to the triptych of the Crucifixion and the Passion (cat. 93).

Christ who raises Adam and Eve is clothed in an Indian princely costume, an outer garment worn over pants and overskirt. This suggests that Ethiopian painters had been introduced to religious paintings produced by Deccani artists, who worked from European models.[1] During the reign of Suseyenos (r. 1607–32), the Jesuits brought Indian craftsmen to Ethiopia.[2] It is also possible that paintings from the Jesuit headquarters at Goa in India were sent to Ethiopia even before the Jesuit ascendancy during the reign of Suseyenos. The *Bahr-Nagash* Yeshaq had settled Portuguese Jesuits at Fremona near Aksum shortly after 1562. Jesuit missionaries were probably responsible for introducing Deccani paintings of Christian subjects.

1. M. C. Beach 1981: 211–13.
2. C. F. Beckingham and G. W. B. Huntingford 1954: 83, 190.

## 96   Processional Cross

Gondar, 1667–82
Silver
$13\frac{7}{16} \times 8\frac{9}{16}$ in. (34.1 × 21.8 cm)
Institute of Ethiopian Studies, no. 4466

Mounted upon a shaft with two beaded moldings, this icon is an example of a leaved cross. The leaves are formed by the lower arms that emerge from the shaft. The inclusion of a dedicatory inscription on the icon is an exception; most processional crosses do not have one. Here, the inscription provides the only embellishment: "This cross was given to the Monastery of the Holy Trinity at Wifat by the King of Kings Aelaf Saggad whose baptismal name is Yohannes, and the empress Sabla Wangel that it may be for the salvation of their body and soul." Yohannes, surnamed Aelaf Saggad, reigned

from 1667 to 1682. Wifat, also spelled Ifat, refers to an area in eastern Shoa; the Monastery of the Holy Trinity is unknown today.

Ethiopian monarchs made gifts of processional crosses to important monasteries whose clergy remembered them in their prayers. An account of a miracle worked by Abba Samuel, founder of Dabra Halle Luya near Aksum, preserves the text incised upon the gold cross that the emperor Dawit (r. 1382–1413) presented to this monastery: "I, Dawit, gave this cross and granted a *gwelt* [fief] to Our Lady Twice Holy Virgin, Mary Mother of God, and to the burial place of My Father Samuel, to be an inheritance for the monks forever and that they may remember me through it and make my memorial services because they and I are members in one community. I hereby anathematize any of my children and the children of my children who may take this away from them. I also take refuge forever in the name of Christ my God."[1]

Although this note is much longer than the dedication inscribed upon the cross of Zara Yaeqob (cat. 74) or the present cross of Yohannes, each dedication combines three standard elements: the name of the donor, the name of the recipient, and the request for salvation by remembrance in prayers; the anathema against alienation is frequently included.

1. Getatchew Haile 1980(A): 170–71.

SELECTED REFERENCES
Moore, E. 1971: 50.
Paris 1974, no. 136.
Stuttgart 1973, no. 45.

## 97   Four Gospels

Gondar, 1664–65
Parchment, original stamped leather-covered end boards, striped and flowered silk lining
$18\frac{5}{16} \times 16\frac{1}{8}$ in. (46.5 × 41 cm), 238 ff.
British Library, Or. 510

Numerous miniatures embellish this manuscript of the Gospels. Evangelist portraits serve as an introduction, and narrative illustrations are placed within the Gospel texts. The narrative images fill the

width of the three columns of text and about two-thirds the height of the page, so that each miniature is set beside the text it illustrates.

The manuscript was beautifully copied in the majestic official script of the Gondarine court, the style of which was known as *Gwelh*.[1] The patrons were probably the emperor Yohannes I (r. 1667–82) and the empress Sabla Wangel. A note on f. 238r states that the manuscript was copied for them, although the original name in another note, which gives the date 1664–65, has been erased.[2]

The combination of image and text departs from the models of Early Solomonic Gospel decoration, in which miniatures, which were never integrated with the text, formed a multiple frontispiece. The decision to combine text and image may have been inspired by more than one source, yet the printed *Evangelium arabicum* of 1590, the engravings of which provided models for the miniatures in this manuscript, clearly offered the most immediate inspiration (cat. 98). Furthermore, the style of neutral-ground illumination apparently was suggested by the printed wood engravings.

The miniatures of the present manuscript are more than painted versions of the engraved images from the printed *Evangelium arabicum*. The black-and-white, three-dimensional compositions of the latter, with cross-hatched modeling and suggestions of rationally reconstructible space, have been transformed into bolder, two-dimensional designs enlivened by a vibrant palette of red-orange, yellow, and blue.

The term "First Gondarine style" was applied by Jules Leroy to these miniatures and related wall paintings from Gondar and Lake Tana.[3] An illuminated manuscript of the *Miracles of Mary* (cat. 99), the property of a Gondarine emperor, and the illuminated *Faith of the Fathers*, which can be associated with Yohannes I and Sabla Wangel (cat. 100), may have been produced at the same scriptorium in which the present manuscript was created. The monastery or church at Gondar to which it was attached remains unidentified. The inscription "Of Takla Maryam," which appears in the margin beneath the portrait of Saint Matthew (f. 7r) and elsewhere in the manuscript,[4] may refer to a scribe or a painter.

MINIATURES    Saint Matthew, f. 7r; Saint Mark, f. 76r; Saint Luke, f. 122r; Saint John, f. 190r; and numerous text illustrations (49 in Matthew, 38 in Mark, 42 in Luke, and 21 in John).[5]

1. S. Uhlig 1988: 545.
2. W. Wright 1877: 24–25.
3. J. Leroy 1961: 158.
4. W. Wright 1877: 24–25.
5. J. Leroy 1961: 16–62.

SELECTED REFERENCES
Leroy, J. 1961.
Leroy, J. 1967, pls. 31–34.
Uhlig, S. 1988: 575–76.
Wright, W. 1877, no. 35, 24–25.

## 98    Four Gospels, Arabic (Evangelium arabicum)

Rome, 1590–91
Paper
New York Public Library, Spencer Collection

The earliest printed Gospels in Arabic, produced by the Stamperia Medicea of Cardinal Ferdinando de Medici, is illustrated with engravings by Leonardo Norsino, later known as Parasole. His compositions are based upon the work of the Florentine artist Antonio Tempesta, who used Dürer's popular *Kleine Passion* series for some Gospel miniatures.[1]

The *Evangelium arabicum* was used as a model by the illuminator of the Gospels made at Gondar for the emperor Yohannes and the empress Sabla Wangel (cat. 97).[2] Such use has been demonstrated by Jules Leroy and Hugo Buchthal.[3]

The popularity of Western European pictorial types in the seventeenth-century arts of Ethiopia, India, and the Far East was due largely to the missionary activities of the Jesuits.

1. For example, see J. Leroy 1961, pls. 45 and 46.
2. British Library, Or. 510.
3. J. Leroy 1961; H. Buchthal 1960.

## 99    Miracles of Mary (Taammera Maryam)

Gondar, c. 1670–80
Parchment; stamped, leather-covered wood end boards
$18\frac{1}{4} \times 15\frac{15}{16}$ in (46.3 × 40.5 cm), 131 ff.
British Library, Or. 635

Numerous pictures within the text illustrate the forty-two stories contained in this collection of the *Miracles of Mary*. In addition, a series of full-page miniatures (f. 18r–f. 23r) represents major Marian feasts commemorated in the Ethiopian Church calendar. The series includes the Dedication of Mary at the Temple where she was fed by angels; the Assumption of Mary; and the Covenant of Mercy (*Kidana Mehrat*). On the feast days which these miniatures signify, three selections from the *Miracles of Mary* were read as part of the church service.

The miniatures are outstanding examples of the First Gondarine style, which is closely associated with the patronage of the Gondarine monarchy (cat. 97). The painter displays an especially sure sense of color and design, although there is no interest in representing three-dimensional space. Details of costume and furniture make clear reference to contemporary fashion. In the miniature of Mary in the Temple, the neckline of Mary's dress is embroidered in a style still popular in rural northern Ethiopia (fig. 32), and the angel brings her food in a basket like those still woven and used to serve food. The Covenant of Mercy depicts Mary and Christ seated on a fabric-draped, baldachin covered throne of the Gondarine emperors.

The French physician Charles Jacques Poncet, who visited Gondar in 1699, described the public audience of Iyyasu I: "I entered into a hall, where the Emperor was seated upon his throne. It was a sort of couch, covered with a carpet of red damask flowered with gold. . . . This throne, of which the feet were of gold, was placed at the bottom of a hall, in an alcove covered with a dome all shining with gold and azure. The Emperor was . . . seated upon his couch, with his legs across, after the manner of the Orientals. The great lords were on each side of him, standing in their ranks, having their hands crossed one upon the other. . . ."[1]

The illustration of the miracle of the

Fig. 32 A woman, northern Ethiopia. [Photo by M. Heldman © 1993]

bishop Ildefonsus of Toledo (f. 37v), to whom Mary appeared when he composed homilies in her honor, depicts them both seated in chairs of Luso-Hispanic style[2] as he presents her book of miracles. The imported chairs exemplify the status-bestowing luxuries that were esteemed by the royal court.

The present manuscript appears to have been made for a royal patron. The name of the original owner has been erased and replaced with the name of the emperor Tewoflos (r. 1708–11). The manuscript was most likely the property of one of the churches of Gondar, from which it was appropriated by Tewoflos, in whose name the manuscript's prayers are now addressed.

The neutral ground illumination and other stylistic similarities with miniatures of *Faith of the Fathers* from Mesraha Maryam at Lake Tana (cat. 100) and the miniatures of the Gospels of the emperor Yohannes I and Queen Sabla Wangel[3] suggest that this manuscript was produced at the same scriptorium, perhaps commissioned by Yohannes I and Sabla Wangel.

1. W. Foster 1949: 116.
2. G. Annequin 1972, fig. 17.
3. British Library, Or. 510.

SELECTED REFERENCES
Leroy, J. 1967, pls. 26–30, 50.
London 1978: 50.
Wright, W. 1877, no. 83: 51–52.

Cat. 100 *Faith of the Fathers*, f. 23v: John, patriarch of Alexandria. [Photo by M. Heldman © 1993]

## 100 *Faith of the Fathers (Haymanota Abaw)*

Gondar, 1667–82
Parchment, leather-covered wood end boards
18$\frac{11}{16}$ × 17$\frac{1}{2}$ in. (47.5 × 44.5 cm), 126 ff.
Library of the Patriarchate, Addis Ababa, EMML no. 1

*Faith of the Fathers* is a collection of excerpts from the writings of Eastern Church Fathers. Each section of text is introduced by an unframed portrait of the author, one text column wide. The author writes upon the parchment sheet in his lap, his ink horn and knife for trimming the reed pen suspended upon the page beside him. The elevated status of the authors is suggested by their Luso-Hispanic (that is, imported) armchairs and their fanciful headgear. Some peaked caps resemble monastic caps, although the attached plumes remain unexplained. Other caps may represent ecclesiastical crowns.

The present manuscript can be compared with the illuminated *Faith of the Fathers* at Chalaqot (cat. 101); the miniatures follow the same schemes. The exotic caps and crowns, the Luso-Hispanic chairs, and the figures, with pseudo-modeling of the face, reflect the illustrations of the *Miracles of Mary* in London (cat. 99). Both manuscripts are decorated with miniatures painted in a neutral-ground illumination style of the miniatures in an illuminated Gospels produced for the emperor Yohannes I and his empress Sabla

Wangel (cat. 97). These miniatures typify the First Gondarine style of painting. The palette of this set of miniatures is limited to a combination of yellow, orange, and maroon-red with spare touches of blue-green or green.

During the first decades of the seventeenth century, when Jesuit missionaries were engaged in doctrinal disputes with the clergy of the Ethiopian Orthodox Church, *Faith of the Fathers* served as the major reference work for Ethiopian clerics.[1] After the emperor Fasiladas (r. 1632–67) expelled the Catholic missionaries and burned Geez translations of their books, *Faith of the Fathers* must have symbolized the triumph of the Ethiopian Orthodox Church. This beautifully copied manuscript is more than a reference book; the large size and the thirty-seven author portraits typify a presentation manuscript.

Datable to the reign of Yohannes (1667–82) by the prayer for him and Sabla Wangel, *Faith of the Fathers* may have been their royal commission. Yohannes and Sabla Wangel are buried at Mesraha Maryam at Lake Tana, as is their son the emperor Iyyasu I. The manuscript had been the property of the Church of Mesraha Maryam,[2] the site of their tombs.

The present volume is not complete; it is either the second half of the original manuscript or the second half of a two-volume set. It can be compared with the illuminated manuscript from Gondaroj Giyorgis, a complete collection of the texts known as *Faith of the Fathers*.[3]

MINIATURES Severus, patriarch of Antioch, f. 8v; Heraclius, bishop of Cyzicus, f. 12r; James, bishop of Sarug, f. 19r; Benjamin, patriarch of Alexandria, f. 20r; John, patriarch of Alexandria, f. 23v; Cyriacus, patriarch of Antioch, f. 27v; Theodosius, patriarch of Antioch, f. 32v; Dionysius, patriarch of Antioch, f. 34r; Gabriel, patriarch of Alexandria, f. 35v; Cosmas, patriarch of Alexandria, f. 37v; Basil, patriarch of Antioch, f. 38v; Cosmas, patriarch of Alexandria, f. 44r; Macarius, patriarch of Alexandria, f. 45v; Dionysius of Antioch f. 47r; Menas, archbishop of Alexandria, f. 50r; Dionysius, patriarch of Antioch, f. 51v; John, patriarch of Antioch, f. 53v; Philotheus, patriarch of Alexandria, f. 60v; Philotheus, patriarch of Alexandria, f. 62v; Athanasius,

patriarch of Antioch, f. 64v; John, patriarch of Antioch, f. 66v; Zacharius, patriarch of Alexandria, f. 70r; Sanutius, patriarch of Alexandria, f. 73v; Dionysius, patriarch of Antioch, f. 85v; Christodolus, patriarch of Alexandria, f. 87v; John, patriarch of Antioch, f. 92r; Habib, bishop of Takrit, f. 98v; Abu Zakkareya Walda Aday, f. 99r; Gregory the Wonderworker, f. 99v; Julius, archbishop of Rome, f. 102v; Natalis (Anastasius ?), patriarch of Rome, f. 103r; Gregory the Theologian, f. 103v; Theodosius, archbishop of Alexandria, f. 110r; John, bishop of Brullos, f. 110v; Cyril, archbishop of Alexandria, f. 113r; Cyril of Alexandria, f. 114v; Gregory the Theologian, f. 114v.

1. Girma Beshah and Wolde Aregay Merid 1964: 90–91.
2. R. E. Cheesman 1936: 192.
3. W. Wright 1877: 232–34; Getatchew Haile 1979: 109–11.

SELECTED REFERENCES
EMML no. 1.
Macomber, W. F. 1975.

## 101 *Faith of the Fathers (Haymanota Abaw)*

Gondar, late seventeenth century
Parchment
23$\frac{9}{16}$ × 18$\frac{7}{8}$ in. (59.9 × 48 cm)
Church of the Trinity, Chalaqot

*Faith of the Fathers* is a collection of excerpts from the writings of the Eastern Church Fathers. It begins with the Creed of the Nicaean Fathers and the Canon of the Council of Nicaea. The frontispiece miniature, a representation of the Council of Nicaea, is a collective author portrait. The most important participants, seated upon Luso-Hispanic armchairs and depicted in larger scale, are Jesus Christ, the emperor Constantine, and four authorities wearing ecclesiastical crowns. Beneath are the Three Hundred and Eighteen Orthodox who attended the Council of Nicaea and condemned the heretical teachings of Arius concerning the nature of Jesus Christ. This miniature is very close to the frontispiece miniature of *Faith of the Fathers* at Gondaroj Giyorgis.[1]

Each of the remaining text sections, like the manuscript from Mesraha Maryam that

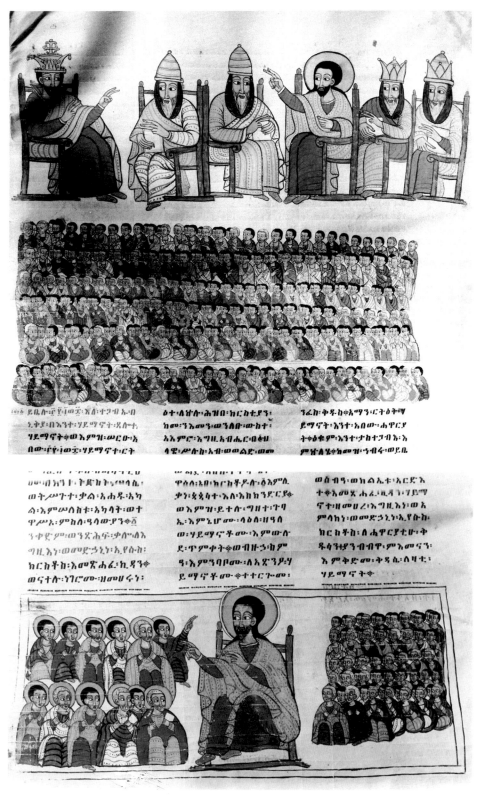

Cat. 101 *Faith of the Fathers*: (top) frontispiece miniature of the Three Hundred and Eighteen Orthodox Bishops at the Council of Nicqea; (bottom) Christ teaching the Apostles. [Photo by M. Heldman © 1993]

was copied for the emperor Yohannes I and the empress Sabla Wangel (cat. 100), is introduced by an author portrait painted in the neutral ground style that is typical of late seventeenth-century Gondarine manuscript illumination. The author portraits closely resemble those in the manuscript from Mesraha Maryam, which lacks the miniature of the Council of Nicaea because it is limited to the second half of the standard collection of *Faith of the Fathers*.

The Council of the Three Hundred and Eighteen Orthodox Fathers, as it is known in the Ethiopian Church, is commemorated on 9 Hedar (November 18). The painter of this frontispiece miniature was conversant with the Synaxary reading and from it created a very literal portrait of the council. The Synaxary names the four presiding patriarchs: Alexander, patriarch of Alexandria; Innocent, patriarch of Rome; the patriarch of Constantinople; and the patriarch of Antioch. These are the four ecclesiastics wearing crowns and painted in larger scale.

The Synaxary's account of the council adds that "our Lord Jesus Christ tarried among them." Some who were present counted 319 figures; the additional figure is construed to have been Christ. Prominently placed between two conversing patriarchs, Christ signifies the divine guiding presence. The rows of figures depicted in smaller scale are a literal portrait of the Three Hundred and Eighteen Orthodox bishops.

After the expulsion of Roman Catholic missionaries and the reestablishment of the Ethiopian Orthodox Church by the emperor Fasiladas, the collection of writings of Eastern Church Fathers known as *Faith of the Fathers* symbolized the restoration of the Alexandrian Faith. The frontispiece miniature presents an ideal portrait of civil authority, the emperor Constantine, and religious leaders uniting in the condemnation of heresy. In Ethiopia, however, doctrinal harmony remained elusive, because theological issues raised by Jesuit missionaries were not easily resolved. The Church was beset by theological controversy concerning the nature of Christ the Son. The emperor Yohannis I summoned several ecclesiastical councils, but consensus was a long time in coming.[2]

1. J. Leroy 1967, pls. 35 and 36.
2. Getatchew Haile 1990: vii–xiii.

243

SELECTED REFERENCES
Leroy, J. 1967, pls. 35 and 36.

## 102 Mary, Saint George, Takla Haymanot, Ewostatewos, Gabra Manfas Qeddus

Gondar, late seventeenth or early
   eighteenth century
Wood, tempera
$4\frac{1}{16} \times 3\frac{9}{16} \times \frac{7}{16}$ in. (10.3 × 9 × 1.1 cm)
   closed
Institute of Ethiopian Studies, no. 3531

Portraits of Ethiopia's most popular saints decorate this small double-sided pendant diptych. On the primary side, Mary, inscribed "Our Lady Mary with her Beloved Son," is accompanied by Saint George spearing the dragon. The two great monastic leaders, Takla Haymanot of Dabra Libanos in Shoa and Ewostatewos of northern Ethiopia, share the reverse of the central panel, and the venerated hermit, Gabra Manfas Qeddus of Zeqwala is depicted in prayer on the adjoining wing.

Paintings of the First Gondarine style are remarkably homogeneous. The miniaturized images of this double-sided diptych are close in style and iconography to monumental painting and manuscript illumination.[1]

The central panel of the diptych is carved with three cylinders along the top, so that it can be worn. Functionally, the double-sided pendant diptych is like the *sensul* (cat. 103). Painted with talismanic images, it may be carried or worn on one's person. The practice of wearing an image of Our Lady Mary on one's chest is documented in fifteenth-century Ethiopian sources.[2]

Unpainted exterior surfaces of the fine-grained olive wood panels are carved with cruciform designs. These intricately carved designs are typical of the small bilateral pendant diptychs of the late seventeenth and early eighteenth centuries. They can be compared with the design carved upon a wood altar tablet (fig. 33) which is dated to the reign of the emperor Bakkaffa (1721–30).[3]

1. J. Leroy 1967, frontis. and pl. 20.
2. E. Cerulli 1933: 93.
3. J. M. Hanssens and A. Raes 1951: 447.

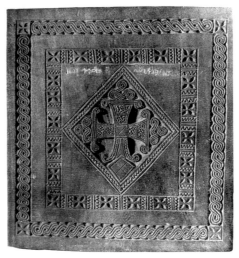

Fig. 33 Altar tablet, Museo Sacro Vaticano, no. 3013. [Photo taken from Hanssens and Raes, "Une collection de tabots au Musée Chrétien de la Bibliothèque Vaticane," *Orientalia Christiana Periodica*, vol. 18, 1951, by permission]

## 103 Equestrian Saints

Gondar, late seventeenth century
Parchment
$3\frac{15}{16} \times 42\frac{1}{2}$ in. (10 × 108 cm)
Institute of Ethiopian Studies, no. 3554

This *sensul* (chain of paintings) is a long parchment strip folded in pleats, creating a series of twelve connected panels, each of which is painted with a military saint mounted on a rearing horse. Although each panel is virtually identical in composition, different-colored backgrounds and horses, the latter painted blue and light green as well as more common hues, give the *sensul* a lively visual aspect. The holy riders and their rearing horses with prominently upswept ears can be compared with the mounted saints of two sets of murals in the First Gondarine style, the wall paintings of Dabra Sina at Lake Tana and the paintings from the Church of Saint Anthony at Gondar.[1]

In the stratified society of highland Christian Ethiopia, where only noblemen were trained in the art of horsemanship and war, the victorious equestrian saint had a specific appeal. Yet, in a more general sense, the equestrian saint was a popular talismanic image, just as the world of Late Antiquity and early Byzantium had utilized the holy rider as an apotropaic image.[2]

The *sensul* form lends itself to apotropaic imagery, because it can be folded and carried on one's person. The *Life* of a fifteenth-century saint tells of a painting (the form is not specified) that was worn on one's person and suspended above the sleeping owner at night.[3] The term *sensul* is first mentioned in an early sixteenth-century note concerning some stolen paintings.[4]

The *sensul* should not be confused with Ethiopian phylacteries or parchment scrolls that combine apotropaic prayers and images.[5] These "magic scrolls" utilize only a few designs that derive from Christian imagery, namely the holy rider, the sword-bearing angel, and the Cross.

MINIATURES  Inscription illegible, panel 1; Marmehnam spearing a bronze statue of an ox, panel 2; Minas, panel 3; Abadir, panel 4; Yostos, panel 5; Eusebius, panel 6; Fasiladas spearing a nude man, panel 7; Victor [Fiktor] spearing a bronze statue of an ox, panel 8; Mercurius spearing Julian the Apostate, panel 9; Theodore spearing an armed man, panel 10; Claudius [Galawdewos] spearing a man, panel 11; George spearing a dragon, panel 12.

1. W. Staude 1959.
2. S. Lewis 1973; G. Vikan 1984.
3. E.A.W. Budge 1898: 30.
4. Getatchew Haile 1987: 191.
5. J. Mercier 1979.

## 104 Our Lady Mary, Christ Teaching the Apostles, Crucifixion, Joseph and Nicodemus with the Body of Christ, Christ Raising Adam and Eve, Covenant of Mercy, Saint George, Gabra Manfas Qeddus, Samuel, and Madhanina Egzie

Provenance unknown, late seventeenth
   to early eighteenth century
Tempera on gesso-covered wood
   panels
$14\frac{3}{4} \times 20\frac{3}{8}$ in. (37.5 × 51.7 cm) open
Institute of Ethiopian Studies, no. 7011

This triptych of Our Lady Mary with her Beloved Son follows the same basic scheme as a number of other Ethiopian triptychs of the

late Solomonic period. The imposing figure of Mary juxtaposed with Christ teaching the apostles symbolizes the Church. The two uninscribed holy men beside Mary may be Takla Haymanot and Ewostatewos, the two great leaders of Ethiopian monasticism. Similarly attired saints on other icons (cat. 11) are inscribed with these names.

The Crucifixion, Joseph and Nicodemus carrying the body of Christ, and Christ Raising Adam and Eve carry a message of redemption. In both iconography and style, the present icon reflects several earlier triptychs (cats. 105 and 106), but it is unique in its inclusion of the composition of Mary and Christ joining hands (left wing). This is known as the *Kidana Mehrat* (Covenant of Mercy), and it signifies Mary's role as Intercessor. The feast of the Covenant of Mercy, one of the principal feasts in the Ethiopian Church calendar, is celebrated on 16 Yakkatit (February 23). It commemorates the promise of Christ to heed His mother's intercessions for those who invoke her name.[1]

On the lower right panel is *Abuna* Gabra Manfas Qeddus, inscribed, wearing his distinctive hermit's garb. Inscriptions identifying the holy men in the lowest register of the right panel are flaked, but the names of Samuel of Waldebba and his spiritual father, Madhanina Egzie of Dabra Bankol near Aksum, are legible. The uninscribed saint with long dark beard in the scene of Christ Raising Adam and Eve appears to be Abba Samuel, for he wears a red and blue garment.

The painter exhibits a strong sense of pattern in both distribution of color and geometric design. Our Lady Mary, with bright red spots on her cheeks and robed in rows of segmented drapery folds, presents an austere version of the Virgin of Santa Maria Maggiore.

> 1. E.A.W. Budge 1928(A), vol. 2: 635–38.

SELECTED REFERENCES
Heldman, M. E. (forthcoming).

## 105 *Our Lady Mary with Her Beloved Son; Christ Our Lord with the Twelve Apostles; Crucifixion with Joseph and Nicodemus; Christ Raising Adam; Saints George, Sebastian, Honorius, Takla Haymanot, and Ewostatewos*

Central Ethiopia (?), seventeenth century
Tempera on gesso-covered wood panels
$15\frac{3}{8} \times 21\frac{1}{4}$ in. (39 × 54 cm) open
Institute of Ethiopian Studies, no. 4128

The majestic figure of Our Lady Mary with her Beloved Son and flanking archangels in the central panel dominates this devotional image. The juxtaposition of her portrait with Christ and the Twelve Apostles beneath suggests that Mary is not only the Mother of God, but also a personification of the Mother Church. Important secondary scenes are the Crucifixion, with angels gathering the blood of Christ in chalices; Joseph and Nicodemus bearing the body of Christ, as in the pre-anaphora Prayer of the Wrapping;[1] and Christ raising Adam while Eve waits.

In the lower registers of the wings are Saint George (left wing) and Saints Honorius, Takla Haymanot, and Ewostatewos (right wing), with Saint Sebastian (shot with arrows) wedged next to the apostles in the central panel. Saint George accompanied Mary in iconic portraits from the mid-fifteenth century onward, and Takla Haymanot and Ewostatewos, Ethiopian monastic leaders, were frequently depicted in Ethiopian devotional images. The inclusion of Saint Sebastian is new.

This portrait of Our Lady Mary with her Beloved Son presents a new iconographic model. Her crossed hands, the left hand carrying a *mappula* (handkerchief), fall in the characteristic gesture of the holy icon of the Virgin of Santa Maria Maggiore in Rome, the likeness of which was widely disseminated by Jesuit missionaries in authorized prints.[2]

The teaching scene of Christ with the Twelve Apostles placed beneath Our Lady Mary resembles the scene that decorates late seventeenth-century manuscripts of *Faith of the Fathers* (cat. 101). After the expulsion of

the Jesuit missionaries by the emperor Fasiladas, the collected writings of the Eastern Church Fathers known as *Faith of the Fathers* came to symbolize the triumph of Ethiopian Orthodox Christianity. In this way the central panel of the present triptych appears to symbolize Ethiopian Orthodoxy as well as the Mother Church.

> 1. M. Daoud and Marsie Hazen 1954: 25.
> 2. U. Monneret de Villard 1947: 15–17.

SELECTED REFERENCES
Chojnacki, S. 1983, fig. 91.

## 106 *Our Lady Mary with Her Beloved Son, the Entry of Christ into Jerusalem, Carrying the Cross, Crucifixion, Flight to Egypt, Christ Raising Adam*

Provenance unknown, after 1600 (?)
Tempera on gesso-covered wood panels
$20\frac{1}{16} \times 19\frac{11}{16}$ in. (51 × 50 cm) open
Institute of Ethiopian Studies, no. 4261

The triptych is dominated by the three-quarter-length portrait of Our Lady Mary and her Son flanked by the archangels Michael and Gabriel; beneath, Christ makes His royal entry into Jerusalem accompanied by the Twelve Apostles and the children, who carry palms and shout Hosannah. The regal pomp of His arrival is suggested by the large ceremonial umbrella (*debab*). Until recently, such umbrellas (fig. 34) accompanied the emperor and other officials when they appeared in public.[1] The juxtaposition of these two subjects in the central panel signifies that Christ is the King

Fig. 34 Procession of umbrellas, commemorative ceremony at Adigrat, Tegre. [Photo by M. Heldman © 1993]

of Kings and suggests that Mary is Zion (*Maryam Seyon*), the Mother Church.

The major subject depicted on the right wing is the Crucifixion, and on the left wing, Christ Raising Adam, inscribed "Image of the Resurrection (*Tensae*)." The Easter feast is known as *Tensae*. While the scene symbolizes the Resurrection, it depicts Christ Raising Adam, as Eve waits her turn. This scene is often juxtaposed with the Crucifixion on devotional images. The redemptive significance of the Crucifixion is emphasized by the angels who gather the blood of Christ in chalices, and by Joseph and Nicodemus beneath. They bear the body of Christ, as in the pre-anaphora Prayer of the Wrapping.[2] The theme of redemption is expanded by the scene of Christ Raising Adam and Eve. The two scenes relate to the prayer of the blessing of the bread and the wine in the anaphora of the apostles:[3] "He stretched out his hands in the passion, suffering to save the sufferers that trust in him. Who was delivered to the passion that He might destroy death, break the bonds of Satan, tread down hell, lead forth the saints, establish a covenant, and make known His Resurrection."

A line from the Synaxary reading for the feast of the Resurrection is even more directly related to this scene of Christ Raising Adam:[4] "Salutation to Thy Resurrection, the day of which became the day of Adam's salvation."

Adam is not only the first man, he is Everyman. "As in Adam all men die, so in Christ all will be brought to life...." promises the Gospel reading (I Cor. 15:23) of the Ethiopian service of the feast of the Resurrection.[5] Thus the scene of Christ Raising Adam and Eve, like the Easter service, both celebrates the Resurrection and offers to the faithful the hope of redemption and eternal life.

The remaining scenes on the wings depict another set of parallel themes. The Flight to Egypt, on the left panel, depicts Mary with her Beloved Son, accompanied by Salome and the elder Joseph, descending to Egypt. This difficult journey prefigured the Passion, exemplified on the right panel by Christ carrying the trunk of the Cross to Golgotha. Men armed with sticks and clubs accompany Him.

The present triptych is difficult to date. The trousers and tunic of Christ, as well as the great blue circle that frames His upper

body, echo the representation of this scene on the double-sided diptych (cat. 95). The triptych is also related to several other triptychs in the collections of the Institute of Ethiopian Studies (cats. 104 and 105). A palette dominated by blues and reds, and a bold design of linear patterns, are the simple means by which the painter created a powerful statement of redemption and the roles of Mary and the Church within it.

1. F. Alvares 1961, vol. 2: 334–35, 359.
2. M. Daoud and Marsie Hazen 1954: 25; R. F. Taft 1978: 245.
3. M. Daoud and Marsie Hazen 1954: 59.
4. E.A.W. Budge 1928(A), vol. 3: 741.
5. S. Strelcyn 1978: 70.

SELECTED REFERENCES
Paris 1974, no. 121.
Stuttgart 1973, no. 11.

## 107 Octateuch, Four Gospels, and Synodicon

Gondar (?), late seventeenth century
Parchment; stamped, leather-covered
    wood end boards
$14\frac{1}{2} \times 13\frac{15}{16}$ in. (36.8 × 35.4 cm), 209 ff.
British Library, Or. 481

This lavishly decorated manuscript is a faithful copy of an illuminated manuscript that was produced in the early fifteenth century at the palace scriptorium of the emperor Dawit and is now the property of the Church of Mary at Amba Geshen (cat. 67). Evidence of historical notes, those copied from the original manuscript and those added to this one, suggests that it was copied for a church of the emperor Iyyasu I (r. 1682–1706), perhaps for Dabra Berhan Sellase, which was dedicated in 1694. It seems to have been produced at his order, either at Amba Geshen or Gondar.

Like its model, this manuscript combines the Octateuch, the Gospels, and the Synodicon. The feat of combining all three standard texts was facilitated by the unusually small size of the script.

Although this is a faithful copy of the Geshen manuscript, there are a few differences between the two. This manuscript, almost square in format, follows the typical proportions of the Ethiopian book of the seventeenth or eighteenth century. Slight but

significant changes were introduced to the miniature of the Crucifixion with Christ mourned by Saint John and Mary. In the London miniature, the representation of Christ follows a more contemporary model, and the head of Adam is depicted at the base of the Cross, where it receives the redemptive blood of Christ. In the Ethiopic *Book of Adam and Eve*, Adam prophesizes his redemption, saying that the Word of God will be crucified on the place in which his body will be laid, and that the crown of his head will be baptized with Christ's blood.[1] According to the description of the Crucifixion in the *Book of the Cave of Treasures*, the blood and water flowed from the wound in Christ's side into the mouth of Adam, and became a baptism to him.[2]

This manuscript, a replica of a precious illuminated manuscript from an earlier age, represents the hope of the emperor Iyyasu that he could revive past glory, indeed reproduce early Solomonic Ethiopia at Gondar. Another example of his program of revival is Dabra Berhan Sellase, the church that was dedicated to the Holy Trinity at a site that he named Dabra Berhan in direct reference to the emperor Zara Yaeqob's famed Church of Jesus at Dabra Berhan in Shoa.

This manuscript neither initiated a revival of the style of the fifteenth-century miniatures nor revived the multiple frontispiece of Gospel decoration. It was a unique commission that made no appreciable impact upon contemporary art of the period.

MINIATURES Moses receiving the tablets of the Law, frontispiece to Genesis, f. 4v; Moses, Servant of the Lord, writing the Law, frontispiece to Exodus, f. 20v; Aaron the Priest with the budding staff, frontispiece to Leviticus, f. 34v; Aaron, frontispiece to Numbers, f. 45v; Moses, frontispiece to Deuteronomy, f. 60v; Joshua and the Angel of the Lord, frontispiece to Joshua, f. 73v; Judah and Kaleb, frontispiece to Judges, f. 82v; Ruth, Naomi, and Boaz, frontispiece to Ruth, f. 90v; Eusebius and Carpianus, f. 93v; Eusebian prologue of the canon tables, ff. 94r–v; canon tables, ff. 95r–98v; Annunciation to Zechariah, f. 99r; Presentation of Mary to the Temple, f. 99v; Annunciation, f. 100r; Nativity, f. 100v; Adoration of the Magi, f. 101r; Baptism,

f. 101v; Massacre of the Innocents, f. 102r; Transfiguration, f. 102v; Entry into Jerusalem, f. 103r–v; Washing of the Feet, f. 104r; Peter Repentant, Mary and John, f. 104v; Arrest of Christ, f. 105r; Crucifixion, with Mary and John, f. 105v; Crucifixion, with the two thieves, f. 106r; Descent from the Cross, f. 106v; Lamentation, f. 107r; Entombment, f. 107v; Holy Women at the Sepulcher, f. 108r; Resurrection (Christ Raising Adam and Defeating the Angel of Darkness), f. 108v; Appearance of Christ to Mary of Magdala, f. 109r; Ascension, f. 109v; vision of Ezekiel, f. 110r; Majestas Domini, f. 110v; Saint Matthew, f. 111r; Saint Matthew and Saint Mark, frontispiece to Gospel of Matthew, f. 111v; Saint Matthew and Saint Mark, frontispiece to Gospel of Mark, f. 125v; Saint Luke and Saint John, frontispiece to Gospel of Luke, f. 133v; Saint Luke and Saint John, frontispiece to Gospel of John, f. 145v; Twelve Apostles, frontispiece to the Synodicon, f. 156v.

1. S. C. Malan 1882: 168–69.
2. E.A.W. Budge 1927: 225.

SELECTED REFERENCES
Heldman, M. E. 1988(B): 167–68.
Leroy, J. 1962(B): 196–97.
Leroy, J. 1967, pl. 25.
London 1978, no. 64.
Wright, W. 1877: 1–6.

## 108 Four Gospels

Lasta, seventeenth century
Parchment, 194 ff.
$10\frac{9}{16} \times 9\frac{13}{16}$ in. (26.8 × 24.9 cm)
British Library, Or. 516

This manuscript is decorated with full-page evangelist portraits that introduce the Gospel texts. The initial page of the text itself is framed by rich bands of interlace (*harag*). A full-page miniature of Saint George, which accompanies the portrait of Saint Luke, depicts him subduing the dragon and rescuing the young woman of Beirut (*Birutawit*). She holds the dragon's tether.[1]

The style of the miniatures is bold in its simplicity. The two-dimensional figures consist of a patchwork of geometric ornament, and the palette is dominated by red, black, and yellow ocher. Figures in a less

accomplished version of this style decorate the facade of the Church of Saint Yemrehanna Krestos in Lasta, near Lalibala, the ceremonial center of the Zagwe dynasty. Several folded parchment strips painted in the same style include a panel with the Holy Kings of Zagwe: Saints Yemrehanna Krestos, Lalibala, and Naakkweto Laab (with King Harbe). Circumstantial evidence thus indicates that this manuscript was decorated in Lasta, perhaps at Lalibala, which, since the fall of the Zagwe dynasty in 1270, has remained an important pilgrimage center.

The evangelists do not follow the traditional iconography of the evangelist portrait, in which the authors are represented seated and writing or standing holding their completed Gospel.[2] These portraits depict the standing evangelist without his Gospel, flanked by a pair of helpers (*ardeetu*, a term that refers to young monks or novices who serve elderly monks).[3] The helpers hold books or unsheathed swords; the swords appear to have an apotropaic function.

The miniature of Saint George, placed before the Gospel of Saint Luke, is not directly related to the Gospel text. The introduction of a single iconic miniature as a preface to each Gospel text is a late development in Ethiopian Gospel decoration. A seventeenth-century manuscript of the Gospels,[4] the miniatures of which are unpublished, places full-page miniatures with the evangelist portraits: the Crucifixion with Saint Matthew, the Raising of Adam and Eve with Saint Mark, Saint George killing the dragon with Saint Luke, and Our Lady Mary with her Beloved Son with Saint John the Evangelist. The combining of Mary and Saint John is inspired by Saint John's vision of the woman robed with the sun (Revelation 12:1), a vision identified by the emperor Zara Yaeqob as Our Lady Mary.[5] The logic of the remaining three groupings is less obvious, although the portrait of Saint Luke was routinely combined with the miniature of Saint George.

MINIATURES    Saint Matthew, f. 4v; Saint Mark, f. 64v; Saint George rescuing the young woman of Beirut, f. 99v; Saint Luke, f. 100v; Saint John, 156v.

1. Jacobus de Voragine 1941: 232–38.
2. A. M. Friend 1927 and 1929.

3. Getatchew Haile 1980(B): 383.
4. Getatchew Haile and W. F. Macomber 1981, EMML no. 1774.
5. Getatchew Haile 1992: 70–81.

SELECTED REFERENCES
Leroy, J. 1967, pl. 55.
London 1978, no. 66, pl. 4.
Wright, W. 1877, no. 41.

## 109 *Sensul*

Lasta, seventeenth century
Provenance unknown
Parchment strip of shorter pieces sewn
    together
$4\frac{1}{16} \times 14\frac{3}{4}$ in. (10.4 × 37.5 cm)

This *sensul* (chain of paintings) is a strip of parchment pieces sewn together and folded to create a series of four rectangular panels. The first panel, at the left, depicts Saint Gabra Manfas. The second panel depicts four kings of the Zagwe dynasty, Saints Yemrehanna Krestos, Lalibala, Naakkweto Laab, and King Harbe. On the third panel are Saints Claudius and George; on the fourth panel is Mary, inscribed "Our Lady," with the Infant Christ and the archangels Michael and Gabriel.

These paintings are so similar in style to the miniatures of the Gospels in London (Or. 516, cat. 108) that they can be assigned to the same painter. The panel with the four kings of the Zagwe dynasty supports the suggestion that the painter worked in the environs of Lalibala. The purported tomb of Saint Lalibala in the Church of Golgotha at Lalibala drew pilgrims to the ceremonial center named after him. Located near Lalibala is the Church of Saint Yemrehanna Krestos, whose tomb there was also a focus of pilgrimage.[1] Nearby is a church dedicated to Saint Naakkweto Laab.

A *sensul* at Church of Mary at Ashatan, in Lasta, which can be attributed to the same painter or workshop, also portrays the four kings of the Zagwe dynasty, and another at the Church of Saint Gabriel, in Lalibala, portrays Our Lady Mary, Saint George, and the four Zagwe kings as well as Gabra Masqai ("Servant of the Cross").[2]

The present amuletic devotional image, which can be folded and carried on the person, may have served as a souvenir of pilgrimage to the churches of Lalibala and

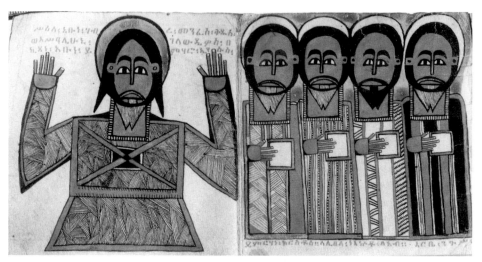

Cat. 109 *Sensul*: (*left*) Saint Gabra Manfas; (*right*) four kings of the Zagwe dynasty. [Photo by M. Heldman © 1993]

environs. The inscription beside the portrait of Gabra Manfas Qeddus states that "Claudius [Galawdewos] had this picture made in the covenant [*kidan*] of Abuna Yemharo Iyyasus." This holy man has not been identified.

    1. F. Alvares 1961, vol. 1: 203–4.
    2. J. Mercier 1975: 121.

## 110 Our Lady Mary, Crucifixion, Christ Raising Adam and Eve, Saint George and the Young Woman of Beirut, Saints

Gondar, eighteenth century
Tempera on gesso-covered wood
    panels
$13\frac{3}{4} \times 8\frac{1}{16}$ in. (35 × 20.5 cm) closed
Institute of Ethiopian Studies, no. 3807

This triptych exhibits some unusual features, although the program, that is, Our Lady Mary and the Infant Christ combined with Saint George, and the Crucifixion paired with Christ Raising Adam and Eve, is typical of Ethiopian devotional images of the late Solomonic period. Most unusual is its form. At its widest, the central panel forms a small base, so that the icon is freestanding. It can be compared with Cretan icons of the late sixteenth and first half of the seventeenth century,[1] from which its form probably derives.

The two wings fold one over the other. The left panel is painted on both faces so that the viewer can contemplate the Crucifixion and Christ Raising Adam and Eve or, by opening the left panel, Mary with Saint George, Ethiopian saints, and the Crucifixion. When the panels are closed, the exterior of the Crucifixion panel is displayed. Its painted design of flowering branches represents the Tree of Life, the Cross.

The figure of Our Lady Mary with the Infant Christ closely follows the icon of the Virgin of Santa Maria Maggiore, and generally the paintings project a sense of elegance. While the backgrounds that shade from yellow to green are typical of the Second Gondarine style, the figures themselves are not heavily modeled. In fact, they are drawn with great finesse. The face of the Crucified Christ looks Ethiopian.

In the Crucifixion scene, inscriptions identify the angels and Our Lady Mary and John, who weep. The sign at the top of the cross reads: "Jesus of Nazareth, King of the Jews." The scene of Christ raising Adam and Eve is inscribed "Resurrection." Inscriptions identify Saint George, the young woman (*Birutawit*), the dragon, and the noble saint's servant or valet (*seqras*). The two saints in the register above Saint George are Takla Haymanot and Ewostatewos.

    1. Baltimore 1988: 224–27.

SELECTED REFERENCES
Chojnacki, S. 1983, fig. 119.

## 111 Kwerata Reesu (Christ with a Crown of Thorns), Passion and Resurrection

Gondar (?), eighteenth century
Tempera on gesso-covered wood
    panels
$10\frac{7}{16} \times 15\frac{3}{4}$ in. (26.5 × 40 cm) open
Institute of Ethiopian Studies, no. 3329

The central panel of this icon depicts Christ wearing a regal mantle and a crown of thorns. Scenes on the wing panels depict the Crucifixion, the Deposition, the Burial, and the Resurrection. The triptych follows the usual pattern of later Ethiopian triptychs, in which the side panels present a series of narrative scenes that relate to the theme of the central panel. On this icon, the side panels follow European Baroque engravings. The ring of angel heads framing the Risen Christ is the most apparent indicator of such influence. The paint on the wing panels is flaked, especially those areas which are painted blue.

The central panel is a replica of the famous icon known as the *Kwerata Reesu*, the palladium of the emperors at Gondar. Allegiance to the emperor was sworn upon the icon, which accompanied him on military expeditions. Although the present triptych may have been made for a patron at the Gondarine court, whose interest in the imperial icon was sustained by personal aristocratic status, the thematic unity of the icon's program suggests that it was created for a patron or client who was devoted to Christ as Savior of the World (*Madhane Alam*). The emperor Fasiladas (r. 1632–67), who founded the capital at Gondar, built seven churches there, one of which was dedicated to the Savior of the World.

## 112 Chalice

Gondar, after 1733
Gold
Victoria and Albert Museum, London

This gold chalice has a broad, shallow cup that rests upon a tall stem and base. The stem is decorated with three flanges and repoussé floral bands. The profile of the base is repeated in the outline of the cup.

An incised dedicatory inscription encircles the top of the cup and the base of the foot: "This is the chalice of our King Iyyasu, whose throne name is Adyam Saggad, and of our Empress Walatta Giyorgis, Berhan Mogasa, which they gave to the *tabot* of Qwesqwam [that is, the church in which the *tabot* was preserved] so that it might be for them salvation of body and soul."

Budge mistakenly identified this king as Iyyasu I. The empress Walatta Giyorgis was the wife of Asma Giyorgis, surnamed Bakkaffa; she was regent for her son Iyyasu II Adyam Saggad (r. 1730–55), who was raised to the throne at age seven. She is more widely known by the name Mentewwab. The empress Mentewwab founded the church dedicated to Our Lady Mary of Qwesqwam in 1732 on the outskirts of Gondar.[1] It was the most lavishly endowed church in eighteenth-century Ethiopia.

The present chalice had apparently been taken from Gondar by the emperor Tewoderos for his dynastic church at Maqdala, but after his defeat by the British expedition in 1868, his treasury was dispersed. Each church must be furnished with a consecrated altar stone or tablet (*sellat*) and the chest in which it is stored (*tabot*, a term often used for the two together); at least one chalice (*sewwa*) and paten (*sahl*); and a communion spoon (*erfa masqal* lit. "spoon of the Cross"). Historical inventories, such as the inventory of the Church of Berber Maryam,[2] list gold and silver chalices and patens. These, as well as crosses, sistra, censers, and lamps, were produced at monasteries by monks trained as metalworkers.

1. R. Schneider 1982: 128–29.
2. A. Caquot 1955(B): 112, 114.

SELECTED REFERENCES
E.A.W. Budge 1928(B), vol. 2: 516.

## 113 History and Miracles of Our Lady Mary (Nagara Maryam)

Gondar, after 1732
Parchment, wood end boards
19 5/16 × 6 1/8 in. (49 × 41 cm), 151 ff.
Church of Dabra Sahay Qwesqwam, Gondar

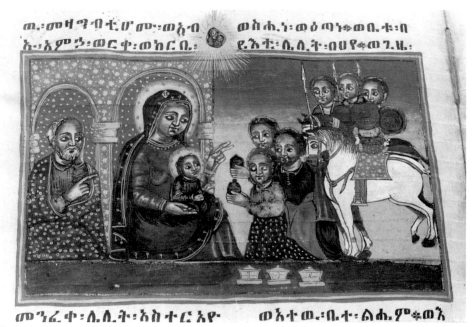

Cat. 113 *History and Miracles of Our Lady Mary*: Adoration of the Magi. [Photo by M. Heldman © 1993]

Numerous miniatures in this manuscript illustrate the apocryphal stories of Mary, who with Joseph, Salome, and her Son Jesus was forced to flee from King Herod. Images of Herod and his adversaries, the good kings Domitianus and Gigar, depict the settings of the Gondarine court. The miniature of Herod ordering the capture of the Holy Family depicts the official beating of the ceremonial drum (*negarit*), an act that preceded each proclamation of the Ethiopian court.[1] The miniature of the Presentation of Mary to the Temple depicts Ethiopian priests wearing white turbans and carrying sistra.

There is little attempt to develop or deviate from established Christian iconography. However, the miniature of the visit of the Magi to the Infant Christ in Bethlehem (Matthew 2:1–12) has an unusual detail: the star that guided the magi is depicted as radiant light in the form of a woman embracing an infant. This miraculous star is described in the Synaxary of the Ethiopian Church.[2] Ultimately, it derives from Syriac apocryphal literature.[3]

Nearly every page of the present manuscript is illustrated with a miniature. Some of the illustrations are primarily decorative. The number of miniatures was so large that only the first ninety-nine were completed. Unfinished miniatures reveal how the painters worked. A drawing was made of the entire composition, and the shaded background was completed before the painters proceeded to the figures. After the figures were painted, finishing touches – the modeling, the decorative designs of the fabrics, and the textures – were added.

The manuscript includes prayers for the emperor Iyyasu, the regent Walatta Giyorgis (better known as the empress Mentewwab), and various members of her family. The emperor Iyyasu II (r. 1730–55) assumed the throne at age seven, and his mother, Mentewwab, acted as regent even after he had reached his majority. Works of art with the names of Iyyasu and Mentewwab were probably created at the order of Mentewwab, who was an important patron of the arts. The present manuscript belongs to the recently rebuilt Church of Dabra Sahay Qwesqwam, which was founded by Mentewwab in 1732. She was devoted to Our Lady Mary of Qwesqwam, named after the site in Egypt where the Holy Family is believed to have lived in exile. The accounts of the hardships endured by the Holy Family when they fled from Herod made the manuscript an appropriate gift for her church.

1. M. Powne 1968: 13–14.
2. E.A.W. Budge 1928(A), vol. 2: 421–22.
3. C. Bezold 1883: 56.

SELECTED REFERENCES
Jäger, O. A. 1960–61: 370–76.
Leroy, J. 1967, pls. 51–54.

## 114 Processional Cross

Gondar, 1730–55
Brass, gilt
$24\frac{3}{16} \times 16\frac{9}{16}$ in. (61.4 × 42.1 cm)
Institute of Ethiopian Studies, no. 4193

Like other processional crosses of the period, this brass cross was cast in four pieces – cross, shaft, and two lower arms – and joined with rivets and welding. The expanding arms of the cross patté join to make a closed form, the surfaces of which are incised with holy images. The decorative scheme is close to that of contemporary painted panels. Like a number of other processional crosses of the fifteenth century (cat. 9), this one is a devotional image.

Both sides of the cross depict the donors as supplicants seeking divine protection. On one side, the empress Mentewwab prostrates herself before Our Lady Mary and Saint George with his foot soldiers and the young woman he rescued from the dragon. On the other, the emperor Iyyasu II prostrates himself before the Holy Trinity and Christ, teacher of the apostles. This scheme resembles the devotional image of Our Lady Mary at Mentewwab's Church of Dabra Sahay Qwesqwam. That icon depicted the empress Mentewwab at the feet of Our Lady Mary seeking her divine protection, while the emperor Iyyasu was represented beneath the crucified body of Christ.[1]

The portrait of the emperor Iyyasu which is engraved upon the cross depicts him as a suppliant before the Holy Trinity. The iconography of the Trinity appears to have been inspired by the great Church of the Trinity at Gondar, Dabra Berhan Sellase, founded by the emperor Iyyasu I in 1692/3, as well as by the *Hymn to the Trinity*,[2] which celebrated the founding of this royal church.[3] The present icon cross would have been an appropriate royal gift for Dabra Berhan Sellase, yet the evidence does not support this suggestion. In 1730 the Church of Saint Takla Haymanot at Gondar replaced Dabra Berhan Sellase as the royal mausoleum, and Mentewwab's church at Dabra Sahay

Qwesqwam became the focus of her lavish patronage.

INSCRIPTIONS   Holy Trinity. How King of Kings Iyyasu seeks divine protection. With her Beloved Son. How Our Empress Walatta Giyorgis [baptismal name of Mentewwab] seeks divine protection.

1. I. Guidi 1912: 106.
2. M. Chaîne 1913, no. 20.
3. Getatchew Haile 1988.

SELECTED REFERENCES
Moore, E. 1971, fig. 47.
Paris 1974, no. 163.
Stuttgart 1973, no. 47.

## 115 *Revelation of Saint John, Apocryphal Acts of Saint John*

Gondar, eighteenth century
Parchment; stamped, leather-covered wood boards lined with red silk
$15\frac{3}{8} \times 14\frac{3}{4}$ in. (39 × 37.5 cm), 115 ff.
British Library, Or. 533

This beautifully copied and generously illustrated manuscript includes the Revelation of Saint John, the Acts and Death of Saint John as narrated by his disciple Prochorus,[1] and a hymn to Saint John. The remarkable miniatures typify the Second Gondarine style and can be associated with the patronage of the empress Mentewwab. The varied palette includes maroon red and an unusual bright green. The flesh of the figures is heavily modeled. The miniatures suggest the luxurious milieu of the Gondarine court during the reign of Iyyasu and Mentewwab. The imposing figure robed in maroon cut-velvet depicts the "one like the son of man" with a two-edged sword issuing from his mouth, who appeared in the midst of seven lamps of gold in the vision of Saint John (Revelation 1:12–13).

The manuscript is undated but may have been copied as early as the first decade of the eighteenth century.[2] The names of Iyyasu and Mentewwab have been added to the manuscript. The miniatures appear to have been added during the reign of Iyyasu II (r. 1730–55). As he was only seven years of age when he assumed the throne, Mentewwab acted as regent.

The miniatures appear to have been produced at the workshop wherein a manuscript of the *Nagara Maryam* (History and Miracles of Our Lady Mary) for Mentewwab's Church of Dabra Sahay at Qwesqwam (cat. 113), the construction of which began between 1732 and 1740. The portrait of the empress Mentewwab before Our Lady Mary on the wall of her church at Lake Tana,[3] a beautiful example of the Second Gondarine style, can be compared with a miniature in the present manuscript, which depicts an emperor bowing deeply, his crown placed above him. In the adjoining prayer, the original name of this emperor has been replaced with the name of the emperor Iyyasu.

According to the Royal Chronicle, the empress Mentewwab provided her Church of Dabra Sahay Qwesqwam with lavish presents, among which was an illustrated copy of the *Revelation of Saint John*.[4] The present manuscript may be the copy mentioned in the chronicle. It is known to have been taken by the emperor Tewoderos II (r. 1855–68) to his royal fortress at Magdala. In 1868 his collection of manuscripts was seized by the Napier expedition, and some of them were subsequently lodged in the British Museum.[5]

MINIATURES   126.

1. E.A.W. Budge 1935: 186–220.
2. S. Uhlig 1988: 638–39.
3. J. Leroy 1967, pl. 40.
4. I. Guidi 1912: 108.
5. W. Wright 1877: iii.

SELECTED REFERENCES
Leroy, J. 1967: 58–59, pls. 41–49.
London 1978: 49–50.
Wright, W. 1877: 39, no. 60.

## 116 Prayers

Gondar, after 1730
Parchment, blue-velvet-covered end boards
$6\frac{5}{16} \times 3\frac{9}{16}$ in. (16 × 9 cm), 79 ff.
Institute of Ethiopian Studies, MS 75

Several iconic portraits, scenes of martyrdom, and scenes of the Passion and the Resurrection embellish this small book of private devotions. As the prayers are quite brief, the

miniatures are the primary devotional focus. Their modeled figures and scenes follow Baroque motifs, and they reflect the Second Gondarine style. The brilliantly conceived compositions suggest that these are the work of a master artist.

The portrait of Saint Gabra Manfas Qeddus ("Servant of the Holy Spirit") captures the nature of the solitary holy man. Wearing heavy chains to mortify his body and clothed only in a garment made of his hair, he stands in the wilderness, flanked by wild beasts who are tamed by his holiness: "He lived standing upright like a pillar for six months, and he gazed into heaven, and he neither dropped his eyelids nor bowed his head, and his hands were stretched out toward heaven."[1]

The iconography of Gabra Manfas Qeddus as a holy hermit was developed during the seventeenth century. What is extraordinary about this miniature is the representation of the wilderness before which he stands. A dense but cultivated growth of delicate leaves and luscious flowers is rendered calligraphically so that the background corresponds with the linear texture of the saint's garment.

The brutal martyrdom of Saint George is depicted with great aesthetic effect. The bound and bleeding body of the saint is trapped within an artful tangle of menacing pincers, spears, vines, and serrate leaves. This miniature can be compared with a far more conventional version of the composition in an eighteenth-century Ethiopian manuscript in Frankfurt.[2]

MINIATURES   Gabra Manfas Qeddus, f. 2v; Martyrdom ("Abuna Abib" is a later inscription), f. 3r; Martyrdom of Saint George, f. 4r; Holy Horseman, f. 4v; Abba Samuel of Waldebba, f. 5r; God the Father, f. 6v; woman with child, f. 14v; Covenant of Mercy (Kidana Mehrat), f. 15v; Mary and the Infant Christ in Egypt, f. 16v; Christ teaching the apostles, f. 17v; Saints, f. 18v; Martyrs, f. 19v; Saint George, f. 20v; Our Lady Mary with her Beloved Son, f. 21v; suppliant (name erased), f. 22r; Annunciation, f. 22v; Annunciation with God the Father, f. 24r; Nativity, f. 25r; Baptism of Christ, f. 26r; Last Supper, f. 27v; Washing of the Feet, f. 28r; Temptation of Christ, f. 29r; Betrayal of Christ, f. 30r; Arrest of Christ, f. 31r; Arrest

of Christ, f. 32r; Christ with a Crown of Thorns, f. 33r; Christ before the chief priest (?), f. 34r; Flagellation, f. 35r; Christ Blindfolded, f. 36r; Christ with a Crown of Thorns, f. 37r; Humiliation of Christ, f. 38r; Christ bearing the Cross, f. 39r; removal of the red garment of Christ, f. 40r; Christ tied to the column, f. 41r; Christ before the head priest, f. 42r; Christ before Pilate, f. 43r; Pilate washes his hands, f. 44r; Christ before Herod, f. 45r; nailing Christ to the Cross, f. 46r; raising the Cross, f. 47r; casting lots for the garment of Christ, f. 48r; praying figure (?), f. 49r; Crucifixion, f. 50r; the side of Christ pierced by a lance, f. 51r; Christ offered vinegar, f. 52r; Deposition, f. 53r; Pieta, f. 54r; Entombment, f. 55r; Resurrection, f. 56r; Ascension, f. 57r; Second Coming, f. 58r; subject not identified; a later inscription names Abuna Ewostatewos, f. 63r; Nero, f. 63v; Beheading of Saint Paul, f. 64r; Crucifixion of Saint Peter, f. 65r; Martyrdom of Saint Andrew, f. 66r; Stoning of Saint James, f. 67r; Saint John, Beloved of the Lord, f. 68r; Martyrdom of Saint Philip, f. 69r; Martyrdom of Saint Bartholomew, f. 70r; Martyrdom of Saint Thomas, f. 71r; Martyrdom of Saint Matthew, f. 72r; Martyrdom of Saint Thaddeus, f. 73r; Martyrdom of Saint Nathaniel, f. 74r; Martyrdom of Saint Mattias, f. 75r; Martyrdom of Saint Mark, f. 76r; Martyrdom, f. 77v; Martyrdom, f. 78r.

1. E.A.W. Budge 1928(A), vol. 3: 765–66.
2. E. Hammerschmidt and O. A. Jäger 1968: 94, fig. 67.

SELECTED REFERENCES
Paris 1974, no. 148.
Stuttgart 1973, no. 28.

## 117   Collection of Prayers to Our Lady Mary

Provenance unknown, after 1730
Parchment, leather-covered end boards
$7\frac{3}{4} \times 4\frac{3}{4}$ in. (19.7 × 12 cm), 114 ff.
Institute of Ethiopian Studies, MS 73

This manuscript of Marian prayers for daily recitation, a small book intended for personal use, is embellished with four full-page miniatures and one additional miniature. All are painted in the Second Gondarine style

that flourished under the artistic patronage of the empress Mentewwab and her son the emperor Iyyasu II.

Although the book's visual appeal is enhanced by the miniatures, they are nonnarrative, iconic images. Each subject, with the exception of the Assumption (Felsata) of Mary, routinely appears in programs of painted triptychs of the late Solomonic period. The miniature of Saint George was used as a talisman, and the manuscript's small size allowed it to be carried on one's person.

The portrait of the Ethiopian monastic saints, Takla Haymanot and Ewostatewos, with the patron prostrating himself before them, depicts a new iconography of Takla Haymanot. Supported by six wings, he prays standing on one foot, having broken a leg after standing too long in his monastic cell.[1] His wings signify attainment of the monastic ideal in which the realms of heaven and earth are united.

The miniature of Mary upon the crescent moon, framed by angelic faces and clouds, represents the Assumption, the bodily taking up of Our Lady Mary into heaven. This event is celebrated as a major feast by the Ethiopian and Coptic Churches on 16 Nahase (August 22; in Egypt, 16 Masri), and by the Orthodox and Roman Catholic Churches on August 15.[2] The miniature is without inscription; however, a similar Ethiopian representation[3] is inscribed "Felsata."

The miniature of the Assumption reflects the remarkably wide range of artistic models that were available to Ethiopian painters. It is based upon a European Baroque engraving of the Immaculate Conception. The engraving, perhaps Spanish, circulated widely and inspired a painting of the Immaculate Conception by the circle of the late seventeenth- or early eighteenth-century Bolivian painter Melchor Pirez Holguin (fig. 35). The Virgins of the two paintings share a particular Baroque torsion of the body, placement of the hands, and radiant halo embellished with stars. The immediate model for the Ethiopian miniature seems to have come from India, and may have been made by a Deccani artist who was familiar with the European engraving. The arrangement of Mary's hair into a topknot has a parallel in the hair of an angel in a mid-seventeenth-century Deccani painting.[4]

251

Fig. 35 The circle of Melchor Perez Holguin, *Immaculate Conception.* [Photo taken from Shalkop, *A Comparative View of Spanish Colonial Painting,* Taylor Museum, Colorado Springs, Colorado, 1970, by permission]

The crescent moon on which Mary stands and her star-studded halo are described in Saint John's vision of a woman (Revelation 11:19–12:1): "Then God's Temple in heaven was laid open, and within the Temple was seen the Ark of his Covenant. There came flashes of lightning and peals of thunder, an earthquake, and a storm of hail. Next appeared a great portent in heaven, a woman robed with the sun, beneath her feet the moon, and on her head a crown of twelve stars."

Many treatises written by the emperor Zara Yaeqob identified the woman of Saint John's vision as Mary.[5] However, not until several hundred years later did Ethiopian artists, inspired by an imported model that depicted Mary standing upon the crescent moon, give visual form to the vision.

The present manuscript was copied and illuminated for a cleric whose name has been erased from the prayers in the text. His name was replaced by the name of the second recorded owner, another cleric, Abba Nesere Ab. A later hand added the name of Gabra Egziabher to the prayers. The additional Crucifixion miniature depicts Gera Warq Hayla Maryam, who prostrates himself at the foot of the Cross. The name of Gabra Egziabher was added in a note beside the Cross.

INSCRIPTIONS  "How Abba Nesere Ab seeks protection," with added name "Gabra Egziabher," f. 2v; "How [name erased] seeks protection," f. 50v; "How Abba Nesere Ab seeks protection," with added name "Gabra Egziabher," f. 98v; (on the garment of the noble) "How Gera Warq Hayla Maryam seeks protection," and added beside the Cross, "How Gabra Egziabher seeks protection," f. 99r.

MINIATURES  Abba Takla Haymanot and Abba Ewostatewos with suppliant, f. 2v; Saint George, f. 50v; Our Lady Mary with her Beloved Son and suppliant, f. 98v; Crucifixion with suppliant at the base of the Cross, a separate parchment leaf attached as f. 99r; Assumption (*Felsata*) of Mary, f. 113r.

1. E.A.W. Budge 1928(A), vol. 4: 1245.
2. For a brief discussion of the Coptic and Ethiopian calendar, see D. Buxton 1970: 182–88.
3. S. Chojnacki 1983, fig. 142b.
4. M. C. Beach 1981: 212–13.
5. Getatchew Haile 1991: 4; id. 1992: 118–19.

SELECTED REFERENCES
Paris 1974, no. 150.
Stuttgart 1973, no. 30.

## 118  *Life and Miracles of Saint Walatta Petros*

Gondar, after 1730
Parchment, leather-covered wood boards
$10\frac{5}{8} \times 9\frac{1}{4}$ in. (27 × 23.5 cm), 138 ff.
Church of Walatta Petros, Qwarata, Hammerschmidt Tanasee 179

A number of narrative miniatures painted in the Second Gondarine style illustrate this manuscript of the *Life* of Walatta Petros. In the eighteenth century, narrative illustrations were added to hagiographies, probably owing in part to the patronage of Mentewwab. According to the Royal Chronicle, she presented her new Church of Dabra Sahay Qwesqwam on the outskirts of Gondar with an illustrated *Life* of Saint George.[1] Mentewwab may have sponsored the illustration of this manuscript as well. She was devoted to the cult of Saint Walatta Petros (d. 1643), who is said to have prophesied the birth of the empress and "her luminous brilliance, which shone like the sun."[2] Although Hammerschmidt[3] dated this manuscript to the reign of the emperor Dawit III (r. 1716–21), the style of the miniatures suggests a date after 1730.

Saint Walatta Petros was the abbess of a monastic community at Qwarata on the east shore of Lake Tana, where the church is dedicated to her. She is interred in the sanctuary of the Church of the Savior (*Madhane Alam*) at Rema Island, the church in which her father, *Dajazmach* Baher Saggad, her brother, *Dajazmach* Yohannes Baher Saggad, and her mother, Krestos Ebaya, are buried.[4] Like many of Ethiopia's religious leaders, she was a member of the aristocracy She lived during the period of conflict when the emperor Suseneyos attempted to convert his country to the beliefs of the Church of Rome. She is probably best known for her courageous resistance to Suseneyos and her refusal to abjure her Orthodox faith.

Holy persons attained permanent recognition of sainthood by means of the written records of their lives. A disciple or fellow religious composed a hagiography relating the struggles and triumphs of the holy person's spiritual life (*gadl*). Because female monastics were less likely to have been trained in writing or the scribal profession (documents have yielded no female scribal names), it was more difficult for a holy woman to achieve recognition as a saint.

The tenth of eleven miracles associated with Saint Walatta Petros recounts that after she died she appeared to a monk, requesting that he assume responsibility for creating the written record of her life. The monk was ill, and gave this charge to another monk.[5] The miniature that accompanies this story depicts three episodes: Walatta Petros, with a red dress, blue robe, and yellow halo, appears above a sleeping monk, her hand extended in a gesture of speech; the ailing monk instructs another to begin the task; he collects accounts of her life from nuns and monks and creates the written record.

The stories and illustrations of the miracles of Saint Walatta Petros reflect monastic life at

Lake Tana. Several miniatures depict travel on the lake by the papyrus boat (*tankwa*) still used today. Several miracles concerning food are illustrated with images of nuns at work baking bread or making and serving beer, roles that they traditionally assumed at the monastery.

MINIATURES   Death of Walatta Petros, nun Falasita Krestos (above) and monk Abba Seela Krestos (beneath) beside her bed, f. 111r; rising of the bread (*injera*) batter in preparation for the commemorative feast (*tazkar*) of Walatta Petros (first miracle), f. 112v; ailing monk in a boat on Lake Tana (second miracle), f. 114r; cure of an ailing child (third miracle), f. 118r; one jar of beer (*sawa*) becomes two (fourth miracle), f. 119v; a goat returns a lost candle at the command of Walatta Petros (fifth miracle), f. 121r; Walatta Petros saves a monk from drowning in Lake Tana during a storm and he tells his community of the rescue (sixth miracle), ff. 122v–123r; at the command of Walatta Petros, a fisherman returns a manuscript lost by a nun (seventh miracle), ff. 124v–125r; the jar breaks but the beer does not spill (ninth miracle), f. 131r; the *Life* of Walatta Petros is written (tenth miracle), f. 132v; Walatta Petros stops the sun in its course (eleventh miracle), f. 134r, Walatta Petros with a nun at her feet, f. 136v; standing nobleman, f. 137r.

1. I. Guidi 1912: 107.
2. Ibid.: 13–17.
3. E. Hammerschmidt 1977: 28.
4. E. Hammerschmidt 1973: 65–66.
5. L. Ricci 1970: 123–25.

SELECTED REFERENCES
Hammerschmidt, E. 1977: 28, 48–51, pls. 138–50.

## 119 *Mary Nursing Her Infant Son, Crucifixion, Christ with a Crown of Thorns (Kwerata Reesu), Donor Portrait*

Gondar (?), after 1730
Tempera on gesso-covered wood panels
$16\frac{3}{8} \times 10\frac{7}{8}$ in. (41.5 × 27.7 cm) closed
Institute of Ethiopian Studies, no. 3524

The central panel is filled with a three-quarter-length portrait of Mary and the Infant Christ, flanked by archangels, whose arms are crossed in an attitude of adoration. Mary offers her breast to her son, who serenely turns to meet the gaze of the faithful. In the Crucifixion of the right panel, Mary, weeping copiously, embraces the Cross, just as she embraces her Infant Son. Saint John the Evangelist weeps too, and the cosmos mourns: in the sky are rows of falling stars, the red moon, having turned to blood, and the darkened sun (Joel 2:31). At the base of the Cross is the head of Adam, a reference to the belief that Christ was crucified upon the site where Adam was buried. This juxtaposition also signifies the redemption of Adam.

The Passion is symbolized by the iconic portrait of Christ with a Crown of Thorns (*Kwerata Reesu*), a copy of the palladium of the monarchy housed at Gondar. Below stands the nobleman for whom this icon was painted; his crossed arms signify that he is a suppliant.

Somewhat unusual is the emphasis on the humanity of Christ, as indicated by the plump, nude body of the Child,[1] the resigned pathos of Christ with a Crown of Thorns, and the bloodied body of Christ on the Cross. The figure of the Infant Christ may be derived from a European Baroque engraving.

Careful attention to contemporary detail is typical of the Second Gondarine style. The round and full hair style of the nobleman reflects the fashion at the Ethiopian court during the late eighteenth century.[2] The nobleman, Saint John, and the angels wear collared tunics and mantles of imported flowered fabrics. A veil of sheer fabric is draped over the naked Infant Christ, and sheer fabric is draped around the waist of the nobleman, allowing his richly decorated sword, a status symbol, to be seen. The back of the Infant Christ is covered with a brown garment that resembles the Ethiopian leather baby carrier.

In contrast to most Ethiopian icons, the engaged frame of which is carved from a single wood panel, the frame of this triptych is constructed of separate pieces of molding attached to the central panel with wood dowels. The reverse side of each wing panel is embellished with a wood ajouré panel overlaying a brass sheet, and a finial or handle is attached to the top of the central panel. This decorative treatment is appropriate for a private icon, the property of the nobleman whose portrait occupies the lower register of the left wing.

1. L. Steinberg 1983: 23–24, 34.
2. J. Bruce 1790, vol. 4: 520.

## 120 Homiliary of the Archangel Michael (*Dersana Mikael*)

Provenance unknown, after 1730
Parchment; stamped, leather-covered wood end boards
$11\frac{1}{4} \times 9\frac{1}{16}$ in. (28.5 × 23 cm), 124 ff.
Church of the Archangel Mikael, Ankobarr, EMML no. 2373

This collection of homilies for the monthly commemoration of the archangel Michael was copied and illuminated with twenty-two miniatures for a patron named Fasiladis, who presented it to a church that was dedicated to the archangel. The full-page double frontispiece miniature (ff. 3v–4r) depicts the donor prostrating himself before the throne of God the Father, while the archangel, dressed in courtly garments of printed fabric, looks on. The double portrait signifies the *Kidane* or Covenant between God and the archangel Michael concerning the reward of those who celebrate his feasts.[1] Frequent observance of the feasts of the archangels had been established by the emperor Zara Yaeqob, and the homiliary in honor of the archangels[2] was compiled under his guidance.

The miniatures of this homiliary, with their colorful representations of luxury garments and other details from daily life, exemplify the Second Gondarine style of painting. A representation of a church edifice (f. 68r) depicts the characteristic central finial decorated with ostrich eggs (fig. 36). Within are priests with sistra, drums, and prayer staffs (fig. 37).

The miracle of Saint Euphemia[3] attested the power of the icons of the archangel Michael. The widow's icon of the archangel revealed that Satan had come to her disguised as Michael (f. 94v), and then Michael himself appeared to save her from Satan's cunning (f. 95r). A pair of miniatures (ff. 26v–27r) illustrates the story of Dorotheus and his wife Theopista, who hosted feasts to celebrate the annual commemoration of the archangel Michael.[4]

Fig. 36 Church with finials decorated with ostrich eggs. [Photo by M. Heldman © 1993]

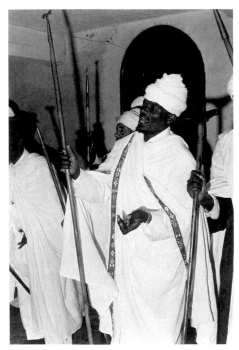

Fig. 37 Priests celebrating Easter. [Photo by M. Heldman © 1993]

1. E.A.W. Budge 1928(A), vol. 4: 992.
2. Getatchew Haile and W. F. Macomber 1981: 318–28.
3. E.A.W. Budge 1928(A), vol. 4: 992–94; id. 1894: 76★–103★.
4. E.A.W. Budge 1928(A), vol. 1: 232–33; id. 1894: 1★–50★.

SELECTED REFERENCES
Getatchew Haile and W. F. Macomber 1982: 450.

## 121 Homiliary in Honor of the Archangel Michael (*Dersana Mikael*)

Gondar (?), after 1730
Parchment, silk-covered wood end boards
$11\frac{9}{16} \times 10\frac{1}{4}$ in. (29.3 × 26 cm), 117 ff.
Church of the Trinity, Azbi

This homiliary of the archangel Michael is prefaced by a series of iconic miniatures. These include a prostrate ruler at the feet of God (f. 3r); Christ with a Crown of Thorns (f. 5v), a copy of the imperial icon known as the *Kwerata Reesu;* the Crucifixion (f. 6r); Saint George (f. 6v); Mary with her Beloved Son (f. 7r); and the archangel Michael with a suppliant at his feet (f. 7v). The text of the manuscript commences on the following page (f. 8r) with the homily for the great annual commemoration of the archangel on 12 Hedar (November 21).

Homilies for the monthly commemorations are embellished with miniatures that illustrate various miracles of the archangel. Because these miniatures are not integrated within the narrative text, they do not illustrate the story as much as embellish and summarize the preceding narrative.

Saint Michael's feast of 12 Genbot is shared with the commemoration of Saint John Chrysostom.[1] His homily is followed by a miniature of the empress Eudoxia, dressed as an Ethiopian empress, meeting with Saint John (f. 96r); a second miniature (f. 96v) depicts his exile and the way in which the archangel appeared to him.

Three miniatures accompany the homily for 12 Hedar, the story of Dorotheus and his wife Theopista. With the intervention of the archangel Michael, they were able to

celebrate his annual commemoration with a large feast, although they had lost their vast wealth. In the scene of the feast (f. 24r), people are seated at a long table, their long-necked drinking vessels filled with yellow honey-wine. Traditional dinner parties are still served in this manner.

Hosting a feast on Saint Michael's feast day in November has been common practice in Ethiopia. The subtext of the story of Dorotheus and Theopista is the promise of the archangel's reward for those who offer a feast in his honor.

The names of the emperor Hezeqeyos and the empress Walatta Qirqos have been added to prayers in the text where the name of the original owner has been erased, and the name *Dajazmach* Subagades has been added to the inscription that accompanies the iconic portrait of Saint Michael. It reads: "How *Dajazmach* Subagades seeks protection." Subagades became ruler of Agame in northern Ethiopia by 1822; he died in 1831. As the following lines from a popular song lamenting his death indicate, his devotion to the archangel Michael was widely recognized: "Alas! Subagades, the friend of all. . . . Who will remember Saint Michael of Hedar [November] to give alms?"[2]

Devotion to the archangel Michael was particularly attractive to military leaders, perhaps because he had promised Joshua victory at Jericho. This promise is featured in the Synaxary reading for 12 Hedar.[3]

1. E.A.W. Budge 1928(A), vol. 3: 879–83.
2. M. Abir 1968: 34–36.
3. E.A.W. Budge 1928(A), vol. 1: 231.

## 122 Book of Isaiah, Book of Daniel, Apocryphal Books, and the Wealth of Kings (*Bela Nagast*)

Gondar (?), late eighteenth century
Parchment
$8\frac{11}{16} \times 8\frac{1}{4}$ in. (22 × 21 cm), 77 ff.
British Library, Or. 503

A single miniature, a portrait of Yekunno Amlak approached by foreign ambassadors, embellishes the *Wealth of Kings*, the final selection in this collection of texts. The

painted portions of the miniature extend to the edges of the parchment, and portions of the royal throne and the camels are cut from view, probably to accommodate the smaller size of the book in which the miniature was placed. The miniature may have been removed from a larger manuscript that was written at about the same time.

The *Wealth of Kings* describes the establishment of the Solomonic dynasty in 1270 by Yekunno Amlak. The story is based upon the Biblical account of David and King Saul. Because King Saul of Israel had incurred the disfavor of the Lord, the prophet Samuel was instructed to anoint David, son of Jesse. As David was being anointed, the spirit of the Lord came upon him (I Samuel 16:1–13), and

in time David became king of Israel (II Samuel 5:1–5). Ethiopia's reigning Zagwe dynasty lost favor with the Lord, who instructed Abba Takla Haymanot to anoint Yekunno Amlak, declaring that the kingdom was to be returned to Yekunno Amlak, the son of David, and to his offspring forever.[1]

In this miniature, Yekunno Amlak is dressed as an eighteenth-century Ethiopian monarch, wearing garments of precious fabrics. His hair style is round and full, and he carries a ceremonial sword, only the decorative hilt of which is visible. Ambassadors, accompanied by attendants with camels, appear to represent a delegation from a neighboring kingdom to the east. The chief ambassador waves a fly whisk, a symbol

of his status, and Yekunno Amlak carries a *mandil*, a handkerchief of precious fabric.[2]

After 1755, regional nobility usurped the authority of the Ethiopian monarchy, but the traditional claim of its descent from the Davidic line through King Solomon and the Queen of Sheba remained.

INSCRIPTIONS   *Tanbalat* [ambassadors]; *Agbert* [attendants]; *Ase* [Yekunno Amlak].

MINIATURES   F. 75v–76r.

1. G. W. B. Huntingford 1965: 11–15.
2. F. Rosenthal 1971: 99.

SELECTED REFERENCES
London 1978, no. 86, pl. 31.
Wright, W. 1877, no. 27.

# BIBLIOGRAPHY

*See also the list of errata at the end of the Bibliography*

d'Abbadie, A. 1868. *Douze ans dans la Haute Éthiopie (Abyssinie)*. Paris. Vol. 2, 1980; vol. 3, 1983. Vatican City.

d'Abbadie, A. T. 1859. *Catalogue raisonné de manuscrits Éthiopiens appartenant à Antoine d'Abbadie: 29*. Paris.

———. 1881. *Dictionnaire de la langue amariñña*. Paris.

———. 1898. *Géographie de l'Éthiopie*. Paris.

———. "Journal et mélanges," d'Abbadie papers, unpublished, cat. France, MSS nouv. acq. 21,300 and 21,301. Bibliothèque Nationale, Paris.

Abbink, J. 1990. *Ethiopian Studies and History: A Bibliography of Ethiopian Studies 1957–1990*. Leiden.

Abd al-Masih, Y., and O.H.E. Burmester, eds. and trans. 1943. *History of the Patriarchs of the Egyptian Church,* by Sawirus ibn al-Mukaffa, vol. 2, pt. 1. Cairo.

Abir, M. 1968. *Ethiopia: The Era of the Princes*. London.

———. 1980. *Ethiopia and the Red Sea: The Rise and Decline of the Solomonic Dynasty and Muslim-European Rivalry in the Region*. London.

Abu Salih. 1895. *The Churches and Monasteries of Egypt and some Neighbouring Countries Attributed to Abu Salih*. Ed. and trans. B. Evetts, with notes by A. J. Butler. Oxford.

Alvares, F. 1961. *The Prester John of the Indies: A True Relation of the Lands of the Prester John, Being the Narrative of the Portuguese Embassy to Ethiopia in 1520*. 2 vols. Hakluyt Society Publications, 2d ser., 114 and 115. Ed. G. F. Beckingham and G.W.B. Huntingford. Cambridge.

Anfray, F. 1965(A). "Chronique archéologique, 1960–64," *Annales d'Éthiopie* 6: 3–48.

———. 1965(B). "Le Musée archéologique d'Asmara," *Rassegna di Studi Etiopici* 21: 5–15.

———. 1978. "Enselalé, avec d'autres sites du Choa, de l'Arssi et un îlot du lac Tana," *Annales d'Éthiopie* 11: 153–80.

Anfray, F., A. Caquot, and P. Nautin 1970. "Une nouvelle inscription grècque d'Ézana, roi d'Axoum," *Journal des Savants* 72: 260–74.

Annequin, G. 1972. "L'illustration des Ta'amra Maryam de 1630 à 1730: Quelques remarques sur le premier style de Gondar," *Annales d'Éthiopie* 9: 193–226.

———. 1975. "Le lac Tana et ses îles," *Les Dossiérs de l'archéologie* 8: 80–115.

———. 1976. "De quand datent l'église actuelle de Dabra Berhan Sellasé de Gondar et son ensemble de peintures?" *Annales d'Éthiopie* 10: 215–26.

Annesley, G. 1809. *Voyages and Travels to India, Ceylon, the Red Sea, Abyssinia and Egypt*. London.

Anzani, A. 1926. "Numismatica Axumita," *Rivista Italiana di Numismatica* 3: 5–110.

Appiah, K. A. 1992. *In My Father's House: Africa in the Philosophy of Culture*. London.

Arnold, P. 1991. *Prelude to Magdala: Emperor Theodore of Ethiopia and British Diplomacy*. London.

Arrowsmith-Brown, J. H. 1991. *Prutky's Travels to Ethiopia and Other Countries*. London.

Atiya, A. S., and O.H.E. Burmester, eds. and trans. 1959. *History of the Patriarchs of the Egyptian Church,* by Sawirus ibn al-Mukaffa, vol. 2, pt. 3. Cairo.

Azaïs, R. P., and R. Chambard. 1931. *Cinq années de recherches archéologiques en Éthiopie.* 2 vols. Paris.

Bahru Zewde. 1990. "Ethiopian Historiography: Retrospect and Prospect." In *Silver Jubilee Anniversary,* ed. R. K. Pankhurst and Taddese Beyene, 89–95. Addis Ababa.

Bairu Tafla. 1981. *Ethiopia and Germany: Cultural, Political, and Economic Relations, 1871–1936.* Wiesbaden.

Baltimore 1988. *Holy Image, Holy Space: Icons and Frescoes from Greece,* exh. cat. The Walters Art Gallery.

Baratti, G. 1670. *The Late Travels of S. Giacomo Baratti into the Remote Country of the Abissins.* London.

Barb, A. A. 1953. "Diva Matrix: A Faked Gnostic Intaglio in the Possession of P. P. Rubens and the Iconology of a Symbol," *Journal of the Warburg and Courtauld Institutes* 16: 193–238.

Basset, R. 1882. *Études sur l'histoire d'Éthiopie.* Reprinted from *Journal asiatique* 1881, 118: 315–434; 119: 93–183.

————. 1924. *Le synaxaire arabe jacobite (redaction copte): Les mois de Baounah, Abib, Mesor et jours complémentaires.* Patrologia Orientalis 17: 526–782.

Beach, M. C. 1981. *The Imperial Image: Paintings for the Mughal Court.* Washington, D.C.

Beccari, C. 1903–17. *Rerum aethiopicarum scriptores occidentali inediti,* 15 vols. Rome.

Beckingham, C. F., and G.W.B. Huntingford. 1961. *The Prester John of the Indies.* Cambridge.

————, eds. and trans. 1954. *Some Records of Ethiopia, 1593–1646.* Hakluyt Society Publications, 2d ser., 107. London.

Beckwith, J. 1970. *Early Christian and Byzantine Art.* 2d ed., 1979. Harmondsworth.

Beke, C. T. 1846. "A Diary Written During a Journey in Abessinia," printed but unpublished text, MS 30, 250, British Library.

Bent, J. T. 1894. *The Sacred City of the Ethiopians.* London.

Bernal, M. 1991. *Black Athena: The Afroasiatic Roots of Classical Civilization.* Vol. 2, *The Archaeological and Documentary Evidence.* London.

Bernand, E. 1982. "Nouvelles versions de la campagne du roi Ezana contre les Bedja," *Zeitschrift für Papyrologie und Epigraphik* 45: 105–14.

Bezold, C. 1909. *Kebra Nagast.* Munich.

————, trans. 1883. *Die Schatzhöhle, aus dem syrischen Text.* Leipzig.

Bianchi Barriviera, L. 1962–63. "Le chiese in roccia di Lalibela e di altri luoghi del Lasta," *Rassegna di Studi Etiopici* 18: 5–76; 19: 5–94.

Bieber, F. J. 1920–23. *Kaffa.* Vienna.

Blondeel van Cuelebrouck, E. 1838–42. *Rapport générale de Blondeel sur son expédition en Abyssinie.* Brussels.

Borelli, J. 1890. *Éthiopie méridionale.* Paris.

Brown, P. 1973. "A Dark Age Crisis: Aspects of the Iconoclastic Controversy," *English Historical Review* 88: 1–34. Reprinted in Brown, 1982. *Society and the Holy in Late Antiquity,* 251–301. London.

Bruce, J. 1790. *Travels to Discover the Source of the Nile in the Years 1768 to 1773.* 5 vols. Edinburgh.

Buchthal, H. 1960. "An Ethiopic Miniature of Christ Being Nailed to the Cross," *Atti del convegno internazionale di studi etiopici, Roma 1959,* 331–35. Accademia dei Lincei, Rome.

Budge, E.A.W., 1898. *The Lives of Maba' Seyon and Gabra Krestos.* London.

————. 1922. *The Queen of Sheba and Her Only Son Menyelek: A Complete Translation of the Kebra Nagast.* London.

————. 1923. *One Hundred Ten Miracles of Our Lady Mary.* London and Boston.

————. 1927. *The Book of the Cave of Treasures.* London.

————. 1928(A). *The Book of the Saints of the Ethiopian Church.* 4 vols. Cambridge.

————. 1928(B). *A History of Ethiopia, Nubia and Abyssinia*. 2 vols. London.

————. 1930. *George of Lydda, Patron Saint of England: A Study of the Cultus of St. George in Ethiopia*. London.

————. 1935. *The Contendings of the Apostles, Being the Histories of the Lives and Martyrdoms and Deaths of the Twelve Apostles and Evangelists*. London.

————, ed. and trans. 1894. *Saint Michael the Archangel: Three Encomiums by Theodosius, Archbishop of Alexandria; Severus, Patriarch of Antioch; and Eustathius, Bishop of Trake*. London.

Bureau, J. 1976. "Note sur les églises du Gamo, *Annales d'Éthiopie* 10: 295–303.

Burton, R. F. 1856. *First Footsteps in East Africa*. London.

Buxton, D. 1970. *The Abyssinians*. London.

Cameron, A. 1978. "The Theotokos in Sixth-Century Constantinople," *Journal of Theological Studies*, new series, 29: 79–108.

Campbell, H. 1987. *Rasta and Renaissance: From Marcus Garvey to Walter Rodney*. Trenton.

Caquot, A. 1955(A). "Aperçu préliminaire sur le Mashafa Tefut de Gechen Amba," *Annales d'Éthiopie* 1: 89–108.

————. 1955(B). "Note sur Berber Maryam," *Annales d'Éthiopie* 1: 109–16.

Caraman, P. 1985. *The Lost Empire: The Story of the Jesuits in Ethiopia*. London.

Casson, L. 1989. *The Periplus Maris Erythraei*. Princeton.

Cecchi, A. 1885–87. *Da Zeila alle frontiere del Caffa*. Rome.

Cerulli, E. 1922. "The Folk-literature of the Galla of Southern Ethiopia," *Harvard African Studies* 2: 9–228.

————. 1933. "L'Etiopia del secolo XV in nuovi documenti storici," *Africa Italiana: Rivista di Storia e d'Arte* 5: 57–112.

————. 1936–51. *Studi etiopici*. 4 vols. Rome.

————. 1941. "Il Sultanato de Scioa nel secolo Xiii secondo un nuovo documento storico," *Rassegna di Studi Etiopici* 1: 5–14.

————. 1943. *Il Libro etiopico dei Miracoli di Maria e le sue fonti nelle letterature del medio evo latino*. Rome.

————. 1947. "Il 'Gesu Percosso' nell'arte etiopica e le sue origini nell'Europa del XV secolo," *Rassegna di Studi Etiopici* 6: 109–29.

————. 1953–57. *Etiopi in Palestina*. 2 vols. Rome.

————. 1956(A). *Storia della letteratura etiopica*. Rome.

————, ed. and trans. 1956(B). *Atti di Krestos Samra*. Corpus Scriptorum Christianorum Orientalium 163 and 164, script. aeth. 33 and 34.

————. 1957(A). *Somalia: Scritti vari editi ed inediti*. Vol. 1, *Storia della Somalia. L'Islam in Somalia. Il Libro degli Zengi*. Rome.

————. 1957(B). "La Festa del Patto di Misericordia e le sue fonti nel greco 'Liber de Transitu' e nel racconto latino dei cinque Dolori di Maria," *Studi Bizantini e Neoellenici (Silloge Bizantina in onore di Silvio Mercati)* 9: 53–71.

————. 1968. *La letteratura etiopica*, 3d ed. Florence and Milan.

Chaîne, M. 1913. "Répertoire des salam et malke'e," *Revue de l'Orient chrétien*, 2d ser., 8: 183–203, 337–57.

Cheesman, R. E. 1936. *Lake Tana and the Blue Nile, An Abyssinian Quest*. London.

Chojnacki, S. 1983. *Major Themes in Ethiopian Painting, Indigenous Development: The Influence of Foreign Models and Their Adaptation from the 13th to the 19th Century*. Äthiopistische Forschungen 10. Wiesbaden.

Cohen, M. 1912. *Rapport sur une mission linguistique en Abyssinie*. Paris.

————. 1923. "Dabra-Warq." In *Mélanges René Basset: études nord-africaines et orientales*, 143–63. Institut des Hautes-Études Marocaines. Rabat.

————. 1936. *Traité de la langue amharique*. Paris.

Colin, G. 1988. *Le Synaxaire éthiopien: Mois de Hedar*. Patrologia Orientalis 44, fasc. 1.

Combes, E., and M. Tamisier. 1838. *Voyage en Abyssinie*. Paris.

Conti Rossini, C. 1896. "Il 'Gadla Takla Haymanot' secondo la redazione Waldebbana," *Memorie della Reale Accademia dei Lincei*, 5th ser., vol. 2, 97–143.

———. 1901. "Il 'Gadla Filipos' ed il 'Gadla Yohannes' de Dabra Bizan," *Memorie della Reale Accademia dei Lincei* 8: 61–170.

———. 1910. "Un documento sul cristianismo nello lemen ai tempi del Re Sarahbil Yakkuf," *Rendiconti della Reale Academia dei Lincei*, 5th ser., 19: 705–50. Rome.

———. 1912. "Il discorso su monte Coscam attribuito a Teofilo d'Alessandria nella versione etiopica," *Atti dell'Accademia Nazionale dei Lincei, Classe di Scienze morali, storiche e filologiche, Rendiconti*, 5th ser., 21: 395–471.

———. 1912–15. "Notice sur les manuscrits éthiopiens de la collection d'Abbadie," *Journal asiatique* 180 (1912): 551–78; 181 (1912): 5–72, 449–94; 183 (1913): 5–183; 187 (1915): 189–238, 445–93.

———. 1927. "Un codice illustrato eritreo del secolo XV," *Africa Italiana* 1: 83–97.

———. 1928. *Storia d'Etiopia*. Bergamo.

———, ed. and trans. 1905. *Vitae sanctorum indigenarum: Acta S. Basalota Mika'el et S. Anorewos*, Corpus Scriptorum Christianorum Orientalium 28 and 29, script aeth. 11 and 12.

———, ed. and trans. 1909, 1910. *Documenta ad illustrandam historiam: Liber Axumae*. Corpus Scriptorum Christianorum Orientalium 54 (1909) and 58 (1910), script. aeth. 24 and 27.

Conti Rossini, C., and L. Ricci, eds. and trans. 1964, 1965. *Il Libro della Luce del Negus Zar'a Ya'qob (Mashafa Birhan)*. Corpus Scriptorum Christianorum Orientalium 250 (1964) and 261 (1965), script. aeth. 47 and 51; tr., 251 (1965) and 262 (1965), script. aeth. 48 and 52.

Conzelman, W. E., ed. and trans. 1895. *Chronique de Galawdewos (Claudius), Roi d'Éthiopie*. Paris.

Crawford, O.G.S. 1958. *Ethiopian Itineraries ca. 1400–1524*. Cambridge.

Crone, P. 1980. "Islam, Judeo-Christianity and Byzantine Iconoclasm," *Jerusalem Studies in Arabic and Islam* 2: 59–95.

Crone, P., and M. Cook. 1977. *Hagarism: The Making of the Islamic World*. Cambridge.

Crummey, D. E. 1973. *Priests and Politicians: Protestant and Catholic Missions in Orthodox Ethiopia, 1830–1868*. London.

Daoud, M., and Marsie Hazen, trans. 1954. *The Liturgy of the Ethiopian Church*. Addis Ababa.

Davies, D. M. 1987. "The Dating of Ethiopic Manuscripts," *Journal of Near Eastern Studies* 46: 287–307.

Dillman, C.F.A. 1857. *Grammatik der Äthiopischen Sprache*. Leipzig.

———. 1859. *Lexicon linguae aethiopicae*. Leipzig.

———. 1907. *Ethiopic Grammar*. London.

Dombrowski, F. A. 1985. *Ethiopia's Access to the Sea*. Leiden and Cologne.

Donzel, E. J. van. 1979. *Foreign Relations of Ethiopia 1642–1700: Documents Relating to the Journeys of Khodja Murad*. Istanbul.

———. 1986. *A Yemenite Embassy to Ethiopia 1647–1649*. Stuttgart.

Doresse, J. 1959. *Ethiopia*. London.

Drewes, A. J., and R. Schneider, eds. 1991. *Recueil des inscriptions de l'Éthiopie des périodes pre-Axoumite et Axoumite*. Paris.

Eleen, L. 1982. *The Illustration of the Pauline Epistles in French and English Bibles of the Twelfth and Thirteenth Centuries*. Oxford.

Essen 1963. *Koptische Kunst: Christentum am Nil*, exh. cat. Villa Hügel.

Evetts, B., ed., trans., and annot. 1915. *History of the Patriarchs of the Coptic Church of Alexandria, Mennas I to Joseph (849)*. Patrologia Orientalis 10, fasc. 5.

Forsyth, G. H., and K. Weitzmann [1973]. *The Monastery of Saint Catherine at Mount Sinai: The Church and Fortress of Justinian*. Ann Arbor.

Foster, W., ed. 1949. *The Red Sea and Adjacent Countries at the Close of the Seventeenth Century as*

*Described by Joseph Pitts, William Daniel and Charles Jacques Poncet*. Hakluyt Society Publications, 2d ser., 100. London.

Frend, W.H.C. 1970. "The Missions of the Early Church, 180–700 A.D.," *Miscellanea Historiae Ecclesiasticae* 3: 3–23. Louvain.

Friend, A. M. 1927 and 1929. "The Portraits of the Evangelists in Greek and Latin Manuscripts," *Art Studies* 5 (1927): 115–47; 7 (1929): 3–29.

Fumagalli, G. 1893. *Bibliographia etiopica: Catalogo alla Etiopia e regioni limitrofe*. Milan.

Galinier, J. G., and P.V.Ad. Ferret. 1847–48. *Voyage en Abyssinie*. Paris.

Gaudefroy-Demombynes, M. 1927. *Ibn Fadl al-Allah, al-'Umari Masalik al-absar fi mamalik al-amsar*. Paris.

Gerster, G. 1970. *Churches in Rock: Early Christian Art in Ethiopia*. London and New York.

Getatchew Haile. 1979. *A Catalogue of Ethiopian Manuscripts Microfilmed for the Ethiopian Manuscript Microfilm Library, Addis Ababa, and for the Hill Monastic Manuscript Library, Collegeville*, vol. 4. Collegeville.

———. 1980(A). "From Strict Observance to Royal Endowment: The Case of the Monastery of Dabra Halle Luya," *Le Muséon* 93: 163–72.

———. 1980(B). "The *Kalilah wa-Dimnah* and the *Mazmura Krestos*," *Proceedings of the Fifth International Conference on Ethiopian Studies*, ed. R. L. Hess, 373–86. Chicago.

———. 1980(C). "A Preliminary Investigation of the *Tomara Tesbe't* of Emperor Zar'a Ya'eqob of Ethiopia," *Bulletin of the School of Oriental and African Studies* 43: 207–34.

———. 1981(A). "An Anonymous Homily in Honor of King Ella Asbaha of Axum," *Northeast African Studies* 3: 25–37.

———. 1981(B). "Religious Controversies and the Growth of Ethiopic Literature in the Fourteenth and Fifteenth Centuries," *Oriens Christianus* 65: 102–36.

———. 1982. "Power Struggle in the Medieval Court of Ethiopia: The Case of Batargela-Maryam," *Journal of Ethiopian Studies* 15: 37–55.

———. 1983(A). *The Different Collections of Nags Hymns in Ethiopic Literature and Their Contributions*. Erlangen.

———. 1983(B). "The Cause of the Estifanosites: A Fundamentalist Sect in the Church of Ethiopia," *Paideuma* 29: 93–119.

———. 1983(C). "Documents on the History of Ase Dawit (1382–1413)," *Journal of Ethiopian Studies* 16: 25–35.

———. 1985(A). *A Catalogue of Ethiopian Manuscripts Microfilmed for the Ethiopian Manuscript Microfilm Library, Addis Ababa, and for the Hill Monastic Manuscript Library, Collegeville*, vol. 8. Collegeville.

———. 1985(B). "Who is Who in Ethiopia's Past, Part 2: The Zagwe Royal Family after Zagwe," *Northeast African Studies* 7: 41–48.

———. 1987. *A Catalogue of Ethiopian Manuscripts Microfilmed for the Ethiopian Manuscript Microfilm Library, Addis Ababa, and for the Hill Monastic Manuscript Library, Collegeville*, vol. 9. Collegeville.

———. 1988. "Builders of Churches and Authors of Hymns: Makers of History in the Ethiopian Church," paper delivered at the Tenth International Conference of Ethiopian Studies, Paris.

———. 1992. *The Mariology of Emperor Zar'a Ya'eqob of Ethiopia: Texts and Translations*. Orientalia Christiana Analecta 242. Rome.

———, ed. and trans. 1990. *The Faith of the Unctionists in the Ethiopian Church (Haymanot Masihawit)*. Corpus Scriptorum Christianorum Orientalium 517 and 518, script. aeth. 91 and 92.

———, ed. and trans. 1991. *The Epistle of Humanity of Emperor Zar'a Ya'eqob* (Tomara Tesbet). Corpus Scriptorum Christianorum Orientalium 522 and 523, script. aeth. 95 and 96.

Getatchew Haile and W. F. Macomber. 1981. *A Catalogue of Ethiopian Manuscripts Microfilmed for the Ethiopian Manuscript Microfilm Library, Addis Ababa, and for the Hill Monastic Manuscript Library, Collegeville*, vol. 5. Collegeville.

————. 1982. *A Catalogue of Ethiopian Manuscripts Microfilmed for the Ethiopian Manuscript Microfilm Library, Addis Ababa, and for the Hill Monastic Manuscript Library, Collegeville,* vol. 6. Collegeville.

————. 1983. *A Catalogue of Ethiopian Manuscripts Microfilmed for the Ethiopian Manuscript Microfilm Library, Addis Ababa, and for the Hill Monastic Manuscript Library, Collegeville,* vol. 7. Collegeville.

Gigar Tesfaye. 1984. "Inscriptions sur bois de trois églises de Lalibala," *Journal of Ethiopian Studies* 17: 107–26.

Girma Beshah and Merid Wolde Aregay. 1964. *The Question of the Union of the Churches in Luso-Ethiopian Relations (1500–1632).* Lisbon.

Girma Kidane. 1989. "Four Traditional Ethiopian Painters and Their Life Histories," *Proceedings of the First International Conference on the History of Ethiopian Art, London 1986,* 72–77, figs. 119–128. London.

Gobat, S. 1834. *Journal of a Three Years' Residence in Abyssinia.* London.

Gopnik, A. 1993. "Out of Africa," *The New Yorker* (March 22): 97–101.

Gouma-Peterson, T. 1968. "Crete, Venice, the 'Madonneri' and a Creto-Venetian Icon in the Allen Art Museum," *Allen Memorial Art Museum (Oberlin College) Bulletin* 25: 53–86.

————. 1972. "The Dating of Creto-Venetian Icons: A Reconsideration in Light of New Evidence," *Allen Memorial Art Museum (Oberlin College) Bulletin* 30: 13–21.

Grabar, A. 1958. *Ampoules de Terre Sainte (Monza A Bobbio).* Paris.

Grébaut, S., and E. Tisserant. 1935. *Codices aethiopici Vaticani et Borgiani, Barberinianus Orientalis 2, Rossianus 865.* Vatican City.

Green, R. B. 1951. "The Flabellum of Hohenbourg," *Art Bulletin* 33: 153–55.

Groom, N. 1981. *Frankincense and Myrrh: A Study of the Arabian Incense Trade.* London.

Grossmann, P. 1991. "Altar." In *The Coptic Encyclopedia,* ed. A. S. Atiya, vol. 1, 105–7. New York.

Guidi, I. 1889. "Le canzoni Ge'ez-Amarina in onore di re abissini," *Rendiconti della Reale Accademia dei Lincei,* 4th ser., 4: 53–56.

————. 1897. *Il Fetha Nagast o legislazione dei re.* Rome.

————. 1901. *Vocabulario amarico-italiano.* Rome.

————. 1911. *Le Synaxaire éthiopien. Le mois de Hamlè. Patrologia Orientalis* 7, fasc. 3.

————. 1932. *(Breve) Storia della letteratura etiopica.* Rome.

————, ed. and trans. 1903, 1905. *Annales Iohannis I, 'Iyasu I et Bakaffa,* Corpus Scriptorum Christianorum Orientalium 22 (1903) and 24 (1903), script. aeth. 5 and 7; tr., 23 (1903) and 25 (1905), script. aeth. 6 and 8.

————, ed. and trans. 1910, 1912. *Annales regum 'Iyasu II et 'Iyo'as.* Corpus Scriptorum Christianorum Orientalium 61 (1910) and 66 (1912), script. aeth. 28 and 29.

Haberland, E. 1969. "Hiob Ludolf, Father of Ethiopian Studies in Europe," *Proceedings of the Third International Conference of Ethiopian Studies* 1, 131–36. Addis Ababa.

Haile Gabriel Dagne. 1989. "The Scriptorium at the Imperial Palace and the Manuscripts of the Addis Ababa Churches," *Proceedings of the Eighth International Conference of Ethiopian Studies* 2, 215–23. Addis Ababa.

Hammerschmidt, E. 1970. "The Ethiopian Orthodox Church." In G. Gerster, *Churches in Rock: Early Christian Art in Ethiopia.* London.

————. 1973. *Äthiopische Handschriften vom Tanasee 1.* Verzeichnis der orientalischen Handschriften in Deutschland 20. Wiesbaden.

————. 1977. *Illuminierte Handschriften der Staatsbibliothek Preußischer Kulturbesitz und Handschriften vom Tanasee.* Graz.

————. 1987. *Studies in the Ethiopic Anaphoras,* 2d ed. Stuttgart.

Hammerschmidt, E., and O. A. Jäger. 1968. *Illuminierte Äthiopische Handschriften.* Verzeichnis der orientalischen Handschriften in Deutschland 15. Wiesbaden.

Hancock, G. 1992. *The Sign and the Seal: A Quest for the Lost Ark of the Covenant.* London.

Hanssens, J. M., and A. Raes. 1951. "Une collection de tabots au Musée Chrétien de la Bibliothèque Vaticane," *Orientalia Christiana Periodica* 17: 435–50.

Harris, W. C. 1844. *The Highlands of Aethiopia*. London.

Hecht, E. D. 1988. "Ethiopia Threatens to Block the Nile," *Azania* 23: 1–10.

Heldman, M. E. 1972. "Miniatures of the Gospels of Princess Zir Ganala: An Ethiopic Manuscript Dated A.D. 1400/1401," Ph.D. diss., Washington University, St. Louis.

———. 1979. "An Early Gospel Frontispiece in Ethiopia," *Konsthistorisk Tidskrift* 48: 107–21.

———. 1980. "The Kebran Gospels: Ethiopia and Byzantium," *Proceedings of the Fifth International Conference on Ethiopian Studies*, ed. R. L. Hess, 359–72. Chicago.

———. 1983. "An Ethiopian Miniature of the Head of St. Mark: Egyptian Influence at the Monastery of St. Stephen, Hayq." In *Ethiopian Studies, Dedicated to Wolf Leslau on the Occasion of His Seventy-fifth Birthday*, ed. S. Segert and A.J.E. Bodrogligeti, 554–68. Wiesbaden.

———. 1984. "The Role of the Devotional Image in Emperor Zar'a Ya'eqob's Cult of Mary," *Proceedings of the Seventh International Conference of Ethiopian Studies*, ed. S. Rubenson, 131–42. Arlov.

———. 1988(A). "Early Byzantine Sculptural Fragments from Adulis," paper presented at the Tenth International Conference of Ethiopian Studies, Paris.

———. 1988(B). "A Gondarine Copy of the Masehafa Tefut (London, British Library, MS Oriental 481)." In "The Fifteenth Saint Louis Conference on Manuscript Studies: Abstracts of Papers," *Manuscripta* 32: 167–68.

———. 1989. "An Ewostathian Style and the Gunda Gunde Style in Fifteenth-Century Ethiopian Manuscript Illumination," *Proceedings of the First International Conference on the History of Ethiopian Art, London 1986*, 5–14, figs. 1–29. London.

———. 1990. "A chalice from Venice for Emperor Dawit of Ethiopia," *Bulletin of the School of Oriental and African Studies* 53: 442–45.

———. 1992(A). "Architectural Symbolism, Sacred Geography and the Ethiopian Church," *Journal of Religion in Africa* 22: 222–41.

———. 1992(B). "Cretan Icons and Holy Images in Ethiopian Collections," *Abstracts of Papers, Eighteenth Annual Byzantine Studies Conference*, 9–10. Champaign-Urbana.

———. Forthcoming. *The Marian Icons of the Painter Fere Seyon: A Study in Fifteenth-Century Ethiopian Art, Patronage, and Spirituality*. Orientalia Biblica et Christiana, Osnabrück.

Heldman, M. E., and Getatchew Haile. 1987. "Who is Who in Ethiopia's Past, Part 3: Founders of Ethiopia's Solomonic Dynasty," *Northeast African Studies* 9: 1–11.

Holum, K. G. 1977. "Pulcheria's Crusade A.D. 421–22 and the Ideology of Imperial Victory," *Greek, Roman and Byzantine Studies* 18: 153–72.

Houtsma, E., ed. 1883. *Historiae*, by Ibn Wadih al-Yaqubi, vol. 1. Leiden.

Hunt, E. D. 1982. *Holy Land Pilgrimage in the Later Roman Empire, A.D. 312–460*. Oxford.

Hunt, L.-A. 1985. "Christian-Muslim Relations in Painting in Egypt of the Twelfth to Mid-Thirteenth Century: Sources of Wall Painting at Deir es-Suriani and the Illustration of the New Testament MS Paris, copte-arabe 1/Cairo, Bibl. 94," *Cahiers archéologiques* 33: 111–55.

Huntingford, G.W.B. 1965(A). "'The Wealth of Kings' and the End of the Zague Dynasty," *Bulletin of the School of Oriental and African Studies* 28: 1–23.

———, trans. and annot. 1965(B). *The Land Charters of Northern Ethiopia*. Monographs in Ethiopian Land Tenure 1. Addis Ababa.

———. 1980. *The Periplus of the Erythraean Sea*. London.

Isaac, E., and C. Felder. 1984. "Reflections on the Origins of the Ethiopian Civilization," *Proceedings of the Eighth International Conference of Ethiopian Studies* 1, 71–83. Addis Ababa.

Isenberg, C. W. 1841. *Dictionary of the Amharic Language*. London.

Isenberg, C. W., and J. L. Krapf. 1843. *Journals of the Rev. Messrs. Isenberg and Krapf, Missionaries of the Church Mission Society, Detailing Their Proceedings in the Kingdom of Shoa and Journeys in Other Parts of Abyssinia in the Years 1839, 1840, 1841, and 1842*. London.

Jacobus de Voragine. 1941. *The Golden Legend*. London.

Jäger, O. A. 1957. *Äthiopische Miniaturen*. Berlin.

———. 1960–61. "Ethiopian Manuscript Paintings," *Ethiopia Observer* 4: 353–91.

Jeffery, A. 1938. *The Foreign Vocabulary of the Qur'an*. Baroda.

Jeffreys, E., M. Jeffreys, and R. Scott, trans. 1986. *The Chronicle of John Malalas*. Byzantina Australiensia 4. Melbourne.

Johnson, S. 1759. *The Prince of Abyssinia: A Tale*. London.

Johnston, C. 1868. *Travels in Southern Abyssinia*. London.

Jones, A.H.M. 1959. "Were ancient heresies national or social movements?" *Journal of Theological Studies,* new series 11: 280–98.

Juel-Jensen, B. 1989. "Was the Design of One of Offa's Coins Inspired by the Silver of King Abana of Aksum?" *Spinks Numismatic Circular* 97: 296.

———. 1991. "A New Aksumite Coin from the Early Christian Period," *Spinks Numismatic Circular* 99: 39.

Juncker, C. 1710. *Commentarius de vida, scriptorisque ac meritis illustris viri Jobi Lodolfi*. Frankfurt.

Kalavrezou, I. 1990. "Images of the Mother: When the Virgin Mary Became *Meter Theou,*" *Dumbarton Oaks Papers* 44: 165–72.

Kane, T. L. 1990. *Amharic-English Dictionary*. Wiesbaden.

Kantorowicz, E. H. 1963. "Oriens Augusti — Lever du Roi," *Dumbarton Oaks Papers* 17: 117–78.

Kaplan, S. 1984. *The Monastic Holy Man and the Christianization of Early Solomonic Ethiopia*. Wiesbaden.

———. 1988. "Falasha Religion: Ancient Judaism or Evolving Ethiopian Tradition," paper delivered at the Tenth International Conference of Ethiopian Studies, Paris.

Kartsonis, A. D. 1986. *Anastasis, the Making of an Image*. Princeton.

Katte, A. von. 1838. *Reise in Abyssinien*. Stuttgart.

Khater, A., and O.H.E. Burmester, ed. and trans. 1970. *History of the Patriarchs of the Egyptian Church,* by Sawirus ibn al-Mukaffa, vol. 3, pt. 2. Publications de la Société d'Archéologie Copte, Textes et Documents 12. Cairo.

Kinefe-Rigb Zelleke. 1975. "Bibliography of the Ethiopic Hagiographical Traditions," *Journal of Ethiopian Studies* 13: 57–102.

Kitzinger, E. 1974. "A Pair of Silver Book Covers in the Sion Treasure." In *Gatherings in Honor of Dorothy E. Miner,* ed. U. E. McCracken, L.M.C. Randall, and R. H. Randall, Jr., 3–17. Baltimore.

Kramers, J. H., and G. Wiet, trans. 1964. *Configuration de la terre,* by Muhammad Ibn Hawqal. 2 vols. Paris.

Krapf, J. L. 1867. *Travels, Researches, and Missionary Labours During an Eighteen Years' Residence in Eastern Africa*. London.

Krencker, D. 1913. *Ältere Denkmäler Nordabessiniens*. Vol. 2 of E. Littmann et al., *Deutsche Aksum-Expedition*. 4 vols. Berlin.

Kur, S., ed. and trans. 1965. *Actes de Iyasus Mo'a, abbé du couvent de St-Étienne de Hayq*. Corpus Scriptorum Christianorum Orientalium 259 and 260, script. aeth. 49 and 50.

———, ed. and trans. 1968. *Actes de Samuel de Dabra Wagag*. Corpus Scriptorum Christianorum Orientalium 287 and 288, script. aeth. 57 and 58.

———, ed. and trans. 1972. *Actes de Marha Krestos*. Corpus Scriptorum Christianorum Orientalium 330 and 331, script. aeth. 62 and 63.

Lefebvre, T. 1845–48. *Voyage en Abyssinie*. Paris.

Lefevre, R. 1965. "Note su alcuni pellegrini etiopi in Roma al tempo di Leone X," *Rassegna di Studi Etiopici* 21: 16–36.

———. 1967–68. "Presenze etiopiche in Italia prima il Concilio de Firenze," *Rassegna di Studi Etiopici* 23: 5–26.

Lepage, C. 1972. "Les monuments chrétiens rupestres de Degum, en Éthiopie (rapport préliminaire)," *Cahiers archéologiques* 27: 167–200.

————. 1977. "Histoire de l'ancienne peinture éthiopienne," *Comptes-rendus des séances de l'Academie des Inscriptions et Belles-Lettres*, 325–75. Paris.

————. 1987. "Reconstitution d'un cycle protobyzantin à partir des miniatures de deux manuscrits éthiopiens du XIVe siècle," *Cahiers archéologiques* 35: 159–95.

Leroy, J. 1960. "L'évangeliaire éthiopien du couvent d'Abba Garima et ses attaches avec l'ancien art chrétien de Syrie," *Cahiers archéologiques* 11: 131–43.

————. 1961. "L'évangeliaire éthiopien illustré du British Museum (Or. 510) et ses sources iconographiques," *Annales d'Éthiopie* 4: 155–80.

————. 1962(A). "Une 'Madonne Italienne' conservé dans un manuscrit éthiopien du British Museum," *Rassegna di Studi Etiopici* 17: 77–82.

————. 1962(B). "Recherches sur la tradition iconographique des canons d'Eusèbe en éthiopie," *Cahiers archéologiques* 12: 173–204.

————. 1967. *Ethiopian Painting in the Late Middle Ages and under the Gondar Dynasty*. London.

————. 1968. "Un nouvel évangeliaire éthiopien illustré du monastère d'Abba Garima," *Synthronon*. Bibliothèque des Cahiers archéologiques 2: 75–87. Paris.

Leslau, W. 1965. *An Annotated Bibliography of the Semitic Languages of Ethiopia*. La Haye.

————. 1987. *Comparative Dictionary of Ge'ez (Classical Ethiopic)*. Wiesbaden.

Levine, D. N. 1974. *Greater Ethiopia: The Evolution of a Multiethnic Society*. Chicago.

Lewis, S. 1973. "The Iconography of the Coptic Horseman in Byzantine Art," *Journal of the American Research Center in Egypt* 10: 27–63. London.

Littmann, E. 1904. *The Legend of the Queen of Sheba in the Legend of Aksum*. Leiden.

————. 1910–15. *Publications of the Princeton Expedition to Abyssinia*. Leiden.

————. 1925. *Indien und Abessinien: Beitrage zur Literaturwissenschaft und Geistgeschichte Indiens*. Berlin.

Littmann, E., et al. 1913. *Deutsche Aksum-Expedition*. 4 vols. Berlin.

Lockhart, D. M. 1984. *The Itinerario of Jeronimo Lobo*. London.

London 1921. *A Guide to the Early Christian and Byzantine Antiquities*, 2d ed. British Museum.

London 1978. *The Christian Orient*, exh. cat. British Library.

Ludolf, H. 1681. *Historia Aethiopica*. Frankfurt.

Ludolf, J. 1682. *A New History of Ethiopia*. London.

Macomber, W. F. 1975. *A Catalogue of Ethiopian Manuscripts Microfilmed for the Ethiopian Manuscript Microfilm Library, Addis Ababa, and for the Hill Monastic Manuscript Library, Collegeville*, vol. 1. Collegeville.

————. 1979. *Catalogue of Ethiopian Manuscripts from the Microfilms of Dr. Donald Davies and the Hill Monastic Microfilm Library, Saint John's University*. Collegeville.

Maguire, H. 1987. *Earth and Ocean: The Terrestrial World in Early Byzantine Art*. University Park and London.

Malan, S. C., trans. 1882. *The Book of Adam and Eve, also Called the Conflict of Adam and Eve with Satan*. London and Edinburgh.

Malécot, G. 1972. *Les voyageurs français et les rélations entre la France et l'Abyssinie de 1835 à 1870*. Paris.

Marcus, H. G. 1972. *The Modern History of Ethiopia and the Horn of Africa*. Stanford.

McCrindle, J. W. 1897. *The Christian Topography of Cosmas*. London.

McGurk, P. 1961. *Latin Gospel Books from A.D. 400 to A.D. 800*. Paris and Antwerp.

Meinardus, O.F.A. 1965. "Ecclesiastica Aethiopica in Aegypto," *Journal of Ethiopian Studies* 3: 23–35.

Mercier, J. 1975. "Les rouleaux protecteurs," *Les Dossiers de l'archéologie* 8: 116–27.

————. 1979. *Ethiopian Magic Scrolls*. New York.

Merid Wolde Aregay 1964. "Two Unedited Letters of Galawdewos, Emperor of Ethiopia," *Studia Rivista Semestral Centro de Estudios Historicos Ultramarinos* 13–14: 363–76.

————. 1984(A). "Millenarian Traditions and Peasant Movements in Ethiopia: 1500–1855,"

*Proceedings of the Seventh International Conference of Ethiopian Studies,* ed. S. Rubenson, 257–62. Arlov.

———. 1984(B). "Society and Technology in Ethiopia 1550–1800," *Journal of Ethiopian Studies* 17: 127–47.

Meyendorff, J. 1974. *Byzantine Theology: Historical Trends and Doctrinal Themes.* New York.

Michalowski, K. 1967. *Faras, die Kathedrale aus dem Wüstensand.* Zurich and Cologne.

Mingana, A., ed. and trans. 1929. "Vision of Theophilus or the Book of the Flight of the Holy Family into Egypt," *Bulletin of the John Rylands Library* 13: 383–474.

Moberg, A., ed. and trans. 1924. *The Book of the Himyarites.* Lund.

Monneret de Villard, U. 1947. "La Madonna di S. Maria Maggiore e l'illustrazione dei Miracoli di Maria in Abissinia," *Annali Lateranensi* 11: 9–90.

Moore, E. 1971. *Ethiopian Processional Crosses.* Addis Ababa.

———. 1989. "Ethiopian Crosses from the 12th to the 16th Century," *Proceedings of the First International Conference on the History of Ethiopian Art, London 1986,* 110–14, figs. 148–82. London.

Mordini, A. 1953. "Il convento di Gunde Gundie," *Rassegna di Studi Etiopici* 12: 29–70.

Muir, W. 1878. *The Life of Mahomet.* London.

Mundell-Mango, M. 1986. *Silver from Byzantium: The Kaper Koraon and Related Treasures.* The Walters Art Gallery Publications in Art History. Baltimore.

Munro-Hay, S. C. 1984(A). *The Coinage of Aksum.* New Delhi.

———. 1984(B). "Aksumite Chronology: Some Reconsiderations," *Jahrbuch für Numismatik und Geldgeschichte* 34: 107–26.

———. 1989(A). "The al-Madhariba Hoard of Aksumite and Late Roman Gold Coins," *Numismatic Chronicle* 149: 83–100.

———. 1989(B). *Excavations at Aksum: An Account of the Research at the Ancient Ethiopian Capital Directed in 1972–74 by the Late Dr. Neville Chittick.* Memoirs of the British Institute in Eastern Africa 10. London.

———. 1990. "A New Silver Coin of King Aphilas of Aksum," *Numismatic Chronicle* 150: 238 and pl. 23B.

———. 1991. *Aksum: An African Civilisation of Late Antiquity.* Edinburgh.

——— Forthcoming. "The Iconography of Aksumite Coinage," paper delivered at the Second International Conference of Ethiopian Art, Nieborow, Poland, October 1990; to be published in the *Proceedings of the Second International Conference on the History of Ethiopian Art,* ed. Paul Hentze.

Muyser, J. 1937. "Le samedi et le dimanche dans l'Église et la littérature copte." In Togo Mina, *Le Martyre d'Apa Epima,* 89–111. Cairo.

Nersessian, V., and R. K. Pankhurst. 1982. "The Visit to Ethiopia of Yohannes To'vmacean, an Armenian Jeweller, in 1764–6," *Journal of Ethiopian Studies* 15: 79–84.

New York 1984. *The Treasury of San Marco Venice,* exh. cat. The Metropolitan Museum of Art.

New York 1985. *"Primitivism" in 20th Century Art,* exh. cat. The Museum of Modern Art.

Nordenfalk, C. 1938. *Die spätantiken Kanontafeln.* Goteborg.

———. 1963. "The Apostolic Canon Tables," *Gazette des Beaux Arts* 43: 17–18.

———. 1979. *Bokmålningar från medeltid och renässans i Nationalmusei samlingar.* Stockholm.

———. 1982. "Canon Tables on Papyrus," *Dumbarton Oaks Papers* 36: 29–46.

Oddy, W. A., and S. C. Munro-Hay. 1980. "The Specific Gravity Analysis of the Gold Coins of Aksum," *Metallurgy and Numismatics* 1: 73–82, pls. 2–4.

Olderogge, D. A. 1974. "L'Arménie et l'Éthiopie au IVe siècle (à propos des sources de l'alphabet arménian)," *IV Congresso Internazionale di Studi Etiopici,* vol. 1, 195–203. Accademia Nazionale dei Lincei, Quaderno 191. Rome.

Oliver, R. 1991. London. *The African Experience.*

Oudenrijn, M.-A. van den. 1959. *Gamaliel: Äthiopische Texte zur Pilatusliteratur.* Freiburg.

Pais [Paes] P. (See also Paez.) 1945. *Historia da Etiopia*. Oporto.

Pankhurst, E. S. 1955. *Ethiopia: A Cultural History*. Woodford Green.

Pankhurst, R. J. 1973. "The Library of Emperor Tewodros at Maqdala (Magdala)," *Bulletin of the School of Oriental and African Studies* 36: 15–42.

———. 1989. "The Legacy of the Magdala Collection," *Proceedings of the Eighth International Conference on Ethiopian Studies* 1, ed. Tadesse Beyene, 111–28. Addis Ababa.

Pankhurst, R. J., and R. K. Pankhurst. 1978. "Annotated Bibliography of Travel Books on Ethiopia," *Africana Journal* 9, 2: 113–32; 3: 101–33 (sic).

Pankhurst, R. K. 1961. *An Introduction to the Economic History of Ethiopia*. London.

———. 1969. "The Saint Simonians and Ethiopia," *Proceedings of the Third International Conference of Ethiopian Studies* 1, 169–223. Addis Ababa.

———. 1974. "The History of Ethiopia's Relations with India Prior to the Nineteenth Century," *IV Congresso Internazionale di Studi Etiopici*, vol. 1, 205–22. Accademia Nazionale dei Lincei, Quaderno 191. Rome.

———. 1977. "The History of Ethiopian-Armenian Relations," *Revue des études arméniennes* 12: 273–79.

———. 1979. "The Kwer'ata Re'esu: The History of an Ethiopian Icon," *Abba Salama* 10: 169–87.

———. 1982. *History of Ethiopian Towns from the Middle Ages to the Early Nineteenth Century*. Äthiopistische Forschungen 8. Wiesbaden.

———. 1984. "Early Pharaonic Contacts with the Land of Punt," *Quaderni de Studi Etiopici* 5: 5–13.

Pankhurst, R. K., and L. Ingrams. 1988. *Ethiopia Engraved*. London.

Panofsky, E. 1953. *Early Netherlandish Painting*. 2 vols. Cambridge, Mass.

Paris 1974. *Éthiopie millénaire*, exh. cat. Petit Palais.

Paris 1992. *Le roi Salomon et les maîtres du regard: Art et médecine en Éthiopie*, exh. cat. Musée national des arts d'Afrique et d'Océanie.

Parkyns, M. 1853. *Life in Abyssinia*. London.

Paulitschke, P. 1888. *Harar*. Leipzig.

Pawlos Sadwa. 1952. "Un manoscritto etiopico degli Evangeli," *Rassegna di Studi Etiopici* 11: 9–28.

Pearce, N. 1831. *The Life and Adventures of Nathaniel Pearce*. London.

Perruchon, J. 1889. "Histoire des guerres d'Amda Seyon," *Journal asiatique* 135: 271–363, 381–493.

———. 1893. *Les Chroniques de Zar'a Ya'eqob et de Baeda Maryam*. Paris.

———. 1894. "Histoire d'Eskender, d'Amda-Seyon II et de Na'od, rois d'Éthiopie," *Journal asiatique* 144: 319–66.

———, ed. and trans. 1892. *Vie de Lalibala, roi d'Éthiopie*. Paris.

Perzcel, C. F. 1989. "Ethiopian Illuminated Ornament," *Proceedings of the First International Conference on the History of Ethiopian Art*, 59–62, pls. 105–12. London.

Pirenne, J. 1961. "La date du Périple de la Mer Erythrée, *Journal asiatique* 249: 441–59.

———. 1987. "La Grèce et Saba, après 32 ans de nouvelles recherches," paper delivered at the colloquium "L'Arabie Préislamique et son environnement historique et culturel." Strasbourg.

Playne, B. 1954. *St. George for Ethiopia*. London.

———. 1965. "Suggestions on the Origin of the 'False Doors' of the Axumite Stelae," *Annales d'Éthiopie* 6: 279–80.

Plowden, W. C. 1868. *Travels in Abyssinia and the Galla Country*. London.

Powne, M. 1968. *Ethiopian Music: An Introduction*. London.

Ray, J. 1991. "Levant Ascendant: The Invasion Theory of the Origins of European Civilization," *Times Literary Supplement* (Oct. 18): 3–4.

Reid, J. M. 1968. *Traveller Extraordinary: The Life of James Bruce of Kinnaird.* London.

Rey, C. F. 1979. *The Romance of the Portuguese in Abyssinia.* London.

Ricci, L. 1991. "Ethiopian Christian Literature." In *The Coptic Encyclopedia*, ed. A. S. Atiya, vol. 3, 975–79. New York.

———, trans. 1970. *Vita di Walatta Pietros.* Corpus Scriptorum Christianorum Orientalium 316, script. aeth. 61; text, 68, script. aeth. 30 (1954).

Robecchi-Bricchetti, L. 1896. *Nell'Harar.* Milan.

Rochet d'Héricourt, C.F.X. 1841. *Voyage sur la côte orientale de la Mer Rouge, dans le pays d'Adel et le royaume de Choa.* Paris.

———. 1846. *Second voyage sur les deux rives de la Mer Rouge, dans le pays des Adels et le royaume de Choa.* Paris.

Rodinson, M. 1964. "Les 'influences juives' en Éthiopie," *Journal of Semitic Studies* 9: 11–19.

———. 1967. *Magie, médecine, et possession en Éthiopie.* La Haye.

———. 1971. *Mohammed.* London.

Rosenthal, F. 1971. "A Note on the Mandil." In *Four Essays on Art and Literature in Islam*, 63–99. Leiden.

Rüppell, W.P.S.E. 1826–31. *Atlas zu der Reise im Nordlichen Afrika.* Frankfurt.

———. 1835–40. *Neue Wirbelthiere zu Faune von Abyssinien.* Frankfurt.

———. 1838–40. *Reise in Abyssinien.* Frankfurt.

———. 1845. *Systematische Uebersicht der Vogel Nord-Ost-Afrikas.* Frankfurt.

———. 1869–73. *Ornithologie Nordost Afrikas.* Kassel.

Said, E. W. 1978. *Orientalism: Western Conceptions of the Orient.* London.

Salt, H. 1809. *Twenty-four Views Taken in St. Helena, the Cape, India, Ceylon, Abyssinia and Egypt.* London.

———. 1814. *A Voyage to Abyssinia.* London.

Schermann, T., ed. 1907. *Prophetarum vitae fabulosae.* Leipzig.

Schiller, G. 1971. *Ikonographie der christlichen Kunst*, vol. 3. Gütersloh.

Schneider, K. 1950. "Achtzahl," *Reallexikon für Antike und Christentum*, vol. 1, cols. 79–81.

Schneider, M. 1967. "Stèles funéraires arabes de Quiha," *Annales d'Éthiopie* 7: 107–22.

Schneider, R. 1972–76. "Documents épigraphiques de l'Éthiopie," *Annales d'Éthiopie* 9: 103–13; 10: 81–93; 11: 128–33.

———. 1974. "Trois nouvelles inscriptions royales d'Axoum," *IV Congresso Internazionale di Studi Etiopici*, vol. 1, 767–86. Accademia Nazionale dei Lincei, Quaderno 191. Rome.

———. 1976. "Les débuts de l'histoire éthiopienne," *Abbay* 7: 47–56.

———. 1982. "Deux inscriptions éthiopiennes," *Journal of Ethiopian Studies* 15: 125–30.

Schoff, W. H. 1912. *The Periplus of the Erythraean Sea.* New York.

Segert, S., and A.J.E. Bodrogligeti, eds. 1983. *Ethiopian Studies, Dedicated to Wolf Leslau on the Occasion of His Seventy-fifth Birthday.* Wiesbaden.

Sergew Hable Sellassie. 1972. *Ancient and Medieval Ethiopian History to 1270.* Addis Ababa.

Shahid, I. 1971. *The Martyrs of Najran: New Documents.* Brussels.

———. 1976. "The *Kebra Nagast* in the Light of Recent Research," *Le Muséon* 89: 133–78.

Shalkop, R. L. 1970. *A Comparative View of Spanish Colonial Painting*, exh. cat. The Taylor Museum of the Colorado Springs Fine Arts Center. Colorado Springs.

Shihab ad-Din. 1909. *Futuh al-Habasha.* Trans. by R. Basset as *Histoire de la conquête de l'Abyssinie par Chihab Eddin 'Ahmed ben 'Abd el Qader.* Paris.

Silverberg, R. 1972. *The Realm of Prester John.* New York.

Skehan, P. W. 1954. "An Illuminated Gospel Book in Ethiopic." In *Studies in Art and Literature for Belle da Costa Greene*, ed. Dorothy Miller, 350–57. Princeton.

Slessarev, V. 1959. *Prester John: The Letter and the Legend.* Minneapolis.

Sotiriou, G., and M. Sotiriou. 1956. *Icônes du Mont Sinai* (plates). Athens.

Spencer, D. 1967. "Trip to Wag and Northern Wallo," *Journal of Ethiopian Studies* 5: 95–108.

———. 1972. "In Search of St. Luke Ikons in Ethiopia," *Journal of Ethiopian Studies* 10: 67–95.

———. 1974. "Travels in Gojjam: St. Luke Ikons and Brancaleon Re-discovered," *Journal of Ethiopian Studies* 12: 201–20.

———. 1989. "The Discovery of Brancaleon's Paintings," *Proceedings of the First International Conference on the History of Ethiopian Art, London 1986*, 53–55, figs. 85–94. London.

Staude, W. 1959. "Étude sur la décoration picturale des églises Abba Antonios de Gondar et Dabra Sina de Gorgora," *Annales d'Éthiopie* 3: 185–250.

Steinberg, L. 1983. *The Sexuality of Christ in Renaissance Art and in Modern Oblivion*. New York.

Stella, G. C. 1984. "Carlo Conti Rossini ed i suoi scritti circa l'Etiopia e l'Eritrea," *Quaderni de Studi Etiopici* 5: 106–28.

Stevenson, E. L., ed. and trans. 1932. *The Geography of Claudius Ptolemy*. New York.

Strelcyn, S. 1968–73. *Médecine et plantes d'Éthiopie*. Warsaw and Naples.

———. 1978. *Catalogue of Ethiopian Manuscripts in the British Library acquired since the Year 1877*. London.

———. 1979. "Quelques inscriptions éthiopiennes," *Bibliotheca Orientalis* 36: 137–56.

Stuttgart 1973. *Religiöse Kunst Äthiopiens/Religious Art of Ethiopia*, exh. cat. Institut für Auslandsbeziehungen.

Taddese Beyene, R. K. Pankhurst, and Shiferaw Bekele. 1990. *Kasa and Kasa: Papers on the Lives, Times, and Images of Tewodros II and Yohannes IV (1855–1889)*. Addis Ababa.

Taddesse Tamrat. 1966. "Some Notes on the Fifteenth-Century Stephanite 'heresy' in the Ethiopian Church," *Rassegna di Studi Etiopici* 22: 103–15.

———. 1970. "The Abbots of Dabra-Hayq, 1248–1535," *Journal of Ethiopian Studies* 8: 87–117.

———. 1972(A). *Church and State in Ethiopia, 1270 to 1527*. Oxford.

———. 1972(B). "Pagan Resistance to the Ethiopian Church," *Journal of Ethiopian Studies* 10: 137–50.

———. 1974. "Problems of Royal Succession in Fifteenth-Century Ethiopia: A Presentation of the Documents," *IV Congresso Internazionale di Studi Etiopici*, vol. 1, 501–35. Accademia Nazionale dei Lincei, Quaderno 191. Rome.

———. 1977. "Ethiopia, the Red Sea and the Horn." In *The Cambridge History of Africa*. Vol. 3, *From c. 1050–c. 1600*, ed. R. Oliver, 98–182. Cambridge.

———. 1988. "Ethnic Interaction and Integration in Ethiopian History: The Case of the Gafat," *Journal of Ethiopian Studies* 21: 121–54.

Taft, R. F. 1978. *The Great Entrance: A History of the Transfer of Gifts and Other Preanaphoral Rites of the Liturgy of St. John Chrysostom*, 2d ed. Rome.

———. 1991. "Altar." In *The Oxford Dictionary of Byzantium*, ed. A. P. Kazhdan, vol. 1, 71. New York and Oxford.

Tedeschi, S. 1966. "Poncet et son voyage en Éthiopie," *Journal of Ethiopian Studies* 4: 99–126.

———. 1974. *Nuova luce sui rapporti tra Venezia e l'Etiopia (secolo XV)*. Addis Ababa.

Tooley, R. V. 1969. *Collector's Guide to Maps of the African Continent and Southern Africa*. London.

Topouzian, O. T. 1974. "Quelques aspects des villes éthiopiens d'après les sources arméniennes du XVIIème, XVIIIème, et XIXème siècles," *IV Congresso Internazionale di Studi Etiopici*, vol. 1, 793–801. Accademia Nazionale dei Lincei, Quaderno 191. Rome.

Trimingham, J. S. 1952. *Islam in Ethiopia*. London and New York.

Tubiana, J. 1966. "'Turning Point' in Ethiopian History," *Rassegna di Studi Etiopici* 21: 162–66.

Turaiev, B. 1905. *Acta S. Eustathii*, Monumenta Aethiopiae Hagiologica 3. St. Petersburg.

Uhlig, S. 1984. "Ornamente und Marginalzeichen in den äthiopischen Handschriften. Ein Vergleich mit anderen semitischen und mit koptischen Codices. *Bibliotheca Orientalis* 41: 318–35.

———. 1988. *Äthiopische Paläographie*. Äthiopistische Forschungen 22. Stuttgart.

————. 1989. "Funktion und Bedentung der Ornamente in äthiopischen Kodizes," *Proceedings of the First International Conference on the History of Ethiopian Art*, 56–58. London.

————. 1990. *Introduction to Ethiopian Paleography*, Äthiopistische Forschungen 28. Stuttgart.

Ullendorff, E. 1955. *The Semitic Languages of Ethiopia: A Comparative Phonology*. London.

————. 1968. *Ethiopia and the Bible*. London.

————. 1973. *The Ethiopians: An Introduction to Country and People*, 3d ed.; 1st ed., 1960; 2d ed., 1965. Oxford.

————, trans. and annot. 1976. *The Autobiography of Emperor Haile Sellassie I: "My Life and Ethiopia's Progress" 1892–1937*. Oxford.

Ullendorff, E., and C. F. Beckingham 1982. *The Hebrew Letters of Prester John*. Oxford.

UNESCO 1961. *Ethiopia: Illuminated Manuscripts*. Greenwich.

Varenbergh, J. 1915–16. "Studien zur abessinischen Reichsordnung (*Ser'ata Mangist*)," *Zeitschrift für Assyriologie und verwandte Gebiete* 30: 1–45.

Vassilaki, M. 1989. "A Cretan Icon of Saint George," *Burlington Magazine* 131: 208–14.

Velat, B. 1966. *Études sur le Me'eraf: Commun de l'office divin éthiopien*. Patrologia Orientalis 33, fasc. 1–4; 34, fasc. 1–2.

Vienna 1964(A). *Christliche Kunst aus Äthiopiean und Nubien*, exh. cat. Museum für Völkerkunde.

Vienna 1964(B). *Frühchristliche und Koptische Kunst*, exh. cat. Akademie der bildenden Künste.

Vikan, G. 1984. "Art, Medicine, and Magic in Early Byzantium," *Dumbarton Oaks Papers* 38: 65–86.

Volbach, W. F., and J. Lafontaine-Dosogne. 1968. *Byzanz und der christliche Osten*. Berlin.

Vööbus, A. 1954. *Early Versions of the New Testament: Manuscript Studies*. Papers of the Estonian Theological Society in Exile 6. Stockholm.

Wajnberg, I. 1936. *Das Leben des hl. Jafqerana'Egzi.'* Orientalia Christiana Analecta 106. Rome.

Walker, P.W.L. 1990. *Holy City, Holy Places?* Oxford.

Watt, W. M. 1953. *Muhammad at Mecca*. Oxford.

Weitzmann, K. 1970. "Some Remarks on the Sources of the Fresco Paintings of the Cathedral of Faras." In *Kunst und Geschichte Nubiens in Christlicher Zeit*, ed. E. Dinkler, 325–39. Recklinghausen. Reprinted in *Studies in the Arts at Sinai: Essays by Kurt Weitzmann*. Princeton 1982.

————. 1974. "Loca Sancta and the Representational Arts of Palestine," *Dumbarton Oaks Papers* 28: 31–55.

————. 1977. *Late Antique and Early Christian Book Illumination*. New York.

————. 1978. *The Icon: Holy Images – Sixth to Fourteenth Century*. New York.

Wendt, K. 1964. "Der Kampf um den Kanon Heiliger Schriften in der äthiopischen Kirche der Reformen des XV. Jahrhunderts," *Journal of Semitic Studies* 9: 107–13.

Wessel, K. 1971. "Flabellum," *Reallexikon zur byzantinischen Kunst*, vol. 2, cols. 550–55. Stuttgart.

White, T. 1991. *Catch a Fire: The Life of Bob Marley*, 2d ed. London.

Whiteway, R. S. 1902. *The Portuguese Expedition to Abyssinia in 1514–1543, as Narrated by Castanhoso*. London.

Wilkinson, J. 1977. *Jerusalem Pilgrims before the Crusades*. Warminster.

Wolff, J. 1839. *Journal*. London.

Wolska-Conus, W., ed. and trans. 1968–73. *Cosmas Indicopleustès: Topographie chrétienne*. 3 vols. Sources Chrétiennes 141, 159, 197. Paris.

Woodward, E. L. 1916. *Christianity and Nationalism in the Later Roman Empire*. London.

Wright, W. 1877. *Catalogue of the Ethiopic Manuscripts in the British Museum acquired since the Year 1847*. London.

Yacob Beyene, ed. and trans. 1990. *Giyorgis di Sagla. Il libro del Mistero (Mashafa Mestir)*. Corpus Scriptorum Christianorum Orientalium 515 and 516, script. aeth. 89 and 90.

Zaghi, C. 1972. *I russi in Etiopia*. Naples.

Zanotti-Eman, C. 1992. "Gli *areg* nei manoscritti dell'Institute of Ethiopian Studies," *Orbis Aethiopicus: Studia in honorem Stanislaus Chojnacki,* ed. P. O. Scholz. 2 vols. Bibliotheca nubica 3. Albstadt.

————. Forthcoming. "The Harag of the Manuscripts of Gunda Gundi," to be published in the *Proceedings of the Second International Conference on the History of Ethiopian Art,* ed. Paul Hentze.

Zotenberg, H. 1877. *Catalogue des manuscrits éthiopiens (Ghe'ez et Amharique) de la Bibliothèque Nationale.* Paris.

Zuurmond, R. 1989. *Novum Testamentum Aethiopice: The Synoptic Gospels, Part 1: General Introduction; Part 2: Edition of the Gospel of Mark.* Äthiopistische Forschungen 27. Stuttgart.

*Errata*

The following are corrected entries for designated endnotes and selected references.

Roderick Grierson, "Dreaming of Jerusalem," endnotes:

10. S. C. Munro-Hay 1991: 66.
13. L. Casson 1989: 5lff.
15. S. C. Munro-Hay 1991: 136.
16. B. Playne 1965: 279–80.
30. Y. Abd al-Masih and O.H.E. Burmester 1943: 330.
35. T. Houtsma 1883.
36. J. H. Kramers and G. Wiet 1964: 56.
40. W. Wolska-Conus 1968–73, vol. 1: 358.
41. Y. Abd al-Masih and O.H.E. Burmester 1943: 118.
47. A. Vööbus 1954: 253ff.
49. Y. Abd al-Masih and O.H.E. Burmester 1943: 171–72.
51. C. Conti Rossini and L. Ricci 1964: 151.
52. Quoted in Getatchew Haile 1983(B): 93–119.
53. Taddesse Tamrat 1966: 103–15.
61. R. Basset 1882: 12, 101.

Richard Pankhurst, "Ethiopia Revealed: Merchants, Travelers, and Scholars," endnotes:

5. Sergew Hable Sellassie 1972: 97–105.
15. A. T. d'Abbadie 1881: 9; I. Guidi 1901: 7; T. L. Kane 1990: 14.
17., 20., and 22. For Taddesse Tamrat 1972, read Taddesse Tamrat 1972(A).
38. E. J. van Donzel 1986.
62. A. d'Abbadie 1868; A. T. d'Abbadie 1898.
63. J. G. Galinier and P.V.Ad. Ferret 1847–48.
66. E. Blondeel van Cuelebrouck 1838–42.
69. C. W. Isenberg 1841; A. T. d'Abbadie 1881.

78. For Yacob Beyene, read Taddese Beyene.
81. E. Littmann 1904; id. 1910–15; E. Littmann et al. 1913; E. Littmann 1925.
90. R. Schneider 1972–76; id. 1976; id., in S. Segert and A.J.E. Bodrogligeti 1983: 412–16.
91. For 1956(B), read 1956(A).
96. Taddesse Tamrat 1972(A).

Taddesse Tamrat, "Church and State in Ethiopia: The Early Centuries," endnotes:

2. L. Casson 1989: 5iff.
3. W. Wolska-Conus 1968–73: 372–78.
5. Sergew Hable Sellassie 1972: 105–7.
6. T. Houtsma 1883: 219.
7. J. H. Kramers and G. W. Wiet 1964: 56.
18. Taddesse Tamrat 1972(A): 169–96.

Getatchew Haile, "Ethiopic Literature," selected references:

For Macomber, F. W. 1975, read Macomber, W. F. 1975.

Siegbert Uhlig, "Ethiopian Manuscripts and Paleography," selected references:

For Leroy, J., S. Wright, and O. A. Jäger 1961, read UNESCO 1961.

Carla Zanotti-Eman, "Linear Decoration in Ethiopian Manuscripts," endnotes:

10. J. Leroy 1962(B): 173–204.
13. A. Mordini 1953: 29–48.
14. A. T. d'Abbadie 1859: 29.